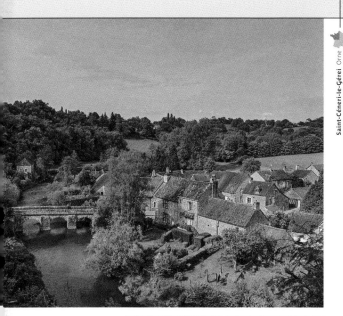

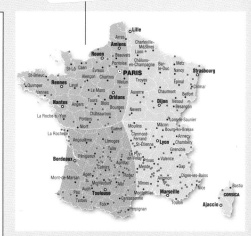

• Forêt d'Écouves, forest; Château de Carrouges (12–19 miles/19–31 km).
• Parc naturel régional Normandie-Maine, nature park; Carrouges (19 miles/31 km).
• Bagnoles-de-l'Orne (25 miles/40 km).
• Haras National du Pin, national stud (34 miles/55 km).

⁐ Did you know?
In the 15th-century chapel built on the site of the Saint Céneri hermitage, there is a statue of the hermit and a granite stela, said to have been used by him as a bed, and believed to heal incontinence. Legend has it that, if young girls pushed a needle into the feet of the saint's statue, they would be able to find a husband.

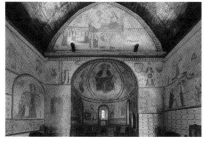

Regions introduced by a map

Selection of walks and hikes

Index of the villages

▣ Events
Markets and key events in the village calendar (fetes, festivals, exhibitions, concerts, etc.).

❦ Outdoor Activities
Excursions and activities in the open air (walking, watersports, mountain-biking, etc.).

❦ Further Afield
Tourist attractions, towns, and other Most Beautiful Villages of France (marked with an asterisk before their name) within a thirty-mile (fifty-km) radius, or a one-hour drive.

⁐ Did you know?
An anecdote, historical detail, or cultural particularity of the village.

THE MOST
BEAUTIFUL VILLAGES
OF FRANCE

Design: Audrey Sednaoui
Text pp. 272–77 by Sylvie Rouge-Pullon

English Edition
Editorial Director: Kate Mascaro
Editors: Samuel Wythe and Helen Adedotun
Editorial Assistance: David Ewing and Isabella Grive
Translated from the French by Kate Ferry-Swainson and Anne McDowall
Copyediting: Penelope Isaac
Typesetting: Claude-Olivier Four
Proofreading: Nicole Foster and Kate van den Boogert
Production: Titouan Roland
Color Separation: IGS-CP, L'Isle d'Espagnac (16)
Printed in Bosnia and Herzegovina by GPS

Simultaneously published in French as *Les Plus Beaux Villages de France:*
Guide officiel de l'Association Les Plus Beaux Villages de France
© Flammarion, S.A., Paris, 2020

First English-language edition
© Flammarion, S.A., Paris, 2016
This English-language edition
© Flammarion, S.A., Paris, 2020

editions.flammarion.com

20 21 22 3 2 1

ISBN: 978-2-08-150828-6

Legal Deposit: 03/2020

THE MOST
BEAUTIFUL VILLAGES
OF FRANCE

THE OFFICIAL GUIDE

Les Plus Beaux Villages de France®
association

Flammarion

Les Plus
Beaux Villages
de France®

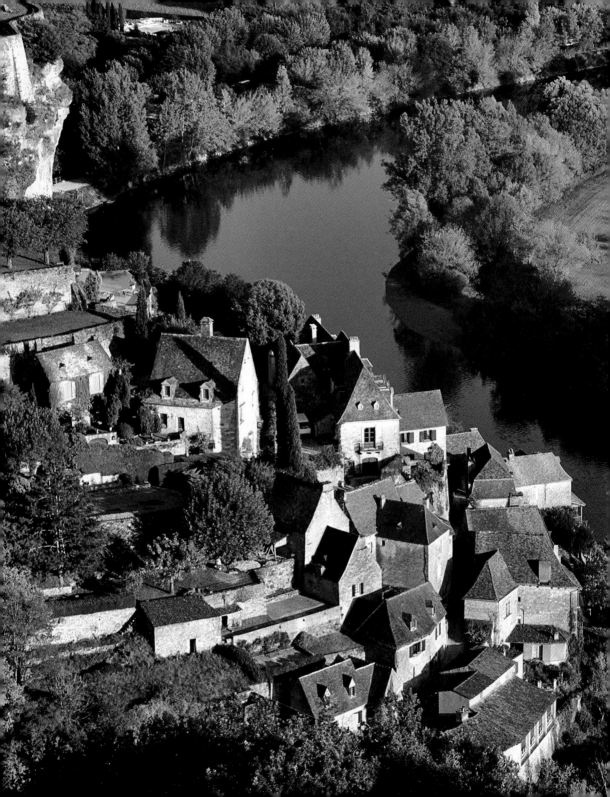

Preface

Come and discover, explore, wonder at, and stroll through The Most Beautiful Villages of France. Listen to the stones tell their story, linger on a café terrace, feel the cool water of a fountain run between your fingers, marvel at the skills of artists and craftspeople, fall asleep in a fairy-tale castle or dovecote, follow delightful walking trails, share in local celebrations and festivals, sample all the regional delicacies, and bring home choice items from the village market.

The Official Guide to the Most Beautiful Villages of France invites you to experience both simple and extraordinary pleasures, in exceptional locations that will awaken all your senses. Nearly 160 distinctive destinations—boasting a wealth of outstanding heritage and architecture, and buzzing with the vibrant energy and enthusiasm of their inhabitants—celebrate the French way of life, in all the diversity of their regions: from Alsace to the Basque Country, from Brittany to Provence, from Picardy to Languedoc, via Corsica and even the overseas department of La Réunion.

Whether you are seeking a short break or an extended vacation, whatever the season or occasion, this guide is the perfect traveling companion to help you enjoy these magical places to their fullest and to organize your stay with ease. If you are longing for a memorable rural getaway, The Most Beautiful Villages of France are ready to welcome you.

Maurice Chabert
President of Les Plus Beaux Villages de France association,
Mayor Emeritus of Gordes, in the Vaucluse

The Most Beautiful Villages of France

The association of Les Plus Beaux Villages de France® was founded in the early summer of 1981 after one man encountered a certain book. That man was Charles Ceyrac, mayor of the village of Collonges-la-Rouge in Corrèze, and the book was *Les Plus Beaux Villages de France*, published by Sélection du Reader's Digest. This book gave Ceyrac the idea of harnessing people's energy and passion to protect and promote the exceptional heritage of France's most beautiful villages. Sixty-six mayors signed up to Charles Ceyrac's initiative, which was made official on March 6, 1982 at Salers in Cantal, France.

Today, this national network of almost 160 villages works to protect and enhance the heritage of these exceptional locations in order to increase their renown and promote their economic development.

Three steps to becoming one of The Most Beautiful Villages of France

Three preliminary criteria

In the first instance, the village looking to join the association must submit an application showing that it meets the following criteria:
- a total population of no more than 2,000 inhabitants
- at least two protected sites or monuments (historic landmarks, etc.)
- proof of mass support for the application for membership via public debate

Twenty-seven evaluation criteria

If the application is accepted, the village then receives a site visit. After an interview with the local council and a photographic report have been completed, a table of twenty-seven criteria is used to evaluate the village's historical, architectural, urban, and environmental attributes, as well as its own municipal initiatives to promote the village.

The verdict of the Quality Commission

The finished evaluation report is put before the Quality Commission, which alone has the power to make decisions on whether a village should be accepted (an outcome requiring a two-thirds majority in the vote). About ten villages apply each year, and about 20% of applications are successful. The approved villages are also subject to regular reevaluation in order to guarantee each visitor an outstanding experience.

A concept that has traveled the globe

Interest in preserving and enhancing rural heritage transcends national boundaries, and several initiatives throughout Europe and the rest of the world have given rise to other associations on the French model: Les Plus Beaux Villages de Wallonie (Belgium) in 1994; Les Plus Beaux Villages du Québec (Canada) in 1998; I Borghi Più Belli d'Italia in 2001; The Most Beautiful Villages of Japan in 2005; and Los Pueblos Mas Bonitos de España in 2011. Collaborating with the Federation of the Most Beautiful Villages of the World, these associations are now taking their expertise to emerging networks.

To read more about the association, visit www.lesplusbeauxvillagesdefrance.org

Save the date

Get to know The Most Beautiful Villages of France from every angle—heritage, cuisine, craftsmanship—and in every season, by taking part in events aimed at those who enjoy the finer things in life.

- **Journées Européennes des Métiers d'Art® (European Festival of Arts and Crafts), 1st weekend in April**

- **Marché aux Vins des Plus Beaux Villages de France® (The Most Beautiful Villages of France Wine Festival), 2nd weekend in April**

- **Nuit Romantique des Plus Beaux Villages de France® (The Most Beautiful Villages of France Romantic Evening), 3rd Saturday in June**

- **Journées Européennes du Patrimoine® (European Heritage Festival), 3rd weekend in September**

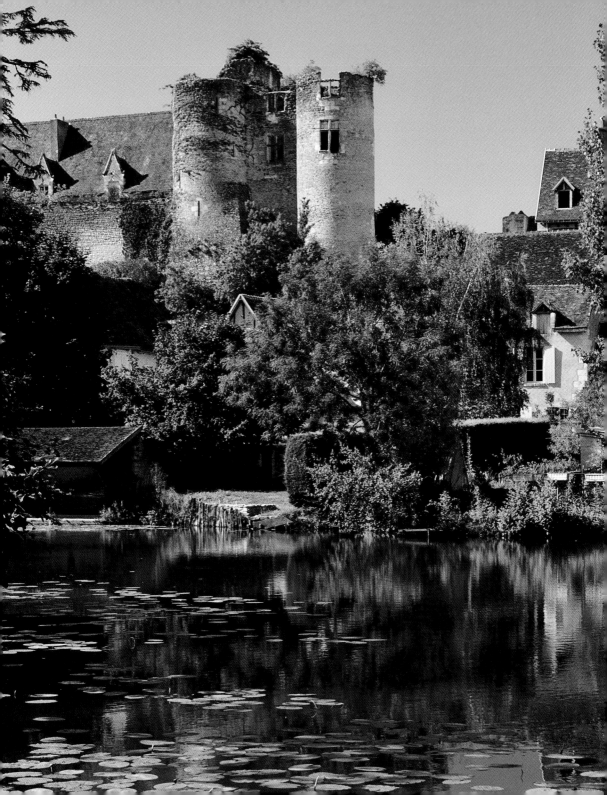

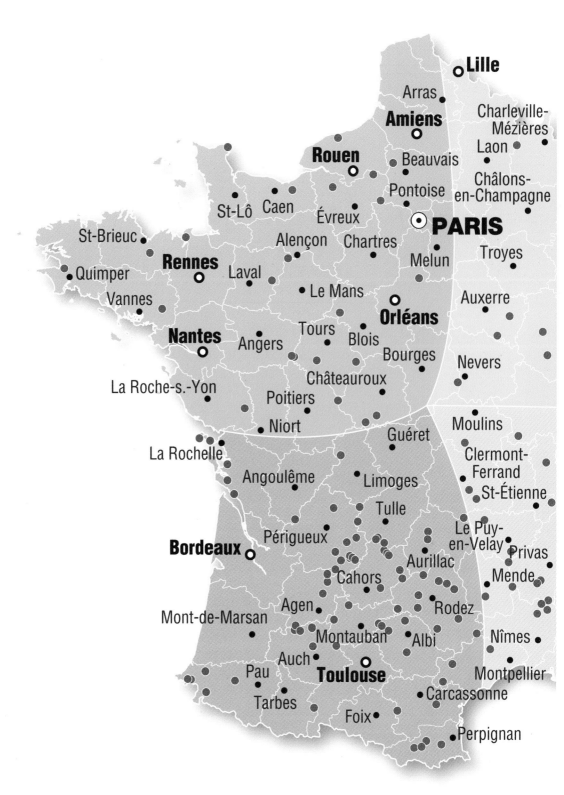

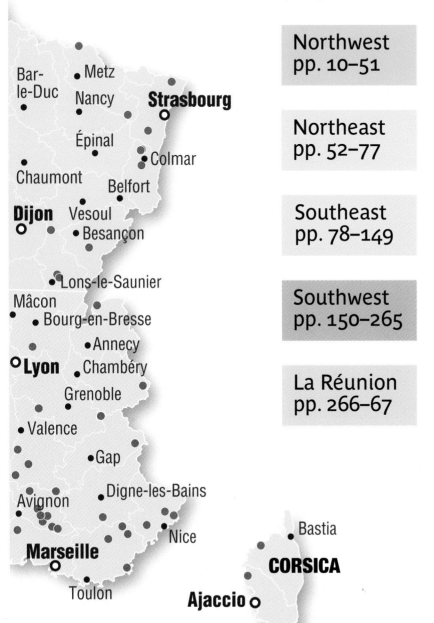

The 159 Most Beautiful Villages of France by geographical region

Northwest
pp. 10–51

Northeast
pp. 52–77

Southeast
pp. 78–149

Southwest
pp. 150–265

La Réunion
pp. 266–67

Bar-le-Duc
Metz
Nancy
Strasbourg
Épinal
Colmar
Chaumont
Belfort
Dijon
Vesoul
Besançon
Lons-le-Saunier
Mâcon
Bourg-en-Bresse
Annecy
Lyon
Chambéry
Grenoble
Valence
Gap
Digne-les-Bains
Avignon
Nice
Marseille
Toulon
Bastia
CORSICA
Ajaccio

©éditerra

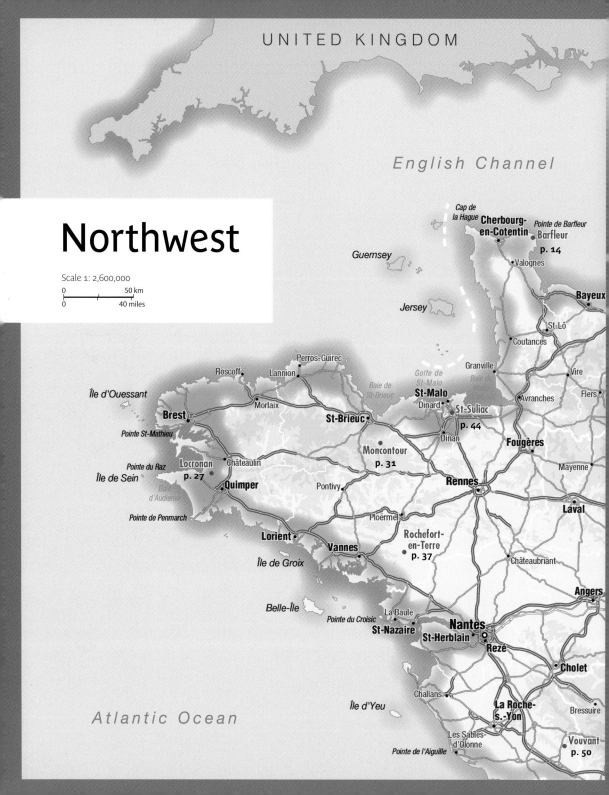

Northwest

Scale 1: 2,600,000

0 50 km

0 40 miles

UNITED KINGDOM

English Channel

Guernsey

Jersey

Cap de
la Hague

Cherbourg-
en-Cotentin

Pointe de Barfleur

Barfleur

p. 14

•Valognes

Bayeux

St-Lô•

Coutances

Vire

Granville

*Golfe de
St-Malo*

*Baie de
St-Brieuc*

Baie du

Flers

Roscoff•

Perros-Guirec

Lannion

St-Malo

Avranches

Dinard

•St-Suliac

Île d'Ouessant

Morlaix

St-Brieuc

p. 44

Dinan

Fougères

Brest

Pointe St-Mathieu

Moncontour

p. 31

Mayenne

Châteaulin

Locronan

Pointe du Raz

p. 27

Quimper

Pontivy

Rennes

Laval

Île de Sein

*Baie
d'Audierne*

Ploërmel

Pointe de Penmarch

Rochefort-
en-Terre

p. 37

•Châteaubriant

Lorient

Vannes

Île de Groix

Angers

Belle-Île

Pointe du Croisic

La Baule

Nantes

St-Nazaire

St-Herblain

Rezé

Cholet

Challans•

Atlantic Ocean

Île d'Yeu

**La Roche-
s.-Yon**

Bressuire

Les Sables-
d'Olonne

Vouvant

p. 50

Pointe de l'Aiguille

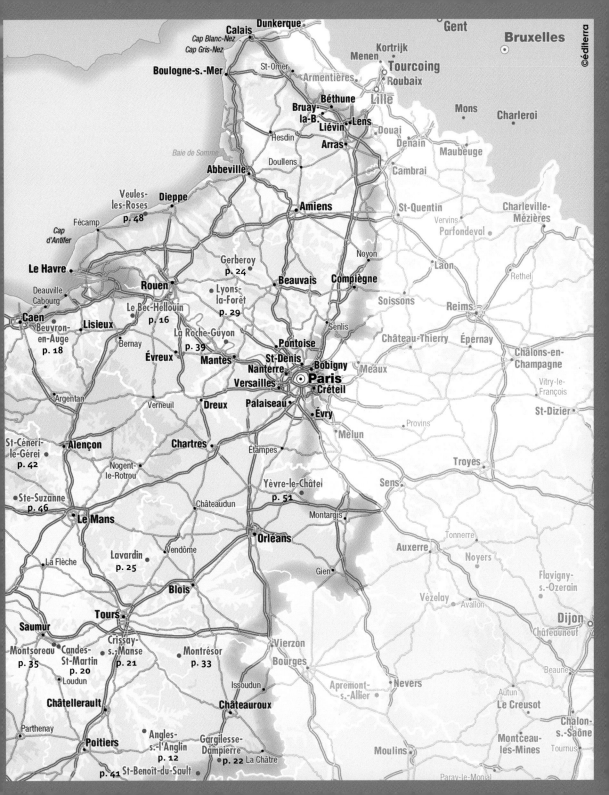

Angles-sur-l'Anglin
Traditional skills and ancient wall carvings

Vienne (86) • Population: 395 • Altitude: 331 ft. (101 m)

The *jours* (openwork embroidery) of Angles is a traditional skill that is still practiced in this village on the banks of the Anglin.

From the top of the cliff, the ruins of the fortress, built by the counts of Lusignan between the 11th and 15th centuries, overlook the river. At the top of the village, the Église Saint-Martin, with its Poitiers-style Romanesque bell tower, stands next to the 12th-century Chapelle Saint-Pierre. The "Huche Corne" offers a magnificent view of the lower part of the village, where the Chapelle Saint-Croix, an old abbey church with a 13th-century doorway, faces the river, which is bordered with weeping willows. With its old bridge and its mill wheel, this romantic environment is the perfect spot for providing artists with inspiration. Several lanes—les Chemins de la Cueille, le Truchon, l'Arceau, and la Tranchée des Anglais—run from top to bottom of the village and are lined with pretty pale stone houses. Nearby, the site of the Roc aux Sorciers (Sorcerers' Rock) houses a unique Paleolithic frieze carved into rock 15,000 years ago, which is now protected.

Angles has been famous for its *jours* for 150 years. Threads are drawn from fabric (such as linen or cotton) using very fine and sharp scissors, and the openings are then embellished with embroidery. Angles has for many years provided Parisian department stores with luxury lingerie.

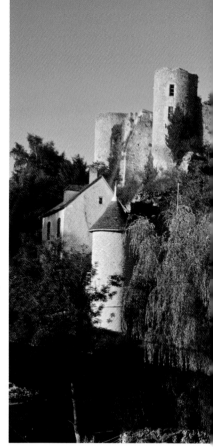

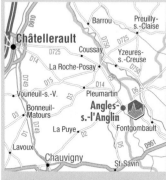

By road: Expressway A10, exit 26– Châtellerault Nord (22 miles/35 km). **By train:** Châtellerault (21 miles/34 km) and Poitiers (31 miles/50 km) TGV stations. **By air:** Poitiers-Biart airport (37 miles/60 km).

ⓘ Tourist information:
+33 (0)5 49 21 05 47
www.tourisme-chatellerault.fr

👁 Highlights
• **Forteresse d'Angles** (July and August): Remains of the fortress built in the 11th–15th centuries.
• **Maison des Jours d'Angles et du Tourisme:** Demonstration of the *jours* technique and sale of embroidered linen. Further information:
+33 (0)6 82 00 78 95.
• **Village:** Guided tour Fridays at 3 p.m. for individuals; groups by appointment only: +33 (0)5 49 21 05 47.

🗝 Accommodation
Hotels
♥ Le Relais du Lyon d'Or***:
+33 (0)5 49 48 32 53.
Guesthouses
Artemisia 🍴🍴🍴: +33 (0)5 49 84 01 83.
L'Atelier des Sources: +33 (0)6 03 00 04 00.
La Forge: +33 (0)6 79 63 19 06.
Le Grenier des Robins:
+33 (0)5 49 48 60 86.
La Ligne: +33 (0)6 18 34 17 96.
Lorna and Tony Wilkes:
+33 (0)5 49 48 29 85.

Mon Plaisir: +33 (0)6 84 73 54 61.
Le Petit Oiseau: +33 (0)5 49 48 14 67.
Gîtes and vacation rentals
www.tourisme-chatellerault.fr

🍴 Eating Out
Le 15, tea room: +33 (0)5 49 91 01 25.
Au P'tit Roc: +33 (0)5 49 91 34 92.
L'Amaretto, pizzeria: +33 (0)5 49 48 57 89.
Le Donjon de Bacchus: +33 (0)5 49 84 36 02.
Le Relais du Lyon d'Or: +33 (0)5 49 48 32 53.

🛍 Local Specialties
Food and Drink
Broyé du Poitou (butter cookies).
Art and Crafts
Antiques • *Jours* (openwork embroidery) • Artists • Cross-stitch, lace, gifts • Wood carving • Fashion design and pattern-making workshops.

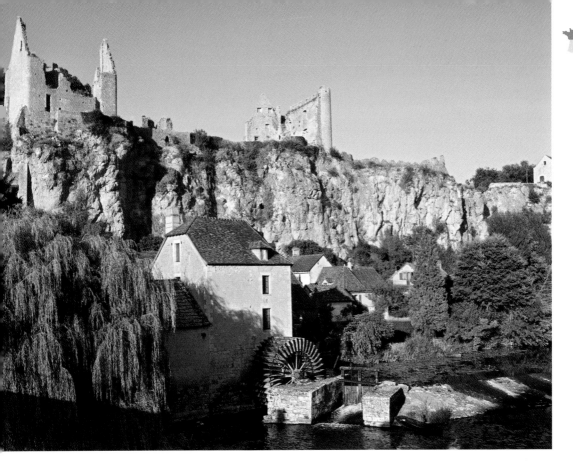

2 Events

April: Spring flea market (Easter weekend)
May–October: Exhibitions.
June: Journée du Petit Patrimoine de Pays, local heritage day.
July: Crafts days (weekend of 14th); "Lumières Médiévales," costumed tour of the village by candlelight (3rd Saturday)
August: firework display with music (1st Sunday); "Des Livres et Vous," book festival (week of 15th).
September: Journées du Patrimoine, local heritage days; flea market.
November: Rouge et Or (arts and crafts fair).

Outdoor Activities

Canoeing • Rock climbing • Fishing • Walking • Mountain-biking • *Pétanque.*

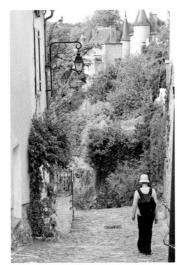

Further Afield

• Parc Naturel Régional de la Brenne (3½ miles/6 km).
• Abbaye de Fontgombault (5½ miles/9 km).
• Musée Mado Rodin, Yseures-sur-Creuse (7½ miles/12 km).
• La Roche-Posay (7½ miles/12 km).
• Abbaye de Saint-Savin (10 miles/16 km).
• Le Blanc (11 miles/18 km).
• Archigny: Ferme Musée Acadienne (15 miles/24 km).
• Chauvigny (16 miles/26 km).
• Le Grand-Pressigny (20 miles/32 km).
• Parc de la Haute-Touche (21 miles/34 km).
• Futuroscope, theme park (30 miles/48 km).
• Poitiers (31 miles/50 km).

Barfleur
A port facing England

Manche (50) • Population: 600 • Altitude: 10 ft. (3 m)

In the Middle Ages, Barfleur was the principal port on the Cotentin Peninsula, and the village's history is tied to that of the dukes of Normandy and England.

It was a man from Barfleur named Étienne who, in 1066, carried William on the longship *Mora* to conquer England. In 1120 William Adelin (heir to King Henry I of England) and Henry's illegitimate son Richard perished when the *White Ship* ran aground at Barfleur Point. In 1346, at the beginning of the Hundred Years War, the English returned to the port, which they looted and burned. The 11th-century Romanesque church, which occupied the present-day site of the lifeboat station, was replaced by the Église Saint-Nicolas, built between the 17th and 19th centuries. Surrounded by its maritime cemetery, the building contains—by way of an ex-voto—a three-masted whaleboat, offered at the birth of the artist Paul Blanvillain (1891–1965). The Chapelle de la Bretonne, built in 1893 by the people of Barfleur in honor of the beatification of Marie-Madeleine Postel, features some remarkable stained-glass windows tracing the life of the saint, as well as numerous statues adorning its walls. Alongside humble fishermen's cottages surrounded by pretty little gardens, the opulent-looking houses of the Cour Sainte-Catherine (15th century), facing the fishing port and marina, are built—like those of the Bourg, La Bretonne, and the old Augustinian Priory (18th century)—from the gray granite that is part of Barfleur's austere charm.

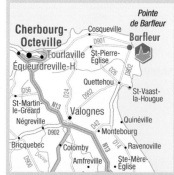

By road: N13, exit Valognes (16 miles/26 km); expressway A84, exit 40–Cherbourg (66 miles/106 km). By train: Valognes station (16 miles/26 km); Cherbourg station (17 miles/ 27 km). By air: Cherbourg-Maupertus airport (11 miles/ 18 km).

ⓘ Tourist information:
+33 (0)2 33 54 02 48
www.barfleur.fr

👁 Highlights
• **Église Saint-Nicolas:** Built in the 17th–19th centuries on a rocky promontory at the center of a maritime cemetery, it is in the classical style and contains a superb Visitation by the Flemish school of the 16th century, which is listed as a historic monument.
• **Old Augustinian Priory** (18th century) and its garden.
• **Chapelle de la Bretonne:** Listed stained-glass windows tracing the life of Marie-Madeleine Postel.
• **Cour Sainte-Catherine:** The remains of a former mansion (late 15th–early 16th century).
• **Lifeboat station:** The first lifeboat station to be built in France, in 1865, modeled on English ones.
• **Village:** Guided tour in summer. Further information: +33 (0)2 33 54 02 48.

🗝 Accommodation
Hotels
Le Conquérant**: +33 (0)2 33 54 00 82.
Guesthouses, gîtes, walkers' lodges, vacation rentals, and campsites
Further information: +33 (0)2 33 54 02 48
www.barfleur.fr

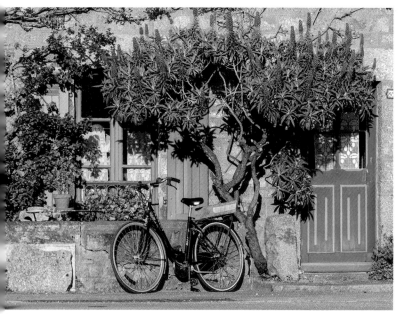

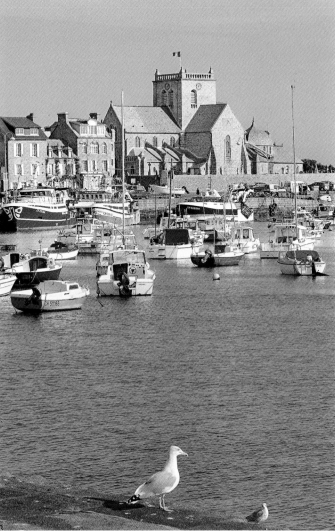

🍴 Eating Out

Café de France: +33 (0)2 33 54 00 38.
Chez Buck, crêperie: +33 (0)2 33 54 02 16.
Le Comptoir de la Presqu'île:
+33 (0)2 33 20 37 51.
La Marée: +33 (0)2 33 20 81 88.
Le Phare: +33 (0)2 33 54 10 33.

Local Specialties

Food and Drink
Shellfish and fish.
Art and Crafts
Antique dealer • Decoration • Art gallery •
Ceramic artist.

📅 Events

Market: Tuesday and Saturday in summer
(Saturday off-season), 8 a.m.–1 p.m.,
Quai Henri-Chardon.
June–August: Painting and sculpture
exhibitions.
Late July to early August: Été Musical
de Barfleur, classical music festival.
August: Village des Antiquaires, antiques
fair (3rd or 4th weekend).

🦋 Outdoor Activities

Walking: Route GR 223; hiking and
mountain-biking trails.
Watersports: Sailing, kayaking, diving.

🦋 Further Afield

• Barfleur Point (2 miles/3 km).
• Gatteville lighthouse (2 miles/3 km).
• Montfarville: church and its paintings
(2 miles/3 km).
• La Pernelle: viewpoint (4½ miles/7 km).
• Saint-Vaast-la-Hougue: Vauban towers
(9½ miles/15.5 km).
• Valognes, "the Versailles of Normandy"
(16 miles/26 km).

• Cherbourg; Cité de la Mer, science park
(18 miles/29 km).
• Château de Bricquebec (24 miles/39 km).

🍴 Did you know?

Some come here just for the Barfleur
"Blonde." This wild mussel, from
natural beds near the port, is best
eaten between June and September.

Le Bec-Hellouin

Spiritual resting place in the Normandy countryside

Eure (27) • Population: 419 • Altitude: 164 ft. (50 m)

Between Rouen and Lisieux, this typical Normandy village takes its name from both the stream that flows alongside it and the founder of its famous abbey. The abbey at Bec was founded in 1034, at the time of William the Conqueror, duke of Normandy and England's first Norman king. Its first abbot was Herluin (Hellouin), knight to the count of Brionne. Both Lanfranc and Anselm followed Herluin into the abbey and were trained by him; both left their mark on Western Christianity. Lanfranc was a scholar and teacher who developed the abbey school; he served as archbishop of Canterbury in England from 1070 to 1089. Saint Anselm, philosopher and theologian, succeeded Lanfranc as prior of Bec Abbey and became abbot on the death of Herluin in 1078. He also became archbishop of Canterbury (1093–1109). Destroyed and rebuilt several times, Bec Abbey fell into ruin during the French Revolution and Napoleon's Empire. The only remaining part of the medieval abbey complex is the tower of Saint-Nicolas (15th century), which still dominates the site. In 1948 new life was breathed into the abbey by the arrival of a community of Benedictine monks. While Le Bec-Hellouin certainly owes its reputation to the religious prestige of this remarkable building, the village itself is also well worth visiting, with its half-timbered houses and flower-decked balconies nestling in the heart of a verdant landscape of woodland and fields.

By road: Expressway A28, exit 13– Le Neubourg-Brionne (3½ miles/5.5 km).
By train: Brionne station (4½ miles/7 km); Bernay station (16 miles/26 km).
By air: Deauville-Saint-Gatien airport (34 miles/54 km).

(i) Tourist information—Bernay de Terres de Normandie: +33 (0)2 32 44 05 79
www.bernaynormandie.fr
www.lebechellouin.fr

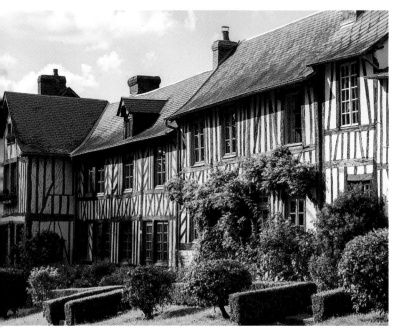

👁 Highlights

• **Abbaye de Notre-Dame-du-Bec:** Maurist (Congregation of Saint Maur) architecture of 17th and 18th centuries; abbey church, cloisters. Further information: +33 (0)2 32 43 72 60.
• **Église de Saint-André** (14th century): Important 13th–18th-century statuary.
• **Organic farm:** production and research site, permaculture school, resource center for permaculture. Further information: +33 (0)2 32 44 50 57.
• **Village:** Guided tours Tuesday 2.30 p.m. in summer, by tourist information center.

🔑 Accommodation

Hotels
Auberge de l'Abbaye***: +33 (0)2 32 44 86 02.
Guesthouses
L'Atelier de Tess: +33 (0)2 27 19 46 25.
La Parenthèse: +33 (0)2 32 45 97 51.
Gîtes and vacation rentals
Further information: +33 (0)2 32 44 05 79
www.bernaynormandie.fr
Campsites
Camping Saint-Nicolas*** (March 15–October 15): +33 (0)2 32 44 83 55.

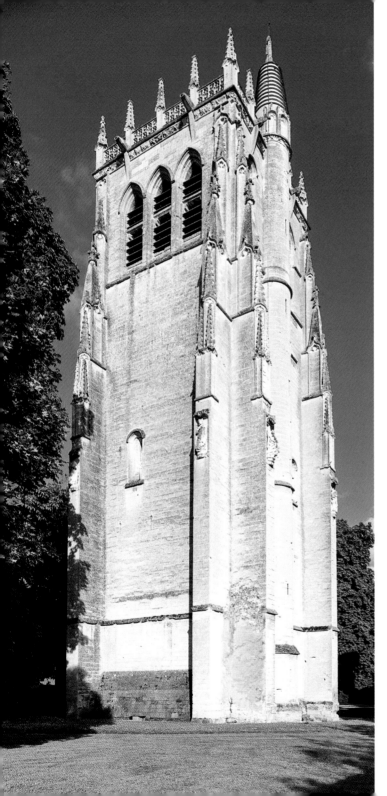

🔔 Eating Out

L'Antre de Cloches, tea room:
+33 (0)6 16 51 63 07.
L'Archange, crêperie: +33 (0)2 32 43 67 64.
Auberge de l'Abbaye: +33 (0)2 32 44 86 02.
La Crêpe dans le Bec, crêperie:
+33 (0)2 32 47 24 46.
Restaurant de la Tour:
+33 (0)2 27 19 61 44.

🧺 Local Specialties

Food and Drink
Organic produce • Chocolates and cookies.
Art and Crafts
Art and antiques • Monastic crafts •
Art gallery • Interior designer • Cabinet
of curiosities.

2️⃣ Events

June: "Festival Aquarelle," watercolor
festival (every other year).
July: General sale (closest Sunday to 14th).
July–August: Exhibitions of painting
and sculpture.
August: Les Estivales du Bec, festival of
local produce and crafts (1st weekend).

🦋 Outdoor Activities

Horse-riding • Fishing (Bec stream) •
Walking (3 marked trails) and green route
(27 miles/43 km) of multi-trail paths along
the former railway line (walking, cycling,
roller-skating).

🌿 Further Afield

• Brionne: keep, former law court,
watersports on the lake (3½ miles/5.5 km).
• Harcourt: castle, arboretum
(6 miles/10 km).
• Sainte-Opportune-du-Bosc: Château
de Champ-de-Bataille (8½ miles/13.5 km).
• Le Neubourg: Musée de l'Ecorché
d'Anatomie, museum of anatomy
(11 miles/18 km).
• Pont-Audemer, "the Venice of
Normandy": Musée A.-Canel, museum
(12 miles/19 km).
• Bernay: museum, abbey church
(14 miles/23 km).
• Beaumesnil: museum, castle, gardens
(24 miles/39 km).
• Évreux: cathedral, Gisacum religious
sanctuary (27 miles/43 km).
• Rouen (27 miles/43 km).

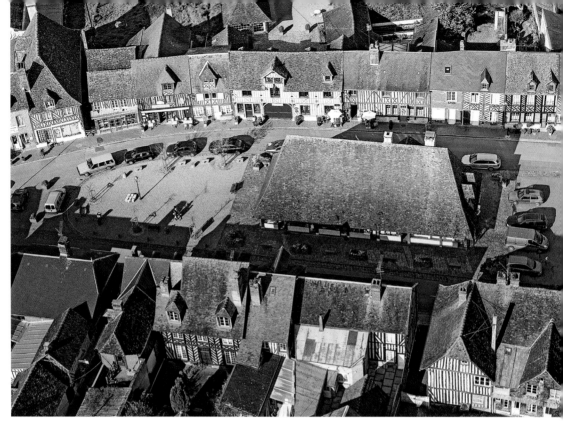

Beuvron-en-Auge
The flavors of Normandy

Calvados (14) • Population: 246 • Altitude: 33 ft. (10 m)

Nestled between valleys dotted with apple trees and half-timbered farmhouses, Beuvron, centered around its covered market, is a showcase for the Pays d'Auge.

In the 12th century, Beuvron consisted of only a small medieval castle and a church. By the end of the 14th century, however, reflecting the fame of the resident Harcourt family, the town was in its heyday. This Norman family with royal connections helped establish the town's commercial activities right up until the French Revolution, and built the present church and chapel of Saint-Michel de Clermont overlooking the Auge valley. Bedecked with geraniums and decorated in rendered plaster or pink brick, the façades of the wooden-frame houses recall the village's four centuries of glory, while the steep roofs are covered with slates or tiles. The houses and businesses huddle around the magnificently restored covered market. On the edge of the village, farms, manors, and stud farms stretch out into the woods and farmland, keeping alive the region's local traditions and specialties.

By road: Expressway A13, exit 29–Cabourg (4½ miles/7 km). By train: Lisieux station (18 miles/29 km); Caen station (19 miles/31 km). By air: Caen-Carpiquet airport (26 miles/42 km).

ⓘ Tourist information:
+33 (0)2 31 39 59 14
www.beuvroncambremer.fr
www.beuvron-en-auge.fr

👁 Highlights
• **Church** (17th century): 18th-century main altar, stained-glass windows by Louis Barillet, pulpit in Louis XVI style.
• **Chapelle de Saint-Michel-de-Clermont** (12th–17th century): Statues of Saints Michael and John the Baptist.
• **Stud farm Haras de Sens:** Visit a stud farm that breeds, raises, and trains horses; groups by appointment only: +33 (0)2 31 79 23 05.
• **Espace des Métiers d'Art:** In the former school are five art and craft studios, and a multipurpose exhibition space. Further information: +33 (0)2 31 39 59 14.
• **Village:** Guided visits for individuals in summer, and for groups by reservation. Further information: +33 (0)2 31 39 59 14.

🔑 Accommodation
Guesthouses
Le Clos Fleuri 🔑🔑🔑: +33 (0)2 31 39 00 62.
Aux Trois Damoiselles:
+33 (0)2 31 39 61 38.
Domaine d'Hatalaya: +33 (0)2 31 85 46 41.
Lieu Bazin: +33 (0)2 31 79 10 20.
Manoir de Sens: +33 (0)2 31 79 23 05.
Le Pavé d'Hôtes: +33 (0)2 31 39 39 10.
Le Pressoir: +33 (0)6 83 29 42 52.
Gîtes
M. Patrick De Labbey 🔑🔑🔑:
+33 (0)2 31 79 12 05.
Le Pressoir des Hauts de Clermont 🔑🔑🔑:
+33 (0)2 31 82 17 65.
Le Camélia: +33 (0)6 98 25 51 84.
RV parks
Further information: +33 (0)2 31 39 59 14.

🍴 Eating Out
Le Boogie Blues, bistro:
+33 (0)2 31 28 35 62.
Le Café du Coiffeur: +33 (0)2 31 79 25 62.
Le Café Forges: +33 (0)2 31 74 01 78.
La Colomb'Auge, crêperie:
+33 (0)2 31 39 02 65.
L'Orée du Village: +33 (0)2 31 79 49 91.
Le Pavé d'Auge: +33 (0)2 31 79 26 71.

🏆 Local Specialties
Food and Drink
Cider AOC, Beuvron cider • Calvados.
Art and Crafts
Antique dealers • Artists' studios • Fashion designer • Painter • Sculptor, *Santon* (crib figure) maker, animal painter • Ceramic artist • Cabinetmaker

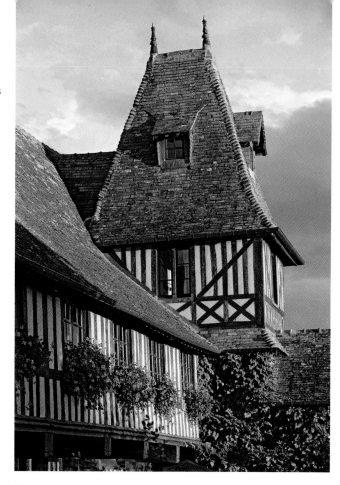

📅 Events
May: Geranium fair, torchlit festival, Boogie blues at Sens stud farm.
July: Antiques fair.
July–August: Art and craft exhibitions.
August: Grand flea market.
October: Large market and traditional cider festival, boogie-woogie at Sens stud farm.
December: Christmas market.

🦋 Outdoor Activities
Fishing • Walking (one marked trail).

🌿 Further Afield
• Manor houses and castles in the Beuvron region (½–6 miles/1–9.5 km).
• Cambremer (6 miles/9.5 km).
• Canon, castle (9½ miles/15 km).
• Côte Fleurie, coast in bloom, Cabourg (9½ miles/15 km).
• Deauville (17 miles/28 km).
• Caen (19 miles/31 km).

⚑ Did you know?
The covered market in Beuvron's main square is not as old as it looks. It was actually built in 1975 on the site of the previous market building, using materials recycled from farms and barns set to be demolished when the Normandy expressway was being built.

Candes-Saint-Martin · Indre-et-Loire

Candes-Saint-Martin

Bright reflections where rivers meet

Indre-et-Loire (37) • Population: 229 • Altitude: 131 ft. (40 m)

Built on a hillside, Candes gazes at its own reflection in the waters of the Vienne and Loire. Springing up where two rivers merge, Candes was for centuries a village of barge people, who contributed to the busy traffic on the Loire and the Vienne by selling local wines, plum brandies, and tufa stone from their *toues* (traditional fishing boats) and barges on the Loire. Indeed, the striking whiteness of tufa stone beneath the dark slate and tiled roofs still brightens the houses and the imposing collegiate church in the village. Built between 1175 and 1225 and fortified in the 15th century, the church is dedicated to Saint Martin, the bishop of Tours, who brought Christianity to Gaul. One of its stained-glass windows recreates the nocturnal removal of his body by monks from Tours. More than sixteen centuries after his death, Saint Martin is still revered through legends of his many miracles. Undoubtedly the best tells the story of how, when his remains were taken by boat to Tours on November 11, 397, the banks of the Loire burst into unseasonal summer blooms. This was the first ever *été de la Saint-Martin*—also known as an Indian summer.

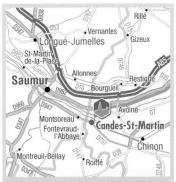

By road: Expressway A85, exit 5–Bourgueil (6 miles/9.5 km). **By train:** Saumur station (8½ miles/13.5 km); Saint-Pierre-des-Corps TGV station (42 miles/68 km). **By air:** Tours-Saint-Symphorien airport (43 miles/69 km).

ⓘ Tourist information—Azay–Chinon
Val de Loire: + 33 (0)2 47 93 17 85
www.azay-chinon-valdeloire.com

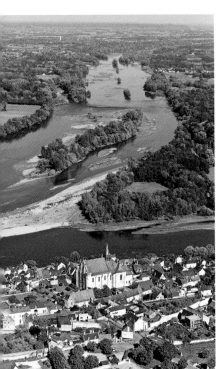

👁 Highlights
• **Collégiale Saint-Martin,** collegiate church (12th and 13th centuries): Plantagenet Gothic style, fortified in the 15th century.
• **Centre Permanent d'Initiative à l'Environnement du Patrimoine Fluvial:** Find out about the area's river heritage; boat trips in July and August: +33 (0)2 47 95 93 57.
• **Village:** Guided tours given by the Association des Amis de Candes: +33 (0)2 47 95 90 71.

🗝 Accommodation
Guesthouses
La Basinière: +33 (0)2 47 95 98 45.
Gîtes and vacation rentals
Le Gîte de la Confluence ▮▮▮▮:
+33 (0)2 45 95 87 12.
Le Logis de la Renaissance ▮▮▮:
+33 (0)2 41 62 25 21.
Le Château de Candes:
+33 (0)6 86 37 06 33 or (0)6 61 09 65 61.
Les Lavandières: +33 (0)2 47 95 86 62.
Le Moulin Saint-Michel: +33 (0)2 41 51 18 23.
Campsites
Camping Belle Rive: +33 (0)2 47 97 46 03.

🍽 Eating Out
La Brocante Gourmande, bookshop and tea room: +33 (0)2 47 95 96 39.
L'Onde Viennoise, brasserie:
+33 (0)2 47 95 90 66.
La Route d'Or: +33 (0)2 47 95 81 10.

🧺 Local Specialties
Food and Drink
AOC wines from Tours, Chinon-Tours, and Saumur-Tours.
Art and Crafts
Ceramic artist • Silver- and goldsmith • Perfumer • Photographer • Painter.

📅 Events
Country market: Saturday mornings, 9 a.m.–1 p.m., east car park.
Throughout the year: Concerts: +33 (0)2 47 95 90 61.
July and August: "Flâneries Piétonnes" (village closed to traffic, various activities): Sundays 2–6 p.m.; village festival.
November: Fête de la Saint-Martin.

🦋 Outdoor Activities
Bathing: Confluence beach (no lifeguard) • Fishing • Boat trips • Walking: path along the Loire, via Sancti Martini • Cycling: "Loire à Vélo" trail.

🌿 Further Afield
• *Montsoreau (½ mile/1 km), see pp. 35–36.
• Abbaye de Fontevraud (4½ miles/6.5 km).
• Seuilly: La Devinière, Rabelais's house (9½ miles/15.5 km).
• Chinon (11 miles/18 km).
• Châteaux of the Loire and Indre (12–23 miles/19–37 km).
• *Crissay-sur-Manse (24 miles/39 km), see p. 21.

20

Crissay-sur-Manse
A backdrop of tufa stone in the Touraine

Indre-et-Loire (37) • Population: 109 • Altitude: 197 ft. (60 m)

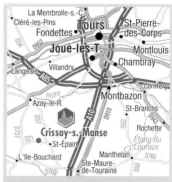

Known as "Chryseio" in the 9th century (meaning "place where a fortress stands"), Crissay has retained its castle, its houses, its gardens, and two washhouses bordering the river Manse, which meanders beneath the poplars.

In the 15th century, the Château de Crissay was built on the foundations of an old fortress belonging to the Turpin de Crissé family. Of this seigneurial residence, which was never completed nor lived in, there remains only the main building, the keep from the 11th and 12th centuries, and underground shelters. Built at the instigation of the Turpins and finished in 1527, the church contains two 16th-century wooden statues representing Saint John and the Virgin, a piscina with floral *rinceaux* in the chancel, and the tomb of Catherine du Bellay, a cousin of the poet Joachin du Bellay (c. 1522–1560). On the upper square, the 15th-century houses recall Crissay's golden age with their mullioned windows and ridged dormers.

👁 Highlights
• **Castle** (15th century): By appointment only: +33 (0)6 86 40 97 96.
• **Église Saint-Maurice** (16th century): 16th-century statues.
• **Village**: Guided tour by appointment: +33 (0)2 47 58 54 05.

🗝 Accommodation
Hotels
L'Auberge de Crissay:
+33 (0)2 47 58 58 11.
Guesthouses
Indian Dream, teepees:
+ 33 (0) 6 67 87 16 39.
Les Vallées: +33 (0)2 47 97 07 81.

Gîtes
Rochebourdeau 🏠🏠🏠: +33 (0)2 47 95 23 84.
La Vieille Chaume 🏠🏠🏠: +33 (0)2 47 97 07 33.
La Grand Croix: +33 (0)7 81 87 72 05.
Le Puy Renault: +33 (0) 6 72 82 74 87.

🍴 Eating Out
L'Auberge de Crissay, wine bar/restaurant:
+33 (0)2 47 58 58 11.

🏛 Local Specialties
Food and Drink
Goat cheeses • Honey • Chardonnay, *vin de pays*, and AOC Chinon wine.
Art and Crafts
Art galleries • Historic bookshop.

By road: Expressway A10, exit 25–Saint-Maure-de-Touraine (7½ miles/12 km).
By train: Noyant-de-Touraine station (6 miles/9.5 km); Tours station (29 miles/47 km); Saint-Pierre-des-Corps TGV station (30 miles/48 km).
By air: Tours-Saint-Symphorien airport (31 miles/50 km).

ⓘ **Town hall:** +33 (0)2 47 58 54 05
www.crissaysurmanse.fr

📅 Events
February: Children's carnival.
April: Walk (3rd Sunday).
Pentecost Sunday: Foire aux "Vieilleries," rummage sale.
June: Feast of St. Jean.
July: Graffiti artists at the castle; festivals of art and performing arts.
August: Native American weekend; classical and modern theater.

🌾 Outdoor Activities
Walking: 2 marked trails • *Boules* playing field • Communal garden • Park • Fishing.

🌿 Further Afield
• Roches-Tranchelion: collegiate church (1 mile/1.5 km).
• Vienne valley: from Île-Bouchard to Chinon (4½–14 miles/7–23 km).
• Panzoult: Cave des Vignerons, sculpted wine cellars (4½ miles/ 7 km).
• Tavant: church frescoes (7 miles/11 km).
• Azay-le-Rideau: castle (12 miles/19 km).
• *Candes-Saint-Martin (24 miles/39 km), see p. 20.
• *Montsoreau (24 miles/39 km), see pp. 35–36.

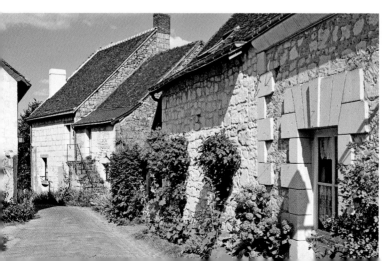

Gargilesse-Dampierre

Inspiration for a novelist

Indre (36) • Population: 325 • Altitude: 476 ft. (145 m)

This romantic village, with its harmonious houses overlooked by the château and church, stretches out over a sloping headland rich in vegetation. In 1844, novelist George Sand discovered this village, whose "houses are grouped around the church, planted on a central rock, and slope down along narrow streets toward the bed of a delightful stream, which, a little further on and lower down, loses itself in the Creuse." Only a postern and two round towers survive of the medieval castle, the rest of which was destroyed in 1650 during the Fronde (civil wars, 1648–53) and the extant château was built on its ruins in the 18th century. The 11th–12th-century Romanesque church, with its fine white limestone stonework, adjoins it. Its nave houses a set of capitals decorated with narrative scenes, including the Twenty-Four Elders (Revelation 4:4) at the crossing and scenes from the Old and New Testaments in the apses. The crypt is decorated with 12th–16th-century frescoes of rare beauty, representing the instruments of the Passion and various scenes from the lives of Christ and Mary. Following in the footsteps of Claude Monet, many artists—such as Paul Madeline (1863–1920) and Anders Österlind (1887–1960)—have been inspired by the charm of the village.

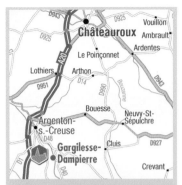

By road: Expressway A20, exit 17–Argenton-sur-Creuse (11 miles/18 km).
By train: Argenton-sur-Creuse station (8 miles/13 km); Châteauroux station (25 miles/40 km). **By air:** Limoges-Bellegarde airport (62 miles/100 km).

ⓘ **Tourist information:**
+33 (0)2 54 47 85 06
www.gargilesse.fr

◉ Highlights

• **Château** (18th century): Art gallery: +33 (0)6 81 19 65 53.
• **Romanesque church** (12th century): Capitals decorated with narrative scenes, including the Twenty-Four Elders from Revelation and scenes from the Old and New Testaments; crypt, 12th–16th-century frescoes representing the instruments of the Passion and various scenes from the lives of Christ and Mary; painted wood Virgin (12th century); guided tour daily in summer: +33 (0)2 54 47 85 06.
• **"Villa Algira," Maison de George Sand:** Collection of the author's personal effects in her former vacation home: +33 (0)2 54 47 70 16.
• **Musée Serge Delaveau:** Collection of works by the painter who lived at Gargilesse. Further information: +33 (0)2 54 47 85 06.

⚷ Accommodation
Hotels
Les Artistes: +33 (0)2 54 47 84 05.
Guesthouses
Le George Sand: +33 (0)2 54 47 83 06.
Le Haut Verger: +33 (0)9 53 54 17 78.
Gîtes
Further information: +33 (0)2 54 47 85 06
www.gargilesse.fr

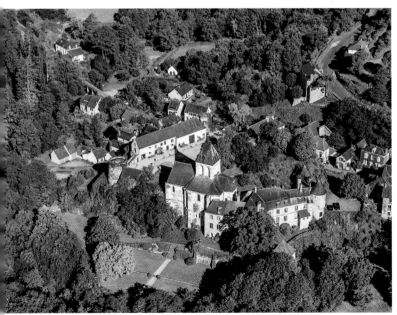

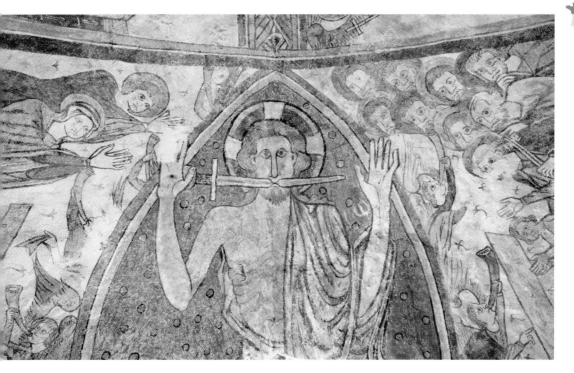

Municipal campsite and chalets
La Chaumerette**: +33 (0)2 54 47 84 22.

🍴 Eating Out
Les Artistes: +33 (0)2 54 47 84 05.
Auberge La Chaumerette:
+33 (0)2 54 60 16 54.
Café de Dampierre: +33 (0)2 54 47 84 16.
Le George Sand, in summer:
+33 (0)2 54 47 83 06.
La Palette, light meals: +33 (0)2 54 60 89 35.

🛍 Local Specialties
Food and Drink
Goat cheese (*Gargilesse*).
Art and Crafts
Picture framer • Metalworker • Art
galleries • Pottery • Jewelry • Sculptor.

🗓 Events
May: Flower and farm produce market
(2nd Sunday).
June–September: Concerts and
exhibitions.
August: Free art exhibition in the street
(Sunday before the 15th); harp and
chamber music festival (3rd week).
September: Journées du Livre book fair
(last weekend).

🦋 Outdoor Activities
Swimming • Fishing • Walking: Routes
GR Pays Val de Creuse and 654, Chemin
de Compostelle (Saint James's Way),
and marked trails.

🌿 Further Afield
• Gorges of the Creuse (1 mile/1.5 km).
• Lac d'Éguzon, lake (7 miles/11.5 km).
• Argenton-sur-Creuse (8½ miles/13.5 km).
• Crozant (11 miles/18 km).
• *Saint-Benoît-du-Sault (15 miles/24 km), see p. 41.
• Nohant-Vic (24 miles/39 km).

ⓘ Did you know?
George Sand wrote of Gargilesse, where
her dry-stone house, Villa Algira, provided
a contrast to her grander mansion at
Nohant: "While waiting for fashion to
extend her scepter on this rustic solitude,
I am careful not to name the village
in question: I simply call it my village,
as one might speak of one's discovery
or one's dream."

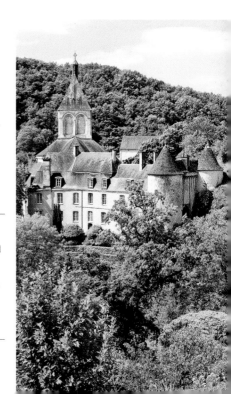

Gerberoy
The roses of Picardy

Oise (60) • Population: 97 • Altitude: 617 ft. (188 m)

On the border between two villages that were once rivals, the houses in Gerberoy combine Normandy and Picardy traditions, featuring wattle-and-daub half-timbering and brick slabs.

The village, on the edge of the Pays de Bray, acquired a castle in 922 at the instigation of the viscount of Gerberoy. His son and successor completed the structure with the addition of a keep, a hospital, and a collegiate church in 1015. Given its strategic position at the crossroads of two kingdoms, the village of Gerberoy was soon coveted and contested. The square tower that controlled the curtain wall is the only remnant of the castle that once adjoined the collegiate church of Saint-Pierre. Rebuilt in the 15th century after having been burned by the English, the latter still contains treasure in its chapter house. From the tower gate can be seen, down below, the paved courtyard and house that hosted Henri IV in 1592 after he was wounded at the Battle of Aumale. Captivated by "the silent Gerberoy," the postimpressionist painter Henri Le Sidaner (1862–1939) created beautiful Italian-style gardens here that are visible from the ramparts, and helped to make Gerberoy a village of roses, which have been celebrated every year since 1928.

By road: Expressway A16, exit 15–Beauvais-Nord (12 miles/19 km); expressway A29, exit 16–Hardivillers (20 miles/32 km). **By train:** Marseille-en-Beauvaisis station (6 miles/9.5 km); Milly-sur-Thérain station (7 miles/11.5 km); Beauvais station (14 miles/23 km). **By air:** Beauvais-Tillé airport (16 miles/26 km); Paris-Roissy-Charles de Gaulle airport (63 miles/101 km).

ⓘ Tourist information—Picardie Verte et Ses Vallées: +33 (0)3 44 46 32 20 or +33 (0)3 44 82 54 86
ot.picardieverte.free.fr / www.gerberoy.fr

👁 Highlights
• Collégiale Saint-Pierre (11th and 15th centuries): 15th-century stalls.
• ♥ Jardins Henri Le Sidaner: Designated a "remarkable garden" by the Ministry of Culture; terraces of the old fortress transformed into 1-acre (4,000 sq.-m) gardens by the artist Le Sidaner; artist's studio/museum: +33 (0)3 44 46 32 20.
• Jardin des Ifs: Award-winning garden unique in France for the age and size of its yew trees: +33 (0) 6 11 85 57 04.
• Musée Municipal: Archeology, crafts, and paintings and drawings by Le Sidaner.
• Village: Guided tour for groups all year round by appointment only: +33 (0)3 44 46 32 20.

🔑 Accommodation
Guesthouses
Le Logis de Gerberoy 🛏🛏🛏:
+33 (0)3 44 82 36 80.

🍴 Eating Out
Les Remparts****, restaurant and tea room: +33 (0)3 44 82 16 50.
IF, local bistro: +33 (0)6 11 85 57 04.
Le Vieux Logis, restaurant and tea room: +33 (0)3 44 82 71 66.
Tea rooms and light meals
L'Atelier Gourmand de Sarah: +33 (0)6 73 19 02 06.

Les Jardins du Vidamé: +33 (0)3 44 82 45 32.
La Terrasse: +33 (0)3 44 82 68 65.

🧺 Local Specialties
Art and Crafts
Rose products (soaps, preserves, candles), potter.

2 Events
April–September: Art and crafts exhibitions.
June: Moments Musicaux de Gerberoy music festival; Fête des Roses (1st Sunday).
November: Country market (last Sunday).

🦋 Outdoor Activities
Walking: Route GR 125 and 3 marked trails • "Histoire et Histoires" heritage trail from Gerberoy to Songeons.

🌿 Further Afield
• Picardy valleys: Songeons; Hétomesnil; Saint-Arnoult (6–25 miles/9.5–40 km).
• Pays de Bray, region: Saint-Germer-de-Fly (8 miles/13 km).
• Forges-les-Eaux (22 miles/35 km).
• *Lyons-la-Forêt (22 miles/35 km), see pp. 29–31.

Lavardin

Grottoes and Gothic architecture

Loir-et-Cher (41) • Population: 220 • Altitude: 262 ft. (80 m)

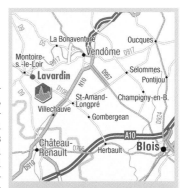

This village, near where the poet Ronsard was born in 1524 (the Promenade du Poète that runs along the Loir river is named after him), bears the marks of centuries of occupation, from prehistoric cave complexes to the Renaissance and beyond. Lavardin became famous when it withstood Richard the Lionheart's attack in 1118, thanks to its castle's tiered defenses. However, the lords of the region were not in a position to fight back when they faced Henry IV—the king of Navarre—and his troops. Furious when his subjects refused to convert to Protestantism, the young king and the duke of Vendôme destroyed the fortresses of Montoire, Vendôme, and Lavardin. Today, the castle ruins command the village from the top of a limestone cliff. A tufa-stone Gothic bridge with eight arches spans the Loir. Standing tall at the heart of the village is the Romanesque church of Saint-Genest, whose nave and choir are decorated with murals from the 12th and 16th centuries. Almost every period of history has left its mark on Lavardin, which blends troglodyte, Gothic, and Renaissance houses. White façades rub shoulders with half-timbered houses topped with flat tiles. Larvardin also boasts the only grottoes in France in which, according to a widely held legend, a powerful druidic sect indulged in bloody sacrificial rites.

By road: N10 (7 miles/11 km); expressway A10, exit 18–Château-Renault (21 miles/34 km). **By train:** Vendôme station (16 miles/26 km); Vendôme TGV station (19 miles/31 km). **By air:** Tours-Saint-Symphorien airport (32 miles/51 km).

ⓘ **Tourist information—Vendôme-Vallée du Loir:** +33 (0)2 54 77 05 07 www.vendome-tourisme.fr
Town hall: +33 (0)2 54 85 07 74 www.lavardin.net

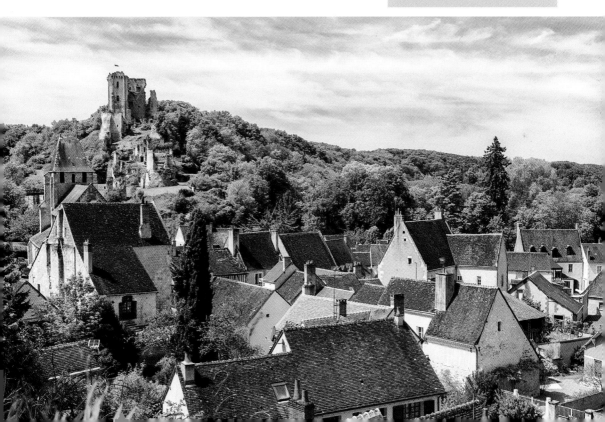

👁 Highlights

• **Castle** (11th and 14th centuries): Lodge, outbuildings, drawbridge, grand staircase, guardroom, keep. Open May–September: +33 (0)6 81 86 12 80.
• **Église Saint-Genest** (11th century): Wall paintings from 12th and 16th centuries, representing Christ's Baptism and Passion: +33 (0)2 54 85 07 74.
• **Musée de Lavardin**: Village history and castle heritage. Open May–September.

🗝 Accommodation

Guesthouses
La Folie en Val de Loir: +33 (0)2 54 72 60 12.
Gîtes
La Folie en Val de Loir 👥:
+33 (0)2 54 72 60 12.
Les Roches Neuves, cave-dwellers' gîte:
+33 (0)2 54 72 26 56.
So Troglo: +33 (0)6 12 31 50 43.

🍴 Eating Out

Chez Arti: +33 (0)2 54 67 05 47.
Ô Saveurs Créatives, lunch only:
+33 (0)6 75 82 27 32.

📅 Events

January: Fête de Saint-Vincent.
March: World Chouine (traditional card game) Championships (1st Sunday).
Ascension: "Peintres au Village" painting contest.
June: "Feu de la Saint-Jean," bonfire.
July: "Embrasement du Château," celebration with fireworks.
December: Christmas market (1st weekend).

🦋 Outdoor Activities

Walking: Routes GR 35 and GR 335, and 3 marked trails • "Randoland," children's play trail.

🌿 Further Afield

• Troo: collegiate church, cave-dwellers' settlement; Couture-sur-Loir: Ronsard's manor (5–9½ miles/8–15.5 km).
• Thoré-la-Rochette: tourist train; Vendôme (6–12 miles/9.5–19 km).

ℹ Did you know?

Each year Lavardin hosts the world championships in *chouine*, a card game that has been played since the 16th century.

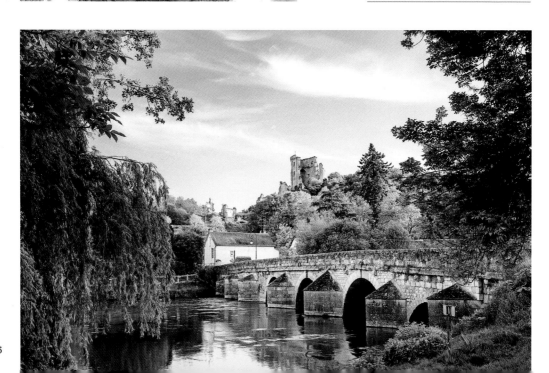

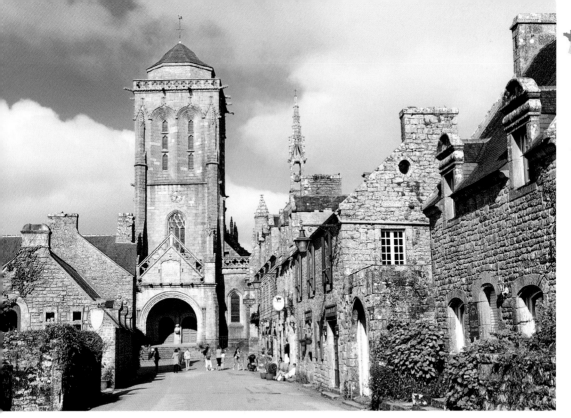

Locronan
Thread and stone

Finistère (29) • Population: 810 • Altitude: 476 ft. (145 m)

A historic weaving village dominated by granite, Locronan owes its name to Saint Ronan, the hermit who founded it.

In the 6th or 7th century, while still haunted with memories of druidic cults, the forest of Névet became home to the hermit Saint Ronan. In the 15th century, thanks to the dukes of Brittany, Locronan became one of the jewels of Breton Gothic art. The priory church was built between 1420 and 1480, while the Chapelle du Pénity (15th–16th centuries), next to the church, houses Saint Ronan's recumbent statue. During the Renaissance, the village became famous for its weaving industry, providing canvas sails for the East India Company and the ships of the French Navy. The East India Company's offices still stand on the village square, as well as 17th-century merchants' dwellings and residences of the king's notaries. Locronan's Renaissance granite buildings regularly provide movie backdrops, for productions such as *A Very Long Engagement* (with Audrey Tautou and Jodie Foster) and *Tess* (directed by Roman Polanski). In the old weaving quarter, the 16th-century Chapelle Notre-Dame-de-Bonne-Nouvelle contains stained-glass windows by the abstract painter Manessier.

By road: N165, exit Audierne-Douarnenez (3 miles/5 km). **By train:** Quimper station (11 miles/18 km). **By air:** Quimper-Cornouaille airport (11 miles/18 km); Brest-Guipavas airport (39 miles/63 km).

ⓘ Tourist information:
+33 (0)2 98 91 70 14
www.locronan-tourisme.bzh

Highlights

• **Église Saint-Ronan** (15th century): 15th-century stained glass, statues, treasure.
• **Chapelle du Pénity** (15th–16th centuries): Recumbent statue of Saint Ronan in Kersanton stone (15th century).
• **Chapelle Notre-Dame-de-Bonne-Nouvelle** (16th century): Modern stained-glass windows by Alfred Manessier; cross and communal washing place.
• **Musée d'Art et d'Histoire:** "L'Industrie de la toile" (the work of an 18th-century weaver, traditional costume collection) and "Locronan, Étape de la Route des Peintres en Cornouaille" (collection of paintings by 50 early 20th-century painters), Breton headdresses and costumes, reconstructed Breton interior; temporary exhibitions.
• **Village:** Guided visits for groups or individuals. Further information: +33 (0)2 98 91 70 14.

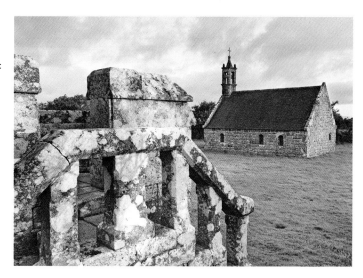

🗝 Accommodation

Hotels
Latitude Ouest***: +33 (0)2 98 91 70 67.
Le Manoir de Moëllien***: +33 (0)2 98 92 50 40.
Le Prieuré**: +33 (0)2 98 91 70 89.

Guesthouses
Mme Camus***: +33 (0)2 98 91 85 34.
Mme Douy: +33 (0)2 98 91 74 85.
Mme Le Doaré: +33 (0)2 98 91 83 97.

Vacation rentals
Further information: +33 (0)2 98 91 70 14
www.locronan-tourisme.org

Campsites
♥ Camping Locronan***: +33 (0)2 98 91 87 76.

🍽 Eating Out

Ar Maen Hir: +33 (0)2 56 10 18 37.
Au Coin du Feu: +33 (0)2 98 51 82 44.
Le Comptoir des Voyageurs: +33 (0)2 98 91 70 74.
Le Grimaldi: +33 (0)2 56 10 18 37.
Le Prieuré: +33 (0)2 98 91 70 89.
Le Restaurant by Latitude Ouest: +33 (0)2 98 91 70 67.

Crêperies
Ar Billig: +33 (0)2 98 95 22 75.
Breiz Izel: +33 (0)2 98 91 82 23.
Chez Annie: +33 (0)2 98 91 87 92.
Le Temps Passé: +33 (0)2 98 91 87 29.
Les Trois Fées: +33 (0)2 98 91 70 23.
Ty Coz: +33 (0)2 98 91 70 79.

🛍 Local Specialties

Food and Drink
Galettes • Breton cake • *Kouign amann* (buttery cake).

Art and Crafts
Watercolorist • Antiques • Ceramic artists • Leather and tin worker • Bronze worker • Leatherworker • Painters • Art photographer • Glass-blowers • Weavers • Wood sculptors • Marriage-spoon sculptor.

📅 Events

Market: Every Tuesday morning, Place de la Mairie.
May: Flower market.
July: Pardon de la Petite Troménie, procession (2nd Sunday).
July–August: "Les Marchés aux Étoiles," evening craft and local produce market (Thursdays, mid-July–mid-August);

concerts (Tuesdays); flea markets and antiques fairs.
December: Illuminations and Christmas market.

🦋 Outdoor Activities

Walking: Route GR 38 and marked trails (Névet forest, circular walk; wheelchair accessible) • Mountain-biking (Névet forest).

🌿 Further Afield

• Douarnenez (6 miles/9.5 km).
• Châteaulin; Nantes–Brest canal (10 miles/16 km).
• Quimper (11 miles/18 km).
• Audierne (19 miles/31 km).
• Crozon peninsula (19 miles/31 km).
• Pays Bigouden, region; Pont-l'Abbé (24 miles/39 km).

🕯 Did you know?

Locronan is one of the few Celtic settlements still to have a *nemeton* in the landscape. This large rectangle of land (making a circuit of 7½ miles/12 km) contains 12 markers corresponding to the 12 months of the Celtic year. It had a sacred purpose: to represent on earth the passage of the stars in the sky. Every six years, the Grande Troménie religious procession takes place in honor of Saint Ronan, and the inhabitants of Locronan walk this sacred path.

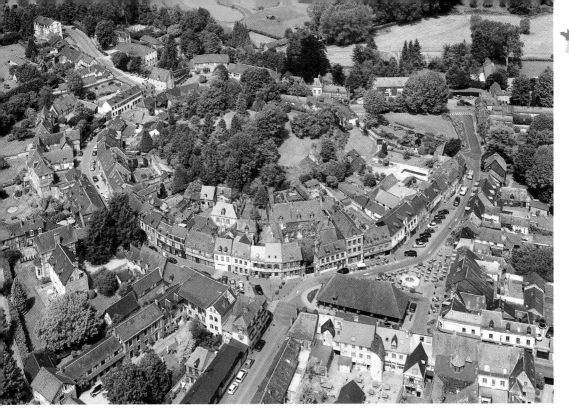

Lyons-la-Forêt
Village in a clearing

Eure (27) • Population: 759 • Altitude: 312 ft. (95 m)

Standing in the middle of one of the most beautiful beech groves in Europe, in Normandy's largest forest, Lyons's attractive half-timbered, pink-bricked buildings are typical of the Normandy style of the 17th and 18th centuries.

Gallo-Roman in origin, Lyons-la-Forêt stretches along the Lieure river. The church of Saint-Denis (12th–16th centuries) and the historic Benedictine and Cordelier convents watch over the river, with its ancient watermills. Right at the heart of Lyons-la-Forêt, the village center encircles an old feudal mound (where ruins of the castle where Henry I of England died are still visible) and the square where "Le Fresne" (the beautiful former home of composer Maurice Ravel) is situated. A stone's throw away, the faded but elegant Place Benserade (named for a court poet of Louis XIV) is home to an iconic eighteenth-century covered market, still in use several times a week. The eighteenth-century former bailiwick court (inside the town hall) is one of the village's main attractions.

By road: Expressway A15, D6012 toward Rouen; expressway A13, exit 17–Gaillon (22 miles/36 km).
By train: Rouen station (21 miles/34 km).
By air: Rouen-Vallée de la Seine airport (17 miles/27 km); Beauvais-Tillé airport (34 miles/55 km); Paris-Roissy-Charles de Gaulle airport (71 miles/114 km).

ⓘ Tourist information—Lyons Andelle:
+33 (0)2 32 49 31 65
www.lyons-andelle-tourisme.com

👁 Highlights
• **Hôtel de Ville:** Law court and 13th-century prison cell: +33 (0)2 32 49 31 65.
• **Village:** Guided visits for groups by appointment only: +33 (0)2 32 49 31 65.

🔑 Accommodation
Hotels
La Licorne****: +33 (0)2 32 48 24 24.
Le Grand Cerf ***: +33 (0)2 32 49 50 90.
Les Lions de Beauclerc:
+33 (0)2 32 49 18 90.
Guesthouses
L'Escapade de Marijac: +33 (0)6 31 44 04 19.
Gîtes
Les Hirondelles: +33 (0)6 31 44 04 19.
The Family House: +33 (0)6 50 16 38 36.
Campsites
Saint-Paul***: +33 (0)2 32 49 42 02.
Further information: +33 (0)2 32 49 31 65
www.lyons-andelle-tourisme.com

🍴 Eating Out
Le Bistrot du Grand Cerf:
+33 (0)2 32 49 50 50.
Le Commerce: +33 (0)2 32 49 49 92.
La Halle: +33 (0)2 32 49 49 92.
La Licorne Royale, gourmet restaurant:
+33 (0)2 32 48 24 24.
Les Lions de Beauclerc:
+33 (0)2 32 49 18 90.
Le Petit Lyons: +33 (0)2 32 49 61 71.

🛍 Local Specialties
Food and Drink
Local Normandy produce.
Art and Crafts
Antiques • Gifts • Fashion accessory and homeware designers • Weaver • Artists.

🗓 Events
Market: Thursday, Saturday, and Sunday 8.30 a.m.–1.00 p.m.
1st May: "Foire à Tout," village fair.
Pentecost: Craft fair.
July: Fête de la Fleur, flower festival (1st weekend).
October: Fête de Saint-Denis (mid-October).
December: Christmas market.

🦋 Outdoor Activities
Arboretum • Horse-riding • Walking • Cycling.

🦢 Further Afield
• Abbaye de Mortemer; castles at Fleury-la-Forêt, Heudicourt, Vascoeuil, and Martainville; Abbaye Notre-Dame de Fontaine-Guérard; Musée de la Ferme de Rome (3–12 miles/ 5–19 km).
• Château-Gaillard; Château de Gisors; Rouen (12–22 miles/19–35 km).
• *Gerberoy (23 miles/37 km), see p. 24.

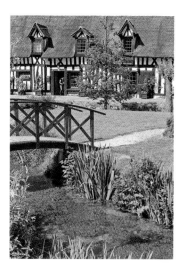

ℹ Did you know?
Lyons-la-Forêt has twice been the location for film versions of *Madame Bovary* by Gustave Flaubert. The first was filmed in 1933 by Jean Renoir. The second was made in 1991; directed by Claude Chabrol, it starred Isabelle Huppert.

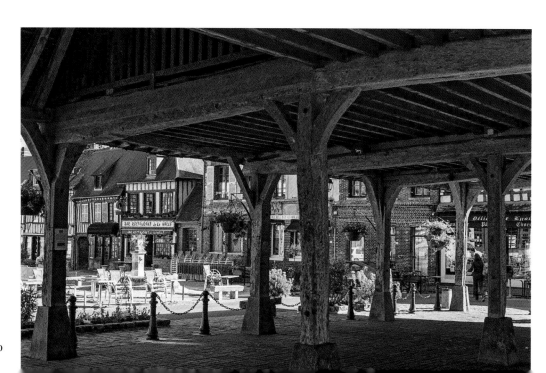

Moncontour

A product of revolution

Côtes-d'Armor (22) • Population: 881 • Altitude: 394 ft. (120 m)

In a spot where two green valleys meet, Moncontour is girdled by its imposing medieval ramparts.

The village was founded in the 11th century as part of the defenses for nearby Lamballe, capital of Penthièvre. Despite being damaged in numerous clashes during the Middle Ages and partly dismantled during the French Revolution by order of Richelieu, the walls still boast eleven of its original fifteen towers, together with the Porte d'en-Haut and Saint Jean's postern. From the 18th century until the Industrial Revolution (and echoing its Finistère neighbor Locronan), Moncontour developed around the production of *berlingue* (canvas and linen cloth), which was exported to South America and the Indies. In this granite-and-slate world, the grand mansions, the town hall, and the Église Saint-Mathurin are reminders of this prosperous era. At the end of the 18th century, during the Chouannerie uprisings against the Revolutionary government, the republican General Hoche established his headquarters in a mansion on the Place Penthièvre.

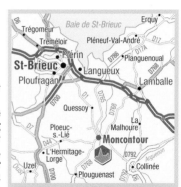

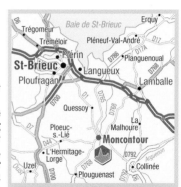

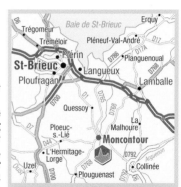

By road: N12, exit Moncontour (8½ miles/ 13 km). **By train:** Lamballe station (10 miles/16 km); Saint-Brieuc station (16 miles/26 km). **By air:** Saint-Brieuc airport (22 miles/35 km); Rennes-Saint-Jacques airport (60 miles/97 km).

ⓘ **Tourist information:**
+33 (0)2 96 73 49 57
www.capderquy-valandre.com

👁 Highlights
• **Église Saint-Mathurin** (16th and 18th centuries): Listed 16th-century stained-glass windows: +33 (0)2 96 73 49 57.
• **Jardin d'Hildegarde:** Medieval vegetable and flower garden; open Sundays in summer: +33 (0)2 96 69 37 96.
• **Théâtre du Costume:** Permanent exhibition on knights in the Middle Ages, and costume from Louis XII (1498–1515) to 1900. Further information: Carolyne Morel, +33 (0)6 81 87 33 40.
• **Village:** Heritage walk, "The medieval fortress" (90 mins). Guided tours available for individuals in summer (Thursdays), and throughout the year for groups by appointment; themed guided tours in summer; carriage rides Mondays in summer: +33 (0)2 96 73 49 57.

🗝 Accommodation
Hotels
Hostellerie de la Poterne**:
+33 (0)2 96 73 40 01.
Guesthouses
À la Garde Ducale 🛈🛈🛈: +33 (0)2 96 73 52 18.
L'Evron 🛈🛈: +33 (0)2 96 73 55 12.
Gîtes and vacation rentals
Les Jardins de l'Abbaye 🛈🛈🛈:
+33 (0)2 96 62 21 73.
Mme Leroux 🛈🛈: +33 (0)2 99 64 52 28 or
+33 (0)6 87 48 30 21.

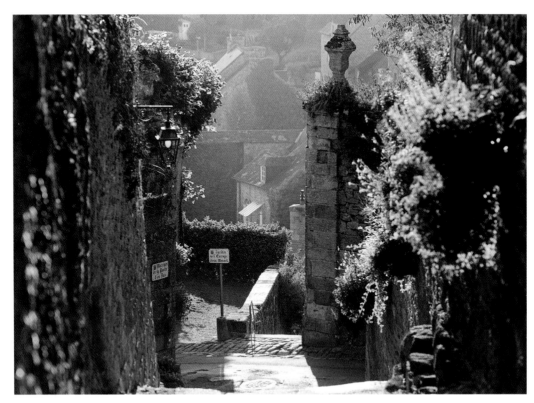

Mme Georgelin ☎☎: +33 (0)2 96 73 44 24 or +33 (0)6 71 20 13 72.
Campsites
La Tourelle**: +33 (0)2 96 73 50 65 or +33 (0)6 76 74 85 04.

🍴 Eating Out
Adana Kebab: +33 (0)2 96 76 02 72.
Au Coin du Feu, crêperie/pizzeria: +33 (0)2 96 73 49 10.
Le Chaudron Magique: +33 (0)2 96 73 40 34.
La Mulette: +33 (0)2 96 73 50 37.
La Poterne: +33 (0)2 96 73 40 01.
Les Remparts: +33 (0)2 96 73 54 83.

🛒 Local Specialties
Art and Crafts
Ceramic artist • Dressmaker and hatter • Beadmaker • Stylist • Costume designer • Painter • Stained-glass artist • Résidence des Arts (exhibitions and residencies by artists and craftspeople).

📅 Events
Market: Local produce, Monday evenings.
May: Urban mountain-bike downhill run.

Pentecost: Pardon de Saint-Mathurin procession, Pentecost festivities.
July–August: Sporting and cultural activities (daily).
August (odd years): Fête Médiévale, medieval festival (1st Sunday).

September: "Journée des Peintres" painting contest; Festival Dell Arte, street art (1st weekend).
December: Ménestrail, cross-country trail.

🦋 Outdoor Activities
Walking, horse-riding, and mountain-biking • Nordic walking • Fishing.

🕊 Further Afield
• Plémy (3 miles/5 km).
• Hénon, Quessoy, and Trébry: parks and residences of Ancien Régime notables (3½–5 miles/5.5–8 km).
• Saint-Glen: Village des Automates, clockwork and robotic toys (July and August) (6 miles/ 9.5 km).
• Lamballe (10 miles/16 km).
• Saint-Brieuc (16 miles/26 km).
• Loudéac (17 miles/27 km).
• Quintin: castle and Musée Atelier du Tisserand et des Toiles, working weaving museum (18 miles/29 km).
• Pléneuf-Val-André, Erquy: beach resorts (19–24 miles/30–38 km).
• Le Foeil (20 miles/32 km).

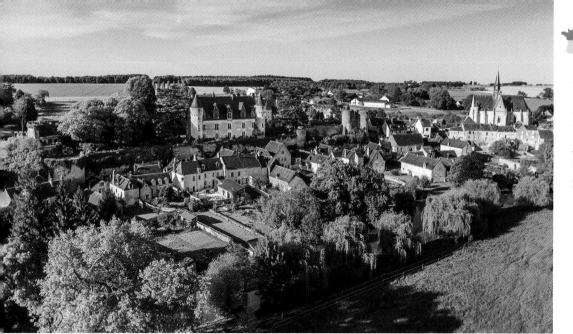

Montrésor

In the heart of the Loire valley, on the banks of the Indrois

Indre-et-Loire (37) • Population: 351 • Altitude: 328 ft. (100 m)

Montrésor get its name from the Treasurer (*Trésorier*) of the chapter house at Tours Cathedral, which owned this area in the 10th century.

In the early 11th century, the powerful count of Anjou, Foulques III, nicknamed "Foulque Nerra" (Fulk III, the Black), began to build a fortress at Montrésor in order to defend the approaches of the Touraine. Remains of the double ring of defenses are still visible. Inside its wall, at the end of the 15th century, Imbert de Bastarnay (advisor to the French kings Louis XI, Charles VIII, Louis XII, and François I) built the present castle in the Renaissance style. He is also responsible for the collegiate church of Saint-Jean-Baptiste, which houses an Annunciation painted by Philippe de Champaigne (1602–1674), as well as tombs of members of his family. In 1849, the castle became the property of Xavier Branicki, a Polish count and friend of Napoléon III. He restored it and filled it with many works of art: sculptures by Pierre Vanneau, and Italian Renaissance and Dutch paintings. Count Branicki also gave his name to one of the streets cut into the rock, where half-troglodytic and half-timbered houses rub shoulders. Cardeux Market, once the wool market, has been restored as a cultural center and exhibition space, and recalls village life in bygone days. The 16th-century Chancelier's Lodge, which has a watchtower, houses the present town hall. The riverside walk, "Balcons de l'Indrois," provides wonderful views of the village from the footbridge to Jardinier Bridge, which was built by Eiffel's workshop.

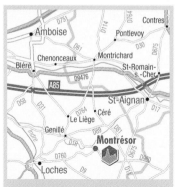

By road: Expressway A85, exit 11–Bléré (17 miles/27 km); N76 (17 miles/27 km).
By train: Tours station (34 miles/55 km); Saint-Pierre-des-Corps TGV station (34 miles/55 km).
By air: Tours-Saint-Symphorien airport (42 miles/68 km).

ⓘ Tourist information:
+33 (0)2 47 92 70 71
www.loches-valdeloire.com

👁 Highlights

- **Castle** (11th–15th centuries): 15th-century fortifications; art collection, romantic gardens: +33 (0)2 47 92 60 04.
- **Collegiate church of Saint-Jean-Baptiste** (16th century): Alabaster tomb with three recumbent statues, Annunciation by Philippe de Champaigne, stained-glass windows, 16th-century stalls, reliquary with the skullcap of Pope John Paul II.
- **Cardeux wool market** (18th century): Permanent exhibition of *gemmail* stained glass and the history of Montrésor.
- **Banks of the Indrois:** Walking paths and information points along the river.
- **Village:** Guided tours for groups only and by appointment: +33 (0)2 47 92 70 71.

🔑 Accommodation

Guesthouses
Le Moulin de Montrésor:
+33 (0)2 47 92 68 20.
Sourire d'Avril: +33 (0)2 47 92 75 31.
La Terrasse: +33 (0)2 47 92 75 31.
Gîtes and vacation rentals
Further information: +33 (0)2 47 27 70 71.

🍴 Eating Out

Café de la Ville: +33 (0)2 47 92 75 31.
Crêperie Barapom: +33 (0)2 47 19 27 48.
La Légende: +33 (0)2 47 92 61 90.

🧺 Local Specialties

Food and Drink
Macarons • Montrésor rillettes and wine.
Art and Crafts
Local crafts (Maison de Pays shop) •
Painter • Mohair products.

2 Events

Market: Saturday mornings, wool market.
July–August: "Nuits Solaires" evening festival, illuminated trail with music and events on the banks of the Indrois; painters' and sculptors' fair (August 15).
December: Christmas market.

🐎 Outdoor Activities

Fishing • Walking: 2 marked trails •
Cycling • Horse-riding trails.

🌿 Further Afield

- Lac de Chemillé, lake (1½ miles/2 km).
- Chartreuse du Liget (2½ miles/4 km).
- Loches, Indre valley (11 miles/18 km).
- Beauval Zoo (12½ miles/20 km).
- Chedigny (12½ miles/20 km).
- Château de Montpoupon; Cher valley: Chenonceaux; Loire valley: Amboise (18½–28 miles/30–45 km).
- Château de Valençay (19 miles/31 km).

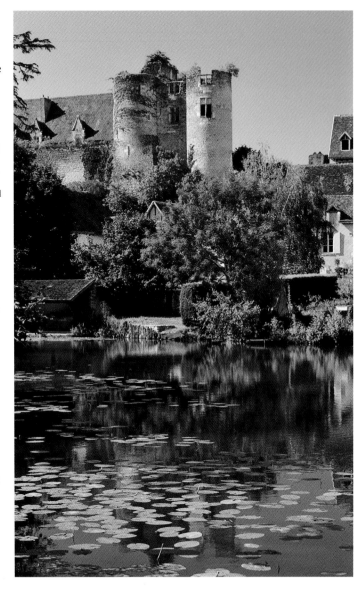

📌 Did you know?

According to legend, the young Gontran, who became king of Burgundy from 561 to 592, fell asleep in his equerry's lap on a riverbank and dreamed of treasure hidden in a cave. The equerry saw a small lizard run over Gontran's face; it dashed toward a nearby hill and returned covered in gold. When the king was told this vision, he quickly had the hill excavated and discovered enormous wealth there. But the chronicles of the Middle Ages reveal that this estate belonged to the Treasurer of Tour Cathedral's chapter house. This explains why during the 10th century it was called Mons Thesauri (mount of the Treasurer), which later became Montrésor.

Montsoreau

The lady's castle

Maine-et-Loire (49) • Population: 447 • Altitude: 108 ft. (33 m)

Montsoreau sits between Anjou and the Touraine, in a land of history, sweetness, and harmony.

Lying between the Loire and a hill, and very close to the royal abbey of Fontevraud, Montsoreau grew up around its 15th-century castle. The village draws a rich heritage from the Loire river and Montsoreau's lady, Françoise de Maridor; Alexandre Dumas wrote tales about her passionate and fatal love affair with Bussy d'Amboise.

There is something for everyone here: wander the village's flower-lined paths that climb toward the vineyards, and admire its white tufa-stone residences and immaculately tended gardens. Stroll the courtyards and alleyways, beyond which the Loire stretches into the distance; roam the Saut aux Loups hillside, where historic cave dwellings nestle. Taste some famous Saumur-Champigny and Crémant de Loire wines at a local vineyard.

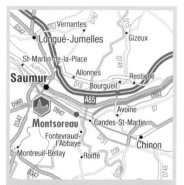

By road: Expressway A85, exit 5–Bourgueil (7½ miles/11.5 km). **By train:** Saumur station (8 miles/13 km). **By air:** Angers-Marcé airport (39 miles/63 km); Tours-Saint-Symphorien airport (45 miles/72 km); Nantes-Atlantique airport (110 miles/177 km).

ⓘ **Tourist information:**
+33 (0)2 41 51 70 22
www.ot-saumur.fr
www.ville-montsoreau.fr

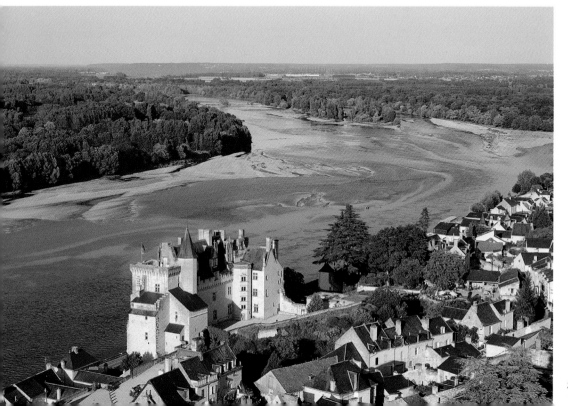

👁 Highlights

• **Castle** (15th century): Museum of contemporary art. Further information: +33 (0)2 41 67 12 60.
• **Église Saint-Pierre-de-Rest** (13th–18th centuries): +33 (0)2 41 51 70 15.
• **Le Saut aux Loups mushroom farm:** Within a group of 15th-century cave dwellings, now used as a mushroom farm, a reconstruction of an early 20th-century mushroom farm: +33 (0)2 41 51 70 30.
• **Maison du Parc Naturel Régional Loire-Anjou-Touraine:** Permanent fauna and flora experience, exhibitions, shop. Further information: +33 (0)2 41 38 38 88.
• **Vins de Loire market:** In a cave dwelling, experience the wines of the Loire valley in 10 stages from Nantes to Sancerre: +33 (0)2 41 38 15 05.
• **Village:** Guided tours. Further information: +33 (0)2 41 51 70 22.

🗝 Accommodation

Hotels
La Marine de Loire****:
+33 (0)2 41 50 18 21.
Le Bussy***: +33 (0)2 41 38 11 11.

Guesthouses, gîtes, and vacation rentals
Further information: +33 (0)2 41 51 70 22
www.ville-montsoreau.fr
Campsites
♥ L'Isle Verte****: +33 (0)2 41 51 76 60.

🍽 Eating Out

Aigue-Marine, floating restaurant:
+33 (0)2 41 38 12 52.
La Cave du Saut aux Loups:
+33 (0)2 41 51 70 30.
La Dentellière, crêperie/salad bar:
+33 (0)2 41 52 41 68.
Diane-de-Méridor, gourmet restaurant:
+33 (0)2 41 51 71 76.
Fleur de Sel, crêperie: +33 (0)2 41 40 82 99.
Jean 2, light meals: +33 (0)2 41 67 12 60.
Le Lion d'Or, brasserie:
+33 (0)2 41 51 70 12.
Le Mail, brasserie: +33 (0)2 41 51 73 29.
Le Montsorelli: +33 (0)2 41 51 70 18.
Le P'tit Bar, brasserie: +33 (0)2 41 51 72 45.
Ververt, gastronomic bistro:
+33 (0)2 41 52 34 89.
Tea rooms
Le 2, art gallery and tea room:
+33 (0)6 51 51 23 36.
La Marine de Loire: +33 (0)6 41 50 18 21.

🧺 Local Specialties

Food and Drink
Mushrooms • Organic apples and pears • AOC Saumur, Saumur-Champigny, Crémant de Loire wines.
Art and Crafts
Antiques dealers and art galleries.

📅 Events

Market: Sundays, 8 a.m.–1 p.m., Place du Mail.
July–August: Les Musicales de Montsoreau music season at the castle and church.
Throughout the year: Montsoreau flea market (2nd Sunday of each month).

🦋 Outdoor Activities

Pony trekking • Mountain-biking • Loire river cruises • Fishing • Watersports on the Loire • Walking: Route GR 3, 1 marked trail (11 miles/18 km), and heritage trail from Montsoreau to Candes-Saint-Martin • Cycling: "La Loire à Vélo" and other trails.

🌿 Further Afield

• *Candes-Saint-Martin (½ mile/1 km), see p. 20.
• Abbaye de Fontevraud (2½ miles/4 km).
• Saumur (7½ miles/12 km).
• Chinon (12 miles/19 km).
• *Crissay-sur-Manse (24 miles/39 km), see p. 21.

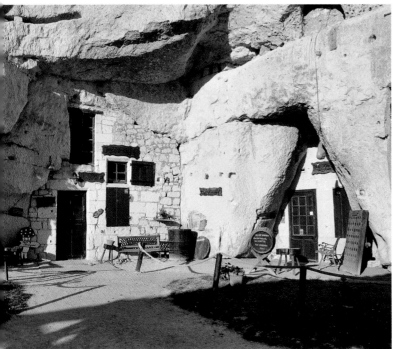

💡 Did you know?

A unique location at the heart of the village plays host to the ancestral game of *boule de fort*. At the Société l'Union, in Montsoreau's old market, is a circular pitch on which players, who must wear slippers, roll *boules* of 6-in. (13-cm) diameter with flattened sides; the balls must get as close as possible to the *maître*, the smallest *boule* at the center of the pitch.

Rochefort-en-Terre
Brittany in flower

Morbihan (56) • Population: 710 • Altitude: 164 ft. (50 m)

Halfway between the Gulf of Morbihan and "Merlin's Forest" (Brocéliande Forest), this village was once a *roche fort* (stronghold), which controlled the trading routes between land and sea.

A medieval village that dates back to the 11th century, Rochefort-en-Terre is one of the oldest fiefdoms in Brittany. Its location, on a rocky outcrop surrounded by deep valleys, gave it a strategic position and a leading role. Traces of this rich history can be seen in the upper village—a legacy of a prosperous past linked to the exploitation of slate quarries—with its old covered market, 12th-century collegiate church, ruins of the medieval castle of the counts of Rochefort, and the 19th-century château, as well as the 16th- and 17th-century mansions with their richly embellished granite and shale façades. Rochefort-en-Terre became an artists' town in the early 20th century, thanks to the American portraitist Alfred Klots, and has retained its pictorial as well as its floral tradition.

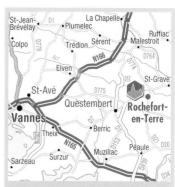

By road: N166, exit Bohal (9½ miles/15.5 km); N165, exit 17–Marzan (14 miles/23 km). **By train:** Questembert (6 miles/9.5 km), Redon (16 miles/26 km), Vannes (20 miles/32 km) stations; Rennes TGV station (62 miles/100 km). **By air:** Rennes-Saint-Jacques (60 miles/97 km), Nantes-Atlantique (62 miles/100 km), Lorient-Lann Bihoué (64 miles/103 km) airports.

(i) **Tourist information:**
+33 (0)2 97 26 56 00
www.rochefortenterre-tourisme.bzh

👁 Highlights
• **Parc du Château:** View of the ruins of the medieval castle and of the 19th-century château built on the site of 17th-century stables.
• **Collegiate church of Notre-Dame de la Tronchaye** (12th–14th centuries).
• **Village:** Sightseeing tour of the Petite Cité; guided tours all year round for groups, booking essential; Monday to Friday in July and August, and Fridays and Saturdays in December when the Christmas lights are on, for individuals: +33 (0)2 97 26 56 00.
• **Naïa Museum:** Contemporary, fantastic, digital, and kinetic art museum; Parc du Château: +33 (0)2 97 40 12 35/ www.naiamuseum.com

🔑 Accommodation
Hotels
Le Pélican**: +33 (0)2 97 43 38 48.
Aparthotel
Domaine Ar Peoc'h: +33 (0)2 97 43 37 88.
Domaine du Moulin Neuf:
+33 (0)5 55 84 34 48.
Guesthouses
François Pinat: +33 (0)2 97 43 30 43.
La Tour du Lion: +33 (0)2 97 43 36 94 or
+33 (0)6 63 34 77 27.

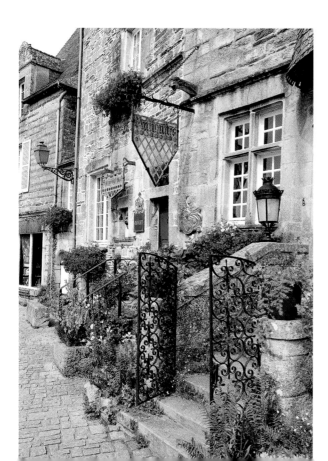

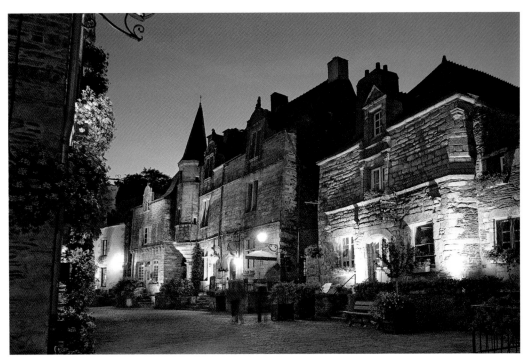

Gîtes and vacation rentals
Further information: +33 (0)2 97 26 56 00
www.rochefortenterre-tourisme.bzh
Campsites
Camping Au Gré des Vents:
+33 (0)2 97 43 37 52 or
+33 (0)6 23 32 51 53.

🍽 Eating Out
À l'Heure de l'Apéro: +33 (0)2 97 68 49 66.
L'Ancolie: +33 (0)2 97 43 33 09.
Les Ardoisières: +33 (0)2 97 43 47 55.
Freine le Temps: +33 (0)2 97 43 31 63.
Les Grées, pizzeria: +33 (0)2 97 44 73 89.
Le Pélican: +33 (0)2 97 43 38 48.
Le Rouge, tapas bar: +33 (0)6 85 67 65 03.
La Terrasse: +33 (0)2 97 43 35 56.
Voyage Gaufré: +33 (0)9 50 44 96 58.
Crêperies
Le Café Breton: +33 (0)2 97 43 32 60.
La Crêperie du Puits: +33 (0)2 97 43 30 43.
La Petite Bretonne: +33 (0)2 97 43 37 68.
La Tour du Lion, crêperie/brasserie:
+33 (0)6 63 34 77 27.

🛒 Local Specialties
Food and Drink
Breton shortbread, *kouign amann* (buttery
cake) • *Pain d'épice* (spice cake) • *Galettes
bretonnes* (butter cookies) • Honey •

Chouchen (type of mead) • Cider •
Apple juice.
Art and Crafts
Wooden handicrafts • Metal handicrafts •
Slate handicrafts • Handmade candles •
Embroidery • Jewelry and sculpture •
Leather craftsman • Artists • Soap-maker.

📅 Events
June: "À travers chants" choir festival.
June–September: Temporary exhibitions
of work by artists, painters, and sculptors;
events at the château.
July and August: Concerts at the Café de
la Pente (every Thursday) and at the Salle
de Spectacle at the Étang Moderne.
August: Medieval fair (around 15th);
Pardon de Notre-Dame de la Tronchaye
procession (Sunday after 15th); music
festival.
December: Christmas lights.

🦋 Outdoor Activities
Walking: Route GR 38 and marked
trails around Rochefort • Moulin Neuf
recreation park.

🌿 Further Afield
• Malansac: Parc de Préhistoire
de Bretagne (2½ miles/4 km).

• Caden: Musée des Maquettes de
Machines Agricoles, museum of models
of farming machinery; arts center
(6 miles/9.5 km).
• Questembert: 16th-century covered
market (6 miles/9.5 km).
• Malestroit (10 miles/16 km).
• La Gacilly: handicrafts, Végétarium
Yves-Rocher, photography festival
(11 miles/18 km).
• La Vraie-Croix: 13th-century chapel
(11 miles/18 km).
• Le Guerno: Branféré animal painter
(12 miles/19 km).
• La Roche-Bernard (12 miles/19 km).
• Monteneuf: menhirs (19 miles/30 km).
• Forêt de Brocéliande, forest (22 miles/
35 km).
• Vannes (22 miles/35 km).
• Gulf of Morbihan: Île d'Arz, Île aux
Moines (25 miles/40 km).

ℹ Did you know?
In 1911, four years after buying the castle,
the American painter Alfred Klots created
a floral window display competition to
brighten up the village's old houses. The
floral-decoration tradition has continued,
earning Rochefort high honors in this area.

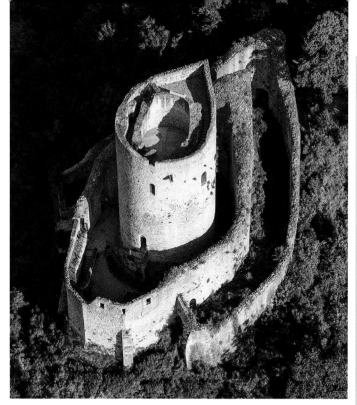

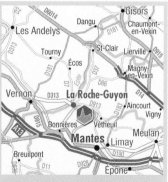

By road: Expressway A13 from Paris, exit 11–Mantes-la-Jolie-Est (11 miles/18 km); expressway A13 from Rouen, exit 15–Chauffour. **By train:** Bannières-sur-Seine station (4½ miles/7 km); Vernon station (8½ miles/13.5 km); Mantes-la-Jolie station (10 miles/16 km); Paris TGV station (47 miles/76 km). **By air:** Paris-Roissy-Charles de Gaulle airport (55 miles/89 km); Paris-Orly airport (56 miles/90 km).

ⓘ Town hall: +33 (0)1 34 79 70 55
www.larocheguyon.fr

La Roche-Guyon
A castle by the Seine

Val-d'Oise (95) • Population: 520 • Altitude: 394 ft. (120 m)

In a bend of the Seine carved into cliffs of chalk and flint, La Roche-Guyon mixes Île-de-France architecture with Normandy half-timbering.

The village, which was originally troglodytic, consisted of *boves*: shelters carved out of the cliff face shared by animals and men. They are still in use, as dwellings, shops, and outhouses. The 12th-century keep is surrounded by a curtain wall and linked to the castle by an impressive secret passage more than 330 ft. (100 m) long. Built in the 13th century and rebuilt in the 18th, the castle has retained its corner pepperpot turrets from its feudal past. The main building was completed with corner pavilions and terraces during the reign of Louis XV. Located on the main road between the castle and the Seine, the castle's kitchen garden, first created in 1697, was restored in 2004 according to 18th-century plans; it provides a setting for artistic creations by sculptors and landscape designers. The village's old streets invite one to stroll around and to follow the Charrière des Bois or de Gasny to the banks of the Seine. La Roche-Guyon forms part of the regional nature park of French Vexin and of the Coteaux de la Seine nature reserve.

👁 **Highlights**
• **Castle** (13th–18th centuries): Guided and self-guided tours (salons, keep, chapel, bunker, and *boves*); activities for children; cultural events: +33 (0)1 34 79 74 42.
• **Castle orchard and vegetable garden** (recognized as a "remarkable garden"): Free entrance during castle opening hours: +33 (0)1 34 79 74 42.
• **Église Saint-Samson** (15th century): Marble statue by François de Silly, who owned the castle in the 17th century: +33 (0)1 34 79 70 55.
• **Village:** Self-guided tour, heritage discovery trail available from tourist information center.

⚒ **Accommodation**
Hotels
Les Bords de Seine**: +33 (0)1 30 98 32 52.
Guesthouses
Les Damiers: +33 (0)1 75 74 41 85.
Vacation rentals
Further information +33 (0)1 34 79 70 55
www.larocheguyon.fr
Walkers' lodge
Further information:
+33 (0)1 34 79 72 67 or +33 (0)7 63 16 31 14.

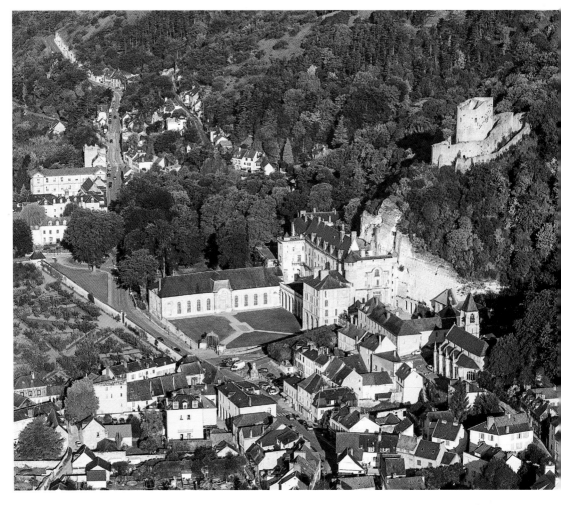

🍴 Eating Out
Les Bords de Seine: +33 (0)1 30 98 32 52.
La Cancalaise, crêperie: +33 (0)1 34 79 74 48.
La Casa Victoria, pizzeria:
+33 (0)1 30 63 23 64.
Galerie T-room, tea room:
+33 (0)1 30 33 54 84.
La Grotte à Bières, light meals:
+33 (0)6 09 40 83 18.
Le Relais du Château: +33 (0)1 34 79 70 52.
La Table de Mademoiselle:
+33 (0)1 30 93 85 42.

🧺 Local Specialties
Art and Crafts
Metalworker • Mosaic artist • Jeweler •
Potter • Weaver • Ceramicist • Bookbinder •
Painting restorer.

📅 Events
January: Fireworks (1st).
May: "Plantes, Plaisir, Passions" plant
festival (1st weekend).
Ascension: Big flea market.
June: Country market (2nd Sunday).
July 14: Citizens' banquet.
November: Wine fair (1st weekend)
and Advent market (last weekend).

🦋 Outdoor Activities
Walking: Marked walks in the forest and
village (topographic guide from the town
hall) • "Route des Crêtes," GR 2, hiking
trail • Mountain-biking.

🦋 Further Afield
• Haute-Isle: underground church
(2 miles/3 km).
• Vétheuil (3½ miles/5.5 km).
• Giverny: Claude Monet's house and
gardens (5½ miles/9 km).
• Chaussy: Château de Villarceaux;
golf course and manor house
(6 miles/9.5 km).
• Vernon: collegial church (8 miles/13 km).
• Mantes-la-Jolie (10 miles/16 km).
• Les Andelys: Château-Gaillard
(19 miles/31 km).

Saint-Benoît-du-Sault

A priory on the edge of Limousin

Indre (36) • Population: 615 • Altitude: 722 ft. (220 m)

Built on a granite spur, the village of Saint-Benoît-du-Sault over-looks a broad bend of the Portefeuille river.

Enclosed by partially intact double ramparts, Saint-Benoît has preserved its medieval past in the form of a fortified gateway, a 14th-century belfry, and an old wall-walk. At the tip of the rocky promontory, a Benedictine priory offers a broad view over the valley. The church, majestic and sober, from the first Romanesque period, contains carved capitals and an 11th-century baptismal font. At the heart of the village, 15th- and 16th-century houses line the narrow, often steep streets: the Portail and Maison de l'Argentier, with its carved lintel, are the most remarkable. Walking trails invite visitors to explore the village, built in the shape of an amphitheater over-looking the Portefeuille river, and the priory, which is reflected in the waters below, with their historic dam.

By road: Expressway A20, exit 20–Saint-Benoît-du-Sault (5 miles/8 km). **By train:** Argenton-sur-Creuse station (13 miles/ 21 km). **By air:** Limoges-Bellegarde airport (50 miles/80 km).

(i) Tourist information:
+33 (0)2 54 47 67 95
www.saint-benoit-du-sault.fr

👁 Highlights
• **Church** (11th, 13th, and 14th centuries): Stained-glass windows of the 19th century and by contemporary master stained-glass maker Jean Mauret.
• **Priory:** Under restoration; open during exhibitions.
• **Village:** Guided tours. Further information: +33 (0)2 54 47 67 95.

⚜ Accommodation
Hotels
Hôtel du Centre: +33 (0)2 54 47 51 51.
Guesthouses
La Châtille ⛿⛿⛿: +33 (0)2 54 47 50 12.
Le Portail ⛿⛿⛿: +33 (0)2 54 47 57 20.
La Treille aux Roses: +33 (0)2 54 26 90 47.
Gîtes
Gîtes de France Indre:
+33 (0)2 54 27 58 61
www.gites-de-france-indre.com
Walkers' lodge
La Maison des Voyageurs:
+33 (0)2 54 47 51 44.

⚇ Eating Out
L'Auberge du Champ de Foire:
+33 (0)2 54 27 43 77.
L'Entrecôte, pizzeria/steak house:
+33 (0)2 54 47 66 82.

🧺 Local Specialties
Art and Crafts
Publisher of artists' and poetry books •
Engraver and painter • Ceramicists.

📅 Events
April: Pays de la Loire wine fair.
June–August: Theater, concerts, exhibitions.
July: Flea market (13th).
August: Inter-regional ram show (1st Wednesday), festivals of baroque music (1st week) and classical music (3rd week), local saint's day (15th), cattle show (last week).
December: Brive goose and duck produce fair.

🦋 Outdoor Activities
Fishing • Tennis • Walking trails.

🌿 Further Afield
• Dolmens of Les Gorces and of Passebonneau (1–2 miles/1.5–3 km).
• Roussines: church (2½ miles/4 km).
• Parc Naturel Régional de la Brenne, nature park (3–31 miles/5–50 km).
• Château de Brosse, ruins (6 miles/ 9.5 km).
• Creuse valley; Musée Archéologique d'Argentomagus; Lac de Chambon, lake; Crozant: ruins (11–17 miles/ 18–27 km).
• *Gargilesse-Dampierre (15 miles/ 24 km), see pp. 22–23.

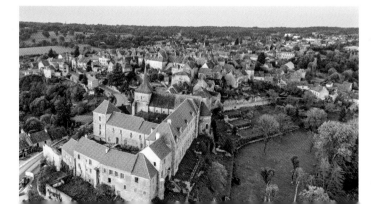

Saint-Céneri-le-Gérei

A painter's paradise

Orne (61) • Population: 140 • Altitude: 417 ft. (127 m)

At the heart of the Mancelles Alps, Saint-Céneri-le-Gérei combines water, stone, and wood.

The village, which nestles in a bend in the Sarthe river, was founded by Saint Céneri, an Italian-born monk who created a monastery that was later burned by the Normans. A church was built on the site in the 11th century. Today, topped with a saddleback roof and a tower adorned with columns and belfry openings, it emerges above the trees. Inside, it houses recently restored 12th-century murals and a ceiling that is unique in France. The village's old houses surrounding the church have been preserved. Below is a charming 15th-century chapel. On the opposite bank is the miraculous spring created by Saint Céneri in 660, which, according to popular belief, has the power to cure eye problems. Over the years, the village has charmed many famous painters, including Camille Corot (1796–1875) and Eugène Boudin (1824–1898), and at the Auberge des Sœurs Moisy, which they frequented, you can still see charcoal portraits of artists and villagers sketched by candlelight.

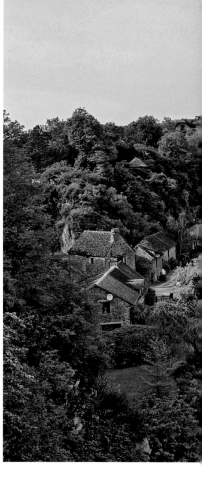

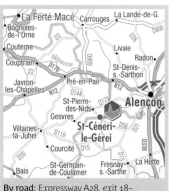

By road: Expressway A28, exit 18– Alençon centre (12 miles/19 km), N12 (7½ miles/12 km).
By train: Alençon station (12 miles/19 km).
By air: Caen-Carpiquet airport (83 miles/134 km).

ⓘ Tourist information— Alençon: +33 (0)2 33 80 66 33 www.saintceneri.org

👁 Highlights
• **Église Saint-Céneri** (11th century): Murals, Stations of the Cross.
• **Chapel** (15th century): Statue of Saint Céneri.
• **Auberge des Soeurs Moisy:** Museum of 19th- and 20th-century painters.
• **Village:** Audioguide tour (www.saintceneri.org).

🗝 Accommodation
Gîtes and vacation rentals
La Cassine: +33 (0)2 33 26 93 66.
Chez Martine: +33 (0)2 33 32 23 93.
La Giroise: +33 (0)2 43 33 79 22.
Bunkhouse: +33 (0)2 33 26 60 00.

🍽 Eating Out
Auberge des Peintres: +33 (0)2 33 26 49 18.
Auberge de la Vallée: +33 (0)2 33 28 94 70.
L' Échoppe Gourmande: +33 (0)2 33 81 91 21.
La Taverne Giroise: +33 (0)2 33 32 24 51.

🍴 Local Specialties
Art and Crafts
Marquetry • Restoration of paintings • Artists • Painter-sculptor.

🗓 Events
Pentecost: Artists' event.
July: "Saint Scène" (music).
August: Open-air rummage sale (1st Sunday).

🦋 Outdoor Activities
Canoeing • Fishing • Walking: Route GR 36, several marked trails via the Normandie-Maine regional nature park and the Chemin des Arts toward the Mont des Avaloirs • Mountain-biking • "Monts et Marche" (signposted walk).

🌿 Further Afield
• Saint-Léonard-des-Bois (3 miles/5 km).
• Alençon: Musée de la Dentelle, lace museum (9½ miles/15.5 km).
• Mont des Avaloirs (9½ miles/15.5 km).

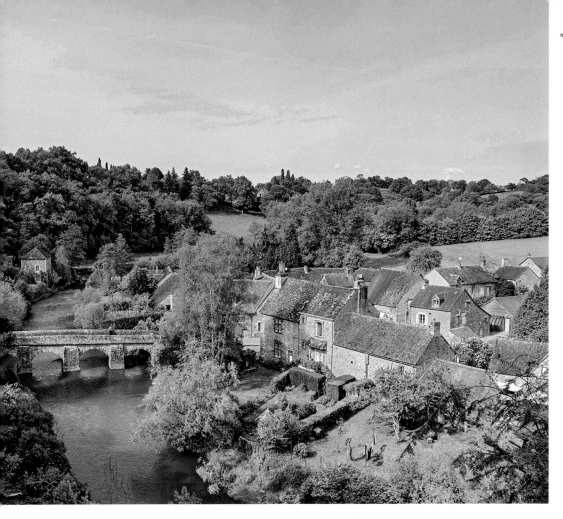

- Forêt d'Écouves, forest; Château de Carrouges (12–19 miles/19–31 km).
- Parc naturel régional Normandie-Maine, nature park; Carrouges (19 miles/31 km).
- Bagnoles-de-l'Orne (25 miles/40 km).
- Haras National du Pin, national stud (34 miles/55 km).

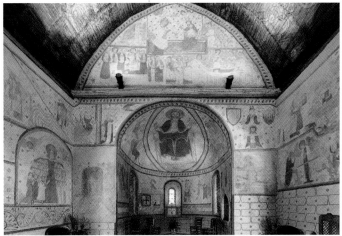

♟ Did you know?

In the 15th-century chapel built on the site of the Saint Céneri hermitage, there is a statue of the hermit and a granite stela, said to have been used by him as a bed, and believed to heal incontinence. Legend has it that, if young girls pushed a needle into the feet of the saint's statue, they would be able to find a husband.

Saint-Suliac

Between land and sea

Ille-et-Vilaine (35) • Population: 930 • Altitude: 69 ft. (21 m)

With a stunning view over the Rance estuary, Saint-Suliac sits in a beautifully unspoilt landscape.

The impressive steeple of the Église de Saint-Suliac rises loftily above an old cemetery that represents a unique kind of churchyard in Haute Bretagne. The church is set in the center of a maze of narrow alleyways lined with fishermen's houses and low granite garden walls. Paths from the village lead to a variety of delightful attractions: the tide mill; the old salt marshes at Guettes, created in 1736; the standing stone of Chablé, dubbed the "Dent de Gargantua" (Gargantua's Tooth), and the intriguing remains of a Viking camp. The port, busy with both fishing and pleasure boats, evokes Saint-Suliac's rich maritime history. This was a population of sailors, and the Vierge de Grainfollet (patron saint of Newfoundland), sitting above the village, reveals the heavy price that these coastal folk paid the sea in order to support their families.

By road: Expressway A84, exit 34–Saint-Malo (32 miles/51 km); N175 then N176, exit Châteauneuf-d'Ille-et-Vilaine (2½ miles/4 km).
By train: Saint-Malo station (8 miles/13 km); Dinan station (16 miles/26 km).
By air: Dinard-Pleurtuit airport (16 miles/26 km); Rennes-Saint-Jacques airport (43 miles/69 km).

ⓘ Tourist information—Saint-Malo-Baie du Mont Saint-Michel:
+33 (0)825 135 200
www.saint-suliac.fr
www.saint-malo-tourisme.com

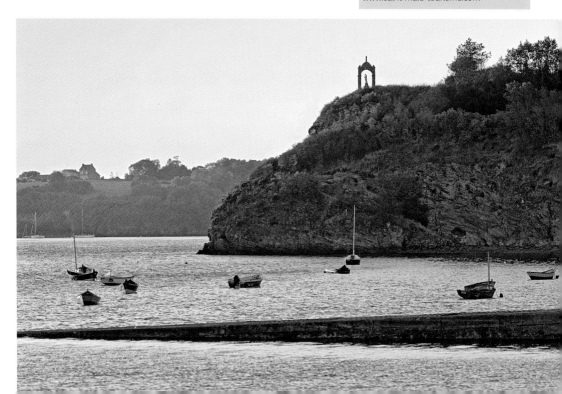

👁 Highlights
• **Church** (13th century): Stained-glass windows, wood carving, sailors' shrine.
• **Village:** Guided tours, Thursdays in July and August: +33 (0)825 135 200; guided visits June–September by the Le Patrimoine organization: www.saint-suliac.fr; themed walks by appointment only, Guillemette Tremaudan: +33 (0)2 23 15 03 85.

🗝 Accommodation
Guesthouses
L'Acadie 🛏🛏🛏🛏: +33 (0)2 23 15 04 94.
Les Mouettes 🗝🗝🗝 and 🗝🗝:
+33 (0)2 99 58 30 41.
À la Mer: +33 (0)5 69 64 13 88.
Les Salines de la Rance:
+33 (0)2 99 58 21 37.
Gîtes
La Métairie du Clos de Broons***:
+33 (0)2 99 89 12 30.
L'Escalier 🛏🛏🛏🛏, Le Mont Garrot 🛏🛏🛏,
Gîte N° 35G11111 🛏🛏🛏, Gîte
N° 35G111063 🛏🛏🛏, Gîte
N° 35G11106 🛏🛏: +33 (0)2 99 89 12 30
www.gîtes-de-france.com
Jean Glemot 🗝🗝🗝: +33 (0)6 51 66 90 36.
Further information: www.saint-suliac.fr
Campsites
Les Cours**: +33 (0)6 81 27 15 30.
Mobile homes
Le Bigorneau: +33 (0)6 59 87 71 72.

🍴 Eating Out
Le Bistrot de la Grève: +33 (0)2 99 58 95 84.
La Ferme du Boucanier:
+33 (0)2 23 15 06 35.
Le Galichon: +33 (0)2 99 58 49 49.
Food trucks from April to October.

🧺 Local Specialties
Food and Drink
Cider • Buckwheat *galettes* (pancakes) • Fish and shellfish.
Art and Crafts
Flowercraft • Painter.

2 Events
Market: Summer market, Tuesday evenings (4.30 p.m.–8.30 p.m.), July and August.
June: "Feu de la Saint-Jean," Saint John's Eve bonfire (2nd fortnight).
August: "Saint-Suliac Autrefois," historical event (1st weekend); Pardon de la Mer ceremony at Notre-Dame-de-Grainfollet (15th).
September: "Trail des Terre-Neuvas," cross-country race (3rd weekend); "Copeaux d'Abord," sea festival (last weekend).
December: Christmas market and living Nativity (1st and 2nd weekends).

🌊 Outdoor Activities
Swimming • Fishing • Sailing • Horse-riding • Walking: 3 marked trails, Route GR 34 and GR route in the Pays Malouin • Mountain-biking.

🌿 Further Afield
• Saint-Malo (6 miles/9.5 km).
• Cancale (11 miles/18 km).
• Mont-Dol (12 miles/19 km).
• Dinan (14 miles/23 km).
• Mont-Saint-Michel (19 miles/31 km).

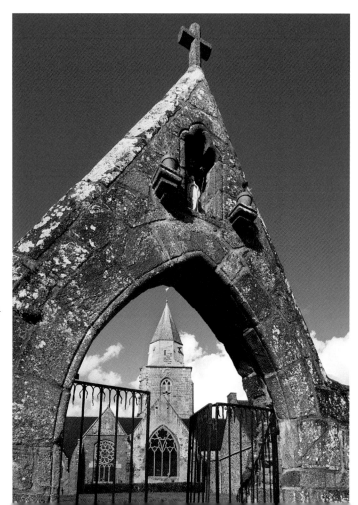

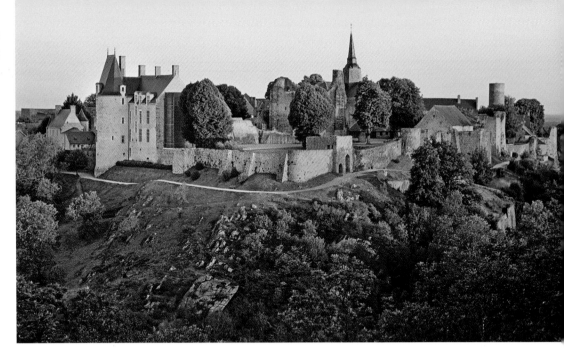

Sainte-Suzanne

Beauty and rebellion

Mayenne (53) • Population: 1,008 • Altitude: 525 ft. (160 m)

This medieval village, the "pearl of Maine," perched on top of a rocky peak dominating the Erve valley, resisted attacks from William the Conqueror.

When relics of Saint Suzanne (patron saint of fiancés) were brought back to Saint-Jean-de-Hautefeuille from the Crusades, the village was renamed in her honor. The medieval village was fortified in the 11th century; both beautiful and rebellious, it proudly resisted William the Conqueror, but had to surrender to the English during the Hundred Years War. Atop a mound opposite the village, the site of Tertre Ganne, occupied by the earl of Salisbury's troops during the 1425 siege, offers a fabulous view of Sainte-Suzanne's striking profile. The keep partly survived this tumultuous period, but the double wall of 12th-century ramparts owes its present appearance to Guillaume Fouquet de La Varenne, comptroller general of posts, who also built the Renaissance lodge and took over ownership of the citadel from Henri IV. The hamlet of La Rivière, where the "Promenade des Moulins" path winds, offers the loveliest vistas toward the medieval village.

By road: Expressway A81, exit 1–Sablé (12 miles/19 km).
By train: Évron station (4½ miles/7 km); Laval station (21 miles/34 km).
By air: Angers-Marcé airport (45 miles/ 72 km).

ⓘ Tourist information—
Sainte-Suzanne – Les Coëvrons:
+33 (0)2 43 01 43 60
www.coevrons-tourisme.com
www.ste-suzanne.fr

👁 Highlights

- **Castle** (17th century): Centre d'Interprétation de l'Architecture et du Patrimoine de la Mayenne, visitor center; exhibitions and activities: +33 (0)2 43 58 13 00.
- **Romanesque keep** (11th century): Self-guided visit (interior staircases and gangways).
- ♥ **Musée de l'Auditoire** (16th century): 3,000 years of the village's history: +33 (0)2 43 01 42 65.
- **Moulin à Papier** (15th–19th centuries): Former communal mill belonging to the village's lords, the only one in France to produce flour and paper using the same wheel. Guided visits, manufacture and sale of artisanal paper: +33 (0)2 43 90 57 17.
- **Camp des Anglais**: Fortified camp, William the Conqueror's base during the siege of 1083–86, military fortifications, self-guided visit: +33 (0)2 43 01 43 60.
- **Dolmen des Erves** (2 miles/3km): 6,500-year-old megalith.
- **Medieval town**: Guided tours by appointment: +33 (0)2 43 01 43 60.
- **Chapelle Saint-Eutrope** (18th century): altarpiece dating to 1706.
- **Tertre-Ganne**: panorama over the town (1½ miles:2 km).

🔑 Accommodation

Hotels
Hôtel Beauséjour**: +33 (0)2 43 01 40 31.
Guesthouses
Côté Jardin 🛏🛏🛏🛏: +33 (0)2 43 98 93 66.
Le Moulin des Forges: +33 (0)2 72 95 01 34.
Gîtes
Le Passe-Muraille****:
+33 (0)6 42 78 11 71.
♥ Les Gîtes des Remparts 🛏🛏🛏🛏:
+33 (0)6 42 78 11 71.
Le Grand Moulin 🛏🛏🛏:
+33 (0)820 153 053.
La Closerie de la Trottinière 🛏🛏:
+33 (0)3 43 67 09 07.
Further information:
www.coevrons-tourisme.com
Farmhouse accommodation
La Sorie, equestrian farm:
+33 (0)2 43 01 40 63.
Vacation villages and campsites
VVF-villages "La Croix Couverte"***:
+33 (0)2 43 01 40 76.
Sainte-Suzanne Camping-Caravaning et Glamping**: +33 (0)6 33 76 87 70.
RV parks
La Madeleine RV park:
+33 (0)8 05 69 48 69.

🍽 Eating Out

La Cabane, light meals:
+33 (0)6 11 32 58 01.
Café des Tours: +33 (0)2 43 66 81 10.
Hôtel-restaurant Beauséjour:
+33 (0)2 43 01 40 31).
Péché de Gourmandise, Le Bistrot:
+33 (0)6 83 75 10 76.

🎩 Local Specialties

Art and Crafts
Candles • Painting, sculpture, and jewelry • Handmade soaps.

📅 Events

Market: Saturday mornings, Place Ambroise-de-Loré.
May: "Les 6 Heures de Sainte-Suzanne," race and sports festival.
June: Soirée Bodega, street party.
July–August: "Journée des Peintres dans la Rue," art festival; photography competition; "Nuits de la Mayenne," theater festival; medieval activities (Wednesdays).
September: Riverside fair; le Roc Suzannais, mountain-biking.
December: Christmas market.

🦋 Outdoor Activities

Recreation area • Pond fishing • Horse-riding trails • Walking and mountain-biking (maps from tourist information center).

🌿 Further Afield

- La Promenade des Moulins, history trail; La Rivière, hamlet (½ mile/1 km).
- Tertre Ganne: view across to the village (1 mile/1.5 km).
- Pays d'Art et d'Histoire Coëvrons-Mayenne, regional cultural heritage: Évron, Saulges, Jublains, Mayenne (3–22 miles/5–35 km).
- Gué de Selle, lake (7½ miles/12 km).
- Laval (22 miles/35 km).
- Le Mans (34 miles/55 km).

🗝 Did you know?

The Musée de l'Auditoire in Sainte-Suzanne has on display the oldest suit of armor in France (1410–30).

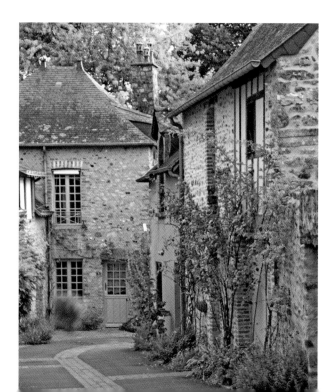

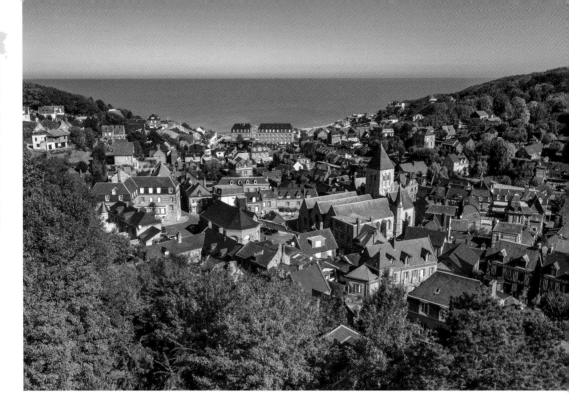

Veules-les-Roses

Beach resort in the Pays de Caux

Seine-Maritime (76) • Population: 586 • Altitude: 260 ft. (79m)

Nestled between land and sea, in the hollow of a valley located on the Caux plateau and ending in a cliff overlooking the Côte d'Albâtre, Veules-les-Roses is bursting with charm. Inhabited since the 4th century, it takes its name from the ancient Saxon word *well*, meaning "water source." Water is everywhere in the local landscape and has shaped the village's history since its foundation. The sea brought prosperity in the Middle Ages, and in the 19th century prompted the development of one of the first beach resorts to be frequented by famous artists and writers. Other tales speak of the Veules, the "shortest river in France," which powered weaving mills and flour mills, and irrigated the still-active watercress beds before flowing into the English Channel. And there are also accounts of the village's rebirth, since history has left its mark even in this little corner of Normandy, in the form of barbarian invasions, the Wars of Religion, and World War II. From its sea front and bathing huts to the heart of the village where fishermen's houses rub shoulders with thatched cottages and villas with flowering gardens, Veules-les-Roses still presents visitors with a variety of architecture and landscape that makes it an unmissable stopping point on the road to Fécamp and Dieppe.

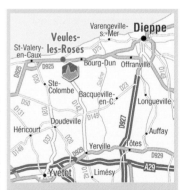

By road: Expressway A150, exit 4–Saint-Valery-en-Caux (20 miles/32 km); expressway A29, exit 8–Yvetot (25 miles/40 km); expressway A28, exit 10–Les Hayons (32 miles/52 km). **By train:** Dieppe station (16 miles/26 km); Yvetot station (21 miles/34 km). **By air:** Rouen-Vallée-de-Seine airport (47 miles/75 km); Deauville-Normandie airport (61 miles/98 km). **By bus:** 61 Dieppe—Saint-Valéry-en-Caux (4½ miles/7 km).

ⓘ **Tourist information—Plateau de Caux Maritime:** +33 (0)2 35 97 63 05
www.plateaudecauxmaritime.com
www.veules-les-roses.fr

👁 Highlights
• **Église Saint-Martin** (13th–16th centuries): Painted murals recently uncovered in the choir vault; polychrome statuary from 15th–17th centuries.
• **Route along the "shortest river in France"**: Follow the Veules to see the local nature and architecture of the village and the beach resort (cliff, mills, religious buildings, cress beds, drinking troughs, thatched cottages, villas). Self-guided tours; guided tours for groups all year round by appointment, and in July–August for individuals: +33 (0)2 35 97 63 05.

🔑 Accommodation
Aparthotel
Relais Hôtelier Douce France: +33 (0)2 35 57 85 30.
Guesthouses
Le Moulin des Cressonnières ▯▯▯▯: +33 (0)2 35 97 60 27 or +33 (0)6 13 17 34 67.
La Petite Maison 🔑🔑🔑: +33 (0)2 35 57 36 10.
La Maison de la Rose 🔑🔑: +33 (0)2 35 97 60 16 or +33 (0)6 82 32 28 81.
Le Jardin Saint-Nicolas: 33 (0)6 48 74 47 13.
Gîtes and vacation rentals
Mme Bourdin***: +33 (0)6 04 16 54 58.
Les Embruns***: +33 (0)6 31 89 57 25.
À l'Abri des Roses**: +33 (0)6 79 13 84 05.
Les Bains de la Mer**: +33 (0)2 35 97 43 67.
M. Defosse**: +33 (0)7 85 85 34 25.
Résidence Le France—Mme Paumelle*: +33 (0)6 74 43 09 68.

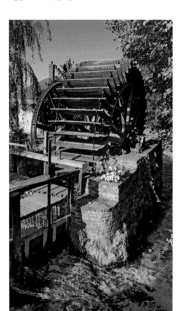

Les Hortensias ▯▯▯: +33 (0)2 35 60 73 34 or +33 (0)6 83 05 19 30.
Champs Elysées 🔑🔑🔑: +33 (0)6 22 51 39 77.
La Dame de la Côte 🔑🔑🔑: +33 (0)6 81 49 42 23.
Les Bains 🔑🔑: +33 (0)6 83 49 42 05.
M. Claire 🔑🔑: +33 (0)6 59 60 52 00.
Les Logis de la Plage 🔑🔑: +33 (0)6 70 29 83 38.
Vacation village
VVF Village***: +33 (0)2 35 97 68 04 or +33 (0)4 73 43 00 43.
Campsite
♥ Les Mouettes***: +33 (0)2 35 97 61 98.

🍴 Eating Out
4 d'Alice: +33 (0)2 35 97 76 41.
L'Abreuvoir: +33 (0)9 51 39 92 81.
Les Galets, gourmet restaurant: +33 (0)2 35 97 61 33.
Le Pinocchio, pizzeria: +33 (0)2 35 97 38 10.
Relais Hôtelier Douce France: +33 (0)2 35 57 85 30.
Le Tropical, brasserie: +33 (0)2 35 57 17 36.
Le Victor Hugo, brasserie: +33 (0)2 35 97 98 98.
Light meals
Bar des Voyageurs, fast food: +33 (0)2 35 57 32 53.
Comme à la Maison, fast food: +33 (0)9 81 05 63 11 or +33 (0)6 64 96 16 12.
La Cressonnière, crêperie: +33 (0)2 35 57 25 32 or +33 (0)6 43 34 35 29.
Le P'tit Veulais, crêperie: +33 (0)2 35 57 32 53.
Tea rooms
Atelier 2—L'art du thé: +33 (0)2 35 97 07 95.
Le Bristol: +33 (0)2 27 13 17 48.

🧺 Local Specialties
Food and Drink
Cress • Veules oysters.
Art and Crafts
Artists' galleries • Upholsterer • Interior designer.

📅 Events
Market: Wednesday mornings.
April: Cress festival.
May: "Salon des Arts," art show.
May and June: "Rose en Fête," rose and garden festival (weekend of Father's Day).
June and August: Exhibitions.
July: Book show; linen festival (2nd weekend).
July and August: Exhibitions; "Read on the Beach," evening market for artisans and designers.
October: "Festival de l'Image," photography and film festival.
September: SITU Festival (theater, circus, cinema).
All year round: "Ciné-Objectifs" film screenings; "Les Vendredis du Patrimoine" (last Friday of month).

🦋 Outdoor Activities
Bathing (beach) • Watersports • Fishing: sea and shore • Walks (4 circuits).

🌿 Further Afield
• Saint-Valery-en-Caux: Maison Henri IV (4½ miles/7 km).
• Sainte-Marguerite-sur-Mer: Vasterival gardens: (9 miles/15 km).
• Tourville-sur-Arques: Miromesnil castle (10 miles/16 km).
• Varengeville-sur-Mer: church and sailors' cemetery; Bois des Moutiers ornamental gardens (12 miles/20 km).
• Dieppe (16 miles/26 km).
• Fécamp: Benedictine palace, museums, abbey church (25 miles/40 km).
• Etretat: cliffs and Notre-Dame-de-la-Garde chapel (35 miles/56 km).

❗ Did you know?
In the 19th century, many writers and artists flocked to Veules-les-Roses on vacation, among them the Goncourt brothers and Victor Hugo. The latter liked to gaze out to sea and chat with locals while sitting in a cave on the cliff road.

Vouvant
Village of painters and legends

Vendée (85) • Population: 919 • Altitude: 361 ft. (110 m)

Deep in the forest of Vouvant-Mervent, the Mère river winds through a landscape that has inspired both art and mystery.

William V, duke of Aquitaine (969–1030), discovered the site of Vouvant while hunting. Struck by its strategic position, he built a castle, a church, and a monastery here in the 11th century. In the church, the 12th-century portal, the 12th-century apse, and the 11th-century crypt are all well worth seeing. The castle has retained only its keep, the Mélusine Tower, sections of the ramparts, and a 13th-century postern gate, which was used by Saint Louis (King Louis IX). A Romanesque bridge straddles the river Mère, linking the two riverbanks. Everyday life in the village is enhanced by numerous artists who form the "Vouvant, Village de Peintres" art association, which organizes a wide range of cultural events.

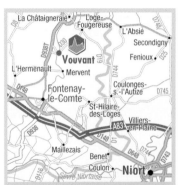

By road: Expressway A83, exit 8– Fontenay-Ouest (11 miles/18 km).
By train: Fontenay-le-Comte station (10 miles/16 km); Niort TGV station (35 miles/56 km). **By air:** La Rochelle-Laleu airport (40 miles/64 km).

ⓘ Tourist information:
+33 (0)2 51 00 86 80
www.fontenay-vendee-tourisme.com
www.vouvant.fr

👁 Highlights
• **Église Notre-Dame** (11th and 13th centuries); sound and light show on the west front, dusk Fridays and Saturdays in summer.
• **Nef Théodelin** (11th century): Exhibition center.
• **Mélusine Tower** (13th century): 115 ft. (35 m) high; views over the village and the Vendée landscape.
• **Village:** Guided visits of 1½ hours by appointment: +33 (0)2 51 69 44 99; walking tour of the ramparts.

🗝 Accommodation
Guesthouses
Auberge de Maître Pannetier:
+33 (0)2 51 00 80 12.
La Grange aux Peintres:
+33 (0)6 98 24 12 00.
Mme Guesdon: +33 (0)6 31 36 37 08.
La Porte aux Moines: +33 (0)2 53 72 01 37.
Les Pousses Vieilles, Pierre Blanche:
+33 (0)2 51 00 36 48.
Le Relais de la Grande Rue:
+33 (0)2 51 00 83 56.
Gîtes and vacation rentals
Further information:
www.fontenay-vendee-tourisme.com
www.vouvant.fr
Family vacation centers
Relais Mélusine: +33 (0)2 51 00 80 14.
Vacation villages
La Girouette: +33 (0)2 51 50 10 50.

⑪ Eating Out
Auberge de Maître Pannetier:
+33 (0)2 51 00 80 12.
Café Cour du Miracle: +33 (0)2 51 00 54 93.

Café Mélusine: +33 (0)2 51 00 81 34.
L'Etable Gourmande: +33 (0)2 51 50 24 45.

🧺 Local Specialties
Food and Drink
Brioches and cakes • Pâtés, foie gras, and duck confit • Honey.
Art and Crafts
Artists' studios • Art galleries • Leather jewelry.

② Events
Market: Summer local produce and crafts market, Monday mornings, June–mid-September.
July–August: "Vouvant, Village de Peintres," exhibitions and activities.
August: "Festival des Nuits Musicales en Vendée Romane," music festival.

🦋 Outdoor Activities
Horse-riding • Fishing • Tennis • Walking and mountain-biking: 3 marked trails.

🌿 Further Afield
• Forêt de Vouvant-Mervent, forest; Mervent (4½ miles/7 km).
• Fontenay-le-Comte (10 miles/16 km).
• Marais Poitevin, region (19 miles/31 km).
• Puy-du-Fou, theme park (28 miles/45 km).

❗ Did you know?
Mélusine—half-woman, half-serpent or fish—often appears in legends told in the north and west of France, the Low Countries, and Cyprus. She is said to have built the castle in Vouvant in one night, "with three aprons-full of stones and one mouthful of water."

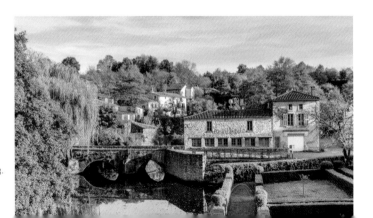

Yèvre-le-Châtel

A medieval inspiration for modern artists

Loiret (45) • Population: 231 • Altitude: 361 ft. (110 m)

On the boundary between the regions of Beauce and Gâtinais, Yèvre-le-Châtel is a happy blend of medieval heritage and contemporary art.

Yèvre Castle, built in the 13th century under King Philip Augustus and recently restored, commands the Rimade valley and a wide horizon. Its high ramparts and four round towers dominate the Romanesque church of Saint-Gault and the unfinished nave of Saint-Lubin. There is a circular walk around the curtain wall and, from the top of the towers, there are stunning views over the surrounding landscape, as far as the forest of Orléans. All along the flower-bedecked streets from the Place du Bourg, near the old well, to the Pont de Souville straddling the Rimarde, old houses and gardens hide behind limestone walls. The village seduced many 20th-century painters, including Maria Vieira da Silva (1908–1992), Árpád Szenes (1897–1985), and Eduardo Luiz (1932–1988), and continues to attract artists and galleries.

By road: Expressway A6, exit 14– Malesherbes (27 miles/43 km), D2152 (5½ miles/9 km); N20 (21 miles/34 km); expressway A19, exit 7–Pithiviers (8½ miles/13.5 km).
By air: Paris-Orly airport (59 miles/95 km).

ⓘ **Tourist information:**
+33 (0)2 38 34 25 91
www.yevre-la-ville.fr

👁 Highlights
• **Castle** (13th century):
+33 (0)2 38 34 25 91.
• **Église Saint-Gault** (12th century).
• **Église Saint-Lubin** (13th century).
• **Village:** Guided tour by appointment:
+33 (0)2 38 34 25 91.

🗝 Accommodation
Gîtes
Les Remparts Fleuris ▮▮▮▮:
+33 (0)2 38 62 04 88.
Le Clos Châtel ▮▮▮: +33 (0)2 38 34 25 22.

🍴 Eating Out
Le Courtil, tea room: +33 (0)2 18 13 21 52.
La Rolanciène: +33 (0)2 38 34 28 47.

🧺 Local Specialties
Food and Drink
Farm produce: e.g. oil, honey, saffron, cider, wine, jam.
Art and Crafts
Art galleries.

📅 Events
Market: Sunday mornings, Place du Bourg.
May–September: Art and sculpture exhibitions indoors and outside.
July–August: Concerts in Église Saint-Gault.
August: Medieval games and activities.

🦋 Outdoor Activities
Walking: Route GR 655 and Rimarde valley.

🌿 Further Afield
• Boynes: Musée du Safran, saffron museum (3½ miles/5.5 km).
• Pithiviers (3½ miles/5.5 km).
• Pithiviers-le-Vieil: Gallo-Roman site (5 miles/8 km).
• Château de Chamerolles (12 miles/19 km).
• Malesherbes (16 miles/26 km): Musée de l'Imprimerie, printing museum.
• Montargis (26 miles/42 km).
• Orléans (28 miles/45 km).

❗ Did you know?
Yèvre and its castle charmed Victor Hugo, who, in a letter to his wife dated August 22, 1834, said, "I had an admirable journey to Pithiviers and its surrounding area. Yèvre-le-Châtel, which is two leagues away and where I went on foot with holes in my shoes, keeps all to itself a convent and a castle, ruined but complete. It is magnificent. I am drawing everything I see." Indeed, two of these drawings are kept at the Maison de Victor Hugo, Paris.

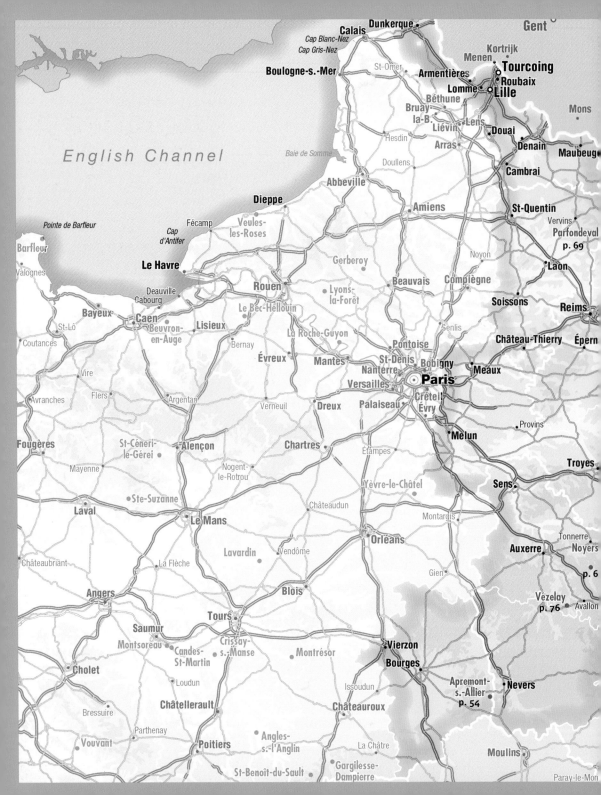

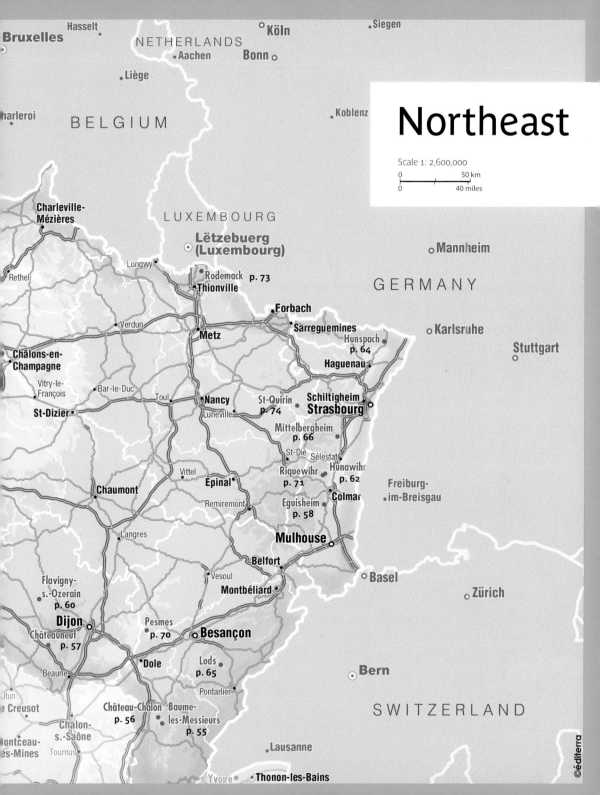

Northeast

Scale 1: 2,600,000

0 50 km

0 40 miles

Bruxelles

Hasselt

NETHERLANDS

Köln

Siegen

Aachen

Bonn

Liège

Charleroi

BELGIUM

Koblenz

Charleville-
Mézières

LUXEMBOURG

Lëtzebuerg
(Luxembourg)

Mannheim

Rethel

Longwy

GERMANY

Rodemack p. 73
Thionville

Forbach

Verdun

Metz

Sarreguemines

Hunspach
p. 64

Karlsruhe

Stuttgart

Châlons-en-
Champagne

Haguenau

Vitry-le-
François

Bar-le-Duc

Toul

Nancy

St-Quirin
p. 74

Schiltigheim
Strasbourg

St-Dizier

Lunéville

Mittelbergheim
p. 66

Vittel

St-Dié

Sélestat

Riquewihr
p. 71

Hunawihr
p. 62

Chaumont

Épinal

Colmar

Freiburg-
im-Breisgau

Remiremont

Eguisheim
p. 58

Langres

Mulhouse

Belfort

Flavigny-
s.-Ozerain
p. 60

Vesoul

Montbéliard

Basel

Zürich

Dijon

Pesmes
p. 70

Besançon

Châteauneuf
p. 57

Dole

Lods
p. 65

Bern

Beaune

Pontarlier

utun

Creusot

Château-Chalon
p. 56

Baume-
les-Messieurs
p. 55

SWITZERLAND

Chalon-
s.-Saône

ontceau-
-Mines

Tournus

Lausanne

Yvoire

Thonon-les-Bains

©éditerra

Apremont-sur-Allier
The garden village

Cher (18) • Population: 77 • Altitude: 581 ft. (177 m)

Overlooked by a castle surrounded by landscaped gardens, the village—which was entirely restored in the last century—is reflected in the Allier river.

In the Middle Ages, the Château d'Apremont, the westernmost possession of the duchy of Burgundy, was a powerful fortress. Four centuries later, in 1894, Eugène II Schneider, third in the dynasty of powerful industrialists based around Le Creusot, married Antoinette de Saint-Sauveur, a direct descendant of the family that had owned the castle since 1722. Until his death in 1942, Schneider worked tirelessly, with the aid of his architect and decorator, M. de Galéa, to restore this château and every house in Apremont in the Berry style. His grandson Gilles de Brissac continued his work, and in 1970 created a garden at the foot of the castle, inspired by Vita Sackville-West's garden at Sissinghurst in England. Among the ponds, waterfalls, and more than a thousand tree and flower species, a Chinese covered bridge, a Turkish pavilion, and a belvedere decorated with Nevers faience, designed in the style of 18th-century follies, add a nice, exotic touch. At the end of the village, the Maison des Mariniers is a reminder that, for a long time, Apremont was a village of quarrymen and bargemen who used the Allier and Loire rivers to transport the stone that still dresses Orléans Cathedral and the Abbaye de Saint-Benoît-sur-Loire.

By road: Expressway A77, exit 37–Bourges (8½ miles/13.5 km); N7, exit 76–Bourges (20 miles/32 km).
By train: Nevers station (10 miles/16 km).
By air: Clermont-Ferrand-Auvergne airport (98 miles/158 km).

ⓘ **Town hall:** +33 (0)2 48 80 40 17
www.mairie-apremontsurallier.info

👁 Highlights
• **Floral gardens** (classed as "remarkable" by the Ministry of Culture): Musée des Calèches, stables and carriage museum; walk around the castle ramparts: +33 (0)2 48 77 55 06.
• **Village:** Guided tour by appointment only: +33 (0)2 48 74 23 93.

🗝 Accommodation
Guesthouses
La Maison d'Apremont 🏠🏠🏠:
+33 (0)2 48 77 55 00.
Gîtes and vacation rentals
La Maison d'Allier 🏠🏠🏠:
+33 (0)2 48 48 00 18.

🍴 Eating Out
La Brasserie du Lavoir: +33 (0)2 48 80 25 76.
Les Petites Causeries de la Carpe Frite (May–September only):
+33 (0)2 48 77 64 72.

📅 Events
Easter: Egg hunt in the floral gardens (Sunday).
May: Fête des Plantes de Printemps (3rd weekend, classical music festival.

June: Brocante de Charme, flea market (4th weekend).
October: Festival of wine, food, and seasonal plants (3rd weekend).
December: Christmas market (2nd weekend).

🌾 Outdoor Activities
Fishing • Walking on the Chemin de Compostelle (Saint James's Way) via Route GR 654; strolling along the banks of the Allier • Cycling: "Loire à Vélo" trail.

🌿 Further Afield
• Bec d'Allier nature reserve and Pont-canal du Guétin (aqueduct) (3 miles/5 km).
• La Guerche-sur-l'Aubois: "La Tuilerie" tile factory, museum, and visitor center (5 miles/8 km).
• Espace Métal/Halle de Grossouvre, museum of industry (6 miles/9.5 km).
• Château de Meauce (6 miles/10 km).
• Nevers (9½ miles/15.5 km).
• Abbaye de Fontmorigny (12 miles/19 km).
• Château de Sagonne (16 miles/26 km).

Baume-les-Messieurs

An imperial abbey in the Jura

Jura (39) • Population: 196 • Altitude: 1,083 ft. (330 m)

Baume-les-Messieurs combines the simplicity of a village with the spirituality of the abbey that inspired the founding of the Order of Cluny, which spread throughout the West during the Middle Ages.

Nestled in a remote valley typical of the Jura landscape formed by the Seille river, Baume Abbey experienced remarkable growth throughout the Middle Ages. Developed from the 9th century at the instigation of Abbot Berno, later the founder of Cluny, it enjoyed such widespread influence that Frederick Barbarossa made it an imperial abbey. Of great architectural wealth (Romanesque with alterations in the 16th century), the abbey contains several convent buildings, a 16th-century Flemish altarpiece, a tomb-chapel, and Burgundian statuary. During the French Revolution, the abbey was divided up into private dwellings. Lulled by the gentle sound of the cloister fountain or by the louder noise of the Seille, which cascades in waterfalls not far off, the pale-fronted, brown-roofed houses live in harmony with this green, wild valley, whose rich soil produces some fine wines.

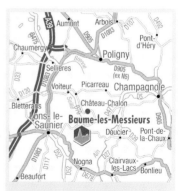

By road: Expressway A39, exit 8–Lons-le-Saunier (17 miles/27 km). **By train:** Lons-le-Saunier station (8½ miles/13.5 km). **By air:** Dijon-Bourgogne airport (61 miles/98 km); Geneva airport (68 miles/109 km).

(i) Tourist information—Coteaux du Jura: +33 (0)3 84 44 62 47
www.tourisme-coteaux-jura.com

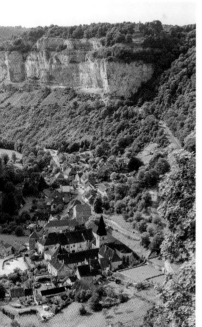

👁 Highlights

• Imperial abbey: Abbey church, 16th-century Flemish altarpiece, 15th-century Burgundian statuary, tomb-chapel, permanent exhibition on the abbey's history. Option of guided tour. Further information and bookings: +33 (0)3 84 44 99 28; audioguides in French, English, and German.
• Baume caves: Considered to be among the most spectacular in Europe, with ½ mile (1 km) of accessible galleries and new lighting effects. Further information and bookings: +33 (0)3 84 48 23 02.
• Cascade des Tufs: waterfalls.

🗝 Accommodation

Guesthouses
Les Trois Cloches 🛏🛏🛏: +33 (0)6 76 54 31 37.
Baume A Villeneuve: +33 (0)6 42 69 34 47.
Ghislain Broulard: +33 (0)3 84 44 64 47.
La DaniMod: +33 (0)9 84 26 58 66.
Le Dortoir des Moines:
+33 (0)3 84 44 97 31.
Le Grand Jardin: +33 (0)3 84 44 68 37.
La Grange à Nicolas: +33 (0)3 84 85 20 39.
Bernard Lechat: +33 (0)3 84 85 26 49.
Presbytère Saint-Jean:
+33 (0)3 84 44 66 76.

Gîtes, vacation rentals, and campsites
Further information: +33 (0)3 84 44 99 28
www.tourisme-coteaux-jura.com

🍴 Eating Out

L'Abbaye: +33 (0)3 84 44 63 44.
Restaurant des Grottes: +33 (0)3 84 48 23 15.
Le Grand Jardin: +33 (0)3 84 44 68 37.

🧺 Local Specialties

Food and Drink
AOC Jura and Côtes du Jura wines •
Honey • Abbey produce.
Art and Crafts
Puppets and figurines made from plants • Potter.

2 Events

December: Christmas market (1st weekend);
Les Fayes, celebration of the winter solstice (25th).

🦋 Outdoor Activities

Walking, riding, and mountain-biking:
Route GR 59 and 5 themed trails.

🌿 Further Afield

• Voiteur (3 miles/5 km).
• *Château-Chalon (7½ miles/12 km), see p. 56.
• Châteaux of Le Pin and Arlay (10 miles/16 km).
• Lons-le-Saunier (11 miles/18 km).
• Lac de Chalain (16 miles/26 km).
• Cascades du Hérisson, waterfalls (19 miles/31 km).

Château-Chalon

Flagship of the Jura vineyards

Jura (39) • Population: 162 • Altitude: 1,529 ft. (466 m)

Overlooking the valley of the Seille and the Bresse plain, Château-Chalon watches over its vineyards, the birthplace of *vin jaune*, the white wine that resembles a dry sherry.

Between the grasslands and forests of the Jura plateau and the vineyards huddled beneath the cliff, the village emerged around a Benedictine abbey, as is evidenced by the Romanesque Église Saint-Pierre, covered with limestone *laves* (flagstones), and a castle, now reduced to a ruined keep. Lined with sturdy winemakers' houses, which are often flanked by a flight of steps and pierced with large arched openings, nearly every street in Château-Chalon leads to one of the four viewpoints overlooking the vineyards, where Savagnin reigns supreme. In the secrecy of their cellars, winemakers use this distinctive grape variety to make *vin jaune*, ageing the nectar in oak casks for at least six years and three months. At the heart of the village, the Maison de la Haute-Seille houses the tourist information center, as well as an interactive museum on wine and terroir.

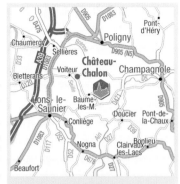

By road: Expressway A39, exit 7–Poligny (7½ miles/11.5 km).
By train: Lons-le-Saunier station (9½ miles/15.5 km). **By air:** Dole-Jura airport (30 miles/48 km).

(i) Tourist information—Coteaux du Jura: +33 (0)3 84 24 65 01
www.tourisme-coteaux-jura.com

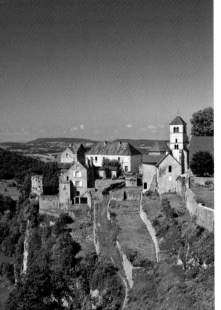

👁 Highlights

• **Maison de la Haute-Seille:** Interactive museum and an introduction to the Jura vineyards: +33 (0)3 84 24 76 05.
• **Église Saint-Pierre:** Romanesque and Gothic art; murals, rich furniture, treasure belonging to the abbey (reliquaries, goldware, statues).
• **École d'Autrefois:** School furniture and teaching materials from 1880 to 1930; activities from April to October: +33 (0)3 84 44 62 47 or +33 (0)3 84 24 76 05.
• **Old cheese factory:** Guided tours: +33 (0)3 84 44 92 25.
• **Vigne conservatoire:** A plot of 53 old Jura grape varieties from the 19th century: +33 (0)3 84 44 62 47.

🗝 Accommodation

Guesthouses
T'Nature 🏠🏠🏠: +33 (0)3 84 85 29 83.
La Maison d'Eusébia: +33 (0)6 86 60 03 23.
Le Relais des Abbesses:
+33 (0)3 84 44 98 56.
La Tour Charlemagne: +33 (0)3 84 47 21 98.
Gîtes
La Maison d'Anna****: +33 (0)3 84 52 50 87.
Les Marnes Bleues 🏠🏠🏠:
+33 (0)3 84 44 62 86.
Le Saint-Vernier: online booking only.

🍽 Eating Out

Le Bouchon du Château: +33 (0)3 84 25 15 60.
Le P'tit Castel: +33 (0)3 84 44 20 50.
Les Seize Quartiers: +33 (0)3 84 44 68 23.
La Taverne du Roc: +33 (0)3 84 85 24 17.

🏛 Local Specialties

Food and Drink
Cheeses • AOC Château-Chalon, Côtes du Jura, and Crémant wines • Bresse chicken in *vin jaune*.
Art and Crafts
Local crafts.

2 Events

April: Fête de la Saint-Vernier festival (3rd Sunday).
June: "L'art se dévoile," major art fair.
June–September: Entertainment, tasting evenings, gourmet walks, art exhibition.
July: Sound and light show of local history.
December: Les Fayes, winter solstice festival (25th).

🦋 Outdoor Activities

Walking: Route GR 59 and 5 marked trails for the vineyards • Mountain-biking: 5 certified circuits • Exploring the area by electric bike.

🌿 Further Afield

• Vineyards and steephead valleys of the Jura.
• Château de Frontenay (3½ miles/5.5 km).
• *Baume-les-Messieurs (7½ miles/12 km), see p. 55.
• Château d'Arlay (7½ miles/12 km).
• Poligny; Arbois (7½–9 miles/12–14.5 km).
• Lons-le-Saunier (9½ miles/15.5 km).

Châteauneuf
A castle in Auxois

Côte-d'Or (21) • Population: 87 • Altitude: 1,558 ft. (475 m)

The castle is situated to the fore of this village, the waters of the Burgundy Canal reflecting its medieval military architecture.

The fortress was built in the late 12th century by Jean de Chaudenay to control the old road from Dijon to Autun. It owes its austere bearing to its polygonal curtain wall flanked by massive towers and wide moats, which are crossed via one of the old drawbridges transformed into a fixed bridge. In the inner courtyard, the original keep is surrounded by two 15th-century *corps de logis* (central buildings). Below the castle, the church contains a Renaissance-style pulpit and a 14th-century Virgin and Child. Opposite the building is the Maison Blondeau, one of many old merchant houses of the 14th, 15th, and 16th centuries. Distinguished by their turrets, ornamented cartouches, mullioned windows, and ogee lintels, these houses are a recurrent feature of the fortified village, which stretches from the north gate to the spectacular mission cross viewpoint on the hilltop. From there, the view takes in the wooded hillsides of Auxois, with, in the background, the mountains of Morvan and Autun.

👁 Highlights
• **Castle:** 12th-century keep, 15th-century grand *logis* (Flemish tapestries, medieval furniture), residence of Philippe Pot (15th century), chapel (15th-century "distemper" paintings, copy of the recumbent statue of Philippe Pot retained at the Louvre), 14th-century south tower; multimedia visitor interpretive center; medieval garden; medieval-themed activities for children: +33 (0)3 80 49 21 89.
• **Église Saint-Jacques-et-Saint-Philippe** (16th century): Statues, 14th-century Virgin and Child: +33 (0)3 80 49 21 59.
• **Village:** Guided tour by appointment only: +33 (0)3 80 49 21 59.

🗝 Accommodation
Hotels
Hostellerie de Châteauneuf**: +33 (0)3 80 49 22 00.
Le Domaine des Prés Verts Spa: +33 (0)3 45 44 05 60.
Guesthouses
Mme Bagatelle 🏠🏠🏠: +33 (0)3 80 49 21 00.
Au Bois Dormant: +33 (0)6 79 49 25 62.
Mme Vigneron: +33 (0)3 80 27 91 54.
Gîtes and vacation rentals
Notre Maison d'Antan 🏠🏠🏠🏠: +33 (0)3 80 49 21 92.
Further information: 03 80 90 74 24
www.pouilly-auxois.com

🍽 Eating Out
Au Marronnier: +33 (0)3 80 49 21 91.
Hostellerie du Château: +33 (0)3 80 49 22 00.

By road: Expressway A6, exit Pouilly-en-Auxois (5½ miles/9 km); expressway A38, exit 24–Autun (5½ miles/9 km).
By train: Dijon station (27 miles/43 km).
By air: Dijon-Bourgogne airport (35 miles/56 km).

ℹ **Tourist information—Pouilly-en-Auxois:** +33 (0)3 80 90 74 24
www.pouilly-auxois.com
www.chateauneuf-cotedor.fr

L'Orée du Bois: +33 (0)3 80 49 25 32.
La Pizz' du Castel: +33 (0)3 80 49 26 82.

🛍 Local Specialties
Art and Crafts
Antique dealers • Ceramicists • Sculptors • Artists • Wood-carvers.

📅 Events
July (in even years): Medieval market (last weekend).
October: Mass of Saint Hubert and gourmet and local produce market (1st Sunday).
December: Christmas Mass with living Nativity scene (24th).
All year round: Art and crafts exhibitions, concerts, theater.

🦋 Outdoor Activities
Riding • Fishing • Mountain-biking • Cycle route • Walking around the Auxois lakes, Romanesque chapels trail.

🌿 Further Afield
• Castles in Auxois: Chailly-sur-Armançon, Commarin, Mont-Saint-Jean (5–19 miles/8–31 km).
• Burgundy Canal: boat trip; Pouilly-en-Auxois (6 miles/9.5 km).
• Abbaye de la Bussière; Ouche valley (7½ miles/12 km).
• Beaune; Burgundy vineyards (22 miles/35 km).
• Dijon (27 miles/43 km).

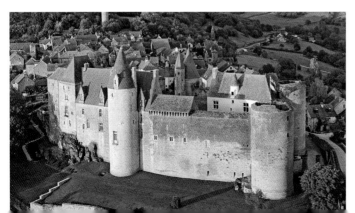

Côte-d'Or

57

Eguisheim
Enter the round

Haut-Rhin (68) • Population: 1,802 • Altitude: 689 ft. (210 m)

Just a short distance from Colmar, Eguisheim—the birthplace of wine-growing in Alsace—winds in concentric circles around its castle.

Whether around the castle at the center of the village, which witnessed the birth of the future Pope Leo IX (1002–1054), or along the ramparts that encircle it, Eguisheim encourages visitors to go round in circles. With every step, from courtyard to fountain, lane to square, the ever-present curve changes one's perspective of the colorful houses arrayed with flowers, half-timbering, and oriel windows. Rebuilt in the Gothic style, the Église Saint-Pierre-et-Saint-Paul is distinguished by its high square tower of yellow sandstone, and a magnificent tympanum depicting Christ in Majesty flanked by two saints, as well as the Parable of the Wise and Foolish Virgins.

The winegrowers' and coopers' houses, with their large courtyards, are a reminder that—as well as being a feast for the eyes—Eguisheim also delights the palate with its *grand cru* wines, which are celebrated with festivals throughout the year.

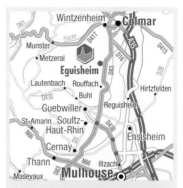

By road: Expressway A35, exit 27–Sainte-Croix-en-Plaine (4½ miles/7 km). **By train:** Colmar station (4½ miles/7 km). **By air:** Bâle-Mulhouse station (35 miles/56 km); Strasbourg-Inter airport (45 miles/72 km).

ⓘ **Tourist information:**
+33 (0)3 89 23 40 33
www.tourisme-eguisheim-rouffach.com

👁 Highlights
• **Chapel of the Château Saint-Léon** (19th century, neo-Romanesque style): Relics of Pope Leo IX.
• **Église Saint-Pierre-et-Saint-Paul** (11th–14th centuries): Polychromed wooden statue known as "the Opening Virgin" (13th century), porch of the old church.
• **Parc des Cigognes** (stork garden): Free entry to the enclosure, information board on Alsace's legendary bird; guided tours Tuesdays mid-June to mid-September.
• **Vineyards:** Guided tour of the wine route followed by a guided tasting session of the wines of Alsace. By arrangement with the winegrowers, and on Saturdays from mid-June to mid-September and on Saturdays and Tuesdays in August: +33 (0)3 89 23 40 33.
• **Village:** Guided tours all year for groups and by arrangement, and Wednesdays and Fridays from mid-June to mid-September: +33 (0)3 89 23 40 23; guided tour on a tourist train and tour of the area on the Train Gourmand du Vignoble Tuesdays and Thursdays: +33 (0)3 89 73 74 24, discovery tour of the old village (information boards with QR codes).

🗝 Accommodation
Hotels
Auberge Alsacienne***:
+33 (0)3 89 41 50 20.
Ferme du Pape***: +33 (0)3 89 41 41 21.
♥ Hostellerie du Château***:
+33 (0)3 89 23 72 00.
Hôtel Saint-Hubert***:
+33 (0)3 89 41 40 50.
À la Ville de Nancy**: +33 (0)3 89 41 78 75.
Auberge des Trois Châteaux**:
+33 (0)3 89 23 70 61.
Colman Vignes**: +33 (0)3 89 41 16 99.
Auberge du Rempart: +33 (0)3 89 41 16 87.
Aparthotel
Résidence*** Pierre et Vacances:
+33 (0)3 89 30 41 20.
Guesthouses, gîtes, and vacation rentals
Further information: 03 89 23 40 33
www.tourisme-eguisheim-rouffach.com
Campsites
Les Trois Châteaux***:
+33 (0)3 89 23 19 39.

🍽 Eating Out
À la Ville de Nancy: +33 (0)3 89 41 78 75.
L'Atelier de Béné: +33 (0)3 68 61 38 04.
Auberge Alsacienne: +33 (0)3 89 41 50 20.
Auberge du Rempart: +33 (0)3 89 41 16 87.
Auberge des Trois Châteaux:
+33 (0)3 89 23 70 61.
Au Vieux Porche: +33 (0)3 89 24 01 90.

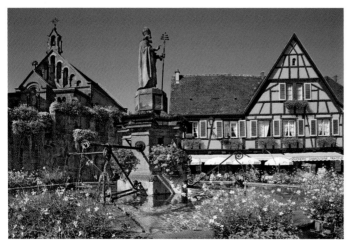

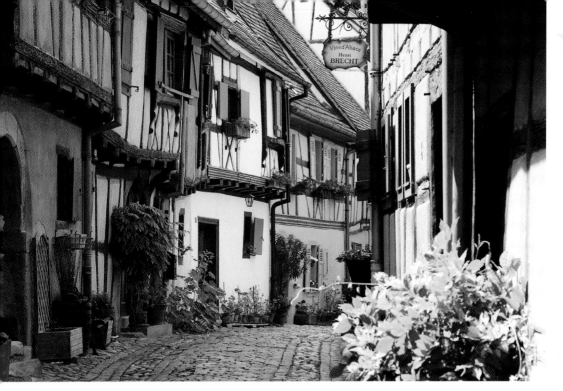

Caveau d'Eguisheim: +33 (0)3 89 01 15 03.
Caveau des Douceurs:
+33 (0)3 89 23 10 01.
Le Dagsbourg: +33 (0)3 89 41 51 90.
Ferme du Pape: +33 (0)3 89 41 41 21.
La Galinette: +33 (0)9 82 37 86 28.
I Soliti Ignoti: +33 (0)9 77 43 04 77.
Le Pavillon Gourmand:
+33 (0)3 89 24 36 88.
Resto des Vignes:+33 (0)3 89 41 16 99.
La Taverne du Château:
+33 (0)3 89 24 13 41.
Wistub-Bierstub Kas Fratz:
+33 (0)3 89 41 87 66.

🏛 Local Specialties

Food and Drink
Pretzels • *Pain d'épice* (spice cake) •
Mushrooms • Alsatian charcuterie •
AOC Alsace wines and Eichberg and
Pfersigberg *grands crus.*

Art and Crafts
Artists' studios • Art gallery • Painting •
Upholstery and decoration.

📅 Events

July: Eguisheim wine festival and "Nuit
des Grands Crus" (2nd fortnight).
August: "Si Eguisheim m'était conté,"
heritage festival (1st week), guided wine
tasting (1st week), Fête des Vignerons,
winegrowers' festival (last weekend).
September: Fête du Vin Nouveau,
new wine festival (last weekend).
October: Fête du Vin Nouveau
(1st weekend), Fête du Champignon,
mushroom festival (last weekend).
November and December: Christmas
market (daily for the four weeks of Advent).

🦋 Outdoor Activities
Discovery of the village by microlight •
Standard and electric bike rental •
Walking: 12 marked trails • Segway rides.

🦢 Further Afield
• Hautes Vosges, region: Munster
valley; Col de la Schlucht (3–19 miles/
5–31 km).
• Colmar (3½ miles/5.5 km).
• Alsace wine route: Turckheim (5 miles/
8 km); Rouffach (7 miles/11.5 km);
Kaysersberg (8 miles/13 km);
*Riquewihr (11 miles/18 km), see
pp. 71–72; *Hunawihr (12 miles/19 km),
see pp. 62–63; Guebwiller (13 miles/21 km).
• Château du Hohlandsbourg and
Five Castles route (5 miles/8 km).
• Neuf-Brisach (13 miles/21 km).

🍴 Did you know?
Here, if stones could speak, they would tell
the story of the illustrious family of the
counts of Eguisheim, into which was born
a certain Bruno, son of Hugh IV. A high-
ranking nobleman, he was called to papal
office. Bruno went to Rome on foot, stick
in hand, cape on his shoulders, just as he
is depicted in his statue on the Place du
Château. On his arrival, he was acclaimed
by the people of Rome and enthroned as
Pope Leo IX.

Flavigny-sur-Ozerain

A sweet-smelling spot

Côte-d'Or (21) • Population: 338 • Altitude: 1,398 ft. (426 m)

First established at the time of Julius Caesar and Vercingetorix, Flavigny produces an aniseed candy that is enjoyed throughout the world; its sweet fragrance perfumes the air here.

The Romans chose this location during the siege of Alesia in 52 BCE, and it grew into a Gallo-Roman settlement, named "Flaviniacum" after Flavinius, a Roman officer. The town expanded with the founding of the Benedictine abbey of Saint-Pierre, which is where the famous candies are now produced. The parish church of Saint-Genest, whose nave and aisles are partially surmounted by a 13th-century gallery, contains stalls made by the brotherhood in the 15th century and fine Burgundian statuary from the 14th and 15th centuries. At Flavigny's heart, the village's artisanal and commercial prosperity is visible today in the bay windows of single-storey houses such as the Maison au Donataire, which contains the "Point I" visitor center. The medieval fortifications of the Portes du Val and du Bourg still stand, as do Flavigny's ramparts, from where the view stretches out over the green hills of Auxois.

By road: Expressway A6, exit 23–Bierre-lès-Semur (14 miles/23 km). **By train:** Venareyles-Laumes station (5 miles/8 km); Montbard TGV station (15 miles/24 km). **By air:** Dijon-Bourgogne airport (45 miles/72 km).

ⓘ Tourist information—"Point I" visitor center: +33 (0)7 57 40 75 87
www.flavigny-sur-ozerain.fr
Tourist information—Pays d'Alésia et de la Seine: +33 (0)3 80 96 89 13

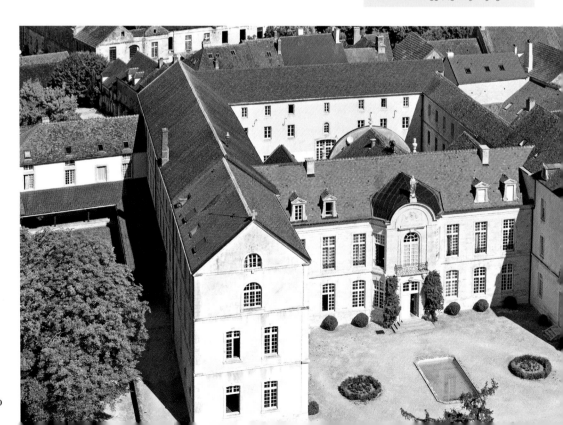

👁 Highlights

• Crypt of the Abbaye Saint-Pierre (8th century).
• Église Saint-Genest (13th–16th centuries): Gothic style with 15th-century stalls and relics of Saint Reine: +33 (0)7 57 40 75 87 or +33 (0)3 80 96 21 73.
• Aniseed factory: In the former Abbaye Saint-Pierre; free entry and tastings, museum: +33 (0)3 80 96 20 88.
• Maison des Arts Textiles et du Design: Algranate museum—collection, exhibitions, traditional Auxois weaving workshop: +33 (0)3 80 96 20 40.
• Village: Guided tour for groups by appointment only: +33 (0)7 57 40 75 87.
• Flavigny-Alésia vineyards: Self-guided visit of the winery and free tasting: +33 (0)3 80 96 25 63.

🗝 Accommodation

Guesthouses
Les Adages: +33 (0)6 64 52 18 60.
Couvent des Castafours: +33 (0)3 80 96 24 92.
Le Logis Abbatial: +33 (0)6 87 25 60 08.

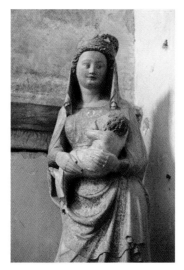

Le Logis de l'Ozerain: +33 (0)6 84 83 18 99.
La Maison des Oiseaux: +33 (0)6 80 56 43 37.
La Maison du Tisserand: +33 (0)3 80 96 20 40.
Maison Galimard: +33 (0)6 73 94 12 88.
Gîtes
Further information: +33 (0)7 57 40 75 87
www.flavigny-sur-ozerain.fr

🍽 Eating Out

L'Échoppe, tea room: +33 (0)3 80 97 32 35.
Le Garum: +33 (0)3 80 89 07 78.
La Grange des Quatre Heures Soupatoires, farmhouse inn: +33 (0)3 80 96 20 62.
Le Relais de Flavigny: +33 (0)3 80 96 27 77.

🛍 Local Specialties

Food and Drink
Abbaye de Flavigny aniseed, specialty confectionery • Charcuterie • Cheese (Époisses) • Burgundy wines; vins de pays des Coteaux de l'Auxois • Snails.
Art and Crafts
Art galleries • Lithographer • Organic wool and vegetable dyes, custom clothing • Artworks.

🗓 Events

Ascension weekend: Walks.
July: Village meal (14th).
August: PontiCelli cello workshops (early August).
October: Marché de la Saint-Simon, market (penultimate Sunday).
December: Christmas market.
December–January: Nativity scenes exhibited in the streets, and at the old *lavoir* (washhouse) on January 1.
Winter: "Hors Saison Musicale" concerts.
All year round: Theater, concerts.

🦋 Outdoor Activities

Hunting • Fishing • Mountain-biking • Walking and riding from Bibracte to Alésia and 5 marked trails.

🌿 Further Afield

• Alésia: archeological site; Château de Bussy-Rabutin (3–6 miles/5–9.5 km).
• Venarey-les-Laumes: Burgundy Canal (5 miles/8 km).
• Semur-en-Auxois (11 miles/18 km).
• Montbard; Buffon: foundry; Abbaye de Fontenay (12–16 miles/19–26 km).

❗ Did you know?

According to the writer Saint-Simon, Louis XIV loved aniseed candies, which he liked to keep with him in special box in his pocket. Madame de Sévigné, Madame de Pompadour, and the comtesse de Ségur also enjoyed the aniseed treats, which they used to offer to their friends.

Hunawihr

The colors of the vines

Haut-Rhin (68) • Population: 603 • Altitude: 525 ft. (160 m)

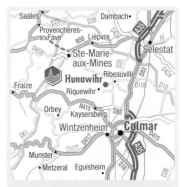

Situated on the Alsace wine route amid the vineyards, Hunawihr is a typical Alsatian village, bedecked with flowers.

Hunawihr owes its name to a laundrywoman, Saint Huna; according to legend, she lived here in the 7th century with her husband, the Frankish lord, Hunon. The 15th–16th-century church contains 15th-century frescoes that recount the life of Saint Nicholas. Surrounded by a cemetery fortified by six bastions, it is built on the hill overlooking the village, whose attractions include the Saint June Fountain with its washhouse, the town hall (formerly the corn exchange), the Renaissance-style Maison Schickhart, half-timbered houses, and bourgeois residences from the 16th and 19th centuries. Nature-lovers can visit the center for reintroducing storks and otters, and the butterfly garden—both magical places.

By road: Expressway A35, exit 23– Ribeauvillé then N83 (5½ miles/9 km).
By train: Colmar station (11 miles/18 km).
By air: Bâle-Mulhouse airport (47 miles/ 76 km).

ⓘ Tourist information:
+33 (0)3 89 73 23 23
www.hunawihr.fr

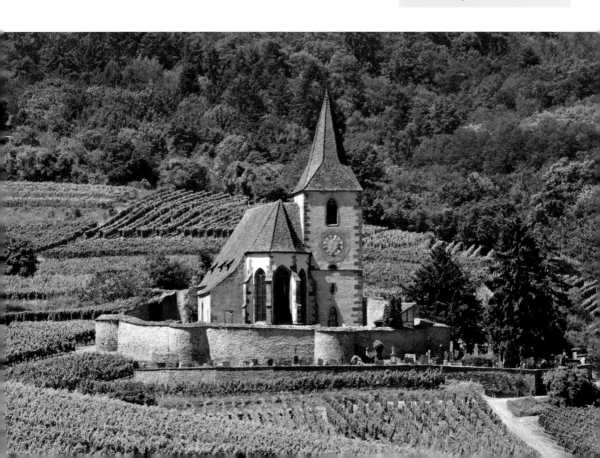

👁 Highlights

• **Church** (15th and 16th centuries)
and its fortified cemetery: Saint Nicholas
frescoes (15th century).
• **NaturOparC, Centre de Réintroduction
des Cigognes et des Loutres:** 12-acre
(5-ha.) wildlife park dedicated to
reintroducing and preserving storks,
otters, and other local species:
+33 (0)3 89 73 72 62.
• **Jardin des Papillons:** Several hundred
exotic butterflies from Africa, Asia, and
the Americas, living in a lush garden:
+33 (0)3 89 73 33 33.
• **Village:** Guided tour of the church and
village every Wednesday and Friday in
July and August, meet at 6.15 p.m. at the
church: +33 (0)3 89 73 23 23; Randoland,
recreational discovery trail around the
village.
• *Grands crus* **wine trail:** Permanent
discovery trail; guided tour by a
winemaker and free tasting sessions in
summer. Further information:
+33 (0)3 89 73 23 23.
• **Vineyards:** Guided tour followed
by a guided tasting session every
Thursday at 3.30 p.m. in July and
August. Further information:
+33 (0)3 89 73 61 67.

🗝 Accommodation

Guesthouses
Sainte-Hune ❀❀❀: +33 (0)3 89 73 62 15.
Gîtes and vacation rentals
Further information:
+33 (0)3 89 73 23 23
www.ribeauville-riquewihr.com
www.hunawihr.fr

🍴 Eating Out

Caveau du Vigneron: +33 (0)3 89 73 70 15.
O'Berge du Parc: +33 (0)3 89 71 74 93.
Wistub Suzel: +33 (0)3 89 73 30 85.

🧺 Local Specialties

Food and Drink
AOC Alsace wines, Crémant d'Alsace, and
grand cru Rosacker (Gewürztraminer,
Riesling, Pinot Gris) • Distilled spirits.

📅 Events

Spring: Gourmet market.
August: Hunafascht, Alsatian open-air
evenings under paper lanterns (1st Friday
and Saturday).

🦋 Outdoor Activities

Cycle touring • Walking • Mountain-biking,
1 marked trail • Chemin de Compostelle
(Saint James's Way) trail.

🌿 Further Afield

• Alsace wine route: *Riquewihr
(1 mile/1.5 km), see pp. 71–72;
Ribeauvillé; Bergheim; Kintzheim;
*Eguisheim (12 miles/19 km), see
pp. 58–59.
• Haut-Koenigsbourg (8½ miles/13.5 km).
• Colmar; Sélestat (9½ miles/15.5 km).
• *Mittelbergheim (23 miles/37 km),
see pp. 66–67.

⚑ Did you know?

The village joined the Reformation in
1537, but after Alsace was annexed
to France in 1648 Catholicism was
reintroduced. "Simultaneum"—whereby
Protestants and Catholics share a church
but worship at different times—was
instigated in 1687 and is ongoing.

Hunspach

Alsace "beyond the forest"

Bas-Rhin (67) • Population: 700 • Altitude: 525 ft. (160 m)

Situated in the heart of the Parc Naturel Régional des Vosges du Nord (nature park), Hunspach features houses with white cob walls and half-timbering that are typical of the Wissembourg region, showing that, in this village, the carpenter is king.

At the end of the Thirty Years War, Hunspach was almost on its knees; it owes its salvation to French refugees and, in particular, to the Swiss immigrants who were granted farmland here. With wood and clay to hand, they built black-and-white half-timbered houses, just like those back home; the village owes its charm and attractiveness to these buildings. With their hipped gables and tiled canopies, they make a lovely sight lined up along the main road and around the pink sandstone bell tower of the Protestant church. Everywhere geraniums bloom at windows or on walls but, in this village where everything is neat and tidy, there still remains some mystery. The balloon-shaped windowpanes of Hunspach work like distorting mirrors, giving passers by a false reflection and preventing them peering inside. Behind their windows, the residents can see out without being seen.

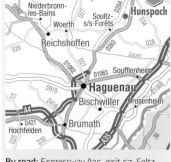

By road: Expressway A35, exit 57–Seltz (12 miles/19 km); expressway A4, exit 47–Haguenau (24 miles/39 km). **By train:** Hunspach station (1 mile/1.5 km); Wissembourg station (6 miles/9.5 km). **By air:** Strasbourg-Inter airport (48 miles/77 km).

ⓘ Tourist information:
+33 (0)3 88 80 59 39 / www.hunspach.com

👁 Highlights
• **Fort Schoenenbourg** (Maginot Line): World War II fortress built 1930–40; the most important Maginot Line construction in Alsace open to visitors. Visit the military blocks, command post, gallery, infantry casemates, kitchen. Accessible for wheelchair users: +33 (0)3 88 80 96 19.
• **Village:** Guided visit for groups of 15+ by reservation: +33 (0)3 88 80 59 39; self-guided trail around the historic site (map available from tourist information center).

⚔ Accommodation
Guesthouses
Mme Billmann***: +33 (0)3 88 54 76 93.
Maison Ungerer 🏠🏠🏠:
+33 (0)3 88 80 59 39.
Gîtes
Maison Ungerer 🏠🏠🏠 and 🏠🏠:
+33 (0)3 88 80 59 39.
Mme Billmann: +33 (0)3 88 54 76 93.
Vacation rentals
Mme Derrendinger: +33 (0)3 88 80 43 95.

🍽 Eating Out
Au Cerf: +33 (0)3 88 80 41 59.
Chez Massimo: +33 (0)3 88 80 42 32.

🏛 Local Specialties
Food and Drink
Wine • *Dickuechen* (brioche loaf) • *Fleischnacka* (meat and pasta roulade).
Art and Crafts
Painter • Alsace artifacts • *kelsch* household linen:

📅 Events
June: Fête du Folklore (last weekend in spring).
July–August: Folklore activities and evenings: +33 (0)3 88 80 59 39.
December: Christmas country market (2nd Sunday of Advent).

🦋 Outdoor Activities
Pedestrian trail around village.

🌿 Further Afield
• Route around picturesque villages: Hoffen, Seebach, Steinselz, Cleebourg (2–6 miles/3–9.5 km).
• Alsace wine route: Steinselz, Oberhoffen, Rott-Cleebourg (4½ miles/7 km).
• Pottery-making villages: Betschdorf, Soufflenheim (5–11 miles/8–18 km).
• Wissembourg (6 miles/9.5 km).
• Germany: Palatinate region, vineyards, the Black Forest (6–25 miles/9.5–40 km).
• Haguenau (14 miles/23 km).
• Niederbronn-les-Bains (17 miles/27 km).
• Strasbourg (34 miles/55 km).

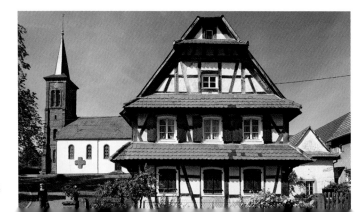

Lods

Born from the river

Doubs (25) • Population: 231 • Altitude: 1,214 ft. (370 m)

Exploiting the energy of the Loue river as it tumbled through the valley, the inhabitants of this little village built thriving iron forges and produced wine in the relatively mild climate.

The smithies may be idle now, and Lods may no longer produce grapes, but the village still has its 16th- and 17th-century wine-growers' houses with their spacious vaulted cellars, clustered higgledy-piggledy around the 18th-century church and its tufa-stone bell tower. The Musée de la Vigne et du Vin (vine and wine museum), which is housed in a beautiful 16th-century building, the old smithy on the other side of the river, and a historical trail through the village all tell the stories of the blacksmiths and winegrowers who used to live here.

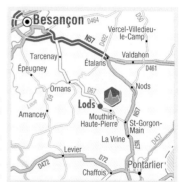

By road: Expressway A36, exit 3–Pontarlier (41 miles/66 km); N57 (7 miles/11.5 km).
By train: Pontarlier station (15 miles/ 24 km); Besançon-Viotte station (23 miles/37 km).
By air: Geneva airport (87 miles/ 140 km); Dijon airport (92 miles/148 km).

(i) Tourist information—Ornans-Vallées de la Loue et du Lison:
+33 (0)3 81 62 21 50
www.destinationlouelison.com
www.lods.fr

Trout • Mountain ham • Comté cheese • Cancoillotte cheese.
Art and Crafts
Painters.

🦋 Outdoor Activities
Canoeing • Fishing • Walking • Mountain-biking.

🌿 Further Afield
• Source of the Loue river; Pontarlier; Joux Fort; Lac de Saint-Point, lake (6–31 miles/9.5–50 km).
• Loue valley; Ornans; Besançon (7½–23 miles/12–37 km).
• Ornans: Musée Courbet and Musée du Costume (7½ miles/12 km).
• Dino-zoo (12 miles/19 km).

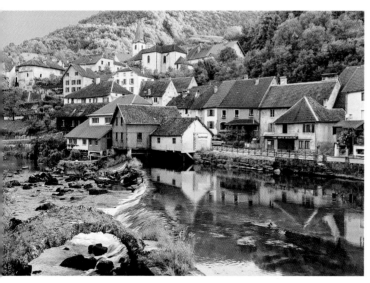

👁 Highlights
• Église Saint-Théodule.
• Musée de la Vigne et du Vin:
+33 (0)3 81 60 90 11.

🔑 Accommodation
Hotels
Hôtel de France: +33 (0)3 81 60 95 29.
Guesthouses
Au Fil de Lods, licensed fishing lodges:
+33 (0)3 81 60 97 51.
Chez Nous: +33 (0)6 50 58 18 85.

Gîtes and bunkhouses
La Truite d'Or: 33 (0)6 76 87 58 50.
Campsites
Le Champaloux**:
+33 (0)3 81 60 90 11.

🍽 Eating Out
Hôtel de France: +33 (0)3 81 60 95 29.

🍴 Local Specialties
Food and Drink
"Jésus de Morteau" smoked sausage •

❗ Did you know?
The heyday of Lods' wine production was in the 17th and 18th centuries. But the arrival of the railways brought cheaper wines from the South, drastically reducing local production; and by the end of the 19th century phylloxera had also wreaked havoc in the vineyards, marking the end of a thriving local industry.

Mittelbergheim
Rainbow colors and fine wines

Bas-Rhin (67) • Population: 682 • Altitude: 722 ft. (220 m)

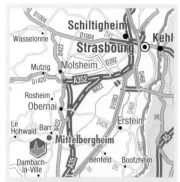

On the wine route in Alsace, at the foot of Mont Sainte-Odile, Mittelbergheim sings with color and produces excellent wines.

Mittelbergheim was founded by the Franks near Mont Sainte-Odile, and was dedicated to Alsace's patron saint; for many years it belonged to nearby Andlau Abbey, erected in the 9th century by the wife of Emperor Charles le Gros. The village is devoted to wine production. Glowing with vibrant colors in fall and wild tulips in springtime, it is surrounded by vineyards from its base (where the Rhine Plain begins) to the Zotzenberg vineyard on the hilltop. Here the Sylvaner grape is grown, among other varieties, making some of the very best *grand cru* wines. Vines are ubiquitous in the landscape—and also in Mittelbergheim's architecture. The façades of the houses lining the streets have a remarkable unity of style. Dating from the 16th and 17th centuries, they are superbly preserved, adorning the streets with their eye-catching pink sandstone frontages. Their massive wooden gates open wide in the morning to reveal huge interior courtyards at the center of buildings dedicated to wine production. Once closed, they guard the secret of the cellars, where Zotzenberg Sylvaner—the only Sylvaner in Alsace classified as *grand cru*—is aged, alongside Rieslings, Pinot Gris, and Gewürztraminers.

By road: Expressway A35, exit 13–Mittelbergheim (2 miles/3 km).
By train: Barr station (1 mile/1.5 km); Strasbourg TGV station (23 miles/37 km).
By air: Strasbourg Inter airport (19 miles/31 km); Bâle-Mulhouse airport (63 miles/101 km).

ⓘ Tourist information—
Pays de Barr et du Bernstein:
+33 (0)3 88 08 66 65
www.paysdebarr.fr

👁 Highlights
• **Former oil mill** (18th century).
• **Museum "Mémoire de Vignerons":** Conserving wine-producing heritage with a large collection of relevant artifacts; open every Sunday July–October, and by appointment: +33 (0)3 88 08 00 96.
• **Wine path:** Open all year.
• **Village:** Guided tour by appointment only; self-guided visit with a dozen information boards; map available: +33 (0)3 88 08 92 29.

🗝 Accommodation
Hotels
Winstub Gilg**: +33 (0)3 88 08 91 37.
Guesthouses
Le Clos de la Hagel 🍴🍴:
+33 (0)3 88 08 96 08.
Henri Dietrich: +33 (0)3 88 08 93 54.
Christian Dolder 🗝🗝🗝:
+33 (0)3 88 08 96 08.
Jacqueline Dolder: +33 (0)3 88 08 15 23.
Marie-Paule Dolder: +33 (0)3 88 08 17 49.
Daniel Haegi: +33 (0)3 88 08 95 80.
Paul Hirtz: +33 (0)3 88 08 54 86.
Le Petit Nid: +33 (0)6 87 36 11 17.
Charles Schmitz: +33 (0)3 88 08 09 39.
Nicolas Wittmann 🍴🍴🍴:
+33 (0)3 88 08 95 79.

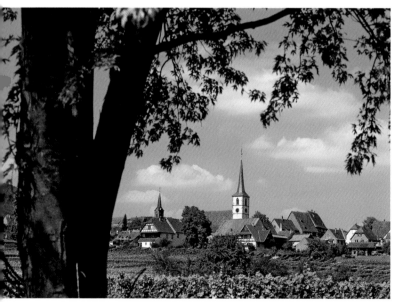

Gîtes and vacation rentals
Further information: 03 88 08 66 65
www.paysdebarr.fr

🍴 Eating Out
Am Lindeplatzel: +33 (0)3 88 08 10 69.
Au Raisin d'Or: +33 (0)3 88 08 93 54.
Winstub Gilg: +33 (0)3 88 08 91 37.

🧺 Local Specialties
Food and Drink
Preserves • Honey • AOC Alsace and
grand cru Zotzenberg wines.
Art and Crafts
Artist.

📅 Events
January–June: Exhibitions.
March–April: "Henterem Kallerladel,"
open house at wine cellars (end March–
beginning April).
July: Fête du Vin, wine festival
(last weekend).
July–August: "Sommermarik," country
market (Wednesday evenings).
October: Fête du Vin Nouveau, new
wine festival (2nd weekend).
December: "Bredelmarik," market for
Alsatian Christmas cakes (1st Sunday).

🦋 Outdoor Activities
Walking: Routes GR 5 and GR 10;
marked trails, including wine path and
"Randocroquis" (walk and draw trail) •
Horse-riding • "Sentier des Espiègles"
(family fun trail) • Mountain-biking.

🕊️ Further Afield
• Barr (1 mile/1.5 km).
• Andlau; Le Hohwald; Champ-du-Feu
(1–12 miles/1.5–19 km).
• Obernai (6 miles/9.5 km).
• Mont Saint-Odile (9½ miles/15.5 km).
• Sélestat (12 miles/19 km).
• Haut-Koenigsbourg (17 miles/27 km).
• Strasbourg (22 miles/35 km).
• *Hunawihr (23 miles/37 km),
see pp. 62–63.
• *Riquewihr (24 miles/39 km),
see pp. 71–72.
• Colmar (26 miles/42 km).

🗝️ Did you know?
At "Mittel," as the locals call it, there is a
long history of wine-growing. Behind its
elegant Renaissance façade on the main
street, the town hall holds the *Weinschlag*,
a precious document that contains records
of vineyards and wines, dating from 1510.

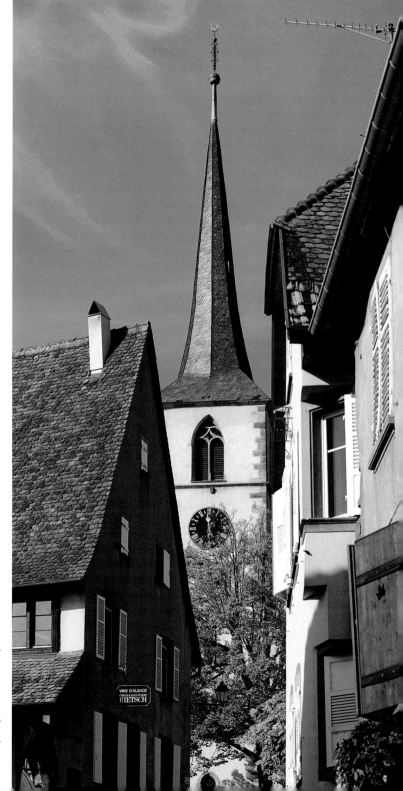

Noyers
Medieval Burgundy

Yonne (89) • Population: 644 • Altitude: 620 ft. (189 m)

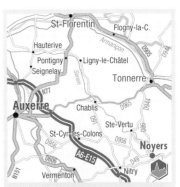

On the doorstep of the vineyards of Chablis and the regional nature park of the Morvan, curved around a meander on the Serein river, Noyers is a typical medieval town.

The village is still protected by ramparts studded with sixteen towers and three fortified gateways: the Tonnerre, topped with lava tiles; the Venoise, on the old castle site; and the painted gateway, with culverin points on the machicolated gatehouse. Renaissance houses rub shoulders with half-timbered and corbeled ones on the Place de la Petite-Étape-aux-Vins, the Place du Marché-au-Blé, and the Place du Grenier-à-Sel. At the base of the village, stone steps outside winegrowers' houses fall smartly into line. In the center of the village, the church of Notre-Dame is in the Flamboyant Gothic style. While decidedly medieval within its ramparts, Noyers moves with the times: it organizes vibrant cultural activities that combine music and craftsmanship with a stunning collection of naive art.

By road: Expressway A6, exit 21–Nitry (7 miles/11.5 km). **By train:** Tonnerre station (14 miles/23 km); Montbard TGV station (20 miles/32 km). **By air:** Dijon-Bourgogne airport (84 miles/135 km).

ⓘ Tourist information—Grand Vézélay: +33 (0)3 86 82 66 06
www.tourisme-serein.fr

👁 Highlights
• **Musée des Arts Naïfs et Populaires de Noyers** (in the 17th-century college): Extensive naive art collection; collection of folk art: +33 (0)3 86 82 89 09.
• **Site of the former castle:** Self-guided visit: +33 (0)3 86 82 66 06.
• **Tour of the ramparts:** +33 (0)3 86 82 61 75.
• **Village:** Guided tours at 3 p.m. in July–August by appointment only: +33 (0)3 86 82 66 06; carriage rides: +33 (0)6 26 29 12 48.

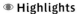

🗝 Accommodation
Guesthouses
Le Clos Malo: +33 (0)3 86 75 04 52.
Le Gratin Mondain: +33 (0)6 98 58 22 11.
La Madeleine: +33 (0)7 88 22 52 60.
La Porte Peinte: +33 (0)3 86 75 05 11.
Le Tabellion: +33 (0)3 86 82 62 26.
La Vieille Tour: +33 (0)3 86 82 87 69.
Gîtes, vacation rentals, and nature zone
Further information: +33 (0)3 86 82 83 72
www.tourisme-serein.fr

🍴 Eating Out
Le Faubourg: +33 (0)6 01 07 38 89.
Les Granges: +33 (0)3 86 55 45 91.
Le Marquis Perché: +33 (0)3 86 75 16 70.
Les Millésimes: +33 (0)3 86 82 82 16.
La Petite Étape aux Vins, light meals: +33 (0)3 86 82 86 38.
Le Pourquoi Pas?: +33 (0)6 98 58 22 11.
Rouge et Blanc, light meals: +33 (0)7 68 75 40 61.
Tom et Mozza, pizzeria: +33 (0)6 20 14 86 34.
La Vieille Tour: +33 (0)3 86 82 87 36.

🍽 Local Specialties
Food and Drink
AOC Chablis and Irancy wines, Crémant de Bourgogne sparkling wine • Farm dairy products.

Art and Crafts
Ceramic artist • Medieval illuminator • Maker of feathered masks • Wrought ironwork • Jewelers • Tapestry artist • Leather craftsman • Potters • Painters • Sculptors • Weaver.

2️⃣ Events
Market: Wednesday mornings; farmers' market Saturday mornings.
July: Musical events, part of the Festival des Grands Crus de Bourgogne; "Gargouillosium," sculpting gargoyles at the old castle.
August: Festival Vallée et Veillée (1st weekend); freestyle painting; concerts.
September: Illuminations as part of the Heritage Weekend (3rd weekend).
October–November: Truffle market.

🦋 Outdoor Activities
Swimming (no lifeguard) • *Boules* area • Fishing • Walking: 3 marked trails.

🌿 Further Afield
• Vausse Priory; Buffon: foundry; Fontenay Abbey (9½–25 miles/15.5–40 km).
• Castles at Ancy-le-Franc, Tanlay, Fosse Dionne, and Tonnerre Hôtel Dieu (12–19 miles/19–31 km).
• *Vézelay (25 miles/40 km), see pp. 76–77.

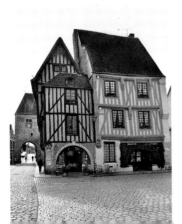

Parfondeval
In the vanguard of the Reformation

Aisne (02) • Population: 500 • Altitude: 725 ft. (221 m)

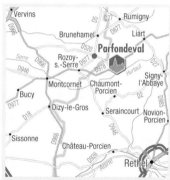

A compact village of red bricks and silver-gray slate roofs, Parfondeval is typical of this region and remains characterized by farming life.

During the reigns of Louis XIII and Louis XIV, to defend themselves against hordes of brigands, the villagers of Parfondeval constructed a fortified church dedicated to Saint Médard, around which they built squat houses that served as ramparts. To get to the church, you have to go through a porch that is set into a house, then pass between two round towers. The road leads to a square that is partially occupied by a pond. In the early 19th century, the village had six others, which provided drinking water for animals. Walking through the village, the visitor sees houses decorated with glazed bricks in diamond shapes, half-timbered façades, and, surprisingly, at the end of the Rue du Chêne, a Protestant church. The latter reflects the peculiarity of Parfondeval's religious history. During the 16th century, villagers and others from the Thiérache region, returning from the annual harvest in the Pays de Meaux, brought back to Parfondeval copies of the Bible translated into French and communicated the new ideas of the Reformation. The present church bears witness to the continuing presence of this community. Apple orchards, pastures, and cornfields separated by copses make up the landscape of Parfondeval, which is almost entirely devoted to farming.

By road: Expressway A34, exit 26–Cormontreuil then N51 (22 miles/35 km); expressway A26, exit 13–Laon then N2 (24 miles/39 km).
By train: Vervins station (21 miles/34 km); Laon station (30 miles/48 km).
By air: Reims-Champagne airport (39 miles/63 km).

(i) **Tourist information—Thiérache:**
+33 (0)3 23 91 30 10
www.tourisme-thierache.fr

👁 Highlights
• **Village:** Self-guided tour with audioguides on the signposted walk. Further information: +33 (0)3 23 91 30 10.
• **Église Saint-Médard** (16th century): Daily 9 a.m.–6 p.m.
• **Protestant church** (1858).
• **La Maison des Outils d'Antan:** Collection of 2,000 farming tools and everyday items from the 1900s: +33 (0)3 23 97 61 59.

🔑 Accommodation
Guesthouses
Françoise and Lucien Chrétien 🛏🛏:
+33 (0)3 23 97 61 59.

Gîtes
Le Village***: +33 (0)3 23 97 62 54 or +33 (0)6 48 73 29 77.

🍴 Eating Out
Françoise and Lucien Chrétien, farmhouse, afternoon tea: +33 (0)3 23 97 61 59.

🍽 Local Specialties
Food and Drink
Cider and apple juice.

② Events
June: Village fête.

August: Flea market (Sunday after the 15th).
October: "Potironnade," squash tastings and guided walk (4th Saturday).

🦋 Outdoor Activities
Walking, horse-riding, and mountain-biking ("Par le Fond du Val" trail).

🌿 Further Afield
• Aubenton (8 miles/13 km).
• Saint-Michel: abbey (17 miles/27 km).
• Liesse-Notre-Dame: basilica (21 miles/34 km).
• Marle: Musée des Temps Barbares, museum of the Middle Ages (21 miles/34 km).
• Rocroi, star-shaped fortified town (31 miles/50 km).

🎗 Did you know?
Parfondeval is the only village in Thiérache to have both a Catholic and a Protestant church as well as a Catholic and a Protestant cemetery. In the past, Catholics used to live at the top of the village, whereas Protestants lived further down, near their place of worship.

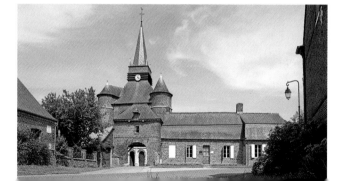

Pesmes
A village with a prosperous past

Haute-Saône (70) • Population: 1,128 • Altitude: 689 ft. (210 m)

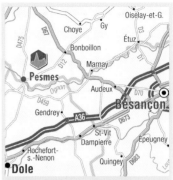

On the banks of the Ognon river, Pesmes bears witness to the work of winemakers, the glory days of the old lords of the town, and the heyday of Franche-Comté's metalworking industry. Pesmes is approached through the valley. At the end of the avenue of hundred-year-old plane trees, the sight of the gap-toothed castle, with houses nestling at its feet, and of the impressive ramparts reflected in the calm waters of the river takes one's breath away. Founded in the Middle Ages on the route leading from Gray to Dole, and coveted for its strategic position, the town was by turns Frankish, Germanic, Burgundian, and Spanish, before becoming French during the reign of Louis XIV (1643–1715). At that time, it was a major trading post that brought together merchants and burghers. The village bears witness to this rich past: along the streets and the alleyways, where private residences and winemakers' houses rub shoulders, visitors can discover the Église Saint-Hilaire, built and rebuilt between the 13th and 17th centuries, with its imperial bell tower; the castle ruins; and the Loigerot and Saint-Hilaire gateways. The old forge, founded in 1660 by Charles de La Baume, marquis of Pesmes, and built on the site of an old mill, was operational until 1993 and has now been converted into a museum.

By road: Expressway A39, exit 5–Saint-Jean-de-Losne (16 miles/26 km); expressway A36, exit 2–Dole (12 miles/19 km). **By train:** Dole station (15 miles/24 km); Besançon-Viotte station (32 miles/52 km); Dijon TGV station (32 miles/51 km). **By air:** Dole-Jura airport (21 miles/34 km).

ⓘ Tourist information:
+33 (0)3 84 65 18 15
www.ot-pesmes.fr

👁 Highlights
• **Château de Pesmes** (17th–18th centuries).
• **Église Saint-Hilaire** (13th–17th centuries): Interior decoration, altarpiece, 16th-century statues, pipe organ.
• **Hôtel Châteaurouillaud** (14th century).

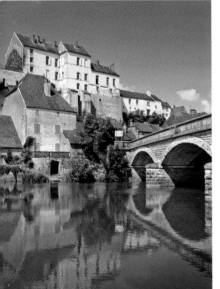

• **Musée des Forges:** Collection of machines and tools in the former workshops, forge-owner's house: +33 (0)9 73 20 35 65 or +33 (0)6 30 54 56 71.
• **Village:** Guided tour: +33 (0)3 84 65 18 15.

🔑 Accommodation
Hotels
Hôtel de France**: +33 (0)3 84 31 20 05.
Guesthouses
La Maison Royale: +33 (0)3 84 31 23 23.
Gîtes
Further information:
+33 (0)3 84 31 22 77.
Campsites
La Colombière***: +33 (0)3 84 31 20 15.

🍴 Eating Out
Hôtel de France: +33 (0)3 84 31 20 05.
Les Jardins Gourmands:
+33 (0)3 84 31 20 20.
O'Ma Pizza, pizzeria: +33 (0)3 84 31 29 68.

🍽 Local Specialties
Food and Drink
Oil • *Poulet d'horloger* (local recipe with potatoes and Cancoillotte cheese) • Pesmes pie and tart • Wine.
Art and Crafts
Cutler • Leatherworker • Wrought ironworker • Artist • Potter • Sculptor • Jewelry.

🗓 Events
Market: Wednesday morning and evenings in summer, Place des Promenades.
April: "Goûtons Voir," festival.
May: Handicrafts fair (Saturday and Sunday).
July: Fête de l'Île festival; international architecture seminar.
July and August: Art exhibition at the Voûtes.
August: Flea market, open-air rummage sale; Fête de Saint-Hilaire (festival).
All year round: Cinema, theater, and entertainment at the Forges de Pesmes.

🦋 Outdoor Activities
Watersports • Canoeing • L'Île des Forges • Fishing • Hiking and Nordic walking: 4 marked trails • Rock climbing • Mountain-biking.

🌿 Further Afield
• **Ognon valley:** Malans ("Île Art" sculpture park), Acey (Cistercian abbey), Marnay (fortified town) (3–12 miles/5–19 km).
• **Moissey; Forêt de la Serre,** forest; Dole (6–12 miles/9.5–19 km).
• **Gray; Musée Baron Martin** (16 miles/26 km).
• **Grotte d'Osselle,** cave (19 miles/31 km).
• **Arc-et-Senans:** Saline Royale, royal salt-works (28 miles/45 km).

Riquewihr

The pearl of Alsatian vineyards

Haut-Rhin (68) • Population: 1,308 • Altitude: 728 ft. (222 m)

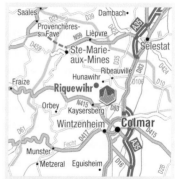

Producing wines that, for centuries, have matched the quality of its architecture, Riquewihr remains a center of Alsatian heritage and lifestyle.

Behind its ramparts, today besieged only by the vines, the village was for a long time linked to the duchy of Wurtemberg. Now it is associated with excellence: that of the architecture of its houses, with their splendid inner courtyards, and of its powerfully aromatic wines, produced on the Sporen and Schoenenbourg hillsides. Walking along the narrow streets, one never tires of admiring the large houses, which—from the richer bourgeois residences of the 16th century to more modest dwellings—are masterpieces of colorful half-timbered façades, carved wooden window-frames, flower-decked balconies, decorated windowpanes, and "beaver-tail"-tiled roofs, which often hide magnificent painted ceilings. Some of the old store signages are the work of Jean-Jacques Waltz (1873–1951), known as "Hansi," an Alsatian illustrator and caricaturist to whom the village has dedicated a museum. From the Dolder, the tall half-timbered bell tower, there is a stunning view over the village and neighboring vineyards.

By road: Expressway A35-N83, exit–Riquewihr (5 miles/8 km); N415, exit–Colmar (19 miles/31 km). **By train:** Colmar TGV station (9½ miles/15.5 km); Strasbourg TGV station (43 miles/69 km). **By air:** Strasbourg-Inter airport (40 miles/64 km); Bâle-Mulhouse airport (45 miles/72 km).

ⓘ Tourist information—
Pays de Ribeauvillé et Riquewihr:
+33 (0)3 89 73 23 23
www.ribeauville-riquewihr.com
www.riquewihr.fr

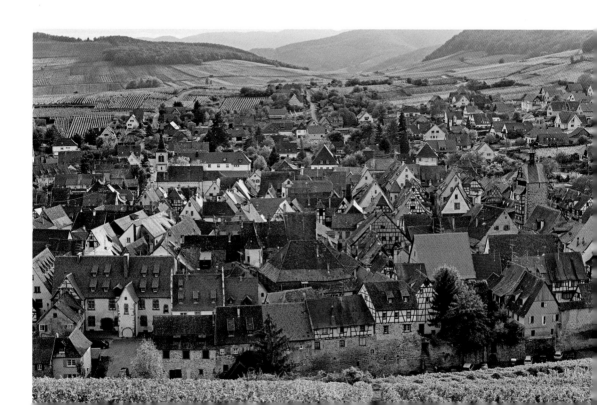

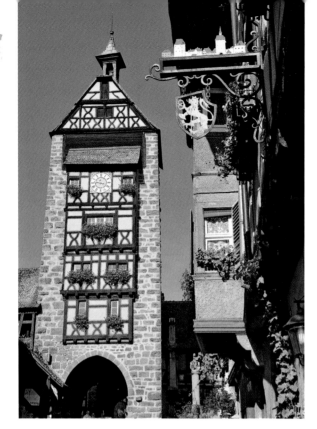

👁 Highlights

• **Musée de l'Oncle Hansi:** Watercolors, lithographs, etchings, decorative tableware, posters, video projections, play area, and store: +33 (0)3 89 47 97 00.
• **Musée du Dolder** (local history): The history of Riquewihr from the 12th to the 17th centuries: +33 (0)3 89 73 23 23.
• **Tour des Voleurs et Maison de Vigneron:** A former Riquewihr prison and its instruments of torture; the interior of a winegrower's house from the 16th century: +33 (0)3 89 73 23 23.
• *Grands crus* **wine trail:** Self-guided visits all year round; guided tour led by a winemaker followed by a visit to the wine cellar, with tastings in summer: +33 (0)3 89 73 23 23.
• **Village:** Guided tour led by tourist information center guides: +33 (0)3 89 73 23 23); tour of the village and vineyard by tourist train: +33 (0)3 89 73 74 24.
• **Signposted nature trail in Riquewihr Forest:** +33 (0)3 89 73 23 23.

🗝 Accommodation

Hotels
À l'Oriel***: +33 (0)3 89 49 03 13.
Le Riquewihr***: +33 (0)3 89 86 03 00.
Le Schoenenbourg***:
+33 (0)3 89 49 01 11.
La Couronne**: +33 (0)3 89 49 03 03.
♥ Saint-Nicolas**: +33 (0)3 89 49 01 51.
Guesthouses
La Cour de l'Abbaye d'Autrey 🛏🛏🛏:
+33 (0)3 89 47 89 81.
Caroline Schmitt: +33 (0)6 49 34 15 80.
Mireille Schwach: +33 (0)3 89 47 92 34.
Le Sentier du Meunier:
+33 (0)6 40 58 80 71.
Gîtes and vacation rentals
Les Remparts de Riquewihr***** to ***:
+33 (0)6 08 03 37 52.
Further information: +33 (0)3 89 73 23 23
www.ribeauville-riquewihr.com
Campsites
Camping de Riquewihr:
+33 (0)3 89 47 90 08.

🍴 Eating Out

À la Couronne: +33 (0)3 89 49 02 12.
Le Cep de Vigne: +33 (0)3 89 47 92 34.
Le Manala, *winstub* (traditional Alsatian brasserie): +33 (0)3 89 49 01 51.
Le Médiéval: +33 (0)3 89 49 05 31.

🧺 Local Specialties

Food and Drink
AOC Alsace and *grands crus* Schoenenbourg and Sporen wines • Beer and distilled spirits • Alsatian cookies • Honey.
Art and Crafts
Handicrafts • Gifts • Art galleries.

📅 Events

Market: Friday morning, Place Fernand Zeyer.
June: International male choir festival; Fête de la Quenelle Alsacienne, local dumpling festival.
December: Christmas market and activities, daily 10 a.m.–7 p.m.

🦋 Outdoor Activities

Fishing • Walking: Route GR 5 and marked trails (including the Saint James's Way and the *Grands crus* wine trail) • Mountain-biking.

🌿 Further Afield

• Alsace wine route: *Hunawihr (2 miles/ 3 km), see pp. 62–63. Ribeauvillé (4½ miles/7 km), *Eguisheim (10 miles/ 16 km), see pp. 58–59.
• Kaysersberg (6 miles/9.5 km).
• Colmar (7½ miles/12 km).
• Haut-Koenigsbourg (16 miles/26 km).
• *Mittelbergheim (24 miles/39 km), see pp. 66–67.
• Écomusée de Haute-Alsace, local heritage museum (28 miles/45 km).

ℹ Did you know?

When, in the 18th century, one of the lords of Riquewihr found himself saddled with debt, he borrowed 500 livres from the writer Voltaire by mortgaging the vineyards of his estate. The sum was eventually repaid, so Voltaire never became owner of Riquewihr.

Rodemack
The little Carcassonne of Lorraine

Moselle (57) • Population: 1,110 • Altitude: 722 ft. (220 m)

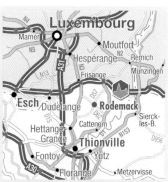

A fief of the house of Luxembourg in the 10th century, Rodemack lived in relative peace and experienced five centuries of prosperity. The fortress, built in the 12th century, then gave way to a castle, which was later extended and rebuilt. The village grew up around the church, built in the 10th century, and the ramparts were erected in the 13th and 15th centuries. Walk along the Ruelle de la Forge, Rue du Four, and the Place de Gargants to discover its defensive walls and towers: the Boucour, Barbacane, and twin towers. The village itself is surrounded by a second wall with demi-lune (half-moon) towers and gateways flanked by round towers. The 14th-century Sierck Gate was built by the villagers themselves.

By road: Expressway A13, exit 10–Frisange (3½ miles/5.5 km); expressway A31, exit 38–Thionville centre (11 miles/18 km).
By train: Thionville TGV station (10 miles/16 km). **By air:** Luxembourg-Findel airport (20 miles/32 km); Metz-Nancy Lorraine airport (43 miles/69 km).

ⓘ Tourist information—Communauté de Communes de Cattenom et Environs: +33 (0)3 82 56 00 02 / www.tourisme-ccce.fr www.mairie-rodemack.fr

👁 Highlights
• **Village:** Guided tour for groups all year round, booking essential. Further information: +33 (0)3 82 56 00 02.
• **Citadelle de Rodemack:** Park open daily May–September, 10 a.m. to 5.30 p.m.
• **Jardin Médiéval** (medieval garden): All year round.

🗡 Accommodation
Gîtes
L'Intra-Muros**: +33 (0)3 82 50 01 49.
M. and Mme Kremer**:
+33 (0)3 82 51 23 07.
Gîte Morisseau: +33 (0)3 54 54 15 89.
Au Relais de la Poste 🍴🛏:
+33 (0)3 82 50 01 49.
Gîtes des Remparts ✹✹✹ and ✹✹:
+33 (0)6 23 40 18 98.
M. Werner: +33 (0)3 82 51 24 07.
Communal gîtes +33 (0)3 82 83 05 50.

🍽 Eating Out
À 2 Pas du Lavoir: +33 (0)9 67 58 72 26.
Histoire de Famille: +33 (0)3 82 57 28 63.
L'Auberge de la Petite Carcassonne, Friday–Sunday: +33 (0)3 82 82 08 78.

🧺 Local Specialties
Food and Drink
Artisan beers.
Art and Crafts
Designers • Artists • Photographers • Jewelry • Ceramics • Leatherwork.

📅 Events
Market: "Le Noyer," large organic vegetable market, Saturday mornings, 9 a.m.-12.30 p.m., Route de Faulbach, and Wednesdays 5 p.m. to 8 p.m., ramparts car park.
April: Most Beautiful Villages of France wine festival (mid-April).
May: Flower market (1st weekend).
June: Rodemack Solex (bike) Tour (mid-June); "Rodemack, Cité Médiévale en Fête," festival (late June).
July and August: Summer activities.
August: Fête de la Grillade barbecue (mid-August).
September: Antiques and collectors' fair.
October: Fête de la Sorcière (magic festival).
November: Lumières d'Hiver (sound and light festival).

🦋 Outdoor Activities
Walking • Mountain-biking.

🌿 Further Afield
• Mondorf-les-Bains (3½ miles/5.5 km).
• Basse Rentgen: Preisch castle (6 miles/10 km).
• Cattenom: Maginot Line fortification (6 miles/10 km).
• Hettange-Grande: nature reserve (6 miles/10 km).
• Sierck-les-Bains; Manderen: Château de Malbrouk (7½–12 miles/12–19 km).
• Schengen: Musée de l'Europe (10 miles/16 km).
• Thionville (10 miles/16 km).
• Luxembourg (16 miles/26 km).
• Veckring: Ouvrage Hackenberg, Maginot Line fortification (19 miles/31 km).
• Neufchef: Ecomusée des Mines de Fer de Lorraine, local iron mining museum (22 miles/35 km).
• Metz: (31 miles/50 km)

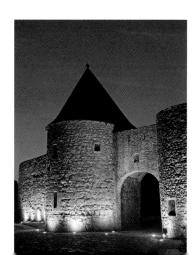

Saint-Quirin
A place of pilgrimage

Moselle (57) • Population: 821 • Altitude: 1,050 ft. (320 m)

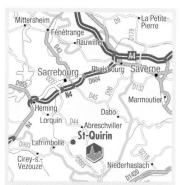

At the foot of an amphitheater of hills, the village is surrounded by the vast and game-filled Vosges forest, where beech and oak grow alongside spruce and larch.

Higher up, the archeological site of La Croix-Guillaume contains important Gallo-Roman remains of the 1st, 2nd, and 3rd centuries, which bear witness to the ancient culture of the peaks. Saint-Quirin is named after Quirinus, the military tribune of Rome who was martyred in 132 CE under the Emperor Hadrian, and whose relics lie in the priory church. Many buildings testify to the village's glorious past: the priory and the Baroque priory church (1722), with its Jean-André Silbermann organ (1746), which is a listed historic monument; the Église des Verriers, a beautiful Rococo-style edifice built in 1756 at Lettenbach; and the Romanesque-style high chapel dating from the 1180s. Below the church, the water from the miraculous spring is said to have healed skin diseases through the intercession of Saint Quirinus. The village thus became a place of pilgrimage and of devotion to its healing saint.

By road: Expressway A4, exit 44–Lunéville (20 miles/32 km), then N4 (16 miles/ 26 km). **By train:** Sarrebourg station (11 miles/18 km). **By air:** Strasbourg airport (65 miles/105 km); Metz-Nancy Lorraine airport (78 miles/126 km).

ⓘ Tourist information:
+33 (0)3 87 08 08 56
www.saintquirin.fr

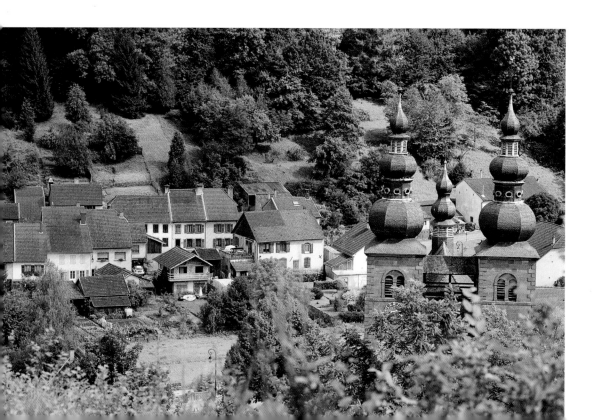

👁 Highlights
• **Priory church** (18th century): Silbermann organ, relics of Saint Quirinus, large crystal chandelier.
• **High chapel** (12th century): Stained-glass windows by V. Honer de Nancy.
• **Chapelle Notre-Dame-de-l'Hor** at Métairies-Saint-Quirin (15th and 18th centuries): Statue of the Immaculate Conception, paintings.
• **Gallo-Roman archeological site of La Croix-Guillaume:** +33 (0)3 87 08 08 56.

🗝 Accommodation
Hotels
Le Prieuré**: +33 (0)3 87 08 65 20.
Guesthouses
Le Temps des Cerises: +33 (0)6 78 15 76 02.
Gîtes
Further information: +33 (0)3 87 08 08 56
www.saintquirin.fr
Campsites
Camping municipal**. Further information: +33 (0)3 87 08 60 34.

🍴 Eating Out
Auberge de la Forêt: +33 (0)3 87 03 71 78.
Hostellerie du Prieuré: +33 (0)3 87 08 66 52.

🧺 Local Specialties
Food and Drink
Honey • Salted meats and fish.
Art and Crafts
Painting and sculpture workshop • Furniture and paintings gallery • Artist • Sculpture in stone and wood • Glassblower.

📅 Events
March: "La Ronde des Chevandiers" car rally.
May: Saint-Quirin-Marmoutier evening market (2nd Saturday).
Ascension: Procession and fair.
June: Organ recitals.
July: International hiking festival.
August: "Barakozart" music festival.
September: Plant sale (4th Sunday).
November: Mass of Saint Hubert.
December: Christmas market, giant Advent calender (1st weekend).

🦋 Outdoor Activities
Fishing • Walking: Route GR 5 and 5 "Moselle Pleine Nature" marked trails.

🌿 Further Afield
• Abreschviller (3 miles/5 km).
• Sarrebourg, Chagall trail (11 miles/18 km).
• Rhodes; Parc Animalier de Sainte-Croix: wildlife park (12 miles/19 km).
• Massif du Donon, mountain; Col du Donon (14 miles/23 km).
• Saint-Louis-Arzviller, inclined plane (16 miles/26 km).
• Phalsbourg (19 miles/31 km).
• Baccarat, crystal glass-making (25 miles/40 km).
• Saverne, Palais des Rohan (25 miles/40 km).
• Lunéville, Château des Lumières (31 miles/50 km).

ⓘ Did you know?
In 1049, Geppa, sister of Alsace-born Pope Leo IX, returned the relics of the tribune Quirinus, who had been tortured in 132 CE under Emperor Hadrian, to Rome. The convoy passed the night on a hill overlooking the village of Godelsadis. The following day, it proved impossible to move the reliquary containing the precious relics. Godelsadis thus became Saint-Quirin, and a chapel was built on the hill to house Quirinus's remains.

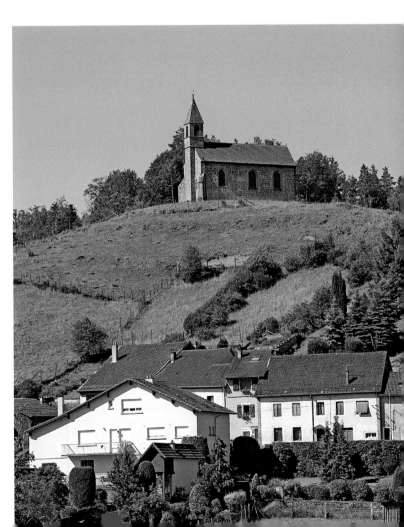

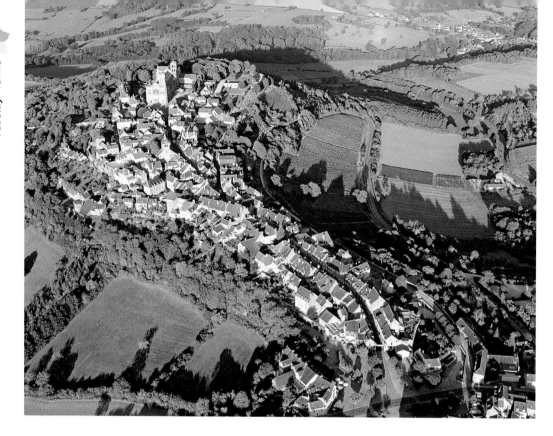

Vézelay
The hill where the spirit soars

Yonne (89) • Population: 450 • Altitude: 991 ft. (302 m)

Gazing at the Monts du Morvan, Vézelay sits on a steep hill sur-mounted by the basilica of Sainte-Madeleine.

Built in the 12th century in honor of Mary Magdalen, whose rel-ics are believed to lie there, the abbey was both a pilgrimage desti-nation and a departure point for Compostela. The arrival in 1146 of the abbot and reformer Bernard de Clairvaux subsequently made it an important Christian center. Beautiful Romanesque and Renaissance residences survive from this thriving era, rubbing shoulders with charming winegrowers' houses in a symphony of stone façades and rooftops, all covered with the flat, brown tiles typical of Burgundy. The basilica was restored in the 19th century by the architect Viollet-le-Duc, and both it and Vézelay hill were listed as UNESCO World Heritage Sites in 1979. The basilica is renowned for its Romanesque art and continues to attract visitors from all over the globe, while the house of writer Jules Roy and the Musée Zervos demonstrate the village's appeal to artists of all kinds.

By road: Expressway A6, exit 22–Avallon (14 miles/23 km); expressway A6, exit 21–Nitry (18 miles/29 km). **By train:** Sermizelles station (6 miles/9.5 km). **By air:** Dijon-Bourgogne airport (81 miles/130 km).

ⓘ Tourist information:
+33 (0)3 86 33 23 69
www.vezelaytourisme.com

👁 Highlights
• **Basilique Sainte-Madeleine** (12th–19th centuries): Carved tympana, Romanesque-style arches, Gothic choir, relics of Mary Magdalen, numerous 12th-century carved capitals. Guided visits for individuals or groups by the Fraternités de Jérusalem: +33 (0)3 86 33 39 50.
• **Maison du Visiteur:** Multimedia exhibition on the world of the 12th-century builder, as preparation for a visit to the basilica and to help interpret it. Slide-show, models, architecture, light show at solstices: +33 (0)3 86 32 35 65.
• **Musée de l'Œuvre-Viollet-le-Duc:** Romanesque capitals and fragments deposited by Viollet-le-Duc during his restoration work at the basilica: +33 (0)3 86 33 24 62.
• **Maison Jules-Roy** (house and gardens): House of the writer, reconstructed study; literary exhibitions and receptions: +33 (0)3 86 33 35 01.
• **Musée Zervos** (modern art 1925–65), in Maison Romain-Rolland: Collection bequeathed to the village by art critic and publisher Christian Zervos. Founder of the journal *Cahiers d'art* (1926–60), he courted major artists such as Picasso, Chagall, Léger, Calder, Kandinsky, Giacometti, Miró. Works by them are exhibited in the museum. Temporary exhibition each year: +33 (0)3 86 32 39 26.
• **Village:** Guided tour for individuals in summer: +33 (0)3 86 33 23 69; for groups all year round by appointment with Guides de Pays des Collines: +33 (0)3 86 33 23 69, or Guides de l'Yonne: +33 (0)3 86 41 50 30.
• **Village and basilica:** Guided tour (art, history, symbolism, tradition) by Lorant Hecquet, professional tour guide, by appointment: +33 (0)3 86 33 30 06; or with Guides de l'Yonne: +33 (0)3 86 41 50 30.

🗝 Accommodation
Hotels
La Poste et Lion d'Or***: +33 (0)3 73 53 03 20.
Le Compostelle**: +33 (0)3 86 33 28 63.
Les Glycines: +33 (0)3 86 47 29 81.
Le Relais du Morvan: +33 (0)3 86 33 25 33.
SY La Terrasse: +33 (0)3 86 33 25 50.
Guesthouses
Le Porc Épic 🍴🍴🍴🍴: +33 (0)6 60 17 47 75.
À l'Atelier 🍴🍴: +33 (0)3 86 32 38 59.
Au Poirier de la Perdrix: +33 (0)3 86 33 20 17.
Cabalus: +33 (0)3 86 33 20 66.
Charlou: +33 (0)3 86 41 01 50.
Le Pressoir de l'Abbaye: +33 (0)6 64 32 58 00.

Gîtes and vacation rentals
Further information: +33 (0)3 86 33 23 69 vezelaytourisme.com
Group accommodation
Auberge de Jeunesse: +33 (0)3 86 33 24 18.
Centre Sainte-Madeleine, Maisons Saint-Bernard et Béthanie: +33 (0)3 86 33 22 14.
Campsites
L'Ermitage*: +33 (0)3 86 33 24 18.

🍴 Eating Out
Auberge de la Coquille: +33 (0)3 86 33 35 57.
Le Bougainville: +33 (0)3 86 33 27 57.
Le Cheval Blanc: +33 (0)3 86 33 22 12.
La Dent Creuse: +33 (0)3 86 33 36 33.
La Poste et le Lion d'Or: +33 (0)3 73 53 03 20.
Le Relais du Morvan: +33 (0)3 86 33 25 33.
SY La Terrasse: +33 (0)3 86 33 25 50.
Le Vézelien, brasserie: +33 (0)3 86 33 25 09.
Tea rooms
Au Tastevin: +33 (0)7 86 63 22 96.
Les Macarons de Charlou: +33 (0)3 86 41 01 50.
Vézelay: +33 (0)3 86 33 23 01.

🏛 Local Specialties
Food and Drink
Honey • Heritage bread • AOC Vézelay wine • Chablis wine.
Art and Crafts
Antiques • Illuminator • Earthenware potter • Icons • Books • Metal, stone, and fabric crafts • Painter-sculptors, galleries • Monastic crafts • Sculptor • Weaver • Glassworker • Jewelry • Candles.

📅 Events
Market: Wednesday mornings, May–October.
May–October: Concerts in the basilica.
July: Pilgrimage Sainte-Madeleine (22nd).
August: Festival d'Art Vocal (2nd fortnight), organic produce market.
November: Truffle market.
December: Christmas celebrations.
All year round: Discussion groups, pilgrimages, workshops, and conferences.

🦋 Outdoor Activities
Canoeing, rafting • Horse-riding • Fishing • Walking: Routes GR 13 and 654, Chemin de Compostelle (Saint James's Way), 4 circular trails • Mountain-biking: 5 circular trails.

🌿 Further Afield
• Église d'Asquins (1 mile/2 km).
• Fontaines-Salées: archeological site; Saint-Père-sous-Vézelay: church (1 mile/2 km).
• Chamoux: Cardo Land, fantasy prehistoric park (4½ miles/7 km).
• Château de Bazoches-du-Morvan (6 miles/9.5 km).
• Avallon (9½ miles/15.5 km).
• Château de Chastellux (11 miles/18 km).
• Grottes d'Arcy-sur-Cure, caves (12 miles/19 km).
• *Noyers (25 miles/40 km), see p. 68.

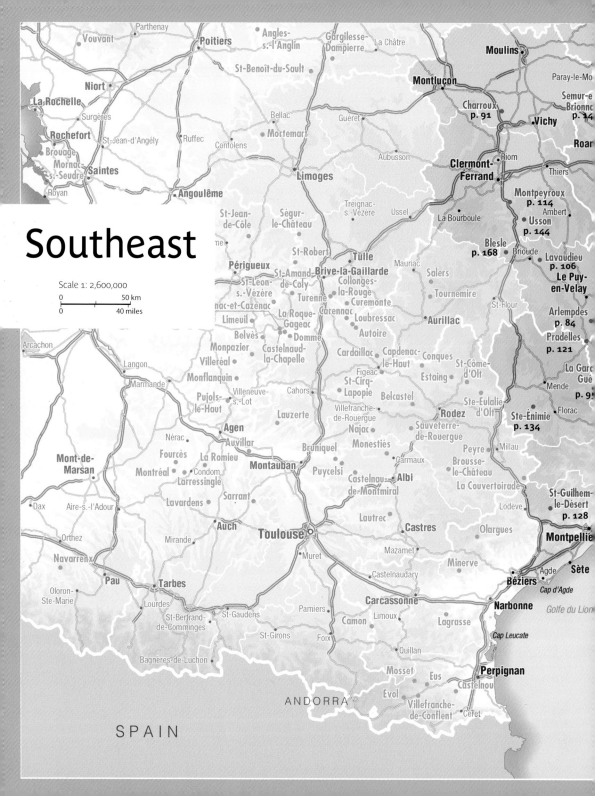

Southeast

Scale 1: 2,600,000

0 50 km
0 40 miles

Vouvant
Parthenay
Angles-s.-l'Anglin
Gargilesse-Dampierre
La Châtre
Moulins

Poitiers
St-Benoît-du-Sault
Montluçon
Paray-le-Mo

Niort
Bellac
Guéret
Charroux
p. 91
Semur-en-Brionno
p. 14
Vichy

La Rochelle
Surgères
Mortemart
Roar

Rochefort
St-Jean-d'Angély
Ruffec
Confolens
Limoges
Aubusson
Clermont-Ferrand
Riom
Thiers

Brouage
Mornac
s.-Seudre
Saintes
Angoulême

Royan
St-Jean-de-Côle
Ségur-le-Château
Treignac-s.-Vézère
Ussel
La Bourboule
Montpeyroux
p. 114
Ambert
Usson
p. 144

St-Robert
Tulle
Mauriac
Salers
Blesle
p. 168
Brioude
Lavaudieu
p. 106

Périgueux
St-Amand-de-Coly
Brive-la-Gaillarde
Le Puy-en-Velay

St-Léon-s.-Vézère
Collonges-la-Rouge
Tournemire
St-Flour

nac-et-Cazenac
Turenne
Curemonte
Arlempdes
p. 84

Limeuil
Carennac
Loubressac
Aurillac
Pradelles
p. 121

La Roque-Gageac
Autoire
Belvès
Domme
Cardaillac
Capdenac-le-Haut
Conques
St-Côme-d'Olt
La Garc
Gué

Monpazier
Castelnaud-la-Chapelle
Figeac
Estaing
Mende
p. 9

Villeréal
St-Cirq-Lapopie
Belcastel
Ste-Eulalie-d'Olt
Florac

Monflanquin
Cahors
Villefranche-de-Rouergue
Rodez
Ste-Énimie
p. 134

Pujols-le-Haut
Villeneuve-s.-Lot
Lauzerte
Najac
Sauveterre-de-Rouergue
Millau

Langon
Marmande
Agen
Nérac
Auvillar
Bruniquel
Monestiès
Carmaux
Peyre
Brousse-le-Château

Arcachon
Fourcès
La Romieu
Montauban
Puycelsi
Albi
La Couvertoirade
Lodève
St-Guilhem-le-Désert
p. 128

Mont-de-Marsan
Montréal
Condom
Larressingle
Castelnau-de-Montmiral
Montpellie

Dax
Aire-s.-l'Adour
Lavardens
Sarrant
Lautrec
Castres
Olargues

Orthez
Auch
Mirande
Muret
Mazamet
Minerve
Béziers
Agde
Sète

Navarrenx
Pau
Tarbes
Castelnaudary
Cap d'Agde

Oloron-Ste-Marie
Lourdes
St-Bertrand-de-Comminges
St-Gaudens
Pamiers
Camon
Limoux
Lagrasse
Carcassonne
Narbonne
Golfe du Lion

Bagnères-de-Luchon
St-Girons
Foix
Quillan
Cap Leucate

ANDORRA
Mosset
Eus
Perpignan
Castelnou

Evol
Villefranche-de-Conflent
Céret

SPAIN

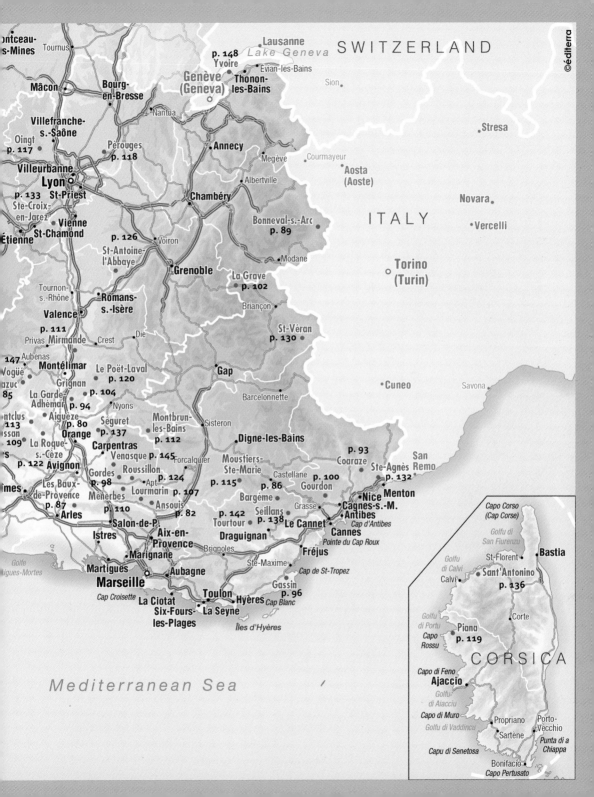

©éditerra

SWITZERLAND

Lausanne
p. 148 Lake Geneva
Yvoire
Genève Thonon- Évian-les-Bains
(Geneva) les-Bains
 Sion
ontceau- Tournus
s-Mines
 Stresa
Mâcon Bourg-
 en-Bresse
 Nantua
Villefranche- Courmayeur
s.-Saône Pérouges
Oingt p. 118 Annecy Megève
p. 117 Aosta Novara
 Megève (Aoste)
Villeurbanne Albertville Vercelli
Lyon St-Priest ITALY
p. 133 Chambéry
Ste-Croix-
en-Jarez Vienne Bonneval-s.-Arc
 St-Chamond p. 126 p. 89
Étienne Voiron
 St-Antoine- Modane Torino
 l'Abbaye Grenoble (Turin)
 La Grave
Tournon- p. 102
s.-Rhône Romans- Briançon
Valence s.-Isère
p. 111 Die
Privas Mirmande Crest
147 Aubenas St-Véran
Vogüé Montélimar Le Poët-Laval p. 130
azuc Grignan p. 120
85 p. 104 Gap
ntclus La Garde- Nyons
113 Adhémar p. 94
ssan Aigueze Séguret Montbrun- Barcelonnette
109 Orange p. 80 p. 137 les-Bains
 La Roque- Carpentras p. 112 Sisteron
 s.-Cèze Venasque p. 145 Forcalquier Digne-les-Bains
p. 122 Avignon Gordes Roussillon Moustiers- p. 93
mes Les Baux- p. 98 Apt p. 124 Ste-Marie Coaraze San
 de-Provence Ménerbes Lourmarin p. 115 Castellane Ste-Agnès Remo
p. 87 Arles p. 110 Ansouis p. 86 Gourdon p. 100 p. 132
 p. 82 Bargème Grasse Nice Menton
 Salon-de-P. p. 142 Seillans Cagnes-s.-M.
Istres Aix-en- Tourtour p. 138 Le Cannet Antibes
 Provence Draguignan Cannes Cap d'Antibes
 Marignane Brignoles Fréjus Pointe du Cap Roux
Martigues Aubagne Cap de St-Tropez
Marseille Ste-Maxime
Cap Croisette La Ciotat Gassin
 Six-Fours- Toulon Hyères p. 96
 les-Plages La Seyne Cap Blanc
Golfe Îles d'Hyères
igues-Mortes

Mediterranean Sea

Cuneo Savona

CORSICA

Capo Corso
(Cap Corse)
Golfu di
San Fiurenzu
Golfu St-Florent Bastia
di Calvi
Calvi Sant'Antonino
 p. 136
Golfu Corte
di Portu
Capo Piana
Rossu p. 119
 C O R S I C A
Capo di Feno
Ajaccio
Golfu-
di Aiacciu
Capo di Muro
Golfu di Vaddincu Propriano
 Sartène Porto-
Capu di Senetosa Vecchio
 Punta di a
 Chiappa
 Bonifacio
 Capo Pertusato

Aiguèze
A phoenix from the ashes

Gard (30) • Population: 220 • Altitude: 292 ft. (89 m)

A fortress perched on a cliff overlooking the Gorges of the Ardèche, Aiguèze protects its medieval heritage, cultivates vines, and ensures its inhabitants are always friendly and welcoming.

Like any strategic defense site, Aiguèze has had a turbulent past. From 725 to 737 CE, the region was occupied by the Saracens, who gave their name to one of the village's towers. The fortification of the site dates back to the 11th century: it was the work of the count of Toulouse, who wanted to make Aiguèze the outpost for his operations against the region of Vivarais. In 1360, uprisings caused Aiguèze its last great period of turmoil: local peasants, oppressed by hefty taxes, became restless, and the village endured more destruction and looting. Often attacked but always liberated afterwards, Aiguèze survived, and managed to preserve traces of its history. The village owes much of its present-day appeal to Frédéric Fuzet, archbishop of Rouen and a local man, who, in the early 20th century, devoted his time and means to its conservation and modernization, notably the main square shaded by plane trees and the 11th-century church. In the narrow cobbled and vaulted streets arch-covered balconies, mullioned windows, and arched doorways are on display. They lead to the *castelas*, the old ramparts of the castle, from where there is a splendid view of the Ardèche, *garrigue* (scrubland), and Côtes du Rhône vineyards.

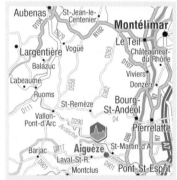

By road: Expressway A7, exit 19–Bollène (14 miles/22 km), N86 (8½ miles/13.5 km).
By train: Montélimar TGV station (27 miles/43 km).
By air: Avignon-Caumont airport (42 miles/68 km).

ⓘ Tourist information—
Provence Occitane:
+33 (0)4 66 39 26 89 or
+33 (0)4 66 82 30 02
www.provenceoccitane.com

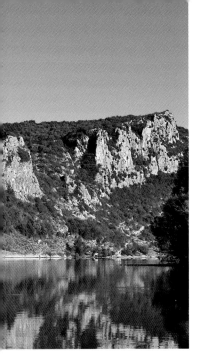

👁 Highlights
• **Church** (11th century): Open daily.
• **Village:** Guided tours in summer, and by appointment off-season:
+33 (0)04 66 39 26 89.

🗝 Accommodation
Aparthotels
Le Castelas**: +33 (0)4 66 82 18 76.
Guesthouses
Le Clos des Vignes: +33 (0)9 74 56 24 75.
Les Jardins du Barry: +33 (0)4 66 82 15 75.
Les Mazets d'Aiguèze: +33 (0)4 66 82 34 28.
La Sarrazine: +33 (0)0352 661 511 023.
Terre & Sud: +33 (0)7 60 70 46 71.
Gîtes, vacation rentals, and campsites
Further information: +33 (0)4 66 82 14 77.

🍴 Eating Out
Le Belvédère, pizzeria: +33 (0)4 66 50 66 69.
Bistrot La Charriotte: +33 (0)4 66 82 11 26.
Le Bouchon, café and wine bar:
+33 (0)4 66 39 47 70.
Café Chabot: +33 (0)4 66 33 80 51.
Le Carioca, pizzeria: +33 (0)6 88 97 80 93.
Le Drillo: +33 (0)9 86 12 84 80.

🧺 Local Specialties
Food and Drink
AOC Côtes du Rhône wines • Honey •
Goat cheese (*pélardons*).
Art and Crafts
Art gallery • Pottery • Craft studios.

② Events
Market: Thursday mornings, mid-June to mid-September.
April: Flower market (2nd weekend).
May: Fête du Pain (bread festival).
Pentecost: Flea market (weekend).
Mid-July and mid-August: Welcome days for vacationers, activities.
October: Fête de la Courge (squash festival).
December: Christmas market (1st Sunday).

🦋 Outdoor Activities
Swimming in the Ardèche river •
Canoeing and boating trips down the Ardèche river • Walking: Trail from Castelvieil *oppidum* (main settlement), walk through the vineyards.

🌿 Further Afield
• Chartreuse de Valbonne, monastery (4½ miles/7 km).
• Gorges of the Ardèche; Vallon-Pont-d'Arc; Grotte Chauvet, cave; Aven d'Orgnac, sinkhole; Grotte de la Madeleine, cave; Grotte de Saint-Marcel-d'Ardèche, cave; Aven-Grotte de la Forestière, cave (4½–22 miles/7–35 km).
• Pont-Saint-Esprit (6 miles/9.5 km).
• *Montclus (9 miles/14.5 km), see p. 113.
• *La Roque-sur-Cèze (11 miles/18 km), see pp. 122–23.

• Cornillon; Goudargues (12 miles/19 km).
• Castles at Suze-la-Rousse (17 miles/27 km) and Grignan (27 miles/43 km).
• Orange: Roman theater (21 miles/34 km).
• *Lussan (22½ miles/36 km), see p. 109.

Ansouis

A fan-shaped refuge in southeast France

Vaucluse (84) • Population: 1,140 • Altitude: 968 ft. (295 m)

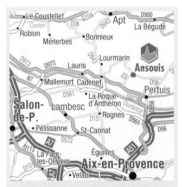

Standing at the heart of the Pays d'Aigues, with the Grand Luberon mountain range and the Durance river on the horizon, the hilltop village of Ansouis is crowned by an old château.

Spread out in a fan shape, open to the sun, the village is criss-crossed by a maze of streets and alleys that remain shady and cool. From the Place Saint-Elzéar, the Rue du Petit-Portail climbs up to a peaceful little square: bordered by the 12th-century perimeter wall, which serves as the façade of the Église Saint-Martin, and by the elegant 13th-century presbytery, it offers a vast panorama of a landscape of vines overlooked by the Grand Luberon. At the top of the village, the castle, owned for generations by the Sabran family, condenses a thousand years of castle architecture. The austerity of the medieval fortress on the north side contrasts with the classical southern façade of the 17th-century residence, which overlooks the terraced gardens with their box topiary.

By road: Expressway A7, exit 26–Sénas (22 miles/35 km); expressway A51, exit 15–Pertuis (7½ miles/12 km). **By train:** Aix-en-Provence TGV station (30 miles/48 km). **By air:** Marseille-Provence airport (37 miles/60 km).

ⓘ Tourist information:
+33 (0)4 90 09 86 98
www.luberoncotesud.com

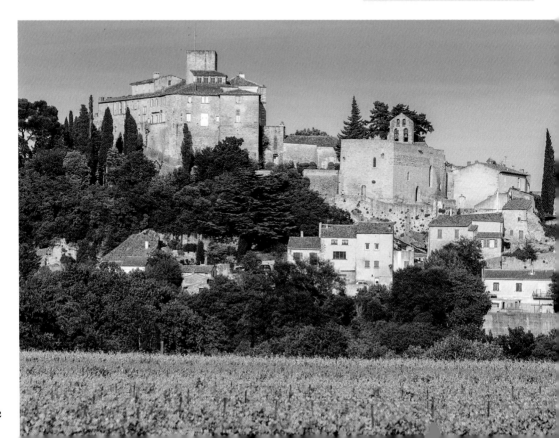

🛈 Did you know?

Elzéar, count of Sabran, was born in 1285 at the Château d'Ansouis and was married very young to Delphine de Signe. The two took a vow of chastity and lived a life of prayer, penance, and devotion to the poor. Elzéar was canonized by Pope Urban V and the cult of Delphine was approved by Pope Innocent VII. This popular cult has survived the centuries and, every year in September, the villagers of Ansouis gather in the village church for a Mass in honor of their saints.

👁 Highlights

• **Castle:** Erected in the 12th and 13th centuries and rebuilt in the 17th century, this imposing fortress has been completely restored and is open to the public from April to October: +33 (0)4 90 77 23 36.
• **Église Saint-Martin:** Fortified 12th-century church, formerly the castle's law court; 18th-century statues and altarpieces.
• **Musée Extraordinaire:** This Provençal building presents artistic creations as well as a collection of fossils, shells, and furniture belonging to its owner, a painter and diver: +33 (0)4 90 09 82 64.
• **Musée des Arts et des Métiers du Vin:** More than three thousand objects used by the winemakers and grape-pickers of the Château Turcan: +33 (0)4 90 09 83 33.

⚷ Accommodation

Guesthouses
Bastide Saint-Maurin*****:
+33 (0)6 25 04 44 20.
Le Jardin d'Antan 🛏🛏🛏:
+33 (0)4 90 09 89 41.
Le Mas de la Huppe: +33 (0)4 90 09 08 41.
Le Mas du Grand Luberon:
+33 (0)4 90 09 97 92.
Un Patio en Luberon: +33 (0)4 90 09 94 25.
Gîtes and vacation rentals
Further information: +33 (0)4 90 09 86 98
www.luberoncotesud.com

🍽 Eating Out

Bar des Sports: +33 (0)4 90 08 44 33.
La Closerie: +33 (0)4 90 09 90 54.
Le Grain de Sel, restaurant and wine bar:
+33 (0)4 90 09 85 90.
Pâtisserie d'Antan, tea room:
+33 (0)6 28 41 45 73.

🧺 Local Specialties

Food and Drink
Homemade ice cream • AOC Luberon wines.
Art and Crafts
Santon (crib figure) maker • Bronze sculptures and jewelry • Artist.

📅 Events

Market: Sunday morning, Place de la Vieille-Fontaine.
May: Les Botanilles, festival and flower market (last two weeks).
June: Ansouis en Musique (music festival).
July and August: Various activities.
September: Fête de la Saint-Elzéar (mid-month).

🦋 Outdoor Activities

Walking: 3 marked trails.

🌿 Further Afield

• La Tour-d'Aigues (5 miles/8 km).
• Villages on the Durance river: Cadenet, Pertuis, Mirabeau (6–12 miles/9.5–19 km).

• *Lourmarin (7 miles/11.5 km), see pp. 107–8.
• Aix-en-Provence (19 miles/31 km).
• *Ménerbes (21 miles/34 km), see p. 110.
• *Roussillon (21 miles/34 km), see pp. 124–25.
• *Gordes (24 miles/39 km), see pp. 98–99.

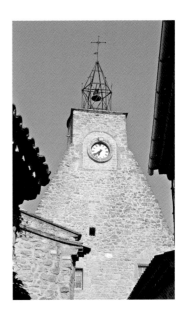

Arlempdes
The first château of the Loire

Haute-Loire (43) • Population: 140 • Altitude: 2,756 ft. (840 m)

Arlempdes (pronounced "ar-lond") sits at the top of a volcanic peak in the Velay, close to the source of the Loire river. The remains of the castle built by the Montlaur family in the 12th–14th centuries are at the top of a basalt dike, into which the Loire has cut deep, wild gorges. Crenellated ramparts and curtain walls enclose the ancient court-yard, dominated by the round tower of the keep and the Chapelle Saint-Jacques-le-Majeur, probably built in the 11th–12th centuries on the site of a Celtic sanctuary, standing some 260 ft. (80 m) above the river. At the foot of this imposing castle, behind a 13th-century gate-way, the village spreads out around a peaceful square. This serves as the forecourt of the Romanesque Église Saint-Pierre, noteworthy for its polylobed door and its four-arched bell gable. From this square, a path leads to the castle, whose entrance is via a Renaissance porch. On the plateau through which the Loire has carved its course, agricultural production has been given a new lease of life by the Puy green lentil, which, benefiting from the area's volcanic soil and microclimate, was the first dried legume to be awarded an AOC, in 1996, and it obtained an AOP in 2008.

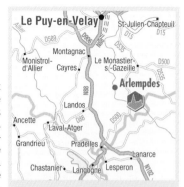

By road: Expressway A75, exit 20– Le Puy-en-Velay (56 miles/90 km), N102-N88 (5½ miles/9 km). **By train:** Puy-en-Velay station (17 miles/28 km). **By air:** Le Puy–Loudes airport (21 miles/ 33 km); Clermont-Ferrand airport (91 miles/146 km).

ⓘ Tourist information—
Pays de Pradelles: +33 (0)4 71 00 82 65
www.gorges-allier.com
www.village-arlempdes.com

👁 Highlights
• Castle: Remains; visits possible: +33 (0)4 71 00 82 65 or +33 (0)4 71 57 17 14); guided tours every afternoon in July and August.
• Écomusée de la Ruralité (museum of rural life): Tools and ways of life of a bygone age.
• Église Saint-Pierre.

🗝 Accommodation
Hotels
Le Manoir: +33 (0)4 71 57 17 14.
Guesthouses
La Freycenette 🛏🛏🛏: +33 (0)4 71 49 43 43.
Gîtes and vacation rentals
Gîte N° 0001223***: +33 (0)4 71 49 43 43.
La Grotte***: +33 (0)6 09 97 31 72.
Les Chaumeilles**: +33 (0)4 71 03 04 16.
Le Clos des Fontaines 🛏🛏🛏: +33 (0)66 48 47 51.
L'Estaou 🛏🛏🛏: +33 (0)4 71 49 43 43.
La Gîte de Coulombs 🛏🛏🛏: +33 (0)4 44 43 93 12.
Les Sources 🛏🛏🛏: +33 (0)4 71 49 43 43.
Le Presbytère 🛏🛏: +33 (0)4 71 49 43 43.
Further information on other gîtes and vacation rentals: +33 (0)4 71 00 82 65
www.gorges-allier.com

🍽 Eating Out
Le Manoir: +33 (0)4 71 57 17 14.

🧺 Local Specialties
Food and Drink
Cheeses • AOP Puy green lentils.

2️⃣ Events
July: Open-air rummage sale (around the 15th).
August: Fête du Pain, bread festival (1st fortnight).
November: Hot-air balloon flights (1st fortnight).

🦋 Outdoor Activities
Swimming (no lifeguard) • Fishing • Walking: Route GR 3 and several marked trails • Mountain-biking.

🌿 Further Afield
• *Pradelles (11 miles/18 km), see p. 121.
• Lac du Bouchet, lake (11 miles/18 km).
• Le Monastier-sur-Gazeille (14 miles/ 23 km).
• Lac d'Issarlès, lake (16 miles/26 km).
• Le Puy-en-Velay (17 miles/27 km).
• Mont Gerbier-de-Jonc (28 miles/45 km).

ⓘ Did you know?
The marquis d'Arlandes, whose family was from Arlempdes, made the first manned hot-air-balloon flight, on November 21, 1783.

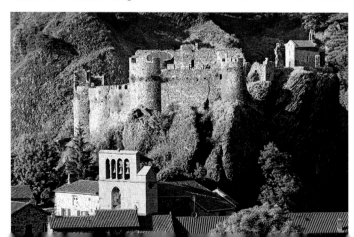

Balazuc

The sentry of the Ardèche

Ardèche (07) • Population: 352 • Altitude: 600 ft. (183 m)

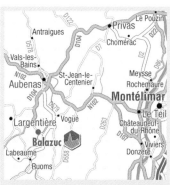

Facing the sunset, Balazuc clings to a steep limestone cliff overlooking the Ardèche river. From the early Middle Ages until the Wars of Religion, the lords of Balazuc—simple knights, crusaders, and troubadours—made this village into an important stronghold. Its historic stature is evident in the 13th-century castle, rebuilt in the 17th and 18th centuries (now privately owned); the 13th-century square tower, whose façade still retains an iron rod on which the public scale for weighing silkworm cocoons used to hang; the fortified Romanesque church, crowned with a Provençal bell gable; and its gates, the Portail d'Été and the Porte de la Sablière. Balazuc has also kept its distinctive layout from the medieval period: a veritable maze of narrow, winding streets, vaulted passageways, and steps carved into the rock. Outside the village, the Chemin Royal leads slowly toward the Ardèche river and, beyond the bridge, to the reemerging hamlet of Le Viel Audon.

By road: Expressway A7, exit 17–Montélimar-Nord (32 miles/51 km), N102 (7½ miles/12 km). **By train:** Montélimar TGV station (25 miles/40 km). **By air:** Avignon-Caumont airport (80 miles/129 km).

(i) Tourist information—Pont-d'Arc Ardèche: +33 (0)4 28 91 24 10 or +33 (0)4 75 37 75 60 (in summer). www.pontdarc-ardeche.fr

👁 Highlights

• **Romanesque church** (11th century): Restored in 2007 and decorated with stained-glass windows by Jacques Yankel. Exhibitions March–September. Further information: +33 (0)4 75 37 75 60 or +33 (0)4 75 37 75 08.
• ♥ **Museum de l'Ardèche:** Exceptional collection of fossils representing 350 million years of natural history: +33 (0)4 28 40 00 35.
• **Le Viel Audon:** This hamlet includes an environment and sustainable development training center.
• **Village:** Guided tour, Wednesday mornings in July and August. Further information: +33 (0)4 75 37 75 08.

🖋 Accommodation

Guesthouses
Château de Balazuc: +33 (0)4 75 88 23 27.
La Cloche Qui Rit: +33 (0)6 07 48 94 71.
Les Dolines: +33 (0)4 75 89 17 70.
Gîtes, walkers' lodges, and vacation rentals
Further information: +33 (0)4 75 37 75 08
www.pontdarc-ardeche.fr
Campsites
La Falaise***: +33 (0)4 75 37 74 27.
Beaume-Giraud**: +33 (0)4 75 89 09 36.
Le Retourtier**: +33 (0)4 75 37 77 67.
Cabanes-Lodges Le Servière: +33 (0)6 48 06 85 11.

🍽 Eating Out

Le Buron (summer only): +33 (0)4 75 37 70 21.
Le Celtis (summer only): +33 (0)4 75 87 13 61.
Chez Paulette: +33 (0)4 75 37 94 52.
Le Cigalou (summer only): +33 (0)4 75 37 02 15.
Le Fazao, snack bar (summer only): +33 (0)4 75 37 27 17.
La Fenière, crêperie/pizzeria: +33 (0)4 75 88 85 50.
La Granja Delh Gourmandás (summer only): +33 (0)4 75 88 04 59.
Le Viel Audon, local dishes (summer only): +33 (0)4 75 37 73 80.

🧺 Local Specialties

Food and Drink
Goat cheeses • Herbal produce (syrups, etc.) • AOC Côtes du Vivarais wines and Coteaux de l'Ardèche *vins de pays*.
Art and Crafts
Pottery • Jeweler • Sculptor.

📅 Events

Market: Tuesdays, 6.30 p.m., Place de la Croisette (July and August).
July: Village festival.
July and August: Concerts and art exhibitions in the Romanesque church.
August: Folk dance.

🦋 Outdoor Activities

Swimming in the Ardèche river (lifeguard) • Canoeing (rental) • Rock climbing • Fishing (Ardèche river) • Walking: marked trails • Mountain-biking • Cycling trail.

🌿 Further Afield

• *Vogüé (4½ miles/7 km), see p. 147.
• Ruoms; Largentière (6 miles/9.5 km).
• Labeaume: village and gorges (9½ miles/ 15.5 km).
• Vallon-Pont-d'Arc; Grotte Chauvet, cave (11 miles/18 km).
• Aubenas (12 miles/19 km).
• Gorges of the Ardèche (12–35 miles/ 19–56 km).
• Aven d'Orgnac, sinkhole (24 miles/39 km).

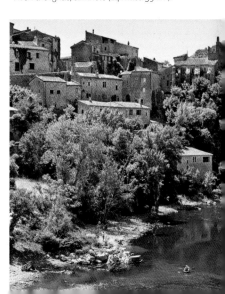

Bargème

A mountain in Provence

Var (83) • Population: 217 • Altitude: 3,599 ft. (1,097 m)

Facing the Canjuers and Var mountains, Bargème is, at 3,599 ft. (1,097 m), the highest village in the Var—still Provençal, yet almost alpine. Sheltered by the ruins of the Château Sabran-de-Pontevès, the silhouette of the feudal village stands out on the steep slopes of the Brouis mountain. In 1393, the lordship of the village passed to Foulques d'Agoult de Pontevès, and it remained in the hands of the Pontevès family for the following two centuries. The region was by then suffering great religious upheaval; the people of Bargème avenged the neighboring village of Callas, which had been betrayed by Jean-Baptiste de Pontevès, by bringing the line of châtelains to an end. After murdering his grandfather, father, and uncles, inhabitants of Bargème slit Antoine de Pontevès's throat in the middle of Mass in 1595. The parliament of Aix-en-Provence issued a judgment requiring the inhabitants to build an expiatory chapel, Notre-Dames-des-Sept-Douleurs, which is located at the end of the esplanade leading to the castle. The village retains its defensive perimeter wall—the two fortified gates, the Levant and the Garde, were added in the 14th century—as well as the white-stone Romanesque church. Under the patronage of Saint Nicholas, this 12th-century church has an apse that ends in a semidomed vault. It has three altarpieces, one of which, dedicated to Saint Sebastian, is a triptych carved in half relief.

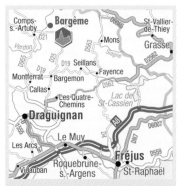

By road: Expressway A8, exit 36–Draguignan (33 miles/53 km); N85, exit Nice (50 miles/80 km). **By train:** Draguignan station (25 miles/40 km). **By air:** Nice-Côte-d'Azur airport (57 miles/92 km).

(i) **Town hall:** +33 (0)4 94 50 21 94
www.mairie-bargeme.fr

👁 Highlights

• **Château Sabran-de-Pontevès** (July and August): First mentioned in 1225, it was partially destroyed during the Wars of Religion but has retained its outer defensive elements: +33 (0)4 94 50 21 94.
• **Église Saint-Nicolas** (July and August): This 12th-century Romanesque church was restored, along with its altarpieces, from 1990 to 2000.
• **Village:** Further information: +33 (0)4 94 50 21 94.

⚷ Accommodation

Guesthouses
La Fontaine: +33 (0)6 15 84 09 04.
Vacation rentals
Pierre Chassigneux***: +33 (0)6 72 95 39 21.
Thiébaut Renger**: +33 (0)6 50 77 66 26.
Gîtes, teepees, wooden trailer
La Ferme Saint-Pierre: +33 (0)4 94 84 21 55.

🍴 Eating Out

L'Amandier Rose, crêperie:
+33 (0)4 94 68 44 35.
Le Goustadou, local specialties:
+33 (0)6 22 75 79 22.
Les Jardins de Bargème:
+33 (0)06 86 85 26 69.

🛒 Local Specialties

Food and Drink
Cheeses • Beef and lamb • Vegetables • Sheep yoghurts • Tastings of local specialties.
Art and Crafts
Art gallery • Painter-sculptor • Sculptor • Flea markets.

📅 Events

June: Transhumance festival.
August: Saint-Laurent festival (2nd weekend).

🏃 Outdoor Activities

Walking and riding: Route GR 49 and 2 marked trails • Hang gliding • Mountain-biking.

🌿 Further Afield

• Route Napoléon (6 miles/9.5 km) and views on the way to Castellane (18 miles/29 km) or Grasse (27 miles/43 km).
• La Bastide: summit of Montagne de Lachens (7½ miles/12 km).
• Le Grand Canyon du Verdon (16 miles/26 km).
• *Seillans (21 miles/34 km), see pp. 138–39.
• *Tourtour (29 miles/47 km), see pp. 142–43.

❢ Did you know?

Just over a mile (2 km) south of the village, on the roadside, stands a chapel dedicated to Saint Petronilla. Shepherds used to visit this chapel for their sheep to be blessed before they led them to summer pastures. Every year, on May 31, a Mass is still celebrated to bless bread and salt, which once formed the shepherds' main diet.

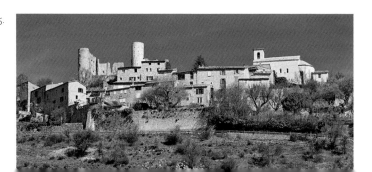

Les Baux-de-Provence

Geological grandeur

Bouches-du-Rhône (13) • Population: 361 • Altitude: 715 ft. (218 m)

Perched on a rocky outcrop of the Alpilles hills in Provence, the village of Baux stands high above the Crau and the Camargue like a beacon.

Rock reigns supreme in the strange landscape of the Val d'Enfer. Outlined against the sky, the *baux* (from the Provençal word *baù*, meaning rocky escarpment) is a majestic outcrop 3,000 ft. (900 m) by 700 ft. (200 m) that dominates the Baux valley, in a landscape that opens into the Camargue and Mont Sainte-Victoire. Since the dawn of time, humans have sought refuge in this rocky mass; but the story of Baux really begins in the 10th century, when its lords built a fortress right at the top of this eagle's nest. They reigned here for five centuries, during which time they waged countless battles against the other lords of the region. The ruins of the medieval citadel still bear witness to the lords' power: they dominate both the Entreconque valley's olive groves and vineyards, and the La Fontaine valley, where the Mistral wind rushes into the gaping mouths of ancient quarries. The Renaissance, too, has left its mark on the center of the village— in the form of the Maison du Roy (the tourist information center), which bears the Calvinist inscription "Post Tenebras Lux" (Light After Darkness) on its window; and in many town houses, such as the Hôtel de Manville (the present town hall), Hôtel de Porcelet (Musée Yves Brayer), Hôtel Jean de Brion (Fondation Louis Jou), and even the former guardroom (Musée des *Santons*). Given a new lease of life by its hoteliers, restaurateurs, oil and wine producers, and artists, this beautiful village today recalls a lost way of life.

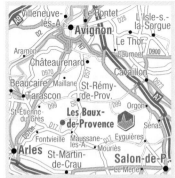

By road: Expressway A7, exit 24–Avignon Sud (18 miles/29 km); expressway A9-A54, exit 7–Arles (12 miles/19 km); expressway A54-N113, exit 7–Avignon (12 miles/19 km).
By train: Arles station (11 miles/18 km); Avignon TGV station (22 miles/35 km).
By air: Nîmes-Arles-Camargue (22 miles/ 35 km), Avignon-Caumont (25 miles/ 40 km), and Marseille-Provence (37 miles/ 60 km) airports.

ⓘ Tourist information:
+33 (0)4 90 54 34 39
www.lesbauxdeprovence.com

👁 Highlights

• **Carrières de Lumières:** Multimedia show projected onto giant natural backdrops throughout the year: +33 (0)4 90 54 47 37.
• **Château des Baux:** Medieval castle with keep, Sarrasine and Paravelle towers, lords' dovecote, castle chapel, Chapelle de Saint-Blaise (showing the movie "A bird's-eye view of Provence"), former Quiqueran hostel, exhibition of medieval siege engines, guided tours; treasure hunt (children age 7–12), medieval activities April–September and during fall school holidays; audioguide in 10 languages: +33 (0)4 90 54 55 56.
• **Fondation Louis Jou:** Exhibition of the works of Louis Jou (master typographer, engraver, printer, publisher) discovered in his workshop, and of his personal collection of incunabula, antiquarian

books, engravings by Dürer and Goya, paintings, sculptures, and ceramics; by appointment only: +33 (0)4 90 54 34 17.
• **Musée Yves Brayer:** Oil paintings, watercolors, sketches, engravings, and lithographs. Temporary exhibitions April–September: +33 (0)4 90 54 36 99.
• **Musée des *Santons*:** Varied collections of china figurines, including 17th-century Neapolitan figurines, 19th-century church figurines, works by local *santon* (crib figures) makers Carbonnel, Fouque, Jouve, Peyron Campagna, Toussaint, Thérèse Neveu, Louise Berger, Simone Jouglas; Christmas Nativity scenes: +33 (0)4 90 54 34 39.
• **Village:** Take the unique "history and architecture" walking trail for individuals, and for groups on request; visit the Trémaïe and take the perfumed trail; enjoy

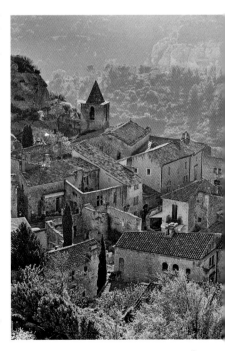

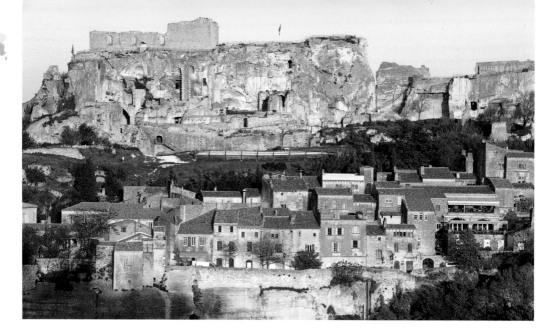

the natural and man-made heritage at the foot of the village; guided visit on request for groups only; accessible visit for the visually impaired: audioguide and touch tours, large print and Braille guides; free E-visit app: town visit accessible for all (general public, visual and hearing impaired): +33 (0)4 90 54 34 39.

🔑 Accommodation
Hotels
Baumanière Les Baux de Provence*****: +33 (0)4 90 54 33 07.
Domaine de Manville*****: +33 (0)4 90 54 40 20.
La Benvengudo****: +33 (0)4 90 54 32 54.
♥ Le Mas de l'Oulivié****: +33 (0)4 90 54 35 78.
Le Fabian des Baux***: +33 (0)4 90 54 37 87.
Le Mas d'Aigret ***: +33 (0)4 90 54 20 00.
Hostellerie de la Reine Jeanne**: +33 (0)4 90 54 32 06.
Guesthouses
Mas de la Fadeto: +33 (0)6 85 80 54 98.
Mas Derrière Château: +33 (0)4 90 54 50 62.
Le Prince Noir: +33 (0)4 90 54 39 57.
Vacation rentals
Further information: +33 (0)4 90 54 34 39
www.lesbauxdeprovence.com

🍽 Eating Out
Historic center
Auberge du Château: +33 (0)4 90 54 50 48.
Au Porte Mages: +33 (0)4 90 54 40 48.
Le Bautezar: +33 (0)4 90 54 32 09.
Les Baux Jus: +33 (0)9 86 39 84 96.
La Bella Vista: +33 (0)6 46 53 85 36.
Le Bouchon Rouge: +33 (0)4 90 18 26 07.
Le Café du Musée: +33 (0)4 86 63 15 01.
Hostellerie de la Reine Jeanne: +33 (0)4 90 54 32 06.
Le Jardin des Délices: +33 (0)6 81 87 30 72.
Le Jujubier: +33 (0)6 27 62 16 09.
La Suite: +33 (0)6 83 99 33 78.
Une Table au Soleil: +33 (0)6 38 68 24 92.
Les Variétés: +33 (0)4 90 54 55 88.
Outside the village
La Benvengudo: +33 (0)4 90 54 32 54.
La Cabro d'Or: +33 (0)4 90 54 33 21.
Le Mas d'Aigret: +33 (0)4 90 54 20 00.
Oustau de Baumanière: +33 (0)4 90 54 33 07.
La Table and Bistro at Domaine de Manville: +33 (0)4 90 54 40 20.

🍴 Local Specialties
Food and Drink
AOP Vallée des Baux-de-Provence olive oil • Pierced black olives and AOP marinated olives • AOC Baux-de-Provence wines • Local wines of the Alpilles.
Art and Crafts
Studios and art galleries • Silver/goldsmith and jewelry studio • Household linen, Provençal specialties • Natural and organic aromatic products • *Santon* (crib figure) workshop • Soaps and beauty products • Weaver • Hatter.

2 Events
April–October: Exhibitions in cultural spaces (self-guided visits).
June: Fête de la Saint-Jean, Saint John's feast day.
October: Exhibition of designers and *santon* (crib figure) makers.
December: "Noël aux Baux-de-Provence" exhibition and Christmas activities, dawn ceremony, Midnight Mass, and living Nativity.
All year round: Monuments and rocks in the village, family activities (themed walks, olive oil workshops, costumed tours, smartphone photography workshops).

🦋 Outdoor Activities
Golf: 18 holes (Domaine de Manville) • Walking: Route GR 6, 1 marked trail and 1 wine-lovers' trail at Saint Berthe, the Trémaïe Path (restricted access to forested massifs June–September). Further information: +33 (0)8 11 20 13 13.

🌿 Further Afield
• Landscape and villages of the Alpille hills: Eygalières, Fontvieille, Maussane, Saint-Rémy-de-Provence (3–22 miles/5–35 km).
• Arles (11 miles/18 km).
• Avignon (19 miles/31 km).
• Les Saintes-Maries-de-la-Mer (36 miles/ 58 km).

Bonneval-sur-Arc

A village of open spaces

Savoie (73) • Population: 244 • Altitude: 5,906 ft. (1,800 m)

Lying between the Vanoise national park and the Grand Paradis national park in Italy, Bonneval's backdrop is nature writ large.

Ringed by dark mountains at the end of the Haute-Marienne valley, for centuries Bonneval was cut off from the rest of the world. But now each winter, when the road to the Col de l'Iseran closes, the inhabitants of Bonneval turn their isolation to their advantage by developing their own breed of tourism that respects both this remarkable environment and the ancient traditions of shepherds and artisans. Just down the road from Tralenta, whose buildings lining the Arc river lead straight to ski slopes, the huge stone houses topped with *lauzes* (schist tiles) and bristling with chimneys still nestle around the cheese dairy, the manor house, and the old village church. A few miles from the village, the hamlet of Écot, which built up around a listed 12th-century chapel, is a perfect example of Bonneval's traditional architecture. Above the rooftops, the Albaron, Levanna, and Ciamarella mountains, rising to nearly 13,000 ft. (4,000 m), tower over an exquisite amphitheater of glaciers: 42 square miles (11,000 hectares) twinkle in the winter silence, or gurgle to the music of summer streams and waterfalls. Bonneval really gets up close and personal with the mountains.

By road: Expressway A43, exit 30—Modane (17 miles/27 km). **By train:** Modane station (27 miles/43 km). **By air:** Chambéry-Aix airport (96 miles/154 km); Lyon-Saint-Exupéry airport (144 miles/232 km).

ⓘ Tourist information:
+33 (0)4 79 05 99 06
www.haute-maurienne-vanoise.com

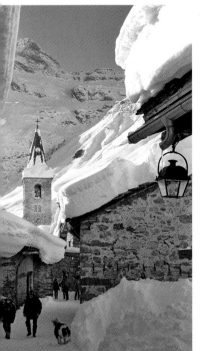

👁 Highlights
• Musée "Espace Neige et Montagne" (snow and mountain museum): Daily life and local crafts, winter sports and historic mountaineering at Bonneval: +33 (0)4 79 05 99 06.
• Village: Guided tours for groups and individuals: +33 (0)4 79 05 99 06.

🗝 Accommodation
Hotels
Le Glacier des Évettes**:
+33 (0)4 79 05 94 06.
Guesthouses
La Rosa ♥♥♥: +33 (0)4 79 05 95 66.
L'Auberge d'Oul: +33 (0)4 79 05 87 99.
La Greppa: +33 (0)4 79 05 32 79.
Gîtes, walkers' lodges, and vacation rentals
Further information: +33 (0)4 79 05 99 10
www.haute-maurienne-vanoise.com
Mountain refuges
Bonneval Village, alt. 5,938 ft. (1,810 m):
+33 (0)6 86 66 90 12.
Le Carro, alt. 9,055 ft. (2,760 m):
+33 (0)4 79 05 95 79.
Les Évettes, alt. 8,497 ft. (2,590 m):
+33 (0)4 79 05 96 64.

🍴 Eating Out
L'Atelier du Tralenta (winter only):
+33 (0)4 79 05 47 99.
Auberge d'Oul: +33 (0)4 79 05 87 99.
La Benna, pizzeria: +33 (0)4 79 05 83 78.
La Cabane: +33 (0)4 79 05 34 60.
Chez Mumu, at l'Écot:
+33 (0)6 87 83 90 52.
Le Criou, mountain-top restaurant (winter only): +33 (0)4 79 05 97 11.
Les Évettes: +33 (0)4 79 05 94 06.
La Greppa, tea room:
+33 (0)4 79 05 32 79.
La Pierre à Cupules: +33 (0)6 81 31 88 23.
Le Vieux Pont: +33 (0)4 79 05 94 07.

🛍 Local Specialties
Food and Drink
Charcuterie, salted meats, and fish •
Cheeses (Beaufort and Bleu de Bonneval).
Art and Crafts
Local crafts.

📅 Events
Market: Every Sunday in winter and summer seasons.
January: La Grande Odyssée (international dog-sled race); ice-climbing rally.

April: "Chants du Monde" music and world singing festival.
July: L'Iserane bicycle touring rally; Fête du Rocher.
December: Christmas festivals (Christmas Eve and Saint Sylvester's Eve).

🦋 Outdoor Activities

Summer
Mountain sports (mountaineering, canyoning, climbing, glacier walks, Via Ferrata) • Paragliding • Fishing in the lake and mountain streams • Lake (bathing and fishing) at Bessans (3½ miles/5.5 km) • Mountain hiking • Summer skiing on the Pisaillas glacier at the Col de l'Iseran.

Winter
Winter sports (Alpine skiing from Christmas through end of April, 5,900–10,000 ft. /1,800–3,050 m, 8 ski lifts, 3 chair lifts; ski touring and walking; snowshoe treks; ice-climbing) • Natural ice-skating.

🌿 Further Afield
• Vanoise national park.
• L'Écot (2½ miles/4 km).
• Haute-Marienne valley: Bessans and surrounding hamlets, Lanslevillard, Termignon (4–19 miles/6.1–31 km).
• Col de l'Iseran (8½ miles/13.5 km).
• Haute-Tarentaise valley and resorts: Val-d'Isère, Tignes (19–27 miles/ 31–43 km).
• Col du Mont Cenis: lake (22 miles/ 35 km).

🛈 Did you know?
In 1957, after the Arc river burst its banks and a torrential flood destroyed half the village, the inhabitants decided to rebuild and to diversify their activities while still protecting their environment.
The shepherds and farmers became businessmen, creating a cooperative and building a modern cheese dairy in a traditional chalet-style; their milk production increased tenfold in 15 years. They even took out loans to build dressed-stone chalets as vacation *gîtes* for tourists. In 1968, the village itself borrowed money to develop a proper ski resort, with all the necessary infrastructure, around the hamlet of Tralenta.

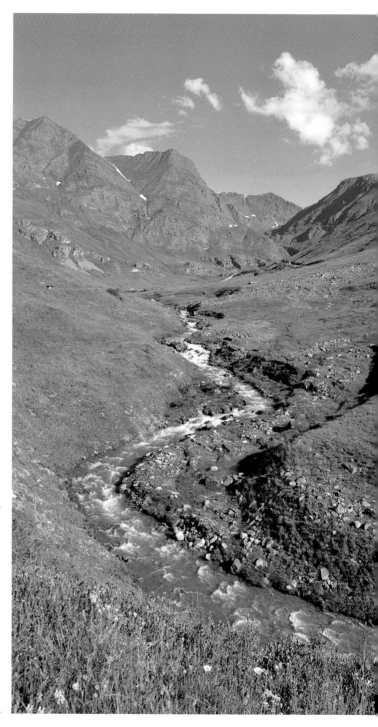

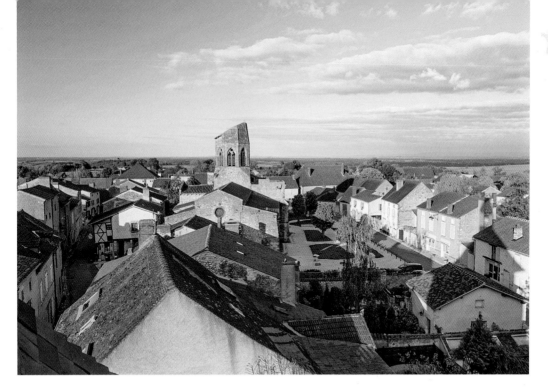

Charroux
A trading town in Bourbonnais

Allier (03) • Population: 387 • Altitude: 1,355 ft. (413 m)

At the crossroads of Roman roads, Charroux became a tax-free stronghold at the time of the dukes of Bourbon.

The rise of Charroux was linked to the charter of franchise that it obtained in 1245. The fortified city flourished in the Renaissance owing to its tannery and winemaking, as well as the fairs and markets that it held regularly, and thus attracted merchants, notaries, doctors, and clergymen. Evidence of this intense economic activity can be seen throughout the streets, some of which are named after the professions or trades that were carried out there at that time. The Halle (covered market), built in the early 19th century, has retained its old wooden pillars, which are protected from horse-and-cart collisions by large stone blocks. Despite the church being burned twice during the Wars of Religion, Charroux has retained its Église Saint-Jean-Baptiste with its distinctive truncated bell tower. Adopting the arrangement of a *bastide*, the village is organized around its square. From the Cour des Dames, a magical place in the village center, the narrow streets pass by the house of the Prince of Condé and finish at the gates of the ramparts, one of which, the Porte d'Occident, received the village clock in the 16th century. During recent years, Charroux has reclaimed its identity as a place of trade, and now attracts many local producers and craftsmen.

By road: Expressway A71, exit 12–Vichy, then exit 14–Gannat (7½ miles/12 km).
By train: Vichy station (21 miles/34 km).
By air: Clermont-Ferrand-Auvergne airport (37 miles/60 km).

ⓘ Tourist information—Val de Sioule:
+33 (0)4 70 56 87 71
www.valdesioule.com
www.charroux03.fr

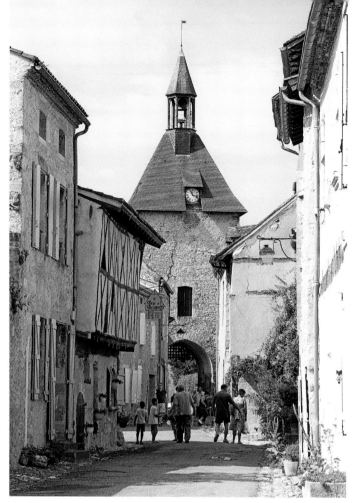

La Ferme Saint-Sébastien:
+33 (0)4 70 56 88 83.
La Palette Vintage; +33 (0)9 73 01 69 76.
Rose-Thé: +33 (0)4 70 56 83 26.
La Table d'Océane: +33 (0)6 80 12 46 75.

🧺 Local Specialties
Food and Drink
Charroux jams • Charroux mustard •
Walnut and hazelnut oil • Charroux
saffron • Handmade candies and organic
sugar • AOC St-Pourçain-sur-Sioule wines •
Teas and coffees • Chocolates • Cookies.
Art and Crafts
Mother-of-pearl objects • Jewelry •
Candles • Stone objects • Decorative
objects • Earthenware potter, sculptor •
Bead and wirework artist • Potter •
Soap-makers • Stained-glass artist • Silk
crafts • Textile accessories • Alpaca wool •
Upholsterer/decorator • Art galleries •
Flea market • Enameled lava objects.

📅 Events
April: Antiques fair (last Sunday).
August: Fête des Artistes et Artisans,
art and craft fair (1st Sunday).
November: Fête de la Soupe (1st Saturday,
unless November 1).
December: Christmas market
(3rd weekend).

🦋 Outdoor Activities
Walking: 3 marked trails.

🌿 Further Afield
• Bellenaves: Musée de l'Automobile,
car museum; Chantelle: abbey; Jenzat
(Maison du Luthier) (3–4½ miles/5–7 km).
• Fleuriel: Historial du Paysan Soldat,
museum of rural participation in World
War I (8 miles/13 km).
• Gannat: Paléopolis, theme park
(8 miles/13 km).
• Gorges of the Sioule (8 miles/13 km).
• Saint-Pourçain-sur-Sioule: Musée du Vin,
wine museum; vineyards (12 miles/19 km).
• Vichy (19 miles/31 km).

👁 Highlights
• **Musée de Charroux** (popular arts
and traditions): Discover the town of
Charroux, which became a village in
the 20th century: +33 (0)4 70 56 87 71.
• **Maison des Horloges:** Antique clock
mechanisms: +33 (0)4 70 56 87 39.
• **Les Pots de Marie:** Exhibition of more
than 500 spice pots: +33 (0)4 70 56 88 80.
• **Église Saint-Jean-Baptiste** (12th century).
• **Village:** Guided tour, by appointment
only, all year round for groups; for
individuals, Wednesday at 11 a.m. in July
and August. +33 (0)4 70 56 87 71.

🗝 Accommodation
Guesthouses
Chambres d'Hôtes Gîte N° 15:
+33 (0)4 70 56 88 16.

La Maison du Prince de Condé:
+33 (0)4 70 56 81 36.
Le Relais de l'Orient: +33 (0)4 70 56 89 93.
Gîtes
Gîte du Vieux Four ▮▮▮▮:
+33 (0)4 70 56 88 37.
Gîte du Pérou ▮▮▮: +33 (0)7 22 29 28 94.
Le Fenil et le Four à Pain ▮▮▮:
+33 (0)6 81 68 41 29.
Gîte de l'Horloge: +33 (0)6 71 50 14 18.
La Maison des Consuls: +33 (0)6 31 12 10 84.
Studio La Chaume du Vent:
+33 (0)6 81 56 36 94.
Studio La Cour des Dames:
+33 (0)6 81 56 36 94.

🍽 Eating Out
Auberge Le Médieval: +33 (0)4 70 56 86 82.
Au Prince Gourmand: +33 (0)4 70 56 81 36.
Le Barapotin: +33 (0)4 70 41 23 71.

❗ Did you know?
Mustard is a specialty of Charroux, where
it is traditionally prepared with Saint-
Pourçain wine. Since the early 19th
century, Messieurs Favier, Portier, and
Poulain have distinguished themselves
here as master mustard-makers.

Coaraze
The sunshine village

Alpes-Maritimes (06) • Population: 783 • Altitude: 2,083 ft. (635 m)

A short distance from the Parc National du Mercantour, Coaraze is a medieval village bathed in sunlight.

In the middle of olive trees, the cobblestone lanes of Coaraze lead to the 14th-century church, the multicolored interior of which was embellished in the Baroque style of Nice in the 18th century with 118 cherubs. The Blue Chapel—decorated with frescoes in different shades of blue by Angel Ponce de Léon in 1962—is an oratory dedicated to the Virgin Mary. The Chapelle Saint-Sébastien, which is decorated with 16th-century frescoes, stands alongside the old mule track that linked the village to Nice. With its steep, narrow streets, its houses with pink-tiled roofs, roughcast walls, and pastel shutters, and its fountains and squares, Coaraze is evocative of nearby Italy. Many artists have contributed their designs to Coaraze's sundials, including Jean Cocteau, Henri Goetz, and Mona Christie.

By road: Expressway A8, exit 55–Nice-Est (13 miles/21 km). By bus: 300 and 303 from Nice bus station (16 miles/26 km). By train: Nice-Ville TGV station (16 miles/26 km). By air: Nice-Côte-d'Azur airport (23 miles/37 km).

(i) Tourist information:
+33 (0)4 93 79 37 47
www.coaraze.eu

👁 Highlights
• **Chapelle Saint-Sébastien:** 16th-century frescoes.
• **Église Saint-Jean-Baptiste:** Built in the 14th century, Baroque interior.
• **Chapelle Bleue:** Old oratory dedicated to the Virgin Mary; frescoes by Angel Ponce de Léon.
• **Village:** Guided tour by arrangement: +33 (0)4 93 79 37 47.
• **Tour of the olive groves:** Organized by the Comité Régional de Tourisme de Nice (tourist board).

🗝 Accommodation
Guesthouses
La Feuilleraie: +33 (0)6 38 83 02 16.
Oliveraie de la Leuzière:
+33 (0)6 22 75 19 91.
La Ruche et l'Olivier: +33 (0)6 34 08 93 32.
Communal gîtes
Gîtes du domaine de l'Euzière***:
+33 (0)6 40 81 58 28.
Walkers' lodges
Gîtes du Prestbytère
Further information: +33 (0)4 93 79 34 79.

🍴 Eating Out
Bar Les Arts "Chez Yanis":
+33 (0)4 93 79 34 90.
Lo Castel, May–September:
+33 (0)4 93 79 34 80.
Oliveraie de la Leuzière:
+33 (0)6 26 80 26 55.

🧺 Local Specialties
Food and Drink
Organic olive oil • Honey, jams.
Art and Crafts
Local crafts on sale at the tourist information center (pottery, turned wood).

📅 Events
March: Le Printemps des Poètes (poetry).
May: Journée du Vide-Grenier (open-air rummage sale, May 1), Voix du Basilic (literary events).
June: La Jòia de la Saint-Jean (cart racing); Côte d'Azur Mercantour trail; "Yakadancé," dance festival.
July and August: Pilo (traditional sport from Nice) world championship; summer concerts; De l'Olivier (choral events); olive tree festival; Coartjazz (music).
October: Nuit de l'Écrit (writing night).
December: Marché de Noël d'Ici et d'Ailleurs (Christmas market).

🦋 Outdoor Activities
Walking: 30 marked trails.

🌿 Further Afield
• Old village of Rocca Sparviera (3½ miles/5.5 km).
• Hilltop villages of Lucéram, Contes, Berre-les-Alpes, Peillon (5½–12 miles/9–19 km).

• Châteauneuf-Villevieille: ruins (11 miles/18 km).
• Nice; Côte d'Azur (16 miles/26 km).
• Peira-Cava; Forêt de Turini, forest; Col de Turini (17 miles/27 km).
• *Sainte-Agnès (24 miles/39 km), see p. 132.

La Garde-Adhémar
The white nymph of the Tricastin

Drôme (26) • Population: 1,177 • Altitude: 558 ft. (170 m)

Set on a limestone spur, La Garde-Adhémar looks out over the Rhône valley and the Tricastin plain.

La Garde-Adhémar has retained its medieval structure—fortifications with gates and curtain wall, elements of the castle and fortified town, narrow streets, and old houses—and is today mostly restored. At the end of the village are the remains of the Renaissance castle built by Antoine Escalin. The Romanesque Église Saint-Michel, a testimony to Provençal architecture of the 12th century, has three naves and a western apse. Nearby, the old Chapelle des Pénitents-Blancs houses an exhibition devoted to the heritage of the Tricastin region. About a mile (1.5 km) away, the Val des Nymphes was a Gallo-Roman, and later a Christian, worship site. Only the 12th-century Chapelle Notre-Dame now remains. During that century, the inhabitants deserted this fertile valley to seek refuge in the fortified town of Adhémar.

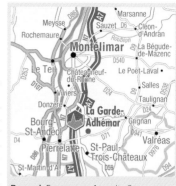

By road: Expressway A7, exit 18–Montélimar Sud (8 miles/13 km), then N7 (3½ miles/5.5 km). **By train:** Pierrelatte station (3½ miles/5.5 km); Avignon TGV station (42 miles/68 km). **By air:** Avignon-Caumont airport (43 miles/69 km).

ⓘ Tourist information:
+33 (0)4 75 04 40 10
www.drome-sud-provence.com

👁 Highlights
• Église Saint-Michel (12th century).
• Jardin des Herbes: A remarkable medicinal garden with 200 species, plus a ¾-acre (3,000-sq. m) botanical garden.
• Val des Nymphes and its chapel.
• Village: Guided tour by arrangement: +33 (0)4 75 04 40 10.

🗝 Accommodation
Guesthouses
Mas Bella Cortis: +33 (0)6 22 00 20 36.
La Ferme des Rosières 🛏🛏🛏:
+33 (0)4 75 04 72 81.

🍴 Eating Out
L'Absinthe, local bistro:
+33 (0)4 75 04 44 38.
L'Auberge Fricot: +33 (0)4 69 26 67 36.
Le Clos Saint-Joseph: +33 (0)4 75 46 72 04.

♥ Gîte du Val des Nymphes 🛏🛏🛏:
+33 (0)4 75 04 44 54.
Les Esplanes: +33 (0)4 75 49 04 16.
La Part des Anges: +33 (0)4 75 52 14 38.
Gîtes
La Cour des Calades: +33 (0)6 85 36 69 16.
Gîte des Remparts: +33 (0)6 37 47 22 70.
Further information: +33 (0)4 75 04 40 10
www.drome-sud-provence.com

Côté Pizza: +33 (0)4 75 46 40 89.
Le Prédaïou: +33 (0)4 75 04 40 08.
O'Ptit Porche: +33 (0)9 83 41 34 66.
Le Tisonnier: +33 (0)4 75 04 44 03.

🧺 Local Specialties
Food and Drink
Cheeses • Fruits • Olive oil • Truffles • Wines.
Art and Crafts
Designer • Ceramicist and enameler • Gifts.

🦋 Outdoor Activities
Walking: 2 marked trails and Sentier des Arts • Mountain-biking (marked trails) • Horse-riding trail.

🌿 Further Afield
• Pierrelatte: crocodile farm (4½ miles/7 km).
• Tricastin villages: Clansayes, Saint-Paul-Trois-Châteaux, Saint-Restitut (4½–9½ miles/7–15.5 km).
• Châteaux de Grignan et de Suze-la-Rousse, Valréas (11–17 miles/18–27 km).
• *Séguret (25 miles/40 km), see p. 137.

La Garde-Guérin

In the knights' shadow

Lozère (48) • Population: 281 • Altitude: 2,953 ft. (900 m)

The archetype of the fortified village, La Garde-Guérin has retained its 12th-century structure.

The fortified village can be seen from afar, built as it is at nearly 3,000 ft. (900 m), and remarkably situated 1,300 ft. (400 m) above the nearby Chassezac Gorge. The site is crossed by the Régordane Way, a natural communication route linking the Mediterranean to the Auvergne through Nîmes and Le Puy. In the Middle Ages, a community of knights, known as the *chevaliers pariers* (knights with equal rights), settled in the village to provide protection to travelers using this route and safeguard their animals and goods. Inside the ramparts stand the tall watchtower and the Chapelle Saint-Michel, which date from the 12th century, and the walls of the castle that the Molette de Morangiès family built in the 16th century. Today, the site's history and its rugged natural landscape lend a wild and mysterious beauty to La Garde-Guérin.

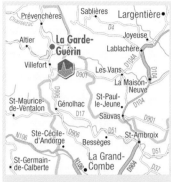

By road: N88 (22 miles/35 km). **By train:** Villefort station (5 miles/8 km); La Bastide-Puylaurent station (11 miles/18 km).
By air: Nîmes airport (72 miles/116 km); Montpellier-Méditerranée airport (97 miles/156 km).

ⓘ Tourist information—Mont-Lozère:
+33 (0)4 66 46 87 30
www.destination-montlozere.fr
www.lagardeguerin.fr

👁 Highlights
• **Village:** Guided tour for groups:
+33 (0)4 66 46 87 12 or +33 (0)6 74 97 22 32.
• **Église Saint-Michel** (12th century):
Romanesque former chapel of the village; gilded wooden statue of Saint Michael (18th century), painting of the Crucifixion.

⚔ Accommodation
Hotel
Auberge Régordane**: +33 (0)4 66 46 82 88.
Guesthouses
La Butinerie, Albespeyres:
+33 (0)4 66 46 06 47 or +33 (0)6 81 98 90 56.
Chez Chiff's, Prévenchères:
+33 (0)4 66 46 01 53.
Le Vieux Tilleul, Prévenchères:
+33 (0)4 66 46 85 86.
Vacation rental
Solène Marzio, Prévenchères:
+33 (0)6 78 00 46 48 or +33 (0)6 74 10 38 69.
Municipal campsite
Les Pervenches: +33 (0)6 44 06 91 05.

🍴 Eating Out
Auberge Régordane: +33 (0)4 66 46 82 88.
Auberge Le Vieux Tilleul, Prévenchères:
+33 (0)4 66 46 85 86.
Comptoir de la Regordane:
+33 (0)4 66 46 83 38.

🧺 Local Specialties
Food and Drink
Local produce.
Art and Crafts
Craftspeople's collective.

🔢 Events
June: Transhumance, movement of livestock to fresh pasture (1st Sunday after the 15th).
August: Prévenchères festival (1st weekend); Fête du Pain, bread festival (2nd weekend).

🦋 Outdoor Activities
Canyoning • Rock climbing and Via Corda • Walking and mountain-biking: Routes GR 700 (Chemin de Régordane) and GR 70 (Chemin de Stevenson); numerous marked trails • Caving • Golf: 9 holes • Trout fishing (Chassezac).

🌿 Further Afield
• Lac de Villefort and Lac de Rachas, lakes (3 miles/5 km).
• Prévenchères: Château de Castanet, 12th-century church and its *tilleul de Sully*, a historic lime tree (3½ miles/5.5 km).
• Mas de La Barque and Mont Lozère (16 miles/26 km).
• Langogne (23 miles/37 km).

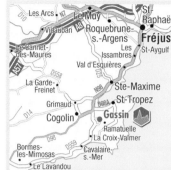

By road: Expressway A57, exit 13–Le Luc (23 miles/37 km); expressway A8, exit 36–Draguignan (22 miles/35 km), N98 (3½ miles/5.5 km). **By train:** Fréjus-Saint-Raphaël TGV station (22 miles/35 km); Les Arcs and Draguignan stations (23 miles/37 km).
By air: Golfe de Saint-Tropez airport (6 miles/10 km); Toulon-Hyères airport (30 miles/48 km); Nice Côte-d'Azur airport (58 miles/93 km).

ⓘ **Tourist information:**
+33 (0)4 98 11 56 51 / www.gassin.eu

👁 **Highlights**
• **Medieval village:** Free guided tour Wednesday at 4 p.m. from April to October, 6 p.m. in July and August, departing from the viewpoint indicator: +33 (0)4 98 11 56 51.
• **Church** (16th century): Listed font, 18th-century reliquary of Saint Lawrence.
• **Vineyards:** Visits to ten local winegrowers, with tastings; tours by tourist train in season: +33 (0)4 98 11 56 51.
• **Jardin L'Hardy-Denonain** (classed as "remarkable" by the Ministry of Culture): Botanical garden with Provençal and Mediterranean aromatic plants; tours from April to October: +33 (0)4 94 56 18 72.

🗝 **Accommodation**
Hotels
Le Domaine de l'Astragale*****: +33 (0)4 94 97 48 98.
Le Kube*****: +33 (0)4 94 97 20 00.
Le Mas de Chastelas*****: +33 (0)4 94 56 71 71.
Villa Belrose*****: +33 (0)4 94 55 97 97.
La Bastide d'Antoine****: +33 (0)4 94 97 70 08.
Le Brin d'Azur***: +33 (0)4 94 97 46 06.
Les Capucines***: +33 (0)4 94 97 70 05.

Gassin
A haven on the Côte d'Azur

Var (83) • Population: 2,557 (500 in the village itself) • Altitude: 656 ft. (200 m)

From its ridge surrounded by vineyards and forests, Gassin has a unique view of the peninsula and Gulf of Saint-Tropez.

Alongside the protection of the surrounding landscape, the development of the new village next door has also been sensitively handled, a feat recognized by several international awards. In addition to the delight of exploring the new village is the pleasure to be had from strolling, accompanied by the fragrance of oleanders and jasmine, along the maze of winding lanes in the old village, with its façades weathered by time. From the Deï Barri terrace, the view stretches from the Îles d'Hyères to the Massif des Maures and, when the Mistral has blown the clouds away, to the snow-capped summits of the Alps.

Dune***: +33 (0)4 94 97 00 83.
Bello Visto: +33 (0)4 94 56 17 30.
Aparthotels
Caesar Domus: +33 (0)4 94 55 86 55.
Odalys: Le Clos Bonaventure:
+33 (0)4 94 97 73 34.
Guesthouses, gîtes, and vacation rentals
Further information: +33 (0)4 98 11 56 51
www.gassin.eu
Campsites
Domaine de Verdagne****:
+33 (0)4 94 79 78 21.
Parc Saint-James Montana****:
+33 (0)4 94 55 20 20.
Jauffret farm campsite:
+33 (0)4 94 56 27 78.

🍴 Eating Out

Au Vieux Gassin: +33 (0)4 94 56 14 26.
Bello Visto: +33 (0)4 94 56 17 30.
Le Belrose: +33 (0)4 94 55 97 97.
Café 23, brasserie: +33 (0)4 94 56 28 02.
Le Carpaccio: +33 (0)4 94 97 48 98.
La Ciboulette: +33 (0)4 94 56 25 52.
Le "G," Golf Country Club restaurant:
+33 (0)4 94 17 42 41.
Inka, Peruvian cuisine: +33 (0)4 94 97 20 00.
Marius: +33 (0)4 94 97 20 00.
Le Micocoulier: +33 (0)4 94 56 14 01.
Le Pescadou: +33 (0)4 94 56 12 43.
Le Pitchoun: +33 (0)4 89 99 45 11.
Les Sarments: +33 (0)4 94 56 38 20.
La Table du 1K: +33 (0)4 94 97 20 00.
La Table du Mas: +33 (0)4 94 56 71 71.
La Torpille: +33 (0)4 94 56 52 80.
La Tour de Pizz, pizzeria:
+33 (0)7 82 97 29 76.
La Verdoyante: +33 (0)4 94 56 16 23.

🧺 Local Specialties

Food and Drink
Jams • Organic olive oil • AOC Côtes
de Provence wines.
Art and Crafts
Gifts • Pottery • Soaps • Painters.

📅 Events

March: Gulf of Saint-Tropez marathon.
April: Internationale Granfondo cycle
race; opening of the art-exhibition
season.
May: La Gassinoise cross-country run.
June: "Fête de la Saint-Jean," Saint John's
feast day; Brazilian festival.
July: Polo Masters at the Haras de Gassin
(international tournament).
July–August: "Les Lundis du Terroir,"
tastings of local produce (Mondays).
August: Fête Patronale de la Saint-
Laurent; August 15th Ball.

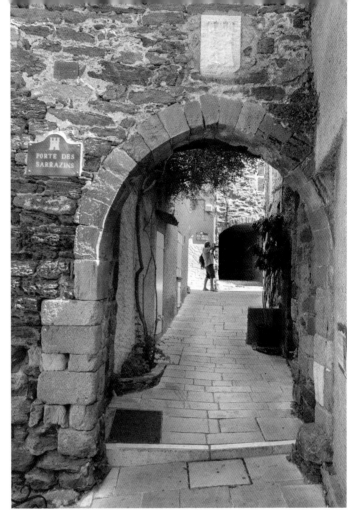

December: Noël des Enfants (children's
Christmas); Noël Provençal.
All year round: Exhibitions, concerts,
activities for children, mountain-biking
competitions, polo tournaments.

🦋 Outdoor Activities

Swimming (no lifeguard) • Horse-riding •
Walking • Mountain-biking • Golf •
Sailing.

🌿 Further Afield

• Ramatuelle (3 miles/5 km).
• Saint-Tropez; Cavalaire-sur-Mer
(3½–6 miles/5.5–9.5 km).
• Pampelonne coastal path; Grimaud
(6 miles/10 km).
• Sainte-Maxime (6 miles/10 km).
• Massif des Maures, uplands; La Garde-
Freinet (8½ miles/14 km).
• Jardins du Rayol, botanical gardens
(12½ miles/20 km).
• Bormes-les-Mimosa (20 miles/32 km).
• Collobrières: Chartreuse de la Verne
(21 miles/34 km).
• Fréjus; Saint-Raphaël (25 miles/40 km).
• Le Lavandou (25 miles/40 km).

ℹ️ Did you know?

Legend has it that, after the plague hit
Gassin, the only surviving villager carried
embers in his bare hands, using them to
rekindle fires in the hearths of the empty
houses to pretend that the village was
still inhabited.

Gordes
Jewel of the Luberon

Vaucluse (84) • Population: 2,100 • Altitude: 1,171 ft. (357 m)

Like an eagle's nest perched on the foothills of the Monts de Vaucluse, facing the famous Luberon mountain, Gordes is the archetypal Provençal village.

Surrounded by a mosaic of holm oaks, wheat fields, and vines, the village's dry-stone houses—solidly attached to the rock—seem to tumble down in cascades. Its history, its rich architecture and heritage, its marvelous views, its cobbled winding lanes, and its fountain shaded by a plane tree on the Place du Château have appealed to numerous artists, from André Lhote (1885–1962) and Pol Mara (1920–1998) to Victor Vasarely (1906–1997). A short distance from the village, at the end of a lavender field, which in springtime enhances the pale stone of its façade, the Abbaye de Sénanque is a perfect example of Cistercian architecture and is still inhabited by monks.

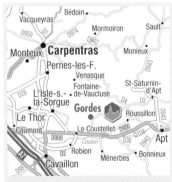

By road: Expressway A7, exit 24–
Avignon Sud (17 miles/27 km).
By train: Cavaillon station (11 miles/18 km);
Avignon TGV station (25 miles/40 km).
By air: Avignon-Caumont airport
(19 miles/31 km); Marseille-Provence
airport (48 miles/77 km).

ⓘ Tourist information—Luberon
Monts de Vaucluse: +33 (0)4 90 72 02 75
www.luberoncoeurdeprovence.com

👁 Highlights

• **Abbaye de Sénanque** (12th century): The church, dormitory, cloister, and chapter house can be visited on guided tours. Further information: +33 (0)4 90 72 02 75.
• **Cellars of the Palais Saint-Firmin:** Situated beneath a large house, the cellars feature caves, cisterns, and an old seigneurial oil press; documentary, museum, MP3 audioguide. Further information: +33 (0)4 90 72 02 75.
• **Moulin des Bouillons and Musée du Vitrail:** One of the oldest preserved oil mills with all its workings, presses from the 1st to the 14th centuries, collections of oil lamps, amphorae; at the same site, the Musée du Vitrail recounts the history of glass and stained-glass windows via a large collection: +33 (0)4 90 72 22 11.
• **Castle** (16th century): Of medieval origin, rebuilt during the Renaissance. Exhibitions by artists who have lived in Gordes or that relate to the history of the village; also temporary exhibtions: +33 (0)4 90 72 02 75.
• **Village des Bories:** Museum of rural dry-stone dwellings (bories) that served as housing until the middle of the 19th century: +33 (0)4 90 72 03 48.
• **Village:** Guided tour by arrangement: +33 (0)4 90 72 02 75.

🔑 Accommodation
Hotels
La Bastide*****: +33 (0)4 90 72 12 12.
Les Bories*****: +33 (0)4 90 72 00 51.
♥ La Ferme de la Huppe****:
+33 (0)4 90 72 12 25.

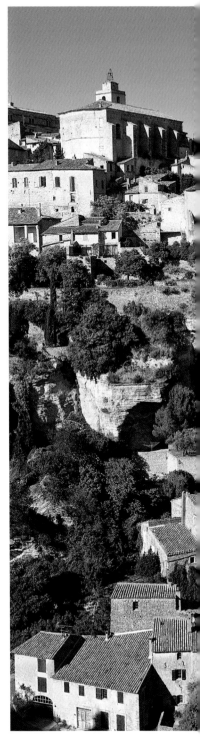

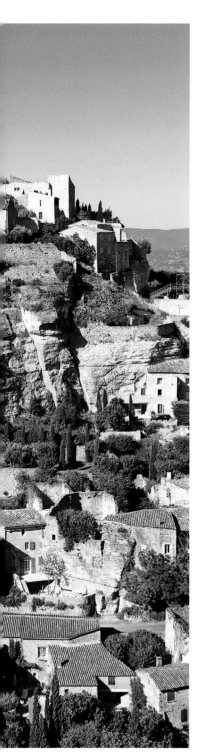

Auberge de Carcarille***:
33 (0)4 90 72 02 63.
Le Jas de Gordes***: +33 (0)4 90 72 00 75.
♥ Le Mas des Romarins***:
+33 (0)4 90 72 12 13.
♥ Le Mas de la Sénancole***:
+33 (0)4 90 76 76 55.
Le Petit Palais d'Aglaé****:
+33 (0)4 32 50 21 02.
Guesthouses, gîtes, and vacation rentals
Further information: +33 (0)4 90 72 02 75
www.luberoncoeurdeprovence.com
Aparthotels
La Bastide des Chênes: +33 (0)4 90 72 73 74.
Campsites
Les Sources***: +33 (0)4 90 72 12 48.

🍴 Eating Out
Restaurants
L'Artégal: +33 (0)4 90 72 02 54.
♥ Auberge de Carcarille:
+33 (0)4 90 72 02 63.
La Bastide: +33 (0)4 90 72 12 12.
Le Bistro de la Huppe: +33 (0)4 90 72 12 25.
Les Bories: +33 (0)4 90 72 00 51.
Casa Rosario: +33 (0)4 90 72 06 98.
Les Cuisines du Château:
+33 (0)4 90 72 01 31.
L'Esprit des Romarins: +33 (0)4 90 72 12 13.
L'Estaminet: +33 (0)4 90 72 14 45.
♥ L'Estellan: +33 (0)4 90 72 04 90.
La Farigoule: +33 (0)4 90 76 92 76.
Le Jardin: +33 (0)4 90 72 12 34.
Le Loup Blanc: +33 (0)4 90 72 12 43.
Le Mas Tourteron: +33 (0)4 90 72 00 16.
Le Renaissance: +33 (0)4 90 72 02 02.
Les Sources: +33 (0)4 90 72 12 48.
Le Table d'Euphrosyne: +33 (0)4 32 50 21 02.
Le Teston: +33 (0)4 32 50 21 74.
Light meals
La Crêperie de Fanny: +33 (0)4 32 50 13 01.
L'Encas: +33 (0)4 90 72 29 82.
Le Goût de la Vie: +33 (0)4 90 72 57 44.

🛍 Local Specialties
Food and Drink
Honey • AOC Côtes du Ventoux wine • Olive oil.
Art and Crafts
Jewelry • Art galleries • Potters • Sculptor.

📅 Events
Market: Tuesday mornings, Place du Château.
January: Fête de la Saint-Vincent (2nd fortnight).
April–October: Painting and sculpture exhibitions in the municipal halls.
July and August: Numerous concerts at the Théâtre des Terrasses.
August: "Les Soirées d'Été," festival (1st fortnight); Fête du Vin des Côtes du Ventoux, wine festival (1st Sunday).
December: "Veillée Calendale," Christmas songs and tasting of the thirteen desserts, representative of Jesus and his apostles (1st fortnight); Christmas market.

🦋 Outdoor Activities
Walking: Route GR 6 and 2 marked trails • Mountain-biking/Electric mountain-bike rentals.

🌿 Further Afield
• Véroncles: water mills (1 mile/1.5 km).
• Murs (5½ miles/9 km).
• *Roussillon (5½ miles/9 km), see pp. 124–25.
• *Ménerbes (7 miles/11.5 km), see p. 110.
• Fontaine-de-Vaucluse (7½ miles/12 km).
• *Venasque (9½ miles/15.5 km), see pp. 145–46.
• *Lourmarin (18 miles/29 km), see pp. 107–8.
• Avignon (24 miles/39 km).
• *Ansouis (24 miles/39 km), see pp. 82–83.

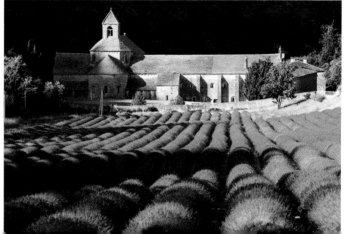

Gourdon
Between sea and sky

Alpes-Maritimes (06) • Population: 406 • Altitude: 2,493 ft. (760 m)

Built on an isolated rock above the Loup valley, Gourdon looks out over the Gorges of the Loup toward the blue waters of the Mediterranean. Designed to repel Saracen invasions in the 8th–10th centuries, Gourdon has often served as a stronghold. Protected by the gorges to the south, the village built fortifications on the side facing the mountain. A first fortress was constructed in the 9th century. In the 12th century, the castle was built, overlooking the whole valley. Sheltered by the imposing fortress, and crisscrossed by infinitely narrow streets, the village showcases its restored houses, the Romanesque Église Saint-Vincent, and numerous artists' stalls: at the end stands its showpiece, the Place Victoria. Immortalized by Queen Victoria's visit in 1891, this panoramic viewpoint offers a breathtaking vista, from Nice and Cap Ferrat in the east as far as the cape of Saint-Tropez and the Massif des Maures in the west, via Antibes, Cannes, the Îles de Lérins, and the Massif de l'Esterel. In the late 19th century, the village spread to the hamlet of Pont-du-Loup, at the foot of the rock, in the Loup valley, where the climate was more conducive to growing herbs.

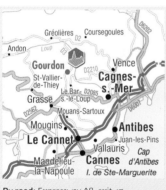

By road: Expressway A8, exit 47–Villeneuve-Loubet (16 miles/26 km).
By train: Grasse station (9½ miles/15.5 km); Nice TGV station (24 miles/38 km).
By air: Nice-Côte d'Azur airport (20 miles/32 km).

ⓘ Tourist information:
+33 (0)4 93 09 68 25
www.gourdon06.fr

👁 Highlights
• **Place Victoria:** Panoramic viewpoint of the Côte d'Azur.
• **Église Saint-Vincent** (12th century).
• **Galerie de La Mairie:** Exhibitions: +33 (0)4 93 09 68 25.
• **Castle gardens designed by André Le Nôtre** (1613–1700). Further information: +33 (0)4 93 09 68 02.
• **Saut du Loup waterfalls** (Gorges du Loup): Guided tours of the waterfalls and viewpoint over the valley, from May to October: +33 (0)4 93 09 68 88.
• **Lavanderaies de la Source Parfumée:** Fields of flowers and herbs; guided tours for groups by a master gardener: +33 (0)4 93 09 68 23.

🗝 Accommodation
Gîtes and vacation rentals
Further information: www.gourdon06.fr

🍴 Eating Out
Auberge de Gourdon: +33 (0)4 93 09 69 69.
Les Grands Hommes: +33 (0)4 93 77 66 21.
La Taverne Provençale: +33 (0)4 93 09 68 22.
Au Vieux Four: +33 (0)4 93 09 68 60.

🛍 Local Specialties
Food and Drink
Nougat and *calissons* (candy) • *Pain d'épice* (spice cake).
Art and Crafts
Perfumery • Soap factory • Glassworks.

📅 Events
August: Open-air theater festival.
November–March: Theater festival (last Fridays), Pont-du-Loup.

🦋 Outdoor Activities
Paragliding • Walking: Chemin du Paradis and numerous marked trails.

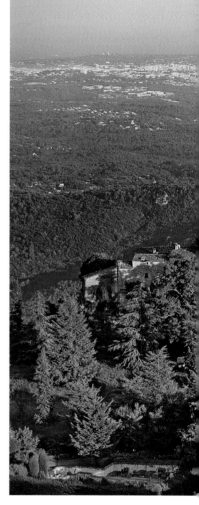

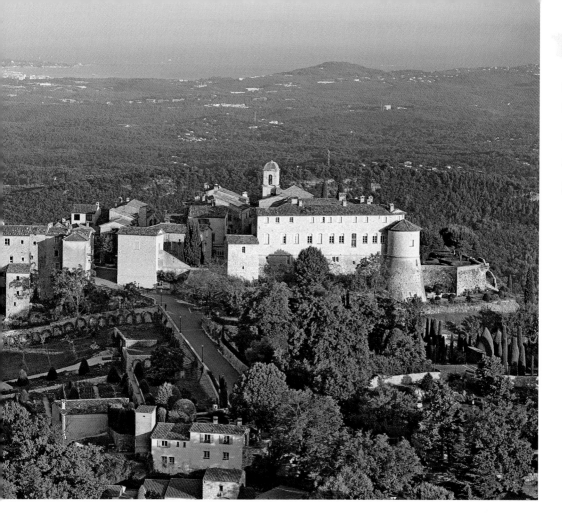

🌿 Further Afield

• Gorges of the Loup (5 miles/8 km).
• Grasse (8½ miles/13.5 km).
• Valbonne; Biot; Tourrettes-sur-Loup; Saint-Paul-de-Vence (9½–19 miles/15.5–31 km).
• Côte d'Azur: Cannes, Antibes, Nice (17–22 miles/27–35 km).
• Corniche de l'Esterel, coastal drive (22–43 miles/35–69 km).

🍴 Did you know?

In the early 20th century, there was no road to link Gourdon to Pont-du-Loup. Locals traveled from one village to the other by mule, on the Chemin du Paradis. Until 1900, caravans of mules could still be seen passing each other on this rocky Provençal road.

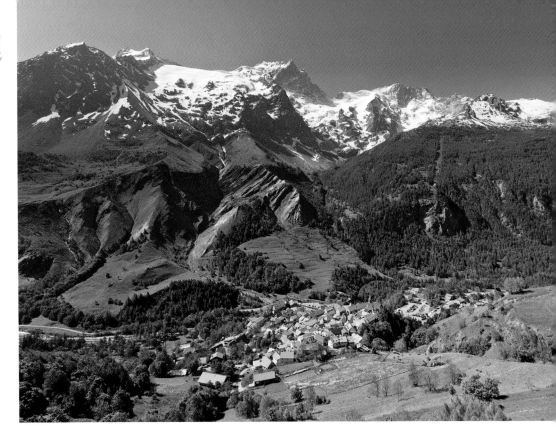

La Grave
On top of the world

Hautes-Alpes (05) • Population: 500 • Altitude: 4,757 ft. (1,450 m)

With its larch trees, rich pastures, and abundant snow, La Grave invites visitors to explore a spectacular mountain.

Teetering on a rocky outcrop, La Grave packs its robust stone houses tightly along narrow streets called *trabucs*, which climb to the top of the village. The Romanesque–Lombard-style Église Notre-Dame-de-l'Assomption, which adjoins the Chapelle des Pénitents-Blancs, offers a breathtaking view of the Massif des Écrins, and in particular La Meije mountain. This legendary summit, which reaches 13,070 ft. (3,983 m), has made La Grave a mecca for mountaineers; laid to rest in the cemetery next to the church, beneath simple wooden crosses, are climbers that the mountain has claimed. Since the 1970s, La Grave has also gained an international reputation for its unique off-piste ski area. In summer, the Meije glaciers' cable cars enable visitors to reach the Col des Ruillans and the Glacier de la Girose. La Grave and Les Traverses—the hamlets scattered on its southern slope—provide ideal starting points for numerous walks.

By road: Expressway A480, exit 8–Vizille (43 miles/69 km). **By train:** Briançon station (24 miles/39 km). **By air:** Grenoble-Isère airport (73 miles/117 km); Chambéry-Aix airport (90 miles/145 km); Lyon-Saint-Exupéry airport (103 miles/166 km).

ⓘ Tourist information:
+33 (0)4 76 79 90 05
www.lagrave-lameije.com

👁 Highlights
• **Église Notre-Dame** (11th century): 18th- and 19th-century furnishings; cemetery. Further information: +33 (0)4 76 79 90 05.
• **Hamlet of Le Chazelet:** Traditional houses, church, communal oven.
• **Meije glaciers** (alt. 10,500 ft./3,200 m) by cable car: Daily mid-June–mid-September. Further information: +33 (0)4 76 79 94 65.
• **Le Chazelet oratory:** Splendid view of La Meije.

🔑 Accommodation
Hotels
L'Edelweiss***: +33 (0)4 76 79 90 93.
Le Castillan**: +33 (0)4 76 79 90 04.
Le Sérac**: +33 (0)4 76 79 91 53.
Panoramic Village, appart'Hôtel: +33 (0)4 76 79 97 97.
Gîtes, walkers' lodges, vacation rentals, family vacation centers, and campsites
Further information: +33 (0)4 76 79 90 05
www.lagrave-lameije.com
Mountain huts
Évariste Chancel, alt. 8,200 ft. (2,500 m): +33 (0)4 76 79 92 32 or +33 (0)4 76 79 97 05.
Refuge Goléon, alt. 8,000 ft. (2,440 m): +33 (0)6 87 26 46 54.

🍴 Eating Out
Alp'Bar, crêperie: +33 (0)4 76 79 96 67.
Auberge Chez Baptiste: +33 (0)4 76 79 92 09.
Au Vieux Guide: +33 (0)4 76 79 90 75.
Le Castillan: +33 (0)4 76 79 90 04.
Le Chalet des Plagnes, crêperie/pizzeria: +33 (0)4 76 79 95 23.
L'Edelweiss: +33 (0)4 76 79 90 93.
Les Glaciers: +33 (0)4 76 79 90 07.
La Pierre Farabo: +33 (0)4 76 79 95 25.
Pizza et Pasta: +33 (0)6 86 12 43 00.
Lou Ratel: +33 (0)4 76 79 92 10.
Le Sérac: +33 (0)4 76 79 91 53.

🧺 Local Specialties
Food and Drink
Goat cheeses • Honey.
Art and Crafts
Fabric designers • Creator of decorative objects (mobiles, pictures) and jewelry.

📅 Events
Markets: Thursday morning, Place du Téléphérique (off-season) or Place de la Salle-des-Fêtes (summer); local farmers' market every Sunday morning (July–August).
January: Rendez-Vous Nordique au Pays de la Meije (end January), "Reines de la Meije," girls' weekend (3rd weekend).
February: Ultimate Test Tour, freeride and security equipment fair (mid-February).
April: Derby de la Meije, ski race (1st weekend).
June: La Grave'y Cîmes mountaineering (2nd weekend), Rencontres de la Haute Romanche arts festival, country trails.
July: Messiaen au Pays de la Meije, music festival (last ten days).
August: Fête du Pain du Chazelet, bread festival (2nd weekend); Fête des Guides de La Grave, celebration of mountain guides (August 15); Tour du Plateau d'Emparis, foot and mountain-bike race (3rd Sunday).
September: Ultra Raid de la Meije, mountain-bike race (3rd weekend).

🦋 Outdoor Activities
In summer
Guided walk on the glacier, Via Ferrata, Via Cordata • Mountaineering • Rock climbing, climbing wall • Paragliding • Walking, walking with donkeys with packsaddles • Mountain-biking • Cycle touring • Astronomy • Fishing • Rafting.
In winter
Ski area (alt. 4,920–11,650 ft./1,500–3,550 m) of the Meije glaciers (off piste) and Le Chazelet (3 ski lifts, 1 chairlift): Downhill skiing, ski touring, off-piste and hiking trails, monoski, kiteboarding, snowboarding, surfing, telemarking, snowshoeing, mountaineering, ice-climbing, and dry tooling, snow and ice school • Sled dogs.

🕊 Further Afield
• **Villar-d'Arène:** Historic bread oven and water mill (2 miles/3 km).
• **Jardin Botanique Alpin du Lautaret,** botanic garden (open during summer) (6 miles/9.5 km).
• **Col du Lautaret:** Maison du Parc National des Écrins, national park visitor center (6 miles/9.5 km).
• **Col du Galibier** (11 miles/18 km).
• **Bourg-d'Oisans:** Musée de la Faune et des Minéraux, museum of geology and wildlife (17 miles/27 km).
• **Saint-Christophe-en-Oisans:** Musée de l'Alpinisme, mountaineering museum (25 miles/40 km).

🔖 Did you know?
In La Grave, locals continue to make black (rye) bread, as they did in the past. This custom is celebrated every year on All Saints' Day.

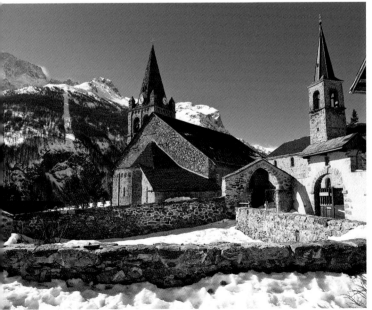

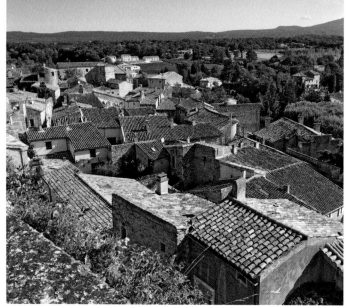

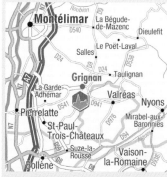

By road: Expressway 17, exit 18–Montélimar Sud (12 miles/19 km) or exit 19-Bollène (16 miles/26 km); expressway A75, exit 20–Le Puy-en-Velay then N102 and N7 (10 miles/16 km). **By train:** Montélimar station (16 miles/26 km); TGV station at Avignon (50 miles/80 km). **By air:** Avignon-Caumont airport (47 miles/75 km); Marseille-Provence airport (89 miles/144 km).

ⓘ Tourist Information—Pays de Grignan – Enclave des Papes:
+33 (0)4 75 46 56 75
www.grignanvalreas-tourisme.com

Grignan

Renaissance and letters in the Provençale Drôme

Drôme (26) • Population: 1,587 • Altitude: 623 ft. (190 m)

Lying between the Dauphiné and Provence, a short distance from the Enclave des Papes region, Grignan and its castle are proud reminders of new beginnings and the famous correspondence of Madame de Sévigné. Just as Grignan's houses seem to spring the base of the imposing fortress, the history of the village is inseparable from that of its castle. As the centuries went by, the word "renaissance" gained a capital letter here . . . as well as other letters of note.

The castle town, first recorded in the 12th century, developed at the behest of the Dauphiné's powerful Adhémar family. The village spread beyond the ramparts during the 16th century, when houses were constructed outside the walls, and a promenade and corn exchange were also created. The collegiate church of Saint-Sauveur was built during this period, and major decorative improvements transformed the medieval fortress into the largest Renaissance château in southeastern France. The count of Grignan, the last descendant of the Adhémar family, secured the village's artistic and literary destiny by marrying the daughter of the marquise de Sévigné in 1669. The marquise's visits here, and her correspondence with her daughter, made the castle famous. Partially destroyed during the Revolution, the castle was carefully restored in the early 20th century, and today it provides both cultural and economic dynamism to the town. From the castle's terraces, a superb view over the landscape of vineyards, lavender fields, and truffle-rich forest is a reminder that some of the best local produce in this part of the Drôme comes from Grignan.

👁 Highlights

• **Castle (11th–20th centuries):** Collections of paintings and works of art from the 16th to the 20th centuries; decorated and furnished rooms (antichamber, Madame's chamber, king's room, Adhémar gallery); interactive exhibition on the architecture of the castle, and the lives of the Marquise de Sévigné and of Marie Fontaine, owner 1912–37; self-guided visits and tours by a heritage expert: +33 (0)4 75 91 83 55.
• **Collégiale Saint-Sauveur,** collegiate church (16th century): 17th-century organ attributed to Charles le Royer, Madame de Sévigné's tomb, contemporary forecourt by P. Decrauzat; self-guided visits all year round: +33 (0)4 75 46 56 75.
• **Chapelle Saint-Vincent** (12th–13th centuries): Contemporary stained-glass windows by artist Ann Veronica Janssens; self-guided visits all year round: +33 (0)4 75 46 56 75.
• **Colophon, Maison de l'Imprimeur:** In the old bailiff's house, museum of printing and book production, typography workshops: +33 (0)4 75 46 57 16.

• **Village:** Guided tours organized by the Tourist Information Center; guided tours of the "botanical village" by the "Grignan, Pierres et Roses Anciennes" association, end April to early June: +33 (0)4 75 46 56 75.

Accommodation

Hotels
♥ Le Clair de la Plume****:
+ 33 (0)4 75 91 81 30.
La Bastide de Grignan***:
+33 (0)4 75 90 67 09.
La Ferme Chapouton***:
+33 (0)4 75 00 01 01.
L'Instant Sévigné***: +33 (0)4 75 46 50 97.
Guesthouses
♥ La Faventine***: +33 (0)6 13 58 48 21.
Le Clos de la Tuilière: +33 (0)6 03 77 29 33.
La Demeure du Château:
+33 (0)4 75 51 86 16.
Ferme Le Grand Cordy:
+33 (0)4 75 46 51 58.
La Maison du Marquis: +33 (0)4 75 91 81 10.

L'Oulivade: +33 (0)4 75 46 92 81.
Le Petit Jeu Grignan: +33 (0)6 99 60 40 91.
La Vie de Château: +33 (0)6 76 52 70 96.
Gîtes and vacation rentals
Further information: +33 (0)4 75 46 56 75
www.grignanvalreas-tourisme.com
Campsites
Les Truffières***: +33 (0)4 75 46 93 62.
Camping de Grignan: +33 (0)4 75 01 92 23.

Eating Out

Restaurants
Le Bistrot Chapouton: +33 (0)4 75 00 01 01.
Le Cabaré: +33 (0)9 62 68 84 20.
Chez Elles: +33 (0)4 75 90 67 09.
Le Clair de la Plume, gourmet restaurant and tea room: +33 (0)4 75 91 81 30.
L'Eau à la Bouche: +33 (0)4 75 46 57 37.
L'Épicurieux: +33 (0)4 75 46 54 43.
L'Étable: +33 (0)4 75 46 93 81.
Le Grenier à Sel: +33 (0)4 75 46 94 36.
La Guinguette du Centre Equestre, light meals May to October: +33 (0)4 75 46 90 02.

L'Hélice: +33 (0)4 75 46 50 89.
Le Poème de Grignan, gourmet restaurant: +33 (0)4 75 91 10 90.
La Table des Délices, gourmet restaurant: +33 (0)4 75 46 57 22.

Local Specialties

Food and Drink
Truffles • Goat cheese • AOP Grignan-les-Adhémar and Côteaux du Tricastin wines.
Art and Crafts
Skilled metalworker • Ceramicist • Potter • Painter • Dress designers • Metal sculptor • Art galleries

Events

Markets: Tuesdays, Place du Mail.
January–February: Book, truffles, and wine events (end January to early February).
May: Village fair.
July–August: Festival de la Correspondance, literary festival (early July); "Les Fêtes Nocturnes," evening markets.
All year round: Cultural events at the castle.

Outdoor Activities

Horse-riding.

Further Afield

• Enclave des Papes: Grillon, Valréas, Visan, Richerenches (2.5–9.5 miles/4–15 km).
• Villages of the Tricastin region: Clansayes, Saint-Paul-Trois-Châteaux, Saint-Restitut (9.5–12 miles/15–20 km).
• *La Garde-Adhémar (10 miles/16 km), see p. 94.
• Suze-la-Rousse: castle (12 miles/20 km).
• Nyons (14 miles/23 km).
• Montélimar (16 miles/25 km).
• *Le Poët-Laval (19 miles/30 km).
• Vaison-la-Romaine (19 miles/30 km).

Did you know?

The letters of Madame de Sévigné—classic works of French literature—are predominantly addressed to her daughter, the countess of Grignan. The marquise was struck by the "triumphant view" and the pleasant lifestyle Grignan offered. On October 15, 1677, she wrote to her daughter: "You, my dear, are absolutely in clover. You are making marvelous use of the good weather: dining in your castle is a wonderful experience. You write to me from Rochecourbière: what a wonderful event! . . . You are so kind to remember me and to wish I had been there too."

Lavaudieu

In God's valley

Haute-Loire (43) • Population: 228 • Altitude: 1,411 ft. (430 m)

In the Middle Ages, Benedictine monks built a monastery in the Senouire valley, turning it into *la vallée de Dieu* (God's valley), which gave the village its name. Robert de Turlande, first abbot of La Chaise-Dieu abbey and later Saint Robert, founded the abbey at Lavaudieu in 1057. Nuns lived here until the French Revolution. It is the only monastery in the Auvergne with a Romanesque cloister. Running along the wall of the refectory, with its line of columns featuring carved capitals, is a 12th-century Byzantine-inspired mural. The abbey sheltered Cardinal de Rohan, when he fled La Chaise-Dieu after the Affair of the Diamond Necklace (an intrigue involving Marie Antoinette, Rohan, and the costly necklace). The 11th–12th-century church adjoining the monastery lost its steeple during the French Revolution. Inside, a 15th-century Pietà in polychrome stone sits alongside 14th-century Italian-influenced murals of an allegory of the Black Death. In the center of the village, the Musée des Arts et Traditions Populaires de Haute-Loire displays a typical Auvergne interior.

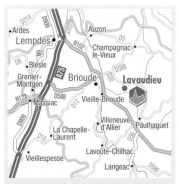

By road: Expressway A75, exit 20–Brioude (13 miles/21 km); N102 (5 miles/8 km).
By train: Brioude station (6 miles/9.5 km).
By air: Clermont-Ferrand-Auvergne airport (48 miles/77 km).

(i) Tourist information—Brioude Sud-Auvergne: +33 (0)4 71 74 97 49 or +33 (0)4 71 76 46 00 / www.ot-brioude.fr www.abbayedelavaudieu.fr

👁 Highlights
• **Abbey:** Cloisters, refectory (12th-century mural); Église Saint-André (Pietà, murals); further information: +33 (0)4 71 76 08 90.
• **Musée des Arts et Traditions Populaires:** Reconstruction of a traditional Auvergne interior (joint tickets with abbey).
• **L'Atelier Nature:** Bookshop specializing in engravings and old books; collection of rare insects (July–August): +33 (0)7 61 22 39 52 or +33 (0)4 71 74 39 25.

🛏 Accommodation
Guesthouses
La Maison d'à Côté 🛏🛏🛏:
+33 (0)4 71 76 45 04 or +33 (0)6 87 73 90 36.
Le Colombier: +33 (0)9 71 45 89 65 or +33 (0)7 82 59 13 40.
Gîtes
M. and Mme Perrey 🛏🛏🛏:
+33 (0)4 71 76 82 39.
M. and Mme Watel 🛏🛏🛏:
+33 (0)4 71 76 45 79.

🍴 Eating Out
Auberge de l'Abbaye: +33 (0)4 71 76 44 44.
Court la Vigne: +33 (0)4 71 76 45 79.
Le Relais de la Fontaine:
+33 (0)6 87 73 90 36 or +33 (0)6 08 23 20 83.

🧺 Local Specialties
Food and Drink
Honey.
Art and Crafts
Essential-oil distillery.

2️⃣ Events
Local market: Wednesdays 5 p.m. to 9 p.m., July–August.
June: Festi'Car (Pentecost).
July: Fête de la Barrique, barrel festival, and craft market (weekend after 14th).
July and August: Choir festivals; music concerts at the abbey; further information: +33 (0)4 71 76 46 00; exhibitions.
December: Christmas market (1st Saturday).

🦋 Outdoor Activities
Climbing • Swimming pool (at Brioude) • Walking: 3 marked trails.

🌿 Further Afield
• Brioude (5 miles/8 km).
• *Blesle (19 miles/31 km), see pp. 168–69.
• La Chaise-Dieu (24 miles/39 km).
• Allier valley: gorges (31 miles/50 km).

❗ Did you know?
The Fête de la Barrique, held each year on the Sunday after July 14, has its origins in the French Revolution, when Lavaudieu's inhabitants surrounded the abbey in order to seize the clergy's possessions—in particular the wine destined for the monks of La Chaise-Dieu. During the festival, this historic village traditionally places a barrel of wine in the square for everyone to share.

Lourmarin
The Provence of Camus and Bosco

Vaucluse (84) • Population: 1,188 • Altitude: 722 ft. (220 m)

Standing at the mouth of a gorge in the Luberon clawed out by a dragon, Loumarin attracted the writers Albert Camus and Henri Bosco, who slumber in the shade of the cemetery's cypress trees.

The rough gash created by the Aiguebrun river is the only route—and an ancient one—through the Luberon mountains, and the water tumbles under an old shell bridge. It is the reason why Lourmarin sprang up around a modest Benedictine monastery and a simple castle, the Castellas, belonging to the lords of Baux-de-Provence. Surrounded by a plain dotted with fortified Provençal *mas* houses, where fruit and olive orchards mingle with vines, the village today winds along streets lined with fountains, and sun-kissed rooftops that cascade around the Castellas (now a belfry and clock tower) and the Romanesque church of Saint-Trophime-et-Saint-André. A stone's throw away is the Protestant church, which recalls the tragic massacre of the Vaud people in the 16th century, survivors of which converted to Protestantism. Just beyond it, the castle of La Colette, built in the 15th and 16th centuries, looks down over fields and terraced gardens. The castle was rescued in the early 20th century by the benefactor Laurent Vibert; he created a stunning collection of furniture and objets d'art, and each year welcomes painters, sculptors, musicians, and writers to the castle.

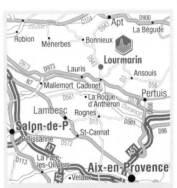

By road: Expressway A7, exit 26–Sénas (17 miles/27 km); expressway A51, exit 15–Pertuis (13 miles/21 km).
By train: Pertuis station (12 miles/19 km); Cavaillon station (25 miles/40 km); Avignon TGV station (40 miles/64 km).
By air: Avignon-Caumont airport (34 miles/55 km); Marseille-Provence airport (41 miles/66 km).

ⓘ Tourist information—
Luberon Coeur de Provence:
+33 (0)4 90 68 10 77
www.luberoncoeurdeprovence.com

👁 Highlights
• **Castle** (15th and 16th centuries): First Renaissance castle in Provence, furnished throughout; collection of engravings and objets d'art: +33 (0)4 90 68 15 23.
• **Village tours:** All year round for groups, and from mid-June to mid-September for individuals, by appointment only: +33 (0)4 90 68 10 77.
• **Protestant church** (19th century), included in village tour: Huge organ attributed to the Lyon manufacturer Augustin Zieger.
• **Romanesque church** (11th century), included in village tour.
• **La Ferme de Gerbaud:** Plants and herb farm. Tastings available Thursdays, booking essential: +33 (0)4 90 68 11 83.

🔑 Accommodation
Hotels
Hôtel Bastide de Lourmarin****: +33 (0)4 90 07 00 70.
Le Mas de Guilles****: +33 (0)4 90 68 30 55.
Auberge des Hautes Prairies: +33 (0)4 90 68 02 89.
Le Moulin de Lourmarin: +33 (0)4 90 68 06 69.
Le Paradou: +33 (0)4 90 68 04 05.
Guesthouses
La Cordière***: +33 (0)4 90 68 03 32.
La Luberonne 🎗🎗: +33 (0)4 90 08 58 63.
1784 Domaine de Lourmarin: +33 (0)6 88 37 39 66.
La Bohème: +33 (0)6 49 86 00 95.
La Chambre d'Hôte: +33 (0)6 07 18 97 92.
Le Chat sur le Toit: +33 (0)7 88 35 65 72.
Domaine de Pierrouret: +33 (0)6 18 90 66 83.
Mas Jolie Garrigue: +33 (0)6 09 61 68 46.
La Villa Saint-Louis: +33 (0)4 90 68 39 18.
Gîtes, walkers' lodges, and vacation rentals
Further information: +33 (0)4 90 68 10 77
www.luberoncoeurdeprovence.com
Campsites
Les Hautes Prairies***: +33 (0)4 90 68 02 89.

🍷 Eating Out
Restaurants
Le Bamboo Thaï: +33 (0)4 90 68 04 05.
Brasserie de la Fontaine: +33 (0)4 86 39 97 12.
Le Café Gaby: +33 (0)4 90 68 38 42.
Le Club: +33 (0)4 90 77 89 98.
Le Comptoir 2 Michel Ange, wine bistro: +33 (0)4 90 08 49 13.
La Cour de l'Ormeau: +33 (0)4 90 68 02 11.

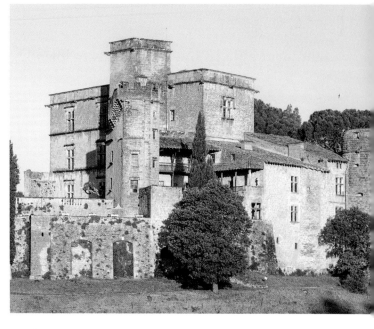

L'Insolite, brasserie: +33 (0)4 90 68 02 03.
La Louche à Beurre, crêperie: +33 (0)4 90 68 00 33.
Le Mas de Guilles: +33 (0)4 90 68 30 55.
Le Moulin de Lourmarin: +33 (0)4 90 68 06 69.
Le Numéro Neuf: +33 (0)4 90 79 00 46.
Le Pan Garni, pizzeria: +33 (0)4 90 68 84 43.
Pizzeria Nonni: +33 (0)4 90 68 23 33.
La Récréation: +33 (0)4 90 68 23 73.
Tea rooms
La Calade: +33 (0)4 90 68 84 43.
La Luce d'Angeuse: +33 (0)4 90 68 89 45.
La Maison Café: +33 (0)4 86 78 48 16.

🧺 Local Specialties
Food and Drink
Herbs • Olive oil and regional produce • AOC Côtes du Luberon wines.
Art and Crafts
Jewelry maker • Fashion designers • Smith • Art galleries • Household linen • Potters • Sculpture • Tools in Damask steel.

2 Events
Markets: Fridays 8 a.m.–1 p.m., Place Henri-Barthélemy and Avenue Philippe-de-Girard; farmers' market with street food, 5–7 p.m., March–April and November–December, and 5–8.30 p.m., May–October.

April: Renaissance festival at the castle.
May–September: music festival at the castle, lectures, shows.
June: Festival Yeah (pop/rock/electro).
July–August: "Rencontres Méditerranéennes Albert Camus," literary festival; craft fairs; artists' markets.
August: "Salon du Livre Ancien," antiquarian book fair.

🦋 Outdoor Activities
Mini-golf • Walks around Lourmarin: PR and GR routes • "Le Luberon à vélo" cycle route.

🌿 Further Afield
• *Ansouis (6 miles/9.5 km), see pp. 82–83.
• Fort de Buoux (6 miles/9.5 km).
• Durance valley; Cavaillon (6–21 miles/ 9.5–34 km).
• Lourmarin valley; Forêt de Cèdres, forest; Apt (7–11 miles/11.5–18 km).
• *Ménerbes (14 miles/23 km), see p. 110.
• *Roussillon (14 miles/23 km), see pp. 124–25.
• *Gordes (18 miles/29 km), see pp. 98–99.
• Aix-en-Provence (21 miles/34 km).
• *Venasque (28 miles/45 km), see pp. 145–46.

Lussan
A medieval epic in the backlands of Uzès

Gard (30) • Population: 502 • Altitude: 978 ft. (298 m)

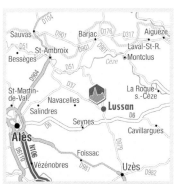

Set on a rocky plateau high above the *garrigue* scrubland, the walls of Lussan bear traces of a rich medieval history.

With its near-circular silhouette surrounded by ramparts, a panoramic view over the Cévennes and Mont Ventoux, and stone façades bleached by the Midi sunshine, Lussan is the archetypal medieval village of the Languedoc region. Only a few remains are left of the earlier castle, founded in the 12th century by the lords of the village, but its 15th-century counterpart stands almost completely intact in the heart of the village. Proudly showcasing its four round towers, including one belfry tower, the castle boasts a magnificent painted ceiling and is today home to the town hall. Façades topped with distinctive *génoise* tiles line the narrow streets that tell the tale of the once-turbulent relations between Catholics and Protestants. Three mills bear witness to the village's role in the more recent regional history of silk production. It is also worth setting out from the village to discover the impressive Conclues—a set of immense gorges carved out by the Aiguillon river, a tributary of the Cèze, that make for a novel walk in the summer when the water has run dry.

By road: Expressway A7, exit 19–Bollène (27 miles/43 km), N86 (7½ miles/12 km); expressway A9, exit 25–Alès (36 miles/58 km), N106 (22 miles/35 km).
By train: Alès station (18 miles/29 km); Nîmes TGV station (28 miles/45 km); Avignon TGV station (37 miles/60 km).
By air: Nîmes airport (35 miles/56 km); Avignon airport (42 miles/67 km); Montpellier airport (68 miles/110 km).

ⓘ Tourist information:
+33 (0)4 66 74 55 27
www.destinationpupg.com

👁 Highlights
• **Castle (town hall):** 17th-century listed painted ceiling. Visit during tours of the village's bell towers: +33 (0)4 66 74 55 27.
• **Jardin des Buis:** Garden dedicated to well-being; a Mediterranean interpretation of *niwaki*, the Japanese art of tree-sculpting. +33 (0)4 66 72 88 93 / buisdelussan.free.fr
• **Forge:** Restored former forge. Artists' studio and exhibition space, dedicated to the arts. Open all year round. Further information: +33 (0)4 66 74 55 27.
• **Village:** Free guided visits from June to September. Further information: www.mairie-lussan.fr.
• **The Conclues:** Gorges cut by the Aiguillon river, walks in summer; site and discovery trail.
• **L'Aiguillon d'Art:** Walking trail through the village, via a series of artworks. Further information: +33 (0)4 66 74 55 27.

🗝 Accommodation
Hotels
♥ L'Auberge des Marronniers: +33 (0)4 30 67 29 46.
Guesthouses
♥ Les Buis de Lussan 🚩🚩🚩: +33 (0)4 66 72 88 93.

Domaine d'Aubadiac: +33 (0)4 66 72 70 70.
L'Occitane: +33 (0)4 66 72 94 39.
Gîtes and vacation rentals
Further information: +33 (0)4 66 74 55 27
www.mairie-lussan.fr

🍽 Eating Out
♥ L'Auberge des Marroniers: +33 (0)4 30 67 29 46.
Le Bistrot de Lussan: +33 (0)4 34 04 86 85.
Les Buis de Lussan, tea room: +33 (0)4 66 72 88 93.
Station du Mas Neuf, weekday lunch only: +33 (0)9 60 07 77 06.
La Table d'Azor, farmhouse inn: +33 (0)9 66 84 27 95.

🍴 Local Specialties
Food and Drink
Goat cheese • Sheep cheese • Truffles.
Art and Crafts
Pottery • Wrought ironworker • Gallery.

📅 Events
April: Art & Garden Festival (last Sunday).
May–September: Tours of the bell towers.
July–August: Art exhibitions at the castle.
August: Farmers' market; Festival de Lussan (1st fortnight); "Lussan se Livre" literary festival (last Sunday).

🦋 Outdoor Activities
Walking: 155 miles (250 km) of marked trails, see map-guide "Garrigues et Conclues autour de Lussan" • Horseriding • Mountain-biking.

🌿 Further Afield
• Grotte de la Salamandre, cave (7½ miles/12 km).
• Uzès (12 miles/19 km).
• Tour of the châteaux around Uzès (11–18 miles/18–29 km).
• *La Roque-sur-Cèze (12½ miles/20 km), see pp. 122–23.
• *Montclus (16 miles/25 km), see p. 113.
• Alès (19 miles/30 km).
• *Aiguèze (22 miles/36 km), see pp. 80–81.
• Vallon (23 miles/37 km).
• Grotte Chauvet, cave (25 miles/40 km).

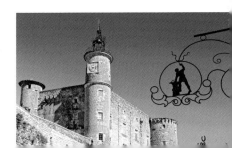

Ménerbes

Tranquility and beauty in the Luberon

Vaucluse (84) • Population: 1,009 • Altitude: 735 ft. (224 m)

Perched on a ridge clinging to the side of the Luberon mountains, Ménerbes looks down over fields of vines and cherry trees. It has been inhabited since prehistoric times, as shown by La Pichoune dolmen (funerary monument), unique in Vaucluse. But it was during the Middle Ages and the Renaissance that the village acquired its heritage buildings, for example the abbey of Saint-Hilaire, the Carmelite convent where Saint Louis (1214–1270) stopped on his return from the Crusades. In a symphony of luminous, golden stone, very fine 16th- and 17th-century residences are dotted along the fortified rocky spine, facing the Vaucluse mountains. The citadel, reinforced after a siege to protect the town's inhabitants, strikes an imposing silhouette at one end of the village.

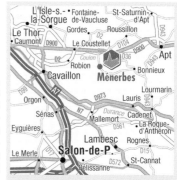

By road: Expressway A7, exit 24– Avignon Sud (17 miles/27 km). **By train:** Cavaillon station (9½ miles/15.5 km); Avignon TGV station (25 miles/40 km). **By air:** Avignon-Caumont airport (19 miles/31 km); Marseille-Provence airport (43 miles/69 km).

ⓘ Tourist information—Luberon Pays d'Apt: +33 (0)4 90 72 21 80
www.luberon-apt.fr
www.menerbes.fr

👁 Highlights

• Abbaye Saint-Hilaire (13th century): Former Carmelite convent; chapel, cloisters, chapter house, refectory (April–November).
• Maison de la Truffe et du Vin (mansion of Astier de Montfaucon, 17th–18th centuries): Showcase for truffles and wines of the Luberon; wine collection, exhibitions, shop: +33 (0)4 90 72 38 37.
• Maison Jane Eakin: House/museum of the American painter (1919–2002), open in summer: +33 (0)4 90 72 21 80.
• Musée du Tire-bouchon at La Citadelle: Collection of more than 1,200 historic and modern corkscrews: +33 (0)4 90 72 41 58.
• Botanical garden: Six 18th-century terraces.
• Chapelle Notre-Dame-des-Grâces (18th century).
• Chapelle Saint-Blaise (18th century).
• Église Saint-Luc (16th century).
• La Pitchoune dolmen (Neolithic site).

⚷ Accommodation

Hotel
La Bastide de Marie: +33 (0)4 90 72 30 20.
Le Ray de Soleil: +33 (0)4 90 72 25 61.
Guesthouses
La Bastide de Soubeyras: +33 (0)4 90 72 94 14.
La Bastide du Tinal: +33 (0)4 90 72 18 07.
Le Jardin des Cigales: +33 (0)4 90 04 87 18.
Nulle Part Ailleurs: +33 (0)6 72 22 81 03.
Gîtes and holiday rentals
Further information: +33 (0)4 90 72 21 80
www.luberon-apt.fr

🍴 Eating Out

Au Goût du Jour, wine bistro: +33 (0)6 70 10 31 84.
Le 5 [cinq]: +33 (0)4 90 72 31 84.
La Bastide de Marie: +33 (0)4 90 72 30 20.
Le Café du Progrès, country fare: +33 (0)4 90 72 22 09.
Chez Auzet, tea room: +33 (0)4 90 72 37 53.
Du Côté de Chez Charles: +33 (0)4 86 69 63 51.
Le Galoubet: +33 (0)4 90 72 36 08.
Maison de la Truffe et du Vin, wine bar and truffle restaurant: +33 (0)4 90 72 38 37.
Les Saveurs Gourmandes: +33 (0)4 32 50 20 53.
La Table de Régis, communal dining: +33 (0)4 90 72 43 20.

🛍 Local Specialties

Food and Drink
Fruit and vegetables • Luberon truffles • AOC Côtes du Luberon wines.
Art and Crafts
Gifts • Fashion • Painters • Potter • Art photographer • Ironworker.

🗓 Events

Market: Thursday mornings April– October.
July: Fête des Vignerons (winegrowers' festival), and "OEno-vidéo" (movies and wine).
July–August: Les Musicales du Luberon; La Strada (open-air cinema).
August: Fête de Saint-Louis (3rd weekend); festival of Italian film.

October: Outdoor rummage sale (1st Sunday).
December: Christmas market; truffle market and concert (last weekend).

🦋 Outdoor Activities

Walking: marked trails • Cycling: "Autour du Luberon à Vélo," Luberon by bike (regional nature park) • Mountain-biking.

🌾 Further Afield

• *Gordes (7 miles/11.5 km), see pp. 98–99.
• Cavaillon; Apt; Avignon (10–25 miles/ 16–40 km).
• Fontaine-de-Vaucluse (10 miles/16 km).
• *Roussillon (10 miles/16 km), see pp. 124–25.
• *Lourmarin (15 miles/24 km), see pp. 107–8.
• *Venasque (15 miles/24 km), see pp. 145–46.
• *Ansouis (21 miles/34 km), see pp. 82–83.

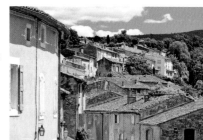

Mirmande

Hilltop orchard in the Rhône valley

Drôme (26) • Population: 504 • Altitude: 640 ft. (195 m)

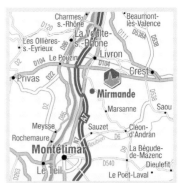

Mirmande clambers up the hill to the Église Sainte-Foy, from where there are far-reaching views of the Rhône valley and the Vivarais mountains. The high façades of Mirmande scale the north face of the Marsanne massif, emerging from the ancient ramparts and overlapping each other to seek protection from the Mistral. Dominating the Tessonne valley, where thousands of fruit trees bloom in spring, this jewel in the Drôme valley is a maze of lanes, cobblestones, and steps, all ablaze with flowers. At the top is the delightful 13th-century Église Sainte-Foy. Mirmande stopped breeding silkworms at the end of the 19th century, but several silkworm nurseries keep the memory of this industry alive. The town was given a new lease of life by growing fruit, and thanks to the input of two individuals: the cubist painter and writer André Lhote (1885–1962), who created his summer school here, and the geologist Haroun Tazieff (mayor 1979–89). The old houses have been beautifully restored; many have been brought back to life by the talent and imaginative spark of local artists and craftsmen.

By road: Expressway A7, exit 16—Loriol (5 miles/8 km). **By train:** Loriol-sur-Drôme station (5½ miles/9 km); Livron-sur-Drôme station (8 miles/13 km); Montélimar TGV station (12 miles/19 km); Valence TGV station (32 miles/51 km).
By air: Lyon-Saint-Exupéry airport (96 miles/154 km).

(i) Tourist information—Val de Drôme: +33 (0)4 75 63 10 88
Town hall: +33 (0)4 75 63 03 90
www.valleedeladrome-tourisme.com

👁 Highlights
• **Église Sainte-Foy** (12th century): Exhibitions and concerts.
• **Chareyron orchard:** Open all year, self-guided visit.
• **Village:** Guided tours throughout the year for groups, booking essential. Further information: +33 (0)4 75 63 10 88.

🗝 Accommodation
Hotels
La Capitelle***: +33 (0)4 75 63 02 72.
L'Hôtel de Mirmande: +33 (0)4 75 63 13 18.
Guesthouses
Le Petit Logis 🛏🛏🛏: +33 (0)4 75 63 02 92.
La Buissière: +33 (0)4 75 63 02 51.
Domaine Les Fougères: +33 (0)4 75 63 01 66.
La Maison de Marinette: +33 (0)6 15 76 24 55.
Margot: +33 (0)4 75 63 08 05.
Le Matignier: +33 (0)6 09 45 12 52.
Les Vergers de la Bouliguaire: +33 (0)4 75 63 22 07.
Gîtes and vacation rentals
Further information: +33 (0)4 75 63 10 88
www.valleedeladrome-tourisme.com
Campsites
La Poche**: +33 (0)4 75 63 02 88.

🍽 Eating Out
Annie's en Provence: +33 (0)6 72 23 61 45.
Atelier Café Patine: +33 (0)4 75 41 21 82.
Café Bert, local bistro, pizzeria: +33 (0)4 75 56 18 51.

La Capitelle: +33 (0)4 75 63 02 72.
Chez Margot: +33 (0)4 75 63 08 05.
Crêperie La Dinette: +33 (0)4 75 41 06 76.
Le Perchoir: +33 (0)6 81 04 56 96.

🧺 Local Specialties
Food and Drink
Seasonal fruit juice, fruit, and vegetables • Drôme vins de pays.
Art and Crafts
Jewelry designer • Painters • Potters • Silkscreen printer • Sculptors • Glassmaker • Gifts • Antiques • Dressmaker • Art galleries.

🗓 Events
Market: Saturday mornings.
March: Nature trail.
April–September: Concerts and exhibitions at the Église Sainte-Foy.
October: Plant and garden fair.
December: Torchlight walks; Nativity scenes.

🐾 Outdoor Activities
Husky dogs and walking with dogs (summer) • Walking • Mountain-biking.

🥾 Further Afield
• Cliousclat, pottery village (1 mile/2 km).
• Crest (11 miles/18 km).
• Montélimar (11 miles/18 km).
• Dieulefit (19 miles/31 km).
• Forêt de Saoû (20 miles/32 km).
• *Le Poët-Laval (21 miles/34 km), see p. 120.
• Gervanne valley (22 miles/35 km).
• Grignan (25 miles/40 km).
• *La Garde-Adhémar (26 miles/42 km), see p. 94.

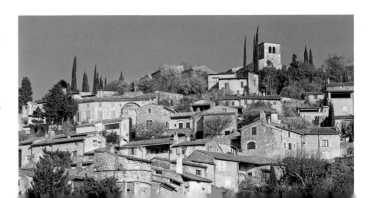

Montbrun-les-Bains

Thermal treatments at the gateway to Provence

Drôme (26) • Population: 430 • Altitude: 1,969 ft. (600 m)

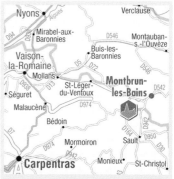

At Montbrun, sandwiched between the Lure and Ventoux mountains, the region of Drôme takes on Provençal features: it is adorned with lavender, *garrigue* scrubland, and vines. Tiered on the steep sides of a hill, the high façades of Montbrun are pierced with windows like arrow slits. They stand as the last line of defense protecting the imposing remains of an historic medieval castle. Rebuilt during the Renaissance, the castle was looted during the French Revolution. From the Place de l'Horloge and its belfry as far as the Sainte-Marie gate, narrow cobblestone alleyways lead from fountain to fountain, right to the 12th-century church. This houses a splendid Baroque altar and several paintings, including *Coronation of the Virgin* by Pierre Parrocel. At the foot of the village, thermal baths in a modern building benefit from a spring that the Romans used; the waters help respiratory and rheumatic ailments, and improve fitness.

By road: Expressway A7, exit 19–Bollène (46 miles/74 km); expressway A51, exit 22–Vallée du Jabron (32 miles/52 km).
By train: Carpentras station (33 miles/53 km); Orange TGV station (44 miles/71 km). **By air:** Avignon-Caumont airport (52 miles/84 km).

ⓘ Tourist information:
+33 (0)4 75 28 82 49
www.baronnies-tourisme.com

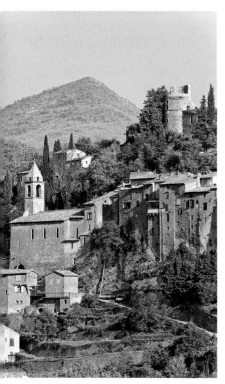

👁 Highlights
• **Church** (12th century): Baroque building, painting by Pierre Parrocel (key at town hall).
• **Village:** Further information: +33 (0)4 75 28 82 49.

🔑 Accommodation
Hotels
Hôtel des Voyageurs: +33 (0)4 75 28 81 10.
Aparthotels
Le Château des Gipières: +33 (0)4 75 28 87 33 or +33 (0)4 85 88 02 37.
Le Hameau des Sources: +33 (0)4 75 26 96 88.
Guesthouses
L'Abbaye: +33 (0)4 75 28 83 12.
Le Bellevue: +33 (0)4 75 28 84 92 .
Le Deffends de Redon: +33 (0)4 75 28 68 19.
La Maison de Marguerite: +33 (0)4 75 28 41 23.
Gîtes, walkers' lodges, and vacation rentals
Further information: +33 (0)4 75 28 82 49.
Vacation villages
Léo Lagrange: +33 (0)4 75 28 89 00.
VVF: +33 (0)4 75 28 82 35.
Campsites
Le Pré des Arbres: +33 (0)4 75 28 85 41.

🍽 Eating Out
L'O Berge de l'Anary: +33 (0)4 75 28 88 14.
L'Ô des Sources: +33 (0)4 75 27 11 09.
La Tentation, pizzeria: +33 (0)4 75 28 87 26.
Les Voyageurs: +33 (0)4 75 28 81 10.

🧺 Local Specialties
Food and Drink
Goat cheese • Honey, herbs, and spices • Einkorn wheat • Organic produce.
Art and Crafts
Potter • Perfumes and herbs.

🗓 Events
Market: Saturday mornings, Place de la Mairie.
April: Cheese and craft market (1st Sunday).
September: Journée Bien-être au Naturel (plant and wellbeing fair); local saint's day and fireworks, Saturday evening (2nd weekend).

🦋 Outdoor Activities
Canyoning and climbing • Via Ferrata • Horse-riding • Walking: Route GR 9 and 10 marked trails • Thermal baths and convalescence (mid-March–end November).

🌿 Further Afield
• Sault (7½ miles/12 km).
• Buis-les-Baronnies (16 miles/26 km).
• Nyons (19 miles/31 km).
• Toulourenc valley; Vaison-la-Romaine (20 miles/32 km).
• Mont Ventoux (24 miles/39 km).

Montclus

Clothed in vineyards and lavender

Gard (30) • Population: 213 • Altitude: 295 ft. (90 m)

Sitting at a bend in the Cèze river, Monclus exudes all the charm of a Languedoc village.

Inhabited since prehistoric times, the site attracted fishing tribes to settle before it became Castrum Montecluso in the Middle Ages, earning its name from its hilltop position at the foot of a mountain. In the 13th century both the abbey of Mons Serratus and an imposing fortified castle were built here. A few ruins of the old troglodyte Benedictine monastery remain, used as a chapel by the Knights Templar, as well as a vast room hewn out of the rock, while the massive square tower of the castle still casts its long shadow over the pink-tiled roofs. From the Place de l'Église, narrow alleys, steps, and covered passageways punctuate the village. As you wander, you catch occasional glimpses, beyond the bright stone façades of lovingly restored residences, of lush green gardens tumbling down to the Cèze.

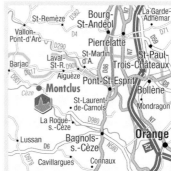

☀ Highlights
• **Church** (19th century): Tuesday mornings in July and August.
• **Castle** (July and August): Main hall, spiral staircase. Guided tours daily July–August. Further information: Association des Amis du Château: +33 (0)6 14 49 48 20.
• **Village:** Guided tours in summer. Further information: +33 (0)4 66 82 30 02.

⚲ Accommodation
Guesthouses
La Micocoule: +33 (0)4 66 82 76 09.
Le Moulin: +33 (0)9 65 38 78 07.
Nid d'Abeilles: +33 (0)6 82 86 83 00 or +33 (0)6 33 09 03 84.
Campsites, farm campsites, gîtes, and vacation rentals
Further information: +33 (0)4 66 82 30 02.

⊞ Eating Out
Le Mûrier: +33 (0)4 66 82 59 98.

⌂ Local Specialties
Food and Drink
Honey • Olive oil • Lavender essence.
Art and Crafts
Painter • Joiner • Ironworker.

② Events
Market: Provençal market Tuesday mornings (July–August).
July and August: Cultural activities and shows.
August: Local saint's day (1st weekend).

🦋 Outdoor Activities
Swimming • Canoeing • Walking • Horse-riding • Mountain-biking.

🌿 Further Afield
• Aven d'Orgnac, sinkhole (5½ miles/9 km).
• Cornillon; Goudargues (6 miles/9.5 km).
• *Aiguèze (9½ miles/15.5 km), see pp. 80–81.

By road: Expressway A7, exit 19–Bollène (21 miles/34 km); expressway A9, exit 23–Remoulins (32 miles/51 km); N86 (14 miles/23 km).
By train: Bollène-La Croisière station (18 miles/29 km); Avignon TGV station (37 miles/60 km).
By air: Avignon-Caumont airport (40 miles/64 km); Nîmes-Arles-Camargues airport (55 miles/89 km).

ⓘ Tourist information—Provence Occitane: +33 (0)4 66 82 30 02 www.provenceoccitane.com

• *La Roque-sur-Cèze (9½ miles/15.5 km), see pp. 122–23.
• Valbonne: monastery (11 miles/18 km).
• Bagnols-sur-Cèze: market (15 miles/24 km).
• Pont-Saint-Esprit (15 miles/24 km).
• *Lussan (15½ miles/25 km), see p. 109.
• Grotte Chauvet, cave (19 miles/30 km).
• Gorges of the Ardèche (21 miles/34 km).

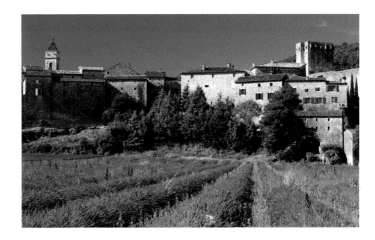

Montpeyroux
A labyrinth of sandstone

Puy-de-Dôme (63) • Population: 355 • Altitude: 1,499 ft. (457 m)

Perched on a mound to the south of Clermont-Ferrand and winding around its castle keep, the medieval village offers a panoramic view of the Auvergne volcanos.

Sitting on the ancient Régordane Way linking the Auvergne with Languedoc, Montpeyroux brings a flavor of southern France. Over the centuries, its inhabitants have lived off the proceeds of its vineyards and its arkose quarry. Arkose is a sandstone rich in crystalline feldspar; the stone lights up Montpeyroux's houses with golden glints, and was used to build the major Romanesque churches in the Auvergne—Saint-Austremoine at Issoire and Notre-Dame-du-Port at Clermond. The vineyards of Montpeyroux disappeared at the end of the 19th century during the outbreak of phylloxera, and the quarry closed in 1935, heralding the village's decline. However, restoration began in the 1960s, and Montpeyroux has recovered its vigor through growing vines again and encouraging artists and craftspeople to come. With its massive, gold-flecked winegrowers' houses and its roofs of round tiles, Montpeyroux is one of the jewels of the Allier valley.

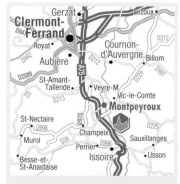

By road: Expressway A75, exit 7–Montpeyroux (1 mile/1.5 km).
By train: Clermont-Ferrand station (19 miles/31 km).
By air: Clermont-Ferrand Auvergne airport (15 miles/24 km).

ⓘ Tourist information—Pays d'Issoire:
+33 (0)4 73 89 15 90
www.issoire-tourisme.com
www.montpeyroux63.com

👁 Highlights
• Ferme Pédagogique de la Moulerette: Discover farm animals:
+33 (0)4 73 96 62 68.
• **Montpeyroux** tower (13th century): Exhibition: +33 (0)4 73 96 62 68.
• Village: Guided tours for groups by appointment only: +33 (0)4 73 89 15 90. Special tours for the visually impaired (tactile models of the tower, the 12th-century gate, and the village) by appointment: +33 (0)4 73 96 62 68.

🔑 Accommodation
Guesthouses
Les Pradets ▮▮▮▮: +33 (0)4 73 96 63 40.
Le Cantou ▮▮▮: +33 (0)4 73 96 92 26.
Le Petit Volcan ▮▮▮: +33 (0)6 78 84 86 64.
L'Écharpes d'Iris ✿✿✿: +33 (0)6 77 19 19 77.
La Casa del Sol: +33 (0)6 20 40 34 51.
Chez Helen: +33 (0)6 81 13 28 23.
Vacation rentals
Further information: +33 (0)4 73 89 15 90
www.issoire-tourisme.com

🍴 Eating Out
Le Bistrot Zen—CZ: +33 (0)4 73 96 63 46.
L'Hortus: +33 (0)4 73 71 11 23 or
+33 (0)6 64 63 27 06.
Ô Dé Tour: +33 (0)4 73 96 69 25.
Une P'tite Pause S'Impose, tea room:
+33 (0)6 75 70 18 42.

🍷 Local Specialties
Local produce
AOC Côtes d'Auvergne wines.
Art and Crafts
Jewelry • Ceramic artists • Art galleries • Painters • Visual artists.

🎫 Events
June: Montpeyroux Alpine, car convention.
September: Dedal'Art, art and craft fair (3rd weekend).

🦋 Outdoor Activities
Fishing • Walking: 1 marked trail, "L'Arkose" (5½ or 7½ miles/9 or 12 km) • Mountain-biking.

🌿 Further Afield
• Issoire (9½ miles/15.5 km).
• Clermont-Ferrand (12 miles/19 km).
• Saint-Nectaire; Besse-en-Chandesse; Massif de Sancy (12–25 miles/19–40 km).
• Abbaye de Mégemont (14 miles/23 km).
• *Usson (15 miles/24 km), see p. 144.
• Route du Dauphiné d'Auvergne, scenic drive to Saint-Germain-Lembron (19 miles/30 km).
• La Chaîne des Puys, series of volcanic domes; Vulcania, theme park (31 miles/50 km).

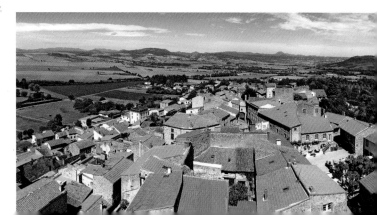

Moustiers-Sainte-Marie

The star of Verdon

Alpes-de-Haute-Provence (04) • Population: 740 • Altitude: 2,100 ft. (640 m)

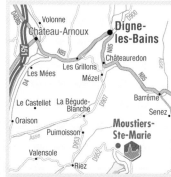

Moustiers sits at the entrance to the Grand Canyon du Verdon, protected by a golden star suspended on a chain high above the village between two rocky cliffs.

Moustiers owes its existence to a body of water, and its fame to an Italian monk. The water is the Adou river: it made medieval Moustiers a village of stationers, potters, and drapers. In the 17th century, a monk from Faenza brought the secret of enameling (tin-glazed earthenware) here, and Moustiers became the capital of "the most beautiful and the finest faience in the kingdom." Although the faience industry disappeared in the 19th century, it has been revitalized in recent years, and now over a dozen studios marry tradition with innovation. The Adou river tumbles through the village and is spanned by little stone bridges. On both sides, the golden houses topped with Romanesque tiles huddle round small courtyards and line alleys linked by steps and vaulted passageways. At the heart of the village, the church has been altered several times and contains a pre-Roman vault, a nave dating to the 14th and 16th centuries, and a square Lombard tower. A flight of 262 steps links the village with the chapel of Notre-Dame-de-Beauvoir, which blends charming Gothic and Romanesque architecture.

By road: Expressway A51, exit 18–Manosque (34 miles/55 km); expressway A8, exit 36–Draguignan (47 miles/76 km). **By coach:** LER No. 27 from Aix-en-Provence bus station (58 miles/93 km; Monday and Saturday April 1–June 30, and daily July–August). **By train:** Digne-les-Bains station (34 miles/55 km); Manosque station (35 miles/56 km). **By air:** Marseille-Provence airport (71 miles/114 km).

(i) **Tourist information:**
+33 (0)4 92 74 67 84
www.moustiers.fr

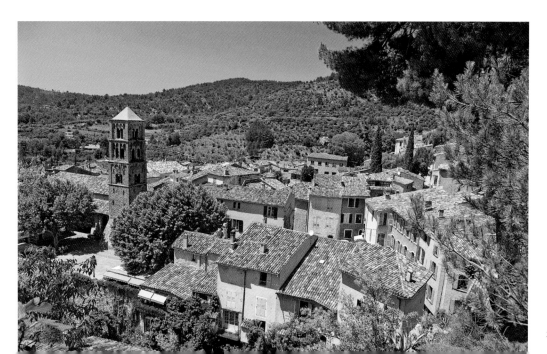

👁 Highlights

• **Chapelle Notre-Dame-de-Beauvoir** (12th and 16th centuries).
• **Parish church** (12th and 14th centuries).
• **Musée de la Faïence:** History of faience ceramics, 17th century to today, a collection of over 400 pieces; temporary exhibitions: +33 (0)4 92 74 61 64.
• **Village:** Guided tours for individuals, Tuesdays 10 a.m. and Thursdays 5 p.m. July–August; groups all year by appointment: +33 (0)4 92 74 67 84.

🗝 Accommodation

Hotels
La Bastide de Moustiers****:
+33 (0)4 92 70 47 47.
La Bastide du Paradou***:
+33 (0)4 88 04 72 01.
La Bonne Auberge***: +33 (0)4 92 74 66 18.
♥ Le Colombier***: +33 (0)4 92 74 66 02.
La Ferme Rose***: +33 (0)4 92 75 75 75.
Les Restanques***: +33 (0)4 92 74 93 93.
Le Clos des Iris**: +33 (0)4 92 74 63 46.
Le Relais**: +33 (0)4 92 74 66 10.
Le Belvédère: +33 (0)4 92 74 66 04.

Guesthouses
Jas 2 🏠🏠🏠🏠: +33 (0)6 07 27 89 61.
L'Atelier 🏠🏠🏠: +33 (0)6 07 27 89 61.
Domaine d'Angouire 🏠🏠🏠:
+33 (0)6 08 48 71 87.
Ferme du Petit Segries 🏠🏠🏠:
+33 (0)4 92 74 68 83.
Le Mas du Loup 🏠🏠🏠: +33 (0)4 92 74 65 61.
Other guesthouses, gîtes, walkers' lodges, vacation rentals, and campsites
Further information: +33 (0)4 92 74 67 84
www.moustiers.fr

🍽 Eating Out

Au Coin Gourmand: +33 (0)6 81 25 66 66.
La Bastide de Moustiers:
+33 (0)4 92 70 47 47.
Le Belvédère: +33 (0)4 92 74 66 04.
La Bonne Auberge: +33 (0)4 92 74 60 40.
La Cantine: +33 (0)4 92 77 46 64.
La Cascade: +33 (0)4 92 74 66 06.
Chez Benoit, brasserie:
+33 (0)4 92 77 45 07.
Clérissy, crêperie/pizzeria:
+33 (0)4 92 77 29 30.
Côté Jardin: +33 (0)4 92 74 68 91.
Le Da Vinci: +33 (0)4 92 77 24 69.
Le Four, pizzeria: +33 (0)4 92 75 01 69.
La Grignotière: +33 (0)4 92 74 69 12.
Jadis, pizzeria: +33 (0)4 92 74 63 01.
Les Magnans, brasserie:
+33 (0)4 92 74 61 20.
La Part des Anges, wine bistro:
+33 (0)6 25 57 53 66.
Le Relais: +33 (0)4 92 74 66 10.

Les Santons: +33 (0)4 92 74 66 48.
La Terrasse du Vieux Colombier, pizzeria:
+33 (0)6 32 37 39 79.
Les Tables de Cloître: +33 (0)6 31 61 72 40.
La Treille Muscate: +33 (0)4 92 74 64 31.

🏺 Local Specialties

Food and Drink
Cookies • Artisan preserves, salted produce • Olive oil • Lavender honey.
Art and Crafts
Faience workshops • Painters.

📅 Events

Markets: Fridays 8 a.m.–1 p.m,
Place de l'École; Wednesdays 6–11 p.m.
July–August, Place de la Mairie.
August–September: "Fête de la Diane," festival (August 31–September 8).

🦋 Outdoor Activities

Walking: Route GR 4 and 12 marked trails • White-water sports: canyoning, kayaking, pedalo • Climbing, paragliding • Mountain-biking.

🌿 Further Afield

• Lac de Sainte-Croix, lake (3 miles/5 km).
• Le Grand Canyon du Verdon;
Castellane (6–28 miles/9.5–45 km).
• Riez; Valensole; Gréoux-les-Bains: spa; Manosque (9½–31 miles/15.5–50 km).

Oingt

A golden nugget at the heart of vineyards

Rhône (69) • Population: 614 • Altitude: 1,804 ft. (550 m)

Overlooking the Beaujolais vineyards, Oingt is a jewel amid the *pierres dorées* (golden stones), rich in iron oxide, found in this region.

Built on a ridge overlooking the Roman roads between Saône and Loire, this former Roman *castrum* saw its heyday in the Middle Ages. It was around the year 1000 CE that the Guichard d'Oingt lords, powerful *viguiers* (judges) for the count of Le Forez, built a motte-and-bailey castle and its chapel here, and in the 12th century a keep was added. Today, the fortified Nizy Gate at the entrance to the village provides the first sign of its medieval past. Houses with yellow-ocher walls, where the play of light and shadow constantly changes, line the road leading to the old chapel, which became a parish church in 1660. Next to it are the remains of the castle's residential buildings and keep, which have now been made into a museum. From the terrace, there is an exceptional view of the Beaujolais vineyards, the Azergues valley, and the Lyonnais mountains.

By road: Expressway A6, exit 31.2–Roanne (10 miles/16 km); expressway A89, exit Saint-Romain-de-Popey (8½ miles/14 km); N7 (8½ miles/13.5 km).
By train: Villefranche-sur-Saône station (9½ miles/15.5 km); Lyon-Part-Dieu TGV station (24 miles/39 km).
By air: Lyon-Saint-Exupéry airport (41 miles/66 km).

ⓘ **Tourist information—Beaujolais:**
+33 (0)4 78 22 70 38
www.destination-beaujolais.com

👁 Highlights

• **Tour d'Oingt** (12th century): Museum of the village's history, panoramic terrace with viewpoint indicator.
• **Église Saint-Matthieu** (10th century): 12th-century polychrome sculptures, Stations of the Cross, Pietà, pulpit; liturgical museum.
• **Musée de la Musique mécanique et de l'Orgue de Barbarie:** Display of old objects (collection of 60 instruments) plus music demonstrations.
• **Maison Commune** (16th century): Exhibition of the works of regional artists (painters, sculptors, ceramicists), April–October.
• **Village:** Guided tour arranged by museum, booking essential: lesamisdoingt@gmail.com

🔑 Accommodation

Guesthouses
M. and Mme Bourbon 🛏🛏🛏:
+33 (0)4 74 71 24 41 or
+33 (0)6 80 50 27 93.
Gîtes
M. and Mme Lucien Guillard*:
+33 (0)4 74 71 20 49 or
+33 (0)6 87 25 62 39.
Mme Banes: +33 (0)4 78 43 03 32.

🍴 Eating Out

Black Horse Saloon: +33 (0)4 74 72 81 09.
Chez Marguerite: +33 (0)4 74 71 20 13.

La Clef de Voûte: +33 (0)4 74 71 29 91.
La Table du Donjon:
+33 (0)4 74 21 20 24.
La Vieille Auberge: +33 (0)4 74 71 21 14.

🍽 Local Specialties

Food and Drink
AOC Beaujolais wines.
Art and Crafts
Calligrapher • Ceramicist • Textile designer • Potter • Stained-glass artist • Art galleries • Jewelry • Watercolour artist • Artists' collective.

📅 Events

Market: Thursday, Place de Presberg, 3 p.m.–7 p.m.
February: "Fête de l'Amour," Oingt craftsmen celebrate Valentine's Day.
July: "Rosé Nuit d'Eté," aperitif and concert (1st week).
September: Festival International d'Orgue de Barbarie et de Musique Mécanique, organ festival (1st weekend).
November: Beaujolais Nouveau festival (3rd Thursday).
December–January: Oingt en Crèches, Oingt nativity scenes (2nd Sunday of December until January 6th).

🦋 Outdoor Activities

Walking • Mountain-biking (marked trails).

🦋 Further Afield

• Pays des Pierres Dorées, region: golden stone villages (2½–12 miles/4–19 km).
• Villefranche-sur-Saône (8½ miles/13.5 km).
• Lyon (23 miles/37 km).

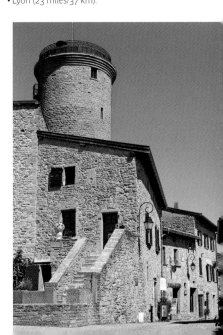

Pérouges
The cobblestones of Ain

Ain (01) • Population: 1,250 • Altitude: 919 ft. (280 m)

At the top of a hill, the medieval village of Pérouges forms a circle around its square, which is shaded by a 200-year-old lime tree.

Long coveted for its prosperity, created by its weaving industry, and for its strategic position overlooking the plain of the Ain river, the town was ruled by the province of Dauphiné, and then the region of Savoy, before becoming French at the dawn of the 17th century. Despite being besieged several times, Pérouges was saved from ruin in the early 19th century and has retained an exceptional heritage inside its ramparts, with no fewer than eighty-three listed buildings. The fortified church, with its ramparts, arrow-slits, and keystones bearing the Savoyard coat of arms, is one of its principal treasures. Surrounded by corbeled and half-timbered mansions built in the 13th century, the Place du Tilleul, shaded by its "tree of freedom," planted in 1792, reflects several centuries of history in the narrow cobblestone streets that lead off the square, with their central gutter to channel away dirty water.

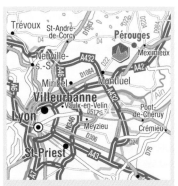

By road: Expressway A42, exit 7–Pérouges (3½ miles/5.5 km). **By train:** Villars-les-Dombes station (13 miles/21 km); Lyon-Saint-Exupéry TGV station (21 miles/ 34 km). **By air:** Lyon-Saint-Exupéry airport (20 miles/32 km).

ⓘ Tourist information:
+33 (0)4 74 46 70 84
www.perouges.org

◉ Highlights
• **Fortified church** (15th century): Altarpiece, wooden statues.
• **Maisons des Princes:** Musée d'Art et d'Histoire du Vieux Pérouges et Hortulus, watchtower, medieval garden.
• **Village:** Guided tours for individuals and groups; dramatized evening tours in July and August; accessible tours for the visually impaired (sensory tour, large print and Braille guidebooks, audioguides). Further information: +33 (0)4 74 46 70 84.

⚷ Accommodation
Hotels
Hostellerie du Vieux Pérouges**** and ***: +33 (0)4 74 61 00 88.
La Bérangère**: +33 (0)4 74 34 77 77.
Guesthouses
Le Grenier à Sel ▮▮▮: +33 (0)6 98 87 62 16.
La Ferme de Rapan ▮▮:
+33 (0)4 74 37 01 26.
Casa la Signora di Perugia:
+33 (0)4 74 61 47 03.
Com' à la Maison: +33 (0)7 77 76 89 11.
The Resid for Calixte: +33 (0)6 72 14 95 18.

⑪ Eating Out
L'Auberge du Coq: +33 (0)4 74 61 05 47.
Hostellerie du Vieux Pérouges:
+33 (0)4 74 61 00 88.
Le Ménestrel: +33 (0)4 74 61 11 43.

Ô Galettes de Sophie:
+33 (0)6 77 99 77 38.
Le Relais de la Tour: +33 (0)4 74 61 01 03.
Les Terrasses de Pérouges:
+33 (0)4 74 61 38 68.
Le Veneur Noir: +33 (0)4 74 61 07 06.

🧺 Local Specialties
Food and Drink
Chocolates • Galettes de Pérouges • Bugey wine.
Art and Crafts
Antique dealer • Ceramicist • Costumer • Stationer • Herbalist • Painter.

② Events
April–November: Exhibitions and creative workshops.
May 1: Crafts market.
May–June: Printemps Musical de Pérouges, spring music festival; plants fair.
June: Medieval festival (1st fortnight).
August: Mechanical music festival.
October: Automnales Oenologiques (autumn wine fair).
December: Christmas market.
All year round: "Les 4 Saisons de Pérouges en Résonances," concerts.

◤ Outdoor Activities
Étang de l'Aubépin (lake) • Étangs des Dombes (lakes) • Walking: 4 marked trails.

⚘ Further Afield
• Villars-les-Dombes: bird sanctuary (11 miles/18 km).
• Ambérieu-en-Bugey: Château des Allymes (11 miles/18 km).
• Ambronay: abbey (13 miles/21 km).
• Lyon (22 miles/35 km).

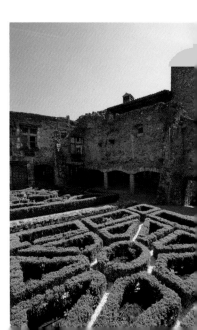

Piana

On Corsica—the Isle of Beauty

Corse-du-Sud (2A) • Population: 439 • Altitude: 1,437 ft. (438 m)

At the entrance to the magnificent Calanque de Piana ("Calanche" in Corsican), which is listed as a UNESCO World Heritage Site, stands Piana, looking down over the Gulf of Porto.

The site was inhabited intermittently from the late Middle Ages until the early 16th century, but the founding of the current village dates back to the 1690s. Twenty years later, the village had thirty-two households, and the Chapelle Saint-Pierre-et-Saint-Paul was built on the ruins of a medieval oratory. It was decided that another, larger church should be built. Completed in 1792, it was dedicated to Sainte-Marie. Its bell tower, which was finished in the early 19th century, is a replica of the one at Portofino, on the Ligurian coast. It was on the sandy beach at Arone, near Piana, on February 6, 1943, that the first landing of arms and munitions for the Corsican Maquis (Resistance fighters) took place, delivered by the submarine *Casabianca* from Algeria.

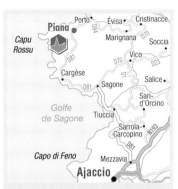

By road: D81 and D84.
By train: Ajaccio station (42 miles/68 km).
By sea: Ajaccio harbor (42 miles/68 km).
By air: Ajaccio-Campo Dell'Oro airport (44 miles/70 km); Calvi-Sainte-Catherine airport (49 miles/79 km).

(i) **Tourist information—**
L'Ouest Corse
+33 (0)9 66 92 84 42
www.ouestcorsica-tourisme.com

👁 Highlights
• **Church** (Baroque style): Polychrome wooden door, frescoes, miniature portraits by Paul-Mathieu Novellini: +33 (0)9 66 92 84 42.
• **Chapelle Sainte-Lucie** (hamlet of Vistale): Byzantine-style frescoes, view of the Gulf of Porto. Open July and August.
• **E Calanche di Piana:** UNESCO World Heritage Site: +33 (0)9 66 92 84 42.

⚔ Accommodation
Hotels
Capo Rosso****: +33 (0)4 95 27 82 40.
Mare e Monti***: +33 (0)4 95 28 82 14.
Les Roches Rouges***:
+33 (0)4 95 27 81 81.
Scandola***: +33 (0)4 95 27 80 07.
Les Calanques: +33 (0)4 95 27 82 08.
Guesthouses
Giargalo ♟♟: +33 (0)9 84 58 40 18.
Aparthotel
Marina d'Arone: +33 (0)6 18 97 93 37.
Campsites
Plage d'Arone: +33 (0)4 95 20 64 54.

🍴 Eating Out
Auberge U' Spuntinu: +33 (0)4 95 27 80 02.
Campanile: +33 (0)4 95 27 81 71.
Capo Rosso: +33 (0)4 95 27 82 40.
Casa Corsa: +33 (0)4 95 24 57 93.
Casabianca, Arone: +33 (0)4 95 20 70 40.
Le Casanova, pizzeria: +33 (0)4 95 27 84 20.
Chez Jeannette: +33 (0)4 95 27 81 73.
L'Onda, Arone: +33 (0)4 95 73 58 86.
La Plage, Arone: +33 (0)4 95 20 17 27.
Les Roches Rouges: +33 (0)4 95 27 81 81.
La Voûte: +33 (0)4 95 27 80 46.

2 Events
Good Friday: La Granitola procession.
July: Rencontres Interconfréries, Mass and procession (last Sunday).
July and August: Exhibitions.
August 15: Festival and procession.
All year round: Exhibition of photographs by André Kertész (town hall).

🏊 Outdoor Activities
Swimming • Walking • Mountain-biking.

🌿 Further Afield
• Calanche (2 miles/3 km).
• Scandola: nature reserve (6 miles/9.5 km, access by sea from Porto).
• Porto (7½ miles/12 km).
• Cargèse (12 miles/19 km).
• Gorges de la Spelunca: rocky trail (12 miles/19 km).
• Forêt d'Aitone, forest (19 miles/31 km).

Le Poët-Laval
On the roads to Jerusalem

Drôme (26) • Population: 957 • Altitude: 1,007 ft. (307 m)

Surrounded by lavender and aromatic plants, this village was once a commandery.

Le Poët-Laval, bathed in Mediterranean light, emerged from a fortified commandery of the order of the Knights Hospitaller, soldier-monks watching over the roads to Jerusalem. At the summit of the village, on a steep slope of the Jabron valley, stands the massive keep of the castle, built in the 12th century. Rebuilt twice, in the 13th and 15th centuries, and topped with a dovecote, it has now been restored and hosts permanent and temporary exhibitions. Of the Romanesque Saint-Jean-des-Commandeurs chapel, situated below the castle, there remains part of the nave and the chancel, topped by a bell gable, against which the fortifications surrounding the village were built. At the southwestern corner of the ramparts, the Renaissance façade of the Salon des Commandeurs harks back to the order's heyday in the 15th century, before the village rallied to Protestantism, as witnessed by the former Protestant church, now a museum, near the Grand Portail.

By road: Expressway A7, exit 17–Montélimar (22 miles/35 km).
By train: Montélimar station (16 miles/26 km). **By air:** Valence-Chabeuil airport (45 miles/72 km); Marseille-Provence airport (106 miles/171 km).

ⓘ Tourist information—Pays de Dieulefit-Bourdeaux: +33 (0)4 75 46 42 49
www.dieulefit-tourisme.com
www.lepoetlaval.org

👁 Highlights
• **Castle** (12th, 13th, and 15th centuries): Permanent exhibition on the reconstruction of the village and temporary exhibitions open April–October: +33 (0)4 75 46 44 12.
• **Centre d'Art Yvon Morin:** Exhibitions, concerts: +33 (0)4 75 46 49 38.
• **Musée du Protestantisme Dauphinois:** Old 15th-century residence that became a church in the 17th century; history of Protestantism in Dauphiné, from the Reformation to the present day; collections of contemporary mosaics: +33 (0)4 75 46 46 33.
• **Village:** Guided tour (€) Wednesday mornings July–August: +33 (0)4 75 46 42 49.

⚷ Accommodation
Hotels
Les Hospitaliers***: +33 (0)4 75 46 22 32.
Guesthouses
Ferme Saint-Hubert: +33 (0)4 75 46 48 71.
Le Mas des Alibeaux: +33 (0)4 75 46 35 59.
Le Mas des Vignaux: +33 (0)4 75 46 55 47.
Les Terrasses du Château: +33 (0)4 75 50 20 30.
Gîtes, walkers' lodges, and vacation rentals
Further information: +33 (0)4 75 46 42 49
www.dieulefit-tourisme.com
Campsites
Lorette**, May–September: +33 (0)4 75 91 00 62.

🍴 Eating Out
Chez So: +33 (0)4 75 53 45 02.
Les Hospitaliers: +33 (0)4 75 46 22 32.
Tous les Matins du Monde, in Gougne: +33 (0)4 75 46 46 00.

🛍 Local Specialties
Art and Crafts
Jewelry and clothing • Artists/galleries • Potters.

▣ Events
July: "Jazz à Poët" festival; three-day local saint's festival in Gougne (last weekend).
August: Les Musicales de Poët-Laval, chamber music (early August).

🦋 Outdoor Activities
Walking: Route GRP "Tour du Pays de Dieulefit," route GR 965: departure point of the Sentier International des Huguenots and 2 short marked trails • Horse-riding • Mountain-biking.

🌿 Further Afield
• Dieulefit: Maison de la Céramique (2½ miles/4 km).
• La Bégude-de-Mazenc: (4½ miles/7 km).
• Comps: 12th-century church; "Ruches du Monde" (beehives of the world) exhibition (6 miles/9.5 km).
• Rochefort-en-Valdaine: 10th-century castle; 14th-century chapel (9½ miles/15.5 km).
• Marsanne (13 miles/21 km).
• Grignan; Nyons (17–22 miles/27–35 km).
• *Mirmande (21 miles/34 km), see p. 111.
• Crest (23 miles/37 km).
• *La Garde-Adhémar (24 miles/39 km), see p. 94.

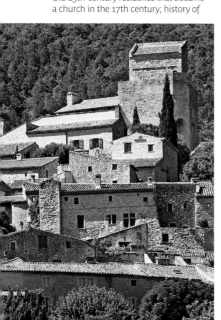

Pradelles
Taking the Stevenson Trail

Haute-Loire (43) • Population: 651 • Altitude: 3,796 ft. (1157 m)

Protecting pilgrims and mule-drivers on the Régordane Way, Pradelles was—in the 11th century—the "stronghold of the high pastures."

Overlooking the Haut Allier valley, with the Margeride mountains to the west, Mont Lozère to the south, and the Tanargue range to the east, Pradelles was for a long time a stronghold surrounded by ramparts. A stopping place on the Régordane Way linking the Auvergne to the Languedoc, the village was also a crossroads for pilgrims traveling to Le Puy-en-Velay or Saint-Gilles-du-Gard; for merchants bringing in salt, oil, and wines from the south by mule; and for armies and free companies (of mercenaries) transporting weapons and ammunition. Throughout the ages, Pradelles' high façades have thus seen generations of travelers as diverse as Saint Jean-François Régis who, in the 17th century, preached the Catholic faith in lands bordering the Cévennes, which had been won over by Protestantism; the 18th-century highwayman and popular hero Louis Mandrin; and, more recently, Robert Louis Stevenson, who, with his donkey, traveled the route that now bears his name.

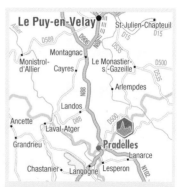

By road: Expressway A75, exit 20– Le Puy-en-Velay (60 miles/97 km), then N102-N88.
By train: Langogne station (4½ miles/ 7 km); Puy-en-Velay station (21 miles/ 34 km).
By air: Clermont-Ferrand-Auvergne airport (95 miles/153 km).

ⓘ Tourist information—
Gorges de l'Allier: +33 (0)4 71 00 82 65
www.gorges-allier.com

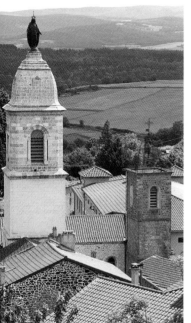

👁 Highlights
• Musée du Cheval de Trait (draft-horse museum; in summer): Miniature village, 19th-century horse-drawn carts and carriages, multimedia show recounting the travels of Robert Louis Stevenson, stables: +33 (0)4 71 00 87 87.
• Village: Guided tour by appointment only: +33 (0)4 71 00 82 65.

🐎 Accommodation
Hotels
Le Ponant**: +33 (0)4 71 00 85 20.
Gîtes, communal gîtes, walkers' lodges, and vacation rentals
Further information: +33 (0)4 71 00 82 65 or +33 (0)4 71 00 85 74.
Holiday villages
La Valette**: +33 (0)4 71 00 85 74.
Campsites and RV parks
Le Rocher du Grelet**: +33 (0)4 71 00 85 74.
RV park: +33 (0)4 71 00 82 65.

🍴 Eating Out
L'Auvergnat Gourmand:
+33 (0)4 71 07 60 62.
Aux Légendes: +33 (0)4 71 00 88 00.
Brasserie du Musée: +33 (0)4 71 00 87 88.
La Ferme de Livarat: +33 (0)4 71 02 91 69.
Le Renaissance: +33 (0)4 71 02 47 03.
Resto Rando: +33 (0)4 71 09 49 71.

🧺 Local Specialties
Food and Drink
Salted meats and fish.

📅 Events
August: Procession of floral floats to celebrate local saint's day (15th).

🦋 Outdoor Activities
Hunting • Fishing • Swimming pool • Horse-riding • Donkey hire • Walking: Routes GR 70 (Stevenson Trail), GR 470 (Sources et Gorges de l'Allier), and GR 700 (Régordane Way); marked trails • Vélorail (pedal-powered railcars) • Mountain-biking.

🌿 Further Afield
• Langogne: Lac de Naussac, watersports base (4½ miles/7 km).
• Lanarce: L'Auberge Rouge, (Red Inn) (5 miles/8 km).
• Lac de Coucouron, lake (7½ miles/12 km).
• *Arlempdes (11 miles/18 km), see p. 84.
• Lac du Bouchet, lake; Devès, volcanic field (12–22 miles/19–35 km).
• Lac d'Issarlès, lake; Mont Gerbier-de-Jonc; Mont Mézenc, (16–28 miles/26–45 km).
• Cascade de la Beaume, waterfall (16 miles/26 km).
• Le Puy-en-Velay (22 miles/35 km).

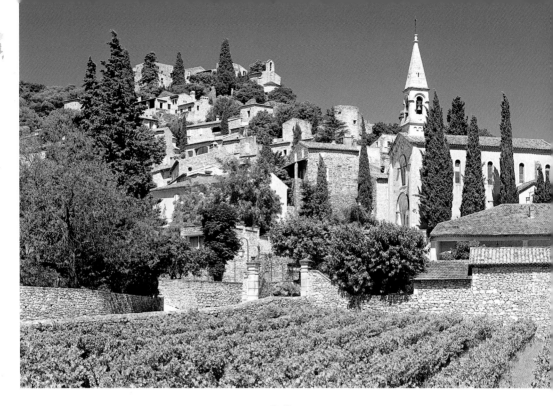

La Roque-sur-Cèze

Stone, vines, and water

Gard (30) • Population: 178 • Altitude: 295 ft. (90 m)

Surrounded by *garrigue* scrubland, La Roque-sur-Cèze has established itself on a rocky slope overlooking the Cèze river and surrounding vineyards.

Past the Pont Charles-Martel with its twelve arches, along steep, winding, cobbled streets, lies an endless jumble of buildings, rooftops, and covered terraces, whose sun-weathered stone walls and Genoese tiles give them a Tuscan feel. When you reach the top of the village, after a certain amount of physical exertion, the ruins of the 12th-century castle and its Romanesque chapel are reminders of the strategic position that the site enjoyed in the Middle Ages on the Roman road leading from Nimes to Alba. Presenting a sharp contrast with the serenity and aridity of the village are the dramatic waterfalls, rapids, and crevices of the Cascades du Sautadet, including the magnificent "giants' cauldrons"—cylindrical cavities, some of them huge, cut into the Cèze; they require great caution but offer a refreshing place to relax in the wilderness.

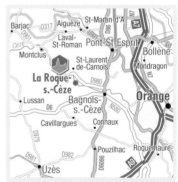

By road: Expressway A7, exit 19–Bollène (17 miles/28 km); expressway A9, exit 22–Roquemaure (19 miles/31 km); N86 (6 miles/9.5 km). **By train:** Bollène-La Croisière station (15 miles/24 km); Avignon TGV station (29 miles/47 km). **By air:** Avignon-Caumont airport (32 miles/51 km); Nîmes-Alès-Camargue-Cévennes airport (50 miles/80 km).

(i) Tourist information—
Provence Occitane: +33 (0)4 66 82 30 02
www.provenceoccitane.com
www.laroquesurceze.fr

Le Mas du Bélier:
+33 (0)4 66 82 21 39.
Pizzeria Camping Les Cascades:
+33 (0)4 66 82 08 42.
Wine and Food: +33 (0)4 66 79 08 89.

🛍 Local Specialties
Food and Drink
AOC Côtes du Rhône wines.

🗓 Events
May: "En mai fais ce qu'il te plait,"
month-long festival of food, wine,
and nature.
Mid-August: Jam fair.
Throughout the summer: Concerts
and entertainment as part of "Les Arts
de la Voix" festival.

🦋 Outdoor Activities
Walking and mountain-biking •
Swimming • Canoeing • Fishing.

🌿 Further Afield
• Chartreuse de Valbonne, monastery
(3½ miles/5.5 km).
• Cornillon; Goudargues (5 miles/8 km).
• Pont-Saint-Esprit (6 miles/9.5 km).
• Bagnols-sur-Cèze: market (7½ miles/
12 km).
• Gorges of the Cèze (9½ miles/15.5 km).
• *Montclus (9½ miles/15.5 km), see p. 113.
• *Aiguèze (11 miles/18 km), see pp. 80–81.
• *Lussan (12½ miles/20 km), see p. 109.
• Méjannes-le-Clap: Grotte de la
Salamandre (14 miles/23 km).
• Barjac: market (15 miles/24 km).
• Gorges of the Ardèche; Aven d'Orgnac,
sinkhole; Vallon-Pont-d'Arc (19–25 miles/
31–40 km).
• Uzès (19 miles/31 km).
• Orange (22 miles/35 km).
• Pont du Gard, Roman aqueduct
(25 miles/40 km).
• Avignon (27 miles/43 km).

👁 Highlights
• **Village:** Guided tour by arrangement:
+33 (0)4 66 82 30 02.
• **Church (10th century):** restored in 2013,
contemporary stained-glass windows.
• **Chapelle du Presbytères:** exhibitions.

🗝 Accommodation
Guesthouses
Les Oliviers: +33 (0)6 23 09 17 09.
Gîtes and vacation rentals
Further information: +33 (0)4 66 82 30 02
www.provenceoccitane.com
Campsites
Les Cascades*****: +33 (0)4 66 82 72 97.
La Vallée Verte****: +33 (0)4 66 79 08 89.

🍴 Eating Out
L'Auberge des Cascades, in summer:
+33 (0)4 66 50 80 98.
Le Bistrot de la Roque, in summer:
+33 (0)4 66 82 78 60.
Cèze Grand Rue: +33 (0)4 66 82 08 42.
Chez Piou, open-air café/restaurant
(summer only): +33 (0)4 66 82 77 72.
Enfin Voilà l'Été (summer only):
+33 (0)6 68 02 89 26.

Roussillon

The flame of the Luberon

Vaucluse (84) • Population: 1348 • Altitude: 1,066 ft. (325 m)

Sparkling with colors in its verdant setting, Roussillon, north of Marseille, is a jewel in its ocher surroundings.

In Roman times, the ocher of Mont Rouge was transported to the port of Marseille, and from there it was shipped to the East. Taking over from silk farming, which was responsible for the village's rise in fortunes from the 14th century, the ocher industry developed in the late 18th century thanks to a local man, Jean-Étienne Astier, who devised the idea of extracting the pigment from the sands. Since then, Roussillon has built its reputation on this brightly colored mineral. Today, ocher presents visitors with an almost infinite palette in every narrow street and on house fronts, and can be seen, too, in its natural setting, on the ocher trail, with its spectacular sites sculpted by water, wind, and humankind. On the Place de la Mairie, a lively meeting place for both locals and visitors, the Hôtel de Ville and the houses facing it date from the 17th century.

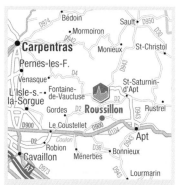

By road: Expressway A7, exit 24–Avignon sud (23 miles/37 km); expressway A51, exit 18–La Brillanne (34 miles/55 km), D900 (16 miles/26 km). **By train:** Cavaillon station (19 miles/31 km); Avignon TGV station (32 miles/51 km). **By air:** Avignon-Caumont airport (25 miles/40 km); Marseille-Provence airport (54 miles/87 km).

ⓘ **Tourist information:**
+33 (0)4 90 05 60 25
www.luberon-apt.fr
www.roussillon-provence.fr

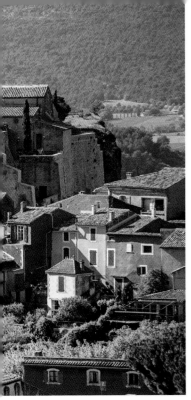

- Sentier des Ocres (ocher trail): July and August, 9 a.m.–7.30 p.m.; off-season: +33 (0)4 90 05 60 16.

Accommodation

Hotels
La Clé des Champs***: +33 (0)4 90 05 63 22.
Le Clos de la Glycine***: +33 (0)4 90 05 60 13.
♥ Hôtel les Ambres***: +33 (0)4 90 05 65 46.
♥ La Maison des Ocres***: +33 (0)4 90 05 60 50.
♥ Les Sables d'Ocre***: +33 (0)4 90 05 55 55.
Guesthouses
Le Clos des Cigales: +33 (0)4 90 05 73 72.
La Lavandine: +33 (0)4 90 05 63 24.
La Mauderle: +33 (0)4 90 05 61 14.
Les Passiflores +33 (0)4 90 71 43 08.
Poterie de Pierroux: +33 (0)4 90 05 68 81.
La Villa des Roses: +33 (0)4 90 04 98 20.
Gîtes and vacation rentals
Further information: +33 (0)4 90 05 60 25
www.luberon-apt.fr
Campsites
Arc-en-Ciel***: +33 (0)4 90 05 73 96.

Eating Out

Le Bistrot: +33 (0)4 90 05 74 45.
Le Café des Couleurs: +33 (0)4 90 05 62 11.
Le Castrum, crêperie: +33 (0)4 90 05 62 23.
Chez Nino: +33 (0)4 90 74 29 17.
David: +33 (0)4 90 05 60 13.
L'Escalier: +33 (0)4 90 74 11 92.
La Grappe de Raisin: +33 (0)4 90 71 38 06.

Highlights

- **Conservatoire des Ocres:** Guided tour on the manufacture, geology, and heritage of ocher; workshops and courses. +33 (0)4 90 05 66 69.

L'Ocrier: +33 (0)4 90 05 79 53.
Le Piquebaure: +33 (0)4 90 05 79 65.
Le P'tit Gourmand: +33 (0)4 90 71 82 58.
La Sirmonde: +33 (0)4 90 75 70 41.
La Treille: +33 (0)4 90 05 64 47.

Local Specialties

Food and Drink
Olive oil • Fruit juices • AOC Côtes du Luberon and Côtes du Ventoux wines.
Art and Crafts
Candles • Ceramicists • Ocher-based crafts • Interior designers • Fossils and minerals • Art galleries • Artists • Sculptors.

Events

Market: Thursday mornings, Place du Pasquier.
June: Saint-Jean des Couleurs, Les Vieux Tracteurs (old tractors; exhibition and country fair).
July: Beckett festival (late July).
July–August: Outdoor film festival.
August: String quartet festival.
September: Le Livre en Fête, book fair.
November: Salon du Livre et de l'Illustration Jeunesse (books and illustrations for children fair, late November).

Outdoor Activities

Walking: Routes GR 6 and 97, and 4 marked trails • Hot-air balloon flights.

Further Afield

- Apt (6 miles/9.5 km).
- *Gordes (6 miles/9.5 km), see pp. 98–99.
- Luberon, region (6–12 miles/9.5–19 km).
- *Ménerbes (11 miles/18 km), see p. 110.
- *Lourmarin (14 miles/23 km), see pp. 107–8.
- *Venasque (15 miles/24 km), see pp. 145–46.
- L'Isle-sur-la-Sorgue (17 miles/27 km).
- Cavaillon (19 miles/31 km).
- *Ansouis (21 miles/34 km), see pp. 82–83.

Did you know?

Raymond d'Avignon, lord of Roussillon, having neglected his wife, Sermonde, to go off hunting, discovered she was enjoying the company of the troubadour Guillaume de Cabestan. In a jealous rage, Raymond killed his wife's lover, tore out his heart, and fed it to Sermonde, before revealing to her the nature of the dish. In despair, the lady threw herself from the cliff top. And this is why, it is said, the cliffs of Roussillon have been blood red ever since.

Saint-Antoine-l'Abbaye

Miracles in medieval Dauphiné

Isère (38) • Population: 1,039 • Altitude: 1,247 ft. (380 m)

Deep in a verdant valley surrounded by the Vercors massif, the Abbaye Saint-Antoine watches over the village that bears its name.

The history of Saint-Antoine-l'Abbaye began in the 11th century, when Geilin, a local lord, brought back from his pilgrimage to the Holy Land the relics of Saint Anthony of Egypt, who was believed to have performed many miracles. In around 1280, building started on the abbey that was to house these famous relics, which were said to have the power to cure "Saint Anthony's Fire," a poisoning of the blood that was treated by the Hospitallers (who had settled in the village after chasing out the Benedictines) in their institutions. The Wars of Religion brought this prosperous period of pilgrimages to an end. Reconstruction work undertaken in the 17th century has enabled visitors to admire the abbey—considered to be one of the most remarkable Gothic buildings in the Dauphiné region—and its rich interior. At the foot of this mighty building, the village bears living witness to the medieval and Renaissance eras: noblemen's houses built in the 15th–18th centuries from *molasse* stone and featuring mullioned windows link—via *goulets* (half-covered narrow streets)—with old shops with half-timbered façades and the medieval covered market.

By road: Expressway A49, exit 9–Saint-Marcellin (8 miles/13 km); expressway A48, exit 9–La Côte-Saint-André (26 miles/42 km).
By train: Saint-Marcellin station (8 miles/13 km); Romans station (15 miles/24 km).
By air: Grenoble-Saint-Geoirs airport (19 miles/31 km); Lyon-Saint-Exupéry airport (63 miles/101 km).

ⓘ Tourist information—Saint-Marcellin Vercors Isère: +33 (0)4 76 38 53 85
www.saintmarcellin-vercors-isere.fr
www.saint-antoine-labbaye.fr

👁 Highlights
• **Abbey church** (12th–15th centuries): Murals, Aubusson tapestries, wood paneling, 17th-century organ: +33 (0)4 76 38 53 85.
• **Abbey treasury:** Liturgical vestments, surgical instruments, antiphonaries, 17th-century ivory Christ, one of the largest reliquaries in France: +33 (0)4 76 38 53 85.
• **Musée de Saint-Antoine-l'Abbaye** (museum of the Isère *département*): Housed in 17th- and 18th-century convent buildings; exhibitions on the Hospitallers of Saint-Antoine, therapeutic perfumes, and the history of the gardens; temporary exhibitions: +33 (0)4 76 36 40 68.
www.musee-saint-antoine.fr
• Jardin Médiéval de l'Abbaye (medieval garden): In the Cour des Grandes Écuries, four symmetrical gardens filled with luxuriant plants, herbs, flowers, and fruit trees, together with a fountain and pools: +33 (0)4 76 36 40 68.
www.musee-saint-antoine.fr

• **Chapelle Saint-Jean-le-Fromental** (12th century): wall paintings; open weekends and holidays in summer; guided tour for groups by reservation, nominal donation: +33 (0)6 33 58 92 53.
• **Stonemason's workshop:** Housed in the abbey's old infirmary; a presentation of building construction techniques in the Middle Ages, with demonstrations: +33 (0)4 76 36 44 12.
• **Village:** Self-guided discovery trail, "Le Sentier du Flâneur" (leaflet available from tourist information center); guided tours all year round for groups and April–October for individuals: +33 (0)4 76 38 53 85.

⚓ Accommodation
Hotels
Chez Camille: +33 (0)4 76 36 86 98.
Guesthouses
L'Antonin***: +33 (0)4 76 36 41 53.
Mme Philibert***: +33 (0)4 76 36 41 65.
Domaine Mäel: +33 (0)6 63 52 95 05.
La Grange du Haut:
+33 (0)4 76 64 30 74.

Philibert Patricia: +33 (0)6 11 96 74 26.
La Voureyline: +33 (0)4 76 36 05 91.
Treehouses
Les Cabanes de Fontfroide:
+33 (0)4 76 36 46 84.
Gîtes and vacation rentals
Les Genets*** and **: +33 (0)4 76 36 43 81.
La Rosée des Petites Choses***:
+33 (0)6 48 83 83 07.
Mme Nivon**: +33 (0)4 76 40 79 40.
Chez Anik: +33 (0)6 84 46 48 70.
Le Dictambule: +33 (0)6 64 02 68 00.
La Grange du Haut: +33 (0)4 76 64 30 74.
Jean-Marc Renevier: +33 (0)4 76 64 91 65.
Les Reynauds: +33 (0)6 72 22 18 19.
Community accommodation
Communauté de l'Arche:
+33 (0)4 76 36 45 97.

🍴 Eating Out
L'Auberge de l'Abbaye:
+33 (0)4 76 36 42 83.
L'Auberge du Chapeau Rouge:
+33 (0)4 76 36 45 29.
Le Belier Rouge: +33 (0)9 67 49 54 82.
Chez Camille: +33 (0)4 76 36 86 98.

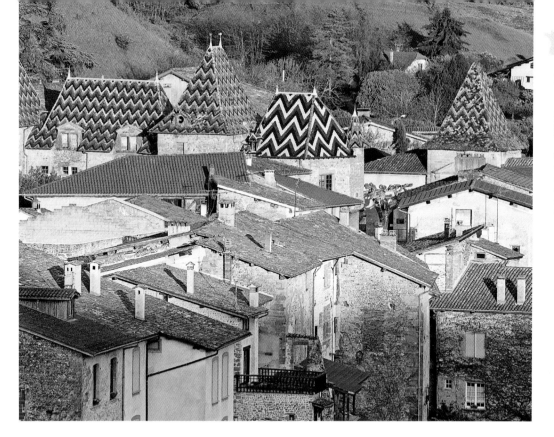

Goûts du Safran, La Calèche:
+33 (0)4 76 64 12 77.
Hostellerie du Vieux Saint-Antoine:
+33 (0)4 76 64 26 19.
Mon Manège à Moi, pizzeria:
+33 (0)4 76 36 40 53.
Les Tentations d'Antoine:
+33 (0)4 76 36 71 77.

Local Specialties

Food and Drink
Honey, mead, hippocras, *pain d'épice* (spice cake) • Fruit wines • Teas.
Art and Crafts
Jewelry designer • Ready-to-wear clothing designer • Cabinetmaker • Potter • Bookbinder • Stonemason and sculptor in stone • Milliner • Painter and mixed-media artist • Antique-furniture restorer • Local artists' galleries and studios.

Events

Market: Local produce and crafts market, May–October, Friday 4–7 p.m., Place de la Halle.

January: Fête de la Truffe and Marché des Tentations, truffle festival (Sunday after 17th).
May: Rare flower and plant fair (3rd Sunday).
June: "Pig'halle," concerts.
Late June–late September: Sacred music festival (organ recitals Sundays at 5 p.m. in the abbey church).
July: "Textes en l'Air" festival, contemporary theater (last week).
August: Saint-Antoine en Moyen Âge (medieval festival, early August); antiques, secondhand goods, and collectors' fair (2nd Sunday).
October: Foire à l'Ancienne et aux Potirons, local produce and pumpkin fair (4th Sunday).
December: "Noël des Tentations": Christmas fair with local produce and crafts (2nd weekend).

Outdoor Activities

Miripili, l'Île aux Pirates theme park, Étang de Chapaize • Walking and mountain-biking.

Further Afield

• La Sône: Jardin des Fontaines Pétrifiantes (exotic plants, rocks, and water; closed from mid-October to May 1); Royans-Vercors paddle steamer (7½ miles/12 km).
• Saint-Marcellin (8 miles/13 km).
• Pont-en-Royans: Musée de l'Eau, water museum; "suspended" houses (14 miles/23 km).
• Romans: Musée de la Chaussure, shoe museum; collegiate church of Saint-Barnard (14 miles/23 km).
• Parc Naturel Régional du Vercors, nature park (14 miles/23 km).
• Grotte de Choranche, cave (16 miles/26 km).
• Hauterives: Postman Cheval's Palais Idéal, naive architecture (19 miles/31 km).

Saint-Guilhem-le-Désert

Romanesque architecture and wilderness

Hérault (34) • Population: 250 • Altitude: 292 ft. (89 m)

At the bottom of a wild gorge, Saint-Guilhem surrounds its abbey, one of the finest examples of Romanesque architecture in the Languedoc.

A stopping place on the Saint James's Way, Saint-Guilhem was, in the Middle Ages, a center of Christianity, where believers, Crusaders, and pilgrims came to pray and to venerate a piece of the True Cross. Although little remains of the original abbey, founded by Saint Guilhem in the 9th century, the present church is a gem of Romanesque architecture, listed as a UNESCO World Heritage Site. The heart of the village is the delightful Place de la Liberté. There is an impressive plane tree, more than 150 years old; fountains dating from 1907; and an old 17th-century covered market with arches, making the square a magical place where people like to gather to enjoy the cool evenings on café terraces. Huddled together along the main streets, sturdy houses, with their sun-weathered façades and traditional pink barrel-tiled roofs, are adorned with double Romanesque windows, Gothic lintels, and Renaissance mullions.

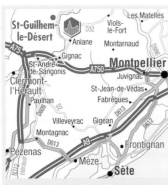

By road: Expressway A75, exit 59–Gignac-Font d'Encauvi (8 miles/13 km).
By train: Montélimar TGV station (27 miles/43 km).
By bus: LiO 668 Hérault Transport from Mosson tram station, Montpellier.
By air: Montpellier and Béziers airports (both 37 miles/60 km).

ⓘ **Tourist information:**
+33 (0)4 67 56 41 97
www.saintguilhem-valleeherault.fr
www.saint-guilhem-le-desert.com

⊚ Highlights
• **Abbaye de Gellone:** Abbey church of the 11th, 12th, and 15th centuries; treasury: +33 (0)4 67 57 58 83.
• **Musée Lapidaire de l'Abbaye:** Collection of Romanesque and Gothic sculpture, remains of the cloister (restored); film on the history of the abbey and its rebuilding (April–October), by appointment for groups: +33 (0)6 98 04 74 72.
• **Musée d'Antan:** History of the village and its traditional trades: +33 (0)4 67 57 77 07.
• **Village:** Daily tours for groups and by appointment: +33 (0)4 67 57 00 03.

⚷ Accommodation
Hotels
Le Guilhaume d'Orange: +33 (0)4 67 57 24 53.
La Taverne de l'Escuelle: +33 (0)4 67 57 72 05.
Guesthouses
Le Lieu Plaisant: +33 (0)4 67 58 07 61.
Gîtes and vacation rentals
Alain Duverge**: +33 (0)4 67 57 40 22.
Lucette Diez: +33 (0)4 67 22 42 70.
Walkers' lodges, group accommodation
CAF: +33 (0)6 89 77 17 59.

Gîte de la Tour: +33 (0)4 67 29 51 25.
Gîte des Lavagnes: +33 (0)4 67 88 60 99.
Gîte Saint-Elie: +33 (0)4 67 57 75 80.
La Maison des Légendes: +33 (0)6 85 39 73 70.
Further information: +33 (0)4 67 57 70 17
www.saint-guilhem-le-desert.com

⊕ Eating Out
Chez Barmy: +33 (0)4 99 65 25 59.
O'Bistrot: +33 (0)4 67 57 33 99.
L'Oustal Fonzes: +33 (0)4 67 57 39 85.
Le Petit Jardin: +33 (0)4 67 57 35 18.
La Source: +33 (0)6 59 29 56 34.
Sur le Chemin: +33 (0)4 99 63 93 71.
La Table d'Aurore: +33 (0)4 67 57 24 53.
La Taverne de l'Escuelle: +33 (0)4 67 57 72 05.
Vent de Soleil, light meals: +33 (0)4 67 57 78 85.

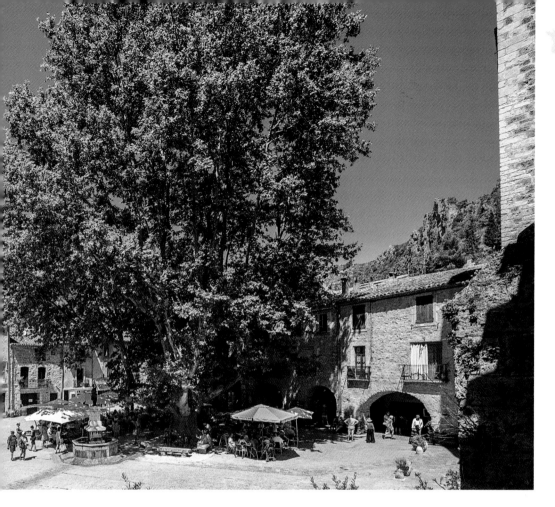

Crêperies and tea rooms
Crêperie Gellone: +33 (0)4 67 57 75 05.
Isaluc, tea room: +33 (0)6 85 34 43 96.
Le Logis des Pénitents, crêperie:
+33 (0)4 67 57 48 63.
Le Musée d'Antan, tea room:
+33 (0)4 67 57 77 07.

🏛 Local Specialties
Food and Drink
Olives and olive oil • Dessert grapes • Wine.
Art and Crafts
Painters • Potters • Sculptors • Perfumers •
Santon (crib figure) makers.

🗓 Events
March–September: Music season and
heures d'orgues (organ recitals), theater,
exhibitions, secondhand book fair.
December: Christmas concert (abbey
church).

🦋 Outdoor Activities
Swimming • Fishing • Canoeing • Walks
for all levels • Caving.

🌿 Further Afield
• Pont du Diable, bridge; listed house with
wine cellar and Provençal farmhouse
(2 miles/3 km).
• Grotte de Clamouse, cave (2 miles/3 km).
• Saint-Jean-de-Fos: Argileum, pottery
workshop (2½ miles/4 km).
• Clermont-l'Hérault, historic clothmaking
town (15½ miles/25 km).
• Cirque de Mourèze, dolomitic rock
formations; Lac de Salagou, lake
(16 miles/26 km).

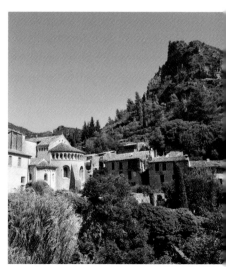

Saint-Véran

"Where hens peck at the stars"

Hautes-Alpes (05) • Population: 235 • Altitude: 6,699 ft. (2,042 m)

The highest inhabited village in Europe—hence its motto, "where hens peck at the stars"—Saint-Véran lies at the heart of the Queyras regional nature park.

As Saint-Véran has been accessible by road for little more than a century, the inhabitants had plenty of time to learn to pull together in this extreme environment (altitude of 6,699 ft./2,042 m). They battled floods, avalanches, and fires; and worked shale and larch in the Queyras to build the *fustes* and *casets* (traditional dwellings that shelter animal fodder and livestock under protruding roofs). They also smelted copper, carved wood, tapped the water from the hillsides for their fountains, and harnessed the sun's rays for their brightly colored sundials. Moreover, they devised both winter and summer tourism, which capitalizes on the great outdoors while respecting their traditions. The mission crosses, erected in tribute to missionaries who came to convert this Queyras backwater, symbolize the area's fervent religious belief and practice, and form part of its heritage.

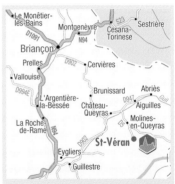

By road: Expressway A32, exit 12–Oulx Circonvalazzione (50 miles/80 km); N94 (35 miles/56 km).
By train: Montdauphin-Guillestre station (24 miles/39 km); Briançon station (30 miles/48 km).
By air: Marseille-Provence airport (162 miles/261 km).

ⓘ Tourist information—Queyras: +33 (0)4 92 45 82 21
www.queyras-montagne.com
www.saintveran.com

👁 Highlights

• **Church** (17th century): Stone lions, font.
• **Copper mine:** Exhibition and discovery tour at the old communal oven at Les Forannes.
• **Maison Traditionnelle:** Traditional house, inhabited and shared with animals until 1976; preserved (furniture, everyday objects, clothes): +33 (0)4 92 45 82 39.
• **Musée Le Soum:** The oldest house in the village (1641); discover village life and traditions in bygone days: +33 (0)4 92 45 86 42.
• **Observatory** (alt. 9,633 ft./2,936 m): Tour of the dome and its equipment, discovery evenings; further information, Saint-Véran Culture Développement: +33 (0)6 60 31 23 33.
• **Maison du Soleil:** Complex dedicated to solar observation, interactive experiences, themed visits, educational workshops, and seasonal activities: +33 (0)4 92 45 83 91.
• **Village:** Guided tour for groups only, by reservation. Further information: +33 (0)4 92 23 58 21.

🗝 Accommodation

Hotels
L'Alta Peyra****: +33 (0)4 92 22 24 00.
Les Chalets du Villard***: +33 (0)4 92 45 82 08.
Le Grand Tétras**: +33 (0)4 92 45 82 42.
La Baïta du Loup, gîte-hotel: +33 (0)4 92 54 00 12.
Guesthouses
Cascavelier: +33 (0)4 92 45 88 31.
Gîtes and vacation rentals
Le Berger Gourmand: +33 (0)6 16 33 16 81.
Le Chant de l'Alpe: +33 (0)6 79 31 07 57.
Further information: +33 (0)4 92 45 82 21
www.queyras-montagne.com
Vacation resort
Ville de Saint-Ouen: +33 (0)1 49 45 77 56.
Walkers' lodges
Auberge Coste Belle: +33 (0)4 92 45 82 17.
Auberge L'Estoilies: +33(0)4 92 45 82 65.
La Baïta du Loup: +33 (0)4 92 54 00 12.
Le Chalet des Routiers: +33 (0)4 75 02 01 12.
Le Chant de l'Alpe: +33 (0)4 92 54 22 41.
Les Gabelous: +33 (0)4 92 45 81 39.
Les Perce-Neige: +33 (0)4 92 45 82 23.
Mountain refuges
Refuge de la Blanche (alt. 8,202 ft./2,500 m): +33 (0)4 92 45 80 24 or +33 (0)6 46 32 88 35.
Auberge L'Estoilies: +33(0)4 92 45 82 65.
RV parks (June–September): +33 (0)4 92 45 83 91.

🍴 Eating Out

Auberge Coste Belle: +33 (0)4 92 45 82 17.
La Baïta du Loup: +33 (0)4 92 54 00 12.
Le Bistro d'en Ô: +33 (0)4 92 22 24 00.
Le Bouticari: +33 (0)4 92 45 89 20.
Les Chalets du Villard—La Gratinée: +33 (0)4 92 45 82 08.
Le Chef: +33 (0)4 92 22 24 00.
Chez Pascal: +33 (0)4 92 20 54 82.
La Fougagno: +33 (0)4 92 45 86 39.
Le Grand Méchant Loup: +33 (0)4 92 51 08 30.
Le Grand Tétras: +33 (0)4 92 45 82 42.
La Marmotte: +33 (0)4 92 45 84 77.
Refuge de la Blanche: +33 (0)6 46 32 88 35.
Le Roc Alto: +33 (0)4 92 22 24 00.

🧺 Local Specialties

Food and Drink
Queyras honey.
Art and Crafts
Craft courses (plant collecting, lace-making, weaving, knitting) • Cutler-blacksmith • Wood-carvers.

📅 Events

February–early March: Tasting workshops, snowshoe outings, torchlit descents, and many other events.

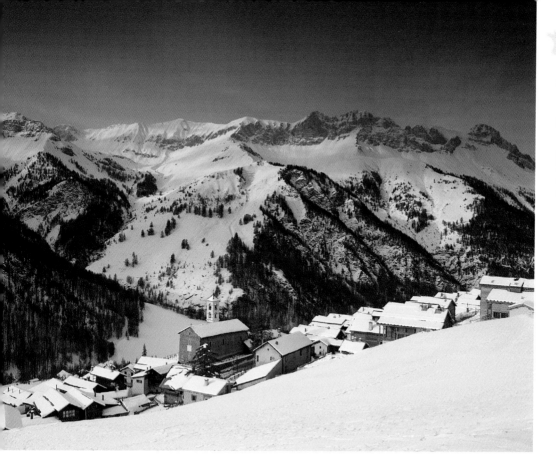

July: Franco-Italian pilgrimage to Clausis chapel (16th); Saint Anne's day at Raux (Sunday nearest 26th); La Risoul Queyras GrandFondo cyclosportive (last Sunday); "Fête des Traditions" festival.
July–August: Sale of bread baked at the communal oven; star-gazing tours.
August: "Saint-Véran en Musique," concerts.

Outdoor Activities

Climbing • Forest adventure course • Fishing • Walking • Pack-donkey or packhorse rides • Skiing: Alpine, cross-country, ski touring, snowshoeing • Mountain-biking.

Further Afield

• Château-Queyras (8½ miles/13.5 km).
• Aiguilles; Abriès (10–13 miles/16–21 km).

• Col d'Agnel and the Italian border (12 miles/19 km).
• Guillestre; Mont-Dauphin (24 miles/39 km).
• Col de l'Izoard (30 miles/48 km).
• Briançon (30 miles/48 km).

Did you know?

In the old days, using wood as a fuel for heating caused many fires. To prevent blazes from ripping through the village, the inhabitants carved up their settlement into five distinct areas, each separated from the others by open spaces in which building was prohibited. This created small neighborhoods that still exist today. Each neighborhood had its own bread oven and fountain—made up of a circular part, used as an animal drinking trough, and a rectangular part acting as a laundry area. Each neighborhood also worshiped separately in its own chapel and with its own mission cross.

Sainte-Agnès
A balcony over the Mediterranean

Alpes-Maritimes (06) • Population: 1,191 • Altitude: 2,559 ft. (780 m)

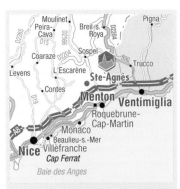

Perched nearly 2,600 ft. (800 m) in the air, the highest coastal village in Europe has an amazing panorama over the Mediterranean from Cap-Martin to the Italian Riviera.

Sainte-Agnès is a strategic site that has been fought over for centuries. It was initially a fortified Roman camp, then the site of a defensive castle built in the 12th century by the House of Savoie, and in 1932–38 its fort was dug out of the rock to become the most southerly post on the Maginot Line, built to defend the Franco-Italian border. Today the village is valued for its unique location away from the crowds and concrete of the coast. The village has an authentic feel, with its crisscrossing alleyways (some of which recall the tales of Saracen inhabitants), old cobblestones, secret vaults, and higgledy-piggledy houses. The lofty ruins of the fortified castle now contain a medieval garden designed on the theme of courtly love. From its highest point, a 360-degree panorama gives the viewer a superb contrast between the blue Mediterranean and, in winter, the snowy peaks of the Mercantour National Park.

By road: Expressway A8, exit 59–Menton (6 miles/9.5 km).
By train: Menton station (6 miles/9.5 km).
By air: Nice-Côte-d'Azur airport (26 miles/42 km).

ⓘ Tourist information—
Menton, Riviera et Merveilles:
+33 (0)4 93 35 84 58
www.sainteagnes.fr

👁 Highlights
• Espace Culture et Traditions: Local heritage museum, archeology, painting, and sculpture: +33 (0)4 93 28 35 31.
• Maginot Line fort: 6,500 sq. ft. (2,000 sq. m) of galleries, multimedia exhibition: +33 (0)6 88 75 70 89.
• Église Notre-Dame-des-Neiges (16th century): Gilded wooden altar, 16th-century stone font, 17th-century statue of Saint Agnes, 16th- and 18th-century paintings, chandeliers from Monaco Cathedral.
• Castle site: Tour of the ruins and medieval garden.
• Village: Guided tour in summer by Menton, Riviera & Merveilles tourist information center.

🔑 Accommodation
Hotels
Le Saint-Yves: +33 (0)4 93 35 91 45.
Private gîtes
+33 (0)4 93 35 84 58 / www.sainteagnes.fr

🍴 Eating Out
Le Logis Sarrasin: +33 (0)4 93 35 86 89.
Le Righi: +33 (0)4 92 10 90 88.
Le Saint-Yves: +33 (0)4 93 35 91 45.

🧺 Local Specialties
Art and Crafts
Leather and cloth crafts • Painter • Master glassblower.

📅 Events
January: Mass and procession for Saint Agnes's day.
May 1: Walking rally.
July: Fête de la Lavande.

🐎 Outdoor Activities
Treasure hunt • Mountain-biking • Horse-riding • Walking.

🌿 Further Afield
• Hilltop villages of Castellar, Gorbio, Peille (3–12 miles/5–19 km).
• Menton (7 miles/11.5 km).
• Monaco (12 miles/19 km).
• *Coaraze (24 miles/39 km), see p. 93.
• Nice (27 miles/43 km).

🛈 Did you know?
A princess named Agnès was once caught in a torrential storm. She prayed to her namesake, Saint Agnes, who showed her a grotto in which to shelter. In gratitude, she decided to build a sanctuary dedicated to the saint near this grotto, around which the present village grew up. There is now a military outwork on the site of this chapel, and an oratory next to the fort. Saint Agnes's day is celebrated on January 21.

Sainte-Croix-en-Jarez

A monastery reborn as a village

Loire (42) • Population: 450 • Altitude: 1,378 ft. (420 m)

Sainte-Croix-en-Jarez has taken root in a former Carthusian monastery, with the Pilat regional nature reserve as a backdrop. Driven out during the Revolution, the monks made way for the villagers, and the former monks' cells subsequently housed a school, a town hall, and dwellings. The monastic church, which has decorated paneling, contains a reproduction of Andrea Mantegna's famous painting the *Martyrdom of Saint Sebastian*, as well as outstanding 15th-century carved stalls. A restored and furnished cell, the iron grille forged in 1692; the clock tower, its fortified façade altered in the 17th century; the cloisters; and the grand staircase all similarly remain intact from the old monastery. In the hamlet of Jurieu, the village also boasts a 12th-century chapel and the megalithic site of Roches de Marlin.

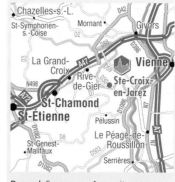

By road: Expressway A47, exit 11–Rive-de-Gier (7½ miles/12 km). **By train:** Rive-de-Gier station (5 miles/8 km); Saint-Etienne station (19 miles/31 km). **By air:** Saint-Étienne-Bouthéon airport (29 miles/47 km); Lyon-Saint-Exupéry airport (39 miles/63 km).

ⓘ **Tourist Information:** +33 (0)4 77 20 20 81
www.chartreuse-saintecroixenjarez.com

👁 Highlights
• **Former charterhouse** (13th century): Bakery, Brothers' court, cloisters, medieval church with 14th-century wall paintings, parish church, Fathers' court, kitchen, cells; hanging garden, covered paths. General and themed guided visits for groups and individuals. Further information: +33 (0)4 77 20 20 81.

🗡 Accommodation
Hotels
Le Prieuré: +33 (0)4 77 20 20 09.
Guesthouses
Le Clos de Jeanne ✤✤✤:
+33 (0)4 77 54 82 28.
La Rose des Vents: +33 (0)4 77 20 29 72.
Gîtes
Le Chant du Ruisseau***:
+33 (0)4 77 20 20 86.
L'Elixir ♦♦♦: +33 (0)4 77 20 20 81.

🍴 Eating Out
Le Cartusien: +33 (0)4 77 20 29 72.
Le Prieuré: +33 (0)4 77 20 20 09.

🧺 Local Specialties
Food and Drink
Charcuterie • Cheese • Honey • Beers.
Art and Crafts
Basketry • Local crafts (shop and information point).

📅 Events
March–November: Art exhibitions, family events, creative workshops.
Pentecost: Traditional fair.
June: "Festin Musical," music festival.
July–September: Music events; nighttime tours.
September: "Les Musicales," classical music festival.
December: Provençal nativity scene and Christmas activities.

🦋 Outdoor Activities
Fishing • Walking: 3 marked trails • Mountain-biking.

🌿 Further Afield
• Monts du Pilat (14 miles/23 km).
• Saint-Étienne (19 miles/31 km).
• Lyon (29 miles/47 km).

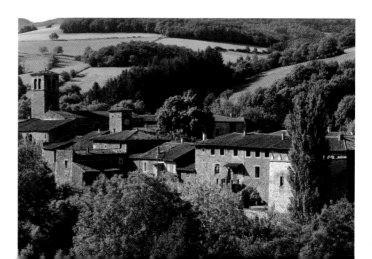

Sainte-Énimie
Amid the wonders of the Tarn Gorges

Lozère (48) • Population: 548 • Altitude: 1,591 ft. (485 m)

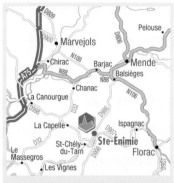

The Merovingian princess Énimie gave her name to the village: legend has it that she was cured of leprosy in spring waters here.

The village is encircled by the cliffs of the limestone plateaus of Sauveterre and Méjean, through which the Tarn has gouged its gorges. Sainte-Énimie retains its distinctive steep alleyways, massive limestone residences that evoke its prosperous past, and half-timbered workshops and houses. The Romanesque church of Notre-Dame-du-Gourg contains some splendid statues from the 12th and 15th centuries. At the top of the village, the chapel of Sainte-Madeleine and a chapter house are all that remain of a Benedictine monastery. At its feet flows the Burle river, which is supposed to have healing properties, and several paths lead to the cell to which Saint Énimie retreated. From here, there is a superb view of the village and the spectacular scenery of the Tarn, Jonte, and Causses gorges, all listed as UNESCO World Heritage Sites.

By road: Expressway A75, exit 40–La Canourgue (17 miles/28 km); N88 (12 miles/19 km); N106 (2½ miles/4 km).
By train: Mende station (17 miles/27 km).
By air: Rodez-Marcillac airport (65 miles/105 km); Nîmes-Arles-Camargue airport (94 miles/151 km).

ⓘ Tourist information—Cévennes-Gorges du Tarn: +33 (0)4 66 45 01 14
www.cevennes-gorges-du-tarn.com

👁 Highlights
• Église Notre-Dame-du-Gourg (13th–14th centuries): Statues, notable artifacts.
• Refectory known as the "salle capitulaire" (12th century).
• Chapelle Sainte-Madeleine (13th century).
• Hermit's hut: Semi-troglodyte hut over the natural grotto (45 minutes' walk from the village); viewpoint.
• Village: Self-guided tour, heritage discovery trail available from tourist information center; guided evening tour at 9.30 p.m., Mondays and Wednesdays in July–August; tour with forge demonstration Thursdays in July–August: +33 (0)4 66 45 01 14.

🗝 Accommodation
Hotels
Auberge du Moulin***:
+33 (0)4 66 48 53 08.
Auberge de la Cascade**:
+33 (0)4 66 48 52 82.
Le Chante-Perdrix**: +33 (0)4 66 48 55 00.
Bleu Nuit: +33 (0)4 66 48 50 01.
Burlatis: +33 (0)4 66 48 52 30.
Guesthouses, gîtes, walkers' lodges, and vacation rentals
Further information: +33 (0)4 66 45 01 14
www.cevennes-gorges-du-tarn.com

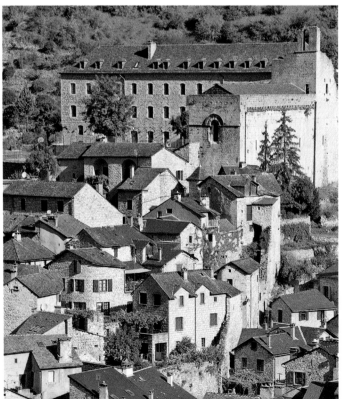

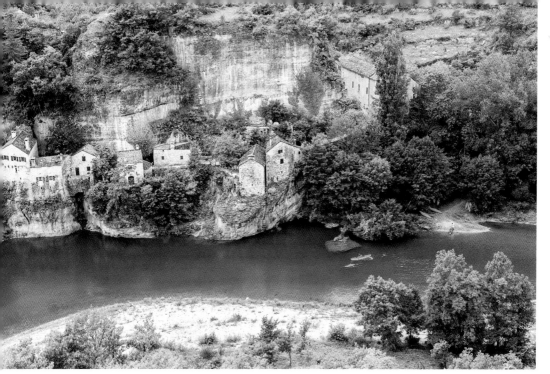

Campsites
Couderc***: +33 (0)4 66 48 50 53.
Nature et Rivière***: +33 (0)4 66 48 57 36.
Les Gorges du Tarn*: +33 (0)4 66 48 59 38.
Le Site: +33 (0)4 66 48 58 08.

🍴 Eating Out
Auberge de la Cascade:
+33 (0)4 66 48 52 82.
Auberge du Moulin: +33 (0)4 66 48 53 08.
Au Vieux Moulin, pizzeria:
+33 (0)4 66 48 58 04.
Aux Petits Galets: +33 (0)9 82 37 70 57.
Le Bel Été: +33 (0)4 66 48 18 24.
La Calabrèse, pizzeria: +33 (0)4 66 31 67 90.
Les Deux Sources, pizzeria:
+33 (0)4 66 48 53 87.
L'Eden: +33 (0)4 66 45 66 71.
Les Gorges du Tarn: +33 (0)4 66 48 50 10.
La Halle au Blé: +33 (0)4 66 48 59 34.
Le Pêcheur de Lune, crêperie:
+33 (0)4 66 48 58 12.
Restaurant du Nord: +33 (0)4 66 48 53 46.
La Tendelle: +33 (0)4 66 47 48 87.

🧺 Local Specialties
Food and Drink
Lozère and local wines • Cheese •
Charcuterie.
Art and Crafts
Jeweler • Potter.

📅 Events
June: cartoon and book festival; music
festival.
July: Pottery market; fireworks (14th).
July–August: Concerts, theater,
exhibitions; evening market (Thursdays);
medieval shows (Tuesdays).
October: Village fête and pilgrimage
(1st Sunday).

🦋 Outdoor Activities
Canoeing, canyoning • Caving • Fishing •
Swimming • Climbing • Adventure park •
Via Ferrata and Via Cordata • Horse-
riding • Walking • Mountain-biking.

🌿 Further Afield
• Causse de Sauveterre, plateau: Utopix;
Boissets farm (5 miles/8 km).
• Causse Méjean: Dargilan caves and Aven
Armand cave (4½–11 miles/7–18 km).
• Parc National des Cévennes, national
park (6 miles/9.5 km).

🗎 Did you know?
Énimie was the daughter of Chlothar II
(584–629) and the sister of Dagobert I
(603–639), both Frankish kings. She was the
founder of the monastery whose remains
can still be seen at the top of the village.

Sant'Antonino

In the skies over the Balagne

Haute-Corse (2B) • Population: 113 • Altitude: 1,624 ft. (495 m)

From its eagle's nest high above the Balagne, Sant'Antonino surveys the Mediterranean and Corsica's mountains.

Although the Chapelle de la Trinité outside the village was built in the 12th century, families began to settle here only in the 15th century. They fused their homes together in the rock so that they became a protective wall to withstand invaders. The houses are so tightly packed that there was not enough space to build churches. Only the Chapelle Sainte-Anne is in the village itself; all the others, including the Chapelle de la Trinité and the parish church of L'Annonciade, were built in a meadow outside the village. Sant'Antonino is one of Corsica's oldest villages, with origins reputedly dating back to the 9th century. Stone reigns supreme here: in the tall façades of houses gripping the granite; in cobblestones mingling with rock in narrow, winding alleyways; in vaulted passageways leading to the old castle ruins. From here you can see right across the plain and the olive-planted hills of the Balagne, all the way to the shining sea. In a secluded spot on the former threshing ground at the foot of the village, the Baroque church of L'Annonciade houses an organ by the Italian artist Giovanni Battista Pomposi, dating from 1744.

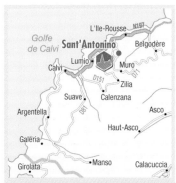

By road: N197 (6 miles/9.5 km). **By boat:** L'Île Rousse port (7½ miles/12 km). **By air:** Calvi-Sainte-Catherine airport (12 miles/19 km).

ⓘ Tourist information—Calvi Balagne: +33 (0)4 95 05 16 67
https://balagne-corsica.com

📅 Events

June: Corsican shepherd songs.
July: Religious festival at Notre-Dame-des-Grâces.
August: Fête de Saint Roch; concert.

🪶 Outdoor Activities

Donkey rides • Walking: 3 marked trails • Mountain-biking.

🌿 Further Afield

• Cateri (2½ miles/4 km).
• Lavatoggio (3 miles/5 km).
• Pigna (3 miles/5 km).
• Lumio (7 miles/11 km).
• Aregno; Corbara; L'Île-Rousse (10 miles/16 km).
• Calvi (11 miles/18 km).

👁 Highlights

• Église de l'Annonciade (17th century): 18th-century organ, historic paintings.
• Chapelle de la Trinité (12th century).

🗝 Accommodation

Gîtes and vacation rentals
Further information: +33 (0)4 95 65 16 67
https://balagne-corsica.com

🍽 Eating Out

A Casa Corsa: +33 (0)4 95 47 34 20.
A Stalla: +33 (0)4 95 61 33 74.
Le Bellevue: +33 (0)4 95 61 73 91.
U Lazzu, light meals: +33 (0)6 43 11 72 08.
I Scalini: +33 (0)4 95 47 12 92.
U Spuntinu, light meals:
+33 (0)6 12 96 94 43.
La Taverne Corse: +33 (0)4 95 61 70 15.
La Voûte, pizzeria: +33 (0)4 95 61 74 71.

🏛 Local Specialties

Food and Drink
Almonds • Citrus fruits • Jams • Wines, muscats • Olive oil • Corsican charcuterie and cheeses.
Art and Crafts
Jeweler • Potter.

🛈 Did you know?

Sant'Antonino was founded in the early 9th century by Guido Savelli, the lieutenant of Count Ugo Colonna, who conquered the Moors and took Corsica. The Savellis were a warrior family who were notorious for their independent spirit: during the Genoese occupation they invited the occupiers to a banquet just so that they could massacre them. Similarly, during the siege of Calvi, Savelli refused to surrender the village, even after seeing his son killed before his own eyes.

Séguret

The vineyards of Montmirail

Vaucluse (84) • Population: 945 • Altitude: 886 ft. (270 m)

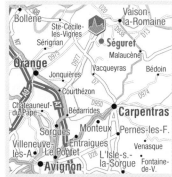

With a front-row seat, Séguret overlooks the Rhône valley from the foot of the Dentelles de Montmirail mountain chain.

On a hillside dominated by its medieval castle tower, Séguret rises above a landscape of vineyards. Inhabited since prehistoric times and improved in the Gallo-Roman era, the village proper was built in the 10th–12th centuries. Until the French Revolution it was a papal state, then rejoined France in 1792. Its heritage is considerable: winding streets, cobblestones, the Reynier Gate, the 15th-century belfry, the Romanesque Saint-Denis church (12th–13th centuries), the chapel of Notre-Dame-des-Grâces (17th century), and the Mascarons fountain (17th century). The Place des Arceaux and the Place de l'Église command marvelous views over the Comtat plain, as far as the Rhône and the Cévennes rivers. The village has great respect for its traditions, and every Christmas celebrates the Bergié, a mystery play that has been handed down orally from generation to generation since the Middle Ages.

👁 Highlights
• Chapelle Notre-Dame-des-Grâces (17th century): By appointment only: +33 (0)4 90 46 91 08.
• Chapelle Sainte-Thècle (18th century): Exhibition of paintings and *santons* (crib figures): +33 (0)4 90 36 02 11.
• Église Saint-Denis (12th–13th century): By appointment only: +33 (0)4 90 46 91 08.
• Village: Signposted walk.

🗝 Accommodation
Hotels
♥ Domaine de Cabasse***: +33 (0)4 90 46 91 12.
La Bastide Bleue: +33 (0)4 90 46 83 43.
Guesthouses
Amour Provence: +33 (0)4 90 46 89 39.
Bouquet de Séguret: +33 (0)4 90 28 13 83.
Maison Sadina: +33 (0)6 71 91 44 25.
Patios des Vignes: +33 (0)4 90 65 47 96.
Le Vieux Figuier: +33 (0)4 90 46 84 38.
Gîtes and vacation rentals
Further information: +33 (0)4 90 67 32 64
www.vaison-ventoux-tourisme.com

🍴 Eating Out
La Bastide Bleue: +33 (0)4 90 46 83 43.
Côté Terrasse: +33 (0)4 90 28 03 48.
L'Églantine, tea room: +33 (0)4 90 46 81 41.
Le Mesclun: +33 (0)4 90 46 93 43.
Ô Cavo, wine bistro: +33 (0)6 65 09 58 92.
La Pause Gourmande, light meals: +33 (0)6 78 15 74 42.
La Table de Cabasse: +33 (0)4 90 46 91 12.

🧺 Local Specialties
Food and Drink
AOC Côtes du Rhône and local wines • Olive oil.
Art and Crafts
Pottery • Santons (crib figures) • Art gallery • Sculptor • Jeweler • Painter.

📅 Events
Market: Daily 5 p.m. to 8 p.m. May–September (car park 2).
July: Local saint's day (3rd weekend).
July–August: "Musiques à Séguret," music festival (July–August); book fair (August 15); harvest festival (end August).
December: "Bergié de Séguret," mystery play (24th); Journée des Traditions, heritage fair (3rd Sunday).
December–January: *Santons* (crib figures) exhibition.

By road: Expressway A7, exit 22–Orange Sud (14 miles/23 km).
By train: Orange TGV station (12 miles/19 km); Avignon TGV station (29 miles/47 km).
By air: Avignon airport (33 miles/53 km); Marseille airport (71 miles/114 km).

ⓘ Tourist information—Pays de Vaison Ventoux: +33 (0)4 90 36 02 11 or +33 (0)4 90 67 32 64
www.vaison-ventoux-tourisme.com
www.seguret.fr

🏹 Outdoor Activities
Hunting • Fishing • Cycle routes • Climbing in the Dentelles de Montmirail • Botanical trail • Walking: Route GR 4.

🌿 Further Afield
• Dentelles de Montmirail, chain of mountains (3 miles/5 km).
• Vaison-la-Romaine (5 miles/8 km).
• Orange (14 miles/23 km).
• Carpentras (14 miles/23 km).
• *Venasque (21 miles/34 km), see pp. 145–46.
• Avignon (25 miles/40 km).
• Mont Ventoux (25 miles/40 km).
• *La Garde-Adhémar (25 miles/40 km), see p. 94.

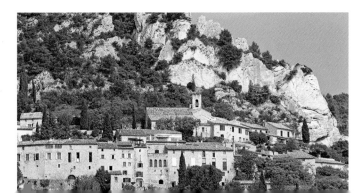

Seillans

Tradition and innovation in a Provençal village

Var (83) • Population: 2,561 • Altitude: 1,201 ft. (366 m)

From below, Seillans looks like a huge staircase, its tall façades scaling the slope in steps.

Gathered at the top, as if on a throne, are the Sarrasine Gate, a medieval castle, a former priory of monks from Saint-Victor Abbey in Marseille, and the 11th-century church of Saint-Léger. Inside its three consecutive walls, Seillans is a patchwork of light and shade, an enticing maze of paved streets still echoing to the sound of horse hooves, steeply sloping cobbled alleys, vaulted passageways, and shady corners in which fountains tinkle musically. On the square at the entrance to the village stands the statue "Génie de la Bastille" by Max Ernst (1891–1976), a permanent reminder that he fell so in love with Seillans that he moved here with his wife, Dorothea Tanning, and used to enjoy playing *pétanque* with the locals on this very spot. In the valley below, where pines, olive trees, and vineyards jostle for space, the chapel of Notre-Dame-de-l'Ormeau protects an altarpiece unique in Provence. The village welcomes artists and craftspeople to its silk farm and old cork factory, emblems of its past economic life, and also spotlights events that celebrate artistic expertise and innovation.

By road: Expressway A8, exit 39– Les Adrets-de-l'Estérel (13 miles/21 km). **By train:** Arcs-Draguignan TGV station (19 miles/31 km); Saint-Raphaël-Valescure TGV station (22 miles/35 km). **By bus:** 3601 from Saint-Raphaël bus station (25 miles/40 km) and 3001 from Grasse bus station (20 miles/32 km). **By air:** Nice-Côte-d'Azur airport (40 miles/64 km).

ⓘ Tourist information:
+33 (0)4 94 76 85 91
www.paysdefayence.com / www.seillans.fr

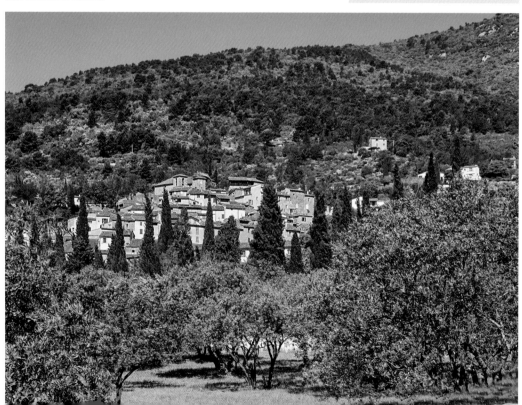

👁 Highlights
• **Chapelle Notre-Dame-de-l'Ormeau** (12th century): Provençal Cistercian building; 16th-century polychrome wood-carved altarpiece, unique in Provence. Tours all year round by appointment for groups 5+, Thursdays 11.15 a.m.: +33 (0)4 94 76 85 91.
• **Max Ernst, Dorothea Tanning, and Stan Appenzeller Collections:** In the Maison Waldberg (mid-13th-century mansion), a collection of lithographs by surrealist artists Max Ernst and Dorothea Tanning, made while the couple lived in Seillans; a collection of works by artist Stanislas Appenzeller (1901–1980). Guided tours all year round for groups of 5+ by appointment: +33 (0)4 94 76 85 91.
• **Village:** Guided tours, Thursdays, 10 a.m. all year round, for groups of 5+, by reservation: +33 (0)4 94 76 85 91.

🔑 Accommodation
Hotels
♥ Les Deux Rocs***: +33 (0)4 94 76 87 32.
Guesthouses
M. and Mme Alendra: +33 (0)4 89 53 06 11.
La Magnanerie de Seillans:
+33 (0)4 94 50 83 56 or +33 (0)6 20 13 73 67.
La Maison des Lavandes:
+33 (0)6 21 79 71 60 or
+33 (0)6 44 02 21 84.
Le Mas de Combelongues:
+33 (0)9 82 12 15 04 or +33 (0)6 24 77 20 23.
Gîtes, vacation rentals, and vacation centers
Further information: +33 (0)4 94 76 85 91
www.paysdefayence.com
Rural campsite
Le Rouquier: +33 (0)4 94 76 86 71 or
+33 (0)6 88 18 00 05.
RV park
Further information: +33 (0)4 94 76 85 91.

🍴 Eating Out
Bar Charlot, light meals:
+33 (0)4 94 76 40 82.
Chez Hugo: +33 (0)4 94 85 54 70.
Les Deux Rocs: +33 (0)4 94 76 87 32.
La Gloire de Mon Père +33 (0)4 94 76 98 68.
Pepperoni and Co, pizzeria, snack bar:
+33 (0)4 94 68 15 85.
Tilleul Citron, tea room:
+33 (0)4 94 50 47 64.

🧺 Local Specialties
Food and Drink
Honey • AOC Côtes de Provence wine • Olive oil • Farm produce • Goat cheese • Institut Gastronomique (cookery courses).
Art and Crafts
Art galleries and studios • Ceramicist •

Wrought ironwork • Figurine maker and history painter • Engraver • Model-maker • Leather craftsman • Painters • Beadmaker • Soap-maker • Silk screening • Sculptor.

📅 Events
Market: Wednesday mornings, 8 a.m.–12.30 p.m.
February: Cycle tour, Haut Var (last weekend).
March: Marché Gourmand, gourmet market (1st Sunday).
May: "Salon de Mai," art exhibition; art and crafts, and local produce market.
May–June: "Les Rencontres de la Photographie et de l'Image," photography exhibition.
July: Feast day of Saint Cyr and Saint Léger (last weekend).
August: "Aïoli des Selves" (1st weekend); "Musique Cordiale," music festival (1st fortnight); pottery market (15th); art and crafts market.
September: Art and crafts market.
September–October: Provençal heritage and history exhibition (mid-September–mid-October).
October: "Musique en Pays de Fayence," music festival (last week).
November: Fête de l'Olive, olive festival (last weekend); Christmas market (last Sunday).
December: Christmas exhibition, craft fair, and "13 Desserts" (Provençal dessert tasting), animated Nativity scene.

🦋 Outdoor Activities
Sports park with multisports area • *Pétanque* • Horse-riding • Swimming pool (July–August) • Walking: 15 marked trails.

🦋 Further Afield
• Pays de Fayence, region: hilltop villages (3–12 miles/5–19 km).
• Gorges of the Siagnole (9½–12 miles/15.5–19 km).
• Lac de Saint-Cassien, lake (12 miles/19 km).
• Grottes de Saint-Cézaire, caves (19 miles/31 km).
• *Bargème (21 miles/34 km), see p. 86.
• Draguignan (22 miles/35 km).
• Grasse (22 miles/35 km).
• La Corniche d'Or, coastal drive; Saint-Raphaël; Fréjus (24 miles/39 km).
• *Tourtour (27 miles/43 km), see pp. 142–43.
• Les Gorges du Verdon, gorges (31 miles/50 km).

Semur-en-Brionnais

Cluny history in Burgundy

Saône-et-Loire (71) • Population: 649 • Altitude: 1,299 ft. (396 m)

Birthplace of Saint Hugh, one of the great abbots at the powerful monastery of Cluny, Semur is the historic capital of the Brionnais region, in the depths of Burgundy.

Founded on a rocky spur, in the 10th century Semur-en-Brionnais became a defensive site ruled by the counts of Chalon. The Château Saint-Hugues is considered one of the oldest fortresses in Burgundy, and its keep is intact. Inside, a collection of posters evokes the French Revolution, during which time the guards' rooms functioned as a prison. The Romanesque church dedicated to Saint Hilaire was erected by Geoffroy V in the 12th and 13th centuries. Its gate shows the saint defending the Catholic orthodoxy against Arians at the Council of Seleucia. Inside, the triple elevation of the nave and the corbeled gallery are directly inspired by Cluny. The chapter house, founded in 1274 by Jean de Châteauvillain, provides information about the Romanesque style in the Brionnais. The main square contains the 18th-century law courts (now the town hall), 16th-century men-at-arms' houses, and the salt store, whose ceiling is decorated with allegorical paintings. The rampart walk still exists, as does the postern gate. Nestled in the valley, the 11th-century church of Saint-Martin-la-Vallée is decorated with 14th-century wall paintings.

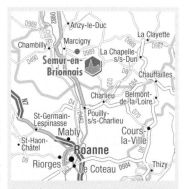

By road: Expressway A6, exit 33–Balbigny (36 miles/58 km); N79 (12 miles/19 km); expressway A89, exit 5.1–Balbigny (40 miles/64 km), then N82-N7 (18 miles/29 km).
By train: Paray-le-Monial station (17 miles/27 km); Le Creusot-Montceau TGV station (49 miles/79 km).
By air: Lyon-Saint-Exupéry airport (79 miles/127 km).

ⓘ Tourist information—
Marcigny-Sémur-en-Brionnais:
+33 (0)3 85 25 13 57
www.brionnais-tourisme.fr
www.chateau-semur-en-brionnais.fr

👁 Highlights

• ♥ **Château Saint-Hugues** (10th century): Keep, towers, medieval warfare room; French Revolution poster collection; family tree of Hugh of Semur, abbot of Cluny: +33 (0)3 85 25 13 57.
• **Collegiate church of Saint-Hilaire** (12th–13th centuries): Important Romanesque church; polychrome wood statues.
• **Église Saint-Martin-la-Vallée** (11th–12th centuries): 15th–16th-century wall paintings.
• **Maison du Chapitre:** Hall with ceiling and fireplace painted late 16th century; exhibition about local Romanesque art.
• **Salt store:** Building where salt tax was paid; ceiling decorated with allegorical paintings from end of 16th century.
• **Former law courts** (now the town hall) (18th century): Louis XVI-style building.
• **Saint-Hugues priory:** Chapel, reception hall (exhibition).
• **Village:** Various guided tours for groups, March–November. Further information: "Les Vieilles Pierres" association: +33 (0)3 85 25 13 57.

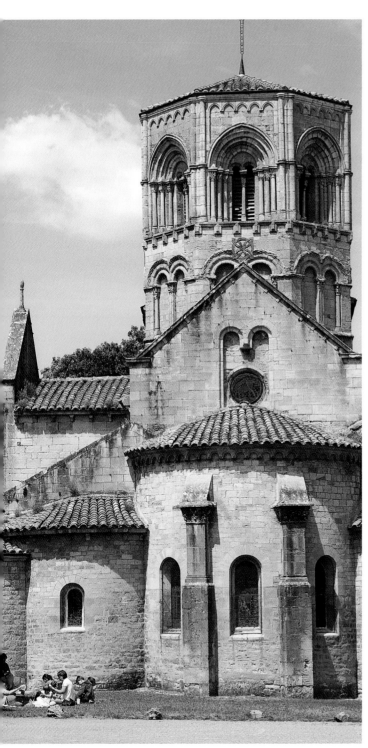

🗝 Accommodation
Guesthouses
Maison Guillon Kopf: +33 (0)3 85 81 55 59.
Gîtes
Belle Vue***, farm accommodation:
+33 (0)6 42 70 03 89.
M. Lorton: +33 (0)3 85 25 36 63.

🍽 Eating Out
L'Entrecôte Brionnaise:
+33 (0)3 85 25 10 21.

🧺 Local Specialties
Food and Drink
Brionnais wines.
Art and Crafts
Monastic crafts.

📅 Events
May–October: Exhibitions in the salt
store.
July: La Madeleine, patron saint's day
(1st weekend after 14th).

🦋 Outdoor Activities
Walking • Mountain-biking.

🦋 Further Afield
• Marcigny: museums and exhibitions
(3 miles/5 km).
• Voie Verte, picturesque greenway
(3 miles/5 km).
• Saint-Christophe-en-Brionnais:
cattle market (5 miles/8 km).
• Romanesque churches in Brionnais
region: Anzy-le-Duc, Iguerande,
Montceaux-l'Étoile, Saint-Julien-de-Jonzy
(6–9½ miles/9.5–15.5 km).
• Charlieu: abbey (12 miles/19 km).
• Paray-le-Monial (16 miles/26 km).
• Château de Drée (16 miles/26 km).
• Roanne (20 miles/32 km).

🛈 Did you know?
In 1024 Hugh was born at Semur castle;
he later became the sixth chief abbot
of the Cluniac order. For 60 years, until
his death, he led the order of more than
10,000 monks across the Christian world.
He also built the great abbey church, sadly
destroyed after the French Revolution,
which was the largest church in all
Christendom before the construction
of Saint Peter's in Rome.

Tourtour

In the skies above Provence

Var (83) • Population: 593 • Altitude: 2,133 ft. (650 m)

Perched on a plateau soaring above Provence, with vineyards to the south and lavender to the north, Tourtour exudes the perfume of thyme and olive trees.

Tourtour was fortified in the early Middle Ages to protect itself from frequent Saracen attacks. From this long-distant and precarious past, it still has some fortifications and its street plan, in which streets encircle the old castle. The narrow alleyways of the medieval village boast buildings of old stone and curved tiles, and they accommodate a traditional oil mill and a fascinating fossil museum. Alleyways, steps, and vaulted passageways are dotted with fountains, refreshing passersby exhausted by the sun. Intertwined streets surround the two castles—a medieval one with two towers, and a 17th-century one with four towers. The church stands high above both village and landscape; built in the 11th century and restored in the 19th, it provides an exceptional view of inland Provence, from Sainte-Baume and Mont Sainte-Victoire as far as the Maures massif and the Mediterranean.

By road: Expressway A8, exit 36–Draguignan (20 miles/32 km), N555 (11 miles/18 km); expressway A51, exit 18–Valensole (41 miles/66 km). **By train:** Draguignan station (13 miles/21 km). **By air:** Toulon-Hyères airport (58 miles/93 km); Nice-Côte d'Azur airport (66 miles/106 km).

ⓘ Tourist information—Lacs et Gorges du Verdon: +33 (0)4 94 76 35 47
www.lacs-gorges-verdon.fr

👁 Highlights
• **Église Saint-Denis** (11th century): Summer concerts.
• **Traditional olive mill:** In operation November–February; art exhibitions mid-May–mid-September.
• **Musée des Fossiles:** Collection of ammonites and local fossils (especially dinosaur eggs).
• **Town hall:** Sculptures by Bernard Buffet (1928–1999) of giant insects and permanent exhibition of drawings by Ronald Searle (1920–2011) at the town gallery.
• **Village:** Guided tours of the village, mill, and museum for groups all year round by appointment: +33 (0)4 94 70 59 47.

🗝 Accommodation
Hotels
La Bastide de Tourtour**** and spa: +33 (0)4 98 10 54 20.
Le Mas des Collines: +33 (0)4 94 70 59 30.
La Petite Auberge: +33 (0)4 98 10 26 16.
Guesthouses
Campagne Saint-Pierre: +33 (0)9 67 19 17 77.
Le Colombier: +33 (0)4 94 70 53 93.
Maison de la Treille: +33 (0)6 15 17 37 64.
Villa Pharima: +33 (0)6 23 74 41 67.

Gîtes
Further information: +33 (0)4 94 76 35 47
www.lacs-gorges-verdon.fr

🍴 Eating Out
L'Aléchou, crêperie: +33 (0)4 94 70 54 76.
La Bastide de Tourtour: +33 (0)4 98 10 54 20.
La Farigoulette: +33 (0)4 94 70 57 37.
Le Mas des Collines: +33 (0)4 94 70 59 30.
La Mimounia, Moroccan cuisine: +33 (0)4 94 47 67 89.
Les Ormeaux, bar: +33 (0)4 94 70 57 07.
La Petite Auberge: +33 (0)4 98 10 26 16.
Les Pins Tranquilles: +33 (0)4 94 50 40 39.
La Place, pizzeria: +33 (0)4 94 84 32 13.
Le Relais de Saint-Denis: +33 (0)4 94 70 54 06.
La Table, gourmet restaurant: +33 (0)4 94 70 55 95.

🏺 Local Specialties
Food and Drink
Organic produce (fruit, vegetables, fruit juice) • Olive oil.
Art and Crafts
Gifts • Art galleries and artists' studios • Fashion.

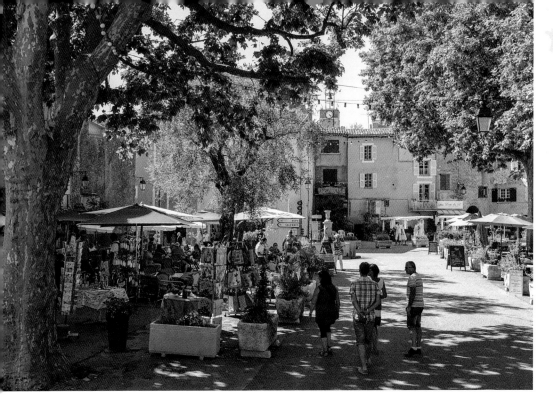

② Events

Market: Small Provençal market, Wednesday and Saturday mornings.
February: "Roustide," olive oil festival.
Easter: "Fête de l'Œuf," Easter festival (Sunday and Monday).
June–September: Exhibitions at the oil mill.
July: "Courts, Courts," short-film festival (last weekend); Journées des Galeries, art fair.
August: Village fair, ball (1st Sunday).
July–August: "Piano dans le Ciel," music festival.
October: Saint Denis's feast day.
December: Christmas market.
December–January: "La Pastorale," Nativity play.

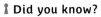 Outdoor Activities

Boules area • Walking and mountain-biking • Horse-riding.

Further Afield

• Villecroze: park, caves, and waterfalls (4½ miles/7 km).
• Salernes; Sillans-la-Cascade; Cotignac; Bargemon; Draguignan; Châteaudouble: gorges (7–18 miles/11.5–29 km).
• Lac de Sainte-Croix, lake (18 miles/ 29 km).
• Le Thoronet Abbey, Sainte-Roseline chapel (19 miles/31 km).
• *Seillans (27 miles/43 km), see pp. 138–39.
• *Bargème (29 miles/47 km), see p. 86.
• Le Grand Canyon du Verdon (31 miles/ 51 km).

⌑ Did you know?

Two statues by French artist Bernard Buffet can be seen in Tourtour, in front of the town hall.

Usson

A gilded cage for Queen Margot

Puy-de-Dôme (63) • Population: 263 • Altitude: 1,772 ft. (540 m)

On the fringes of the regional nature park of Livradois-Forez, Usson perches on a volcanic mound and surveys the vast panorama of the mountains of Puy de Dôme, Mont Dore, and Cézallier. The village, overshadowed by a statue of the Virgin, used to be overlooked by an impressive castle. After improvements by Jean de Berry and restoration work by Louis XI in the late 15th century, the castle of Usson housed the exiled Queen Margaret (1553–1615), known as Margot—sister of Charles IX and foolish young wife of the future Henri IV. She eloped with her lover, the equerry Jean d'Aubiac, but they were discovered at Ybois; her lover was executed and Margaret was held at Usson. She remained there for nineteen years, leading both a courtly and religious life. Behind the village's basalt façades remain parts of its triple surrounding walls flanked by towers, which were destroyed under Cardinal Richelieu (1585–1642). The Église Saint-Maurice, Romanesque in origin, was extended in the 16th century with the addition of the Queen's Chapel, under whose starry vault Margaret prayed. South of this building, a path leads to the village's impressive basalt columns and to a summit that towers above the village.

By road: Expressway A75, exit 13–Sauxillanges (6 miles/9.5 km). **By train:** Issoire station (7½ miles/12 km); Clermont-Ferrand station (26 miles/42 km). **By air:** Clermont-Ferrand-Auvergne airport (29 miles/47 km).

ⓘ Tourist information—Pays d'Issoire: +33 (0)4 73 89 15 90
www.issoire-tourisme.com

👁 Highlights
• **Église Saint-Maurice** (12th–16th centuries): 17th-century tabernacle, statues, paintings: +33 (0)4 73 71 05 90.
• **Basalt columns:** Above the village.
• **Old forge:** Restored with all its tools (e.g. hearth, bellows, anvil).
• **Village:** Guided tour of the village and church for groups by reservation: +33 (0)4 73 89 15 90.
• **Exhibition on the history and culture of Usson** (at the Usson tourist office): +33 (0)4 73 71 05 90.

🗝 Accommodation
Hotels
Auberge de Margot: +33 (0)4 73 71 97 92.
Gîtes
De Deux Choses Lune: +33 (0)6 84 77 58 38.
La Maison du Tilleul: +33 (0)4 73 71 07 74.
Jean-Claude Millot: +33 (0)7 62 89 15 04.
Bernard Moing: +33 (0)4 73 71 00 71.
Jean-Claude Roux: +33 (0)4 73 96 80 69.
Gérard Serre: +33 (0)4 73 96 84 88.

🍴 Eating Out
Auberge de Margot: +33 (0)4 73 71 97 92.

🛍 Local Specialties
Art and Crafts
Painter • Stone-carver.

📅 Events
April–September: Exhibitions at the tourist information center.
May: Pilgrimage to Notre-Dame-d'Usson (Ascension); "Les Médiévales," archery tournament.

🦋 Outdoor Activities
Fishing • Walking: 4 marked trails.

🌿 Further Afield
• Château de Parentignat (5 miles/8 km).
• Issoire (7 miles/11.5 km).
• Hilltop villages: Nonette, Auzon (9½–16 miles/15.5–26 km).
• *Montpeyroux (15 miles/24 km), see p. 114.
• Billom (20 miles/32 km).
• Clermont-Ferrand (28 miles/45 km).
• Massif du Livradois; Ambert (32 miles/51 km).

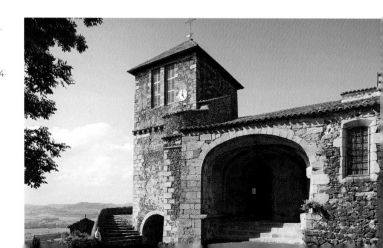

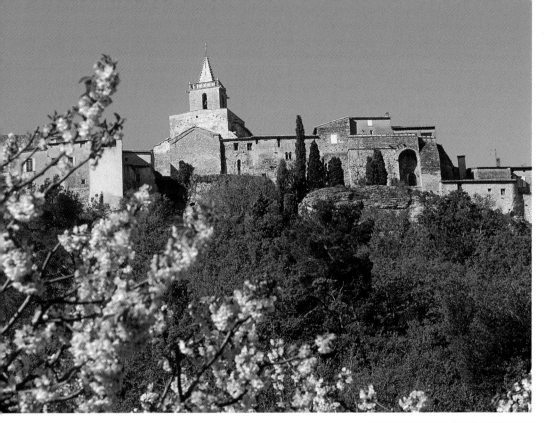

Venasque
The taste of Provence

Vaucluse (84) • Population: 1,017 • Altitude: 1,050 ft. (320 m)

Giving its name to the Comtat Venaissin region, Venasque is a look-out post towering above a sea of *garrigue* scrubland, vineyards, and cherry orchards.

Facing Mont Ventoux, Venasque has molded itself to a rocky spur at the northwestern tip of the Vaucluse plateau. Occupied in Neolithic times and during the Roman period, this naturally defensive site is reinforced by a rampart and three towers. It is thought that Saint Siffrein (Siffredus of Carpentras), who was bishop here in 542, built the foundations of both the Romanesque Église de Notre-Dame and a church dedicated to Saint John the Baptist on this outcrop. Notre-Dame contains two marvels of the Avignon School: a Crucifixion and a processional cross, both dating to 1490. To the north of the church is a stunning baptistery in the form of a Greek cross containing marble columns from Roman buildings. Dotted along the steep alleyways are houses with golden façades, built in the 14th–17th centuries, which echo the old hospice in Rue de l'Hôpital. The village is proud of its local heritage, and is the capital of cherry growing, a fruit celebrated each June.

By road: Expressway A7, exit 22– Orange-Sud (27 miles/43 km).
By train: Avignon station (22 miles/ 35 km); Orange station (23 miles/37 km); Avignon TGV station (25 miles/40 km).
By air: Avignon-Caumont airport (16 miles/25 km); Marseille-Provence airport (55 miles/25 km).

ⓘ Tourist information—Ventoux Provence: +33 (0)4 90 66 11 66
www.venasque.fr
www.ventouxprovence.fr

👁 Highlights

• **Baptistery** (6th century, much altered): Greek cross floorplan with semicircular apses and blind arcades. Further information: +33 (0)4 90 66 62 01.
• **Église Notre-Dame** (13th century): Avignon school Crucifixion of 1498, processional cross from the same period in the treasury.
• **Village:** Information boards; guided tours in summer, book at tourist information center; "Visites en Scènes," musical and theatrical history show, presented in July–August: +33 (0)9 67 50 11 66.

🗝 Accommodation

Hotels
La Garrigue**: +33 (0)4 90 66 03 40.
Les Remparts: +33 (0)4 90 66 02 79.
Guesthouses
Mme Maret***: +33 (0)4 90 66 03 04.
Mme Lubiato ▮▮▮: +33 (0)4 90 66 60 71.
Mme Ruel ▮▮▮: +33 (0)4 90 66 02 84.
M. Velay ▮▮▮: +33 (0)7 71 02 88 33.
Mme Charles ▮▮: +33 (0)6 09 54 79 01.
Mme C. Ruel ▮▮: +33 (0)4 90 66 63 47.
Mme Dulière: +33 (0)4 90 66 04 69.
M. Tourrette: +33 (0)4 90 69 95 62.
Gîtes and vacation rentals
Further information: +33 (0)4 90 66 11 66
www.ventouxprovence.fr

🍴 Eating Out

Bistro La Fontaine: +33 (0)4 32 85 14 29.
Côté Fontaine: +33 (0)4 90 66 64 85.
Le Petit Chose, snack bar:
+33 (0)4 90 66 66 07.
Les Remparts: +33 (0)4 90 66 02 79.

🧺 Local Specialties

Food and Drink
Cherries and dessert grapes • Heritage vegetables.
Art and Crafts
Ceramicists • Weaver • Painters • Potters • Sculptor.

📅 Events

Market: Fridays, 5–8 p.m. (mid-June–mid-September).
April: Automobile rally.
June: Festival de la Cerise, cherry festival (early June).
June-August: Art exhibitions in the vaulted gallery behind the church.
July: July 14 festival; "Fête des Belges" (21st)
August: Comic-book festival (early August).

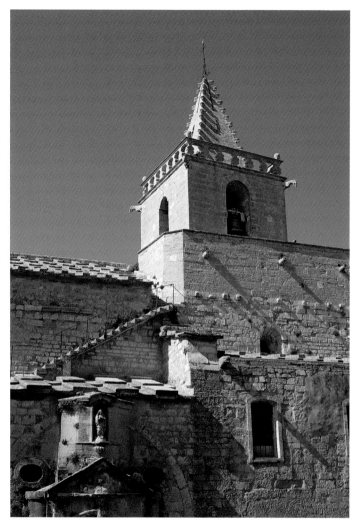

🦋 Outdoor Activities

Climbing • Donkey-riding • Walking • Cycle touring.

🌿 Further Afield

• Hilltop villages: Beaucet, La Roque-sur-Pernes (3 miles/5 km).
• Pernes-les-Fontaines (4½ miles/7 km).
• Carpentras (7 miles/11.5 km).
• Gorges de la Nesque; canyon (9½ miles/15.5 km).
• *Gordes (9½ miles/15.5 km), see pp. 98–99.
• *Ménerbes (15 miles/24 km), see p. 110.
• *Roussillon (15 miles/24 km), see pp. 124–25.
• Avignon (19 miles/31 km).
• *Séguret (21 miles/34 km), see p. 137.
• Mont Ventoux (22 miles/35 km).
• Vaison-la-Romaine (24 miles/39 km).
• Pays de la Lavande, region; Sault (25 miles/40 km).

Vogüé

A castle in the south of France

Ardèche (07) • Population: 1,020 • Altitude: 486 ft. (148 m)

Nestled in an amphitheater at the foot of a cliff, Vogüé dips its toes in the almost Mediterranean-like waters of the Ardèche river.

The riverside roads dotted with arched passageways lead to the castle that dwarfs the village. This ancestral home of the Vogüés, one of the most illustrious families in the region, was rebuilt in the 16th and 17th centuries. It has a tower at each corner, and façades decorated with mullioned windows. It is now managed by Vivante Ardèche and houses an exhibition on the region's history and architecture, the works of Ardèche engraver Jean Chièze (1898–1975), and contemporary art. In the old village streets, medieval houses roofed with curved tiles are interspersed with arcades. Their stepped terraces overflow with flowers, and in the Midi sunshine everything radiates a Mediterranean air.

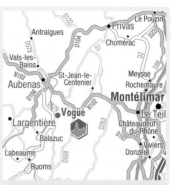

By road: Expressway A7, exit 17– Montélimar (30 miles/48 km); N102 (4½ miles/7 km). **By train:** Montélimar station (23 miles/37 km). **By air:** Lyon-Saint-Exupéry airport (123 miles/198 km).

(i) Tourist information—Pont-d'Arc Ardèche: +33 (0)4 28 91 24 10 www.pontdarc-ardeche.fr

👁 Highlights
• **Castle (16th and 17th centuries):** 12th-century state room, keep, and kitchen, Jean Chièze room, Vogüé room, chapel, hanging garden; temporary art and craft exhibitions: +33 (0)4 75 37 01 95.
• **Wine cellar:** +33 (0)4 75 37 71 14.
• **Village:** Guided tours by reservation in summer: +33 (0)4 28 91 24 10.

🗝 Accommodation
Hotels
Les Falaises: +33 (0)4 75 37 72 59.
Guesthouses
Le Mas des Molines ▮▮▮▮: +33 (0)6 61 72 83 78.
Les Carriers: +33 (0)6 84 43 35 73.
Gîtes
Further information: +33 (0)4 28 91 24 10 www.pontdarc-ardeche.fr
Aparthotels
Domaine Lou Capitelle: +33 (0)4 75 37 71 32.
Campsites
L'Oasis des Garrigues***: +33 (0)4 75 37 03 27.
Les Chênes Verts**: +33 (0)4 75 37 71 54.
Les Roches*: +33 (0)4 75 37 70 45.
Residential leisure parks
Les Roulottes de Saint-Cerice: +33 (0)6 11 49 75 33.

🍽 Eating Out
L'Ardèche: +33 (0)4 75 37 03 71.
Au Cabanon: +33 (0)6 61 19 67 81.
Chez Papytof: +33 (0)4 75 37 01 62.
L'Esparat: +33 (0)4 75 38 86 21.
La Falaise: +33 (0)4 75 37 72 59.
La Rôtisserie: +33 (0)4 75 88 40 78.
Le Temps'Danse: +33 (0)4 75 37 72 52.
La Voguette, crêperie: +33 (0)4 75 37 01 61.

🧺 Local Specialties
Food and Drink
Honey • Coteaux de l'Ardèche wines.

2 Events
Market: Monday mornings, July–August.
July–August: Musical theater shows; art exhibitions.
August: Flea market (1st Sunday).
Easter–All Saints' Day: Contemporary art exhibitions at the castle.

🦌 Outdoor Activities
Canoeing • Climbing • Walking: *Topo-guide*, book of walks, available at tourist information center • Mountain-biking.

🦋 Further Afield
• Sauveplantade: church; Rochecolombe (1–2½ miles/1.5–4 km).
• *Balazuc (4½ miles/7 km), see p. 85.
• Aubenas (6 miles/9.5 km).
• Le Pradel: estate of Olivier de Serre; Coiron plateau (8–12 miles/13–19 km).
• Ruoms: winegrowers' boutique (9½ miles/15.5 km).
• Gorges of the Ardèche; Vallon-Pont-d'Arc; Grotte du Pont-d'Arc, cave (12 miles/19 km).

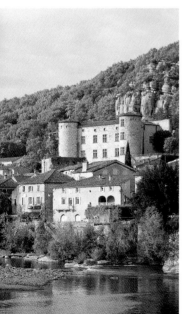

Yvoire

Medieval reflections in the waters of Lake Geneva

Haute-Savoie (74) • Population: 931 • Altitude: 1,181 ft. (360 m)

Yvoire combines the pleasures of a lakeside village with the strength of its medieval heritage as a sentry overlooking an important waterway. Its strategic position between the Petit Lac and the Grand Lac inspired the count of Savoy, Amadeus V the Great, to begin important fortification works here in 1306, at the height of the Delphino-Savoyard war. He built the castle on the site of a former stronghold and surrounded it with a fortified village. Castle, ramparts, gates, ditches, and medieval houses have miraculously survived an extremely stormy past. The whole village is overflowing with flowers in all colors of the rainbow, which makes for a wonderful sight against the stone squares and façades. The flower display changes with the seasons, so that there is always something new to discover. The dazzling setting—with its dramatic backdrop of mountains and lake, and the bustle of fishing boats, yachts, and steamers on the water—make it easy to see why Yvoire is known as the "pearl of Lake Geneva."

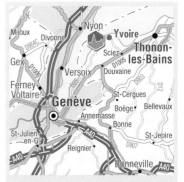

By road: Expressway A40, exit 14–Annemasse (18 miles/29 km); expressway A41-A40, exit 15–Vallée Verte (18 miles/29 km). **By train:** Thonon-les-Bains station (10 miles/16 km); Geneva station (16 miles/26 km). **By air:** Geneva airport (19 miles/31 km).

ⓘ Tourist information—Léman: +33 (0)4 50 72 80 21 www.destination-leman.com

👁 Highlights

• ♥ Le Jardin des Cinq Sens (classified as "remarkable" by the Ministry of Culture): Plant maze on the theme of the five senses in the castle's old vegetable garden, recreating the style and symbolism of medieval gardens: +33 (0)4 50 72 88 80.

• La Maison de l'Histoire: Permanent exhibition, "Un Patrimoine Écrit Exceptionnel": documents from Yvoire's heritage: +33 (0)4 50 72 80 21.
• Le Domaine de Rovorée-La Châtaignière: Nature reserve of 59 acres (24 ha); walking trails: +33 (0)4 50 72 80 21.

• La Châtaignière (mansion, 20th-century architecture typical of the lakeside): "Domaine Départemental d'Art et de Culture" (exhibitions), June–September: +33 (0)4 50 72 26 67.
• La Grange à la Marie: Restored small 19th-century farm: +33 (0)4 50 72 80 21.
• Village: Guided tours with tour guides from "Patrimoine des Pays de Savoie"; for individuals July–August, for groups all year round by appointment: +33 (0)4 50 72 80 21.

🔑 Accommodation

Hotels
Le Jules Verne****: +33 (0)4 50 72 80 08.
Le Port****: +33 (0)4 50 72 80 17.
Villa Cécile****: +33 (0)4 50 72 27 40.
Le Pré de la Cure***: +33 (0)4 50 72 83 58.
Le Vieux Logis: +33 (0)4 50 72 80 24.
Gîtes
La Falescale**: +33 (0)4 50 72 92 95.
L'Alcôve d'Amédée V: +33 (0)6 95 32 33 88.
Loft de Rovorée: +33 (0)6 95 32 33 88.
Maison de La Porte: +33 (0)6 51 96 64 67.
La Pointe d'Yvoire: +33 (0)6 09 17 85 26.
Campsites
Léman I**: +33 (0)4 50 72 84 31.

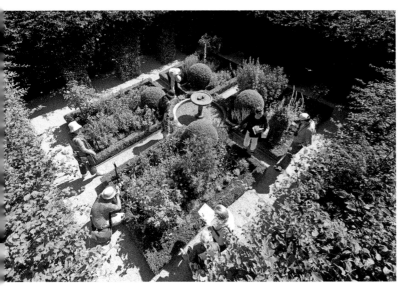

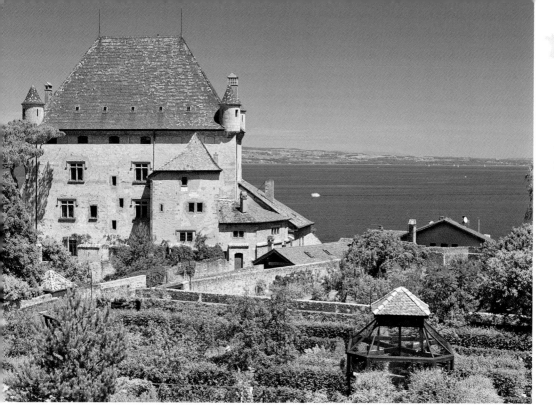

🍴 Eating Out

Le Bacouni: +33 (0)4 50 72 85 67.
Le Bar des Pêcheurs: +33 (0)4 50 72 80 26.
Le Bateau Ivre: +33 (0)4 50 72 81 84.
Le Café de la Marine: +33 (0)4 50 72 87 82.
Le Chardon, brasserie: +33 (0)4 50 72 81 71.
La Crêperie d'Yvoire: +33 (0)4 50 72 80 78.
Les Cygnes, brasserie: +33 (0)4 50 72 82 88.
La Dîme, pizzeria: +33 (0)4 50 72 89 87.
Les Galets, crêperie: +33 (0)4 50 72 69 73.
Les Jardins du Léman:
+33 (0)4 50 72 80 32.
Le Jules Verne: +33 (0)4 50 72 80 08.
Le Passe Franc: +33 (0)4 50 16 46 24.
La Perche: +33 (0)4 50 72 89 30.
Petit Cabri: +33 (0)4 50 72 88 55.
Le Pirate: +33 (0)4 50 72 83 61.
Le Port: +33 (0)4 50 72 80 17.
Le Pré de la Cure: +33 (0)4 50 72 83 58.
La Traboule: +33 (0)4 50 72 83 73.
La Vieille Porte: +33 (0)4 50 72 80 14.
Le Vieux Logis: +33 (0)4 50 72 80 24.
Villa Cécile: +33 (0)4 50 72 27 40.

🏺 Local Specialties

Food and Drink
Lake Geneva perch • Artisan ice creams •
Artisan cookies • Savoy produce.

Art and Crafts
Wood crafts • Crystal artist • Lacemaker •
Art galleries • Potter • Rocks and minerals
specialist • Basketmaker • Glassblowers •
Contemporary artists.

📅 Events

Seasonal market: "Rencontres
Gourmandes" (local produce): monthly
events in June, July, and August
May: Parade Vénitienne, Venetian
parade.
July–August: Yvoire Jazz Festival;
"Fête du Sauvetage," festival organized
by the Yvoire Lifesavers association;
local fairs, concerts.
September: Journée du Patrimoine,
heritage festival.
October: Fête des Ânes, donkey fair;
Marché Bio, organic market.

🦋 Outdoor Activities

Boat trips on Lake Geneva • Walking.

🌿 Further Afield

• Nernier (1 mile/1.5 km).
• Château d'Allinges (9½ miles/15.5 km).
• Thonon-les-Bains; Ripaille: castle;
Évian-les-Bains (10–16 miles/16–26 km).
• Geneva (17 miles/27 km).
• Nyon (20 minutes by boat).

ℹ Did you know?

At dusk on September 29, 1844, the
traveler and writer Alfred de Bougy arrived
at Yvoire. In a chapter titled "Chez les
sauvages du Léman" ("Among the savages
of Lake Geneva"), he wrote this damning
description of Yvoire as, "A jumble of
ugly huts, hovels that resemble pig-sties."
He added that he "would never have
imagined such a sordid collection of
uncivilized men at the heart of Europe."
He spoke of "the most detestable village,"
and finished by saying that "when the
magnificent steam boats tour the lake,
they pass in sight of Yvoire, they round its
protruding headland, but they take care
not to put into port there." It's fair to say
that Yvoire has had its revenge on both
fate and history.

Southwest

Scale 1: 2,600,000

```
0                    50 km
0                    40 miles
```

Atlantic Ocean

Les Sables-d'Olonne

Vou

Pointe de l'Aiguille

Île de Ré
Ars-en-Ré La Flotte p. 194
 p. 153
 La Rochelle Ni

 Surg
 Rochefort St-Jean-d'

Île d'Oléron

 Brouage Mornac-
 p. 170 s.-Seudre Sa
 p. 216

 Royan

 Talmont-
 s.-Gironde
 p. 257

 Blaye

 Bordeaux

 Cap Ferret Arcachon

 Mont-de-
 Marsan

 • Dax Aire-s.-l'

 Bayonne • Orthez
Anglet La Bastide-
Biarritz Clairence Navarrenx
 Sare **p. 160** **p. 220**
 p. 250 • Ainhoa
 p. 152
 Oloron-
 St-Jean- Ste-Marie
 Pied-de-Port
 p. 242

Santander

Bilbao • San Sebastián

 • Vitoria-
 Gasteiz

 • Pamplona

 • Logroño

Burgos •

SPAIN

©éditerra

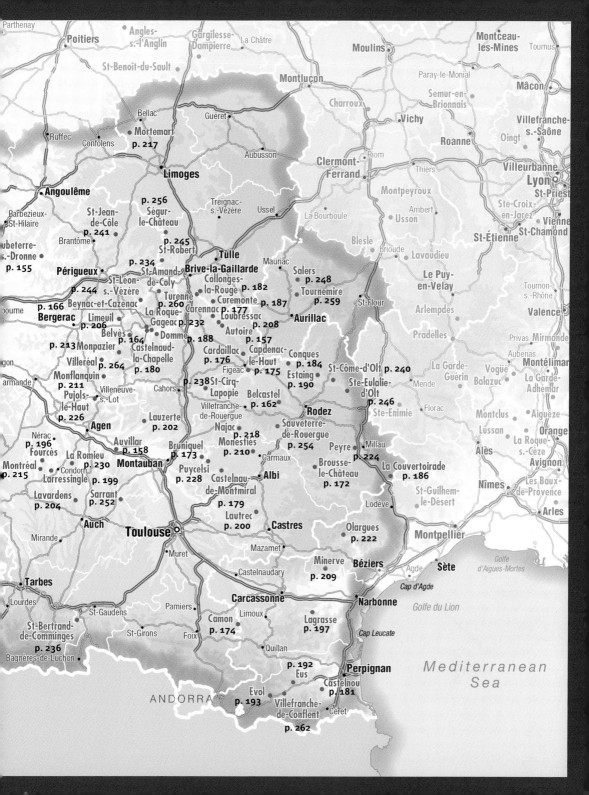

Ainhoa

All the colors of the Basque Country

Pyrénées-Atlantiques (64) • Population: 680 • Altitude: 394 ft. (120 m)

Marrying its green hillsides with the red-and-white façades of its Labourdin and Navarrese houses, Ainhoa displays the colors of the Basque Country along its single street. In the 13th century, the Roman Catholic religious order known as the Premonstratensians set up a vicariate at Ainhoa to provide assistance to pilgrims traveling to Santiago, and a *bastide* (fortified town) emerged from the plain to provide for their welcome. Rebuilt in the 17th century, its finest façades face east. The rings for tying up mules on the *lorios* (doors) of some houses bear witness to their former role as merchant inns on the road to Pamplona. The immaculate house fronts, some of which have balconies, are full of character, with typically Basque red and green shutters and timbering. Next to the *fronton* (Basque pelota court), which still hosts a few games in summer, the 13th-century church has been rebuilt, but the cut stones of its lower parts date back to the founding of the *bastide*. Higher up, the Notre-Dame-d'Arantzazu chapel (*arantza* means "hawthorn" in Basque; it is also known as Notre-Dame-de-l'Aubépine in French) stands on the Atsulai mountainside.

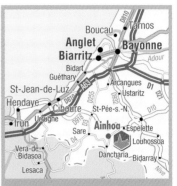

By road: Expressway A63, exit 5–Bayonne Sud (16 miles/26 km). **By train:** Cambo-les-Bains station (8 miles/13 km); Biarritz station (16 miles/26 km). **By air:** Biarritz-Bayonne-Anglet airport (16 miles/26 km).

ⓘ **Tourist information—Pays Basque:** +33 (0)5 59 29 93 99
www.ainhoa-tourisme.fr

👁 Highlights

• Église Notre-Dame-de-l'Assomption: Spanish-style gilded wooden altarpiece.
• **Maison du Patrimoine:** Exhibition, film on the history of the village and the border area: +33 (0)5 59 29 93 99.
• Village: *Bastide, fronton*, church, and open-air washhouse. Guided tour from June to September; groups of 7+ all year by appointment: +33 (0)5 59 29 93 99.

🗝 Accommodation

Hotels
Argi-Eder****: +33 (0)5 59 93 72 00.
Ithurria****: +33 (0)5 59 29 92 11.
Oppoca***: +33 (0)5 59 29 90 72.
Ur-Hegian**: +33 (0)5 59 29 91 16.
Etchartenea: +33 (0)5 59 29 90 26.
Guesthouses
Maison Tartea 🛏🛏🛏: +33 (0)5 59 03 82 38.
Maison Gorloki: +33 (0)6 21 20 92 34.
Maison Xaharenea: +33 (0)6 21 37 40 71.
Ohantzea: +33 (0)5 59 29 57 17.
Gîtes, vacation rentals, and campsites
For information: +33 (0)5 59 29 93 99
www.ainhoa-tourisme.com

🍽 Eating Out

Argi-Eder: +33 (0)5 59 93 72 00.
Auberge Alzate: +33 (0)5 59 29 77 15.
Ferme Segida, farmhouse inn:
+33 (0)5 85 69 93 82.
Ithurria: +33 (0)5 59 29 92 11.
Maison Oppoca: +33 (0)5 59 29 90 72.
Ohantzea, tea room: +33 (0)5 59 29 90 50.
Pain d'Épice d'Ainhoa, tea room:
+33 (0)5 59 29 34 17.
Ur-Hegian: +33 (0)5 59 29 91 16.

🏠 Local Specialties

Food and Drink
Pain d'épice (spice cake) • Salted meats and fish • Basque specialties.
Art and Crafts
Artisan perfumer • Jeweler, artist-creator.

📅 Events

April: Mountain-biking tour.
Pentecost: Pilgrimage to Notre-Dame-de-l'Aubépine (Monday).
May: Journée de la Nature et du Terroir, desmonstrations relating to farm animals and plants by local producers and breeders.
June–September: Basque pelota games, Basque songs in the church.
July: "Xareta Oinez" hiking trail (3rd Sunday).
August: *Romeria* (open-air meal); festivals (15th).
October: Fête de la Palombe, pigeon festival, including cooking demonstrations, Basque songs, local produce and craft fair.

🦋 Outdoor Activities

Basque pelota • Walking: Routes GR 8 and 10, and 5 marked trails • Mountain-biking: 1 marked trail.

🌿 Further Afield

• Urdax and Zugarramurdi caves (3–5 miles/5–8 km).
• Espelette (4 miles/6.5 km).
• *Sare (5 miles/8 km), see pp. 250–51.
• Cambo-les-Bains (7 miles/11.5 km).
• Saint-Pée-sur-Nivelle (7½ miles/12 km).
• Saint-Jean-de-Luz; Bayonne; Biarritz (14–17 miles/23–27 km).
• *La Bastide-Clairence (19 miles/31 km), see pp. 160–61.
• *Saint-Jean-Pied-de-Port (27 miles/43 km), see pp. 244–45.

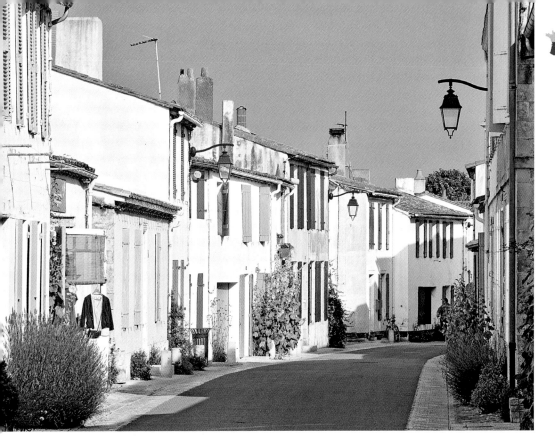

Ars-en-Ré

Between port and marshes

Charente-Maritime (17) • Population: 1,315 • Altitude: 10 ft. (3 m)

At the far west of the island, the village's bell tower keeps vigil over the ocean and the Fiers d'Ars marshes. Born from the salt marshes created in the 11th century and still exploited by more than sixty salt merchants, Ars is one of the Île de Ré's oldest parishes. The church retains its 12th-century door and its 15th-century bell tower, whose 130 ft. (40 m) black-and-white spire used to serve as a day-mark for seafarers. In the Rue des Tourettes, the two corner towers of the Maison du Sénéchal, built in the 16th century, are a reminder that the village was once under the jurisdiction of a seneschal. Abandoned by ships coming from Northern Europe to load salt, the port now provides shelter for pleasure craft. Pleasant to explore on foot or bike, the narrow streets, dotted with hollyhocks, are lined with white houses with green or light blue shutters, typical of the traditional architecture of this region.

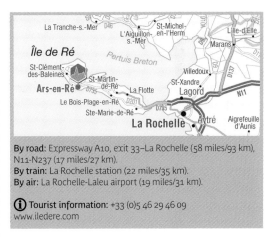

By road: Expressway A10, exit 33–La Rochelle (58 miles/93 km), N11-N237 (17 miles/27 km).
By train: La Rochelle station (22 miles/35 km).
By air: La Rochelle-Laleu airport (19 miles/31 km).

ⓘ **Tourist information:** +33 (0)5 46 29 46 09
www.iledere.com

👁 Highlights

- **Église Saint-Étienne (12th, 15th, and 17th centuries):** Romanesque style; arched door, rich furnishings.
- **Tours of the bell tower and salt marshes:** April to September.
- **Huîtrière de Ré, oyster farm:** Guided tours April to September, Wednesday evening with tasting and Thursday evening: +33 (0)5 46 29 44 24.

🗝 Accommodation

Hotels
Le Clocher***: +33 (0)5 46 29 41 20.
Le Martray***: +33 (0)5 46 29 40 04.
Le Sénéchal***: +33 (0)5 46 29 40 42.
Le Parasol**: +33 (0)5 46 29 46 17.
Thalassotherapy resorts
Côté Thalasso Ile de Ré***:
+33 (0)5 46 29 10 00.
Vacation rentals and guesthouses
Further information: +33 (0)5 46 29 46 09
www.iledere.com
Holiday villages
La Salicorne, VVF: +33 (0)5 46 29 45 13.

Campsites
Le Cormoran*****: +33 (0)5 46 29 46 04.
Les Dunes****: +33 (0)5 46 29 41 41.
ESSI***: +33 (0)5 46 29 44 73.
Le Soleil***: +33 (0)5 46 29 40 62.
La Combe à l'Eau*: +33 (0)5 46 29 46 42.

🍽 Eating Out

Le 120 [cent vingt], wine bar, world cuisine: +33 (0)5 46 29 69 52.
L'Annexe: +33 (0)5 46 30 13 51.
Au Goûter Breton: +33 (0)5 46 29 41 36.
Aux Frères de la Côte, brasserie: +33 (0)9 67 08 68 95.
La Cabane du Fier: +33 (0)5 46 29 64 84.
Le Café du Commerce, brasserie/crêperie: +33 (0)9 67 42 34 25.
Chez Pierro: +33 (0)6 88 56 46 49.
Chez Rémi: +33 (0)5 46 29 40 26.
Le Clocher: +33 (0)5 46 29 41 20.
Côté Thalasso: +33 (0)5 46 29 10 00.
Le Grenier à Sel: +33 (0)5 46 29 08 62.
Le K'Ré d'Ars: +33 (0)5 46 29 94 94.
Le Martray: +33 (0)5 46 29 40 04.
Maynard's: 33 (0)5 46 43 05 58.

L'Océane: +33 (0)5 46 29 24 70.
Ô de Mer: +33 (0)5 46 29 23 33.
Le Parasol: +33 (0)5 46 29 46 17.
Sans Foie ni Loix, beer and tapas bar: +33 (0)9 50 44 37 97.
Le Soleil d'Ars: +33 (0)5 46 43 09 27.
La Tour du Sénéchal, light meals, seafood: +33 (0)5 46 29 41 12.
Le "V": +33 (0)9 63 29 09 70.

🧺 Local Specialties

Food and Drink
Strawberries • Shrimp • Oysters • AOP early potatoes • Salt and *fleur de sel* sea salt • Wine and Pineau.
Art and Crafts
Antique dealers • Artists.

📅 Events

Markets: Daily 8 a.m.–1 p.m., Place du Marché-d'Été (April–November) or Tuesdays and Fridays 8 a.m.–1 p.m., port (winter).
July and August: Concerts, illuminated bell tower, firework display and dance, regattas.

🦋 Outdoor Activities

Bathing: La Grange beach • Cycling: Cycle paths across the marshes to the nature reserve at Fiers d'Ars • Walking: 3 marked trails • Sailing • Riding • Thalassotherapy.

🌿 Further Afield

- Saint-Clément-des-Baleines: Lighthouse and Parc des Incas (3 miles/5 km).
- Les Portes-en-Ré: Maison du Fier et de la Nature (6 miles/9.5 km).
- Loix-en-Ré: Écomusée du Marais Salant, local heritage museum (7½ miles/12 km).
- Saint-Martin-de-Ré: fortifications (7½ miles/12 km).
- *La Flotte (11 miles/18 km), see pp. 194–95.
- La Rochelle (21 miles/34 km).

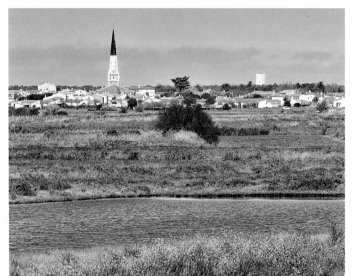

🍴 Did you know?

Producing more than 2,000 tons of salt every year, the salt marshes lie behind the development of Ars. The huge *salorge*, where the salt was stored, now houses the covered market, and some fine merchant houses are still visible on the Rue du Havre.

Aubeterre-sur-Dronne

Monolithic grandeur amid the white rocks

Charente (16) • Population: 422 • Altitude: 295 ft. (90 m)

Nestled against a chalky limestone cliff, Aubeterre overlooks the verdant valley of the Dronne river and boasts an extraordinary cultural heritage. Around its central square, a labyrinth of roofs and house fronts bedecked with wooden galleries and balconies stretches out. Facing the castle of this old fortress town, which was destroyed by the English and then by the Huguenots, and whose imposing gate still overlooks the Dronne, stands the Église Saint-Jacques, with its fine Romanesque façade. At the turn of every street and steep alleyway, the visitor is reminded of Aubeterre's religious past: pilgrims on their way to Santiago de Compostela would stop at the church and three former convents, and the village also features the monolithic Église Saint-Jean, which was carved into the rock near a primitive worship site in the 12th century. For an unforgettable experience, explore the underground building and necropolis beneath its high vaults of light and shade.

By road: Expressway A89, exit 11–Coutras (27 miles/43 km). **By train:** Chalais station (7½ miles/12 km). **By air:** Bergerac-Roumanière airport (43 miles/69 km).

ⓘ Tourist information:
+33 (0)5 45 98 57 18
www.sudcharentetourisme.fr
www.aubeterresurdronne.com

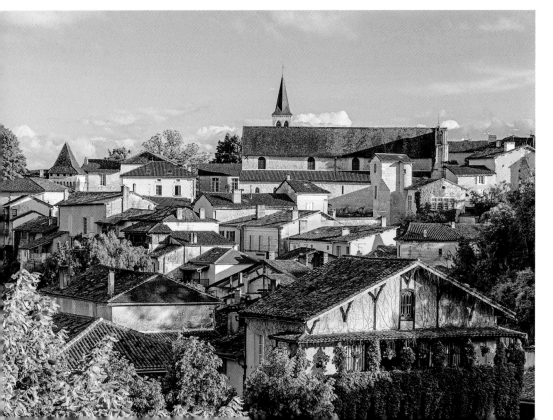

👁 Highlights

• **Église Saint-Jacques:** Originally built in the 12th century but rebuilt in the 17th century; Romanesque façade with finely carved vaulted archways and Moorish ornamentation.
• **Monolithic underground Église Saint-Jean:** Hewn into the cliff face in the 12th century. A unique construction housing a reliquary, a central relic pit, and a necropolis containing more than 160 stone sarcophagi.
• **Musée-espace Ludovic-Trarieux:** An exhibition focusing on human rights and on Ludovic Trarieux, the founder of the French Human Rights League.
• **Village:** Guided tours all year round by appointment only for groups; in the summer, possibility of individual visits: +33 (0)5 45 98 57 18 or +33 (0)6 79 85 81 26.

🗝 Accommodation

Hotels
Hostellerie du Périgord**:
+33 (0)5 45 98 50 46.
Guesthouses
Le Logis de la Tour 🛏🛏🛏🛏:
+33 (0)6 43 61 40 77.
Aubeterre-sur-Dronne:
+33 (0)5 45 98 04 08.
Gaillardon: +33 (0)6 22 13 39 40.
Gîtes
Further information: +33 (0)5 45 98 57 18
www.sudcharentetourisme.fr
Campsites
Bord de Dronne***: +33 (0)6 23 01 03 47.

🍽 Eating Out

Au Cochon Prieur: +33 (0)5 45 78 87 43.
Café Prégo, tea room:
+33 (0)5 45 78 32 68.
Le Comptoir d'Alba Terra:
+33 (0)5 45 78 38 45.
Crêperie de la Source, in summer:
+33 (0)5 45 98 61 78.
Le Garage, light meals:
+33 (0)5 45 98 18 19.
Hostellerie du Périgord:
+33 (0)5 45 98 50 46.
Hôtel de France: +33 (0)5 45 98 50 43.
Restaurant de la Plage, in summer:
+33 (0)5 45 98 75 43.
Sel et Sucre, crêperie, in summer:
+33 (0)5 45 98 60 91.
La Tapazzeria, in summer:
+33 (0)5 45 98 37 11.
La Taverne de Pierre Véry:
+33 (0)5 45 98 15 53.

🛍 Local Specialties

Food and Drink
Foie gras and duck confit • Pineau • Cognac.
Art and Crafts
Antique dealer • Cabinetmaker • Potters • Wood turners • Metalworker • Ceramicist • Dressmaker • Leatherwork.

📅 Events

May: Fête de l'Ascension; artists' festival.
July: Fête de la Saint-Jacques (last weekend).
July and August: Evening musical events in the monolithic church.
August: Evening market (1st Thursday).
September: Pottery festival (3rd weekend).

🦋 Outdoor Activities

Swimming • Canoeing • Fishing • Walking.

🌿 Further Afield

• Romanesque churches at Pillac, Rouffiac, and Saint-Aulaye (5 miles/8 km).
• Chalais: medieval town (7 miles/11.5 km).
• Villebois-Lavalette: castle; covered market (12 miles/19 km).
• Cognac and Bordeaux vineyards (28 miles/45 km).
• Angoulême (30 miles/48 km).
• Périgueux (34 miles/55 km).

ⓘ Did you know?

Hewn into the hillside on which the castle stands, Aubeterre-sur-Dronne's subterranean church is one of the largest in Europe. The vault, carved into the limestone, is 56 ft. (17 m) high. A stairway cut into the rock leads to a gallery that surrounds the church on three sides. In the sanctuary is a hexagonal reliquary, 20 ft. (6 m) high, which was carved from a single block of stone during the Romanesque period.

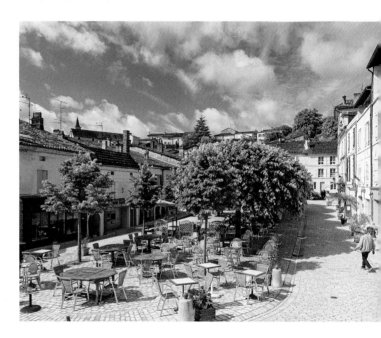

Autoire

Medieval stone and red tiles amid vines and tree-covered hills

Lot (46) • Population: 345 • Altitude: 738 ft. (225 m)

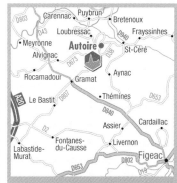

The village takes its name from the Autoire, the mountain stream that rushes down from the Causse de Gramat limestone plateau in a series of waterfalls before reaching the first ocher manor houses.

At the center of a cirque—a deep, high-walled basin—square dovecotes and the corbeled façades of rustic dwellings stand next to the turrets of manor houses. The Laroque-Delprat manor and the Château de Limargue are located downhill from the village. Higher up, the Château de Busqueille, built in the late 16th century, rises above the brown-tiled roofs. In the 14th century Autoire was besieged by the English, who had already been victorious in the region of Haut Quercy. One of the village's castles (the Château des Anglais) served as a hideout for traveling mercenaries during the Hundred Years War. Autoire was laid waste by the Calvinists in 1562 and did not see peace again until 1588. The only remains of the village's fortified ensemble is the Église Saint-Pierre, which dates back to the 11th and 12th centuries. The square bell tower is covered with flat stone *lauzes* (schist tiles) rather than the tiles used on other roofs in the village.

By road: Expressway A20, exit 54–Gramat (24 miles/39 km). **By train:** Biars-sur-Cèren station (9½ miles/15.5 km). **By air:** Brive-Vallée de la Dordogne airport (30 miles/48 km).

ⓘ Tourist information—Vallée de la Dordogne: +33 (0)5 65 33 22 00
www.vallee-dordogne.com

👁 Highlights
• Église Saint-Pierre (11th–12th centuries).
• Village: Guided tours in July and August: +33 (0)5 65 33 81 36.

🔑 Accommodation
Hotels
Auberge de la Fontaine: +33 (0)5 65 10 85 40.
Guesthouses
M. Sebregts: +33 (0)6 71 71 07 89.
Gîtes and vacation rentals
M. Blankoff: +33 (0)1 43 80 69 76.
Mlle Chovanec: +33 (0)5 65 38 15 61.
M. Frauciel: +33 (0)5 65 10 98 86.
M. Lemonnier: +33 (0)2 33 95 13 16.
M. Magnac: +33 (0)6 10 02 53 25.
M. Marchandet: +33 (0)5 65 38 13 50.
M. Santolaria: +33 (0)2 33 94 22 54.
M. Sebregts: +33 (0)6 71 71 07 89.
Mme Trassy: +33 (0)5 65 38 21 74.

🍽 Eating Out
Auberge de la Fontaine: +33 (0)5 65 10 85 40.
La Cascade, crêperie: +33 (0)6 07 86 90 62 or (0)5 65 38 20 02.

🏛 Local Specialties
Food and Drink
Cabécou cheese • Mushrooms • Honey • Wine • Walnut oil.

Art and Crafts
Weaving workshop • Leather crafts.

📅 Events
July: Flea market (14th); local saint's day with firework display (last weekend).
August: Gourmet market.

🦋 Outdoor Activities
Rock climbing • Fishing • Mountain-biking • Walking: Route GR 480 and 8 marked trails.

🌿 Further Afield
• Cascade d'Autoire, waterfall (½ mile/1 km).
• *Loubressac (3 miles/5 km), see p. 208.
• Saint-Céré (3 miles/5 km).
• Grotte de Presque, caves (4½ miles/7 km).
• Montal and Castelnau castles (4½ miles/7 km).
• Gouffre de Padirac, chasm (6 miles/9.5 km).
• *Carennac (8 miles/13 km), see p. 177–78.
• Rocamadour (12 miles/19 km).
• *Curemonte (16 miles/26 km), see p. 187.
• *Collonges-la-Rouge (22 miles/35 km), see pp. 182–83.
• *Turenne (22 miles/35 km), see pp. 260–61.
• *Capdenac-le-Haut (29 miles/47 km), see p. 175.

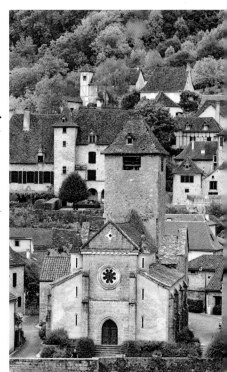

Auvillar

A port on the Garonne river

Tarn-et-Garonne (82) • Population: 999 • Altitude: 377 ft. (115 m)

A stopping place on one of the pilgrimage routes to Santiago de Compostela, the former fiefdom of the kings of Navarre still watches over the Garonne river.

Located on the Via Podiensis linking Le Puy-en-Velay to the Chemin de Saint-Jacques-de-Compostelle (Saint James's Way), on the banks of the Garonne, Auvillar bears traces of its dual religious and trading role. Unique in the southwest, the covered market, built in 1824 during the city's heyday, is composed of an outer circular building—embellished with Tuscan columns—and a central structure. Inside, you can still see stone and metal grain measures, recalling the importance of the market for locally produced cereals. Serving as its setting, the magical triangular plaza, which dates from the Middle Ages, has 15th- and 17th-century half-timbered red-brick mansions. This former stronghold stands on a rocky spur and has retained traces of its fortifications, including a door crowned with a brick-and-stone clock tower dating from the late 17th century. Outside of the upper town, the former Benedictine priory attached to the Abbaye de Moissac has become the Église Saint-Pierre (12th and 14th centuries), and is considered one of the finest in the diocese of Montauban. For a long time an inland shipping center, the port has retained its chapel dedicated to Saint Catherine, the patron saint of mariners.

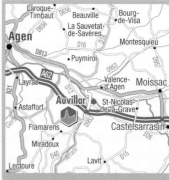

By road: Expressway A62, exit 8–Valence-d'Agen (3 miles/5 km).
By train: Valence-d'Agen station (3½ miles/5.5 km); Moissac station (12 miles/19 km).
By air: Agen-La Garenne airport (21 miles/34 km); Toulouse-Blagnac airport (56 miles/90 km).

(i) Tourist information—Deux Rives: +33 (0)5 63 39 89 82
www.auvillar.fr

👁 Highlights
• **Chapelle Sainte-Catherine** (in summer): Murals: +33 (0)5 63 39 89 82.
• **Église Saint-Pierre:** Contains a remarkable Baroque altarpiece.
• **Musée du Vieil Auvillar:** Museum of popular art and traditions with a collection of 18th- and 19th-century Auvillar earthenware: +33 (0)5 63 39 89 82.
• **Musée de la Batellerie:** Located in the clock tower, the museum presents the history of navigation on the Garonne river in past centuries. Further information: +33 (0)5 63 39 89 82.
• **Village:** Guided tour for groups of 10+. Further information and bookings: +33 (0)5 63 39 89 82.

🗝 Accommodation
Hotels
L'Horloge: +33 (0)5 63 39 91 61.
Guesthouses
Allison Feeley ♂♂♂♂: +33 (0)5 81 11 51 26.
Jacques Sarraut ♟♟♟: +33 (0)5 63 39 62 45.
Claude Dassonville ♟♟:
+33 (0)5 63 29 07 43.
Further information and other guest rooms: +33 (0)5 63 39 89 82
www.auvillar.fr

Gîtes
Gisèle Chambaron ♟♟♟:
+33 (0)5 63 29 04 31.
Nicole Lamer ♟♟: +33 (0)5 63 39 70 02.
Marie-Thérèse Desprez ♂♂♂:
+33 (0)5 63 39 01 08.
Communal gîte ♟♟♟, walkers' lodge, and other gîtes
Further information: +33 (0)5 63 39 89 82
www.auvillar.fr

🍽 Eating Out
Al Dente, pizzeria:
+33 (0)5 63 32 20 55.
Le Bacchus: +33 (0)5 63 29 12 20.
Le Raladin, crêperie/steak house (summer only): +33 (0)5 63 39 73 61.
Le Bistrot du Coin:
+33 (0)5 81 78 66 16.
L'Horloge: +33 (0)5 63 39 91 61.
Le Petit Palais: +33 (0)5 63 29 13 17.

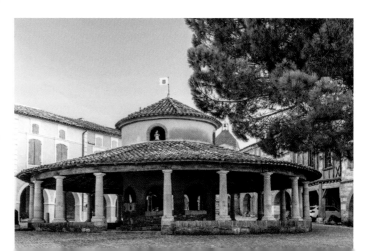

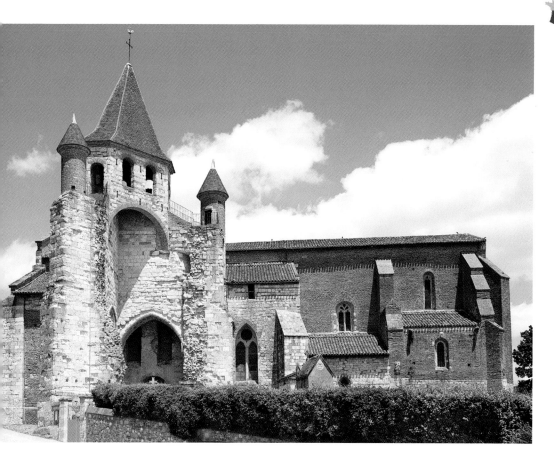

🧺 Local Specialties
Food and Drink
Fruit juice, fruit produce • Brulhois
wines • Jams and honey.
Art and Crafts
Calligrapher • Potter • Ceramicist •
Art galleries • Artists • Soap.

📆 Events
Market: Sunday mornings, farmers'
market.
Palm Sunday: Dressmakers' market.
May–August: Music events.
Pentecost: Saint-Noé, Fête des
Vignerons et des Félibres, winemakers'
and Provençal poets' festival
(1st weekend after Pentecost).
July: Antiques fair (July 13–14);
Craftsmen's event (last weekend);
treasure hunt.

August: Port festival and fireworks (15th);
open-air cinema.
October: Pottery market (2nd weekend).
December: Christmas market (2nd
Saturday).
All year round: Art and crafts exhibitions.

🦋 Outdoor Activities
Hunting • Fishing • Walking: Route GR 65
and various trails.

🌿 Further Afield
• Voie Verte, picturesque greenway
(3 miles/5 km).
• Golfech: nuclear site, "fish elevator"
linking two canals (3½ miles/5.5 km).
• Donzac : Musée de la Ruralité
(5 miles/8 km).
• Fortified towns of Dune, Castelsagrat,
and Monjoi (8–17 miles/13–27 km).

• Moissac (12 miles/19 km).
• Agen (21 miles/34 km).
• *Lauzerte (21 miles/34 km),
see pp. 202–3.

🏺 Did you know?
Auvillar potters have used clay and marl
from the deposits found in the Garonne
plains since Gallo-Roman times.
Earthenware manufacture was very
important here in the 18th and 19th
centuries. Auvillar earthenware is
distinguished by its colored—combed
or sponged—edges, and predominant
colors of blue and red. The Musée du
Vieil Auvillar has an interesting collection
of it on display.

La Bastide-Clairence
A bastide for the arts in Basque Country

Pyrénées-Atlantiques (64) • Population: 1,016 • Altitude: 164 ft. (50 m)

La Bastide-Clairence has a Basque face and a Gascon accent, with its white façades and its attractive half-timbering painted in red or green.

Bastida de Clarenza was founded in 1312 to secure a river port on the Joyeuse, and thus provide the kingdom of Navarre with a new maritime outlet. The founding charter signed by the king of Navarre, the future Louis X the Headstrong, granted land and tax benefits to the city, which developed throughout the Middle Ages and was home to the states of Navarre from 1627 to 1706. The town planning of the *bastides* of Aquitaine has been retained here; a grid pattern is observed with, in the center of the village, the Place des Arceaux. Characteristic spaces separate not only the houses but also the *cazalots*. These small gardens at the rear of the houses, built originally on identical plots known as *plaza*, were allocated to the first settlers, Basques, Gascons, and "Francos"—Compostela pilgrims who stayed on here. In one of the streets leading from the square, the world's oldest *trinquet* or *jeu de paume* court, dating from 1512, is still in use. The church of Notre-Dame-de-l'Assomption, built in 1315, is remarkable for its porch, the only remains of the original 14th-century building, and its lateral cloisters paved with tombstones. Next to the Christian cemetery, the Hebrew inscriptions in the Jewish cemetery, like the Hebrew names of some of the houses, are a reminder that in the 17th and 18th centuries La Bastide-Clairence welcomed an important Sephardic community fleeing the Spanish and Portuguese inquisitions. Motivated by its artisanal past, the village is currently home to more than a dozen artists and craftspeople, who combine tradition with innovation.

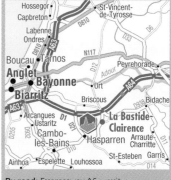

By road: Expressway A64, exit 4–Urt (3½ miles/5.5 km). **By train:** Cambo-les-Bains station (11 miles/18 km); Bayonne station (16 miles/26 km). **By air:** Biarritz-Bayonne-Anglet airport (23 miles/37 km).

ⓘ Tourist information—Pays Basque: +33 (0)5 59 29 65 05
www.hasparren-tourisme.fr

◉ Highlights
• **Village:** Guided tours for individuals Tuesdays 10 a.m. July–September; guided tours for groups all year round by appointment only: +33 (0)5 59 29 65 05.
• *Trinquet:* The oldest *jeu de paume* court still in use (1512).

⚷ Accommodation
Guesthouses
Le Clos Gaxen 🛏🛏🛏: +33 (0)5 59 29 16 44.
Maison Hegoa: +33 (0)5 59 93 96 34.
Maxana: +33 (0)5 59 70 10 10.
Gîtes and vacation rentals
Further information: +33 (0)5 59 29 65 05
www.hasparren-tourisme.fr
Aparthotels
Les Collines Iduki****: +33 (0)5 59 70 20 81.
Holiday villages
Les Chalets de Pierretoun: +33 (0)5 59 29 68 88.

⑪ Eating Out
Les Arceaux: +33 (0)5 59 29 66 70.
Iduki Ostatua: +33 (0)5 59 56 43 04.
La Table Gourmande de Ghislaine Potentier: +33 (0)5 59 70 22 78.

🏛 Local Specialties
Food and Drink
Beef and farm produce • Basque country cider • Foie gras and duck confit • Sheep and goat cheese • Macarons • *Gâteau basque.*

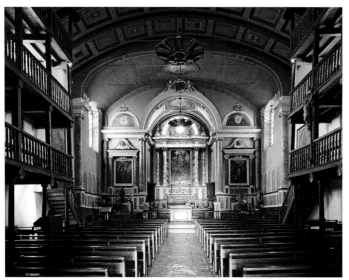

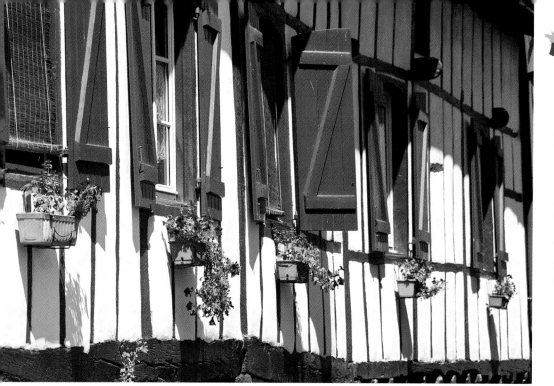

Art and Crafts

Jeweler • Luthier • Picture framer • Perfumer • Sculptor in stone • Lacemaker • Multimedia designer • Upholsterer-decorator • Glassblower • Potters • Cosmetics made from asses' milk • Textile designer • Leather craftsman • Artist • Floral art • Medieval art • Galleries.

🗓 Events

Market: Farmers' market, every Tuesday 9 a.m. to 1 p.m., July–September.
Easter: Show by Esperantza traditional dance group.
Spring and autumn: Cultural events organized by the Clarenza association.
June: Book fair.

July and August: *Sardinade*, La Bastide-Clairence festival, neighborhood festivities (La Chapelle, Pont de Port, Pessarou, La Côte).
September: Ceramics market.

🦋 Outdoor Activities

Basque pelota • Fishing • Walking: 2 marked trails • Canoeing.

🦋 Further Afield

• Hasparren (5 miles/8 km).
• Isturitz and Oxocelhaya prehistoric caves (8 miles/13 km).
• Cambo-les-Bains (9½ miles/15.5 km).
• Arbéroue valley (12 miles/19 km).
• Bayonne (16 miles/26 km).
• *Ainhoa (19 miles/31 km), see p. 152.
• *Sare (24 miles/39 km), see pp. 250–51.
• *Saint-Jean-Pied-de-Port (27 miles/ 43 km), see pp. 242–43.

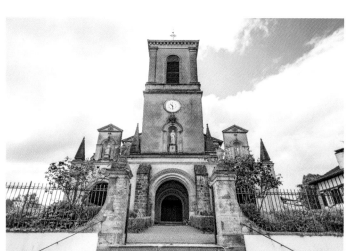

Belcastel

A medieval gem on the banks of the Aveyron

Aveyron (12) • Population: 219 • Altitude 1,335 ft. (407 m)

Clinging to vertiginous wooded slopes, Belcastel village is dominated by its spectacular fortified castle and dips its toes in the Aveyron river at its base.

In the 13th century, the fortress belonged to the lords of Belcastel, whose influence extended along both sides of the Aveyron, before entering into the hands of the Saunhac family at the end of the 14th century. Abandoned during the 18th century, the fortress gradually fell into disrepair. It was in 1973 that the renowned architect Fernand Pouillon discovered the ruins; he bought the site and began eight years of renovation work on it, encouraging the inhabitants of Belcastel to restore their village streets and homes too. The château-fortress now looks fondly down on the renovated village with its cobbled streets, its oven, metalworking trades, and old fountain. The 15th-century church houses the tomb of its founder, Alzias de Saunhac, who built the stone bridge with its unique altar, where passersby paid for their crossing with prayers and offerings. A stone's throw from the village, the fortified site of the Roc d'Anglars dates from the 5th century.

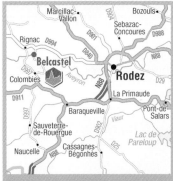

By road: Expressway A75, exit 42–Rodez (44 miles/70 km); D994 (15 miles/24 km); expressway A20, exit 59–Decazeville (53 miles/85 km). **By train:** Rodez station (15 miles/24 km). **By air:** Rodez-Marcillac airport (14 miles/23 km); Toulouse-Blagnac airport (103 miles/166 km).

ⓘ Tourist information—Pays Rignaçois/ Belcastel: +33 (0)5 65 64 46 11 www.tourisme-pays-rignacois.fr

◉ Highlights

• **Castle:** Fortress dating from 9th century; 16th-century arms and armour collection; contemporary art galleries inspired by the Animazing Gallery in Soho, New York: +33 (0)5 65 64 42 16.
• **Church** (15th century): Way of the Cross by Casımır Ferrer, recumbent statue on the tomb of Alzias de Saunhac, 15th-century statues: +33 (0)5 65 64 46 11.
• **Maison de la Forge et des Anciens Métiers** (smithy and traditional crafts): Tours of the village's old smithy and exhibition of tools; permanent exhibition of "sylvistructure" wood sculptures by the artist Pierre Leron-Lesur: +33 (0)5 65 64 46 11.
• **Village:** Guided tour and audioguide: +33 (0)5 65 64 46 11.

⚷ Accommodation

Hotels
Le Vieux Pont***: +33 (0)5 65 64 52 29.
Guesthouses
Le Château: +33 (0)5 65 64 42 16.
M. Rouquette: +33 (0)5 65 64 40 61.
Gîtes
www.mairie-belcastel.fr
Campsites
Camping de Belcastel**: +33 (0)5 65 63 95 61 or +33 (0)6 47 11 24 76.

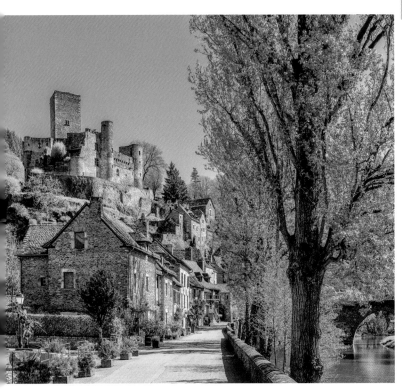

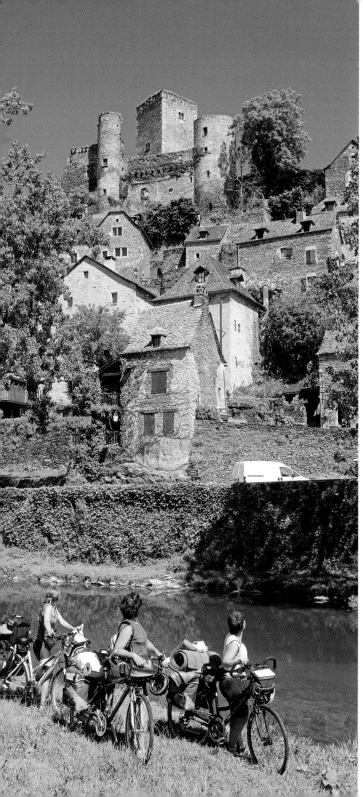

🍴 Eating Out

Le 1909 [mille neuf cent neuf]:
+33 (0)5 65 64 52 26.
Auberge Rouquette, farmhouse inn:
+33 (0)5 65 64 40 61.
Chez Anna: +33 (0)5 65 63 95 61 or
+33 (0)6 47 11 24 76.
Le Vieux Pont: +33 (0)5 65 64 52 29.

🗓 Events

Market: July–August, sampling and
purchase of local products every Friday
evening.
Throughout the summer: Exhibitions
of paintings, photography, sculpture,
and art and crafts.
June: "Feu de la Saint-Jean," Saint John's
Eve bonfire (last Saturday).
July: Local saint's day with village supper,
fireworks, multimedia show (penultimate
weekend).
September: Fête Nationale des Villages
(national celebration of villages) and flea
market.

🐾 Outdoor Activities

Fishing • Walking: Route GR 62B and
7 marked trails.

🌿 Further Afield

• Château de Bournazel (9½ miles/15.5 km).
• Rodez (16 miles/26 km).
• *Sauveterre-de-Rouergue (17 miles/27 km),
see pp. 254–55.
• Peyrusse-le-Roc (20 miles/32 km).
• Villefranche-de-Rouergue (23 miles/
37 km).
• *Capdenac-le-Haut (24 miles/39 km),
see p. 175.
• *Conques (24 miles/39 km),
see pp. 184–85.

🛈 Did you know?

The village's most unusual feature, which
affords a good view of the village and its
valley, is the rock of Roquecante, which
has seven seats cut into it. According to
legend, these "lords' seats," which probably
date to the 16th century, were used when
the local lords were dispensing justice.

Belvès
The village of seven bell towers

Dordogne (24) • Population: 1,482 • Altitude: 591 ft. (180 m)

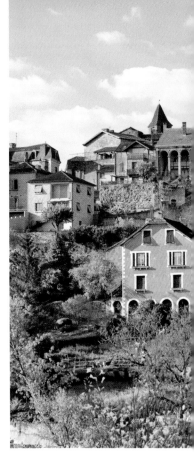

Dominating the verdant valley of the Nauze river from its hilltop position, Belvès provides a sweeping panorama across the landscape of Périgord Noir.

Owing to its strategic position, the village has had a turbulent past, despite the protection it received from both its rampart walls and from Pope Clement V, who granted Belvès the status of papal town when he was archbishop of Bordeaux (1297–1305). The town was besieged and invaded seven times by English forces during the Hundred Years War, and was later under siege again from Protestant forces during the Wars of Religion. It is miraculous that many legacies of Belvès' tumultuous past have survived: troglodyte cave dwellings, apparently occupied since prehistoric times; towers and bell towers from the Middle Ages; and residences and mansions in which Gothic flamboyance blends with Renaissance artistry. In the heart of the village, a historic covered market comes to life once a week, and here you can sample the many tasty products of Périgord, which change with the seasons. Beyond the gates of the town, the marked trails of the vast Bessède forest welcome walkers, horse-riders, and mountain-bikers all year round for both competition and leisure.

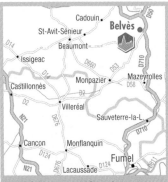

By road: Expressway A89, exit 17–Saint-Yrieix-la-Perche (33 miles/53 km); expressway A20, exit 55 (39 miles/63 km).
By train: Belvès station.
By air: Bergerac-Roumanière airport (30 miles/48 km); Brive-Vallée de la Dordogne airport (50 miles/80 km).

ⓘ Tourist information—
Vallée Dordogne Forêt Bessède:
+33 (0)5 53 29 10 20
www.perigordnoir-valleedordogne.com

◉ Highlights
• **Troglodyte dwellings:** Discover how peasants lived in these caves in the 13th to 18th centuries; games book for children aged 6-13. Further information and bookings: +33 (0)5 53 29 10 20.
• **Castrum:** Guided tours in summer, self-guided visits all year round. Further information: +33 (0)5 53 29 10 20.
• **Église de Notre-Dame-de-l'Assomption:** Renaissance painting; guided tours in summer, self-guided visits all year round. Further information: +33 (0)5 53 29 10 20.
• **Castle and wall paintings** (14th–16th centuries): Visit the principal furnished rooms; only wall paintings in Aquitaine representing the Nine Valiant Knights of legend, as well as a historical scene of Belvès in 1470. Further information: +33 (0)5 53 29 10 20 or +33 (0)6 35 29 13 71.
• **La Filature de Belvès:** Spinning mill and impressive machine room, testament to the village's industrial past. Self-guided visits and activities for children. Further information: +33 (0)5 53 31 83 05.
• **Village:** Guided tours for groups by arrangement: +33 (0)5 53 29 10 20; self-guided family trail with educational booklet for children, free audio-guided route available to download: +33 (0)5 53 29 10 93.

🗝 Accommodation
Hotels
Le Clément V***: +33 (0)5 53 28 68 80.
Le Home*: +33 (0)5 53 29 01 65.
Guesthouses
Le Manoir de la Moissie:
+33 (0)5 53 29 93 49 or
+33 (0)6 85 08 80 26.
Le Petit Bonheur: +33 (0)5 53 59 67 88.
Gîtes, walkers' lodges, and vacation rentals
Le Madelon: +33 (0)5 53 31 15 70.
Further information: +33 (0)5 53 29 10 20
www.perigordnoir-valleedordogne.com
Holiday villages
Domaine de la Bessède:
+33 (0)5 53 31 94 60.
L'Échappée Verte: +33 (0)5 53 29 15 51.
Les Hauts de Lastours:
+33 (0)5 53 29 00 42.

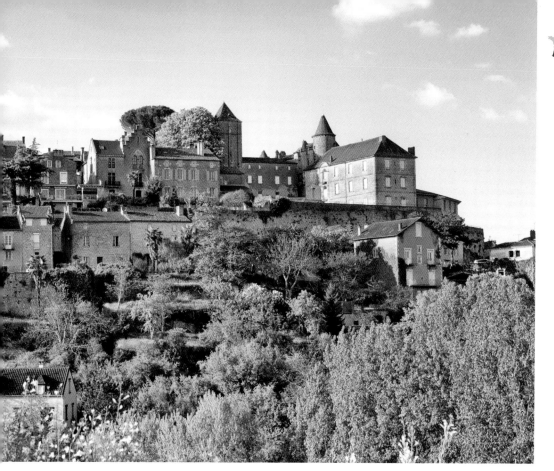

Campsites

Le Moulin de la Pique****:
+33 (0)5 53 29 01 15.
Les Nauves***: +33 (0)5 53 29 12 64
or +33 (0)6 85 15 32 73.

🍴 Eating Out

Le Café de Paris, brasserie:
+33 (0)5 53 59 62 40.
Le Calascio, pizzeria: +33 (0)6 23 82 39 84.
Le Médiéval Café, brasserie:
+33 (0)5 53 30 29 83.
Le Père William: +33 (0)5 53 29 01 65.

🛒 Local Specialties

Food and Drink

Foie gras • Honey • Organic farm produce •
Farmers' market.

Art and Crafts

Antique dealer • Cutler • Cabinetmaker •
Metalworker • Painters • Wool spinner •
Sculptor • Stained-glass artist • Mosaic
artist.

📅 Events

Market: Saturday mornings, Place
de la Halle.
April: "Les 100 km du Périgord Noir,"
ultra-marathon.
July: Flea market (1st Sunday),
Republican supper (14th).
July–August: Bach festival; gourmet
market (Wednesday evenings).
August: Medieval festival; air display (15th),
open-air rummage sale.
September: Pilgrimage to Notre-Dame-
de-Capelou (start of the month).

🦋 Outdoor Activities

Swimming • Horse-riding • Fishing •
Walking: 75 miles (121 km) of marked
trails, Route GR 36 and other routes in
the Dordogne valley along the Saint
James's Way to Santiago de Compostela •
Aerial sports.

🦋 Further Afield

• Abbaye de Cadouin (8½ miles/14 km).
• Dordogne valley: *Castelnaud-la-Chapelle
(11 miles/18 km), see p. 180; *Limeuil
(12 miles/19 km), see pp. 206–7; *Beynac-
et-Cazenac (14 miles/23 km), see
pp. 166–67; *La Roque-Gageac
(14 miles/23 km), see pp. 232–33; *Domme
(15 miles/24 km), see pp. 188–89.
• Pays des Bastides (9–19 miles/
14.5–31 km): *Monpazier (10 miles/16 km),
see pp. 213–14.
• Sarlat (22 miles/35 km).
• Vézère valley (16–31 miles/26–50 km):
*Saint-Léon-sur-Vézère (24 miles/39 km),
see p. 244.

Beynac-et-Cazenac
Two villages, one castle, and a river

Dordogne (24) • Population: 569 • Altitude: 427 ft. (130 m)

Curled at the foot of an imposing castle that surveys the Dordogne, Beynac-et-Cazenac is a beautiful spot enhanced by both the sublime river and the food of the region.

Occupied since the Bronze Age (c. 2000 BCE), the naturally defensive site of Beynac became the seat of one of the four baronies of Périgord during the Middle Ages. Besieged by Richard the Lionheart in 1197, then demolished by Simon de Montfort, the castle was rebuilt before being captured and recaptured during the Hundred Years War (1337–1453) by the armies of both the English and French kings. It was then abandoned during the French Revolution. Its owner began restoration work in 1961 and opened it to the public. The impressive castle towers over the village's *lauze* (schist-tiled) rooftops and golden façades. Nestling between river and cliff, and protected by a wall in which only the Veuve gateway remains, for many years Beynac made its living from the passing trade on the Dordogne. The *gabares* (sailing barges) have abandoned the old port, which is now a park, and are today used for river trips, sharing the water with other boats and canoes. On the plateau dominating the valley, the chapel at Cazenac, a village joined to Beynac in 1827, is moving in its simplicity.

By road: Expressway A89, exit 18–Terrasson-la-Villedieu (39 miles/63 km); expressway A20, exit 55 (27 miles/43 km).
By train: Sarlat-la-Canéda station (7 miles/11.5 km).
By air: Brive-Vallée de la Dordogne airport (35 miles/56 km); Bergerac-Roumanière airport (40 miles/64 km).

ⓘ Tourist information—
Sarlat-Périgord Noir: +33 (0)5 53 31 45 45
www.sarlat-tourisme.com

👁 Highlights
• **Château de Beynac:** Range of 12th–17th century buildings, restored in 20th century: +33 (0)5 53 29 50 40.
• **Village:** Regular guided tours June–September, by appointment the rest of the year: +33 (0)5 53 31 45 42. Special event August 15: guided tour.
• ♥ **Gabarres de Beynac:** Boat trips along the Dordogne river: +33 (0)5 53 28 51 15.

🗝 Accommodation
Hotels
Hostellerie Maleville–Hôtel Pontet**:
+33 (0)5 53 29 50 06.
Hôtel du Château**:
+33 (0)5 53 29 19 20.
Guesthouses
Ferme de la Porte: +33 (0)5 53 29 51 45.
Le Petit Versailles: +33 (0)5 53 29 35 06.
La Rossillonie: +33 (0)5 55 10 70 69.
Vacation rentals and gîtes
Further information: +33 (0)5 53 29 43 08 in season or +33 (0)5 53 31 45 45 off-season
www.sarlat-tourisme.com
Campsites
Le Capeyrou***: + 33 (0)5 53 29 54 95.

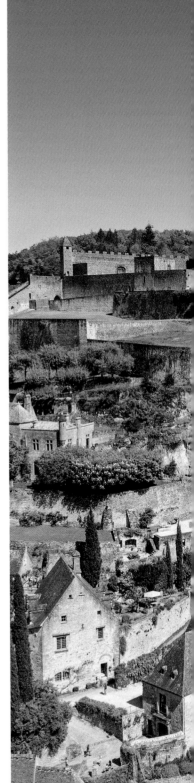

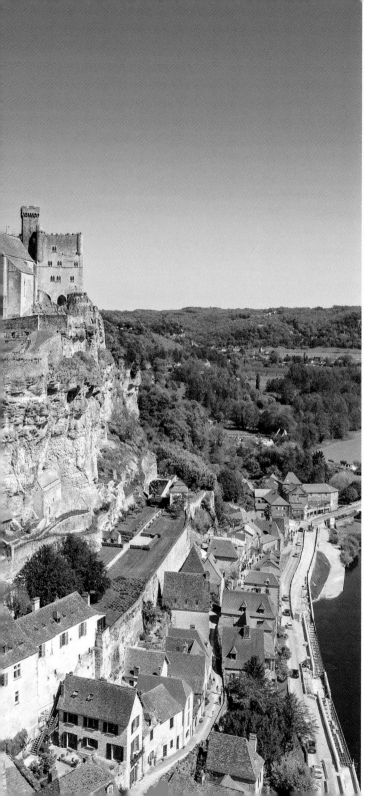

🍽 Eating Out

Auberge Lembert: +33 (0)5 53 29 50 45.
Le Bo Bar: +33 (0)5 53 28 16 64.
Hôtel du Château: +33 (0)5 53 29 19 20.
La Petite Tonnelle: +33 (0)5 53 29 95 18.
Restaurant Maleville: +33 (0)5 53 29 50 06.
La Taverne des Remparts:
+33 (0)5 53 29 57 76.
La Terrasse des Châteaux:
+33 (0)5 53 29 42 85.

🧺 Local Specialties

Food and Drink
Duck, goose • Traditional preserves.
Art and Crafts
Painter • Painter-enamelists • Potters •
Metal artist.

📅 Events

Mid-June to mid-September: Farmers'
market every Monday morning on the
river bank.
August: Fireworks (15th).

🦋 Outdoor Activities

Canoeing on the Dordogne • Fishing •
Walking: 2 marked trails • Balloon flights •
Mountain-biking: 5 marked trails.

🦋 Further Afield

• Dordogne valley: Château de
Marqueyssac: park and hanging gardens
(1 mile/1.5 km); Château de Castelnaud;
Château des Milandes; *Castelnaud-la-
Chapelle: Ecomusée de la Noix, walnut
museum (2½ miles/4 km), see p. 180;
*La Roque-Gageac (3 miles/5 km), see
pp. 232–33; *Domme (7 miles/11.5 km),
see pp. 188–89; *Belvès (14 miles/23 km),
see pp. 164–65; *Limeuil (18 miles/
29 km), see pp. 206–7.
• Sarlat (7 miles/11.5 km).
• Les Eyzies; Vézère valley (16–31 miles/
26–50 km).
• *Saint-Léon-sur-Vézère (21 miles/34 km),
see p. 244.
• *Saint-Amand-de-Coly (22 miles/35 km),
see pp. 234–35.
• *Monpazier (24 miles/39 km), see
pp. 213–14.

ℹ Did you know?

The *gabares* sailing barges evolved from
a different kind of barge that plied the
waters of the Dordogne. They carried
locally made wines to the port of
Bordeaux. Many *gabares* used to dock
at the old port of Beynac right up until
the 19th century.

Blesle

Benedictine memories at the gateway to the Haute-Loire

Haute-Loire (43) • Population: 653 • Altitude: 1,706 ft. (520 m)

At the end of a narrow, isolated valley that invites meditation, the echoes of Benedictine monks' prayers have for centuries blended with the murmurs of the rivers that bring life to the village of Blesle.

At the end of the 9th century, Ermengarde, countess of Auvergne, founded an abbey dedicated to Saint Peter here; then, two centuries later, the barons de Mercoeur built an impressive fortress. The village grew up under the protection of these two powers: one spiritual and the other temporal. It became one of the thirteen *bonnes villes* (which received privileges and protection from the king in exchange for providing a contingent of armed men) of Auvergne, and welcomed lawyers and merchants; they rubbed shoulders with tanners, weavers, and wine producers. Sheltered within its medieval surrounding wall, Blesle invites visitors to discover more than ten centuries of heritage. Several towers that were part of the old wall can still be seen on Boulevard du Vallat, itself built on the site of earlier ditches. Only the keep and a watchtower remain of the fortress, but the Église de Saint-Pierre and nearly fifty houses, many of which are half-timbered, preserve the memory of the Benedictine founders and the many trades that brought prosperity to the village.

By road: Expressway A75, exit 22– Blesle (5 miles/8 km). **By train:** Brioude station (14 miles/23 km). **By air:** Clermont-Ferrand Auvergne airport (46 miles/74 km).

ⓘ Tourist information:
+33 (0)4 71 74 02 76
www.tourismeblesle.fr

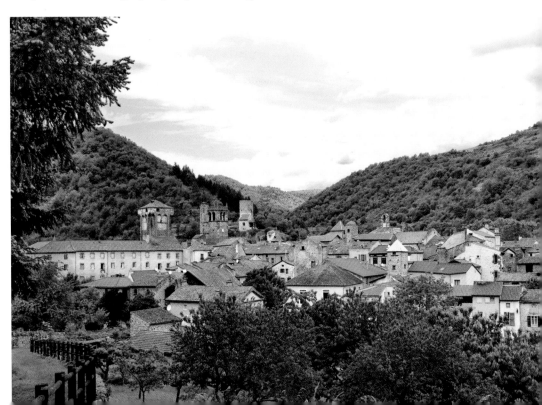

👁 Highlights
• Abbey church of Saint-Pierre:
12th–13th centuries.
• Église de Saint-Pierre: Liturgical
vestments, silver plate, statues from
the abbey; visits by appointment only:
+33 (0)4 71 74 97 49.
• Musée de la Coiffe: Headdresses,
bonnets, ribbons, hats from the region
(late 18th century–early 20th century):
+33 (0)4 71 74 97 49.
• Village: Guided tours in summer by
appointment for individuals, all year
for groups; accessible tours for visually
impaired (large-print and Braille
guidebooks): +33 (0)4 71 74 97 49.

🗝 Accommodation
Hotels
La Bougnate***: +33 (0)4 71 76 29 30.
Le Scorpion: +33 (0)4 71 76 28 98.
Guesthouses
Chez Margaridou 🕯🕯🕯:
+33 (0)4 71 76 22 29.
Aux Amis de Bacchus, M. and
Mme Doremus: +33 (0)4 71 76 21 38 or
+33 (0)6 84 50 97 12.
Le Bailli de Chazelon: +33 (0)4 71 76 21 98.
**Gîtes, vacation rentals, and walkers'
lodges**
Further information: +33 (0)4 71 74 02 76
or +33 (0)4 71 76 20 75
www.tourismeblesle.fr
Campsites
Camping municipal de la Bessière**:
+33 (0)4 71 76 25 82 or +33 (0)4 71 76 20 75
off-season.

🍴 Eating Out
La Barrière: +33 (0)4 71 74 64 22.
♥ La Bougnate: +33 (0)4 71 76 29 30.
Le Scorpion: +33 (0)4 71 76 28 98.
La Tour: +33 (0)4 71 76 22 97.

🧺 Local Specialties
Food and Drink
Charcuterie, salted meats, and fish •
Local cheeses • Local beers • Auvergne
liqueurs and wines.
Art and Crafts
Antiques dealer • Potter.

📆 Events
July: Painting and sketching competition
in the village streets (2nd Saturday);
flea market and open-air rummage
sale (last Sunday).
July–August: Local market (preserves,
foie gras), Fridays from 5 p.m., Place
du Vallat.

August: Festival of Les Apéros Musique
(weekend of 15th); Fête d'Été summer
fair (weekend before 15th); flea market.
November: Saint-Martin Fair (11th).

🦋 Outdoor Activities
Fishing • Walking: 17 trails, 2 mountain-
biking trails.

🌿 Further Afield
• Gorges of the Alagnon: Chateaux
of Montgon, Torsiac, and Léotoing
(3–6 miles/5–9.5 km).
• Cézallier (4½–12 miles/7–19 km).
• Château de Lespinasse (6 miles/9.5 km).
• Gorges of the Sianne (6 miles/9.5 km).
• Brioude (14 miles/23 km).
• Ardes-sur-Couze: safari park
(16 miles/26 km).
• *Lavaudieu (19 miles/31 km), see p. 106.
• Issoire (22 miles/35 km).
• Saint-Flour (24 miles/39 km).

❗ Did you know?
Blesle has had many famous residents:
Gaspard de Chavagnac, friend of the
prince of Condé (Protestant leader during
the Wars of Religion); Laurent Bas, who
arrested Charlotte Corday after she killed
Marat in the French Revolution; the abbé
de Pradt, Napoléon's chaplain; the author
Maurice Barrès; the 19th-century artist
Édouard Onslow; and even the holy
martyr Natalène, who was beheaded by
her father and then buried in a spot that
became the spring that bears her name.

Brouage
Fortified town in the marshes

Charente-Maritime (17) • Population: 650 • Altitude: 10 ft. (3 m)

Between the Île d'Oléron and Rochefort, the fortified town of Brouage looks down over the gulf of Saintonge and its marshland. This singular landscape, a veritable paradise for hundreds of species of birds, was shaped by man, who in the Middle Ages made it the salt cellar for the whole of Northern Europe. The 12th-century fortifications were built by order of Cardinal Richelieu, then governor of Brouage, in order to provide military resistance to the Protestants of La Rochelle. The town was created by Samuel de Champlain, founder of the city of Quebec and father of New France, and still bears witness to its rich history in its food market, foundries, underground ports, gunpowder magazine, and church. If, beyond the ramparts, the manufacture of salt has given way to oyster farming, mussel farming, and animal husbandry, inside the village shops and artists' workshops have taken the place of market stalls and bring the simple, bright façades typical of Charentes architecture to life.

By road: Expressway A89-A10, exit 35– Île d'Oléron–Saintes. **By train:** Stations at Rochefort (12 miles/20 km), Saintes (28 miles/45 km), La Rochelle (31 miles/ 50 km). **By air:** Rochelle-Île-de-Ré (37 miles/60 km).

ⓘ Tourist information—Île d'Oléron – Bassin des Marennes:
+33 (0)5 46 85 19 16
www.hiers-brouage-tourisme.fr

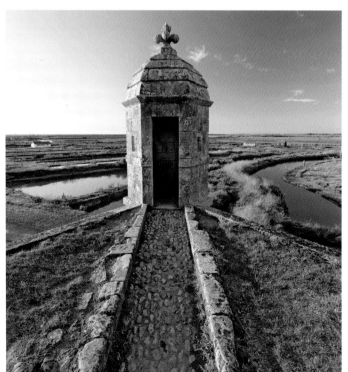

👁 Highlights
• **Église Saint-Pierre** (17th century): Memorial to the religious origins of New France, tombs of rich salt merchants (17th century), soldiers, and governors; stained-glass windows celebrating friendship between France and Quebec.
• **Halle aux Vivres** (17th–20th centuries): Permanent exhibition on the history of Brouage and the salt trade; information center on military architecture: +33 (0)6 48 85 80 60.
• **Ramparts:** 1 mile (2 km) long and 26 ft. (8 m) high, reinforced with 7 bastions and 19 watchtowers; panoramic views over the marshland from the rampart walk.
• **Village:** Self-guided visit, treasure hunt on the theme of Champlain; guided or dramatized tours: +33 (0)5 46 85 19 16.

🗝 Accommodation
Hotels
Hôtel Le Brouage: +33 (0)5 46 85 03 06.
Guesthouses
Découverte Nature: 33 (0)5 46 85 11 16.
La Marouette: +33 (0)5 46 76 14 01.
Mme Rabette: +33 (0)6 09 73 42 75.
Gîtes
Mme Natacha Renoux 🛏🛏🛏:
+33 (0)5 46 36 42 87 or +33 (0)6 17 50 43 65.

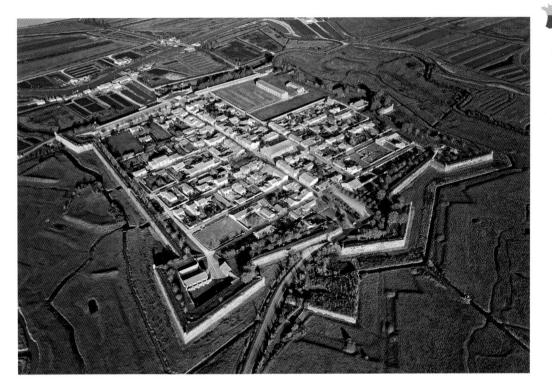

Le Temps d'une Pause (M. and Mme
Duc) ∎∎∎: +33 (0)5 46 85 11 35 or
+33 (0)6 28 27 12 83.
Mme Mylène Bernard: +33 (0)5 46 85 32 21
or +33 (0)5 46 36 37 07.
M. Pierre Bugeon: +33 (0)5 46 75 12 05.
Mme Huguette Gaillard:
+33 (0)5 46 95 62 98 or
+33 (0)6 15 09 41 11.
Mme Marie-Claire Lefebvre:
+33 (0)6 37 34 91 05.
M. Vincent Meriglier: +33 (0)5 46 36 88 27.
M. André Sauve: +33 (0)7 50 87 86 82.

🍴 Eating Out
L'Auberge Saint-Denis: +33 (0)5 46 75 45 46.
La Belle Epoque: +33 (0)5 46 47 95 98.
Le Brouage: +33 (0)5 46 85 03 06.
Le Champlain: +33 (0)5 46 76 72 68.
La Citadelle: +33 (0)5 46 85 30 65.
La Conserverie: +33 (0)7 69 35 76 05.
L'Escale du Roy: +33 (0)6 78 22 28 56.
Le P'tit Biniou: +33 (0)5 46 85 13 89.

🏛 Local Specialties
Food and Drink
Salt • Oysters • Artisan candy • Local and
Quebec products.

Art and Crafts
Potter • Artisan jewelry • Painter on canvas •
Leatherwork artisan • Lace-maker •
Glassblower.

📅 Events
April to September: Art exhibitions in
military buildings (forges, cooperage,
La Brèche gunpowder magazine).
May: Flower fair in village streets (8th).
May–September: Cycling museum open
every afternoon.
June: Costumed historical fête (end
of June).
July and August: Nuits Buissonnières
(tales by torchlight), "Jeudis de Brouage"
(free family activities on Thursdays),
designers' markets.
November: Flea market in village streets
(1st).

🦋 Outdoor Activities
Walking.

🌿 Further Afield
• Marennes (4 miles/7 km).
• St-Just-Luzac and le Moulin des Loges
(6 miles/10 km).

• Bourcefranc-le-Chapus and le Fort
Louvois (7 miles/11 km).
• Île d'Oléron (9 miles/15 km).
• Rochefort-sur-Mer (11 miles/18 km).
• Saint-Sornin and la Tour de Broue
(11 miles/18 km).
• *Mornac-sur-Seudre (19 miles/30 km),
see p. 216.
• Pays Royannais (22 miles/35 km).
• Saintes (26 miles/42 km).
• *Talmont-sur-Gironde (31 miles/50 km),
see pp. 257–58.

ℹ Did you know?
In the 17th century, Brouage was the
setting for an impossible love affair
between the French King Louis XIV and
Marie Mancini, niece of Cardinal de
Mazarin. The cardinal was fiercely opposed
to the union and exiled his niece to the
palace of the governor of Brouage, which
is no longer standing. The staircase that
the young Sun King climbed to reach the
ramparts in order to weep for his lost love
can still be seen flanking the Royal Forge.

Brousse-le-Château

Medieval stopover at the confluence of the Tarn and the Alrance

Aveyron (12) • Population: 171 • Altitude: 787 ft. (240 m)

Brousse stands on the banks of the Alrance river, overlooked by the imposing silhouette of its medieval castle that gives the village its name. In 935, when the Château de Brousse was first mentioned in historical records, it was just a modest fort above the Tarn. Between the 10th and 17th centuries, the fort grew steadily until it filled the whole rock. Dominating the village, it also strengthened the position of the counts du Rouergue and then, from 1204 onward, the d'Arpajon family, one of whom became a duke and French dignitary in the 17th century. Restoration work started in 1963, funded by the Vallée de l'Amitié charity, and the castle opened to the public. Between the Middle Ages and the Renaissance, Brousse was a typical fortress: its keep, towers, ramparts, arrow-slits, crenellations, and machicolations indicate its military function, while the lord's apartments and the gardens reveal the level of comfort that was to be found there. Ancient winding lanes lead to the 15th-century fortified church, which sits between a graveyard and a small chapel. Crossing the 14th-century stone bridge over the Alrance brings you to the road at the bottom of the village. Stepped terraces, cut into the sloping banks of the Alrance and the Tarn, show that vines used to grow here; these, along with chestnut groves, used to be the main source of income for Brousse-le-Château.

By road: Expressway A75, exit 46–Saint-Rome-de-Cernon (32 miles/51 km).
By train: Albi station (32 miles/51 km); Millau or Rodez stations (37 miles/60 km).
By air: Rodez airport (42 miles/68 km); Toulouse airport (93 miles/150 km).

ⓘ Tourist information—Raspes du Tarn: +33 (0)5 65 99 45 40
www.tourisme-muse-raspes.com
www.brousselechateau.net

👁 Highlights

• **Castle:** Typical of the medieval Rouergue military style. Interior includes lord's apartments, well and water tank, bread oven: +33 (0)5 65 99 45 40.
• **Church** (15th century): Dedicated to Saint James the Greater: +33 (0)5 65 99 41 14.
• **Illuminations** of château, church, and chapel.

🗝 Accommodation

Hotels
Le Relays du Chasteau**:
+33 (0)5 65 99 40 15.
Gîtes
M. Miron***: +33 (0)5 65 35 48 04.
M. and Mme Rolland**:
+33 (0)5 65 99 47 18.
M. Tuffery**: +33 (0)4 90 75 62 79.
M. Boudet: +33 (0)6 81 98 32 08.
M. and Mme Platet: +33 (0)6 22 99 52 67.
M. and Mme Rugen: +33 (0)5 65 55 18 11.
M. and Mme Sénégas: +33 (0)5 65 99 40 15.
Mme Winstanley: +33 (0)6 08 55 31 62.

🍴 Eating Out

♥ Le Relays du Chasteau:
+33 (0)5 65 99 40 15.

🧺 Local Specialties

Art and Crafts: Potter.

🎫 Events

Market: Tuesday mornings.
July: Bonfire and fireworks at the castle (13th); flea market.
July–August: Activities, music, exhibitions.
August: Local saint's day for Saint Martin de Brousse with traditional stuffed chicken (3rd weekend).

🦋 Outdoor Activities

Swimming • Fishing • Canoeing • Rowing • Walks • Mountain-biking.

🌿 Further Afield

• Châteaux de Coupiac, de Saint-Izaire, and de Montaigut (9–12 miles/14.5–19 km).
• Peyrebrune tower, Saint-Louis dolmen, Ayssènes, Saint-Victor, and Melvieu (12 miles/19 km).
• Lévezou and Villefranche-de-Panat lakes (12½ miles/20 km).
• Pays de la Muse, region; Raspes du Tarn, gorges (22 miles/35 km).

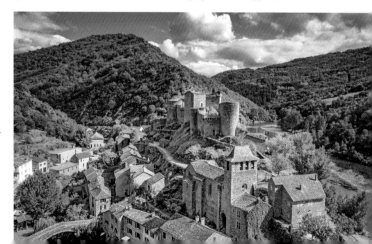

Bruniquel

Defying the enemy from the cliff top

Tarn-et-Garonne (82) • Population: 583 • Altitude: 541 ft. (165 m)

Bruniquel and its two medieval castles sit atop a high rocky promontory, towering over the village and surveying the confluence of the Aveyron and Vère rivers. Bruniquel certainly shows its defensive side to approaching visitors: the massive façades of its 600-year-old castles perched on the escarpment are truly impressive.

The village itself feels completely different, however. The whole ensemble constitutes a remarkable showcase of medieval houses, and it is wonderful to wander down the flower-bedecked streets, with their ornate façades of mullioned windows and twin bay windows. These evidence the village's rich mercantile past—a heritage that many artisans are bringing back to life today. Although indelibly touched by its medieval history, this ancient stronghold of the counts of Toulouse in fact has much older roots: inside an extraordinary cave, a mass of stalagmites—the only one of its kind in the world—dates from 176,000 years ago.

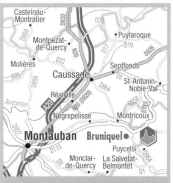

By road: Expressway A20, exit 59–Saint-Antonin-Noble-Val (13 miles/21 km).
By train: Montauban station (18 miles/29 km). **By air:** Toulouse-Blagnac airport (51 miles/82 km).

(i) **Tourist information:**
+33 (0)5 63 67 29 84
www.bruniquel.fr

👁 Highlights
• Chateaux: Vaulted chambers, chapel, state room, Renaissance gallery; exhibitions on prehistory: +33 (0)5 63 67 27 84.
• Village: All-year-round audioguide tours for individuals: +33 (0)5 63 67 29 84.

🔑 Accommodation
Guesthouses
Mme Artusi: +33 (0)5 63 24 15 26.
M. and Mme Bouvet: +33 (0)5 63 67 75 68.
M. Caulliez: +33 (0)5 63 24 17 31.
Le Moulin de Mirande: +33 (0)5 63 24 50 50.
M. Rouquet: +33 (0)6 78 30 78 47.
Mme Vildary: +33 (0)9 75 21 11 25.

Gîtes, vacation rentals, and campsites
Further information: + 33 (0)5 63 67 29 84
www.bruniquel.fr

🍴 Eating Out
Les Bastides: +33 (0)5 63 67 21 87.
Le Café Elia: +33 (0)5 63 24 19 87.
Chez Pigassou: +33 (0)5 63 93 47 33.
Le Délice des Papilles:
+33 (0)5 63 20 30 26.
Les Gorges de l'Aveyron:
+33 (0)5 63 24 50 50.
La Taverne du Temps:
+33 (0)5 63 65 35 96.

🛍 Local Specialties
Art and Crafts
Jewelry maker • Ceramic artist • Artists • Potter • Glassblower • Weaver.

📅 Events
May: "Vert-Tige" plant market (1st Sunday).
End July–early August: Offenbach Festival.
September: Les Nuits Frappées de Bruniquel, drumming festival (1st Saturday).
December: Rencontre des Métiers d'Art, craft festival (1st weekend).

🦋 Outdoor Activities
Walking: Route GR 46 and 5 marked trails.
Trail with pack mules: L'Abri-Niquel:
+33 (0)5 63 24 15 26.

🦅 Further Afield
• Montricoux; Bioule; Montauban (3–19 miles/5–31 km).
• Gorges of the Aveyron and Caylus (4½–22 miles/7–35 km).
• Penne: castle (6 miles/10 km).
• *Puycelsi (8 miles/13 km), see pp. 228–29.
• *Castelnau-de-Montmiral (14 miles/23 km), see p. 179.
• Cordes-sur-Ciel (21 miles/33 km).

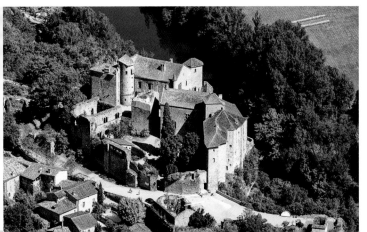

Camon

The village of 100 roses

Ariège (09) • Population: 147 • Altitude: 1,148 ft. (350 m)

Nestling at the bottom of a valley in Ariège, Camon has a historic fortress-abbey within the ring of its ramparts.

The village is situated on a bend in the Hers river, on the boundary between Ariège and Aude, and grew out of an abbey that had been founded in the 10th century by Benedictine monks. The monastery became a priory belonging to the abbey at Lagrasse in 1068, but it was destroyed on June 18, 1279, by a catastrophic flood, caused when the natural barrier holding back the waters of the Lac de Puivert broke. Restored during the 14th century, the priory was again devastated in 1494 by bands of rovers and was abandoned. In the early 16th century, Philippe de Lévis, the new bishop of Mirepoix, rebuilt and fortified it, at the same time as reconstructing the church shared by the monks and local inhabitants. He guaranteed them protection by enclosing the town within a second defensive wall. At the end of the 16th century, Cardinal George d'Armagnac, then prior of Camon, strengthened the fortifications and gave the village and the priory their current appearance. Typical of the fortified villages of the Ariège *département*, whose houses made from local materials hunch together cheek by jowl and are covered in curved tiles, Camon is also dubbed "the village of 400 roses" and celebrates this delicate flower every May.

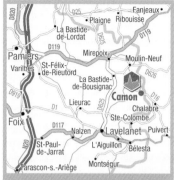

By road: Expressway A66, exit 6–Mirepoix (21 miles/34 km); expressway A61, exit 22–Foix (25 miles/40 km). **By train:** Foix station (29 miles/47 km). **By air:** Carcassonne-Salvaza airport (35 miles/56 km); Toulouse-Blagnac airport (70 miles/113 km).

ⓘ Tourist information:
+33 (0)5 61 68 83 76
www.camon09.org

👁 Highlights

• **Village** (abbey, church, ramparts): Guided tours in July–August. Further information: +33 (0)5 61 68 83 76.
• *Cabanes* (stone huts) **of Camon:** Themed path around the historic drystone winegrowers' huts; wild orchids in springtime; guided tours in July–August: +33 (0)5 61 68 83 76.
• **Roseraie:** Fragrant rose garden (free entry).

🗝 Accommodation

Guesthouses
L'Abbaye–Château de Camon: +33 (0)5 61 60 31 23.
Gîtes
Colin Atkins: +33 (0)5 81 06 15 81.
M. et Mme Barrière: 33 (0)6 14 79 03 46.
Gîtes de Daurat, Mme Vercauteren: +33 (0)5 61 68 24 92.
Lisa Hope: +33 (0)6 88 57 88 20.
Campsites
La Pibola***: +33 (0)5 61 68 12 14.
La Besse**, farm campsite: +33 (0)5 61 68 84 63.

🍴 Eating Out

L'Abbaye–Château de Camon (evenings; booking essential): +33 (0)5 61 60 31 23.
La Besse, seasonal farm produce: +33 (0)5 61 68 84 63.
La Camonette, light meals using local, seasonal ingredients (summer only): +33 (0)6 86 72 80 21.

🧺 Local Specialties

Food and Drink
Charcuterie • Croustades (flaky fruit pastries) • Grapes.

📅 Events

May: Fête des Roses and classical music festival (3rd Sunday).

🦋 Outdoor Activities

Canoeing • Fishing (accessible fishing facilities) • Walking • Voie Verte, picturesque greenway (disused railway line, Lavelanet–Mi repoix): suitable for walking, mountain-biking, and horse-riding.

🌾 Further Afield

• Chalabre, fortified town; Lac de Montbel, lake; Puivert: castle, museum; Nébias: natural maze (6–12 miles/9.5–19 km).
• Mirepoix; Vals (7½–16 miles/12–26 km).
• Lavelanet; Château de Montségur (10–22 miles/16–35 km).
• Carcassonne (31 miles/50 km).

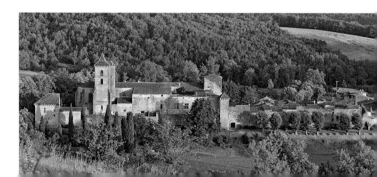

Capdenac-le-Haut

The figurehead on the ship's prow

Lot (46) • Population: 1,111 • Altitude: 853 ft. (260 m)

Perched on a protruding rock, more than 360 ft. (110 m) above a meander in the Lot river, Capdenac "on high" suffered attacks by Julius Caesar and Simon de Montfort.

Shaped like the figurehead at the prow of a ship, Capdenac allegedly got its Occitan name from the configuration of the site. It was coveted for its strategic position, and what we know today as the medieval fortress was conquered in the 13th century by the count of Toulouse. However, well before that, this was the location of one of the most important Roman towns in Quercy: Uxellodunum, the site of Roman Emperor Julius Caesar's last battle against the Gauls. The Gaulish spring and Caesar's spring, fed by magnificent underground cisterns, are reminders of these ancient times. The monumental gates to the citadel, the keep, and several handsome 18th-century residences show Capdenac's second face—a place that navigated the trials and tribulations of the Middle Ages, and in which lived Maximilien de Béthune, duke of Sully (1560–1641), Henri IV's loyal minister.

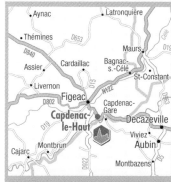

By road: Expressway A20, exit 56–Rodez (32 miles/51 km). **By train:** Capdenac-Gare station (2 miles/3 km); Figeac station (3½ miles/5.5 km). **By air:** Rodez-Marcillac airport (31 miles/50 km).

ⓘ Tourist information—Pays du Grand Figeac: +33 (0)5 65 38 32 26 or +33 (0)5 65 34 06 25
www.tourisme-figeac.com

👁 Highlights

• **Keep** (13th and 14th centuries): Exhibition on the prehistoric, Gallo-Roman, and medieval periods: +33 (0)5 65 38 32 26.
• **Fontaine des Anglais:** Troglodyte spring with two underground pools: +33 (0)5 65 38 32 26.
• **Jardin des 1001 Pattes:** Ecological garden featuring an enormous "insect hotel".
• **Jardin Médiéval Cinq Sens:** Plants arranged according to the five senses—smell, sight, touch, taste, and a fountain to stimulate hearing; medicinal plants: +33 (0)5 65 38 32 26.
• **Village:** Torchlit visits in July and August: +33 (0)5 65 38 32 26.

🔑 Accommodation

Hotels
Le Relais de la Tour***: +33 (0)5 65 11 06 99.
Gîtes and vacation rentals
M. Tayrac**: +33 (0)5 65 34 03 81 or 33 (0)5 81 24 07 64.
M. Couderc ▮▮▮: +33 (0)5 65 34 19 50.

🍴 Eating Out

L'Oltis, crêperie: +33 (0)5 65 34 05 85.
Le Relais de la Tour: +33 (0)5 65 11 06 99.

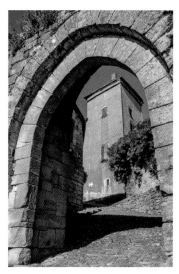

🛒 Local Specialties

Food and Drink
Goat cheese • *Fouaces* (brioche/cake).
Art and Crafts
Organic soap-maker • Mosaic artist.

🗓 Events

Summer market: Wednesday mornings in July and August, Place de la Mairie.
April: Foire aux Chevaux, horse fair (3rd Saturday).
May–September: Exhibitions in the keep.
July–August: Evening markets, concerts, art exhibitions, open-air cinema, guided visits.
September: Local saint's day (3rd weekend).

🦋 Outdoor Activities

Walking: 1 marked trail: +33 (0)5 65 38 32 26.

🌿 Further Afield

• Figeac: Musée Champollion (3½ miles/5.5 km).
• *Cardaillac (10 miles/16 km), see p. 176.
• Peyrusse-le-Roc (11 miles/18 km).
• Decazeville (14 miles/23 km).
• Villefranche-de-Rouergue (21 miles/34 km).
• *Belcastel (24 miles/39 km), see pp. 162–63.
• *Conques (26 miles/42 km), see pp. 184–85.
• *Autoire (29 miles/47 km), see p. 157.

Cardaillac

The powerhouse of Quercy

Lot (46) • Population: 614 • Altitude: 1,175 ft. (358 m)

The powerful feudal Cardaillac family founded this village on the fringes of Quercy and Ségala, and gave it its name.

When Pépin the Younger (714–768) granted Cardaillac lands to his knight Bertrand and descendants, he guaranteed a bright future for the village. The fort, completed in the 12th century, sits on a triangular spur, two cliffs providing natural fortifications. Three towers are all that survive of the ramparts: the round tower, the clock tower (which served as the prison), and the tower of Sagnes, which affords a panoramic view of the village. Cardaillac was attacked during both the Hundred Years War and the Wars of Religion; these events drove the local people to become the most fervent Protestant community in Haut Quercy, and they participated in the destruction of Saint Julian's Church. The church was restored to Catholicism by the Edict of Nantes, then rebuilt in the 17th century, when the fort passed into the hands of Protestant reformers. At the Revocation of the Edict of Nantes, the ramparts and towers were razed to the ground.

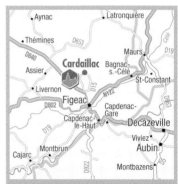

By road: Expressway A20, exit 56–Rodez (27 miles/43 km).
By train: Figeac station (7½ miles/12 km).
By air: Rodez-Marcillac airport (41 miles/66 km).

ⓘ Tourist information—Grand de Figeac: +33 (0)5 65 34 06 25
www.tourisme-figeac.com

👁 Highlights

• **Fort:** Ruins of 11th-century medieval fort (Sagnes and clock towers); guided visits in summer. Further information: +33 (0)5 65 34 06 25.
• **Medieval kitchen garden:** Medicinal plants and plants used in dyeing; self-guided visit with information boards.
• **Musée Éclaté:** Multisite museum; visit several sites that tell the story of the village and its people since the Middle Ages. Visit La Maison du Semalier (13th century), containing the workshop of Émile Cros—poet, inventor, and last master craftsman of the *comporte* baskets used for bringing in the grape harvest; La Maison de l'Oustal, house of the Cardaillac-Thémines (fortified medieval house), collection of farming equipment and craftsman's tools; *l'étuve à pruneaux* (plum steam-room) and the bread oven, the *saboterie* (clogmaker), and the *moulin à huile de noix* (walnut mill): +33 (0)5 65 40 10 63 or +33 (0)5 65 40 15 65.
• **Village:** Signposted route with information boards; guided tours by appointment only: +33 (0)5 65 34 06 25.

⚷ Accommodation

Guesthouses
Le Relais de Conques: +33 (0)5 65 40 17 22.
Gîtes and vacation rentals
Gîte de La Grave ♟♟♟: +33 (0)5 33 09 27 37.
Gîte du Lavoir ♟♟♟: +33 (0)5 65 40 15 26.
L'Oustal Pitchou ♟♟♟: +33 (0)5 53 09 27 37.
Le Chalet du Ségala ⚷⚷:
+33 (0)5 65 34 56 88.
Raymond Davet ⚷⚷: +33 (0)5 65 40 16 39.

🍴 Eating Out

Auberge du Mercadiol: +33 (0)5 65 33 19 97.
Le Bar du Fort: +33 (0)5 65 11 08 86.

🗓 Events

Market: Sunday mornings, 8.30 a.m.–1 p.m., Place du Boulodrome.
May: Foire du Renouveau, flea market, crafts, local produce.
June: National gardens day.
July–August: Ciné-village, film sceening preceded by a meal at the village hall; exhibitions; local saint's day; Fête de la Peinture, painting festival.
November: Saint Martin's Fair, flea market, trees and flowers, local produce.

🦋 Outdoor Activities

Children's playground • Picnic area • *Boules* court • Hunting • Fishing (lake; Murat 1st category permit) • Mountain-biking • Walking: Route GR 6 and marked trails.

🌿 Further Afield

• Figeac (6 miles/9.5 km).
• *Capdenac-le-Haut (11 miles/18 km), see p. 175.
• Lacapelle-Marival (9½ miles/15.5 km).
• Célé valley (16 miles/26 km).
• Rocamadour (22 miles/35 km).
• Saint-Céré (22 miles/35 km).
• *Autoire (24 miles/39 km), see p. 157.
• Gouffre de Padirac, chasm (25 miles/40 km).

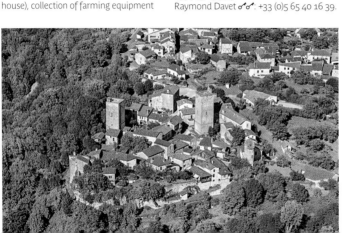

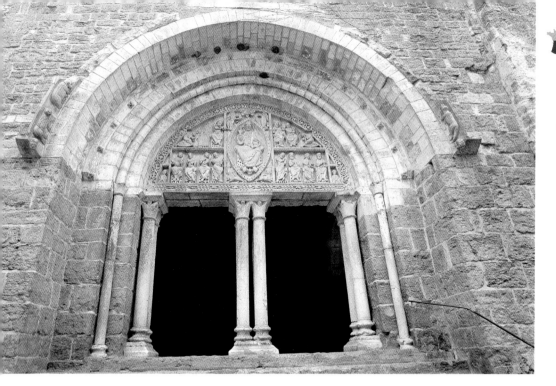

Carennac

Renaissance elegance and Quercy charm

Lot (46) • Population: 386 • Altitude: 387 ft. (118 m)

Carennac sits on the banks of the Dordogne, facing the Île de Calypso, where it shelters Renaissance houses adorned with sculptured windows.

In the days when it was called Carendenacus, the village huddled around a church that was dedicated to Saint Sernin and annexed to Beaulieu Abbey. On the orders of Cluny Abbey, the parish became a priory, and in the 11th century it built the existing Romanesque Église de Saint-Pierre, whose door is decorated with a magnificent 12th-century tympanum. The Flamboyant part-Romanesque, part-Gothic cloisters stretch out on either side of a hexagonal tower and contain a chapter house with a 16th-century sculpture of the Entombment, 15th-century bas-reliefs of Christ's life and passion, and various statues by different craftsmen. In the Château des Doyens, the heritage center hosts an exhibition staged by the Pays d'Art et d'Histoire association, of which Carennac is a member. The village houses, nestling up to this exquisite building, live up to the beauty of the church. Built in stone, some boast ornate mullioned windows, while others have watchtowers or exterior staircases, and they are covered in a patchwork of steeply sloping brown-tiled roofs, typical of this area.

By road: Expressway A20, exit 56–Rodez (27 miles/43 km). **By train:** Rocamadour station (14 miles/23 km); Gramat station (19 miles/31 km); Brive-la-Gaillarde station (30 miles/48 km). **By air:** Brive-Vallée de la Dordogne airport (21 miles/34 km).

ⓘ Tourist information—
Vallée de la Dordogne:
+33 (0)5 65 33 22 00
www.vallee-dordogne.com

👁 Highlights
• Église de Saint-Pierre and its cloister (11th–12th centuries).
• Espace Patrimoine, heritage center (16th-century building): Permanent exhibition on the area's natural, architectural, and patrimonial wealth: +33 (0)5 65 33 81 36.
• Priory and village: Guided tours by appointment only. Further information: +33 (0)5 65 33 81 36 or +33 (0)5 65 33 22 00.

🗝 Accommodation
Hotels
♥ Hostellerie Fénelon**: +33 (0)5 65 10 96 46.
Guesthouses
La Maison du Rocher ▮▮▮: +33 (0)6 81 03 14 80.
La Farga: +33 (0)5 65 33 18 97 or +33 (0)6 73 73 56 79.
Les Perluètes: +33 (0)6 84 75 75 63.
La Petite Auberge: +33 (0)5 65 50 25 84.

Vacation rentals
Further information: +33 (0)5 65 33 22 00
www.vallee-dordogne.com
Campsites
L'Eau Vive**: +33 (0)5 65 10 97 39.

🍴 Eating Out
La Bodega: +33 (0)5 65 39 77 77.
L'Epicure: +33 (0)5 65 40 34 52.
Le Fénelon: +33 (0)5 65 10 96 46.
Le Prieuré: +33 (0)5 65 39 76 74.

🍽 Local Specialties
Food and Drink
Walnuts and walnut oil.
Art and Crafts
Ceramic artist • Marquetry • Sculptor (summer).

🗓 Events
Market: July–August, local products on Tuesdays, 5–8 p.m.
July–September: Painting and sculpture exhibitions.
August: Journée de la Prune Dorée de Carennac, plum festival and market (1st Monday).
November: Mois de la Pierre, "month of the stone" exhibition.
December: Christmas market.

🦋 Outdoor Activities
Canoeing • Fishing • Walking: Route GR 52 • Mountain-biking.

🌿 Further Afield
• *Loubressac (6 miles/9.5 km), see p. 208.
• Castelnau and Montal castles, Saint-Céré (6–10 miles/9.5–16 km).
• Gouffre de Padirac, chasm; Rocamadour (6–12 miles/9.5–19 km).
• *Autoire (8 miles/13 km), see p. 157.
• *Curemonte (9½ miles/15.5 km), see p. 187.
• Dordogne valley (11–22 miles/18–35 km).
• Martel (11 miles/18 km).
• *Collonges-la-Rouge (14 miles/23 km), see pp. 182–83.
• *Turenne (15 miles/24 km), see pp. 260–61.

🍴 Did you know?
After the Wars of Religion, the 17th century saw the return of prosperity to Carennac. The priory became part of the fiefdom of the Salignac family of La Mothe-Fénelon, whose most famous member was François Fénelon, prior of the abbey from 1681 to 1685 and later bishop of Cambrai. He chose this "happy corner of the globe" in which to write his instructional novel *The Adventures of Telemachus*.

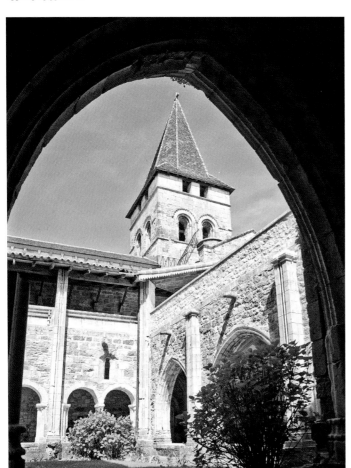

Castelnau-de-Montmiral

The treasure of the counts of Armagnac

Tarn (81) • Population: 1,000 • Altitude: 951 ft. (290 m)

The *bastide* of Castelnau-de-Montmiral boasts a rich heritage bequeathed by the counts of Toulouse and Armagnac.

Proudly perched on its rocky outcrop, the village is ideally situated as a lookout and, in the Middle Ages, saw remarkable growth and the building of a seignorial castle coupled with an impregnable fortress. The castle was destroyed in the 19th century, but part of the fortifications have been preserved, along with the Porte des Garrics, dating from the 13th century. At the center of the *bastide*, founded in 1222 by the Count of Toulouse Raymond VII, 16th- and 17th-century houses surround the covered square and old well. The Église Notre-Dame-de-l'Assomption contains a superb Baroque altarpiece, a Pietà, and a Pensive Christ from the 15th century, as well as the reliquary cross of the consuls from the late 14th century: a masterpiece of southern religious goldsmithery, which was originally decorated with 354 precious stones.

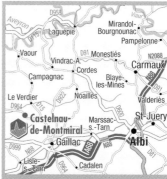

By road: Expressway A68, exit 9–Gaillac (12 miles/19 km); expressway A20, exit 59–Saint-Antonin-Noble-Val (26 miles/42 km). **By train:** Gaillac station (7 miles/11.5 km). **By air:** Toulouse-Blagnac airport (50 miles/80 km).

ⓘ Tourist information:
+33 (0)8 05 40 08 28
www.tourisme-vignoble-bastides.com

👁 Highlights
• **Église Notre-Dame-de-l'Assomption** (15th–16th centuries): 14th-century cross, altarpiece, Pensive Christ, Pietà, frescoes.
• **Permanent exhibition:** "Castelnau, Pages d'Histoire" at the tourist information center.
• **Château de Mayragues** (12th–17th centuries): Open for visits on Thursdays in July and August: +33 (0)8 05 40 08 28.
• **Village:** Guided tour for groups by appointment only; in summer also for individuals: +33 (0)8 05 40 08 28.

Accommodation
Hotels
Les Consuls***: +33 (0)5 63 33 17 44.
Guesthouses
Castelmazars 🏠🏠🏠🏠: +33 (0)6 18 44 33 11.
Maison de la Rose 🏠🏠🏠🏠:
+33 (0)6 16 66 33 31.
Les Miquels 🏠🏠🏠🏠: +33 (0)5 63 40 17 25.
Pechauzi 🏠🏠🏠🏠: +33 (0)6 47 81 87 23.
Les Anglades 🏠🏠🏠: +33 (0)5 63 40 47 93.
La Maison du Chai 🏠🏠🏠: +33 (0)6 19 02 26 65.
Mme Camalet: +33 (0)5 63 33 12 02.
Mas Castel: +33 (0)5 63 33 40 67.
Château de Mayragues:
+33 (0)5 63 33 94 08.
Mme Robert-Vautier: +33 (0)6 76 57 20 59.
Gîtes and walkers' lodges
Further information: +33 (0)8 05 40 08 28
www.tourisme-vignoble-bastides.com

Campsites
Domaine du Chêne Vert***:
+33 (0)5 63 33 16 10.

🍽 Eating Out
Les Arcades: +33 (0)5 63 33 20 88.
Au Baladin de la Grésigne, light meals:
+33 (0)5 63 42 78 99.
Marina Pizza: +33 (0)5 63 34 47 43.
Le Ménagier: +33 (0)5 63 42 08 35.

🧺 Local Specialties
Food and Drink
Foie gras, duck confit, duck breast (*magret*)
• AOC Gaillac wines.
Art and Crafts
Perfumer • Artists • Art gallery.

📅 Events
Market: All year round, Tuesday mornings, Place des Arcades.

Pentecost: Village festival (weekend).
July: "Les Musicales," rock, blues, and pop festival (mid-July).
August 15: Honey and local produce fair, village festival.

🦋 Outdoor Activities
Base de Vère-Grésigne: Swimming, fishing, paddleboat, mountain-bike trail departure point • Walking: Routes GR 36 and 46 and 3 marked trails.

🌿 Further Afield
• Gaillac (7½ miles/12 km).
• *Puycelsi (8 miles/13 km), see pp. 228–29.
• *Bruniquel (14 miles/23 km), see p. 173.
• Cordes-sur-Ciel (14 miles/23 km).
• Albi (20 miles/32 km).
• *Monestiés (20 miles/32 km), see p. 210.

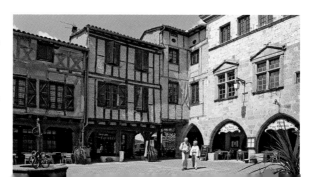

Castelnaud-la-Chapelle

A tale of two châteaux

Dordogne (24) • Population: 461 • Altitude: 459 ft. (140 m)

Clinging to the cliffside overlooking the confluence of the Dordogne and Céou rivers, the Château de Castelnaud and its houses, which are typical of the Périgord region, are arranged in tiers along the steep, narrow streets. Built in the 12th century on a strategic site for controlling the region's main river and land transportation routes, the Château de Castelnaud was much coveted during the many wars that marked the Middle Ages. Abandoned during the French Revolution, it was even used as a stone quarry in the 19th century, until, in 1966, it was listed as a historic monument and was thus prevented from falling into total ruin. Today, after extensive restoration, it once again casts its shadow over the valley, offering an exceptional view over the neighboring villages. It houses the Musée de la Guerre au Moyen Âge (medieval warfare museum). In the village, the characteristic houses, with their pale façades and brown sloping roofs, contrast with the green vegetation of the area. Not far from the river, the Château des Milandes preserves the memory of the French jazz entertainer Josephine Baker, who owned the property from 1947 to 1968.

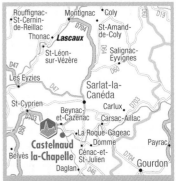

By road: Expressway A20, exit 55–Sarlat (23 miles/37 km). **By train:** Sarlat-la-Canéda station (7½ miles/12 km).
By air: Brive-Vallée de la Dordogne airport (35 miles/56 km); Bergerac-Roumanière airport (42 miles/68 km).

ⓘ Tourist information—
Périgord Noir–Vallée Dordogne:
+33 (0)5 53 31 71 00
www.perigordnoir-valleedordogne.com

👁 Highlights

• **Château de Castelnaud** (12th century, restored): Musée de la Guerre au Moyen Âge in the halls of the seigneurial home, a collection of 200 items of weapons and armor, collection of furniture, scenography: +33 (0)5 53 31 30 00.
• **Château des Milandes** (15th century): Exhibition on the life of Josephine Baker; garden: +33 (0)5 53 59 31 21.
• **Écomusée de la Noix du Périgord:** History and culture of the walnut in Périgord in an old restored farmhouse surrounded by a walnut grove. Museum, discovery tour, oil press: +33 (0)5 53 59 69 63.
• **Gardens of the Château de Lacoste:** Boxwood and rose garden, vegetable garden, park: +33 (0)5 53 29 89 37.

🔑 Accommodation

Guesthouses
Les Machicoulis: +33 (0)5 53 28 97 27.
La Tour de Cause B&B: +33 (0)5 53 30 30 51.
Gîtes and vacation rentals
L'Escalier***: +33 (0)5 53 31 45 40.
Les Terrasses de Fondaumier***:
+33 (0)5 53 31 45 40.
La Treille ⏐⏐ and ⏐: +33 (0)6 37 58 57 07.

Campsites and holiday villages
Camping-village de Vacances Lou Castel****: +33 (0)5 53 29 89 24.
Camping Maisonneuve***:
+33 (0)5 53 29 51 29.

🍴 Eating Out

Bar du Château: +33 (0)5 53 29 51 16.
La Cour de Récré: +33 (0)5 53 31 89 85.
Les Jardins des Milandes:
+33 (0)5 53 30 42 42.
Les Machicoulis, crêperie:
+33 (0)5 53 28 23 15.
La Taverne du Château: +33 (0)5 53 31 30 00.
Les Tilleuls, brasserie: +33 (0)5 53 29 58 54.
Le Tournepique: +33 (0)5 53 29 51 07.

🧺 Local Specialties

Art and Crafts: Miniature models.

📅 Events

July: Fête de la Plage (beach festival, weekend after the 14th).

🦋 Outdoor Activities

Municipal canoeing center:
+33 (0)5 53 29 40 07 • Walking: Route GR 64 and marked trails • Mountain-biking • Horse-riding.

🌿 Further Afield

• Dordogne Valley: *La Roque-Gageac (2 miles/3 km), see pp. 232–33; *Beynac-et-Cazenac (2½ miles/4 km), see pp. 166–67; *Domme (6 miles/9.5 km), see pp. 188–89; *Belvès (11 miles/18 km), see pp. 164–65; *Limeuil (21 miles/34 km), see pp. 206–7.
• Sarlat (8 miles/13 km).
• Les Eyzies (15 miles/24 km).
• *Monpazier (21 miles/34 km), see pp. 213–14.
• *Saint-Amand-de-Coly (22 miles/35 km), see pp. 234–35.
• Vézère valley: *Saint-Léon-sur-Vézère (23 miles/37 km), see p. 244.

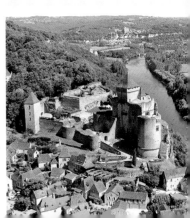

Castelnou

In the foothills of the Pyrenees

Pyrénées-Orientales (66) • Population: 365 • Altitude: 804 ft. (245 m)

Nestled in the Aspres, foothills accentuated by the magnificent Canigou mountain, Castelnou is a village that typifies Catalan rural architecture. Surrounded by two limestone plateaus—the Causse de Thuir and the Roc de Majorque—the village, founded in the 10th century, seems to have been forgotten by time after having been the capital of the viscountcy of Vallespir for more than three centuries. The castle follows the natural shape of the rock and forms a pentagon. The steepness of the rock, the castle's 10-ft. (3-m) thick walls, and the 14th-century fortified walls surrounding the village, of which eight towers remain, assured its defense. To the northeast of the village, a tower erected on a hill allowed for the sending of smoke signals between France and the kingdom of Spain. The harshness of this steep, tiered, stone-built site contrasts with the intimacy of the narrow flower-filled streets lined with warm-hued houses with round-tiled roofs. To the north of the village, the Église Santa Maria del Mercadal (Saint Mary of the marketplace) is in the Catalan Romanesque style.

By road: Expressway A9, exit 42–Perpignan Sud (10 miles/16 km). **By train:** Perpignan station (12 miles/19 km). **By air:** Perpignan-Rivesaltes airport (17 miles/27 km).

ⓘ **Tourist information— Aspres-Thuir:**
+33 (0)4 68 28 32 38 or
+33 (0)4 68 53 45 86
www.aspres-thuir.com

👁 Highlights
• Église Santa Maria del Mercadal (12th century).
• **Village:** Guided tour by appointment only.

🗝 Accommodation
Hotels
Domaine des Aspres: +33 (0)6 17 90 02 72.
Guesthouses
Les Coricos: +33 (0)6 76 96 47 00.
La Figuera: +33 (0)4 68 53 18 42.
La Font Castelnou: +33 (0)6 87 12 73 72.
La Planquette: +33 (0)4 68 53 48 13.
Gîtes
Further information: +33 (0)4 68 53 45 72
www.aspres-thuir.com

🍽 Eating Out
Restaurants
D'Ici et d'Ailleurs: +33 (0)4 68 53 23 30.
L'Hostal: +33 (0)4 68 53 45 42.
Light meals
Le Coin Catalan: +33 (0)4 68 53 26 88.
Comme Chez Mémé, tapas:
+33 (0)4 62 29 27 11.
La Font: +33 (0)4 68 53 66 25 or
+33 (0)6 87 12 73 72.

🍴 Local Specialties
Food and Drink
Preserves • Farm produce • Local honey and bee products • Castelnou wine.

Art and Crafts
Cutler • Wirework workshop • Artist-mosaicist • Potters • Wood turner • Artworks made from eggshells • Sculptural ceramicist • Lampshades • Objects created from recycled paper • Jewelry design • Crafts using natural materials • Sculptor • Jewelry designer.

📅 Events
Market: Mid-June–mid-September, Tuesday 9 a.m.–7 p.m., at the foot of the church.
April–October: Temporary exhibitions, Carré d'Art Gili.

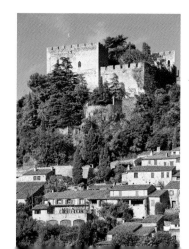

June: Les Lucioles de Castelnou, 11-mile/18-km night race; "Feu de la Saint-Jean," Saint John's Eve bonfire (end of June).
October: Farmers' market (2nd weekend).

🦋 Outdoor Activities
Walking • Mountain-biking • Donkey or pony rides.

🌿 Further Afield
• Camélas; Fontcouverte; Monastir-del-Camp; Sainte-Colombe; Serrabonne (2½–9½ miles/4–15.5 km).
• Thuir (Byrrh wine cellars), Perpignan (13 miles/21 km).
• Céret; Tech valley (18 miles/29 km).
• *Eus (18 miles/29 km), see p. 192.
• Elne; Collioure (19 miles/31 km).
• *Villefranche-de-Conflent (23 miles/37 km), see pp. 262–63.

🛈 Did you know?
The architectural style of Catalonia is well established in Castelnou. Reserving the ground floor for livestock and servants' accommodation, the ocher-fronted houses have an outside staircase that leads to the living quarters. Bread ovens, accessible from inside the house, make the walls protrude.

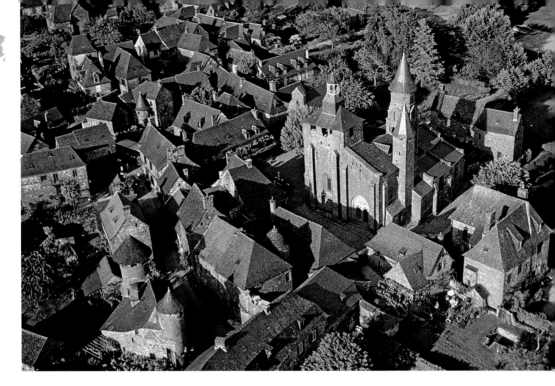

Collonges-la-Rouge
Russet-colored Corrèze

Corrèze (19) • Population: 455 • Altitude: 755 ft. (230 m)

On the border between Limousin and Quercy, the red sandstone of Collonges harmonizes with the green of the vines rambling on its façades. Built up around a Benedictine priory founded in the 8th century, the village came under the lordship of the powerful neighboring viscount of Turenne in the 13th century and was the place of residence of his judicial officers. Collonges then acquired the Renaissance castles of Maussac, Vassinhac, Benge, and Beauvirie. With its imposing proportions, *lauze* (schist stone) roofs, towers, turrets, and watchtowers, both rural and bourgeois, robust and refined, Collonges-la-Rouge displays a rare homogeneity and has been remarkably well preserved. Every building, every monument declares the village's rich history. The Église Saint-Pierre, built in the 11th and 12th centuries, bears witness to the time when Collonges was one of the stopping places on the Saint James's Way pilgrim route via Rocamadour. The Priory gate, which is vaulted and ogival shaped, and the Flat gate (it has no tower) are the only remains of the village's ramparts. At the center of the village, the former grain and wine market dating from the 16th century recalls the village's commercial activity and prosperous history, and still houses the communal bread oven. The Chapelle des Pénitents, which can be admired today thanks to restoration work by the Friends of Collonges, was, from 1765 to the end of the 19th century, home to the Brotherhood of Black Penitents, whose charitable missions included burying the dead free of charge.

By road: Expressway A20, exit 52–Collonges-la-Rouge (9½ miles/15.5 km).
By train: Brive-la-Gaillarde station (12 miles/19 km). **By air:** Brive-Vallée de la Dordogne airport (14 miles/23 km).

ⓘ Tourist information—Vallée de la Dordogne: +33 (0)5 65 33 22 00
www.vallee-dordogne.com

👁 Highlights
• **Chapelle des Pénitents** (15th century):
Restored in 1927 by the Friends of
Collonges.
• **Église Saint-Pierre** (11th–12th centuries):
Carved tympanum.
• **Maison de la Sirène** (16th century):
A typical Collonges house with furniture
and everyday objects from the past,
explaining the history of the village.

🗝 Accommodation
Hotels
Le Relais Saint-Jacques**:
+33 (0)5 55 25 41 02.
Guesthouses
Domaine de Peyrelimouse***:
+33 (0)5 55 84 07 17 or
+33 (0)6 73 57 08 99.
La Vigne Grande 🍷🍷: +33 (0)5 55 25 39 20.
La Douce France: +33 (0)5 55 84 39 59 or
+33 (0)6 88 65 69 95.
La Fermette: +33 (0)6 83 30 53 99.
Le Jardin de la Raze: +33 (0)5 55 25 48 16
or +33 (0)6 04 18 89 91.
Holiday villages
Les Vignottes: +33 (0)5 55 25 30 91.
Campsites
Moulin de la Valane***:
+33 (0)5 55 25 41 59 or
+33 (0)6 84 40 36 23.

🍴 Eating Out
L'Auberge de Benges: +33 (0)5 55 85 76 68.
Lou Brasier, pizzeria: +33 (0)6 16 59 69 49.
Le Cantou: +33 (0)5 55 84 25 15.
Le Collongeois: +33 (0)5 55 84 59 16.
La Ferme de Berle, farmhouse inn,
booking essential: +33 (0)5 55 25 48 06.
La Halle Fermière des Gariottes, regional
light meals: +33 (0)5 44 31 89 97.
Le Pause & Vous: +33 (0)5 55 22 67 03.
Le Pèlerin et la Sorcière, crêperie:
+33 (0)5 55 74 23 49.
Les Pierres Rouges: +33 (0)5 55 74 19 46.
♥ Le Relais Saint-Jacques:
+33 (0)5 55 25 41 02.

🧺 Local Specialties
Food and Drink
Duck • Purple mustard • Walnuts.
Art and Crafts
Leatherworkers • Hats • Cutlery •
Decoration • Art galleries • Linen •
Artists • Pottery • Glass • Artisan perfumes.

📅 Events
May: Local saint's day (3rd weekend).
Mid-July–mid-August: Theater on
Tuesday evenings.
August: Fête du Pain, bread festival
(1st weekend); painting and visual arts
festival (15th).

🦋 Outdoor Activities
Walking: Route GR 480 and several
marked trails.

🍃 Further Afield
• Ligneyrac, Noailhac, and Saillac: churches
(2 miles/3 km).
• *Turenne (6 miles/9.5 km), see pp. 260–61.
• Dordogne valley (6 miles/10 km).
• *Curemonte (7½ miles/12 km), see p. 187.
• Brive-la-Gaillarde: market
(12 miles/19 km).
• Varetz: Jardins de Colette, gardens
(12½ miles/20 km).
• *Carennac (15 miles/24 km), see pp. 177–78.
• *Loubressac (21 miles/34 km), see p. 208.
• Souillac (21 miles/34 km).
• *Autoire (22 miles/35 km), see p. 157.

ℹ Did you know?
The incomparable color of this stone is due
to a geological phenomenon dating back
millions of years. The "Meyssac Fault,"
which passes through Collonges-la-Rouge,
was formed by the sliding of the red
sandstone of the Massif Central beneath
Aquitaine's limestone plate. The oxidized
iron of the sandstone of Corrèze gives the
stone its dark red color, which is
characteristic of the Meyssac Fault.

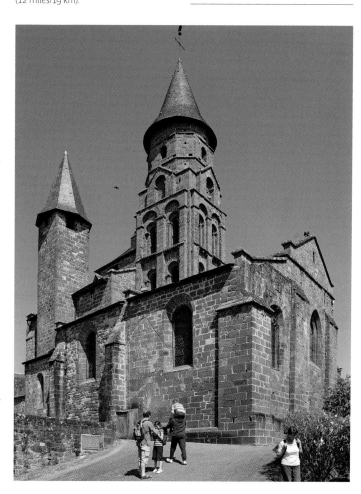

Conques
Muse of Romanesque artists

Aveyron (12) • Population: 283 • Altitude: 820 ft. (250 m)

A hotspot for Romanesque art, Conques contains treasures inspired by the faith of artists in the Middle Ages.

Conques was established on the slope of a valley shaped like a shell (*concha* in Latin, hence its name), at the heart of a rich forested massif situated at the confluence of two rivers: the Ouche and the Dourdou. Its heyday, in the 11th and 12th centuries, coincided with the building of the abbey church, a true masterpiece of Romanesque architecture. Beneath its vaults, 250 capitals are enhanced by contemporary stained-glass windows designed by Pierre Soulages (b. 1919), and on the tympanum of its western portal 124 figures in stone illustrate the Last Judgment. Depicted in all her splendor, Saint Foy keeps watch, with an enigmatic expression, over a unique collection of reliquaries covered in gold, silver, enamelwork, and precious stones. The Barry and Vinzelle gates, remains of the ramparts built during the same period, flank a village where stone reigns. Lining the narrow cobbled streets, the village houses, the oldest of which date from the late Middle Ages, display façades that combine half-timbering, yellow limestone, and red sandstone, and are topped with splendid silver shale roofs.

By road: Expressway A75, exit 42–Rodez, N88-Rodez, D 901 (24 miles/39 km). **By train:** Saint-Christophe-Vallon station (21 miles/34 km); Rodez station (28 miles/45 km). **By air:** Rodez-Aveyron airport (21 miles/34 km).

(i) Tourist information:
+33 (0) 65 72 85 00
www.tourisme-conques.fr

◉ Highlights
• **Abbatiale Sainte-Foy:** Guided tour of the tympanum, the lower level of the church, and the tribunes to discover the Roman column heads and Soulages stained-glass; for information on days and times: +33 (0)5 65 72 85 00. Evening tours of the tribunes with organ and lights daily at 9 p.m. from May to September, illuminations on the tympanum at 10.15 p.m. Guided tour for groups all year round, booking essential: +33 (0)5 65 72 85 00.
• **Trésor de Sainte-Foy:** Abbey treasury: daily, for times: +33 (0)5 65 72 85 00; guided tour for groups all year round, booking essential: +33 (0)5 65 72 85 00.
• **Village:** Self-guided tours with digital tablets, July and August:

+33 (0)5 65 72 85 00; tours for the visually impaired (tatcile models, reliefs, guidebooks in Braille and large print). Further information: +33 (0)5 65 72 85 00.

🗝 Accommodation
Hotels
Hervé Busset—Domaine de Cambelong****: +33 (0)5 65 72 84 77.
Auberge Saint-Jacques**: +33 (0)5 65 72 86 36.
Sainte-Foy 🏠🏠🏠: +33 (0)5 65 69 84 03.
Guesthouses
La Maison des Sources 🏠🏠🏠: +33 (0)5 65 47 04 54 or +33 (0)6 19 49 23 92.
Les Chambres de Marie Scépé 🏠🏠: +33 (0)5 65 72 83 87 or +33 (0)7 78 24 34 45.
Chez Alice et Charles 🏠🏠: +33 (0)5 65 72 82 10 or +33 (0)6 87 19 17 59.

Les Chambres de Montignac: +33 (0)5 65 69 84 29.
Le Castellou: +33 (0)5 65 78 27 09 or +33 (0)6 48 15 66 91.
Les Grangettes de Calvignac: +33 (0)6 75 50 59 19.
Gîtes and vacation rentals
Further information: 05 65 72 85 00 www.tourisme-conques.fr
Bunkhouses and walkers' lodges
Maison Familiale de Vacances Relais Cap France: +33 (0)5 65 69 86 18.
Centre d'Accueil de l'Abbaye Sainte-Foy: +33 (0)5 65 69 89 43.
Communal walkers' lodge: +33 (0)5 65 72 82 98.
Campsites
Le Beau Rivage*** (mobile home rentals), Le Faubourg: +33 (0)5 65 69 82 23.

🍽 Eating Out
Auberge Saint-Jacques: +33 (0)5 65 72 86 36.
Au Parvis, crêperie/brasserie: +33 (0)5 65 72 82 81.
Le Charlemagne, crêperie/ice cream parlor: +33 (0)5 65 69 81 50.
Chez Dany Lo Romiu, pizzeria/snack bar: +33 (0)5 65 46 95 01.
Chez Germain, wine bistro: +33 (0)6 83 18 34 87.

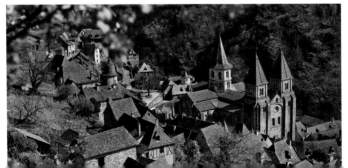

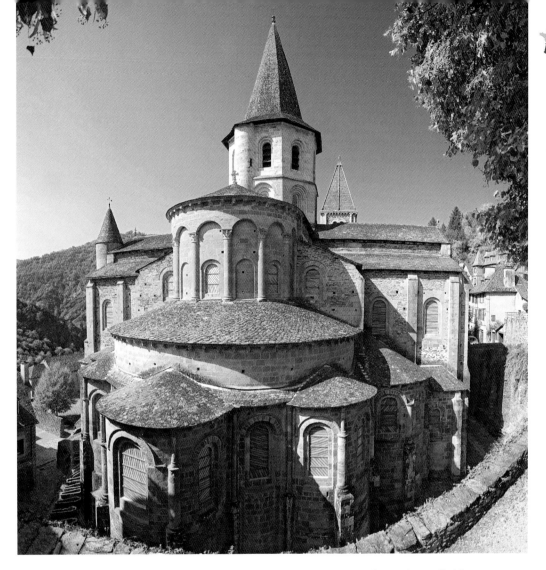

Hervé Busset—Domaine de Cambelong:
+33 (0)5 65 72 84 77.
La Rivière: +33 (0)5 65 78 13 14.
Sainte-Foy: +33 (0)5 65 69 84 03.
Sur le Chemin du Thé, tea room/organic
food: +33 (0)9 60 02 81 95.

🍽 Local Specialties

Food and Drink
Conquaises (walnut shortbread) •
Conques wine.

Art and Crafts
Antique dealer • Beadmaker • Art gallery •
Etcher • Engraver • Leather craftsmen •
Artist • Sadler • Wood-carvers •
Sculptor-stonemason • Low-warp tapestry •
Art foundry • Ceramicists • Bookbinding •
Felt-worker.

📅 Events

July and August: Music festival.
October: Procession de la Sainte-Foy
(the 6th or the 1st Sunday after the 6th).
All year round: Lectures, concerts, shows,
workshops, exhibitions, etc.

🦋 Outdoor Activities

Fishing • Walking: Routes GR 62, 65,
and 465, and 7 marked trails.

🦋 Further Afield

• Dourdou valley and gorge: viewpoint
at Le Bancarel (1 mile/1.5 km).
• Lot valley (4½ miles/7 km).
• La Vinzelle (7½ miles/12 km).
• Vallon de Marcillac, AOP vineyards and
wine route (11 miles/18 km).
• Salles-la-Source, waterfall (16 miles/26 km).
• *Belcastel (24 miles/39 km), see
pp. 162–63.
• *Estaing (24 miles/39 km), see
pp. 190–91.
• Rodez: cathedral and Musée Soulages
(24 miles/39 km).

La Couvertoirade
In the footsteps of the Templars

Aveyron (12) • Population: 188 • Altitude: 2,546 ft. (776 m)

At the heart of the wide-open spaces of the Causse du Larzac, La Couvertoirade is the work of the Templars and Hospitallers. Built in the 12th century, the Château de La Couvertoirade formed part of the command network developed by the Templars throughout the West and in the Holy Land. After they were declared heretics in the early 14th century by Philippe le Bel, the Templars were replaced by the Hospitallers, who inherited all their assets. The latter, too, were soldier-monks and encircled the city with ramparts in the 15th century to protect it from attack and from epidemics. From the top of the ramparts, the view stretches over Larzac and the whole of the village: at the foot of the 12th-century church, a labyrinth of narrow streets lined with "Caussenard"-style houses (built of thick stone to protect the men and livestock inside) and 16th- and 17th-century mansions provides an enticing place to stroll.

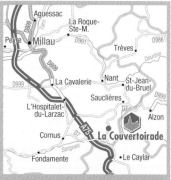

By road: Expressway A75, exit 49–Le Caylar (4½ miles/7 km). **By train:** Millau station (30 miles/48 km). **By air:** Montpellier-Méditerranée airport (58 miles/93 km).

ⓘ Tourist information—
La Couvertoirade: +33 (0)5 65 58 55 59
www.lacouvertoirade.com
Tourist information—Larzac et Vallées:
+33 (0)5 65 62 23 64
www.tourisme-larzac.com

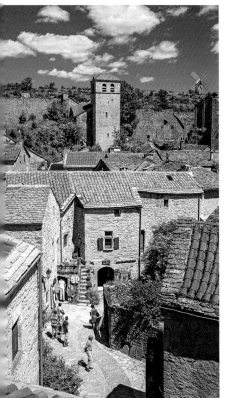

👁 Highlights
• Village: 15th-century ramparts, 17th-century castle, Hospitallers' church, 14th-century oven. Self-guided visit (audioguide) or guided tour, evening tours in summer. Further information: +33 (0)5 65 58 55 59.

🗝 Accommodation
Guesthouses
M. et Mme Augustin, La Salvetat: +33 (0)5 65 62 13 15.
La Chambre du Chat: +33 (0)5 65 42 14 61.
Les Mourguettes: +33 (0)6 11 08 35 30 or +33 (0)6 14 57 12 31.
L'Oustalinette: +33 (0)5 65 42 81 59.
Gîtes, walkers' lodges, and vacation rentals
Further information: 05 65 62 23 64
www.tourisme-larzac.com
Rural campsites
Les Canoles, La Blaquèrerie: +33 (0)5 65 62 15 12.

🍽 Eating Out
L'Auberge du Chat Perché: +33 (0)5 65 42 14 61.
Au 20 [vingt], light meals/wine bar: +33 (0)5 65 62 19 64.
Café Montes, crêperie: +33 (0)5 65 58 10 71.
Café des Remparts: +33 (0)5 65 62 11 11.
Les Fées des Causses: +33 (0)5 65 58 14 23.
Les Gourmandises de l'Aveyron, light meals: +33 (0)6 83 03 61 31.
L'Hospitalier: +33 (0)6 38 51 88 31.
Le Médiéval: +33 (0)5 65 62 27 01.
Tour Valette: +33 (0)5 65 62 09 69.

🛍 Local Specialties
Food and Drink
Sheep cheese • Local charcuterie • Spit cake.
Art and Crafts
Art gallery • Workshops in summer (potters, weavers, sculptors) • Jewelry • Leather craftsmen.

2️⃣ Events
July and August: "Les Mascarades," medieval festival (last Tuesday in July); country market (Thursday evenings); children's days; lectures, concerts, etc.

🦋 Outdoor Activities
Trail through the rocks • Walking: Routes GR 71 C and GR 71 D and circular walks around the village • Mountain-biking.

🌿 Further Afield
• Gorges of the Dourbie; Nant: Romanesque churches (8½ miles/14 km).
• Larzac Templar and Hospitaller sites: La Cavalerie; Sainte-Eulalie-de-Cernon (reptilarium, rail bike; Viala-du-Pas-de-Jaux; Saint-Jean-d'Alcas (12–19 miles/19–31 km).
• Lodève (15 miles/24 km).
• Cirque de Navacelles (21 miles/34 km).
• Millau Viaduct (22 miles/35 km).
• Caves de Roquefort (29 miles/47 km).
• *Peyre, "The Most Beautiful Village of France" (29 miles/47 km), see pp. 224–25.

Curemonte

A village of lords and winegrowers

Corrèze (19) • Population: 211 • Altitude: 689 ft. (210 m)

Punctuated by the towers of its three castles, the profile of Curemonte stands out above the Sourdoire and Maumont valleys.

The village is built on a long sandstone spur. Viewed from above, its medieval architecture is astonishing. Standing near the three castles (the square-towered Saint-Hilaire, the round-towered Plas, and La Johannie), the Romanesque Église Saint-Barthélemy contains an altarpiece from 1672, and altars of Saint John the Baptist and the Virgin Mary from the 17th and 18th centuries. The late 18th-century covered market houses a Gothic cross shaft. In an enduringly simple, rural atmosphere, Renaissance mansions stand side by side with old winegrowers' houses in a harmony of pale sandstone and brown roof tiles. Outside the village, the Romanesque Église Saint-Genest, decorated with 15th-century paintings, houses a museum of religious artifacts, while the recently restored Église de La Combe is a masterpiece of 11th-century architecture and one of the oldest religious buildings in Corrèze.

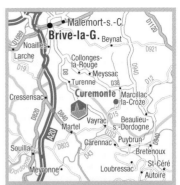

By road: Expressway A20, exit 52–Noailles (11 miles/18 km). **By train:** Brive-la-Gaillarde station (19 miles/31 km). **By air:** Brive-Vallée de la Dordogne airport (17 miles/27 km).

ⓘ **Tourist information—Vallée de la Dordogne:** +33 (0)5 65 33 22 00 or +33 (0)5 55 25 47 57 www.vallee-dordogne.com

👁 Highlights

• **Église Saint-Barthélemy** (12th century): 17th-century wooden altarpiece.
• **Église de La Combe** (11th century): Exhibitions in summer.
• **Église Saint-Genest:** Museum of religious artifacts.
• **Castles:** Guided tours July–September: +33 (0)5 55 25 47 57.

🗝 Accommodation

Guesthouses
Mme Raynal***: +33 (0)5 55 25 35 01.
Gîtes and vacation rentals
Gîte de la Barbacane 🌢🌢🌢:
+33 (0)5 55 87 49 26.
La Maison de la Halle 🌢🌢🌢:
+33 (0)5 55 85 20 92.
La Maison Lale 🌢🌢🌢: +33 (0)5 55 84 00 09.

Gîte de la Mairie 🌢🌢:
+33 (0)5 55 27 38 38.
Gîte de Fleuret: +33 (0)6 10 50 47 44.
Lou Pé Dé Gril: +33 (0)5 55 25 45 53.
La Maison de Marguerite:
+33 (0)4 42 01 77 13.
Le Roc Blanc: +33 (0)5 55 25 48 02.

🍽 Eating Out

Auberge de la Grotte, farmhouse inn:
+33 (0)5 55 25 35 01.
La Barbacane: +33 (0)5 55 25 43 29.

🛍 Local Specialties

Food and Drink
Garlic and shallots • Aperitifs and jams made from dandelion flowers • Artisanal beer.

🎟 Events

July and August: Festive market, sale of regional produce followed by a barbecue (Wednesdays at 4 p.m.); concerts.

🦌 Outdoor Activities

Hunting • Fishing • Walking: Route GR 480 and the "Boucle Verte" linking Curemonte with Collonges-la-Rouge.

🌾 Further Afield

• La Chapelle-aux-Saints: prehistoric site; museum (2 miles/3 km).
• Dordogne valley: Beaulieu; Argentat (6–22 miles/9.5–35 km).
• *Collonges-la-Rouge (7½ miles/12 km), see pp. 182–83.
• *Carennac (8½ miles/13.5 km), see pp. 177–78.
• *Turenne (11 miles/18 km), see pp. 260–61.
• *Loubressac (14 miles/23 km), see p. 208.
• *Autoire (16 miles/26 km), see p. 157.
• Brive-la-Gaillarde: Jardins de Colette, gardens; market (25 miles/40 km).

🛈 Did you know?

In 1940, the French novelist Colette came here to seek refuge with her daughter, Colette de Jouvenel, owner of the Châteaux de Saint-Hilaire et de Plas. In the tranquility of the village, the writer wrote part of her novel *Looking Backwards*.

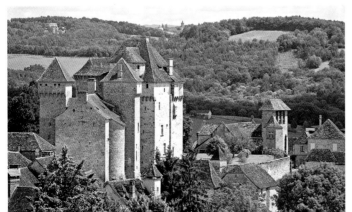

Domme
A panoramic viewpoint over the Dordogne

Dordogne (24) • Population: 1,019 • Altitude: 689 ft. (210 m)

On the edge of a breathtakingly high cliff, Domme offers a remarkable view over the Dordogne valley.

Towering 492 ft. (150 m) over the meandering river, Domme's exceptional site accounts for it being one of the most beautiful *bastides* in the southwest of France, as well as a coveted place marked by a long and turbulent history. Its ramparts, fortified gates, and towers, which served as prisons in the early 14th century, and held French and English soldiers during the Hundred Years War, stand as imposing witnesses of its past. From the Place de la Rode, randomly dotted along flower-decked streets, are fine houses with golden façades and irregular roofs covered with brown tiles, such as the Maison du Batteur de Monnaie, embellished with a triple mullioned window, and the former courthouse of the seneschal, both built in the 13th century. Continuing on from the Place de la Halle, Domme offers a panoramic view of the Dordogne valley, rural landscapes, cultivated land, and a few local heritage sites, such as the Château de Monfort, the village of La Roque-Gageac, and the Jardins de Marqueyssac.

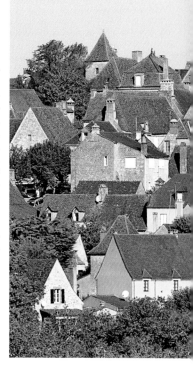

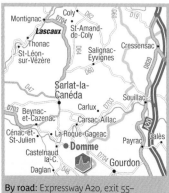

By road: Expressway A20, exit 55– Sarlat (22 miles/35 km). **By train:** Sarlat-la-Canéda station (7½ miles/12 km). **By air:** Brive-Vallée de la Dordogne airport (33 miles/53 km).

(i) Tourist information— Périgord Noir:
+33 (0)5 53 33 71 00
www.perigordnoir-valleedordogne.com

👁 Highlights
• Église Notre-Dame-de-l'Assomption: Open daily.
• "Les Mystérieux Graffiti": Guide to the graffiti carved into the prison walls. Guided tours in autumn: +33 (0)5 53 33 71 00
• **Cave with stalactites:** The largest accessible cave in the Périgord Noir. More than a quarter of a mile (450 m) of tunnels beneath the *bastide*; ascent by panoramic elevator with a view of the Dordogne valley. Further information: +33 (0)5 53 33 71 00.
• **L'Oustal du Périgord** (popular arts and traditions museum): Collection of 19th- and 20th-century farming objects. Further information: +33 (0)5 53 33 71 00.
• **Village:** Guided tours in July and August and by appointment only off-season: +33 (0)5 53 33 71 00; tour of the village by tourist train.

🔑 Accommodation
Hotels
L'Esplanade***: +33 (0)5 53 28 31 41.
Nouvel Hôtel**: +33 (0)6 38 32 91 23.
Guesthouses
Le Manoir du Rocher ✍✍✍✍
and ✍✍✍✍: +33 (0)6 15 25 91 75.
1 Logis à Domme: +33 (0)9 75 44 51 68.

Vacation rentals and campsites
Further information: +33 (0)5 53 31 71 00
www.perigordnoir-valleedordogne.com
Holiday villages
La Combe: +33 (0)5 53 29 77 42.
Les Ventoulines: +33 (0)5 53 28 36 29.
Village du Paillé: +33 (0)6 73 38 32 94.

🍷 Eating Out
Auberge de la Rode: +33 (0)5 53 28 36 97.
Alexandre Bar: +33 (0)5 53 28 53 47.
Le Belvédère: +33 (0)5 53 31 12 01.
La Borie Blanche, farmhouse inn: +33 (0)5 53 28 11 24.
Cabanoix et Châtaignes: +33 (0)5 53 31 07 11.
Le Carreyrou: +33 (0)6 82 01 08 36.
Le Chalet: +33 (0)5 53 29 32 73.
L'Esplanade: +33 (0)5 53 28 31 41.
Le Jacquou Gourmand: +33 (0)5 53 28 36 81.
Le Médiéval: +33 (0)5 53 28 24 57.
La Pizzeria des Templiers: +33 (0)6 06 45 15 09.
Rafaello: +33 (0)5 53 28 32 52.

🏛 Local Specialties
Food and Drink: Geese • Walnuts.
Art and Crafts: Jeweler • Artist.

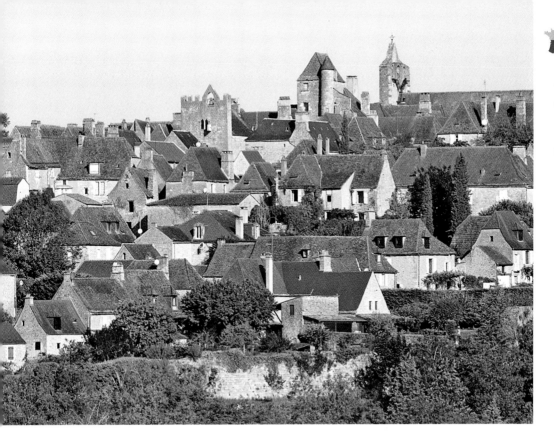

▣ Events

Market: Thursday morning, Place de la Halle.
June: Fête de la Saint-Clair (1st weekend); "Feux de la Saint-Jean," Saint John's Eve bonfire; music festival; amateur dramatics festival.
July 14: Torchlight procession, fireworks.
July and August: Crafts market (Thursdays); "Domme Contemporaine Pas à Pas," art exhibition.

◗ Outdoor Activities

Canoeing • Tennis • Mountain-biking • Walking: Route GR 64 and marked trails • Air sports: Light aircraft and microlights.

⚶ Further Afield

• Sarlat (7½ miles/12 km).
• Dordogne valley: *La Roque-Gageac (3 miles/5 km), see pp. 232–33; *Castelnaud-la-Chapelle (6 miles/9.5 km), see p. 180; *Beynac-et-Cazenac (6 miles/ 9.5 km), see pp. 166–67; *Belvès (16 miles/ 26 km), see pp. 164–65.
• *Gourdon (17 miles/27 km), see pp. 100–101.
• Les Eyzies (21 miles/34 km).
• *Saint-Amand-de-Coly (23 miles/37 km), see pp. 234–35.
• *Limeuil (24 miles/39 km), see pp. 206–7.
• Vézère valley: *Saint-Léon-sur-Vézère (24 miles/39 km), see p. 246.
• *Monpazier (27 miles/43 km), see pp. 213–14.

❢ Did you know?

Whom do we have to thank for the strange graffiti carved into the walls of the medieval towers? Was it the Templars, who were suppressed and imprisoned by Philip the Fair? Archaeologists continue to debate this question in the hope of solving the mystery. But one thing is clear: nobody can come to Domme and fail to see this enigmatic treasure.

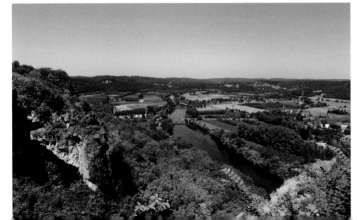

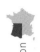

Estaing
One family, one castle

Aveyron (12) • Population: 560 • Altitude: 1,050 ft. (320 m)

A short distance from the Gorges of the Lot, set against a backdrop of greenery, Estaing is distinguished by an imposing castle that overlooks the *lauze* (schist stone) roofs of the shale houses.

The illustrious Estaing family left its mark on the history of Rouergue, but also on that of France. The Château des Comtes d'Estaing (11th century to present) mixes Romanesque, Gothic, Flamboyant, and Renaissance styles. On the Place François Annat, named after Louis XIV's confessor, the 15th-century church, which has some remarkable altarpieces and stained-glass windows, houses the relics of Saint Fleuret. The fine Renaissance houses at the heart of the village continue to draw tourists. Providing a magnificent entrance point from the Saint James's Way, the 16th-century Gothic bridge is on the UNESCO World Heritage list and offers unique views of the castle, the village's crowning feature.

By road: Expressway A75, exit 42–Rodez (34 miles/55 km). **By train:** Rodez station (24 miles/39 km). **By air:** Rodez-Marcillac airport (30 miles/48 km).

(i) Tourist information—
Terres d'Aveyron: +33 (0)5 65 33 03 22
www.terresdaveyron.fr

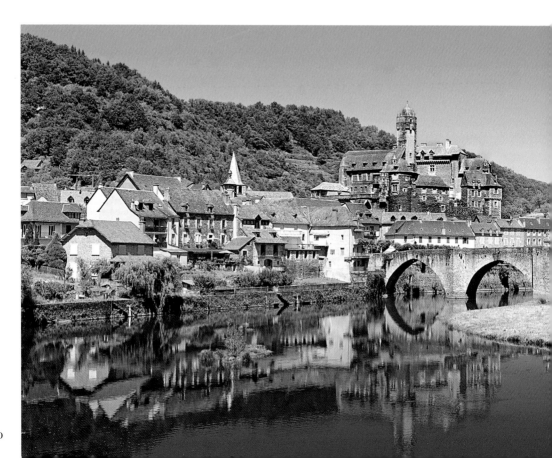

👁 Highlights

• ♥ **Castle** (11th century to present): Birthplace of the Estaing family. Open to the public in summer: self-guided visit of the restored rooms; guided tour (€) by appointment only: +33 (0)5 65 44 72 24.
• **Église Saint-Fleuret** (15th century): Gilded wooden altarpieces (17th and 18th centuries), relics of Saint Fleuret; contemporary stained-glass windows by Claude Baillon.
• **Chapelle de l'Ouradou** (16th century).
• **Village**: Guided tour for groups by appointment only: +33 (0)5 65 44 03 22.

🗝 Accommodation

Hotels
Auberge Saint-Fleuret**:
+33 (0)5 65 44 01 44.
Aux Armes d'Estaing**: +33 (0)5 65 44 70 02.
B and B Manoir de la Fabrègues:
+33 (0)5 65 66 37 78.
Guesthouses
L'Oustal de Cervel 🛏🛏🛏:
+33 (0)5 65 44 09 89.

Chez Tifille: +33 (0)6 51 12 41 46.
Lou Bellut: +33 (0)6 80 66 77 79.
M. Dijols. +33 (0)5 65 44 71 51.
Gîtes, vacation rentals, and campsites
Further information: +33 (0)5 65 44 03 22
www.terresdaveyron.fr

🍴 Eating Out

Auberge Saint-Fleuret:
+33 (0)5 65 44 01 44.
Aux Armes d'Estaing: +33 (0)5 65 44 70 02.
Brasserie du Château: +33 (0)5 65 44 12 89.
Chez Lilou: +33 (0)5 65 44 35 56.
Chez Mon Père: +33 (0)5 65 44 02 70.
Le D'Estaing, light meals:
+33 (0)6 71 72 81 90.

🧺 Local Specialties

Food and Drink
AOC and IGP Aveyron wines.
Art and Crafts
Bags and accessories designer • Jewelers • Cutlery maker • Illuminator • Unique handcrafted objects.

📅 Events

Market: July and August, evening and gourmet markets, Place du Foirail, Fridays from 7 p.m.
June 15–September 15: "Son et Lumière d'Estaing, 1500 ans d'histoire," sound and light show (Wednesday evenings).
July: Fête de la Saint-Fleuret, traditional parade (1st Sunday).
August: Nuit Lumière, illumination of the village by candlelight, sound and light show, fireworks (15th).
September: Les Médiévales d'Estaing, Estaing celebrates its medieval past (2nd weekend).

🦋 Outdoor Activities

Trout-fishing • Walking: Routes GR 65 and 6; topographic guide (23 circular walks), and walking tour of the village.

🌿 Further Afield

• Maison de la Vigne, du Vin, et des Paysages d'Estaing (all things wine-related) (3 miles/5 km).
• Espalion: Château de Calmont (8 miles/ 13 km).
• *Saint-Côme-d'Olt (8½ miles/13.5 km), see p. 240.
• Villecomtal (9½ miles/15.5 km).
• Gorges of the Truyère (16 miles/26 km).
• Laguiole; l'Aubrac (16 miles/26 km).
• *Sainte-Eulalie-d'Olt (21 miles/34 km), see pp. 246–47.
• Rodez (22 miles/35 km).
• *Conques (24 miles/39 km), see pp. 184–85.

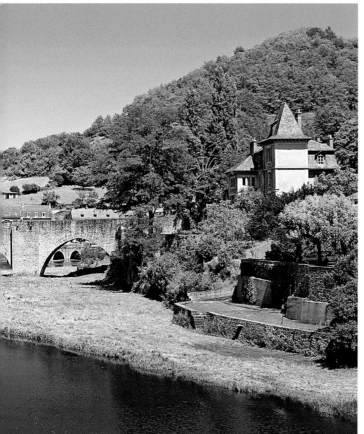

Eus
A feel of the South

Pyrénées-Orientales (66) • Population: 435 • Altitude: 1,270 ft. (387 m)

Eus is filled with the fragrance of orchards, old olive groves, and the *garrigue*. Built on terraces sheltered from the wind, the village takes its name from the surrounding *yeuses* (holm oaks). Designed for defense, Eus repelled the French in 1598 and, in 1793, the Spanish army, which at that time dominated the region. The 18th-century Église Saint-Vincent stands on the site of the Roman camp that kept watch over the road from Terrenera to Cerdagne, and of the former castle chapel, Notre-Dame-de-la-Volta, built in the 13th century. At the entrance to Eus, a Romanesque chapel is dedicated to the patron saint of winegrowers and to Saint Gaudérique. It opens onto a 13th-century porch made from pink marble from Villefranche-de-Conflent. Clinging to the steep, cobblestone streets, the old restored shale-stone houses give the village a harmonized feel.

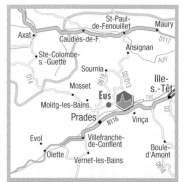

By road: Expressway A9, exit 42–Perpignan Sud (25 miles/40 km).
By train: Prades-Molitg-les-Bains station (3½ miles/5.5 km). **By air:** Perpignan-Rivesaltes airport (29 miles/47 km).

ⓘ Tourist information—
Conflent-Canigó: +33 (0)4 68 05 41 02
www.tourisme-canigou.com

👁 Highlights
• **Romanesque chapel** (11th–13th centuries): Listed as a historical monument.
• **Église Saint-Vincent** (18th century): Altarpieces and statues.
• **Musée La Solana:** Popular traditions.
• **Village:** Guided tour by arrangement: +33 (0)4 68 96 22 69.
• **Pépinières d'Agrumes Bachès** (citrus fruit nursery): Guided tours for groups by appointment only October–February: +33 (0)4 68 96 42 91.

⚷ Accommodation
Guesthouses
Casa Ilicia ▮▮▮: +33 (0)6 95 34 15 32.
Gîtes and vacation rentals
Further information: +33 (0)4 68 68 42 88 or +33 (0)4 68 05 41 02
www.tourisme-canigou.com

🍴 Eating Out
Des Goûts et des Couleurs, tea room: +33 (0)6 09 53 32 47.
El Lluert, bar & tapas: +33 (0)4 68 05 37 28.
Little Jeanne Burger, food truck: +33 (0)7 63 55 58 94.
Le Vieux Chêne d'Eus: +33 (0)4 68 96 35 29.

🏛 Local Specialties
Food and Drink
Regional fruit and vegetables • Fruit juice • Honey.
Art and Crafts
Wrought ironwork • Cutlery • Paintings • Photographs • Sculptures • Stained-glass windows • Herbs, oils, and perfumes.

📅 Events
January: Feast of Saint Vincent (22nd).
Easter Monday: "Goig Dels Ous," Catalan Easter songs presented by the Cant'Eus choir.
June: Croisée d'Arts, contemporary art festival.
July: "Mès De Jazz," jazz festival (1st weekend).
August: "Nits d'Eus," cultural festival; Course des Lézards, lizard-racing (last Sunday).

🦋 Outdoor Activities
Walking: 9 marked trails • Adventure park, recreation park.

🌿 Further Afield
• Prades; Abbaye Saint-Michel-de-Cuxa (3½ miles/5.5 km).

• Marcevol: priory (5 miles/8 km).
• *Villefranche-de-Conflent (7½ miles/12 km), see pp. 262–63.
• Vernet-les-Bains; Abbaye Saint-Martin-du-Canigou (11 miles/18 km).
• Serrabone: priory (14 miles/23 km).
• *Évol (15 miles/24 km), see p. 193.
• *Castelnou (17 miles/27 km), see p. 181.
• Têt valley; Perpignan (27 miles/43 km).
• Rivesaltes; Salses fort (30 miles/48 km).

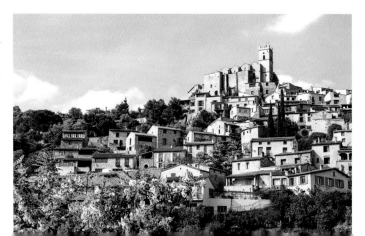

Évol

"A piece of sky on the mountain"

Pyrénées-Orientales (66) • Population: 40 • Altitude: 2,625 ft. (800 m)

In the foothills of the Massif du Madrès, on the side of a valley, the hamlet of Évol emerged from the mountain.

According to Catalan bard Ludovic Massé, who was born here in 1900, Évol, "far from everything," was "a piece of the sky on the mountain whose only shade is from cloud." Invisible from the road that leads from the plain to Cerdagne, the village emerges like a jewel in its verdant setting. Overlooked by the old fortress of the viscounts of So and the bell tower of its Romanesque church, Évol remains in perfect communion with the mountain, which provides a livelihood for its shepherds and is present in the shale of its walls and the blue *lauze* (schist tiles) of its roofs, the cutting of which was one of the occupations undertaken by locals in winter. Along the winding, flower-filled streets, bread ovens, a fig-drying kiln, barns, and interior courtyards bear witness to the daily life of a bygone era.

By road: Expressway A9, exit 42–Perpignan Sud (39 miles/63 km).
By train: Prades-Molitg-les-Bains station (12 miles/19 km).
By air: Perpignan-Rivesaltes airport (42 miles/68 km).

ⓘ Tourist information—
Conflent-Canigó: +33 (0)4 68 05 41 02 or +33 (0)4 68 04 25 06
www.tourisme-canigou.com

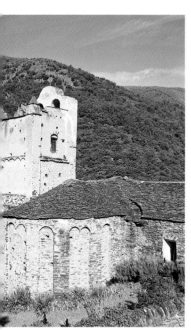

👁 Highlights
• **Église Saint-André** (11th century): Conjuratory (small religious building), altarpieces of the 15th century and 16th centuries, Romanesque statue of the Virgin (13th century); closed for restoration until late 2021.
• **Viscounts' castle** (13th century).
• **Chapelle Saint-Étienne** (13th century).
• **Cabinet Littéraire Ludovic-Massé:** Literary room devoted to the Catalan writer, storyteller, and bard, born in Évol in 1900.
• **Musée des Arts et Traditions Populaires:** Museum of popular arts and traditions housed in a former local school, featuring old tools; "Si Évol m'était conté," exhibition. Guided tour by appointment only, Évol la Médiévale association: +33 (0)4 68 97 09 72 or +33 (0)6 13 04 19 86.
• **Église Saint-André at Olette** (11th–13th centuries).

⚜ Accommodation
Guesthouses
La Fontaine, Olette: +33 (0)4 68 97 03 67.
Gîtes and vacation rentals
Gîtes de France: +33 (0)4 68 68 42 88.
Communal gîtes
Further information: +33 (0)4 68 97 02 86.

🍴 Eating Out
L'Houstalet, at Olette: +33 (0)4 68 97 03 90.

② Events
Market: Traditional market at Olette, Thursdays 8 a.m.–1 p.m, Place du Village.
May: Transhumance des Mérens, moving the horse herd.
June: Fête de la Transhumance (1st weekend).
August: Open-air rummage sale.

🦋 Outdoor Activities
Trout fishing (Évol river) • La Bastide lakes • Walking • Mountain-biking: "Madres-Coronat" biking area.

🦋 Further Afield
• Train Jaune: Olette station (1 mile/1.5 km).
• Saint-Thomas-les-Bains (6 miles/9.5 km).
• *Villefranche-de-Conflent (8 miles/13 km), see pp. 262–63.
• Prades (11 miles/18 km).
• Vernet-les-Bains: Abbaye Saint-Martin-du-Canigou (12 miles/19 km).
• Mont-Louis (14 miles/23 km).
• *Eus (15 miles/24 km), see p. 192.

La Flotte

Port on the Île de Ré

Charente-Maritime (17) • Population: 2,789 • Altitude: 56 ft. (17 m)

Facing the Pertuis Breton tidal estuary and the mainland, the pretty houses of La Flotte circle the harbor and reflect the ocean's light.

Now effectively a peninsula, located as it is at the end of a long bridge, Ré still retains its magical light, which changes with the tides; its gentle landscapes, which combine coastal flowers, vines, and salt marshes with oyster beds and fields of fruit and vegetables; and the dazzling white of its green-shuttered houses. To this "sandy, windswept island," as Richelieu called it, in a natural environment that has been very well preserved, La Flotte adds the soulful remains of the Abbaye des Châteliers, built by Cistercian monks in the 12th century; the imposing Fort La Prée, built in the 17th century in the face of English invasions and the Protestant La Rochelle; a maze of restored and flower-decked alleyways around the Église Sainte-Catherine, and the old round-tile-covered market; and a picturesque harbor that is enlivened year round with pleasure craft. The other side of its double pier, the ocean still separates the "white island" from the mainland.

By road: N11-N237 (7 miles/11.5 km).
By train: La Rochelle station (14 miles/23 km).
By air: La Rochelle-Laleu airport (8 miles/13 km).

ⓘ **Tourist information:** +33 (0)5 46 09 60 38
www.iledere.com

◉ Highlights

• **Fort La Prée** (17th century): A Vauban construction; open April–September and last two weeks of October; guided tour by appointment only: +33 (0)5 46 09 61 39 or +33 (0)5 46 09 73 33.
• **La Maison du Platin:** Museum dedicated to life on the Île de Ré, with collections centered on the island's traditional occupations, its relations with the mainland, housing, and costumes; temporary exhibitions: +33 (0)5 46 09 61 39.
• **Ruins of the Cistercian Abbaye des Châteliers** (12th century): Self-guided visit or guided tour by appointment.

• **Village:** Guided tour by appointment: +33 (0)5 46 09 61 39.

⚷ Accommodation

Hotels
Le Richelieu*****: +33 (0)5 46 09 60 70.
♥ La Galiote en Ré***: +33 (0)5 46 09 50 95.
Le Français**: +33 (0)5 46 09 60 06.
L'Hippocampe** +33 (0)5 46 09 60 68.
Aparthotels
Les Hauts de Cocraud** Odalys: +33 (0)5 46 68 29 21 or +33 (0)8 25 56 25 62.
Guesthouses
Stéphanie Gaschet: +33 (0)5 46 09 05 78.
M. Rocklin: +33 (0)5 46 09 51 28.
Mme Wyart: +33 (0)5 46 09 63 93.
Gîtes, vacation rentals, and campsites
Further information: +33 (0)5 46 09 60 38
www.iledere.com

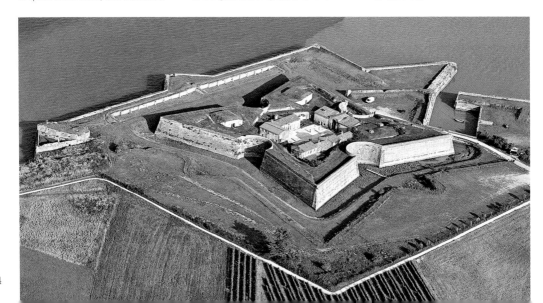

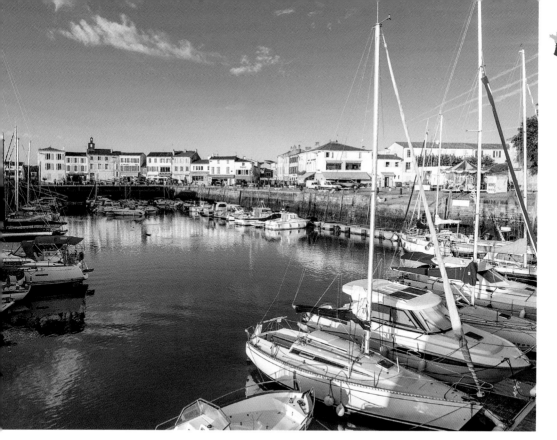

🍴 Eating Out
À la Plancha: +33 (0)5 46 68 10 34.
Chez Nous Comme Chez Vous:
+33 (0)5 46 09 49 85.
Le Corner du Môle: +33 (0)5 46 09 60 43.
La Croisette: +33 (0)5 46 09 06 06.
L'Écailler, gourmet: +33 (0)5 46 09 56 40.
L'Endroit du Goinfre: +33 (0)5 46 09 50 01.
L'Escale, brasserie: +33 (0)5 46 05 63 37.
La Fiancée du Pirate, crêperie/pizzeria:
+33 (0)5 46 09 52 46.
Le Français: +33 (0)5 46 09 60 06.
Il Gabbiano, Italian specialties:
+33 (0)5 46 09 60 08.
Le Nautic: +33 (0)9 67 37 31 73.
Le Passage du Marché:
+33 (0)5 46 00 32 18.
Les Pieds dans l'Eau: +33 (0)5 46 09 45 68.
Le Pinocchio, pizzeria: +33 (0)5 46 09 13 13.
La Poissonnerie du Port, except January
and February: +33 (0)5 46 09 04 14.
Le Richelieu, gourmet:
+33 (0)5 46 09 60 70.
Le Saint-Georges: +33 (0)5 46 09 60 18.
Sushifolie: +33 (0)5 46 01 98 37.
La Tribu: +33 (0)5 54 48 55 29.

🧺 Local Specialties
Food and Drink
Ré oysters • Spring vegetables • Pineau,
wines • *Sel de Ré* (salt).
Art and Crafts
Decoration • Art galleries • Artists •
Painter-decorator.

2️⃣ Events
Market: Medieval market daily, 8 a.m.–
1 p.m., Rue du Marché.
June: Music festival; flea markets.
July: Journée des Peintres, artists' day;
fireworks.
July–August: Regattas, musical events at
the harbor (every evening); evening crafts
market.
July 1–September 15: Concerts in
the Église Sainte-Catherine and tours;
classical concerts at the harbor.
August: Gathering of traditional sailing
vessels (1st fortnight); music and firework
display (mid-August).

🦋 Outdoor Activities
Swimming (lifeguard) in July and August
(Plage de l'Arnérault) • Riding • Pleasure
boating • Shellfish gathering • Bike rides
(rental) • Watersports: swimming, sailing,
windsurfing • Thalassotherapy.

🌿 Further Afield
• La Rochelle (9½ miles/15.5 km).
• *Ars-en-Ré (11 miles/18 km),
see pp. 153–54.
• Islands of Aix, Madame, and Oléron
(19–28 miles/31–45 km).
• Marais Poitevin, region (25 miles/40 km).
• Rochefort (25 miles/40 km).

Fourcès

A medieval circle in Gascony

Gers (32) • Population: 295 • Altitude: 213 ft. (65 m)

In a loop of the Auzoue river, at the end of a bridge, Fourcès forms a circle around a central square shaded by plane trees.

Set on the banks of the Auzoue, and facing the Église Saint-Laurent on the other side of the river, Fourcès has a circular shape that is unique in Gascony. The village developed in the 11th century under the protection of a castle, which occupied the main square, and ramparts, of which the Porte de l'Horloge remains. In 1279, Fourcès fell into the hands of Edward I of England who, ten years later, made it a *bastide* by granting it a charter of customs. Every year, in a theatrical setting of arches and half-timbered façades, the square hosts an exceptional flower market. The late 15th-century Château des Fourcès escaped ruin by becoming a hotel-restaurant; since 2010 it has been a guesthouse.

By road: Expressway A62, exit 6– Nérac (28 miles/45 km).
By train: Agen station (32 miles/51 km).
By air: Agen-La Garenne airport (30 miles/48 km).

ⓘ Tourist information—Ténarèze:
+33 (0)5 62 28 00 80
www.tourisme-condom.com

👁 Highlights
• Arboretum: Free entry.
• Église Saint-Laurent and Église Sainte-Quitterie.
• Village.

🗝 Accommodation
Guesthouses
Du Côté de Chez Jeanne 🗝🗝🗝🗝:
+33 (0)9 53 06 04 06.
♥ Le Château de Fourcès:
+33 (0)5 62 29 49 53.
Solange and Pierre Mondin, Bajolle:
+33 (0)5 62 29 42 65.
Gîtes and vacation rentals
Further information: +33 (0)5 62 28 00 80
www.tourisme-condom.com
RV parks
Further information: +33 (0)5 62 29 40 13.

🍽 Eating Out
L'Auberge: +33 (0)5 62 29 40 10.
Le Carroussel Gourmand, tea room:
+33 (0)9 53 06 04 06.

🛍 Local Specialties
Food and Drink
Armagnac • Foie gras, duck fillet and confit • AOC Côtes de Gascogne wines.
Art and Crafts
Antique dealers • Jewelry and accessories designer • Craft boutique.

📅 Events
April: Flower market (last weekend).
May: Pottery and ceramics market.
May–November: Flea market (2nd Sunday of each month).

June: Artists in the street.
July: Antiquarian book fair (3rd Sunday); aperitif and concert.
August: "Marciac in Fourcès," jazz concert (mid-August); village fair (3rd weekend).
December: Christmas market.

🦌 Outdoor Activities
Hunting • Fishing • Theme park, adventure playground for children • Walking • Lake • *Pétanque.*

🌿 Further Afield
• *Montréal (3½ miles/5.5 km), see p. 215.
• Poudenas (5 miles/8 km).
• Mézin, fortified town (5½ miles/9 km).
• *Larressingle (6 miles/9.5 km), see p. 199.
• Condom (8 miles/13 km).
• Château de Cassaigne (9½ miles/15.5 km).
• Abbaye de Flaran (11 miles/18 km).
• Trésor d'Eauze, archeological museum (13 miles/21 km).
• Nérac (15 miles/24 km).
• *La Romieu (22 miles/35 km), see pp. 230–31.
• *Lavardens (25 miles/40 km), see pp. 204–5.

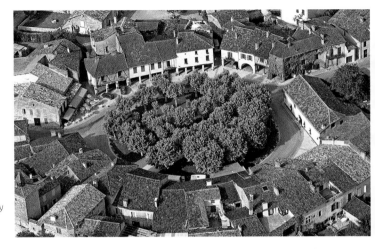

Lagrasse
An abbey amid the vineyards

Aude (11) • Population: 545 • Altitude: 433 ft. (132 m)

At the heart of the Corbière mountains, where vines mingle with perfumed Mediterranean *garrigue* scrubland, Lagrasse is a rare bloom in Cathar country.

The Benedictine abbey of Lagrasse, founded in 800 CE in the valley on the left bank of the Orbieu river, is considered to have been one of the oldest and richest in France, and is still today the biggest abbey in the Aude. Its material, political, and spiritual influence extended beyond the Pyrenees. During the French Revolution, the abbey became state property, and it was split into two sections—as can be seen by the two entrance gates—before being sold. Mainly medieval, the oldest part can be visited and hosts concerts, exhibitions, and other cultural events all year round. Lagrasse is linked to this architectural jewel by a medieval bridge straddling the Orbieu. It is delightful to wander along its picturesque lanes, to share the wonderful atmosphere on its terraces or in its lively market hall, as people have been doing since the 14th century, and to appreciate the skills of its many craftspeople.

By road: Expressway A61, exit 25–Lézignan-Corbières (10 miles/16 km). **By train:** Lézignan-Corbières station (12 miles/19 km). **By air:** Carcassonne-Salvaza airport (35 miles/56 km).

ⓘ Tourist information:
+33 (0)4 68 43 11 56
https://vivonslagrasse.org

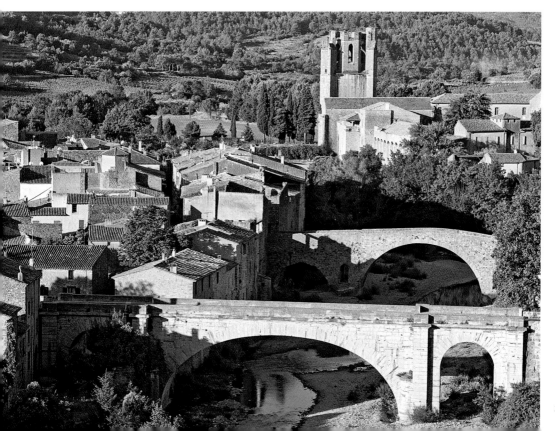

👁 Highlights

• **Abbaye Saint-Marie d'Orbieu** (9th–18th centuries): Guided tour available: +33 (0)4 68 43 15 99.
• **Église Saint-Michel** (14th century): Gothic style, paintings by the studio of Giuseppe Crespi (1665–1747) and by Jacques Gamelin (1738–1803), 13th-century wood sculpture of the Virgin.
• **Maison du Patrimoine, heritage center:** Former presbytery, 15th-century painted ceilings; permanent exhibition on the painted ceilings of Languedoc-Roussillon; restored works from three Renaissance painted ceilings in Lagrasse, and a rare medieval painted ceiling from a mansion in Montpellier: +33 (0)4 68 43 11 56.
• **Village:** Guided visit for groups by appointment only: +33 (0)6 81 42 79 63.

🗝 Accommodation

Hotels
Hostellerie des Corbières**:
+33 (0)4 68 43 15 22.
Guesthouses
Château Villemagne 🍴: +33 (0)4 68 24 06 97.
À la Porte d'Eau: +33 (0)4 68 43 10 45.
M. Alquier: +33 (0)4 68 43 13 92.
Aux 1000 Délices: +33 (0)6 87 60 34 50.
Château Saint-Auriol: +33 (0)4 68 91 25 92.
Chez Françoise: +33 (0)4 68 43 12 04.
Chez Shona: +33 (0)4 68 65 24 33.
Les Glycines. +33 (0)4 68 43 14 54.
La Maison Bleue: +33 (0)6 59 12 85 30.
La Maison de la Promenade:
+33 (0)6 20 71 48 37.
Sabine's: +33 (0)6 76 10 74 07.
Les Trois Grâces: +33 (0)4 68 43 18 17.
Further information: +33 (0)4 68 43 11 56
https://vivonslagrasse.org
Gîtes
♥ Le Studio Blanc: +33 (0)6 78 96 64 72.
Further information: +33 (0)4 68 43 11 56
https://vivonslagrasse.org
Campsites
Camping Boucocers: +33 (0)4 68 43 15 18 or +33 (0)4 68 43 10 05.

🍽 Eating Out

Le 1900 [mille neuf cent]:
+33 (0)4 68 12 17 67.
Au Coupa Talen, pizzeria:
+33 (0)4 68 43 19 36.
Café de la Promenade: +33 (0)4 68 43 15 89.
La Cocotte Fêlée: +33 (0)4 68 75 90 54.
L'Entrepote: +33 (0)4 68 43 16 59.
Hostellerie des Corbières:
+33 (0)4 68 43 15 22.
La Petite Maison, tea room:
+33 (0)4 68 91 34 09.
Le Recantou, ice-cream parlor, tapas:
+33 (0)4 68 49 94 73.

Le Temps des Courges: +33 (0)4 68 43 10 18.
Le Ziveli, cheese and charcuterie:
+33 (0)4 68 49 58 70.

🛒 Local Specialties

Food and Drink
Olive oil • Vinegar • Honey • AOC Corbières wines.
Art and Crafts
Antiques • Leather craftsman • Jewelry maker • Furniture designer • Wrought ironworker • Painters • Ceramic artist • Sculptor and caster • Fashion and hat designer • Upholsterer • Stained-glass artist.

🗓 Events

Market: Saturday mornings, Place de la Halle.
May–September: Flea markets.
July: Piano festival (early July); village fête (13th); "Les Abracadagrasses," music festival (3rd weekend).
August: Summer banquet, literature, and philosophy festival (1st fortnight); potters' market; "Les P'tibals" festival (end of August).
September: "Les Loges Musicales," chamber music festival (1st fortnight).

🦋 Outdoor Activities

Fishing • Saint-Jean Lake • Walking: Route GR 36 and themed family trails.

🥾 Further Afield

• Termes and Villerouge-Termenès castles (12 miles/19 km).
• Abbaye de Fontfroide (17 miles/27 km).
• Carcassonne (22 miles/35 km).
• Narbonne (27 miles/43 km).

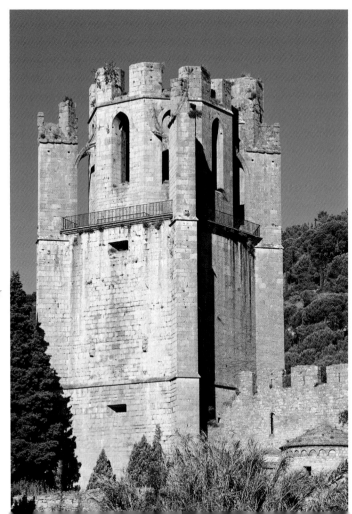

Larressingle

A mini-Carcassonne in the Midi-Pyrenees

Gers (32) • Population: 217 • Altitude: 469 ft. (143 m)

Towering above the vines, the fortress-village of Larressingle cultivates the Gascon way of life.

The village lies beyond a fortified gateway, just past a bridge straddling a green moat. It backs onto a crown of ramparts encircling the castle keep (for many years the residence of the bishops of Condom) and a high church with two naves. Larressingle was saved from ruin by the enthusiastic duke of Trévise, who created a rescue committee financed by generous Americans. Today the village is a delightful collection of heritage buildings from the area's rich medieval past, including the castle, dating from the 13th, 14th, and 16th centuries, which has three floors and a pentagonal tower, a fortified gateway, and the remains of its surrounding walls; the Romanesque church of Saint-Sigismond; and the charming and finely built residences, decorated with mullioned windows and roofed with ocher tiles. Rooted to the land, Larressingle is a showcase for local Gers produce, particularly Armagnac, foie gras, and apple croustade.

By road: Expressway A62, exit 7–Périgueux (25 miles/40 km).
By train: Auch station (29 miles/47 km); Agen station (29 miles/47 km).
By air: Agen-La Garenne airport (25 miles/40 km); Toulouse-Blagnac airport (68 miles/109 km).

ⓘ Tourist information—Ténarèze:
+33 (0)5 62 68 22 49 or +33 (0)5 62 28 00 80
www.tourisme-condom.com

👁 Highlights

• **Medieval siege camp:** Camp with siege engines for attack and defense, firing demonstrations of war machines: +33 (0)5 62 68 33 88.
• **Église Saint-Sigismond** (12th-century): Modern Madonna and Child stained-glass windows inspired by Marc Chagall paintings.
• **Orchard:** Series of vineyards around the village ramparts. 7-acre (3-hectare) agro-ecological site comprised of a vineyard of dessert grapes (23 varieties) and an orchard (65 varieties); historic and local collection: +33 (0)6 89 12 92 33.
• **Village:** Self-guided visit; guided tour (admission fee) by appointment only in summer for individuals: +33 (0)5 62 28 00 80.

🗝 Accommodation

Hotels
Auberge de Larressingle**: +33 (0)5 62 28 29 67.
Guesthouses
Maïder Papelorey: +33 (0)5 62 28 26 89.
Martine Valeri: +33 (0)5 62 77 29 72.
Gîtes
M. Teoran, "Couchet": +33 (0)5 62 28 17 50.
Walkers' lodges
Further information: +33 (0)5 62 68 82 49 or +33 (0)5 62 28 00 80.

🍽 Eating Out

Auberge de Larressingle:
+33 (0)5 62 28 29 67.
Bistrot du Château: +33 (0)5 62 68 48 93.
L'Estanquet, pizzeria:
+33 (0)9 83 95 20 23.
Le Glacier: +33 (0)6 80 10 90 66.

🧺 Local Specialties

Food and Drink
Armagnac • Floc de Gascogne aperitif • Free-range duck preserves (confit, foie gras), and free-range pork • Organic wines.

📅 Events

July: Medieval fair (3rd weekend).
July–August: Theater productions; night visit to the fortified village with falconry demonstration; night markets; military encampment and medieval-themed events.

🦋 Outdoor Activities

Walking: Route GR 65 and short marked trails.

🌿 Further Afield

• Pont de l'Artigues (½ mile/1 km).
• Condom (3 miles/5 km).
• Mouchan Priory belonging to Cluny (3½ miles/5.5 km).
• Château de Cassaigne (4½ miles/7 km).
• Abbaye de Flaran (6 miles/9.5 km).
• *Fourcès (6 miles/9.5 km), see p. 196.
• *Montréal (6 miles/9.5 km), see p. 215.
• *La Romieu (10 miles/16 km), see pp. 230–31.
• Trésor d'Eauze, archeological museum (15 miles/24 km).
• Lectoure (16 miles/26 km).
• *Lavardens (20 miles/32 km), see pp. 204–5.
• Auch (28 miles/45 km).

Lautrec

Pays de Cocagne—the land of milk and honey

Tarn (81) • Population: 1,807 • Altitude: 1,033 ft. (315 m)

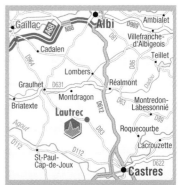

This medieval town in the heart of Tarn's Pays de Cocagne is the birthplace of painter Toulouse-Lautrec's family. From the top of La Salette hill there are far-reaching views over the whole Casters plain and the Montagne Noire. A castle stood here; now there is a Calvary cross and a botanical trail. For many years the village was the only fortified place between Albi and Carcassonne, and some of its ramparts remain. Its shady plane-tree promenade runs alongside them, and each year Lautrec, the center of pink garlic farming, holds garlic markets. The gateway of La Caussade leads straight from the rampart walk to the central square. The Rue de Mercadial also leads there, passing an old Benedictine convent, which became the town hall after the French Revolution. The square still holds a traditional Friday morning market under the beams of its covered hall. With its well and its lovely half-timbered and corbeled residences, it remains a delightful part of Lautrec. The Rue de l'Église leads to the collegiate church of Saint-Rémy, built in the 14th century then extended. The pastel blue walls celebrate a color that brought riches to Lautrec, earning the Pays de Cocagne its name—from the *coques* or *cocagnes* (balls of dried woad) that were ground down to produce dye—as well as its reputation as an earthly paradise.

By road: Expressway A68, exit 9–Gaillac (18 miles/29 km). **By train:** Castres station (10 miles/16 km). **By air:** Castres-Mazamet airport (15 miles/24 km); Toulouse-Blagnac airport (47 miles/76 km).

ⓘ Tourist information—Lautrécois-Pays d'Agout: +33 (0)5 63 97 94 41
www.lautrectourisme.com
www.lautrec.fr

👁 Highlights
• **Clogmaker's workshop:** Recreated workshop that existed until the 1960s, with vintage machines and tools: +33 (0)7 86 91 98 77.
• **Église Collégiale Saint-Rémy** (14th–16th centuries): Marble altarpiece by Caunes-Minervois, sculpted lectern (17th century).
• **La Salette windmill:** For opening hours: +33 (0)5 63 97 94 41. By appointment off-season.
• **La Salette botanical trail:** Self-guided walk to learn about the plants of the Lautrec region, plus panoramic view of the area with viewpoint indicator.
• **Village:** Daily guided tours for groups of 10+ people, by reservation: +33 (0)5 63 97 94 41.

🗝 Accommodation
Guesthouses
Château de Montcuquet 🏠🏠🏠: +33 (0)5 63 75 90 07.
Cadalen: +33 (0)7 86 02 88 48.
Les Chambres de la Caussade: +33 (0)5 63 75 33 21.
Château de Brametourte: +33 (0)5 63 75 01 25.

La Fontaine de Lautrec: +33 (0)5 63 50 15 72.
Gîtes and vacation rentals, bunkhouses
16 gîtes (1–4*) and bunkhouse. Further information: +33 (0)5 63 97 94 41 www.lautrectourisme.com
Campsites and RV parks
RV park with facilities: further information at tourist information center.

🍴 Eating Out
Café Plùm: +33 (0)5 63 70 83 30.
Le Clos d'Adèle: +33 (0)5 81 43 61 91.
La Ferme dans l'Assiette: +33 (0)5 63 74 23 29.
Le Jardin du Clocher: +33 (0)9 83 65 54 56.
Ô D'Tour: +33 (0)5 63 98 25 70.
Ô Terrasses, brasserie: +33 (0)5 63 75 37 10.

🏛 Local Specialties
Food and Drink
Lautrec pink garlic, garlic specialties (bread, vinegar, pâté) • Duck foie gras.
Art and Crafts
Ceramic artist • Cabinetmaker • Leather craftsman • Pastel dyeing • Art galleries • Jewelry • Household linen • Clothing • Wooden objects.

Lautrec Tarn



200



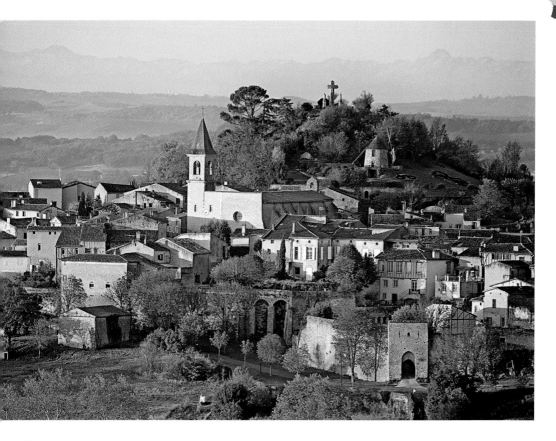

② Events

Market: Fridays 8–12 a.m., Place Centrale.
May: Fêtes de Lautrec (last weekend).
June: Fête des Moulins, windmill festival and open-air rummage sale (3rd Sunday).
July: Fête des Sabots, clog festival (3rd Sunday).
August: Fête de l'Ail rose, pink garlic festival (1st Friday and Saturday); Fête du Pain, bread fair (15th); "Festivaoût," 3 days of concerts (around the 15th).
September: Festival of the Arts in Pays de Cocagne (1st weekend).
October: "Outilautrec," traditional tool and machine festival (1st weekend).
December: Christmas market (weekend before Christmas).

🦋 Outdoor Activities

Aquaval watersports (open mid-June–end August): swimming, beach volleyball, *boules* area, minigolf, model-making, fishing, field volleyball, family games • *Boules* area: Place du Mercadial (*pétanque* competition on Tuesday evenings in summer) • Cycling and walking: marked trails.

🌾 Further Afield

• Lombers: Écomusée du Pigeon, pigeon museum (5½ miles/9 km).
• Réalmont, royal walled town (7 miles/11 km).
• Castres (Musée Goya) and Le Sidobre (9½–14 miles/15.5–23 km).
• Saint-Paul-Cap-de-Joux: Musée du Pastel and Château de Magrin (12 miles/19 km).
• Albi, UNESCO World Heritage Site: Musée Toulouse-Lautrec, museum (19 miles/31 km).
• Cascade d'Arifat, waterfall (19 miles/31 km).

ℹ Did you know?

Pink garlic appeared in Lautrec during the Middle Ages. An itinerant merchant stopped at the place known as L'Oustallarié at Lautrec, wanting a feast. Since he had no money, he settled his bill with pretty pink garlic cloves. The hotelier planted the cloves and pink garlic began to grow in the region.

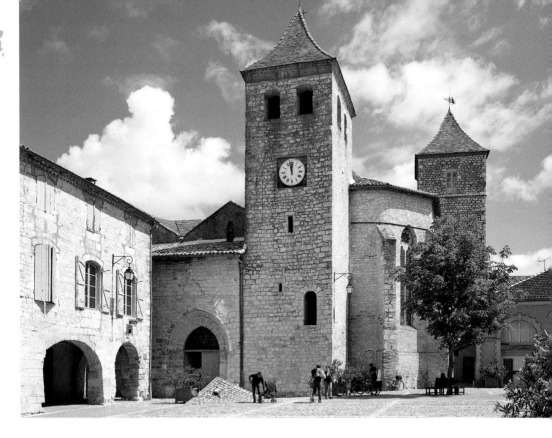

Lauzerte

A walled town in Quercy Blanc

Tarn-et-Garonne (82) • Population: 1,535 • Altitude: 722 ft. (220 m)

Lauzerte dominates the surrounding valleys and hills from its lofty position atop a spur of land. In the late 12th century, the count of Toulouse began construction of this fortified town. Granted an official charter in 1241, Lauzerte was simultaneously a trading town, a stronghold, and a staging post along the ancient Via Podiensis, or Saint James's Way, the pilgrims' route to Santiago de Compostela. Many buildings tell the prestigious history of this successful and wealthy town: the old fortifications, the 13th-century church of Saint-Barthélémy (restored on several occasions), houses that once belonged to local notables, and the Place des Cornières, the town's commercial and artistic center. Today Lauzerte hosts numerous festivals, cultural events, and markets. It makes *cocagne* dyes, and its fertile farmlands and temperate climate also produce the Chasselas grape, Quercy melons, plums, peaches, pears, and nectarines, as well as poultry, foie gras, and confits.

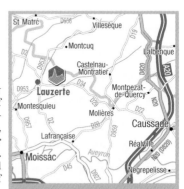

By road: Expressway A62, exit 8–Cahors (22 miles/35 km) or exit 9–Castelsarrasin (21 miles/34 km); expressway A20, exit 58–Cahors Sud (20 miles/32 km).
By train: Moissac station (15 miles/24 km).
By air: Toulouse-Blagnac airport (62 miles/100 km).

ⓘ **Tourist information—Quercy-Sud-Ouest:** +33 (0)5 63 94 61 94
www.quercy-sud-ouest.com

👁 Highlights
• **Église Saint-Barthélemy** (13th–18th centuries): Stalls, paintings, Baroque altarpiece, painted paneling attributed to Joseph Ingres (1755–1814) and his pupils.
• **Jardin du Pèlerin** (pilgrim's garden): Designed as a game of giant snakes and ladders on the theme of the pilgrimage to Santiago; history, life as a medieval pilgrim, European cultural and linguistic heritage are explored through play.
• **Village:** Guided visits; evening tour by torchlight; escape room. Further information: +33 (0)6 19 13 66 53.

🔑 Accommodation
Hotels
Le Belvédère***: +33 (0)5 63 95 51 10.
Le Luzerta*: +33 (0)5 63 94 64 43.
Le Quercy*: +33 (0)5 63 94 66 36.
Guesthouses
Moulin de Tauran ✃✃✃✃:
+33 (0)5 63 94 60 68.
Bounetis Bas: +33 (0)5 63 39 56 61.
Camp Biche: +33 (0)5 63 29 23 86.
Castelmac: +33 (0)5 63 94 55 51.
Chez Françoise: +33 (0)6 99 62 79 12.
Domaine Saint Fort: +33 (0)9 67 02 04 28.
Les Figuiers: +33 (0)5 63 94 61 29.
L'Horizon: +33 (0)5 63 32 55 04.
Le Jardin Secret: +33 (0)5 63 94 80 01.
Lavande en Quercy: +33 (0)5 63 94 66 19.
Millial: +33 (0)6 09 63 81 41.
Sainte Claire: +33 (0)5 63 39 08 62.
Saint-Fort: +33 (0)6 89 03 09 49.
La Stinoise: +33 (0)5 63 95 21 90.
Wallon-nous dormir?:
+33 (0)5 63 04 56 44.
Gîtes, walkers' lodges, and vacation rentals
Further information:
+33 (0)6 19 70 89 49.
Campsites
Le Beau Village***: +33 (0)5 63 29 13 68.

🍴 Eating Out
L'Auberge d'Auléry: +33 (0)5 63 04 79 13.
Auberge des Carmes, brasserie:
+33 (0)5 63 94 64 49.
Aux Sarrazines du Faubourg, crêperie:
+33 (0)5 65 20 10 12.
Le Belvédère: +33 (0)5 63 95 51 10.
L'Étincelle: +33 (0)9 82 39 02 09.
L'Etna, pizzeria: +33 (0)5 63 94 18 60.
Le Luzerta: +33 (0)5 63 94 64 43.
Le Puits de Jour, music café and light meals: +33 (0)5 63 94 70 59.
Le Quercy: +33 (0)5 63 94 66 36.
La Table des 3 Chevaliers:
+33 (0)5 63 95 32 69.

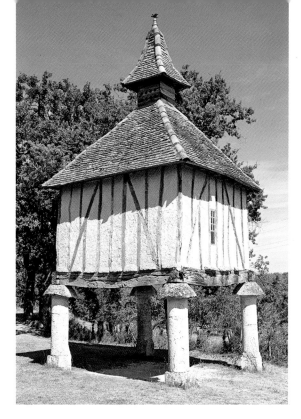

🧺 Local Specialties
Food and Drink
Foie gras and other duck products • Fruit, Chasselas grapes AOP de Moissac • Macarons.
Art and Crafts
Ceramic artists • Illuminator • Metalworker • Leather and wood engravers • Sculptors • Photographers • Leather crafts • Jeweler.

📅 Events
Markets: Wednesday mornings, Foirail; Saturday mornings, Cornières.
April: "Place aux fleurs," flower market (3rd Sunday).
April–November: "Espace Points de Vue," exhibitions.
June: "Fête de la Musique," music festival.
July: Ball and fireworks (14th); "Métalik' Art," metallic sculpture symposium (2nd weekend); Pottery market (3rd weekend).
July–August: Guided visit (Mondays); open-air cinema (Tuesdays); food and music festival (Thursdays).

August: Afro-Latino music and dance festival (1st weekend); "Rencontres Musicales Européennes," music festival (2nd weekend); professional flea market and "Festival du Quercy Blanc," music festival (15th.)
September: "Place aux Nouvelles," book festival (2nd weekend).
November: "Journée de L'Arbre et du Bois," tree and wood festival (penultimate Sunday).
December: "Place à Noël," poetry and drinks (2nd Wednesday).

🦋 Outdoor Activities
Horse-riding • Fishing • Walking: Route GR 65 on the Saint James's Way, and shorter walks.

🌿 Further Afield
• Saint-Sernin-du-Bosc: Romanesque chapel (2½ miles/4 km).
• Montcuq (6 miles/9.5 km).
• Moissac (16 miles/26 km).
• *Auvillar (21 miles/34 km), see pp. 158–59.

Lavardens

A stone nave in the Gascon countryside

Gers (32) • Population: 407 • Altitude: 646 ft. (197 m)

Like a ship moored on a rocky outcrop, the imposing Château de Lavardens dominates the green crests and troughs of central Gascony.

Once the military capital of the counts of Armagnac, the medieval fortress of Lavardens was besieged and destroyed in 1496 on the order of Charles VII. The castle passed into the hands of the d'Albret and later the de Navarre families, and was granted by Henri IV to his friend Antoine de Roquelaure in 1585. De Roquelaure began rebuilding the castle out of love for his young wife, Suzanne de Bassabat. This work was interrupted several years later when he died in a plague outbreak, and was completed by the Association de Sauvegarde du Château de Lavardens (which restores and manages the castle) only in the 1970s. Its work respects all the individuality of this unique architectural site: the space, the ocher tiles and original bricks of the rooms, the exterior galleries, and the squinch towers—a unique architectural feature. At the foot of this white-stone sentinel, the charming 18th-century village houses line the cobbled streets, which are bordered with hollyhocks.

By road: Expressway A62, exit 7–Auch (36 miles/58 km); N21 (14 miles/23 km).
By train: Auch station (14 miles/23 km).
By air: Agen-La Garenne airport (40 miles/ 64 km); Toulouse-Blagnac airport (54 miles/87 km).

ⓘ Tourist information—Grand Auch Coeur de Gascogne: +33 (0)5 62 05 22 89 www.auch-tourisme.com

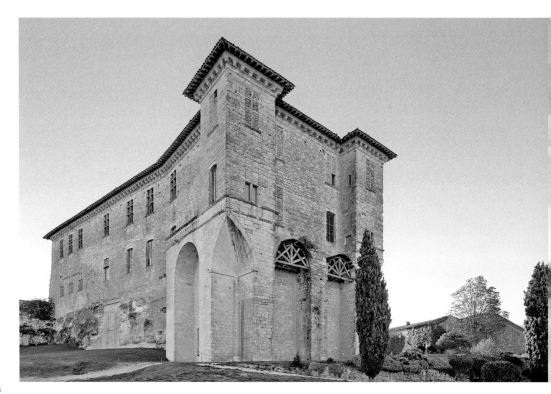

👁 Highlights
- **Castle** (12th–17th centuries): Including guardroom, ballroom, games room, chapel; exhibitions: +33 (0)5 62 58 10 61.
- **Church** (13th century): Pulpit, stalls, 15th-century stained glass.
- **Chapelle Sainte-Marie des Consolations:** Medieval chapel with views over the village.
- **Petit Musée du Téléphone:** Telephone museum. By appointment only: +33 (0)5 62 64 56 61.
- **Village:** Guided visits in summer, and for groups all year round by appointment: +33 (0)5 62 05 22 89 / www.pass-en-gers.fr.

🗝 Accommodation
Guesthouses
Domaine de Mascara 🕯🕯🕯: +33 (0)5 62 64 52 17.
Gîtes and vacation rentals
Gîte de Bordères ⚘⚘⚘: +33 (0)5 62 64 56 92.
La Buse Bleue: +33 (0)6 02 22 35 83.
Le Mondon: +33 (0)5 62 64 50 70.
Les Moulins de Sainte-Marie: +33 (0)6 07 41 54 54.
Plaisance: +33 (0)5 62 64 59 67.

🍴 Eating Out
Le Malthus, brasserie: +33 (0)5 62 64 57 18.
Le Restaurant du Château: +33 (0)5 62 66 20 83.

🧺 Local Specialties
Food and Drink
Gers green lentils • *Vin de pays*.
Art and Crafts
Stonecutters • Furniture restorer.

📅 Events
March–June: Art exhibition at the castle.
July–August: Evening markets.
August: "Rétromotion," car exhibition.
September: Village fête (3rd weekend).
October–January: *Santon* (crib figures) exhibition at the castle.
December: Christmas market.

🦋 Outdoor Activities
Walking: marked trails.

🌿 Further Afield
- Jégun, fortified town (3½ miles/5.5 km).
- Castéra-Verduzan: spa, sports, recreation park, racetrack (6 miles/9.5 km).
- Biran: castle, church (10 miles/16 km).
- Saint-Jean-Poutge: castles; canoeing on the Baïse river (10 miles/16 km).
- Valence-sur-Baïse: Abbaye de Flaran (14 miles/23 km).
- Auch: cathedral (14 miles/23 km).
- *Larressingle (20 miles/32 km), see p. 199.
- *Montréal (24 miles/39 km), see p. 215.
- *Fourcès (25 miles/40 km), see p. 196.
- *Sarrant (27 miles/43 km), see pp. 252–53.

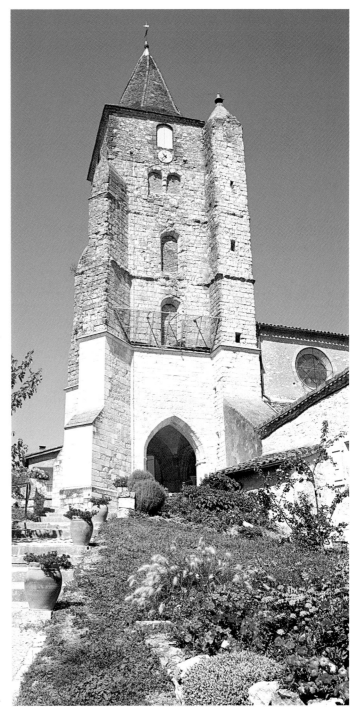

Limeuil

Barges and boatmen—
a bustling trading center

Dordogne (24) • Population: 354 • Altitude: 295 ft. (90 m)

Where the Dordogne and Vézère rivers meet, the once-flourishing port of Limeuil is now a welcoming and shady bank. The village knew dark days defending itself against the Vikings and then, during the Hundred Years War, the English. Three fortified gateways remain from this time, which visitors pass through to reach the village, built on a steep slope. The houses wind along its lanes, showing their façades of golden stone decorated with coats of arms. Halfway up, at the Place des Fossés, the castle comes into view, medieval in origin but renovated in the Moorish style. Down below, an arched double bridge straddles both rivers, and the Place du Port is a reminder that Limeuil was an important commercial center in the 19th century. In the valley not far from the village stands the 12th-century chapel of Saint-Martin, considered one of the most beautiful Romanesque chapels in Périgord.

By road: Expressway A89, exit 16–Périgueux Est (25 miles/40 km); N221 (24 miles/38 km).
By train: Buisson-de-Cadouin station (3½ miles/5.5 km); Bergerac station (29 miles/47 km).
By air: Bergerac-Roumanière airport (28 miles/45 km).

ⓘ Tourist information—Lascaux-Dordogne: +33 (0)5 53 63 38 90
www.lascaux-dordogne.com

👁 Highlights
• **Chapelle Saint-Martin** (12th century): Frescoes: +33 (0)5 53 63 33 66.
• **Panoramic gardens** (castle park): Gardens on the themes of colors, sorcerers, water, arboretum, landscaped garden; discovery trails on the themes of trees, landscape, river transport, and seamanship; craft workshops: +33 (0)5 53 57 52 64.
• **Village and park:** Self-guided visit (information panels). Further information: +33 (0)5 53 63 38 90.

🔑 Accommodation
Hotels
Les Terrasses de Beauregard**: +33 (0)5 53 63 30 85.
Guesthouses
Au Bon Accueil: +33 (0)5 53 63 30 97.
La Rolandie Haute 🛏🛏🛏: +33 (0)5 53 73 16 12.
Le Béquie 🛏🛏: +33 (0)5 53 63 01 59.
Gîtes and vacation rentals
Further information: +33 (0)5 53 63 38 90
www.lascaux-dordogne.com
Aparthotels
Domaine de la Vitrolle: +33 (0)5 53 61 58 58.
Campsites
La Ferme de Perdigat****: +33 (0)5 53 63 31 54.
La Ferme des Poutiroux***: +33 (0)5 53 63 31 62.

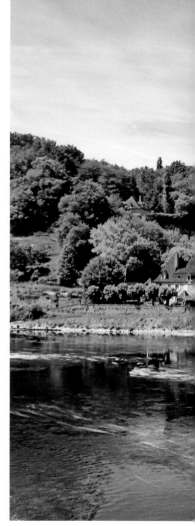

🍴 Eating Out
À l'Ancre de Salut, bar/brasserie: +33 (0)5 53 63 39 29.
Au Bon Accueil: +33 (0)5 53 63 30 97.
Le Chai, crêperie/pizzeria: +33 (0)5 53 63 39 36.
Garden Party: +33 (0)5 53 73 36 65.
Les Terrasses de Beauregard: +33 (0)5 53 63 30 85.

🧺 Local Specialties
Food and Drink
Local beer • Périgord apples and *vin de pays* • Organic produce.

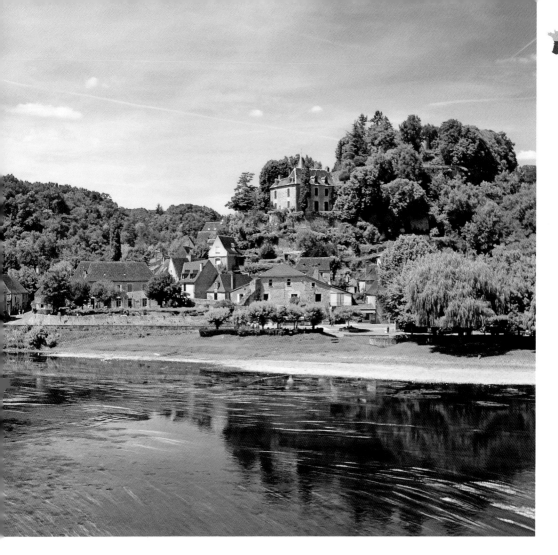

Art and Crafts
Jewelry • Art gallery • Silver/goldsmith •
Painters • Potters • Glassblowers •
Beadmaker • Straw-weaver.

② Events
Market: Sunday mornings, local produce,
Place du Port (1st weekend in July through
last weekend in August).
July: Flea market, local saint's day
(weekend closest to 14th); pottery
market (last weekend).
July–August: Evening markets (every
Sunday); exhibitions.

🦋 Outdoor Activities
Swimming (no lifeguard) • Canoeing •
Fishing • Walking, horse-riding, or
mountain-biking: Route GR 6, Boucle
de Limeuil (8 miles/13 km) and Route
de Périgueux (3 miles/5 km).

🦆 Further Afield
• Vézère valley (3–25 miles/5–40 km):
Le Bugue; Les Eyzies; *Saint-Léon-sur-
Vézère (19 miles/31 km), see p. 244;
Lascaux; *Saint-Amand-de-Coly (29 miles/
47 km), see pp. 234–35.

• Cingle de Trémolat, meander; Bergerac
(6–26 miles/9.5–42 km).
• Walled towns and medieval villages
(6–25 miles/9.5–40 km): Cadouin;
*Belvès (12 miles/19 km), see pp. 164–65;
*Monpazier (17 miles/27 km),
see pp. 213–14; Issigeac.
• Dordogne valley: *Beynac-et-Cazenac
(18 miles/29 km), see pp. 166–67;
*Castelnaud-la-Chapelle (21 miles/34 km),
see p. 180; *La Roque-Gageac (21 miles/
34 km), see pp. 232–33.
• Sarlat (22 miles/35 km).

Loubressac
Pointed roofs in the Dordogne valley

Lot (46) • Population: 536 • Altitude: 1,115 ft. (340 m)

From its cliff top, Loubressac commands a panoramic view of the valley of the Dordogne. Loubressac was ruined during the Hundred Years War but came back to life when the people of the Auvergne and Limousin moved back in, and it owes its current appearance to their efforts. Today, the flower-decked village lanes meet at a shady village square, where the church of Saint-Jean-Baptiste, dating from the 12th and 15th centuries, stands tall. The limestone medieval houses topped with antique tiles turn golden in the warm rays of the sun. Dominated by its castle perched on a natural promontory, the village offers far-reaching views of the Dordogne and Bave valleys. Numerous walking trails, which start in Loubressac, crisscross the area, linking the surrounding villages. Taking one of these snaking paths leads the visitor past springs or prehistoric dolmens to emerge on the limestone Causse plateau nearby.

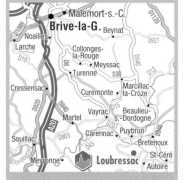

By road: Expressway A20, exit 54–Gramat (27 miles/43 km); expressway A89, exit 21–Aurillac (40 miles/64 km).
By train: Gramat station (10 miles/16 km).
By air: Brive-Vallée de la Dordogne airport (34 miles/55 km).

ⓘ Tourist information—Vallée de la Dordogne: +33 (0)5 65 33 22 00
www.vallee-dordogne.com
www.loubressac.fr

👁 Highlights
• **La Ferme de Siran:** Angora goat farm and movie on how mohair is produced: +33 (0)5 65 38 74 40.
• **Village:** Guided tour organized by local culture group Le Pays d'Art et d'Histoire de La Vallée de la Dordogne Lotoise: +33 (0)5 65 33 81 36.

🗝 Accommodation
Hotels
Le Relais de Castelnau***: +33 (0)5 65 10 80 90.
Lou Cantou**: +33 (0)5 65 38 20 58.
Gîtes and vacation rentals
Further information:
www.vallee-dordogne.com

Campsites
♥ La Garrigue***: +33 (0)5 65 38 34 88.

🍴 Eating Out
Lou Cantou: +33 (0)5 65 38 20 58.
Le Relais du Castelnau: +33 (0)5 65 10 80 90.
Le Vieux Pigeonnier, crêperie in Py hamlet: +33 (0)5 65 38 52 09.

🛍 Local Specialties
Food and Drink
Cabécou goat cheese • Walnut oil • Flour.
Art and Crafts
Handicrafts • Painters • Artist-potters • Mohair clothing.

📅 Events
June: "Fête de Bien-Vivre," local produce and craft festival
July: Local saint's day.
August: Marché de Producteurs, farmers' market, and food-lovers' picnic (2nd Thursday); flea market (4th Sunday).
December: Christmas market (mid-December).

🦋 Outdoor Activities
Walking • Mountain-biking.

🌿 Further Afield
• *Autoire (3 miles/5 km), see p. 157.
• Château de Castelnau (3½ miles/5.5 km).
• Gouffre de Padirac, chasm (3½ miles/5.5 km).
• *Carennac (5½ miles/9 km), see pp. 177–78.
• Château de Montal; Saint-Céré (5½ miles/9 km).
• Rocamadour (12 miles/19 km).
• *Curemonte (14 miles/23 km), see p. 187.
• *Collonges-la-Rouge (19 miles/31 km), see pp. 182–83.
• *Turenne (19 miles/31 km), see pp. 260–61.

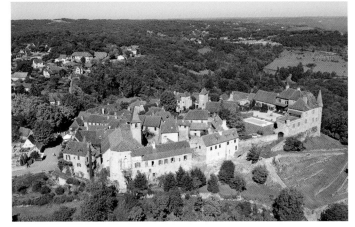

Minerve

Vines and stone

Hérault (34) • Population: 122 • Altitude: 745 ft. (227 m)

Commanding a dominant position in the Languedoc landscape, Minerve is a stone ship beached in the *garrigue* scrubland.

Below this wine-producing village, the Brian and Cesse rivers meet and carve out deep gorges. A viscounty in the Middle Ages, Minerve erected a Romanesque church to Saint-Étienne in the 11th century and built a ring of ramparts up against a castle. This system of defense allowed the inhabitants of the village, who had converted to the heretic Cathar religion, to resist Simon de Montfort's crusading army for seven weeks. The Rue des Martyrs and a monument near the church keep alive the memory of 180 Cathars burned at the stake after the town fell on July 22, 1210. The castle was destroyed in the 17th century; only one octagonal tower remains. A path at the bottom of the village leads from the southern postern to the Cesse river, following the course of the river underground for some 900 feet (300 meters) through impressive limestone caves.

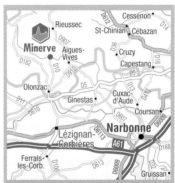

By road: Expressway A9, exit 36–Castres (29 miles/47 km); expressway A61, exit 24–Carcassonne Est (24 miles/39 km).
By train: Lézignan-Corbières station (14 miles/23 km); Narbonne station (22 miles/35 km). **By air:** Carcassonne-Salvaza airport (30 miles/48 km); Béziers-Vias airport (40 miles/64 km); Montpellier-Méditerranée airport (75 miles/121 km).

ⓘ Tourist information—
Minervois au Caroux: +33 (0)4 68 91 81 43
www.minervois-caroux.com

👁 Highlights
• **Musée Archéologique et Paléontologique** (Archeology and Paleonthology Museum): "3,000 Years of History" exhibition: +33 (0)4 68 91 22 92.
• **Musée Hurepel:** History of the Cathars and the Crusades: +33 (0)4 68 91 12 26.

• **Village:** Guided tour for groups only and by appointment only: +33 (0)4 68 91 81 43.

🏹 Accommodation
Hotels
Relais Chantovent: +33 (0)4 68 91 14 18.
Gîtes
Further information: +33 (0)4 68 91 81 43
www.minervois-caroux.com
Campsites
Le Maquis: +33 (0)4 67 23 94 77.

🍴 Eating Out
Choco Bar, tea room: +33 (0)6 40 40 88 53.
D'Âme Crêpe, crêperie: +33 (0)6 21 47 23 07.
M. and Mme Poumayrac, farmhouse inn: +33 (0)4 67 97 05 92.
Relais Chantovent: +33 (0)4 68 91 14 18.
La Table des Troubadours, steak house: +33 (0)4 68 91 27 61.
La Terrasse: +33 (0)4 68 65 11 58.

🛒 Local Specialties
Food and Drink
Goat cheese • AOC Minèrve wines.
Art and Crafts
Local crafts • Gifts • Bookshop • Paintings and sculptures.

📅 Events
July: Activities and commemorative concert "1210" (around 22nd).

🏊 Outdoor Activities
Swimming • Walking: Route GR 77 and 2 marked trails.

🌿 Further Afield
• Caunes-Minervois; Lastours; Carcassonne (16–28 miles/26–45 km).
• Montagne Noire (19 miles/31 km).
• Narbonne (20 miles/32 km).
• Oppidum d'Ensérune, archeological site; Béziers (28 miles/45 km).
• *Olargues (29 miles/47 km), see pp. 222–23.

ℹ Did you know?
The name Minerve is an adaptation of "Menerba" in the Romance language, Occitan. In turn, this probably derives from the Celtic words *men* (stone or rock) and *herbec* (refuge, sanctuary).

Monestiés

Hispanic influences in France's southwest

Tarn (81) • Population: 1,410 • Altitude: 689 ft. (210 m)

Coiled in a loop of the Cérou river, Monestiés lies in a valley that has been occupied since the Iron Age.

The once-fortified medieval village grew up around the Église Saint-Pierre, a seat of religious and political power from the 10th century. Monestiés has retained its historic maze of streets and lanes lined with old residences. Throughout the village, half-timbered houses, doors with carved lintels, and corbeled arcades and houses all reflect the warm colors and simple style typical of villages in southwest France. One of these buildings today houses the Bajén-Vega museum, dedicated to the work of two exiled Spanish artists who set up home in the Tarn. While the Chapelle Saint-Jacques, at the gates to the village, no longer welcomes the pilgrims from Santiago who used to seek refuge in the hospital, it still contains an exceptional 15th-century altarpiece. It is composed of twenty life-size polychrome stone statues, which depict the last three Stations of the Cross: the Crucifixion, the Pièta, and the Entombment.

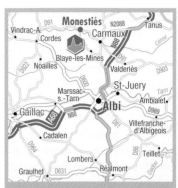

By road: Expressway A68-N88 (5 miles/8 km); expressway A20, exit 58–Villefranche-de-Rouergue (53 miles/86 km).
By train: Carmaux station (4½ miles/7 km).
By air: Rodez-Marcillac airport (48 miles/77 km); Toulouse-Blagnac airport (68 miles/109 km).

ⓘ **Tourist information—Ségala Tarnais:**
+33 (0)5 63 76 19 17
www.monesties.fr

👁 Highlights

• Chapelle Saint-Jacques (16th century): 15th-century group in polychrome limestone representing the three last Stations of the Cross: +33 (0)5 63 76 19 17.
• Musée Bajén-Vega: Collection of paintings by Francisco Bajén and Martine Vega, important members of the 20th-century Tarnaise art movement: +33 (0)5 63 76 19 17.
• Église Saint-Pierre (10th and 16th centuries): Monumental 17th-century altarpiece and 18th-century painting (*Swooning Virgin Supported by Saint John*).
• Village: Guided tour for groups of 15+ April–October by appointment: +33 (0)5 63 76 19 17.

🗝 Accommodation

Gîtes and vacation rentals
Le Candèze 🛏🛏🛏: +33 (0)5 63 48 83 01.
Au Village de Monestiés 🛏🛏:
+33 (0)5 63 48 83 01.
Le Petit Gîte en Pierre 🛏🛏:
+33 (0)6 07 98 66 69.
Mme Risse 🛏🛏: +33 (0)5 63 54 35 65.
Philippe Buttin 🗝🗝🗝: +33 (0)6 64 21 71 87.
Campsites
Camping municipal Les Prunettes*, mid-June–mid-September:
+33 (0)5 63 76 19 17.

🍴 Eating Out

Further information: +33 (0)5 63 76 19 17 or +33 (0)5 63 43 46 44.

🛒 Local Specialties

Food and Drink
Green lentils • Vegetable oils • Honey • Herbs and medicinal plants • AOC Gaillac wine.
Art and Crafts
Luthier and bow-maker.

2 Events

May: Flea market (beginning of the month).
June: Dressmakers' flea market; Fête de l'Âne, donkey festival.
July–August: Art exhibitions, medieval village fête; eco-friendly market (every Thursday, 5.30 p.m.).

September: Journées du Patrimoine, heritage festival.
November: Flea market (beginning of the month).
December: Christmas market.

🦋 Outdoor Activities

Horse-riding • Fishing • Tennis • Walking and mountain-biking: Marked trails • "Les Secrets de la Rivière" (botanical river trail) • Watersports: La Roucarié lakeside leisure park.

🌾 Further Afield

• Cagnac-les-Mines: mining museum (5 miles/8 km).
• Carmaux: Musée du Verre, glasswork museum (5 miles/8 km).
• Le Garric: Cap'Déecouverte, outdoor activities center (5 miles/8 km).
• Cordes-sur-Ciel (9½ miles/15.5 km).
• Albi; Gaillac (12–17 miles/19–27 km).
• *Najac (19 miles/31 km), see pp. 218–19.
• *Castelnau-de-Montmiral (22 miles/35 km), see p. 179.
• *Sauveterre-de-Rouergue (23 miles/37 km), see pp. 254–55.
• *Bruniquel (30 miles/48 km), see p. 173.

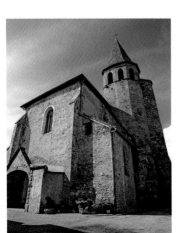

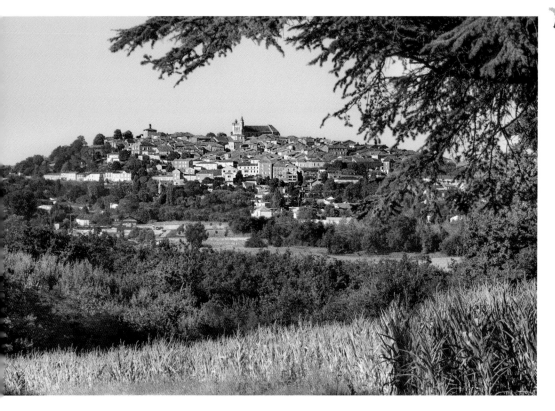

Monflanquin
A Tuscan air

Lot-et-Garonne (47) • Population: 2,398 • Altitude: 594 ft. (181 m)

French writer Stendhal (1783–1842) called the landscape around Monflanquin in the southwest of France "a little Tuscany."

Founded in 1256 by Alphonse de Poitiers, brother of Louis IX (Saint Louis), Monflanquin is one of about 300 fortified towns or villages that were typically built by the kings of France and England or the counts of Toulouse, who were fighting for control of the south-west of France. At the end of the 14th century, the village became the center of a bailiwick and was enclosed within ramparts punctuated by fortified gates and topped with towers. The ramparts were destroyed in 1622 by royal proclamation after the clashes of the Wars of Religion. Monflanquin has nevertheless retained its characteristic checkerboard street plan. At the heart of the village, the Place des Arcades features a broad colonnade supported by stone pillars; it contains stunning residences, including the House of the Black Prince. From the Cap del Pech there is a spectacular view over the Lède valley.

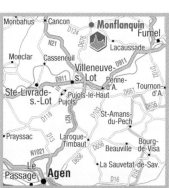

By road: Expressway A62, exit 7–Périgueux (34 miles/55 km); expressway A89, exit 15–Agen (32 miles/51 km), N21 (8½ miles/13.5 km). **By train:** Monsempron-Libos station (11 miles/18 km); Agen station (30 miles/48 km). **By air:** Bergerac-Roumanière airport (31 miles/50 km); Agen-La Garenne airport (35 miles/56 km).

ⓘ Tourist information—Coeur de Bastides: +33 (0)5 53 36 40 19
www.coeurdebastides.com

👁 Highlights

• **Musée des Bastides:** Exhibition about fortified towns, the new towns of the Middle Ages; interactive family guide, escape game, calligraphy studio, and children's games: +33 (0)5 53 36 40 19.
• **Village:** Take a discovery walk through the lanes of the fortified town with your jester guide Janouille la Fripouille, a medieval troubadour. Tours for individuals in July–August, by day or evening, and special events; throughout the year only for booked groups: +33 (0)5 53 36 40 19.
• **"Pollen," contemporary art hub and artists' residence:** Exhibitions, education, and talks: +33 (0)5 53 36 54 37.

🔑 Accommodation

Hotels
Monform**: +33 (0)5 53 49 85 85.
La Bastide des Oliviers: +33 (0)5 53 36 40 01.
Guesthouses and gîtes
Further information: +33 (0)5 53 36 40 19
www.coeurdebastides.com
Aparthotels
Résidence du Lac***, Pierre et Vacances: +33 (0)5 53 49 72 00.
Résidence du Lac Mondésir: +33 (0)5 53 49 03 27.

🍽 Eating Out

La Baldoria, pizzeria: +33 (0)5 53 49 09 35.
La Bastide, crêperie: +33 (0)5 53 36 77 05.
La Bastide des Oliviers: +33 (0)5 53 36 40 01.
Le Bistrot du Prince Noir: +33 (0)5 53 36 63 00.
L'Effet Maison: +33 (0)9 52 13 07 73.
La Grappe de Raisin: +33 (0)5 53 36 31 52.
Le Jardin: +33 (0)5 53 36 54 15.
La Marmaille: +33 (0)5 53 40 97 58.
Le Restaurant du Lac: +33 (0)5 53 49 85 85.
La Terrasse des Arts'cades, brasserie: +33 (0)5 53 36 32 18.

🧺 Local Specialties

Food and Drink
Foie gras • Cheese • Organic produce • Hazelnuts • Prunes • Wine • Beer.
Art and Crafts
Flea market and antiques • Contemporary art • Ceramic artist • Wooden toys • Painters • Soap • Clothes and jewelry • African crafts • Art galleries • Textiles and leather objects • Sculptors.

📅 Events

Markets: Traditional market, Thursday mornings, Place des Arcades.
Little market, Sunday mornings, entrance to the fortified town, July–August.
Throughout the year: exhibitions, concerts, and theater.
February: Photography festival.
April: Spring fair, book fair.
May: Horse-racing
June: Art and heritage festival; "Nuit de la Saint-Jean," Saint John's Eve ball with traditional music.
July: Antiques fair (mid-July); "Les Soirées Baroques de Monflanquin," baroque music (2nd fortnight); world music concerts.
July–August: Local farmers' market (Thursday evenings).
August: "Soirée des Étoiles," stargazing (early August)
December: Saint André's day (1st Monday in December and preceding weekend).

🦋 Outdoor Activities

Boules area • Horse-riding • Fishing: Lac de Coulon (1st and 2nd categories) • Walking and mountain-biking.

🌿 Further Afield

• Montagnac-sur-Lède: mill (5 miles/8 km).
• Castle at Gavaudun (7 miles/11.5 km).
• Fortified towns of Villeréal, Villeneuve-sur-Lot, Castillonnès, and Beaumont-du-Périgord (7½–18 miles/12–29 km).
• Medieval towns of Cancon, Penne-d'Agenais, and Issigeac (7½ 18 miles/ 12–29 km).
• Saint-Avit: Musée Bernard-Palissy, museum (7½ miles/12 km).
• Château de Biron (11 miles/18 km).
• *Monpazier (14 miles/23 km), see pp. 213–14.
• Château de Bonaguil (14 miles/23 km).
• *Pujols-le-Haut (16 miles/26 km), see pp. 226–27.
• *Belvès (24 miles/39 km), see pp. 164–65.
• Bergerac (28 miles/45 km).
• Agen (31 miles/50 km).

ⓘ Did you know?

The Black Prince (1330–1376), eldest son of the English king Edward III, perhaps owed his dark nickname to an act of revenge perpetrated during the sack of Limoges in 1370, where one chronicler claimed he killed more than 3,000 citizens, though other sources suggest this was much exaggerated.

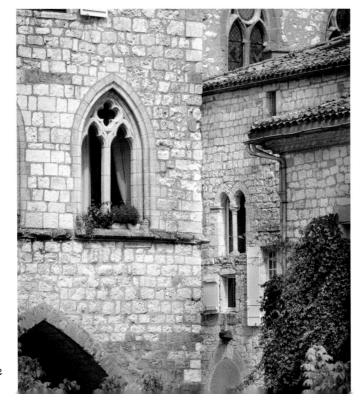

Monpazier
An iconic fortified town

Dordogne (24) • Population: 484 • Altitude: 650 ft. (198 m)

Eight hundred years after its foundation, Monpazier retains its original street plan and remains an excellent example of a medieval fortified town. It was founded in 1284 by Edward I, king of England. Given that the Hundred Years War, famine, and epidemics all hit Monpazier hard during the Middle Ages, the town is remarkably well preserved. Amid the three hundred fortified towns of the south-west, Monpazier's singularity and exemplarity as a masterpiece of architecture and urban planning earned it a certain reputation: both 19th-century architect Viollet le Duc and Le Corbusier considered it to be a model for all fortified towns. Crisscrossed by *carreyras* (streets) and *carreyrous* (alleys), the village is laid out around the delightful Place des Cornières. Perfectly square, this is lined with 18th-century buildings and surrounded by 14th- and 18th-century arcades. Among the superb medieval structures are the 13th-century central market, which still has its grain measures; the Église Saint-Dominique (13th and 15th centuries); the square tower; the oldest (1292) and tallest chapter house in Monpazier; Dîmes barn, and also the three fortified gates. Nearby is the historic Récollets convent and the Bastideum, which houses the Centre d'Interprétation de l'Architecture et du Patrimoine (architecture and heritage center).

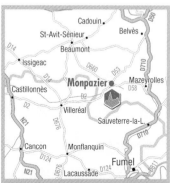

By road: Expressway A89, exits 16–Angoulême (41 miles/66 km) and 13–Bergerac (43 miles/69 km); N21 (17 miles/27 km). **By train:** Belvès station (10 miles/16 km); Bergerac station (27 miles/43 km). **By air:** Bergerac-Roumanière airport (29 miles/47 km).

ⓘ Tourist information:
+33 (0)5 53 22 68 59
www.pays-bergerac-tourisme.com
www.monpazier.fr

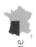

👁 Highlights

• **Bastideum:** Centre d'Interprétation de l'Architecture et du Patrimoine. Archive documents, oral testimonies, 3D reconstruction of the fortified town, several ancient games, medieval garden: +33 (0)5 53 57 12 12.
• **Église Saint-Dominique** (13th and 15th centuries): Stalls.
• **Village:** Guided tour in French, Tuesdays at 11 a.m. in July–August for individuals, throughout the year for groups by appointment only. Tours by torchlight, Mondays at 9.30 p.m. in July–August; accessible tours for the visually impaired (tactile models, guidebooks in Braille and large print): +33 (0)5 53 22 68 59.

🗝 Accommodation

Hotels
♥Hôtel Edward Ier****: +33 (0)5 53 22 44 00.
Guesthouses
Chez Edèll: +33 (0)5 53 63 26 71.
Chez Janou: +33 (0)6 73 70 09 13.
Les Fleurs: +33 (0)5 53 27 97 12.
Les Hortensias: +33 (0)5 53 58 18 04.
Gîtes and vacation rentals
Further information: +33 (0)5 53 22 68 59
www.pays-bergerac-tourisme.com

🍴 Eating Out

La Bastide: +33 (0)5 53 22 60 59.
Le Bistrot 2 [deux]: +33 (0)5 53 22 60 64.
Le Chêne Vert, pizzeria and light meals: +33 (0)5 53 74 17 82.

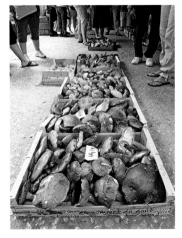

Chez Minou, pizzeria: +33 (0)5 53 22 46 59.
Le Croquant: +33 (0)5 53 22 62 63.
Eleonore, gourmet restaurant: +33 (0)5 53 22 44 00.
Le Privilège du Périgord: +33 (0)5 53 22 43 98.

🧺 Local Specialties

Food and Drink
Local Périgord specialties (foie gras etc.) • Wine.
Art and Crafts
Jewels • Turned wood • Ceramics • Dress design • Bookbinding • Gilding on wood • Framing • Clock-maker • Leather goods •
Marquetry • Painting • Glass painting • Glassblowing • Wall coverings • Soft furnishings • Ladies' fashion.

📅 Events

Markets: Market on Thursday mornings;. Marché aux Cèpes, mushroom market (according to yield), every afternoon in autumn.
Marché aux Truffes, truffle market, December–February.
April: Theater; "Printemps de Minou," concerts (2nd Saturday).
May: Art and crafts fair (3rd weekend after Ascension); Fête des Fleurs, flower festival; horse races (end of May).
June: "Rendez-vous aux Jardins," open gardens (1st weekend); flea market (2nd weekend); Journée Nationale de l'Archéologie, archeology festival.
July: Horse-racing (2nd Sunday); "Les Médiévales," medieval fair (3rd weekend) cycling after dark (last Thursday); Fête du Livre, book festival (last Sunday).
August: "Eté Musical en Bergerac," music festival (beginning of August); horse-racing (1st Sunday); flea market (2nd weekend); "Adoreed," endurance horse competition (last weekend).
July–August: Open-air cinema; farmers' market.
October: Flea market (2nd weekend).

🦋 Outdoor Activities

Boules area • Sports playing field • Walking.

🌿 Further Afield

• Château de Biron (5 miles/8 km).
• Abbaye de Cadouin (10 miles/16 km).
• *Belvès (10 miles/16 km), see pp. 164–65.
• *Monflanquin (14 miles/23 km), see pp. 211–12.
• Dordogne valley: *Limeuil (17 miles/27 km), see pp. 206–7; *Castelnaud-la-Chapelle (21 miles/34 km), see p. 180; *Beynac-et-Cazenac (24 miles/39 km), see pp. 166–67; *La Roque-Gageac (24 miles/39 km), see pp. 232–33; *Domme (25 miles/40 km), see pp. 188–89.
• Château de Bonaguil (19 miles/31 km).
• Issigeac (19 miles/31 km).
• Monbazillac (27 miles/43 km).
• Bergerac (28 miles/45 km).

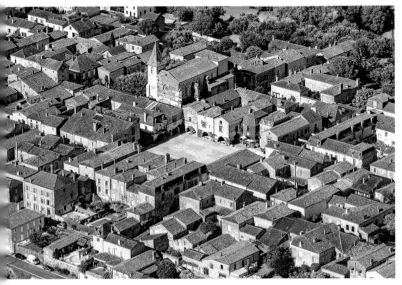

Montréal
Ancient and medieval Gascony

Gers (32) • Population: 1,266 • Altitude: 427 ft. (130 m)

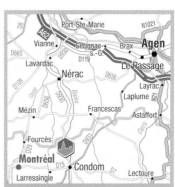

The fortified town of Montréal is surrounded by vineyards and stands proudly at the heart of Gascony in the southwest of France.

In 1255, Alphonse de Poitiers, brother of Louis IX (Saint Louis), built the first Gascon *bastide* (fortified town) on a rocky spur around which twists the Auzoue river. Following the classic grid pattern, roads and cobbled streets lead to the central square, which has arcades on three sides. The 13th-century Gothic church of Saint-Philippe-et-Saint-Jacques is built into the fortifications, and its flat, square tower looks down on half-timbered houses. An ogee gate survives from the fortifications. To the north, the pre-Romanesque church of Saint-Pierre-de-Genens (11th century) has a reused Roman colonnade and a Chi-Rho (symbol for Christ) carved into the antique marble. With its Flamboyant Gothic plan and vaulting, the chapel of Luzanet represents an architectural style that is rare in southwest France. Just over a mile (2 km) from Montréal, the 4th-century Séviac Roman villa is an enormous palace boasting sumptuous mosaics and vast thermal baths. This luxurious wine-growing estate dominated the territory of Elusa (Eauze), capital city of the Roman province of Novempopulania.

By road: Expressway A62, exit 6–Nérac (34 miles/55 km); N124 (29 miles/47 km).
By train: Auch station (33 miles/53 km); Agen station (34 miles/55 km). **By air:** Agen-La Garenne airport (31 miles/50 km); Toulouse-Blagnac airport (78 miles/126 km).

ⓘ Tourist information—Ténarèze:
+33 (0)5 62 29 42 85 or +33 (0)5 62 28 00 80
www.tourisme-condom.com

👁 Highlights
• Collegiate church of Saint-Philippe-et-Saint-Jacques (13th century).
• Église Saint-Pierre-de-Genens (11th century): Carved portal, white marble tympanum.
• Séviac Gallo-Roman villa: Vast multicolored mosaic floor, thermal baths. Further information: +33 (0)5 62 29 48 57 www.elusa.fr.
• Winemaking discovery center: +33 (0)5 62 29 42 85.
• Village: Guided tour of the fortified town on request: +33 (0)5 62 29 42 85.

🗝 Accommodation
Guesthouses
Le Couloumé 🎏🎏🎏: +33 (0)5 62 29 47 05.
Agapé du Gers ✱✱✱✱: +33 (0)6 22 78 68 80.
La Métairie du Clos Saint-Louis ✱✱✱✱: +33 (0)6 09 99 43 72.
Château de Malliac: www.vie-de-chateau.com
Carpe Diem: +33 (0)5 62 28 37 32.
Lou Prat de la Ressego: +33 (0)5 62 29 49 55.
La Pôse de Mont Royal: +33 (0)6 74 80 07 48.
Aparthotels
Résidence Hotesia***: +33 (0)5 62 68 38 93.
Gîtes, walkers' lodges, and vacation rentals
Further information: +33 (0)5 62 29 42 85.
www.tourisme-condom.com

Campsites
M. Lussagnet, farm campsite: +33 (0)5 62 29 44 78.

🍴 Eating Out
L'Escale: +33 (0)5 62 29 59 05.
Mura & Co, tea room: +33 (0)5 62 29 45 91.

🧺 Local Specialties
Food and Drink
Preserves (foie gras, duck confit, etc.) • Cheese • Honey • Wine, Floc de Gascogne, and Armagnac.
Art and Crafts
Ceramic artist • Paintings on cardboard • Painters • Statues in reconstituted marble.

2️⃣ Events
Market: Fridays 8 a.m.–1 p.m.
March, June, September, December: "Foire des 4 Saisons," food, produce, and crafts fair.
July–August: Evening medieval fair; evening walk (every Thursday).
August: "Courses Landaises," bullfighting, and Montréal festival (1st fortnight).
November: "Flamme de l'Armagnac," Armagnac festival (3rd weekend).

🦋 Outdoor Activities
Recreation area • Fishing • Walking: PR and GR routes.

🌿 Further Afield
• Auzoue valley: *Fourcès (3½ miles/5.5 km), see p. 196; Nérac (21 miles/34 km).
• *Larressingle (6 miles/9.5 km), see p. 199.
• Condom (9½ miles/15.5 km).
• *Lavardens (26 miles/42 km), see pp. 204–5.

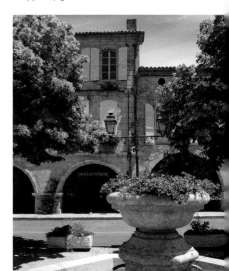

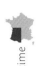

Mornac-sur-Seudre

A pearl in the marshes

Charente-Maritime (17) • Population: 859 • Altitude: 16 ft. (5 m)

Typical of Charente-Maritime, the house façades in the little port of Mornac, trimmed with hollyhocks, are bleached by the sun.

During Gallo-Roman times, the attractions of the Seudre river turned the budding village of Mornac into a small fishing town on a hill near the present castle. As commerce developed, attractive low houses began to replace modest huts. Today, Mornac-sur-Seudre is a center of oyster farming and salt production, which you can see by visiting the marshes. Brimming with medieval charm, the old town is crisscrossed by alleys leading to the port. The Romanesque church, built in the 11th century over a Merovingian shrine, is topped by a fortified square tower and has a magnificent chevet.

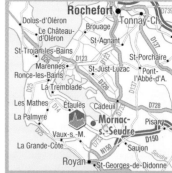

By road: Expressway A10, exit 35–Saintes (24 miles/39 km); N150, exit D14–Saujon/La Tremblade (5½ miles/9 km).
By train: Royan station (7½ miles/12 km).
By air: La Rochelle-Laleu airport (45 miles/72 km); Bordeaux-Mérignac airport (100 miles/161 km).

ⓘ Tourist information:
+33 (0)5 46 08 17 58
www.royanatlantique.com

👁 Highlights
• **Église Saint-Pierre** (11th century): Medieval frescoes, reliquary treasure.
• **Seudre marshes:** Guided biodiversity walk with the Huître Pédagogique organization: +33 (0)6 83 71 34 87.
• **Musée Ferroviaire** (railroad museum): In Mornac-sur-Seudre's 150-year-old disused railway station: +33 (0)7 51 66 92 36.
• **Village:** Guided tours: +33 (0)5 46 08 17 58.
• **Salt-marsh tour:** Meet salt producer Sébastien Rossignol: +33 (0)6 71 09 03 03.

🔑 Accommodation
Guesthouses
Côté Chenal: +33 (0)7 89 23 79 53.
Le Mornac: +33 (0)5 46 22 63 20.
Gîtes, vacation rentals, and campsites
M. Cougot: +33 (0)5 46 50 63 63.
Michel Vinay, campsite:
+33 (0)5 46 22 72 25.
Further information: +33 (0)5 46 22 92 46
www.royanatlantique.fr

🍽 Eating Out
Aux Clairs du Grand Téger, seafood bar:
+33 (0)6 73 39 36 30.
Le Bar'Ouf: +33 (0)5 46 22 75 24.
Les Basses Amarres: +33 (0)5 46 22 63 31.
Le Café des Arts, crêperie:
+33 (0)5 46 06 40 43.
La Cambuse: +33 (0)9 83 27 62 24.
Les Ecluses Vertes: +33 (0)6 11 77 09 53.
La Gourmandine, crêperie:
+33 (0)5 46 23 38 47.
Le Marais: +33 (0)5 46 22 16 78.

Le Moulin, crêperie: +33 (0)5 46 02 89 69.
Ô Saline: +33 (0)5 46 06 49 53.
Le Parc des Graves: +33 (0)5 46 22 75 14.

🍴 Local Specialties
Food and Drink
Oysters • Shrimps • Salt.
Art and Crafts
Leather crafts • Jewelry • Bag, fashion, and accessories designer • Crafts from natural materials • Salt dough • Painters and sculptors • Potters • Torch glass artist.

📅 Events
Market: Wednesdays, 9 a.m.–12.30 p.m.
April: Romanesque fair.
July–August: "Jeudi Musical Nocturne des Artisans," evening music and craft fairs (every Thursday); exhibitions at the port.
August (depending on tide): "Voiles de Mornac," annual gathering of traditional sailboats.
September: Pottery market.
December: Christmas market.

🦋 Outdoor Activities
Seudre river cruises • Horse-riding • Canoeing • Fishing • Walking: marked trails.

🦋 Further Afield
• Saujon: Le Train des Mouettes, tourist steam train (6 miles/9.5 km).
• Royan (7½ miles/12 km).
• La Palmyre: zoo (9½ miles/15.5 km).
• Saint-Georges-de-Didonne: Parc de l'Estuaire, nature reserve (9½ miles/15.5 km).

• Meschers-sur-Gironde: Grottes de Régulus, cliff-face cave dwellings (15 miles/24 km).
• *Talmont-sur-Gironde (18 miles/29 km), see pp. 257–58.
• Marennes; Isle of Oléron (19 miles/31 km).
• *Brouage (20 miles/32 km), see pp. 170–71.

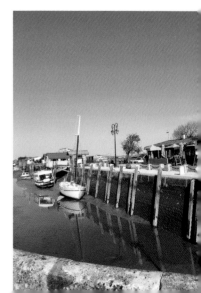

Mortemart

The great and the good in Limousin

Haute-Vienne (87) • Population: 115 • Altitude: 984 ft. (300 m)

A flower-bedecked Limousin town with a glorious past, Mortemart resonates with ten centuries of history. Established on a marshy plain that gave the village its name (*Morte mortuum*; "dead sea"), Mortemart did not remain primitive for long. In 995, as a reward for his victorious defense of the neighboring town of Bellac against Count Guillaume de Poitiers, Abon Drut, lord of Mortemart, was authorized to build the Château des Ducs. This became the birthplace of the Rochechouart-Mortemart family; Madame de Montespan, born into the family in 1640, was a favorite of Louis XIV's. In the 10th-century castle, while the fortifications have disappeared, the keep, courtroom, and guards' room are a reminder of the perils that threatened medieval towns, as are the drawbridge, pond, and dried-up moat. The Carmelite and Augustinian convents, designed to a square grid, were begun in 1330 but were not completed until the 18th century. The Augustinian chapel, which became the parish church, contains 15th-century carved wooden stalls: their misericords, which allowed monks to rest, recall the long church services of times gone by. The historic market and the superb houses of prominent townsfolk evoke a thriving 17th-century commercial town.

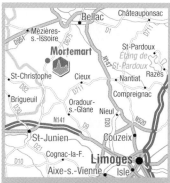

By road: Expressway A20, exit 23–Bellac (27 miles/43 km); N145 (9½ miles/15.5 km); N141, exit Bellac (11 miles/18 km).
By train: Bellac station (8 miles/13 km); Limoges-Bénédictins station (28 miles/45 km). **By air:** Limoges-Bellegarde airport (24 miles/39 km).

ⓘ Tourist information:
+33 (0)5 55 68 12 79
www.mortemarttourismelimousin.com

👁 Highlights
• **Château des Ducs** (10th century): Keep, courtroom, guards' room (July–August).
• **Carmelite convent** (14th–17th centuries): Monumental staircase; art and craft gallery.
• **Church:** 15th-century stalls, 17th-century altarpiece.
• **Village:** Guided visits for groups by appointment only: +33 (0)5 55 68 12 79.

🔑 Accommodation
Hotels
Le Relais: +33 (0)5 44 25 54 16.
Guesthouses
M. Thomas: +33 (0)5 55 60 20 23.

🍽 Eating Out
Le Café du Marché:
+33 (0)5 55 68 98 61.
Le Relais: +33 (0)5 44 25 54 16.

🧺 Local Specialties
Art and Crafts
Poetry publisher • Artists and craftspeople at Carmelite convent.

📋 Events
Market: Sunday mornings, local produce, at La Halle covered market (July–August).
April: Natural wine fair.
June: Concert by the Josquin des Prés vocal ensemble.

July–August: Concerts; painting and sculpture exhibitions; Haut Limousin music and heritage festival; "Peintres dans la Rue," street painting competition.
September: Open-air rummage sale.
November: Local trail discovery day, on dog sleds.

🦋 Outdoor Activities
Walking: 3 marked trails • Mountain-biking • Golf Club Villars (9 holes) • Electric bike rental • Horse-drawn carriage rides.

🌿 Further Afield
• Monts de Blond, uplands (1–9½ miles/1.5–15.5 km).
• Bellac; Le Dorat (8–16 miles/13–26 km).
• Oradour-sur-Glane: Centre de la Mémoire, center for remembrance (9½ miles/15.5 km).
• Saint-Junien: landscape depicted by the painter Corot (12½ miles/20 km).
• Confolens: folklore festival (19 miles/31 km).
• Limoges; Vienne valley (25 miles/40 km).

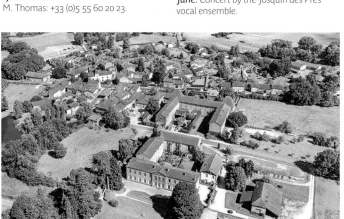

Najac

Tumbling rooftops in the Aveyron

Aveyron (12) • Population: 754 • Altitude: 1,115 ft. (340 m)

Set on a steep hill, the fortress of Najac dominates the village and wild gorges of this southern French region.

A simple square tower in the 12th century, the Château de Najac became a fortress a century later by order of Louis IX (Saint Louis). Its strategic position made it the linchpin of the valley and earned it a turbulent history. Kings of France and England, counts of Toulouse, Protestants, and locals have all desired this "key to the whole land." From round towers, the view plunges to the valley of the Aveyron and over the village's *lauze* (schist tile) rooftops. The inhabitants converted to the "Cathar heresy" in the 1200s, and were sentenced by the Inquisition to build the Église Saint-Jean at their own expense. Its southern-French style of pointed arch makes it one of the first Gothic churches in the area. The village extends over the rocky crest at the foot of the castle. At its center, the Place du Barry evokes the village's role as a commercial center: its stone or half-timbered houses from the 15th and 16th centuries feature arcades to shelter merchandise.

By road: Expressway A20, exit 59–Rodez (31 miles/50 km); expressway A75, exit 42–Rodez (75 miles/120 km), N88 (33 miles/53 km); expressway A68, exit 9–Gaillac (36 miles/58 km). **By train:** Najac station; Villefranche-de-Rouergue station (14 miles/22 km). **By air:** Rodez-Marcillac airport (50 miles/81 km); Toulouse-Blagnac airport (77 miles/124 km).

ⓘ Tourist information—
Ouest Aveyron +33 (0)5 65 29 72 05
www.ouest-aveyron-tourisme.fr

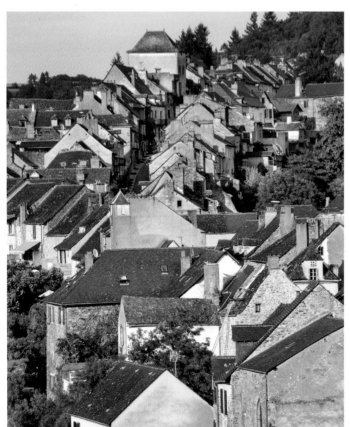

👁 Highlights
• **Royal fortress** (12th and 13th centuries): Keep, Saint-Julien's Chapel (frescoes), governor's chamber (panoramic view from the terrace): +33 (0)5 65 29 71 65.
• **Église Saint-Jean** (13th and 14th centuries).
• **Maison du Gouverneur:** Visitor center dedicated to the architecture and history of the local fortified towns; events and exhibitions all year round: +33 (0)5 65 81 94 47.
• **Village:** Guided tours Tuesdays 10 a.m., June 15–September 15; for groups off-season by appointment; torchlit tours July–August; "Le Maître des Secrets de Najac," treasure hunt for children (age 6–12): +33 (0)5 65 29 72 05.

🗝 Accommodation
Hotels
Le Belle Rive***: +33 (0)5 65 29 73 90.
L'Oustal del Barry**: +33 (0)5 65 29 74 32.
Guesthouses
Marie Delerue 👙👙, La Prade Haute: +33 (0)5 65 29 74 30.
J.-P. Verdier 👙👙, La Prade Basse: +33 (0)5 65 29 71 51.
El Camino de Najac: +33 (0)5 65 81 29 19.

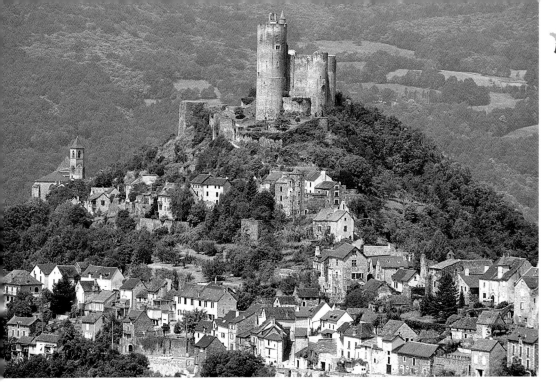

Elelta: +33 (0)7 50 43 52 17.
Sylvie Frazier, La Contie:
+33 (0)5 65 29 70 79.
L'Insolite: +33 (0)6 23 57 54 73.
Somn'en Bulle, bubble hotel:
+33 (0)6 63 41 08 33.
Gîtes, walkers' lodges, vacation rentals
Further information: +33 (0)5 65 29 72 05
www.ouest-aveyron-tourisme.fr
Vacation villages
VVF Villages: + 33 (0)8 25 39 49 59,
site reception: +33 (0)5 65 29 74 31.
Campsites
Le Païsserou***, information and booking:
+33 (0)5 65 29 73 96.
Camping des Étoiles*: +33 (0)5 65 29 77 05.
La Prade Basse, farm campsite:
+33 (0)5 65 29 71 51.
RV parks
Further information: +33 (0)5 65 29 71 34.

🍽 Eating Out
L'Air du Temps: +33 (0)5 65 81 22 76.
La Belle Rive: +33 (0)5 65 29 73 90.
La Cantine Pirate: +33 (0)5 65 81 59 27.
Il Cappello, pizzeria: +33 (0)5 65 29 70 26.
L'Insolite: +33 (0)6 23 57 54 73.
L'Oustal del Barry: +33 (0)5 65 29 74 32.
La Salamandre: +33 (0)5 65 29 74 09.
Tartines et Compagnie: +33 (0)5 65 29 57 47.
VVF Villages: +33 (0)5 65 29 74 31.

🧺 Local Specialties
Food and Drink
Ostrich and duck (confits, foie gras) •
Fouace de Najac • Cheese • *Gâteau à la
broche* (fire-baked cake) • *Astet najacois*
(roast stuffed pork).
Art and Crafts
Jewelry designer • Cutler • Potter.

🗓 Events
Market: Sunday 8 a.m.–1 p.m, June–
September.
April: "Salon du Goût," tasting fair
(1st weekend).
June: "Nuit des Chiens Bleus,"
music festival; medieval festival; hot-air
balloon day (every other year).
July: Open-air cinema.
July–August: Contemporary art
exhibitions, "Ateliers du Patrimoine"
and "L'Été des 6–12 ans"; flea market
(July 14–August 15); evening market
(Wednesdays).
August: "Festival en Bastides," theater
and street performances (1st week),
village fête (3rd weekend); "Les Nuits
Musicales du Rouergue," music festival.
October: "Lame à Najac," cutlery fair.

🦋 Outdoor Activities
Canoeing • Orienteering • Climbing •
Tree-climbing • Horse-riding • Fishing •
Via Ferrata • Mountain-biking (cross-country
mountain-biking area) • Walking: Route GR
36 and 8 marked trails.

🌿 Further Afield
• Abbaye de Beaulieu; Caylus
(9½–12 miles/15.5–19 km).
• Fortified towns of Villefranche-de-Rouergue
and Villeneuve (14–22 miles/ 23–35 km).
• Cordes-sur-Ciel (16 miles/26 km).
• Saint-Antonin-Noble-Val (17 miles/27 km).
• *Monestiés (19 miles/31 km), see p. 210.
• *Sauveterre-de-Rouergue (27 miles/43 km),
see pp. 254–55.
• Gorges of the Aveyron (27 miles/44 km).
• Albi (31 miles/50 km).

❗ Did you know?
A local specialty, the *fouace de Najac* was
originally cooked in the ashes of a fire (the
word comes from the Latin *focus*, meaning
hearth). Nowadays the bread is made of
flour, yeast, eggs, milk, sugar, orange-
blossom water, and salt, and is presented
in the shape of a crown.

Navarrenx
The first fortified town in France

Pyrénées-Atlantiques (64) • Population: 1,131 • Altitude: 394 ft. (120 m)

Situated at the place where the Gave d'Oloron river and the Saint James's Way meet, Navarrenx is one of the oldest towns in the old independent state of Béarn.

Navarrenx has its origins in the 1st century CE, but it was in the Middle Ages that the town had its glory days. Built as a *bastide* (walled town) in 1316, Navarrenx enjoyed a number of privileges that helped it to expand. From 1538 onward Henri II d'Albret, king of Navarre, made important alterations to it in an attempt to protect this vital commercial center and crossroads from the Spanish. The designer was Italian architect Fabricio Siciliano; his work is still visible today in the historic stronghold, and his style was copied a century later by Vauban (commissioner for fortifications in the 17th century). The impressive ramparts 33 ft. (10 m) high, from which you can see the Pyrenees, provide a magnificent view over the Gave d'Oloron, as well as over several bastions and military structures. Navarrenx, once an important stopover on the path to Santiago de Compostela, now gives a nod to the village's defensive past by welcoming pilgrims in search of peace to the historic 17th-century arsenal, partly converted into gîtes. The Gave d'Oloron, the longest salmon river in France, has also given Navarrenx its reputation as a "salmon capital," and freshwater fishermen still enjoy its bounties.

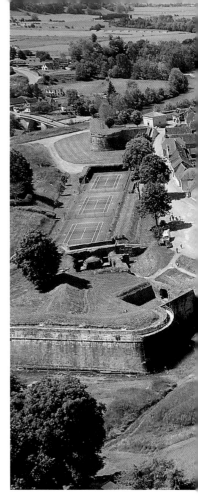

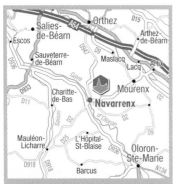

By road: Expressway A64, exit Salies-de-Béarn (17 miles/27 km) and exit 9– Mourenx (14 miles/23 km), N117 (13 miles/ 21 km). **By train:** Orthez station (14 miles/ 23 km); Pau station (25 miles/40 km). **By air:** Pau-Pyrénées airport (25 miles/ 40 km); Biarritz-Anglet-Bayonne airport (50 miles/80 km).

ⓘ Tourist information—Béarn des Gaves: +33 (0)5 59 38 32 85 www.tourisme-bearn-gaves.com

👁 Highlights

• **Centre d'Interprétation, visitor center**: Museum inside the former arsenal, dedicated to the history of Navarrenx, e.g. models, plans: +33 (0)5 59 66 10 22.
• **"La Poudrière"**: Permanent exhibition on gunpowder: +33 (0)5 59 38 32 85.
• **La Porte Saint-Antoine**: Musée des Vieux Outils, museum of old tools: +33 (0)5 59 38 32 85.
• **La Maison du Cigare**: Production site of the luxury "Le Navarre" cigar combining French and Cuban expertise; see the different stages of production of premium cigars and a cigar-rolling demonstration. Open throughout the year, Monday–Friday: +33 (0)5 59 66 51 96.
• **Village**: Self-guided tour using leaflet (available from tourist information center); themed tour for individuals led by tour guide from "Pays d'Art et d'Histoire"; guided group tour throughout the year by appointment; guided view of model of the fortified town at tourist information center.

🔑 Accommodation

Hotels
Hôtel du Commerce**:
+33 (0)5 59 66 22 54.
Guesthouses
Caselas Cottage 🏠🏠🏠: +33 (0)6 81 52 84 84.
Le Cri de la Girafe: +33 (0)5 59 66 24 22.
Lalanne: +33 (0)6 89 46 80 76.
Monique and Jean-Pierre Lasarroques:
+33 (0)5 59 66 27 36 or
+33 (0)6 75 59 36 56.
Le Relais du Jacquet: +33 (0)5 59 66 57 25 or +33 (0)6 75 72 89 33.
Gîtes, vacation rentals, and walkers' lodges
Further information: + 33 (0)5 59 38 32 85 www.tourisme-bearn-gaves.com
Campsites
Camping Beau Rivage***:
+33 (0)5 59 66 10 00.

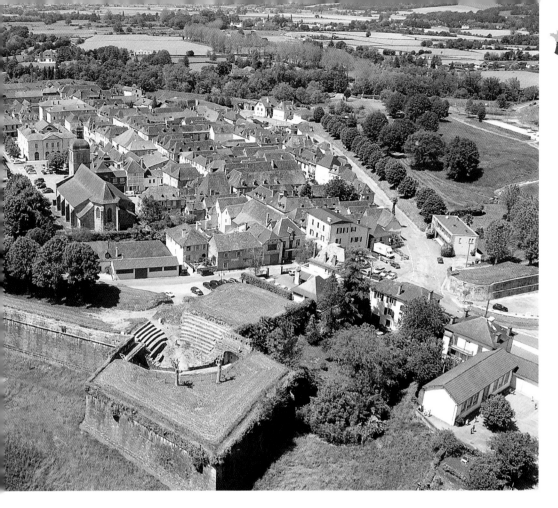

🍴 Eating Out
Auberge du Bois:
+33 (0)5 59 66 10 40.
Bar des Sports: +33 (0)5 59 66 50 63.
Le Commerce: +33 (0)5 59 66 22 54.
La Taverne de Saint-Jacques:
+33 (0)5 59 66 25 25.

🛒 Local Specialties
Food and Drink
Salted products • Jam • Artisan beers •
Gave river salmon and trout.
Art and Crafts
Artist and interior designer • Jewelry
designer • Photographer • Potter •
Stylist and designer • Ceramicist.

🎟 Events
Markets: Wednesday mornings,
Place Darralde; summer market,
Sunday mornings, at the town hall
(June–September).
January: Large agricultural and second-
hand equipment fair; book fair.
Easter weekend: Craft fair.
June: "Feu de la Saint-Jean," Saint John's
(Midsummer's) Eve bonfire.
July–August: "Festival des Pierres
Lyriques," tapas evening, and "Alto"
concerts in Béarn; concerts.
August: Patron saint's feast (beginning
of August); medieval fête (end of August).
December: Christmas markets and
activities (first three Sundays).

🦋 Outdoor Activities
Walking: several marked trails •
Mountain-biking: Navarrenx mountain-
biking base—140 miles (225 km) of
marked trails • Salmon and trout fishing
(1st category) • Rafting, mini-rafts,
canoeing, stand-up paddle-boarding •
Le Domaine Nitot leisure complex •
Golf: 18-hole course • "Piste du Brané":
national motocross track.

🦋 Further Afield
• Gurs former internment camp (3½ miles/
5.5 km).
• Laàs castle and gardens (6 miles/9.5 km).
• Église de l'Hôpital-Saint-Blaise, UNESCO
World Heritage Site (9½ miles/15.5 km).
• Église Saint-Girons-de-Monein (11 miles/
18 km).
• Sauveterre-de-Béarn, medieval town
(12 miles/19 km).
• Orthez, former medieval capital
(14 miles/23 km).
• Salies-de-Béarn, salt city (19 miles/
31 km).

Olargues
The natural charm of the Languedoc

Hérault (34) • Population: 600 • Altitude: 600 ft. (183 m)

Situated in a bend in the Jaur river, Olargues provides walks flavored with history at the heart of the Haut-Languedoc regional nature park. At the foot of Mont Caroux, the "mountain of light," Olargues combines the coolness of Massif Central rivers with the sunshine of the South, and its landscapes of chestnut and cherry trees with vineyards and olive groves. Although this exceptional site has been occupied since prehistoric times, it was in the 12th century that lords in the region built a castle and fortified village here. From the old bridge over the Jaur, *calades* (decorative cobblestones) invite visitors to discover stone houses, now covered with barrel tiles rather than the traditional *lauzes* (schist rooftiles); the remains of the ramparts; the covered stairway of the commandery, and the Église Saint-Laurent, built in the 17th century with stones from the original Romanesque church, whose bell tower was formerly a castle keep.

By road: Expressway A75, exit 57–Clermont-l'Hérault (34 miles/55 km); expressway A9, exit 36–Valras Plage (42 miles/68 km). **By train:** Bédarieux station (14 miles/23 km); Béziers station (40 miles/64 km). **By air:** Béziers-Cap-d'Agdes-en-Languedoc airport (40 miles/64 km); Montpellier-Méditerranée airport (73 miles/117 km); Toulouse-Blagnac airport (93 miles/150 km).

ⓘ Tourist information—Minervois au Caroux: +33 (0)4 67 23 02 21
www.minervois-caroux.com

👁 Highlights
• **Centre Cebenna:** An ecosystems study and research center. Multimedia library, 3D projection, giant kaleidoscope; exhibitions, activities, and nature tours: +33 (0)4 67 97 88 00.
• **Musée des Arts et Traditions Populaires** (May–September): Museum of village history, old tools, the geology of the region, famous people, models of life in the past, life-size reproduction of a forge, medieval hall: +33 (0)4 67 23 02 21.
• **Forge:** restored tool-making forge. Tours by appointment: +33 (0)4 67 23 02 21
• **Village:** Self-guided visit and guided tours every Monday at 6 p.m. in July and August; by appointment only off-season for 10+ people: +33 (0)4 67 23 02 21.

🔑 Accommodation
Hotels
Laissac-Speiser: +33 (0)4 67 97 70 89.
Guesthouses
Les Quatr' Farceurs 🛏🍽: +33 (0)4 67 97 81 33.
Fleurs d'Olargues: +33 (0)4 67 97 27 04 or +33 (0)6 80 51 96 55.

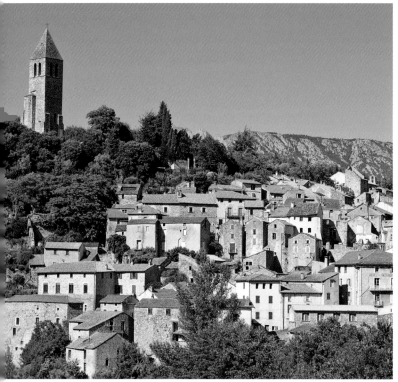

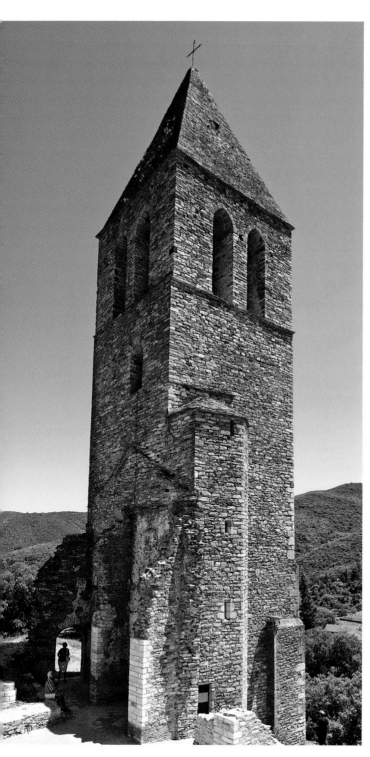

Gîtes, walkers' lodges, and vacation rentals
Further information: +33 (0)4 67 23 02 21
www.minervois-caroux.com
RV parks
Further information: +33 (0)4 67 23 02 21.

🍴 Eating Out
Brasserie L' École: +33 (0)6 30 42 76 13.
Fleurs d'Olargues: +33 (0)4 67 97 27 04.
Le Funambule: +33 (0)4 67 97 72 06.
Laissac-Speiser: +33 (0)4 67 97 70 89.
La Lampisterie, pizzeria:
+33 (0)6 23 87 32 51.

🧺 Local Specialties
Food and Drink
Olargues chestnut-based specialties •
Wild plants and fruits.
Art and Crafts
Artists • Luthiers • Artisan potter •
Ceramicist • Artists' collective.

📅 Events
Market: Sunday mornings, Place
de la Mairie.
May: Fête de la Brouette, wheelbarrow
festival (mid-May).
August: "Festibaloche," contemporary
music festival; "Estival de la Bio," organic
produce festival; "Autour du Quatuor,"
classical music festival, organ concert.
September: Fête Médiévale d'Olargues,
medieval fête (3rd weekend in September).
November: Fête du Marron et du Vin
Nouveau, chestnuts and wine (1st weekend
after All Saints).
December: Christmas market.

🦋 Outdoor Activities
Swimming • *Boules* area • Canoeing,
canyoning, caving • Rock climbing •
Walking • Mountain-biking and hybrid
biking • "Passa Païs": Haut Languedoc
greenway for walkers and cyclists from
Mazamet to Bédarieux (47 miles/76 km).

🌿 Further Afield
• Saint-Julien priory (2 miles/3 km).
• Le Caroux, massif; Gorges of the Héric
(3½ miles/5.5 km).
• Gorges of the Orb; Vieussan (5 miles/
8 km).
• Monts de l'Espinouse (7½ miles/12 km).
• Saint-Pons-de-Thomières (11 miles/18 km).
• Roquebrun (12 miles/19 km).

Peyre

A vertiginous viaduct

Aveyron (12) • Population: 251 • Altitude: 1,214 ft. (370 m)

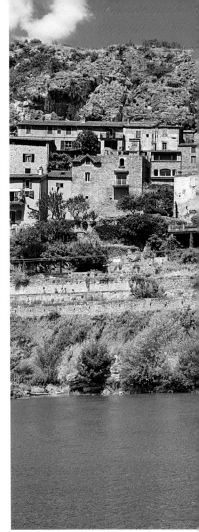

Clinging to a sheer cliff where the original church was built, Peyre overlooks the Tarn downstream of Millau.

Beneath the plateau of the Causse Rouge, dotted with *caselles* (drystone shelters) whose *lauze* (schist-tiled) roofs protected shepherds and winegrowers, the lower village, crisscrossed with narrow, cobbled, stepped streets, descends steeply toward the river. The top of Peyre stretches out at the foot of a high tufa cliff, whose corbeled overhang towers above the village. Like the houses that surround it, the Église Saint-Christophe backs onto this cliff face. Fortified in the 17th century to serve as a refuge for residents of the parish, it has retained brattices and murder holes that bear witness to its defensive history. Recently restored as a venue for concerts and exhibitions, the church, which is bathed in changing light diffused by its glass and crystal stained-glass windows, now faces another symbol of modernity: the P2 pier, which, soaring upward from the Tarn, makes the Millau Viaduct the tallest bridge in the world.

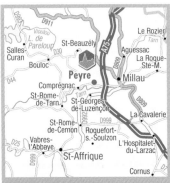

By road: Expressway A75, exit 45–Millau (7½ miles/12 km). **By train:** Millau station (5 miles/8 km). **By air:** Rodez-Marcillac airport (62 miles/100 km); Montpellier-Méditerranée airport (84 miles/135 km).

ⓘ Tourist information—Millau:
+33 (0)5 65 60 02 42
www.millau-viaduc-tourisme.fr
www.compregnac12.fr

👁 Highlights
• **Église Saint-Christophe:** Partially dug into the rock face, this church holds contemporary art exhibitions from June to September.
• **Village:** Guided tour from July 1 to National Heritage Days in September, by appointment only: +33 (0)5 65 60 02 42.
• **Colombier du Capelier,** Comprégnac (14th century): Self-guided visit.
• **Maison de la Truffe,** Comprégnac: Presentation of truffle cultivation, and typical architecture from the Causses.

🗝 Accommodation
Guesthouses
La Callade du Tarn ▮▮▮: +33 (0)5 65 58 15 52 or +33 (0)6 84 90 32 07.
La Terrasse de Pérouges: +33 (0)6 21 79 61 82.
Gîtes
Further information: +33 (0)5 65 60 02 42
www.millau-viaduc-tourisme.fr
Campsites
Le Katalpa, Comprégnac: +33 (0)5 65 62 30 05.

🍴 Eating Out
L'Estival, July and August: +33 (0)5 65 62 39 37.

🧺 Local Specialties
Food and Drink
Truffles and truffle-based produce.
Art and Crafts
Gifts, tableware • Potter • Atelier Terralhas, Comprégnac.

🗓 Events
June: Choeurs de Peyre, choirs and concerts.
July: Fête de la Saint-Christophe, festival (last weekend).
Mid-July–mid-August: Festival de la Vallée et des Gorges du Tarn.
Late July–early August: Fête du Pain au Four Communal, bread festival.

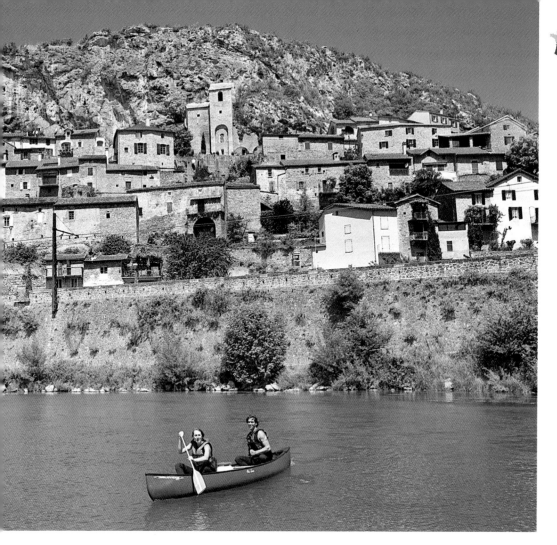

December: Truffle festival at Comprégnac and local produce market (weekend before Christmas).

🦋 Outdoor Activities

Aire de Loisirs des Pyramides, on the banks of the Tarn: children's games, picnic area • Walking: *caselles* (drystone shelters) discovery trails, circular walks of 3 miles (5 km, 1½ hrs) or 4½ miles (7 km, 3 hrs) leaving from Peyre or Comprégnac, and (short) "Randocroquis" drawing trails around the village.

🌿 Further Afield

• Millau (5 miles/8 km).
• Millau Viaduct discovery area (9½ miles/15.5 km).
• Castelnau-Pégayrolles (12 miles/19 km).
• Gorges of the Dourbie (13–24 miles/ 21–39 km).
• Saint-Léon: Micropolis, insect museum and birthplace of the entomologist Henri Fabre (16 miles/26 km).
• Chaos de Montpellier-le-Vieux (17 miles/ 27 km).
• Larzac Templars and Hospitallers sites (17–32 miles/27–51 km).
• Gorges of the Jonte (17–30 miles/ 27–48 km).

• Gorges of the Tarn (17–39 miles/ 27–63 km).
• *La Couvertoirade (30 miles/48 km), see p. 186.

see p. 186.

ℹ️ Did you know?

Periodically, following prolonged heavy rain, rumblings that warn of an inflow of underground water wake up some locals, and water pours down the rock overhanging the village. The water forms an impressive cascade, hurtling down the slope toward the Tarn. This phenomenon, which can last for several days, attracts a lot of local attention.

Pujols-le-Haut
A former stronghold in the Albi region

Lot-et-Garonne (47) • Population: 3,844 (Pujols commune) • Altitude: 614 ft. (187 m)

A fiefdom of the heretics, Pujols was destroyed during the Albigensian Crusade then rebuilt; it has preserved its medieval character. The former stronghold of the barony of Pujols has lived through many troubled times in the course of its history, from the Hundred Years War to the French Revolution, yet most of its 13th-century architectural heritage has been preserved. In addition to part of the outer wall and the castle, there remain two fortified gates, one of which serves as the bell tower to the old seigniorial chapel of Saint-Nicolas. The Église Sainte-Foy has retained its 16th-century frescoes. On the square, the covered market, built in 1850 with materials recovered from the Église Saint-Jean-des-Rouets, faces some fine late 13th-century half-timbered houses. The stone walls of the ground floor are topped with black oak beams interspersed with flat bricks.

By road: Expressway A62, exit 6–Aiguillon (25 miles/40 km)/exit 7–Agen (21 miles/34 km), N21 (15 miles/24 km). **By train:** Agen station (18 miles/29 km). **By air:** Agen-Lagarenne airport (22 miles/35 km); Bordeaux-Mérignac airport (93 miles/150 km).

ⓘ Tourist information—Villeneuvois:
+33 (0)5 53 36 78 69
www.tourisme-villeneuvois.fr
www.pujols47.fr

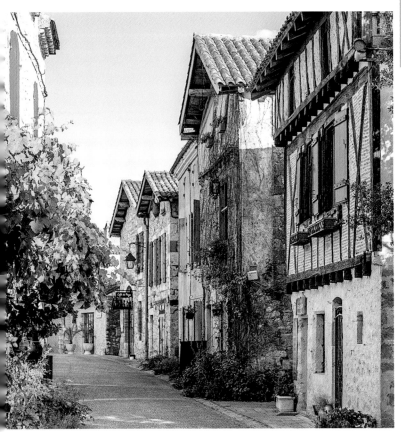

👁 Highlights
• **Collégiale Saint-Nicolas** (16th century): Old castle chapel, collegial church since 1547; fine Flamboyant Gothic architecture.
• **Église Sainte-Foy** (15th century): 16th-century frescoes.
• **Village:** Guided tours for individuals by appointment: +33 (0)5 53 36 78 69; guided tours for groups by arrangement, and workshops for young people: +33(0)9 64 41 87 73.

🔑 Accommodation
Hotels
Campanile**: +33 (0)5 53 40 27 47.
Bel Air: +33 (0)5 53 36 89 43.
Guesthouses
Pech des Renards: +33 (0)5 53 36 04 93.
Gîtes and vacation rentals
Gîte des Copains et du Pigeonnier***: +33 (0)5 53 01 22 93.
Gîte Plaine de Fourtou***: +33 (0)6 08 24 72 42.
Le Gîte Salabert***: +33 (0)5 53 66 11 82.
Les Chênes ♦♦♦: +33 (0)5 53 47 80 87.
La Petite Maison ⚭: +33 (0)5 53 70 78 14.
Les Moulinières: +33 (0)5 53 71 11 14.
La Parenthèse: +33 (0)6 81 72 80 94.
Further information: +33 (0)5 53 36 78 69
www.tourisme-villeneuvois.fr

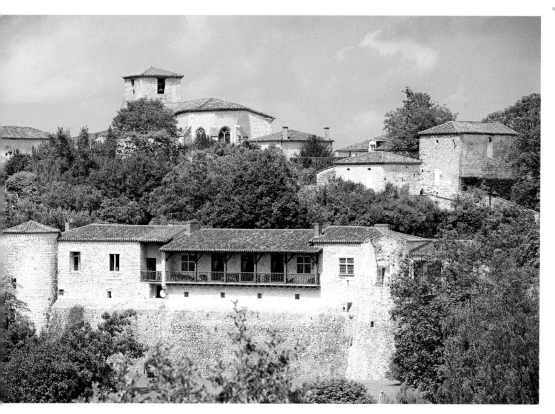

Campsites
Camping Lot & Bastides***:
+33 (0)5 53 36 86 79.

🍽 Eating Out
Aux Délices du Puits, pizzeria:
+33 (0)5 53 71 61 66.
Campanile: +33 (0)5 53 40 27 47.
Le Fournil de Pujols: +33 (0)5 53 70 15 55.
Le Pianothé, crêperie: +33 (0)5 53 71 90 91.
La Toque Blanche: +33 (0)5 53 49 00 30.
Villa Smeralda: +33 (0)5 53 36 72 12.

🧺 Local Specialties
Food and Drink
Walnut, hazelnut, and prune-kernel oils •
Walnuts, chocolate-covered walnuts •
Macarons and shortbread cookies • Prunes.
Art and Crafts
Artists • Potters • Toys • Artists' association.

🎟 Events
Market: Sunday mornings, Place Saint-
Nicolas (all year round).
April–October: Painting and sculpture
exhibitions at the Église Sainte-Foy and
at the Salle Culturelle.

May: "Mai de la Photo" photo exhibition.
July and August: Gourmet market
(Wednesday evenings); "Couleurs du
Monde" festival (1st week of August).
August: Book sale (1st Sunday); potters'
market (3rd Sunday).
September: Fête des Associations,
societies' fair (2nd Saturday).
December: Christmas market and activities.

🦋 Outdoor Activities
Hunting • Horse-riding • Fishing • Walking
and mountain-biking: Route GR 652 and
3 marked trails.

🦋 Further Afield
• Villeneuve-sur-Lot (2 miles/3 km).
• Grottes de Lastournelle, caves
(3 miles/5 km).
• Penne-d'Agenais (9½ miles/15.5 km).
• Le Temple-sur-Lot (11 miles/18 km).
• *Monflanquin (14 miles/23 km),
see pp. 211–12.
• Agen (18 miles/29 km).
• Bonaguil: castle (22 miles/35 km).
• *Monpazier (29 miles/47 km),
see pp. 213–14.

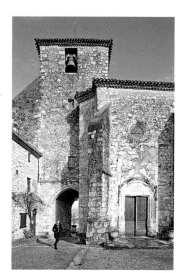

Puycelsi

Forest fortress

Tarn (81) • Population: 484 • Altitude: 981 ft. (299 m)

At the edge of the Grésigne forest, Puycelsi watches over the Vère valley.

Occupied since prehistoric times, then besieged by the Celts and later by the Romans, Puycelsi passed, in the late 12th century, into the ownership of the counts of Toulouse, who made it one of their favorite fortified residences. Because of its strategic position and its walls, the village was able to resist many sieges: those of Simon de Montfort from 1211 to 1213 during the Albigensian Crusade; the Shepherds' Crusade in 1320; Duras's English troops in 1386; and the Huguenots during the Wars of Religion. Confined within its medieval walls, of which there remain more than 875 yards (800 meters) of ramparts and the Irissou double gate, Puycelsi offers splendid views over the Grésigne forest, the Vère valley, and the Causses du Quercy from its wall walks. At the heart of the village, the Église Saint-Corneille, with its listed altarpiece, is bordered by a medicinal-herb garden and surrounded by mostly 14th- and 15th-century houses, which combine stone with wood and brick beneath fine hollow-tile roofs. On the horizon, the Grésigne forest can be seen, on the outskirts of which the village's master glassworkers located their workshops, in order to be close to a wood source.

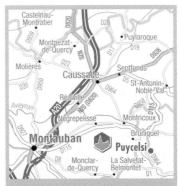

By road: Expressway A20, exit 59–Saint-Antonin-Noble-Val (20 miles/32 km); expressway A68, exit 9–Gaillac (17 miles/27 km). **By train:** Gaillac (15 miles/24 km) station; Caussade (19 miles/31 km) station; Montauban-Ville Bourbon station (27 miles/ 43 km). **By air:** Toulouse-Blagnac airport (59 miles/95 km).

ⓘ Tourist information—
Bastides and Vignoble du Gaillac:
+33 (0)8 05 40 08 28
www.tourisme-vignoble-bastides.com
www.puycelsi.fr

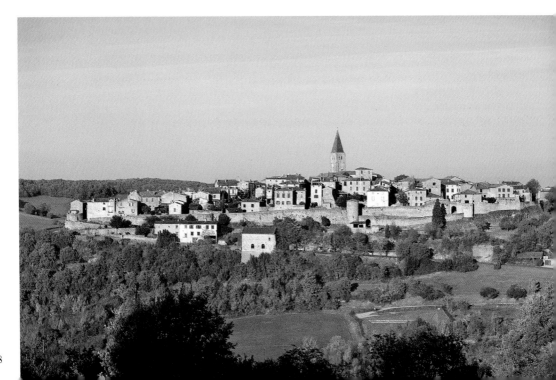

👁 Highlights
• **Église Saint-Corneille** (15th and 17th centuries): Statuary, altarpiece, 18th-century bell tower.
• **Institut International du Darwinisme:** Further information: +33 (0)5 63 33 86 59.
• **Heritage walk:** Free entry.
• **Research and conservation orchard:** For old species of fruit trees (cherry, peach, pear, apple) and vines; option of guided tours: +33 (0)5 63 33 19 41.
• **Village:** Guided tour, booking essential; map of the historic village available from tourist information center.

🗝 Accommodation
Hotels
L'Ancienne Auberge***:
+33 (0)5 63 33 65 90.
Guesthouses
La Bâtisse Belhomme:
+33 (0)9 53 17 53 51.
Chez Delphine: +33 (0)5 63 33 13 65.
Chez Julia: +33 (0)6 74 80 72 72.
La Maison de Martine:
+33 (0)6 28 63 34 05.
Les Planètes: +33 (0)6 08 50 89 16.
La Première Vigne: +33 (0)9 75 30 06 13.
Gîtes, vacation rentals, and campsites
Further information: +33 (0)8 05 40 08 28
www.tourisme-vignoble-bastides.com

🍽 Eating Out
Au Cabanon de Puycelsi, local bistro:
+33 (0)5 63 33 11 33.
Le Jardin des Lys, local bistro:
+33 (0)5 63 33 15 69.
Le Puycelsi Roc Café, snack bar:
+33 (0)5 63 33 13 67.

🧺 Local Specialties
Food and Drink
Cookies and crackers • Fruits, fruit purées, juices, and sorbets • Honey • AOC Gaillac wines.
Art and Crafts
Artists and craftsmen (Artistes Créateurs à Puycelsi) • Ceramicist • Painter-sculptor • Potters • Painting and model-making workshop.

📅 Events
July: "Le Festival de Puycelsi Grésigne," choral festival (2nd fortnight).
August: "Fêtes de Puycelsi," village festival (end of August).

🐾 Outdoor Activities
Walking: Route GR 46, heritage walks, Grésigne forest.

🌾 Further Afield
• *Bruniquel (8 miles/13 km), see p. 173.
• *Castelnau-de-Montmiral (8 miles/ 13 km), see p. 179.
• Gorges of the Aveyron: from Bruniquel to Saint-Antonin-Noble-Val (9½–22 miles/ 15.5–35 km).
• Gaillac (13 miles/21 km).
• Caussade (16 miles/26 km).
• Montauban (24 miles/39 km).
• *Monestiés (27 miles/43 km), see p. 210.
• Albi (28 miles/45 km).

ℹ Did you know?
In 1386, having been unable to take the fortress, English troops decided to reduce the villagers' resistance by besieging them. With no supplies left, the villagers walked their last squealing pig several times around the ramparts in order to make the enemy believe they still had resources despite the siege. The English eventually left. It is for this reason that a little pig can be seen carved into the stone on the church door.

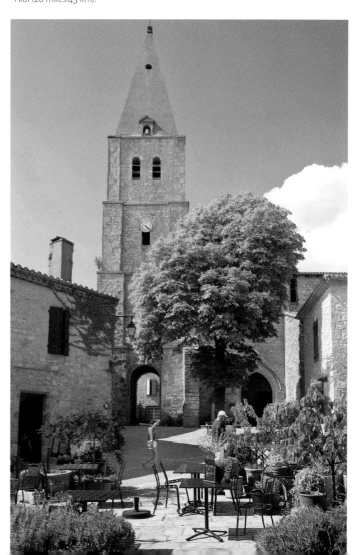

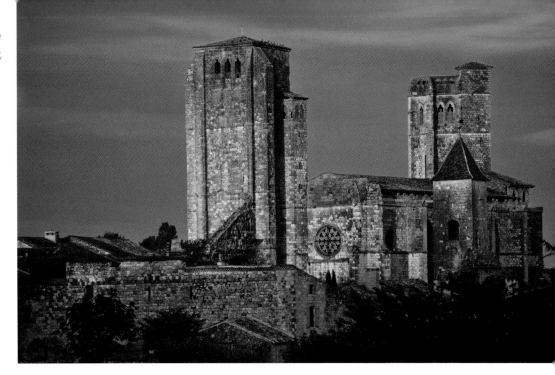

La Romieu
At the crossing of the ways

Gers (32) • Population: 573 • Altitude: 614 ft. (187 m)

Amid the simplicity and charm of the Gascon countryside, La Romieu and its collegiate church are a stopping place at the intersection of paths leading from Puy and Rocamadour to Santiago de Compostela. Taking its name from the Gascon word *roumiou*, meaning "pilgrimage," the village was founded at the end of the 11th century by Albert, a German monk returning from a pilgrimage to Rome. The area gained greater importance in the 15th century when the powerful Cardinal Arnaud d'Aux, cousin of Pope Clement V and a native of the village, established the collegiate church of Saint-Pierre here. This building, which has been on the UNESCO World Heritage list since 1998, survived the agonies of the Wars of Religion and the French Revolution, and today provides visitors with a remarkable example of Southern Gothic architecture. The solemn beauty of its cloisters, its high, octagonal bell tower, and the recently restored frescoes in the sacristy are among the building's riches. At its feet, the village blends in seamlessly. While the ancient *sauveté*—a refuge for pilgrims—retains only some of its fortifications, the arcaded square and the houses with their bright stone façades typical of the region create a unified and graceful ensemble around the religious site. Like everywhere in the Gers, La Romieu is a destination prized for its local specialties—in particular its fruit, vegetables, and poultry—carefully produced by outlying farms.

By road: Expressway A62, exit 7–Agen (17 miles/27 km).
By train: Agen station (21 miles/33 km); Auch station miles (48 km).
By air: Agen-La Garenne airport (19 miles/30 km); Toulouse-Blagnac airport (68 miles/110 km).

ⓘ Tourist information—Gascogne-Lomagne: +33 (0)5 62 64 00 00
Town hall: +33 (0)5 62 28 15 72
www.gascogne-lomagne.com
www.la-romieu.fr

👁 Highlights

• **Collégiale Saint-Pierre** (14th century): Church, cloisters, octagonal tower, sacristy with polychrome frescoes, bell, Cardinal's Palace (ruins). Self-guided and guided tours throughout the year; combined ticket with Les Jardins de Coursiana: +33 (0)5 62 28 86 33.

• **Les Jardins de Coursiana:** 15-acre (6-hectare) vegetable garden, English landscape garden, medicinal plant garden, aromatic and scented garden, arboretum, kitchen garden, and orchard (April–October): +33 (0)5 62 68 22 80 or +33 (0)6 61 95 01 89.

🗝 Accommodation

Guesthouses
♥ La Maison d'Aux ✨✨✨: +33 (0)5 62 28 14 89 or +33 (0)6 82 76 66 59.
Au Bon Repos: +33 (0)5 62 28 10 13.
Clairière des Sept Hountas: +33 (0)5 62 28 81 37 or +33 (0)6 88 73 95 02.
L'Étape d'Angeline: +33 (0)5 62 28 10 29 or +33 (0)6 69 63 88 99.
Maison d'Artiste: +33 (0)5 62 28 23 22 or +33 (0)6 73 16 63 61.
Le Perrouet: +33 (0)5 81 68 13 11.
Gîtes and vacation rentals
L'Étable 🛏🛏🛏🛏: +33 (0)5 62 28 10 93.
Boulevard Quintilla 3 🛏🛏🛏: +33 (0)5 62 61 79 00.
Beausoleil 🛏🛏: +33 (0)5 62 68 48 22 or +33 (0)6 71 58 50 21.
Gratuzous 🛏🛏: +33 (0)5 62 28 03 17.
Lepine 🛏🛏: +33 (0)6 80 17 85 42.
Pellecahus ✨✨✨: +33 (0)5 62 28 03 89 or +33 (0)6 76 29 73 73.

Walkers' lodges and campsites
Le Camp de Florence****, campsite: +33 (0)5 62 28 15 58.
Le Couvent de La Romieu: +33 (0)5 62 28 73 59.
Le Refuge du Pèlerin: +33 (0)6 80 05 09 31.
RV park
School car park: +33 (0)5 62 64 00 00.

🍴 Eating Out

Le Cardinal: +33 (0)5 62 68 42 75.
L'Étape d'Angéline: +33 (0)5 62 28 10 29.
Restaurant du Camping: +33 (0)5 62 28 15 58.

🏛 Local Specialties

Food and Drink
Honey • Prunes • Apples • Strawberries • Melons • Garlic • Asparagus • Côtes de Gascogne wines.
Art and Crafts
Art galleries and artists' studios.

2 Events

May: Rose market.
June: "L'Art au mieux" art festival.
July: "Musique en Chemin" music festival.
August: Medieval festival.
September: Marché de Potiers, potters' market.

🦋 Outdoor Activities

Walking: Route GR 65 Chemin du Puy and GR 652 Voie de Rocamadour • Mountain-biking (marked trails) • Caving (karst trail).

🌾 Further Afield

• Condom: cathedral (7 miles/11 km).
• Lectoure: cathedral (9 miles/15 km).
• *Larressingle (11 miles/17 km), see p. 199.
• Cassaigne: castle (12 miles/20 km).
• Valence-sur-Baïse: Flaran Cistercian abbey (12 miles/20 km).
• *Fourcès (16 miles/25 km), see p. 196.
• *Montréal(16 miles/26 km), see p. 215.
• Séviac: Gallo-Roman villa (17 miles/28 km).
• Agen: fine art museum (19 miles/31 km).
• *Lavardens: castle (19 miles/31 km), see pp. 204–5.
• Auch: cathedral (31 miles/50 km).

ℹ Did you know?

In the Middle Ages, during a terrible famine, the inhabitants of La Romieu had to eat their own cats in order to survive. But the village was rapidly invaded by rats, which destroyed the harvests. A local girl who had hidden her two felines managed to get rid of these rodents thanks to her cats' numerous descendants. To keep this legend alive, about twenty cat sculptures decorate façades on Place Bouet and Rue Surmain. To this day La Romieu is known as the "village of cats."

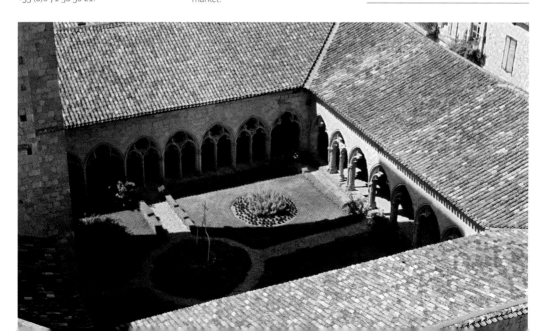

La Roque-Gageac
Sheltered by a cliff

Dordogne (24) • Population: 430 • Altitude: 430 ft. (131 m)

Protected from the coldest weather by the cliff behind, La Roque-Gageac's golden buildings catch the sun's rays and are reflected in the Dordogne river.

An important stronghold in the Middle Ages, the village gained its fine mansions, including that of humanist Jean Tarde (1561–1636), during the Renaissance. In the 19th century, it saw heavy traffic of *gabares* (flat-bottomed boats) on the Dordogne river that transported wines from Domme to Bordeaux. Sheltered by the south-facing cliffs, and overlooked by the 16th-century church, Mediterranean and tropical plants flourish along the village's streets and in its gardens. The yellow-stone façades and pitched roofs covered with brown tiles contrast with their green setting. The beauty and character of the houses of La Roque-Gageac can also be admired from a boat on the Dordogne.

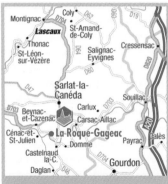

By road: Expressway A20, exit 55–Sarlat (22 miles/35 km). **By train:** Sarlat-la-Canéda station (8 miles/13 km). **By air:** Brive-Vallée de la Dordogne airport (32 miles/51 km); Bergerac-Roumanière airport (42 miles/68 km).

(i) Tourist information—
Sarlat-Périgord Noir:
+33 (0)5 53 31 45 45
www.sarlat-tourisme.com

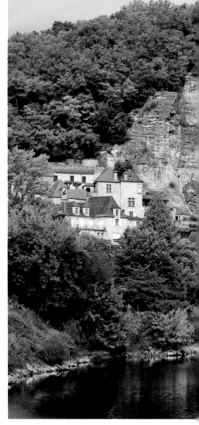

👁 Highlights
• **Jardin Exotique:** Mediterranean and tropical plants. Free self-guided visit: +33 (0)5 53 29 40 29.
• **Bambouseraie:** Self-guided tour to discover different varieties of bamboo. Open 10 a.m.–7 p.m.: +33 (0)7 81 69 00 56.
• **Jardin de la Ferme Fleurie:** Terraced gardens (romantic garden, grandmother's garden, wild garden, medicinal-herb garden): +33 (0)5 53 28 33 39.
• **Village:** Guided tour June–September. Further information: +33 (0)5 53 31 45 45.

🛏 Accommodation
Hotels
La Belle Étoile***: +33 (0)5 53 29 51 44.
Auberge des Platanes**: +33 (0)5 53 29 51 58.
Le Périgord**: +33 (0)5 53 28 36 55.
Guesthouses
Mme Alla: +33 (0)5 53 28 33 01.
Le Clos Gaillardou: +33 (0)5 53 59 53 97.
La Ferme Fleurie: +33 (0)5 53 28 33 39.
Les Hauts de Gageac: +33 (0)5 47 27 51 30.
La Maison d'Anne Fouquet: +33 (0)6 37 76 83 81.
Le Pigeonnier de Labrot: +33 (0)5 53 28 37 00.
Gîtes, walkers' lodges, and vacation rentals
Further information: +33 (0)5 53 31 45 45
www.sarlat-tourisme.com

Campsites
Beau Rivage***: +33 (0)5 53 28 32 05.
La Butte**: +33 (0)5 53 28 30 28.
Verte Rive*: +33 (0)5 53 28 30 04.

🍴 Eating Out
L'Ancre d'Or: +33 (0)5 53 31 27 66.
Auberge des Platanes: +33 (0)5 53 29 51 58.
La Belle Étoile: +33 (0)5 53 29 51 44.
"Chez Tom," pizzeria: +33 (0)5 53 29 71 97.
Le Colombier, farmhouse inn: +33 (0)5 53 28 33 97.
La Ferme Fleurie, farmhouse inn: +33 (0)5 53 28 33 39.
Ò Plaisir des Sens: +33 (0)5 53 29 58 53.
Le Palmier: +33 (0)5 53 29 42 61.
Le Patio: +33 (0)5 53 30 22 13.
Le Périgord: +33 (0)5 53 28 36 55.
Les Prés Gaillardou: +33 (0)5 53 59 67 89.
Les Terrasses de La Roque: +33 (0)5 53 28 71 92.

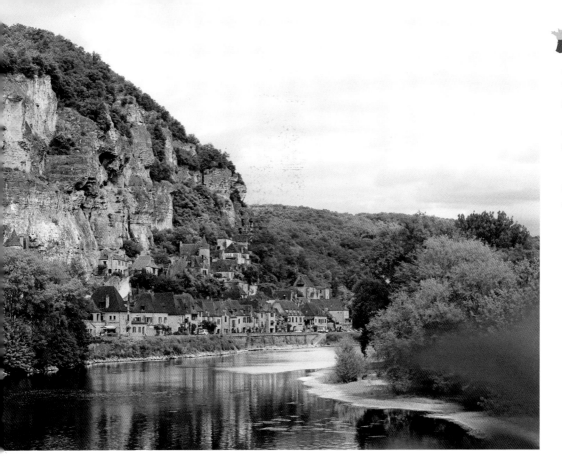

🧺 Local Specialties

Food and Drink
Foie gras • Périgord specialties.
Art and Crafts
Watercolorist • Painter-decorator.

🗓 Events

Market: Friday mornings (May–September).
August: Village fête; gourmet food market.

🦋 Outdoor Activities

Swimming (no lifeguard) in the Dordogne •
Gabare (traditional flat-bottomed boat) •
Canoeing • Fishing • *Boules* area • Périgord
hot-air balloons • Walking • Mountain-
biking • Cycling.

🍃 Further Afield

• Dordogne valley: *Castelnaud-la-Chapelle
(2 miles/3 km), see p. 180; *Beynac-et-
Cazenac (3 miles/5 km), see pp. 166–67;
*Domme (3½ miles/5.5 km), see pp. 188–89;
*Belvès (14 miles/23 km), see pp. 164–65;
*Limeuil (21 miles/34 km), see pp. 206–7.
• Marqueyssac: park and gardens
(2½ miles/4 km).
• Sarlat (8 miles/13 km).
• Vézère valley: Les Eyzies (16 miles/26 km);
*Saint-Amand-de-Coly (21 miles/ 34 km),
see pp. 234–35; *Saint-Léon-sur-Vézère
(22 miles/35 km), see p. 246.
• *Monpazier (24 miles/39 km),
see pp. 213–14.

❗ Did you know?

The village, which faces south, enjoys an
amazing microclimate, and one resident
of the village, M. Dorin, founded a
Mediterranean and tropical garden here.
Palms, banana trees, date palms, albizias,
yuccas, bamboos, and oleanders flourish
beneath the Périgord sun.

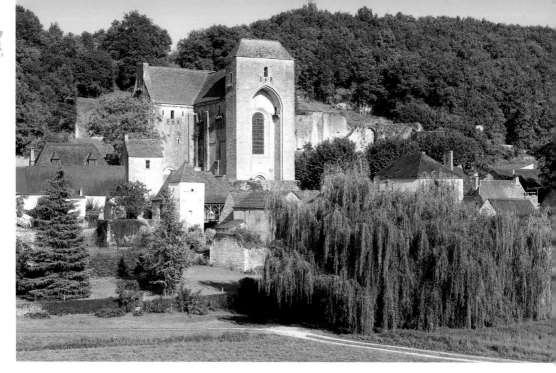

Saint-Amand-de-Coly

An abbey in Périgord

Dordogne (24) • Population: 405 • Altitude: 568 ft. (173 m)

Nestled at the intersection of three wooded valleys, the abbey at Saint-Amand-de-Coly watches over houses that are typical of the Périgord Noir region. The village owes both its name and its religious heritage to the monk Amand, who came to evangelize the Coly valley in the 6th century. The abbey was founded in the 12th century and ensured Saint-Amand's prosperity for two centuries. Before the Hundred Years War and the development of defense systems, the abbey church was considered the most beautiful fortified church in Périgord. The splendid 100-ft. (30-m) tall bell-tower porch, its huge Gothic arch, and its triple-arched door have a simple strength about them that is sustained inside the building. Indeed, the nave is a fine expression of the subtle balance between the sobriety of Romanesque architecture and the soaring verticality of the Gothic period. Around the church, which continues to make the village famous and which is the venue for excellent classical concerts throughout the year, are houses built in a typically Périgord style. In a harmonious contrast of ocher and gray tones, Sarlat stones and *lauze* (schist tile) roofs dress both grand and humble elements of the village's heritage: the abbey, houses, dovecotes, and old tobacco-drying barns.

By road: Expressway A89, exit 17 (10 miles/16 km). By train: Condat-le-Lardin station (6 miles/9.5 km); Sarlat-la-Canéda station (15 miles/24 km); Brive-la-Gaillarde station (22 miles/35 km). By air: Brive-Vallée de la Dordogne airport (34 miles/55 km).

ⓘ Tourist information—Lascaux-Dordogne Vallée Vézère:
+33 (0)5 53 51 04 56
www.lascaux-dordogne.com
www.saint-amand-de-coly.org
Maison du Patrimoine (July and August):
+33 (0)9 64 01 46 39

👁 Highlights
• Guided tour of the abbey-church (12th century): In July and August: +33 (0)9 64 01 46 39; off-season by appointment only: +33 (0)5 53 51 47 85.
• Maison du Patrimoine: +33 (0)9 64 01 46 39.
• La Ferme du Peuch: Walnut groves, harvesting, drying, and cracking of walnuts; tour of the oil press: +33 (0)5 53 51 27 87.
• Signposted walk: Historical trail and recreational nature trail.

⚷ Accommodation
Hotels
Hôtel de l'Abbaye**: +33 (0)5 53 51 68 50.
Guesthouses
La Ferme de Larnaudie ♂♂♂:
+33 (0)5 53 51 68 76.
Au Logis de la Vignolle:
+33 (0)5 53 51 60 48 or +33 (0)6 84 57 11 08.
La Ferme du Peuch, rooms and evening meal: +33 (0)5 53 51 27 87.
Gîtes
Further information: +33 (0)9 64 01 46 39 or +33 (0)5 53 51 47 85
www.lascaux-dordogne.com

Campsites
Lascaux Vacances**: +33 (0)5 53 50 81 57.
Hamelin Périgord Vacances:
+33 (0)5 53 51 60 64.

🍴 Eating Out
Restaurant de l'Abbaye: +33 (0)5 53 51 68 50.

🎁 Local Specialties
Food and Drink
Walnut, walnut oil, Périgord *choconoiseries* (chocolate-covered walnuts), walnut preserves.
Art and Crafts
Copperwork.

📅 Events
July: "Saint-Amand Fait Son Intéressant," concerts and shows in the street (around the 14th); "Les Fabulesques," theatre festival (end of July).
July and August: Périgord Noir classical music festival (late July–early August); local farmers' market (Tuesday, 6 p.m.–10 p.m.).
August: Village festival (Saint-Hubert Mass, drawing competition) (15th).
October: Marché aux Saveurs de l'Automne, fall produce market (last weekend).
All year round: Concerts, lectures.

🦋 Outdoor Activities
Walking, horse-riding, and mountain-biking (70 marked trails): Périgord Noir mountain-biking center.

🌱 Further Afield
• Montignac (5½ miles/9 km).
• Prehistoric sites at Lascaux (7½ miles/12 km) and Eyzies (19 miles/31 km).
• *Saint-Léon-sur-Vézère (12 miles/19 km), see p. 244.
• Sarlat (14 miles/23 km).
• Dordogne valley: *La Roque-Gageac (20 miles/32 km), see pp. 232–33; *Beynac-et-Cazenac (21 miles/34 km), see pp. 166–67; *Castelnaud-la-Chapelle (21 miles/34 km), see p. 180; *Domme (22 miles/35 km), see pp. 188–89; *Limeuil (29 miles/47 km), see pp. 206–7.

❗ Did you know?
Here's how people greet one another in Saint-Amand-de-Coly: "Adieu soit, brave monde (homme), si vous l'êtes, et à se revoir," or, in Occitan, "Adiussatz brave monde, si sou setz, e a nous tourna veire." ("Farewell good men/man, if such you be, and until we meet again.")

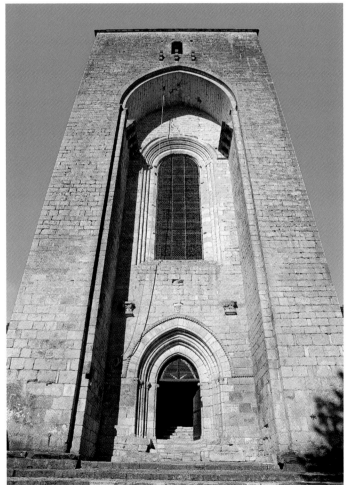

Saint-Bertrand-de-Comminges
Ancient guardian of the Pyrenees

Haute-Garonne (31) • Population: 259 • Altitude: 1,700 ft. (518 m)

Saint-Bertrand-de-Comminges owes its name to the bishop who built its cathedral. Located at the foot of the Pyrenees, the village still contains the ruins of a Roman forum, established in 72 BCE by Pompey on his return from Spain. Considered to be King Herod's place of exile, the town grew up around a basilica in the 4th century before it was destroyed by the Vandals and then the Burgundians. Bertrand, bishop of Comminges, rebuilt the village from its ruins and installed an episcopal court here. Military in appearance, the Cathédrale Sainte-Marie, which was remodeled in the 14th century by the future pope Clement V, retains its 12th-century bell tower, its cloisters giving onto the Pyrenees, and its portal representing the Adoration of the Magi, the Virgin and Child, and Saint Bertrand. A rood screen stands in front of the choir and its sixty-six carved oak stalls and 16th-century episcopal throne. Fine dwellings from the 16th–18th centuries huddle around the cathedral. Forming a girdle around the old town, the ramparts are punctuated by the Majou, Cabirole, and l'Hyrisson gateways.

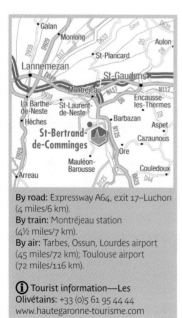

By road: Expressway A64, exit 17–Luchon (4 miles/6 km).
By train: Montréjeau station (4½ miles/7 km).
By air: Tarbes, Ossun, Lourdes airport (45 miles/72 km); Toulouse airport (72 miles/116 km).

ⓘ Tourist information—Les Olivétains: +33 (0)5 61 95 44 44
www.hautegaronne-tourisme.com

👁 Highlights
• **Cathédrale Sainte-Marie** (11th–14th centuries): Tympanum showing the Adoration of the Magi, the Virgin and Child, and Saint Bertrand; ensemble of 66 stalls carved from wood; 16th-century corner organ. Self-guided or guided tours, audioguides: +33 (0)5 61 89 04 91.
• **Early Christian basilica:** Ruins of a basilica (date unknown, but 4th-century coins were found inside date) whose foundations incorporate 28 sarcophagi in marble from the Pyrenees.
• **Chapelle Saint-Julien:** 19th-century reconstruction of an ancient chapel.
• **Les Olivétains Cultural and Tourist Center:** Archaeological museum, bookstore, contemporary art exhibitions: +33 (0)5 61 95 44 44.
• **Musée du Blason et des Ordres de Chevalerie** (heraldry museum): Renaissance mansion housing a collection of over 2,000 coats of arms, coins, illuminated manuscripts, and medieval weapons; retells legends concerning the orders of chivalry; by appointment: +33 (0)6 22 35 30 10.
• **Village:** Guided tour for groups, only by prior arrangement: +33 (0)5 61 95 44 44.

🗝 Accommodation
Hotels
L'Oppidum**: +33 (0)5 61 88 33 50.
Le Comminges*: +33 (0)5 61 88 31 43.
Guesthouses
La Randonnée de Saint-Jacques: +33 (0)6 76 15 32 13.
Gîtes, walkers' lodges, and vacation rentals
Further information: +33 (0)5 61 95 44 44.
Campsite
Es Pibous**: +33 (0)5 61 94 98 20.

🍽 Eating Out
Restaurants
Chez Betty: +33 (0)6 74 00 74 94.
Chez Simone: +33 (0)5 61 94 91 05.
La Table de Saint-Bertrand: +33 (0)5 61 88 36 60.

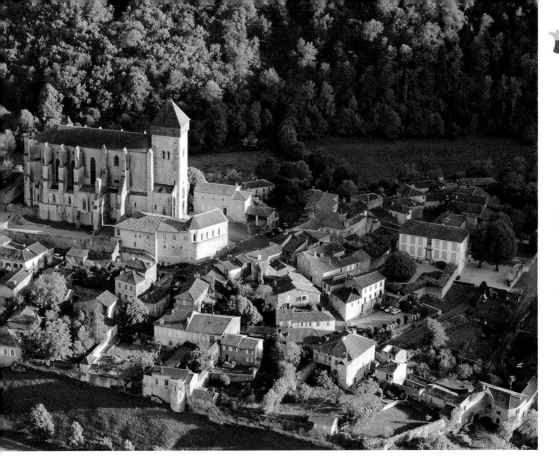

🏛 Local Specialties

Food and Drink

Cassoulet • Foie gras • *Porc noir de Bigorre* (rare-breed pork) • Croustade (flaky fruit pastry) • Tome des Pyrénées cheese

Art and Crafts

Jewelry, fossils, and minerals • Leatherwork, saddlery • Umbrella-maker • Blacksmith • Clogs.

🗓 Events

Market: Every Friday, Place du Plan (lower town).

July: "Les Médiévales," medieval festival.

July–September: "Festival du Comminge," classical music festival.

🦋 Outdoor Activities

Walks: GR 656 and 2 trails.

🕊 Further Afield

- Valcabrère: basilica (1 mile/2 km).
- Barbazan (3 miles/5 km).
- La Barousse valley (4½ miles/7 km).
- Gargas: caves (5 miles/8 km).
- Montréjeau and Saint-Gaudens (5½–11 miles/9–17 km).
- Bagnères-de-Luchon (20 miles/32 km).

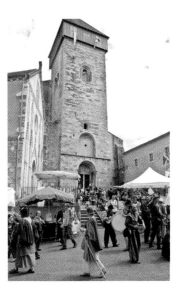

Saint-Cirq-Lapopie
A panoramic viewpoint

Lot (46) • Population: 223 • Altitude: 722 ft. (220 m)

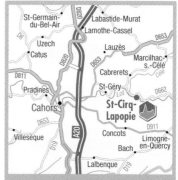

By road: Expressway A20, exit 57 (from Paris) or 58 (from Toulouse)–Cahors Centre (19 miles/31 km).
By train: Cahors station (16 miles/26 km).
By air: Rodez-Marcillac airport (52 miles/ 84 km); Brive-Vallée de la Dordogne airport (62 miles/100 km); Toulouse-Blagnac airport (84 miles/135 km).

ⓘ Tourist information—Cahors Saint-Cirq-Lapopie: +33 (0)5 65 31 31 31
www.tourisme-cahors.fr

Perched on an escarpment whose ridge is silhouetted against a background of high cliffs, Saint-Cirq-Lapopie overlooks a bend in the Lot river.

Controlling the Lot valley, which for a long time saw a flourishing trade in the transportation of goods by barge, the site of Saint-Cirq has been occupied since Gallo-Roman times. In the Middle Ages it became a powerful fortified complex that included the castles of the four dynasties that shared power here (Cardaillac, Castelnau, Gourdon, and Lapopie). Owing to its coveted strategic position, Saint-Cirq was constantly besieged. Although Richard the Lionheart failed to capture the fortress in the 12th century, it passed alternately under English and French rule during the Hundred Years War. In the late 16th century, the Huguenots twice seized it, before Henri IV—following the example set by Louis XI and Charles VIII—totally demolished it. Its castles thus vanished, and only the Rocamadour Gate still stands, but Saint-Cirq remains a place of rare harmony between the village, its architecture, and its landscapes. Of the numerous artists and writers who succumbed to the magic of this place in the 19th century, it is probably André Breton who paid it its finest tribute. Discovering the village one evening in 1950, like "an impossible rose in the night," he made the old Auberge des Mariniers his summer residence and ceased "wishing to be elsewhere."

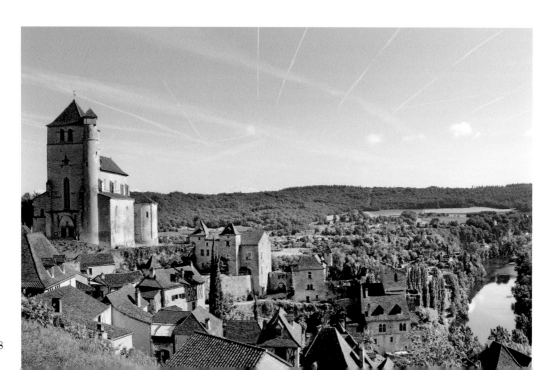

👁 Highlights

• Maison André Breton: Cultural center dedicated to surrealism and artistic creation in a house (11th–13th centuries) once owned by the surrealist writer: +33 (0)6 51 22 22 38.
• Maison Daura: Center for contemporary art, research, and artistic innovation; exhibition of artworks: +33 (0)5 65 40 78 19.
• Musée Départemental Rignault: Permanent collections of furniture and works of art assembled by the collector Émile Joseph-Rignault; temporary exhibitions; gardens with an exceptional view of the Lot: +33 (0)5 65 31 23 22.
• Village: Guided tours all year round: +33 (0)5 65 31 31 31; by appointment for groups: +33 (0)5 65 24 13 95.

🔑 Accommodation

Hotels
Auberge du Sombral**: +33 (0)5 65 31 26 08.
Hôtel du Causse: +33 (0)5 65 21 76 61.
Guesthouses
À la Source: +33 (0)5 65 23 56 98.
M. Balmes, farmhouse guest rooms: +33 (0)5 65 31 26 02.
Chambres de Cantagrel: +33 (0)5 65 23 81 45.
Château de Saint-Cirq-Lapopie: +33 (0)6 11 17 20 62.
Le Mas de Laval: +33 (0)6 60 45 06 92.
Gîtes, vacation rentals, and walkers' lodges
Further information: +33 (0)5 65 31 31 31
www.tourisme-cahors.fr
Campsites
La Plage****: +33 (0)5 65 30 29 51.
♥ La Truffière***: +33 (0)5 65 30 20 22.

🍽 Eating Out

Auberge du Sombral: +33 (0)5 65 31 26 08.
Brasserie Les Fadas: +33 (0)5 65 30 20 36.
Le Cantou: +33 (0)5 65 35 59 03.
Le Gourmet Quercynois: +33 (0)5 65 31 21 20.
Hôtel du Causse: +33 (0)5 65 21 76 61.
Le Lapopie: +33 (0)5 65 30 27 44.
Lou Bolat: +33 (0)5 65 30 29 04.
L'Oustal: +33 (0)5 65 31 20 17.
La Plage, pizzeria: +33 (0)5 65 30 29 51.
Le Saint-Cirq Gourmand, light meals: +33 (0)5 65 35 30 30.
Soleil Or, light meals: +33 (0)5 65 30 24 94.
La Table du Producteur: +33 (0)5 65 22 18 37.
La Terrasse: +33 (0)6 15 71 60 60.
La Tonnelle, brasserie: +33 (0)5 65 31 21 20.
La Truffière, pizzeria: +33 (0)5 65 30 20 22.

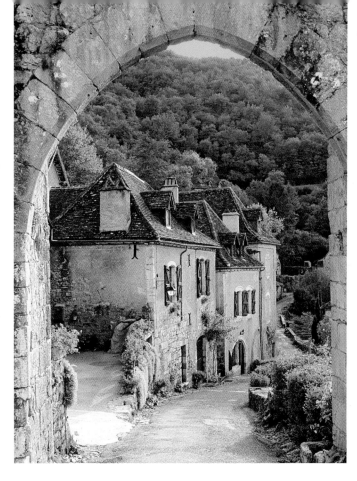

🧺 Local Specialties

Food and Drink
Duck foie gras • Walnuts • Truffles • Saffron • Cahors wine • Rocamadour cheese.
Art and Crafts
Leather crafts • Jewelry • Hats • Ceramics • Gifts, tableware • Wooden toys • Paintings • Engraving • Sculpture • Wood turning • Clothing.

📅 Events

Market: Farmers' market, Wednesdays 4–8 p.m., Place du Sombral (July–August).
July: Village festival (weekend following July 14).
All year round: Cultural events, cinema; dance; theater; concerts; exhibitions; workshops.

🦋 Outdoor Activities

Canoeing • Walking: Route GR 36 and marked trails.

🌿 Further Afield

• Château de Cénevières (5½ miles/9 km).
• Célé valley: Cabrerets, Pech Merle caves, Marcilhac (6–16 miles/9.5–26 km).
• Causse de Limogne, Villefranche-de-Rouergue (9½–24 miles/15.5–39 km).
• Cajarc; Figeac (12–28 miles/19–45 km).
• Cahors (16 miles/26 km).

Saint-Côme-d'Olt

A pilgrims' stopping place on the Lot river

Aveyron (12) • Population: 1,364 • Altitude: 1,234 ft. (376 m)

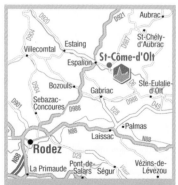

Located on the Saint James's Way in the fertile Lot valley, Saint-Côme-d'Olt is distinguished by its twisted spire and its delightful houses.

Bordered on the south side by the green hills that overlook the basaltic mass of Roquelaure, and to the north by terraces of old vineyards, the village has built up over time inside the circular ditches of the old medieval town, of which three fortified gates remain. The 16th-century church, whose twisted spire dominates the village, is of Flamboyant Gothic style. Its heavy carved-oak doors are reinforced with 365 wrought-iron nails. The 11th-century Chapelle des Pénitents, with its *ajouré* (pierced) bell tower, is topped with a hull roof. The Château des Sires de Calmont, built in the 12th century and rebuilt in the 15th, presents a Renaissance façade and has two 14th-century towers. The narrow streets retain old medieval shops and houses from the 10th and 16th centuries, such as the Consul of Rodelle's house, which has mullioned windows and is embellished with sculptures. The Ouradou, a building with an octagonal roof, was erected in memory of the victims of the 1586 plague.

By road: Expressway A75, exit 28–Espalion (54 miles/87 km) or exit 42–Rodez (27 miles/43 km), N88 (12 miles/19 km). **By train:** Rodez station (21 miles/34 km). **By air:** Rodez-Marcillac airport (27 miles/43 km).

ⓘ Tourist information—Terres d'Aveyron: +33 (0)5 65 44 10 63 or +33 (0)5 65 48 24 46
www.tourisme-espalion.fr

👁 Highlights

• Chapelle des Pénitents (11th century): Exhibition on Romanesque architecture and the White Penitents.
• Église Saint-Côme-et-Saint-Damien (16th century): Twisted spire, 16th-century wooden Christ, 18th-century altarpiece, listed 16th-century oak doors.
• Village: Guided tours all year round by arrangement; themed visits, discovery tour June–August: +33 (0)5 65 48 24 46.

🗝 Accommodation

Hôtel
Espace Rencontre Angèle Mérici 2**: +33 (0)5 65 51 03 20.
Guesthouses
Au Pont d'Olt 🏠🏠🏠: +33 (0)6 47 81 12 63.
M. Burguière: +33 (0)5 65 44 10 61.
Les Jardins d'Éliane: +33 (0)5 65 48 28 06.
Le Plateau: +33 (0)5 65 48 07 04.
Gîtes, vacation rentals, and walkers' lodges
Further information: +33 (0)5 65 44 10 63
www.tourisme-espalion.fr
Campsites
Camping Bellerive**: +33 (0)5 65 44 05 85.

🍽 Eating Out

Brasserie du Théron: +33 (0)5 65 48 01 10.
La Fontaine: +33 (0)5 65 44 05 82.
Le Saint-Damien: +33 (0)5 65 44 39 68.

🛒 Local Specialties

Art and Crafts
Jewelry • Potter.

📅 Events

Market: Sunday mornings.
May: "La Transhumance Aubrac," moving cattle to new pastures (Sunday nearest 25th).
July: Evening market (14th).
August: Folk festival (2nd Saturday); evening market (Wednesday before 15th); local saint's day festivities (4th Sunday).

🦋 Outdoor Activities

Boules area • Bowling • Canoeing • Fishing • Walking: Route GR 65, Chemin de Compostelle (Saint James's Way) and 10 marked trails • Mountain-biking.

🌿 Further Afield

• Flaujac, fortified hamlet (1 mile/1.5 km).
• Roquelaure: castle, lava flow (2–3 miles/3–5 km).
• Espalion: Musée du Scaphandre, Calmont d'Olt medieval castle, 11th-century Romanesque chapel of Perse and Pont-Vieux, Chapelle des Pénitents (2½ miles/4 km).
• Abbaye de Bonneval, Laguiole, and L'Aubrac (6–19 miles/9.5–31 km).
• *Estaing (8 miles/13 km), see pp. 190–91.
• Trou de Bozouls, horseshoe gorge (9½ miles/15.5 km).
• *Sainte-Eulalie-d'Olt (12 miles/19 km), see pp. 246–47.

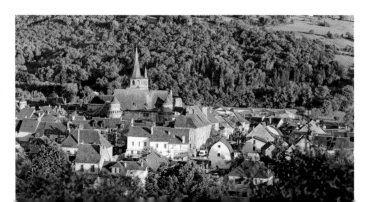

Saint-Jean-de-Côle

Architectural symphony in Périgord Vert

Dordogne (24) • Population: 361 • Altitude: 489 ft. (149 m)

Nestling in the hills, Saint-Jean-de-Côle is an inviting place to dream and meditate in an exceptional architectural setting. Overlooking the village square, the Château de la Marthonie has replaced the original fortress that was built here in the 11th century to defend the Périgord and Limousin borders. Burned during the Hundred Years War, the latter made way for a 15th- and 16th-century building that combines Renaissance elegance and classical precision in its two wings, which share a magnificent straight-flight staircase. Adjoining a priory with cloisters and ambulatory, the Romanesque–Byzantine-style church was built in the 12th century. It contains some beautiful paintings and a polychrome stone Madonna from the 17th century. At the edge of the village, near the old mill, a medieval bridge with cutwaters spans the Côle river. This prestigious architectural ensemble is completed by the village's unusual little streets and old houses, some of which are half-timbered.

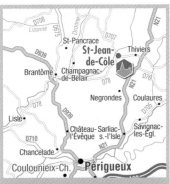

By road: Expressway A89, exit 15–Agen (31 miles/50 km); N21 (5 miles/8 km).
By train: Thiviers station (5 miles/8 km).
By air: Périgueux-Bassillac airport (24 miles/39 km); Limoges-Bellegarde airport (42 miles/68 km).

(i) Tourist information:
+33 (0)5 53 62 14 15
www.perigord-limousin-tourisme.com
www.ville-saint-jean-de-cole.fr

👁 Highlights
• **Château de la Marthonie** (12th, 15th, 16th, and 17th centuries): Guided tour of exterior only: +33 (0)5 53 62 14 15.
• **Église Saint-Jean-Baptiste** (11th and 12th centuries): Wood paneling, paintings; interior sound and light show.

• **Priory** (12th century): Braille guide available from tourist information center: +33 (0)5 53 62 14 15.
• **Village:** Audioguide tour; treasure hunt for children; guided tours and braille guides available. Further information: +33 (0)5 53 62 14 15.

🗝 Accommodation
Guesthouses
Le Moulin du Pirrou:
+33 (0)5 53 52 35 38.
Le Relais de Montgeoffroy:
+33 (0)6 37 20 85 81 or
+33 (0)6 13 46 29 29.
Mme Trennet: +33 (0)6 17 61 60 08.
M. Wolff: +33 (0)5 53 52 53 09.
Gîtes and vacation rentals
Further information:
+33 (0)5 53 62 14 15
www.perigord-limousin-tourisme.com

🍷 Eating Out
Chez Robert: +33 (0)5 53 52 53 09.
Le Moulin du Pirrou:
+33 (0)5 53 52 35 38.
La Perla Café, in summer:
+33 (0)5 53 52 38 11.
Le Saint-Jean: +33 (0)5 53 52 23 20.
Le Temps des Mets: +33 (0)9 67 78 25 72.
Thé Zen, tea room: +33 (0)6 17 61 60 08.

🍴 Local Specialties
Art and Crafts
Ceramicist • Art gallery • Painter.

🗓 Events
May: Flower show (weekend nearest May 8).
June: "Feu de la Saint-Jean," bonfires of Saint John.
July–August: Classical music concerts; street theater; "Les Jeudis de l'Art," Thursday exhibitions at La Halle covered market.
July–mid-September: Art exhibitions at the tourist office.

🦋 Outdoor Activities
Fishing • Voie Verte (11 miles/18 km): greenway for walkers, riders, cyclists, and mountain-bikers; marked trails and railway-themed signposted walk.

🌿 Further Afield
• Thiviers: Maison du Foie Gras (4½ miles/7 km).
• Villars: Château de Puyguilhem; cave; Abbaye de Boschaud ruins (5–7 miles/8–11.5 km).
• Limousin-Périgord regional nature park (6 miles/9.5 km).
• Sorges: Écomusée de la Truffe, truffle trail (9½ miles/15.5 km).
• Brantôme (12 miles/19 km).
• Jumilhac: castle and gold museum (15½ miles/25 km).
• Périgueux (22 miles/35 km).
• *Ségur-le-Château (28 miles/45 km), see p. 256.

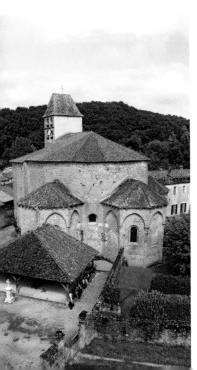

Saint-Jean-Pied-de-Port

Fortified town in the Pays Basque

Pyrénées-Atlantiques (64) • Population: 1,851 • Altitude: 525 ft. (160 m)

Situated on the banks of the Nive river, between the Basque coast and the Spanish border, this historically defensive site now watches over pilgrims on their way to Santiago de Compostela.

At the end of the 12th century, the king of Navarre ordered a fortress to be built on a hill overlooking the Nive river, in the foothills of the mountains around Cize, in a bid to secure control of the main passage through the Pyrenees via Roncevalles. Shortly afterward, a new town was constructed around the fortress. The strategic position of this "key town" in the kingdom of Navarre meant that it was not only a military linchpin but also a thriving commercial center. The town assumed an enduring religious importance when it was made an indispensable stop on the pilgrimage to Santiago de Compostela. This three-pronged identity can still be seen in the village's architecture: from the citadel—founded on the site of the former castle of the kings of Navarre in the 17th century and reworked by Vauban—to the 13th-century ramparts of the upper town, and from the Rue d'Espagne, lined with artisans' and traders' houses that are typical of the region's traditional architecture, to the Porte Saint-Jacques, and the Église Notre-Dame-du-Bout-du-Pont (13th–14th centuries), built in pink sandstone from nearby Arradoy. With a backdrop spanning the verdant valleys of the Cize countryside, the vineyards of Irouleguy, and the Pyrenees, Saint-Jean-Pied-de-Port encapsulates all the colors and flavors of Basque culture.

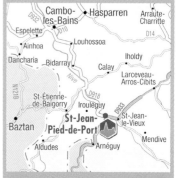

By road: Expressway A63, exit 5–Bayonne Sud (30 miles/48 km); expressway A64, exit 7–Salies-de-Béarn (36 miles/58 km).
By train: Saint-Jean-Pied-de-Port station; Bayonne station (35 miles/56 km).
By air: Pau-Pyrénées airport (72 miles/116 km); Biarritz-Bayonne-Anglet airport (35 miles/56 km).

(i) Tourist information—Pays Basque:
+33 (0)5 59 37 03 57
www.otpaysbasque.com

👁 Highlights

- **Citadel** (17th century): Bastioned fortification overhauled by Vauban. Guided visits on Monday and Wednesday in July and August: +33 (0)5 59 37 03 57.
- **Prison des Évêques** (14th century): Medieval building used as a warehouse, then as a prison. Permanent exhibition on the pilgrimage to Santiago de Compostela. Open from Easter until All Saints' Day: +33 (0)5 59 37 00 92.
- **Église Notre-Dame-du-Bout-du-Pont** (13th–14th centuries): One of the most important Gothic church buildings in the French Basque Country. Open every day.
- **Village**: Guided tour for groups all year round by appointment only and guided tour for individuals by a "Raconteur de Pays" (specialist) from July to August: +33 (0)5 59 37 03 57; audioguide tour (route can be downloaded from tourist information website); tourist train from April to October: +33 (0)5 59 37 00 92.

🗝 Accommodation

Hotels
Hôtel Les Pyrénées****: +33 (0)5 59 37 01 01.
Hôtel Itzalpea**: +33 (0)5 59 37 03 66.
Hôtel Les Remparts **: +33 (0)5 59 37 13 79.
Hôtel Ramuntcho**: +33 (0)5 59 37 03 91.
Hôtel Central: +33 (0)5 59 37 00 22.

Guesthouses
Maison Harria 🏠🏠🏠: +33 (0)5 59 37 09 74.
Maison Garicoitz: +33 (0)6 80 00 49 51.
Maison Gure Lana: +33 (0)5 24 34 14 97.
Mme Paris: +33 (0)5 59 37 22 32.
Casas Rurales Portaleburu: +33 (0)5 59 49 10 74.
Further information: +33 (0)5 59 37 03 57
www.otpaysbasque.com

Gîtes and vacation rentals
Appartement Sejournant***: +33 (0)6 64 43 88 96.
M. and Mme Iribarne***: +33 (0)5 59 37 28 37.
Appartement Aguergaray**: +33 (0)5 59 37 10 61.
M. and Mme Elizalde**: +33 (0)5 59 37 37 81.
Mme Larre**: +33 (0)5 59 37 30 18.
Further information: +33 (0)5 59 37 03 57
www.pyrenees-basques.com

Stopover gîtes and bunkhouses
Further information: +33 (0)5 59 37 03 57
www.otpaysbasque.com

Holiday villages
VVF Villages Garazi: +33 (0)5 59 37 06 90.

Campsites and RV parks
Camping municipal Plaza Berri**: +33 (0)5 59 37 11 19.
RV park: +33 (0)5 59 37 00 92.

🍴 Eating Out

Café de la Paix, brasserie/pizzeria: +33 (0)5 59 37 00 99.
Café Ttipia, wine bistro: +33 (0)5 59 37 11 96.
Le Central: +33 (0)5 59 37 00 22.
Le Chaudron: +33 (0)5 59 37 20 15.
Cidrerie Hurrup Eta Klik: +33 (0)5 59 37 09 18.
Crêperie Kuka: +33 (0)5 59 49 08 86.
Oillarburu: +33 (0)5 59 37 06 44.
Les Pyrénées, gourmet restaurant: +33 (0)5 59 37 01 01.
Ramuntcho: +33 (0)5 59 37 03 91.
Le Relais de la Nive: +33 (0)5 59 37 04 22.
Txitxipapa, world cuisine: +33 (0)5 59 37 36 74.
La Vieille Auberge – Chez Dédé: +33 (0)5 24 34 11 49.

🛒 Local Specialties

- **Food and Drink**
AOP Ossau-Iraty cheese • AOC Irouleguy wine • AOC Kintoa Basque pork • Distilled spirits • *Gâteau basque* • Macarons • Banka trout.
- **Art and Crafts**
Artisan sandal-maker • Potter • Gallery of local arts.

📅 Events

Markets: Monday, all day, Place Charles de Gaulle; Monday until 1 p.m. at covered market; farmers' market on Thursdays in season.

April–October: Exhibitions at the townhall and Prison des Évêques.
June–September: Exhibitions of local arts and crafts.
Mid-August: Patron saint's day (around the 15th); theater festival (late August).
September: Irouleguy vineyards festival; village festivals.

🦋 Outdoor Activities

- **Walking:** Routes GR 10 and GR 65; several marked trails • Mountain-biking: "Grande Traversée du Pays Basque" • Fly fishing.

🌿 Further Afield

- Saint-Jean-le-Vieux: archeological museum (3 miles/5 km).
- Spanish border (4½ miles/7 km).
- Irouleguy (5 miles/8 km).
- Esterençuby: Grottes d'Harpea, caves (5½ miles/9 km).
- Saint-Etienne de Baïgorry (7 miles/11 km).
- Vallée des Aldudes, valley (7 miles/11 km).
- Bidarray, frontier village (12½ miles/20 km).
- Forêt d'Iraty, forest (19 miles/30 km).
- Cambo-les-Bains (21 miles/34 km).
- Espelette (22 miles/36 km).
- Mauléon-Licharre (25 miles/40 km).
- *Ainhoa and *La Bastide-Clairence (27 miles/43 km), see pp. 152 and 160–61.
- *Sare (31 miles/50 km), see pp. 250–51.

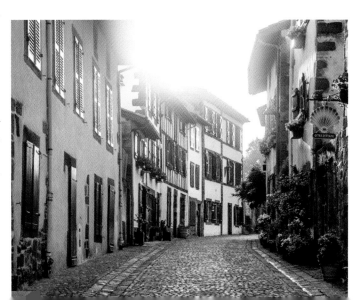

Saint-Léon-sur-Vézère

Treasure of the Vézère valley

Dordogne (24) • Population: 429 • Altitude: 230 ft. (70 m)

Tucked away in a bend in the Vézère river, halfway between Lascaux and Les Eyzies, Saint-Léon is at the heart of this cradle of civilization. Occupied since prehistoric times, as evidenced in the remains of dwellings at Conquil, Saint-Léon is named after one of the first bishops of Périgueux. Located near a Roman road, the village was, until the arrival of the railway, a thriving port on the Vézère river, earning itself the name Port-Léon during the French Revolution. From the cemetery chapel at the village entrance, the road leads past the Château de Clérans and the Manoir de La Salle, to a 12th-century Romanesque church with a *lauze* (schist-tiled) roof, which is one of the venues for the popular Périgord Noir music festival. Its plan resembles that of Byzantine churches. Near the Côte de Jor, the Château de Chabans dates from the Middle Ages to the 17th century.

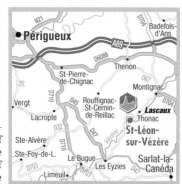

By road: Expressway A89, exit 17 (14 miles/23 km). **By train:** Eyzies station (6 miles/10 km); Condat-le-Lardin station (12 miles/19 km); Sarlat-la-Canéda station (23 miles/37 km). **By air:** Brive-Vallée de la Dordogne airport (40 miles/64 km); Périgueux-Bassillac airport (43 miles/69 km).

ⓘ **Tourist information:**
+33 (0)5 53 51 08 42
www.lascaux-dordogne.com

👁 Highlights

• **Buddhist study and meditation center:** Main European center for the Kagyupa Buddhist tradition; meditation, Buddhist philosophy courses: +33 (0)5 53 50 70 75.
• **Romanesque church** (12th century): Frescoes.
• **Le Conquil prehistoric theme park:** Cave site, dinosaur park.

🔑 Accommodation

Guesthouses
Le Clos des Songes: +33 (0)5 53 42 25 72.
Esprit Nature: +33 (0)5 53 51 35 71.
Gîtes and vacation rentals
♥ Le Bel Orme: +33 (0)7 87 14 81 08.
Further information: +33 (0)5 53 51 08 42
www.lascaux-dordogne.com
Campsites and RV parks
Le Paradis*****: +33 (0)5 53 50 72 64.
Municipal campsite: +33 (0)5 53 51 08 42.
RV park: +33 (0)5 53 51 08 42.

🍴 Eating Out

L'Auberge du Pont: +33 (0)5 53 50 73 07.
Le Déjeuner sur l'Herbe, local light meals: +33 (0)5 53 50 69 17.
Lou Camillou: +33 (0)6 58 53 92 57.
Le Jardin: +33 (0)6 43 45 24 66.
Le Martin Pêcheur: +33 (0)5 33 02 12 58.
Le Restaurant de la Poste: +33 (0)5 53 50 73 08.
SmooVie Grignothèque, vegan/vegetarian restaurant: +33 (0)6 07 24 20 01.

🛍 Local Specialties

Art and Crafts
Artists • Wood-carver • Sculptor • Workers in felt and glass.

📅 Events

Market: Gourmet and crafts market, Thursdays in July and August from 6 p.m.
July: Flea market (1st or 2nd Sunday).
August: Périgord Noir music festival: concerts in the Romanesque church (mid-August); village festival (2nd weekend).

🦋 Outdoor Activities

Canoeing • Fishing • Forest adventure park • Horse-riding • Walking: Route GR 36 (3 marked trails) • Hang gliding • Mountain-biking • *Boules*.

🌾 Further Afield

• **Côte de Jor:** viewpoint (2 miles/3 km).
• **Vallée de l'Homme,** prehistoric sites: Lascaux, Les Eyzies (2–9½ miles/3–15.5 km).
• **Montignac-sur-Vézère** (6 miles/9.5 km).
• **Grotte de Rouffignac,** cave (11 miles/18 km).
• ***Saint-Amand-de-Coly** (11 miles/18 km), see pp. 234–35.
• **Dordogne valley:** *Limeuil (19 miles/31 km), see pp. 206–7; *Beynac-et-Cazenac (21 miles/34 km), see pp. 166–67; *La Roque-Gageac (22 miles/35 km), see pp. 232–33; *Castelnaud-la-Chapelle (23 miles/37 km), see p. 180; * Belvès (24 miles/39 km), see pp. 164–65; *Domme (24 miles/39 km), see pp. 188–89.
• **Sarlat** (22 miles/35 km).

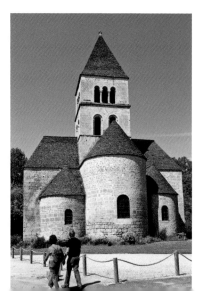

Saint-Robert

The hill of the Benedictines

Corrèze (19) • Population: 350 • Altitude: 1,148 ft. (350 m)

Built around a monastery founded by Saint Robert's disciples, the village was named after the founder of La Chaise-Dieu Benedictine abbey in the Auvergne.

The village stands on a hill, in landscape typical of Corrèze, on the site of an old Merovingian city. On the Saint-Robert plateau, the ruins of a curtain wall encircle the Benedictine monastery and its Romanesque abbey church. The prosperous-looking cut-stone buildings, small castles, and houses with towers were, in their time, home to noblemen. The fortified church has preserved its 12th-century structure almost intact. The ambulatory once displayed saints' relics to pilgrims on their way to Santiago; scenes charged with biblical symbolism are engraved on the capitals, and a 13th-century, life-size Christ, carved in wood, testifies to the religious intensity of the Middle Ages. Saint-Robert, a city-state on the borders of Périgord, was itself the scene of violent religious clashes.

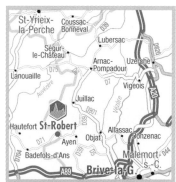

By road: Expressway A20, exit 50–Objat (14 miles/23 km); expressway A89, exit 17–Thenon (16 miles/26 km).
By train: Objat station (8 miles/13 km); Brive-la-Gaillarde station (17 miles/27 km).
By air: Brive-Vallée de la Dordogne airport (24 miles/39 km).

(i) Tourist information—Brive et Son Pays: +33 (0)5 55 24 08 80
www.brive-tourisme.com

👁 Highlights
• **Église Notre-Dame** (12th century).
• **Village:** Guided tour on Tuesdays at 11 a.m. and Thursdays at 4.30 p.m. in July and August; by appointment only the rest of the year:
+33 (0)5 55 25 21 01.

🗝 Accommodation
Guesthouses
Le Saint-Robert: +33 (0)5 55 25 58 09.
Gîtes and vacation rentals
Further information:
+33 (0)5 55 24 08 80
www.brive-tourisme.com

🍴 Eating Out
Restaurants
La Vieille École: +33 (0)5 55 23 53 92.

🧺 Local Specialties
Food and Drink
Foie gras and confit • Bread baked in a wood-fired oven.
Art and Crafts
Local crafts.

📅 Events
Spring: Milk-fed veal prize-giving fair.
July and August: Festive markets, classical music festival.

August: Local saint's day (15th).
October: Fête du Vin Nouveau, wine festival (2nd Sunday).
November: Milk-fed veal prize-giving fair (2nd Monday).

🦋 Outdoor Activities
Walking: 2 marked trails.

🌿 Further Afield
• Église de Saint-Bonnet-la-Rivière and Yssandon site (7½ miles/12 km).
• Château de Hautefort (10 miles/16 km).
• Pompadour (14 miles/23 km).
• Vézère valley; Terrasson (14 miles/23 km).
• Brive (16 miles/26 km).
• *Ségur-le-Château (17 miles/27 km), see p. 256.

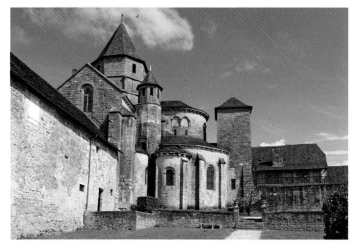

ℹ Did you know?
Filming of the French TV mini-series adapted from the novel *Firelight and Woodsmoke* by local author Claude Michelet remains etched on the memory of villagers. The story reflected the history of their village in its depiction of the Vialhe family living through the momentous changes of the 20th century.

Sainte-Eulalie-d'Olt

Creativity and artistry in the Lot valley

Aveyron (12) • Population: 377 • Altitude: 1,345 ft. (410 m)

Deep in the Lot valley, numerous artists and craftspeople are breathing life into the old stones of Sainte-Eulalie-d'Olt.

This typically medieval village is laid out in a series of alleyways and small squares around the Place de l'Église. Wealthy residences from the 15th and 16th centuries are reminders of the village's prosperous past, and houses built in Lot shingle up to the 18th century are architectural jewels. The large wheel of the restored flour mill rumbles away once again. The church, cited in records in 909, has a Romanesque choir surrounded by impressive cylindrical columns, while the nave and the chapel are Gothic in style. Three apsidal chapels open off the ambulatory, and a reliquary chest contains two thorns supposedly from Christ's crown. Also worth seeing in the village are the Château des Curières de Castelnau, dating from the 15th century, and a corbeled Renaissance residence, whose façade is punctuated with fourteen windows. This rich heritage, and the views that Sainte-Eulalie-d'Olt commands over the Lot valley, have encouraged numerous artists to make this village their home and inspiration.

By road: Expressway A75, exit 41–Campagnac (16 miles/26 km).
By train: Campagnac-Saint-Geniez station (12 miles/ 19 km).
By air: Rodez-Marcillac airport (33 miles/53 km).

ⓘ Tourist information—Causses à l'Aubrac: +33 (0)5 65 47 82 68
www.causses-aubrac-tourisme.com

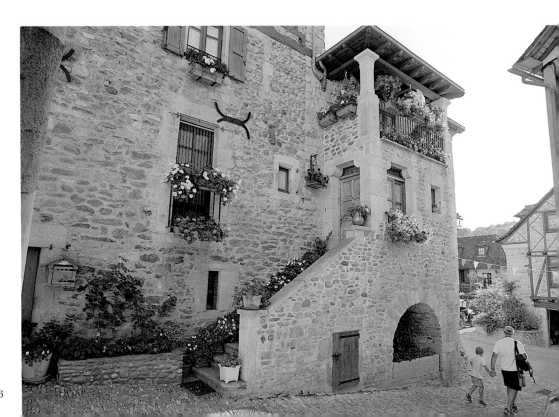

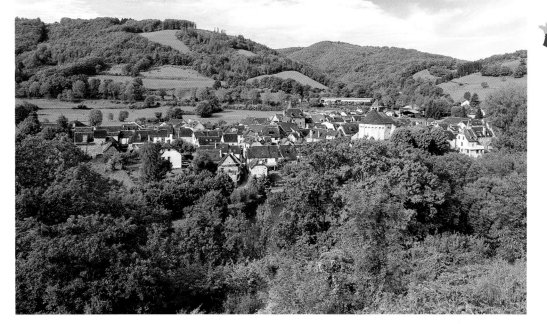

👁 Highlights

• **Romanesque and Gothic church** (11th, 12th, and 16th centuries): Relics.
• **"Eulalie d'Art" and various artists' studios:** Art and craft studios, demonstrations, exhibitions, workshops: +33 (0)5 65 47 82 68.
• **Musée-Galerie Marcel Boudou:** Temporary exhibitions, July–August: +33 (0)5 65 47 82 68.
• **Village:** Self-guided visit (information boards and map available at tourist information center); guided tour for individuals, Mondays and Fridays 5 p.m., July–August; for groups by appointment all year round, except January 1 and May 1: +33 (0)5 65 47 82 68.

🔑 Accommodation

Hotels
Au Moulin d'Alexandre**: +33 (0)5 65 47 45 85.
Guesthouses
La Draye: +33 (0)5 65 70 46 45.
L'Oustal: +33 (0)6 83 28 99 45.
Gîtes and vacation rentals
Further information: +33 (0)5 65 47 82 68 www.causses-aubrac-tourisme.com
Aparthotels
♥ La Cascade***: +33 (0)5 65 78 65 97.
Campsites and RV parks
La Grave**, municipal campsite, May 15–September 15: +33 (0)5 65 47 44 59.
Brise du Lac, rural campsite: +33 (0)5 65 47 44 76.
RV park (open all year): +33 (0)5 65 47 44 59.

🍴 Eating Out

Au Moulin d'Alexandre: +33 (0)5 65 47 45 85.
Caravan Kitchen, in summer: +33 (0)6 78 74 12 89.
Chez Simone, in summer: +33 (0)6 50 84 34 72.

🧺 Local Specialties

Food and Drink
Traveling home distiller (November 1–end April) • Wood-baked *pain au levain* bread • Organic chicken • Fruit farm.
Art and Crafts
Potter • Enamel engraver • Glassblower • Wooden caravan builder • Jewelry designer • Artist • Sculptor • Dressmaker • Leaf-painter.

🗓 Events

Market: Monday mornings, Place de l'Église (July–August).
May: "Marché des Senteurs et Saveurs," local produce market (1st Sunday); fishing competition (Thursday of Ascension).
June: "Feu de la Saint-Jean," Saint John's (Midsummer's) Eve bonfire with fireworks.
July: Historic procession of the Holy Thorn (2nd Sunday) and local saint's day; Vallée d'Olt classical music festival; concerts.
July–September: Exhibition of photographs in the streets.
August: Concerts.
September: "Trophée Cabanac," European carp fishing competition (end of September).
November 1: "Poule Un," charity auction to redeem souls in Purgatory.

🦋 Outdoor Activities

Canoeing • Stand-up paddle-boarding • Motorboats • Fishing • Walking and mountain-biking • Electric bikes • Swimming • Cycling tours.

🌿 Further Afield

• Saint-Geniez-d'Olt (2 miles/3 km).
• Hamlets of Cabanac, Lous, Malescombes (2–4½ miles/3–7 km).
• Parc Naturel Régional des Grands Causses, nature park (3½ miles/5.5 km).
• Pierrefiche; Galinières: keep (3½–6 miles/5.5–9.5 km).
• Parc Naturel Régional de l'Aubrac, nature park (4 miles/6 km).
• *Saint-Côme-d'Olt (12 miles/19 km), see p. 240.
• Sévérac-le-Château (19 miles/30 km).
• *Estaing (19 miles/31 km), see pp. 190–91.
• Gorges of the Tarn (25 miles/40 km).

❗ Did you know?

Legend has it that the nickname "Encaulats"—cabbage eaters—was given in jest to the local inhabitants because cabbages grew in every garden. Every winter since 2000, the inhabitants of Sainte-Eulalie have gathered together for a huge annual cabbage dinner.

Salers

Volcanic majesty and gastronomic delights

Cantal (15) • Population: 329 • Altitude: 3,117 ft. (950 m)

In the majestic scenery of the Monts du Cantal, Salers prides itself on its geological beauty and its unique regional taste sensations.

Salers stands right at the edge of an ancient lava flow, surveying the Maronne valley from a height of 3,117 ft. (950 m). The village was the seat of a baronetcy whose lords distinguished themselves in the First Crusade, and in 1428 it was granted a license by Charles VII to build ramparts, from which the Beffroi and La Martille gates survive. Here, in 1550, Henri II established the royal bailiwick of the Hautes-Montagnes d'Auvergne. On Place Tyssandier-d'Escous, the former bailiwick is surrounded by magistrates' residences, including Hôtel de Ronade, Maison de Flogeac, and Maison de Bargues. The house of commander de Mossier, Knight of Malta, has been turned into a museum celebrating the history and folklore of Salers. The Église de Saint-Mathieu boasts a Romanesque portal, five 17th-century Aubusson tapestries, and a 15th-century Entombment sculpture. At the village's eastern end, the Barrouze Esplanade overlooks the Puy Violent peak and the Monts du Cantal. Acclaimed equally for meat and cheese, from Salers's own breed of cows, the village represents the high point of gastronomy in the Auvergne.

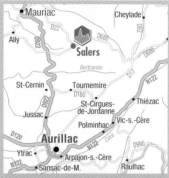

By road: Expressway A89, exit 22–Egletons (41 miles/66 km); expressway A75, exit 23–Aurillac, then N122 (49 miles/79 km). **By bus:** Mauriac bus station (12 miles/ 19 km). **By train:** Aurillac station (26 miles/ 42 km). **By air:** Aurillac-Tronquières airport (27 miles/43 km); Brive-Vallée de la Dordogne airport (81 miles/130 km); Clermont-Ferrand-Auvergne airport (89½ miles/144 km).

ⓘ Tourist information—Pays de Salers: +33 (0)4 71 40 58 08 www.salers-tourisme.fr / www.salers.fr

👁 Highlights
• **Maison du Commandeur:** Known as the Templars' House. Museum of the history of Salers and its folk traditions; Renaissance residence and historic pharmacy; temporary exhibitions; open April–November 1st: +33 (0)4 71 40 75 97.

• **Cellar of Salers:** Cheese-ageing cellar specializing in AOP Salers cheese. Tours, exhibitions, and tastings; open all year round: +33 (0)4 71 69 10 48.
• **Village:** Guided tour by tourist information center, June–September; by appointment only: +33 (0)4 71 40 58 08.

⚔ Accommodation
Hotels
Le Bailliage*** : +33 (0)4 71 40 71 95.
Les Remparts*** : +33 (0)4 71 40 70 33.
Le Beffroi** : +33 (0)4 71 40 70 11.
La Bastide du Cantal: +33 (0)4 77 69 35 49.
Hôtel Saluces: +33 (0)4 71 40 70 82.
Guesthouses
Le Jardin du Haut Mouriol 🛏🛏🛏:
+33 (0)4 71 40 74 02.
La Maison de Barrouze 🛏🛏🛏:
+33 (0)4 71 40 78 08.
L'Asphodèle ✂✂✂: +33 (0)4 71 40 70 82.
Les Sagranières: +33 (0)4 71 40 70 50.
Gîtes and vacation rentals
Chez Manon et Pierre**** :
+33 (0)4 71 68 64 58.
Au Petit Nid Douillet*** :
+33 (0)4 71 68 79 10.
Le Gîte de Barrouze*** :
+33 (0)4 71 40 76 42.
Le Gîte Chareyrade*** :
+33 (0)4 71 40 70 67.
Le Gîte de la Jourdanie*** :
+33 (0)4 71 40 29 80.
À La Petite Maison Sagranière** :
+33 (0)4 71 67 34 75.
Le Gîte du Foirai** : +33 (0)4 71 40 70 13.

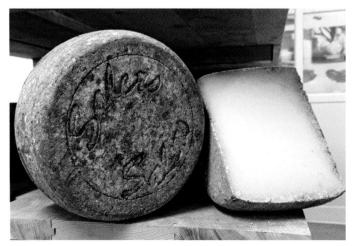

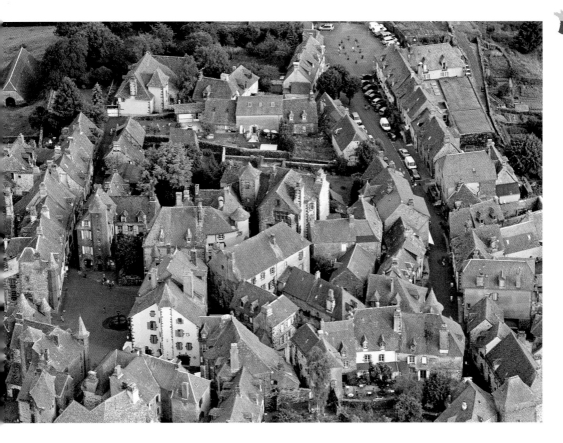

Les Gîtes des Prés de Fauve:
+33 (0)6 82 71 66 19.
Campsites
Camping Municipal Le Mouriol***:
+33 (0)4 71 40 73 09.

🍴 Eating Out
♥ Le Bailliage: +33 (0)4 71 40 71 95.
Le Beffroi: +33 (0)4 71 40 70 11.
La Diligence: +33 (0)4 71 40 75 39.
Le Drac, crêperie: +33 (0)4 71 40 72 12.
L'Evasion: +33 (0)4 71 40 74 56.
La Martille: +33 (0)4 71 68 87 10.
La Poterne: +33 (0)4 71 40 75 11.
La Préfète, brasserie:
+33 (0)4 71 40 70 55.
♥ Les Remparts: +33 (0)4 71 40 70 33.
Le Rétro, crêperie: +33 (0)4 71 40 72 00.
Les Templiers: +33 (0)4 71 40 71 35.

🛎 Local Specialties
Food and Drink
Carré de Salers (cookie) • Salers gentian
aperitif • Salers meat • Salers cheese.

Art and Crafts
Jewelry • Wooden toys • Lithographs and
watercolors • Pottery • Wood carvings •
Glassworking • Cutlery • Foundry • Horn
sculpture • Fashion • Art photography •
Basketry.

🗓 Events
Market: Wednesday mornings.
May: "Salon des Sites Remarquables du
Goût," food fair (1st); "La Pastourelle,"
walking, running, and mountain-biking
races.
July–August: Concerts.
August: Journée de la Vache et du
Fromage, cow and cheese festival; Folklore
gala (15th); pottery market.

🦋 Outdoor Activities
Auvergne Volcanoes regional natural
reserve • Walking, bike tours, and bridle
paths • La Peyrade: rock-climbing.

🌿 Further Afield
• Route du Puy May, scenic drive:
Les Burons de Salers, shepherds' huts
(2½ miles/4 km); Récusset and Falgoux,
volcanic landscape (7½ miles/12 km);
Puy Mary, volcano (12½ miles/20 km).
• Route de Mauriac, scenic drive: Maison
de la Salers (3 miles/5 km); Château
de la Trémolière (7 miles/11 km);
Estives pathways (10½ miles/17 km).
• Route de Saint-Paul-de-Salers, scenic
drive: monolithic Fontanges chapel
(3½ miles/6 km); Puy Violent, summit
(7 miles/11 km); Château de Saint-
Chamant (11 miles/18 km); *Tournemire
and Château d'Anjony (17½ miles/28 km),
see p. 259; Jordanne gorges (19 miles/
31 km).
• Route des Crêtes, scenic drive: Aurillac
(28 miles/ 45 km).

Sare

Frontier traditions

Pyrénées-Atlantiques (64) • Population: 2,411 • Altitude: 230 ft. (70 m)

The Rhune and the Axuria, legendary mountains of the Basque Country, tower over this village, famous for both its tradition of hospitality and its festivals.

Ringed by mountains separating it from the Bay of Biscay and from Spanish Navarra, Sare honors vibrant Basque Country traditions. In particular, the tradition of the "Etxe," the Basque house, finds full expression here. Among the eleven scattered parts of this former shepherds' village, the Ihalar neighborhood is one of the oldest, and here houses date from the 16th and 17th centuries. Ortillopitz is an authentic residence from 1660, restored by a local family keen to keep their history and the significance of the Basque home alive for future generations; the house allows visitors to experience "L'Etxe où bat le cœur des hommes" ("The house where human hearts beat"). Numerous chapels and shrines contain votive offerings of thanks for survival in storms at sea—reminders that Sare inhabitants were also seafarers. A tradition of smuggling, made famous by Pierre Loti's classic novel *Ramuntcho* (1897), is also revisited each summer in a walking trail.

By road: Expressway A63, exit 4–Saint-Jean-de-Luz (10 miles/16 km); expressway A64, exit 5–Bayonne-Sud (15 miles/24 km).
By train: Saint-Jean-de-Luz station (8½ miles/13.5 km).
By air: Biarritz-Bayonne-Anglet station (18 miles/29 km).

ⓘ **Tourist information:**
+33 (0)5 59 54 20 14
www.sare.fr

👁 Highlights

• **Grottes de Sare, prehistoric caves:** New multimedia show tour about the geology of the site, and the origins and mythology of the Basque people: +33 (0)5 59 54 21 88.
• **La Maison Basque du Sare, Ortillopitz, traditional Basque house** (1660): Explore the Labourd architecture of the "Etxe," its authentic furniture, and Basque family life, on a substantial estate: +33 (0)5 59 85 91 92.
• **Musée du Gâteau Basque** (Maison Haranea): Explore the history, flavor, and appeal of the *gâteau basque* (filled cake), and learn how it was traditionally made: +33 (0)5 59 54 22 09.
• **Etxola animal park:** Many different types of domestic animal from France and abroad: +33 (0)6 15 06 89 51.
• **Village:** Church, Basque pelota court, medieval way, oratoires, evocation of Basque traditions and customs. Guided tours June–September; all year for groups by appointment: +33 (0)5 59 54 20 14.
• **Bell tower:** Guided tours of the bell tower and the most ornate bell in France; tower with oak floor and beams. Guided tours June–September for individuals; all year for groups by appointment: +33 (0)5 59 54 20 14.

• **La Rhune tourist train** (alt. 2,969 ft./ 905 m): 35-minute climb to the top of La Rhune: +33 (0) 59 54 20 26.
• **Suhalmendi, Basque pork discovery trail:** See Basque pigs in their natural habitat on a family walk up to the peak of Suhalmendi. Further information: +33 (0)5 59 54 20 14.

🗝 Accommodation

Hotels
Arraya***: +33 (0)5 59 54 20 46.
Lastiry***: +33 (0)5 59 54 20 07.
Baratxartea**: +33 (0)5 59 54 20 48.
Pikassaria**: +33 (0)5 59 54 21 51.
Guesthouses
Further information: Gîtes de France: +33 (0)5 59 46 37 00.
Locals' guest rooms, gîtes, walkers' lodges, and vacation rentals
Further information: +33 (0)5 59 54 20 14 www.sare.fr
Vacation villages
VVF Villages Ormodia +33 (0)5 59 54 20 95.
Campsites
La Petite Rhune***, chalets for rent: +33 (0)5 59 54 23 97.
Tellechea*: +33 (0)5 59 54 26 01.
Goyenetche (including rural campsite): +33 (0)5 59 54 28 34.

🍽 Eating Out

Akoka, wine bistro: +33 (0)5 40 07 58 55.
Antton, light meals: +33 (0)9 48 59 91 61.
Arraya: +33 (0)5 59 54 20 46.
Baketu: +33 (0)6 37 38 01 22.
Baratxartea: +33 (0)5 59 54 20 48.
Berrouet: +33 (0)5 59 54 21 96.
Halty: +33 (0)5 59 54 24 84.
Hordago Ostatua: +33 (0)6 85 55 10 13.
Olhabidea: +33 (0)5 59 54 21 85.
Pikassaria: +33 (0)5 59 54 21 51.
Pleka: +33 (0)5 59 54 22 06.
Sare et Thé, tea room: +33 (0)5 24 33 46 10.
Les Trois Fontaines: +33 (0)5 59 54 20 80.
Urtxola: +33 (0)5 59 54 21 31.
Venta Lizaieta: +33 (0)9 48 98 71 36.

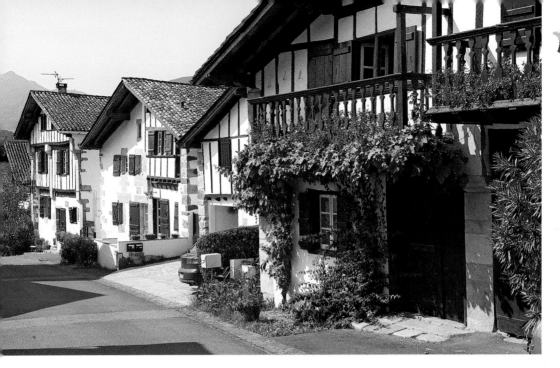

🛒 Local Specialties

Food and Drink
Gâteau basque • Farm produce • Cheese • Honey • Cider.

Art and Crafts
Bentas (border shops) • Fabric and Basque designs.

🗓 Events

Markets: Farmers' market and craft market, Fridays 4.30 p.m.–8.30 p.m. (April–September).
Farmers' market, Saturdays 9 a.m.–1 p.m. (November–March).
Summer fair (craft market), Mondays 8 a.m.–1 p.m. (September–October).
February or March: Carnival.
Easter Monday: "Biltzar," Basque Country writers' fair.
June: Sare mountain-biking excursion (last Sunday).
July–August: Basque singing and dancing, trials of strength, *boules* games.
July: National Pottok horse competition (3rd Saturday).
August: "Cross des Contrebandiers," cross-country race (Sunday after 18th).
September: Sare festival (2nd week, Saturday–Wednesday).

October: "Les Charbonnières," traditional charcoal fires (demonstrations, workshops, etc.); "La Palombe," wood pigeon hunt.
November: Santa Katalina's day (3rd Sunday).
December: La Rhune, ascent by train, descent on foot (1st Saturday).

🦋 Outdoor Activities

Hunting wood pigeons (October–November) • Wild-salmon river fishing (tuition and guide) • Horse-riding • Basque pelota • Walking: Routes GR 8 and GR 10, and 8 marked trails; hiking across the Spanish border • Mountain-biking: 3 trails.

🥾 Further Afield

• Old farms in Ihalar, Istilart, Lehenbiskaï, and Xarbo Erreka (1 mile/1.5 km).
• Église Saint-Martin (17th century) (1 mile/1.5 km).
• Xareta: *Ainhoa, see p. 152; Urdax; Zugarramurdi (5–6 miles/8–9.5 km).
• Ascain, Ahetze, Arbonne, Biriatou, Ciboure, Guéthary, Hendaye, Saint-Jean-de-Luz, Saint-Pée-sur-Nivelle, Urrugne (8½–10 miles/13.5–16 km).
• Espelette (9½ miles/15.5 km).
• Cambo-les-Bains: poet and dramatist

Edmond Rostand's house (12 miles/19 km).
• Biarritz, Bayonne (12–15 miles/19–24 km).
• Bidassoa valley (14–28 miles/23–45 km).
• *La Bastide-Clairence (24 miles/39 km), see pp. 160–61.
• Saint-Jean-Pied-de-Port (31 miles/50 km), pp. 242–43.

ⓘ Did you know?

Sare has a frontier 18 miles (29 km) long, which gives it the longest shared boundary with Spanish Navarra in the whole province. Smuggling began as an act of solidarity, as a means of providing basic essentials, but was equally an expression of the common values and identity the Basques shared. Among the many stories linked to this tradition, a popular one tells of a movie filmed at Sare in 1937, based on Pierre Loti's novel *Ramuntcho*, about a Basque smuggler. The orchestra of 120 singers and musicians was a little unusual as it included a number of smugglers—as well as the popular Basque singer Luis Mariano, who was making his debut.

Sarrant

A circular stronghold

Gers (32) • Population: 400 • Altitude: 410 ft. (125 m)

Sitting on the ancient Roman road between Toulouse and Lectoure, at the edges of the Lomagne, Sarrant wraps itself around the church of Saint-Vincent.

Sarrant's ancient origins are known because Roman maps include "Sarrali" along one of the five main routes out of Toulouse. The village started to expand in 1307, thanks to the "charter of customs" and the privileges it was accorded by Philippe Le Bel. Sarrant is separated from the simple chapel of Notre-Dame-de-la-Pitié and its cemetery by a wide boulevard shaded by plane trees, and its main entrance is a 14th-century vaulted gate cut into a massive square tower, a vestige of Sarrant's protective walls. While the ramparts, blocked off by the houses embedded in them, have in part disappeared, and the ditches been filled in, the village itself has kept its circular street plan. Inside the historic center, the main street is lined with tall, stone houses whose upper stories are frequently corbeled and are made from cob and half-timbering. The parish church stands in the middle of the circle; it was rebuilt and enlarged after the Wars of Religion, before being topped in the 19th century by a fine octagonal flèche that soars above the beautiful rooftops of Sarrant.

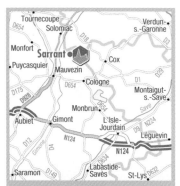

By road: Expressway A20, exit 65–Agen (31 miles/50 km); expressway A624–N124, exit L'Isle-Jourdain (15 miles/24 km).
By train: L'Isle-Jourdain station (14 miles/23 km); Auch station (24 miles/39 km).
By air: Toulouse-Blagnac airport (35 miles/56 km).

ⓘ Tourist information:
+33 (0)5 62 65 00 32 / www.sarrant.com

◉ Highlights
• **Église Saint-Vincent and medieval village:** Guided tours by appointment: +33 (0)5 62 06 79 70; program of children's activities exploring the Middle Ages: +33 (0)6 86 22 06 58.
• **Tour of the town gate:** Exhibitions.
• **Medieval garden:** Free entry.
• **Roman fountain.**
• **Chapel:** Exhibitions
• **Maison d'Illustration:** Exhibitions of illustration; workshops: +33 (0)5 62 66 00 32.

⚷ Accommodation
Guesthouses
Domaine Mahourat****: +33 (0)6 70 28 26 43.
En Louison: +33 (0)7 85 10 34 56.
Gîtes
Au Terrascle***: +33 (0)5 62 65 00 33.
Les Clarettes***: +33 (0)5 62 65 02 89.
Le Clos de Sarrali***: +33 (0)6 76 38 59 20.
En Gardian***: +33 (0)5 62 61 79 00.

Les Gruets**: +33 (0)5 62 07 49 32.
Lefèvre**: +33 (0)5 62 65 19 40.
La Clé des Champs, gypsy caravan: +33 (0)5 62 65 01 40.
Le Clos d'Ondres: +33 (0)5 76 38 59 20.
Lo Riberot: +33 (0)6 83 70 64 11.
Plaisance: +33 (0)6 77 82 20 41.
RV parks
Route de Solomiac: +33 (0)5 62 65 00 34.

⑪ Eating Out
Des Livres et Vous, bookshop and restaurant; 11 a.m.–6 p.m.; evening booking recommended: +33 (0)5 62 65 09 51.
Le Family: +33 (0)5 62 07 61 60.

🎒 Local Specialties
Art and Crafts
Wood turner and -carver • Bookbinder.

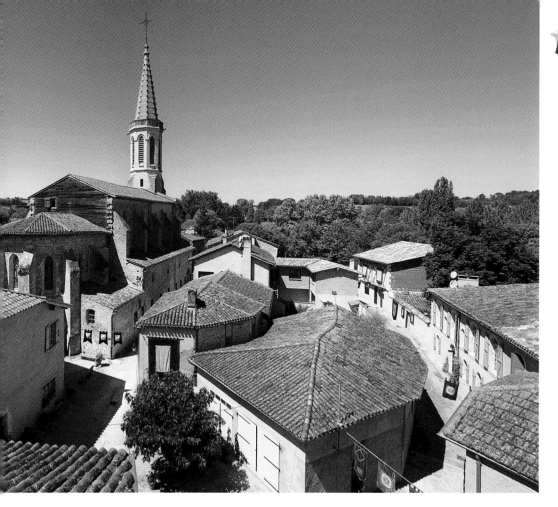

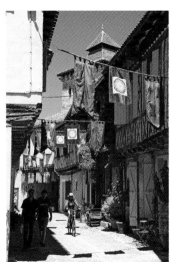

▨ Events

May: "Tatoulu," young people's literature prize: +33 (0)5 62 65 09 51.
July: "Les Estivales de l'Illustration," art and illustration festival (Thursday–Sunday, after 14th).
July–August: Exhibitions at the chapel.
August: Pottery market (1st weekend); local festival (last weekend).

🦋 Outdoor Activities

Donkey rides and carriage rides • Walking and mountain-biking: 2 marked trails.

🌿 Further Afield

• Brignemont: mill (3 miles/5 km).
• Cologne, fortified village (4½ miles/7 km).
• Mauvezin, fortified village (5 miles/8 km).
• Château de Laréole (7 miles/11.5 km).
• Beaumont-de-Lomagne, fortified village (9½ miles/15.5 km).

• L'Isle-Jourdain (14 miles/23 km).
• Fleurance (17 miles/27 km).
• Auch: cathedral (25 miles/40 km).
• *Lavardens (27 miles/43 km),
see pp. 204–5.

❗ Did you know?

During the French Revolution, Sarrant became an enclave of fierce resistance to Republican abuses of power. On Palm Sunday 1793, young revolutionaries cut down the tree of liberty, a symbol of the Republic, which had been planted the previous year in front of the town gate. Such a crime could only bring trouble on those who committed it: they were imprisoned at Auch, in Armagnac Tower, whence none of them came out alive.

Sauveterre-de-Rouergue

Royal fortified village rich in arts and crafts

Aveyron (12) • Population: 803 • Altitude: 1,575 ft. (480 m)

The royal *bastide* of Sauveterre-de-Rouergue, halfway between Albi and Rodez, is brought alive by the passion and expertise of its crafts-people.

From its medieval past the village has kept its original 1281 street plan, the Saint-Christophe and Saint-Vital fortified gates, the rectilinear streets, and the central square complete with forty-seven arcades. The history of this centuries-old, lively site is told through its superbly corbeled stone and half-timbered houses, its 14th-century collegiate church of Saint-Christophe and its contents, and its coats of arms and stone carvings sprinkled across the façades. Proud of its illustrious past as an important center for artisanal skills, the village had new life breathed into it a few decades ago by pioneering modern artists. Widely acknowledged as a center for arts and crafts, Sauveterre continues to showcase its cultural heritage, passion for beauty, and commitment to excellence.

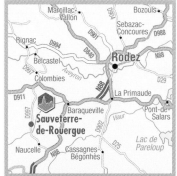

By road: Expressway A75, exit 42–Rodez (55 miles/89 km), N88, exit Baraqueville (8 miles/13 km); expressway A68, then N88, exit Naucelle (5½ miles/9 km). **By train:** Naucelle station (5½ miles/9 km). **By air:** Rodez-Marcillac airport (31 miles/50 km); Toulouse-Blagnac airport (86 miles/138 km).

ⓘ Tourist information:
+33 (0)5 65 72 02 52
www.sauveterre-de-rouergue.fr

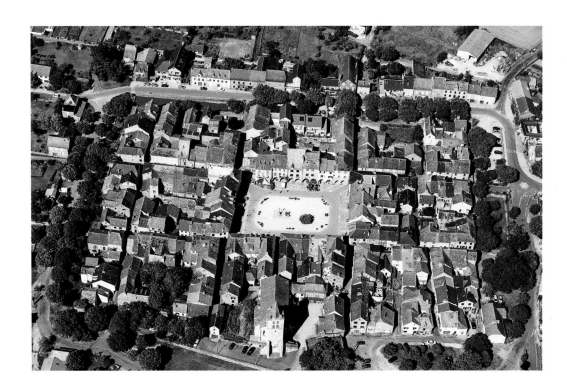

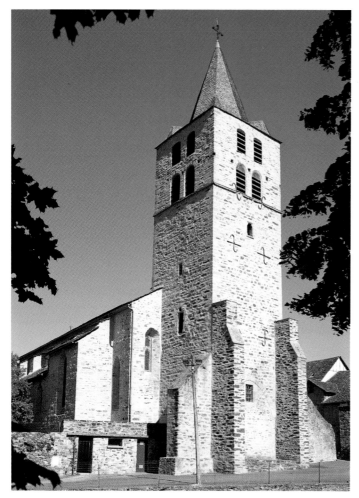

Le Restaurant de la Gazonne:
+33 (0)6 29 82 19 11.
Le Sénéchal: +33 (0)5 65 71 29 00.
La Terrasse du Sénéchal:
+33 (0)5 65 71 29 00.

🧺 Local Specialties
Food and Drink
Duck and foie gras • *Échaudés* (Aveyron cakes) • Goat cheese.
Art and Crafts
Painters • Jeweler • Ceramicist-engraver • Cutlers • Glassblowers • Cabinetmaker • Leather crafts • Painted furniture • Illustrator • Sculptor • Landscape watercolorist • Photographer • Luthiers.

🗓 Events
Market: Sundays 8 a.m.–1 p.m.; evening farmers' market, Fridays 6 p.m.–11 p.m. (July–August).
May: "Soft'R," contemporary music festival.
August: Fête de la Lumière, festival of lights (2nd Saturday).
September: "Fête du Melon et de l'Accordéon," festival of rock music and melon-eating (1st Sunday).
October: "Root'sergue," reggae and world music festival (last Saturday); Fête de la Châtaigne et du Cidre Doux, chestnut and cider festival (last Sunday).

🦋 Outdoor Activities
La Gazonne recreation areas: swimming pool, disc golf: 18 baskets • *Boules* area • Walking and moutain-biking: marked trails.

🌿 Further Afield
• Pradinas: wildlife park (6 miles/9.5 km).
• Château du Bosc (9½ miles/15.5 km).
• Viaur Viaduct (11 miles/18 km).
• *Belcastel (17 miles/27 km), see pp. 162–63.
• Rodez (22 miles/35 km).
• *Monestiés (23 miles/37 km), see p. 210.

👁 Highlights
• **Collegiate Church of Saint-Christophe** (14th century): Southern Gothic style; 17th-century altarpiece.
• **Village:** Guided tours by appointment, from tourist information center; braille guides and spoken-word tour of the village narrated by its inhabitants available.
• **"La Bastide au 16e Siècle":** Multimedia exhibition of life in the fortified town in the 16th century, based on the travel diary of a Swiss student who visited here.
• **Espace Lapérouse:** Permanent and temporary craft exhibitions; tour of art and craft studios by arrangement with tourist information center.

🗝 Accommodation
Hotels
Le Sénéchal****: +33 (0)5 65 71 29 00.
Guesthouses
Les Eaux Vives: +33 (0)6 07 89 31 57.
Lou Cambrou: +33 (0)7 86 68 41 87.
Villa Elia: +33 (0)6 63 98 36 60.
Gîtes
Further information: +33 (0)5 65 72 02 52
www.sauveterre-de-rouergue.fr
Chalets and RV parks
Les Chalets de la Gazonne:
+33 (0)5 65 72 02 46.
Le Sardou, RV park: +33 (0)5 65 72 02 52.

🍽 Eating Out
Le Bar des Amis, pizzeria:
+33 (0)5 65 72 02 12.

❗ Did you know?
The family of naval officer and explorer Jean-François de Galaup owned properties in and around Albi, and in Sauveterre, from where his mother and grandmother came. The family house in the village was for a long time the presbytery, but it has recently been restored, and now artists and craftspeople work and exhibit there. It is called the Espace Lapérouse and is part of the fortified village's artistic center.

Ségur-le-Château

A safe haven in the depths of Limousin and Périgord

Corrèze (19) • Population: 240 • Altitude: 984 ft. (300 m)

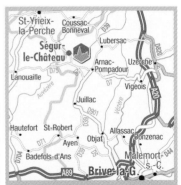

Birthplace of the viscounts of Limoges, Ségur is lit up brightly at night, and the reflections of its fortress shimmer in the waters of the Auvezère.

Ségur comes from the French *lieu sûr*, meaning "place of safety," and it is exactly that: situated on a rocky outcrop, surrounded by forbidding hills, and encircled by a network of outpost castles. All these factors helped a village to develop here, huddling against the protective fortress walls. Then craft and commercial activities expanded. The village's reputation spread during the 15th to 18th centuries, owing to the presence of a court of appeal, responsible for dispensing justice to 361 seignorial estates between Limousin and Périgord. From this prosperous period, there remain noble houses with turrets or half-timbering, towers with spiral staircases, huge fireplaces, and carved granite mullioned windows. Among the village's other noteworthy buildings are a 15th-century granite residence topped with a tower and turrets, the watchtower, the tower of Saint Laurent, and Maison Henri-IV.

By road: Expressway A20, exit 44–Saint-Ybard (16 miles/26 km); expressway A89, exit 17–Thenon (29 miles/47 km); N21 (24 miles/39 km). **By train:** Saint-Yrieix-la-Perche station (9½ miles/15.5 km). **By air:** Limoges-Bellegarde airport (42 miles/68 km); Brive-Vallée de la Dordogne airport (47 miles/76 km).

ⓘ **Tourist information—Pays de Saint-Yrieix:**
+33 (0)5 55 73 39 92
www.tourisme-saint-yrieix.com

👁 Highlights
• **Église Saint-Léger** (19th century): Stained-glass window by contemporary artist Vincent Corpet, symbolizing Saint-Léger's torture.
• **Village:** Guided tours Mondays and Fridays, 10.30 a.m., July–August; by appointment out of season for groups of 10 or more. Further information: +33 (0)5 55 73 39 92.

⚷ Accommodation
Gîtes
Village gîte: +33 (0)5 55 73 53 21.

🍴 Eating Out
La Part des Anges:
+33 (0)5 55 73 35 27.
Le Pti Bar: +33 (0)6 52 09 38 94.

🧺 Local Specialties
Food and Drink
Trout • *Cul noir* (black-bottomed) farm pigs.
Art and Crafts
Terra-cotta sculptures and models • Porcelain painter.

▣ Events
July: Exhibitions.
July–August: Farmers' market (Mondays, 4 p.m.); exhibitions.
August: "Fête des Culs Noirs," pig festival (1st Sunday); flea market/outdoor rummage sale (2nd Sunday); street-painters' fair (close to 15th).

🦋 Outdoor Activities
Fishing • Walking: 4 marked trails.

🌿 Further Afield
• Château de Coussac-Bonneval (6 miles/9.5 km).
• Château de Pompadour; stud farm (6 miles/9.5 km).
• Vaux: ecomuseum of local heritage; paper-maker (6 miles/9.5 km).
• Saint-Yrieix-la-Perche (9½ miles/15.5 km).
• Uzerche (16 miles/26 km).
• *Saint-Robert (17 miles/27 km), see p. 245.
• Hautefort (25 miles/40 km).
• Brive (28 miles/45 km).
• *Saint-Jean-de-Côle (28 miles/45 km), see p. 241.

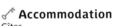

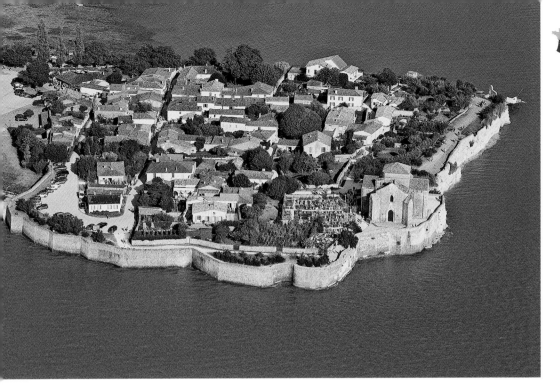

Talmont-sur-Gironde

Fortified village on an estuary

Charente-Maritime (17) • Population: 102 • Altitude: 16 ft. (5 m)

The Talmont promontory, girded by ramparts and crowned by its Romanesque church, seems to rise above the waves, in defiance of the waters of the Gironde.

This walled town was built in 1284 on the orders of Edward I of England, who also ruled Aquitaine. On a promontory encircled by the Gironde estuary, Talmont has kept its original medieval street plan. The streets and alleyways are punctuated by flowers, dotted with monolithic wells and sundials, and enlivened by craftspeople and traders. Streets lead to the tip of the promontory, where the 12th-century church of Saint Radegonde watches over the largest estuary in Europe. From the Romanesque church, a stop on one of the routes to Santiago de Compostela, the rampart walk follows the cliff to the port, still used by traditional skiffs. Unmissable features of Talmont's landscape and heritage are the stunning panorama over the bay, the port, the village, the estuary, and the fishermen's huts.

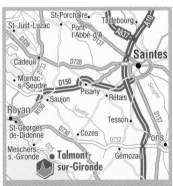

By road: Expressway A10, exit 36– Jonzac (17 miles/27 km). **By train:** Royan station (13 miles/21 km). **By air:** Angoulême-Brie-Champniers airport (70 miles/ 113 km); Bordeaux-Mérignac airport (81 miles/130 km).

ⓘ Tourist information—Royan Atlantique: +33 (0)5 46 08 17 62 www.royanatlantique.fr

👁 Highlights
• Église Sainte-Radegonde (6th–7th centuries).
• **Musées Historique et de la Pêche:** Local history museum on the site's geology; the church; the construction of the fortified town by Edward I, king of England; the American port built in 1917; and fishing in the lower Gironde estuary. Further information: +33 (0)5 46 90 16 25.
• **Naval cemetery:** Unique on the Atlantic coast; many memorials overflowing with hollyhocks.
• **Village:** Guided tour by appointment: +33 (0)5 46 08 17 62.

🔑 Accommodation
Hotels
L'Estuaire**: +33 (0)5 46 90 43 85.
Guesthouses
Le Portail du Bas 🛏🛏: +33 (0)5 46 90 44 74.
La Maison de l'Armateur:
+33 (0)5 46 93 68 01.
La Talamo: +33 (0)5 46 91 16 66.
La Vieille Maison de la Douane:
+33 (0)6 79 87 44 18.
Gîtes and vacation rentals
L'Escale 🛏🛏🛏: +33 (0)6 02 24 03 98.
Chantevent 🛏🛏: +33 (0)5 46 02 50 97.
Le Pigeonnier 🛏🛏: +33 (0)6 88 34 81 04.
Le Portail du Bas 🛏🛏: +33 (0)5 46 90 44 74.
Jarriault: +33 (0)6 82 40 95 70.
La Maison du Puits: +33 (0)6 48 47 24 08.
Mille Fleurs: +33 (0)5 46 86 03 06.
L'Oubliance: +33 (0)6 48 47 24 08.
La Presqu'île: +33 (0)5 46 95 58 02.
Rose Trémière: +33 (0)6 34 52 34 51.

🍴 Eating Out
L'Âne Culotté: +33 (0)5 46 90 41 58.
La Brise: +33 (0)5 46 90 40 10.
L'Estuaire: +33 (0)5 46 90 43 85.
La Petite Cour: +33 (0)6 33 43 17 61.
Le Promontoire: +33 (0)5 46 90 40 66.
La Talmontaise: +33 (0)5 46 93 28 24.
Tea rooms
Les Délices de l'Estuaire:
+33 (0)5 46 96 31 44.
Merci Mamie: +33 (0)7 83 75 37 83.
Le P'tit Patio: +33 (0)6 62 21 13 69.
Les Saveurs de Talmont:
+33 (0)6 48 47 24 08.

🧺 Local Specialties
Food and Drink
Charente produce • Talmont wines.
Art and Crafts
Jewelry and clothes • Handmade gifts • Rocks, fossils, gems • Artists • Pottery • Moroccan crafts • Soap • Leather goods • Lace.

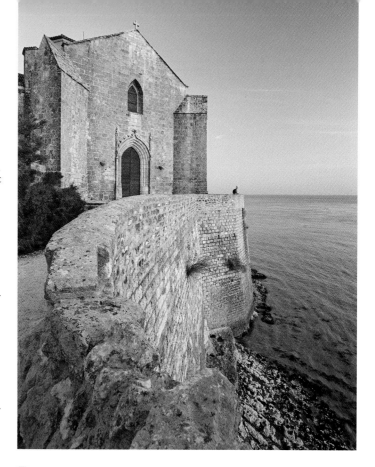

📅 Events
Market: Farmers' market, Sundays 9 a.m.–3 p.m (April 1–September 31).
April–October: Art exhibitions, Salle du Presbytère.
May: "Festival du Vent," kite festival.
July–August: Wander the village by candlelight, shops remain open, Tuesdays from 9 p.m.; multimedia show.
August: Talmont grand fair (2nd Sunday).

🦋 Outdoor Activities
Fishing • Mountain-biking and hybrid biking • Walking: Route GR 36 and walk to Caillaud cliff.

🌿 Further Afield
• Le Caillaud: vineyard activity trail (½ mile/1 km).
• Barzan: Fâ, Gallo-Roman site (1 mile/1.5 km).
• Arces-sur-Gironde: 12th-century church of Saint-Martin (2½ miles/4 km).
• Meschers-sur-Gironde: cave dwellings; beaches; estuary walks (3 miles/5 km).
• Cozes: church; covered market (5 miles/8 km).
• Saint-Georges-de-Didonne (6 miles/9.5 km).
• Royan (11 miles/18 km).
• *Mornac-sur-Seudre (18 miles/29 km), see p. 216.
• La Palmyre: zoo (22 miles/35 km).
• Saintes (22 miles/35 km).
• *Brouage (31 miles/50 km), see pp. 170–71.

❗ Did you know?
Around 1917, during the Russian Revolution, a Romanov princess was exiled to this area. When visiting Talmont-sur-Gironde, she was horrified to see sturgeon eggs being thrown to the hens and ducks. She brought in an expert, who taught the fishermen the real value of caviar; since then the little port has become an important center for its production.

Tournemire

A battle for supremacy

Cantal (15) • Population: 142 • Altitude: 2,625 ft. (800 m)

Set in the Volcans d'Auvergne regional nature park, Tournemire dominates the Doire river valley. In medieval times, two families fought for control of this village of tufa stone, which stretches down as far as the Château d'Anjony. In the Middle Ages the Tournemire family built a fortress on the tip of the Cantal massif, but a rivalry with the Anjony family, whose own castle, built in 1435, was close to the keep at Tournemire, signaled destruction for this fortress— nothing but ruins remain today. However, the Château d'Anjony, with its square body and four corner towers, remains intact, as does the low wing added in the 18th century. Inside, the building still has its vaulted lower hall at basement level. The chapel and knights' hall are decorated by 16th-century murals. Flanked by 14th- and 15th-century houses, the 12th-century village church is characteristic of the Auvergne Romanesque style. It contains wood carvings and the Holy Thorn, brought back from the Crusades by Rigaud de Tournemire.

👁 Highlights
• **Château d'Anjony** (15th century): Guided tours, concerts: +33 (0)4 71 47 61 67.
• **Church** (12th century): Sculptures, reliquary.

🗡 Accommodation
Hotels
Auberge de Tournemire: +33 (0)4 71 47 61 28.

Gîtes
Gîte: +33 (0)4 71 62 85 45.

🍴 Eating Out
La Petite Boutique, picnic bags, every day in summer

🏺 Local Specialties
Food and Drink
Traditional Auvergne produce.

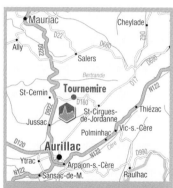

By road: Expressway A75, exit 23–Aurillac (52 miles/84 km); N122 (18 miles/29 km); expressway A89, exit 22–Egletons (54 miles/87 km). By train: Aurillac station (14 miles/23 km). By air: Aurillac-Tronquières airport (16 miles/26 km).

ⓘ Tourist information—Pays de Salers: +33 (0)4 71 40 58 08
www.salers-tourisme.fr

Art and Crafts
Strip-cartoon illustrator.

📅 Events
Market: Country market, Wednesdays 6 p.m. (July–August).
April: Journées Européennes des Métiers d'Art, European crafts festival (1st weekend).
July–August: Theater, concerts at the castle.
August: Local saint's day.
September: Journées du Patrimoine, heritage festival.
October: "Trail d'Anjony," cross-country race.
December: Christmas market (2nd Sunday).

🦋 Outdoor Activities
Walking.

🌿 Further Afield
• Col de Legal (7½ miles/12 km).
• Aurillac (16 miles/26 km).
• *Salers (17 miles/27 km), see pp. 248–49.
• Puy Griou and Puy Mary, volcanoes (22 miles/35 km).

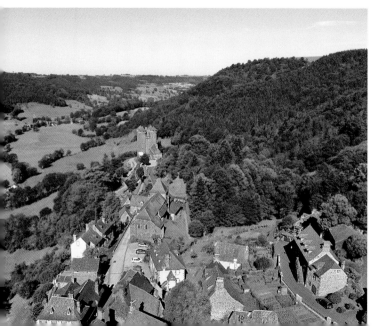

Turenne

A powerful ruling family in southwest France

Corrèze (19) • Population: 811 • Altitude: 886 ft. (270 m)

Located at the foot of an old citadel bearing still-impressive remains, Turenne was for ten centuries the seat of an important viscountcy.

The Caesar and Trésor towers, on top of a limestone mound (an outlier of the Causse de Martel), mark the site of the earlier fortress of the viscounts of Turenne, who ruled the Limousin, Périgord, and Quercy regions until 1738. Along its narrow streets and on its outskirts, the village has kept a remarkably homogeneous architectural heritage from this period of history. There are mansions from the 15th to 17th centuries, sporting turrets and watchtowers, and simple houses-cum-workshops too, all topped by *ardoise* (slate) tiles and presenting spotlessly white façades to the hot sun in this southern part of Limousin. They rub shoulders with the collegiate church of Saint-Pantaléon, consecrated in 1661, and the 17th-century Chapel of the Capuchins.

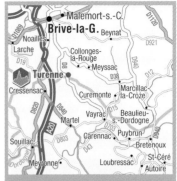

By road: Expressway A20, exit 52–Noailles (5½ miles/9 km). **By train:** Brive-la-Gaillarde station (9½ miles/15.5 km). **By air:** Brive-Vallée de la Dordogne airport (5 miles/8 km).

(i) Tourist information—Brive et Son Pays: + 33 (0)5 55 24 08 80
www.brive-tourisme.com
www.turenne.fr

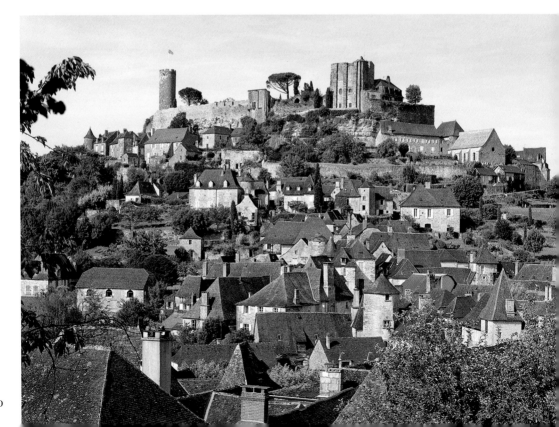

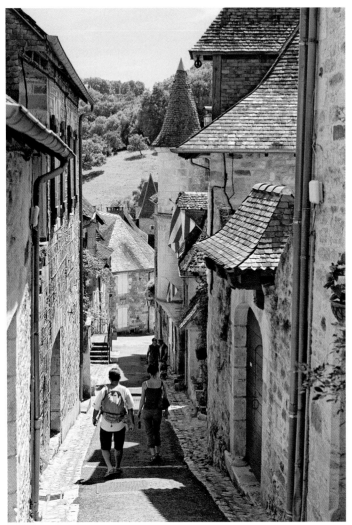

② Events

March or April (Maunday Thursday): "Foire aux Bœufs," cattle show.
July: Local saint's day (1st weekend); torchlit tour (3rd weekend); "Festival de la Vézère," music festival.
August: Outdoor rummage sale (3rd weekend).

🦋 Outdoor Activities

Fishing • Walking: Routes GR 46 and GR 480, and 6 marked trails.

🌿 Further Afield

• Gouffre de la Fage, cave (4½ miles/7 km).
• *Collonges-la-Rouge (6 miles/9.5 km), see pp. 182–83.
• Brive-la-Gaillarde (11 miles/18 km).
• Lac du Causse, lake (11 miles/18 km).
• *Curemonte (11 miles/18 km), see p. 187.
• *Carennac (15 miles/24 km), see pp. 177–78.
• Abbaye d'Aubazine (16 miles/26 km).
• Dordogne valley (16 miles/26 km).
• *Loubressac (19 miles/31 km), see p. 208.
• *Autoire (22 miles/35 km), see p. 157.
• Padirac; Rocamadour (22 miles/35 km).
• *Saint-Robert (25 miles/40 km), see p. 245.

ⓘ Did you know?

The viscount gained substantial benefits from his geographical location. These privileges were granted by the kings of England and France. The viscount raised an army, minted coins, ennobled his faithful servants, and answered only to the king. His subjects did not pay the king's taxes, did not accommodate his soldiers, and assembled each year to vote their viscount's grant. Until the estate was purchased by Louis XV in 1738, the viscountcy was what we would today call a tax haven, practically autonomous from the authority of the kings of France, with the right even to summon the Estates (nobles, clergy, and commoners). These freedoms aroused the envy of its neighbors and the bitterness of royal functionaries. No wonder the French have the adage "as proud as a Viscount"!

👁 Highlights

• **Castle:** César and Trésor towers, and garden: +33 (0)5 55 85 90 66.
• **Village:** Historical tours, interactive costumed tours, and evening visits in summer; group tours available: +33 (0)5 55 85 59 97.

🔑 Accommodation

Hotels
La Maison des Chanoines***: +33 (0)5 55 85 93 43.
Gîtes and vacation rentals
Further information: +33 (0)5 55 24 08 80
www.brive-tourisme.com

Vacation villages
La Gironie: +33 (0)5 55 85 91 45.

🍴 Eating Out

Au Temps Gourmand: +33 (0)9 84 34 93 06.
Les Capucins: +33 (0)5 55 24 43 11.
La Maison des Chanoines: +33 (0)5 55 85 93 43.
La Vicomté: +33 (0)5 55 85 91 32.

🏛 Local Specialties

Food and Drink
Walnut oil • Honey • Farmhouse bread.
Art and Crafts
Wood turner.

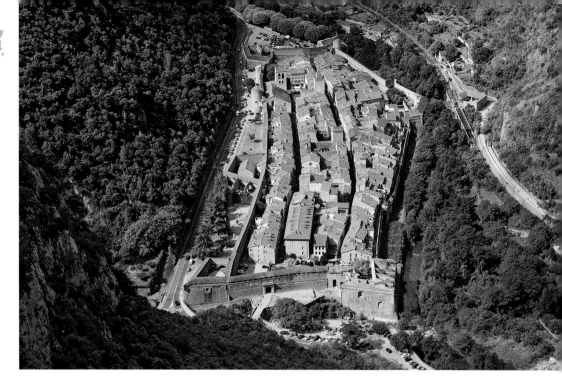

Villefranche-de-Conflent

A trading center and defensive site

Pyrénées-Orientales (66) • Population: 225 • Altitude: 1,417 ft. (432 m)

Villefranche-de-Conflent owes its reputation as a commercial center to its founder, Guillaume Raymond, count of Cerdagne, and its fortifications to the works of Vauban (1633–1707), a marshal of France.

Lying in a deep valley where the Cady and Têt rivers meet, the village occupied a strategic site since its foundation at the end of the 11th century; it later became the capital of the Conflent region. The belfry tower of La Viguerie was the administrative center, and the many shops are reminders that Villefranche was a commercial center. In the 17th century, the military engineer Vauban strengthened its role as military capital of this border region by adding his fortifications to the medieval ramparts, today listed as a UNESCO World Heritage Site. The Liberia Fort, linked to the village by the Mille Marches steps built up the mountainside, is an ingenious network of galleries equipped with twenty-five cannon ports. Inside the village, the buildings and the finest residences have stunning pink marble façades, and the Romanesque church of Saint-Jacques, filled with remarkable artifacts, is a reminder that Villefranche was on one of the key routes into Spain and on to Santiago.

By road: Expressway A9, exit 42– Perpignan-Sud (31 miles/50 km), N116.
By train: Villefranche-Vernet-les-Bains-Fuilla station (1 mile/1.5 km); Prades-Molitg-les-Bains station (5½ miles/9 km).
By air: Perpignan-Rivesaltes airport (34 miles/55 km).

ⓘ Tourist information—Conflent-Canigó: +33 (0)4 68 51 41 02
www.tourisme-canigou.com

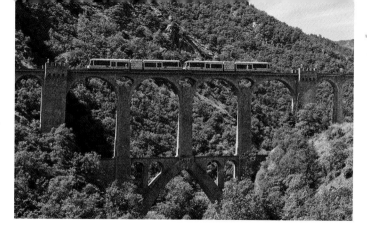

👁 Highlights
• **Église Saint-Jacques** (11th–14th centuries): 12th-century Romanesque carved portal, Baroque furniture (altarpiece by Joseph Sunyer, 1715). Further information: +33 (0)4 68 05 87 05.
• **Ramparts.** Further information: +33 (0)4 68 05 87 05.
• **Fort Liberia** (17th century): Tours of Vauban's site: +33 (0)4 68 96 34 01.
• **Petites and Grandes Canalettes** grottoes, stalactites, and stalagmites: Stunning geological display and multimedia show: +33 (0)4 68 05 20 20.
• **Cova Bastéra** (prehistoric grotto): Cave fortified by Vauban.
• **Village:** Village, ramparts, etc; guided tour (sensory tour, audioguides, Braille, and large-print guidebooks available). Further information: +33 (0)4 68 05 87 05.

🗝 Accommodation
Aparthotels
Le Vauban**: +33 (0)4 68 96 18 03.
Guesthouses
♥ L'Ancienne Poste 🎏🎏🎏🎏:
+33 (0)4 68 05 76 78.
Gîtes and vacation rentals
Further information: +33 (0)4 68 05 41 02
www.tourisme-canigou.com

🍴 Eating Out
L'Alchimiste, snack bar:
+33 (0)6 70 91 40 94.
Ar'Bilig, crêperie: +33 (0)6 47 73 68 57.
Auberge Saint-Paul:
+33 (0)4 68 96 30 95.
La Bonafogassa, light meals:
+33 (0)7 81 75 89 41.

Le Canigou, country bistro:
+33 (0)4 68 96 12 13.
L'Échauguette: +33 (0)4 68 96 21 58.
La Forge d'Auguste, crêperie:
+33 (0)4 68 05 08 65.
Forza Real, pizzeria: +33 (0)6 17 06 74 48.
Le Patio: +33 (0)4 68 05 01 92.
La Pizzeria des Remparts:
+33 (0)6 09 45 10 29.
Le Relais: +33 (0)4 68 96 31 63.
Le Saint-Jean: +33 (0)4 30 45 61 93.
La Senyera: +33 (0)4 68 96 17 65.
Le Vauban, light meals:
+33 (0)4 68 96 18 03.

🧺 Local Specialties
Food and Drink
Tourteaux à l'anis (aniseed cake).
Art and Crafts
Jeweler • Leather crafts • Ceramicist • Cabinetmaker • Wrought ironworker • Lapidary studio • Wax painting • Potters • Witch doll manufacturer • Soap and candles.

📅 Events
Easter Sunday: "Fêtes des Géants," Easter festival.
Easter Monday: "Aplec," pilgrimage to Notre-Dame-de-Vie.
June: Saint-Jean's and Saint-Pierre's feast days.
July: Saint-Jacques's feast day.

🦋 Outdoor Activities
Adventure park • Canyoning, caving • Walking.

🌿 Further Afield
• Saint-Martin-du-Canigou (5 miles/8 km).
• Saint-Michel-de-Cuxa (5 miles/8 km).
• *Eus (7½ miles/12 km), see p. 192.
• *Évol (8 miles/13 km), see p. 193.
• Cerdagne valley (19 miles/31 km).
• *Castelnou (23 miles/37 km), see p. 181.

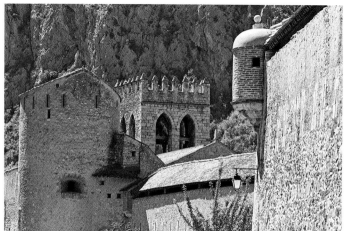

ℹ Did you know?
Each Easter, Villefranche-de-Conflent hosts the "Fête des Géants"—the festival of giants. In this traditional Catalan festival, two enormous papier-maché figures—nearly 10 ft. (3 m) high—dressed in medieval costumes and with a person inside, represent the founders of the village, Guillaume Raymond de Cerdagne and his wife, Sancia de Barcelona.
They wander the streets accompanied by musicians playing traditional instruments, as well as "giants" invited from other villages or towns in France and southern Catalonia.

Villeréal
Royal bastide and artistic center

Lot-et-Garonne (47) • Population: 1,321 • Altitude: 338 ft. (103 m)

Overhanging the Dropt valley, on the borders of Lot-et-Garonne and the Dordogne, the royal *bastide* of Villeréal combines a vibrant history with a gentle pace of life and an artistic vocation. Founded in 1267 by Alphonse de Poitiers, the *bastide* of Villeréal tells the tale, as do a number of its neighbours, of how Aquitaine was fought over at this time by England and France. The village has the classic arrangement of streets at right angles lined with half-timbered houses, but is also unique in having two squares. As is typically the case, the Place aux Cornières has a remarkable early 16th-century market hall in its center, whose upper storey is supported by impressive oak pillars; since 1269 it has teemed with life during the weekly market. Not far away, the 13th-century church overlooks the second square. Its massive silhouette, crenellated rampart walk, and two towers with pointed roofs linked by a gallery are reminders that this religious building also had a defensive role. Today, it is satisfying to see that the village has retained one of its original purposes as an active commercial center. In addition to the various markets that showcase local products (foie gras and confits, cheese, organic meat and vegetables, prunes) throughout the year, more than 150 traders and artisans provide for the inhabitants' daily needs. For a decade or so, a theater festival presenting plays created by the village's artists in residence has reinforced the cultural fiber of Villeréal. Indeed, from its horse festival to its jazz festival, not forgetting the "Feria de la Grande Bodega," this village is dedicated to bringing art into the heart of the community.

By road: Expressway A62, exit 7–Agen (22 miles/35 km); expressway A89, exit 13–Mussidan (35 miles/56 km); expressway A20, exit 15–Périgueux (30 miles/48 m).
By train: Bergerac station (22 miles/35 km); Agen station (37 miles/60 km); TGV Bordeau-Saint-Jean (93 miles/150 km).
By air: Bergerac-Dordogne-Périgord airport (19 miles/30 km); Agen–La Garenne airport (40 miles/64 km); Bordeaux-Mérignac airport (91 miles/147 km).

ⓘ Tourist information—Coeur de Bastides: +33 (0)5 53 36 09 65
www.coeurdebastides.com
www.mairie-villereal.fr

👁 Highlights
• **Église Notre-Dame de Villeréal** (13th century): Fortified church with crenellated rampart walk: +33 (0)5 53 36 43 84.
• **Guided tour of the *bastide*:** Further information: +33 (0)5 53 36 00 37.

🗝 Accommodation
Hôtel
Hôtel de l'Europe: +33 (0)5 53 36 00 35.
Guesthouses
La Maison Bleue***: +33 (0)5 53 70 34 20.
Lys de Vergne 🎵🎵: +33 (0)5 53 36 61 54.
Chambre Sainte Colombe:
+33 (0)5 53 71 29 11.
Lune et Croissant: +33 (0)9 54 70 00 58.
Gîtes and vacation rentals
La Colombière: +33 (0)5 53 36 02 41.
Gîte de Laplagne 🎵🎵: +33 (0)5 56 84 94 11.
Gîte de Jeancel 🎵🎵🎵: +33 (0)5 53 36 06 15.
Gîte de Rouilles: +33 (0)5 53 36 04 49.
Gîte de Rouquet: +33 (0)5 53 36 06 97.
Le Jeanquet de Villeréal:
+33 (0)5 53 36 09 33.
Maison Sirgue: +33 (0)6 33 57 22 99.
Moulin de Barbot: +33 (0)5 53 36 62 82.
Le Moulin de la Fage Haute:
+33 (0)5 53 36 02 55.
Mme and M. Pichet: +33 (0)5 53 71 79 35.
Une Maison Rue Saint Michel:
+33 (0)6 40 64 58 64.

🍽 Eating Out
Restaurants
Le Boudoir: +33 (0)7 67 83 46 90.
Casa Real: +33 (0)7 82 66 45 17.
La Dolce Vita: +33 (0)5 53 71 64 02.
Fromages et Plus, wine bar and regional light meals: +33 (0)5 53 49 25 39.
L'Hippocampe: +33 (0)5 47 99 05 36.
Les Marronniers: +33 (0)5 53 36 03 33.
Le Moderne: +33 (0)5 53 40 78 39.
Restaurant de l'Europe:
+33 (0)5 53 36 00 35.
La Roma: +33 (0)5 53 71 27 52.
Tea rooms
Le Boudoir: +33 (0)7 67 86 46 90.
Maggie's: +33 (0)5 53 01 21 27.
Pâtisserie Rodot: +33 (0)5 53 36 00 61.

🧺 Local Specialties
Food and Drink
Products from southwest France • Flour.
Art and Crafts
Potter • Upholsterer and interior designer.

📅 Events
Market: Saturdays at the market hall; July to mid-September, farmers' market every Monday evening

May: Antiques market (1st).
June–September: Concerts beneath the market hall (every Sunday).**July:** Villeréal Festival (theater); "Feria la Grande Bodega," music festival (last Sunday).
July–August: Horse racing at the racetrack.
August: Rummage sale (3rd Sunday).
September: Horse festival (last Sunday).
All year round: Flea market (2nd Sunday of every month); live opera broadcasts from the Metropolitan Opera House, New York, and performances from the Comédie Française.

🦋 Outdoor Activities
Walking (2 circuits from Villeréal) • Tour of the *bastide* by bike.

🌿 Further Afield
• Château de Biron (7 miles/12 km).
• *Monflanquin (7 miles/12 km), see pp. 211–12. • *Monpazier: Musée des Bastides (9 miles/15 km), see pp. 213–14.
• Beaumont-du-Périgord (11 miles/17 km).
• Château de Gavaudun (11 miles/17 km).
• Château de Monbazillac (17 miles/28 km).
• Cloître de Cadouin (18 miles/29 km).
• *Belvès (19 miles/31 km), see pp. 164–65.
• Château de Bonaguil (19 miles/31 km).
• *Pujols-le-Haut (21 miles/33 km), see pp. 226–27.

♟ Did you know?
The *bastide* of Villeréal was founded through a *paréage*—a collaborative agreement in feudal law—made between Gaston III de Gontaut, who was lord of Biron, the abbots of Aurillac, and Alphonse de Poitiers, who was the brother of Louis IX. The new royal town (*ville royale*) thus obtained its name from its prestigious connections.

Hell-Bourg
(commune of Salazie)

Creole heritage at the heart of the "intense island"

La Réunion (97) • Population: 2,000 • Altitude: 886 ft. (270 m)

On the southern side of the Cirque de Salazie amphitheater, the natural entrance to the "peaks, cirques, and ramparts" designated as a UNESCO World Heritage Site, Hell-Bourg devotes itself to Creole tradition, lifestyle, and hospitality.

The Cirque de Salazie (a volcanic caldera) sets the scene for Hell-Bourg: ravines plunge into the Rivière du Mât, and waterfalls gush down the rock face, its lush vegetation maintained by the humidity of the trade winds blowing in from the Indian Ocean. For a long time the refuge of slaves fleeing from plantations on the coast, the Hell-Bourg area was colonized from 1830. With the discovery, the following year, of therapeutic springs, Hell-Bourg became a fashionable spa that was frequented by the island's well-to-do families every summer. Thatched huts gave way to villas adorned with pediments and mantling and surrounded by verandas opening onto gardens with bubbling freshwater fountains. Since the thermal springs dried up as the result of a cyclone in 1948, Hell-Bourg has maintained and perpetuated the architectural heritage of this lavish period, and has sought to return to the roots of its Creole heritage.

By road: N2 (16 miles/26 km), D48.
By air: Saint-Denis airport (31 miles/50 km).

ⓘ Tourist information—
Intercommunal de l'Est:
+33 (0)2 62 47 89 89
reunionest.fr / www.ville-salazie.fr

👁 Highlights

• **La Case Tonton:** Creole home, beliefs, and traditions. Guided tour daily from 8.30 a.m. Further information: Freddy Lafable, +33 (0)6 92 15 32 32, or Guid'A Nou, +33 (0)6 92 86 32 88.
• **Tour of Creole huts.** Guided tour by Freddy Lafable, +33 (0)6 92 15 32 32, or Guid'A Nou, +33 (0)6 92 86 32 88; self-guided tour with audioguide, rental from tourist information center.
• **Villa Folio and its garden:** 19th-century Creole house, visitor interpretive center, park, garden. Guided tours for individuals and groups: +33 (0)2 62 47 80 98.
• **Old thermal spa:** Explore the history of the former spa. Guided tour or self-guided tour. Further information: +33 (0)2 62 47 89 89.
• **Mare à Poule d'Eau:** Explore the tropical flora and fauna of one of La Réunion's most beautiful stretches of water. Guided tour with Guid'A Nou: +33 (0)6 92 86 32 88.
• **Landscaped cemetery.**
• **Museum of Musical Instruments:** +33 (0)2 62 46 72 23.

🔑 Accommodation

Hotels
Les Jardins d'Héva**:
+33 (0)2 62 47 87 87.
Relais des Cimes**: +33 (0)2 62 47 81 58.
Guesthouses
Le Relais des Gouverneurs 👤👤👤:
+33 (0)2 62 47 76 21.
L'Orchidée Rose: +33 (0)2 62 47 87 22.
Gîtes and vacation rentals
Further information: +33 (0)2 62 47 89 89.
Campsites
Le Relax, farm campsite:
+33 (0)2 62 47 83 06.

🍽 Eating Out

Chez Alice: +33 (0)2 62 47 86 24.
La Cuisine d'Héva: +33 (0)2 62 47 87 87.
Le Gouléo, fast-food restaurant:
+33 (0)6 92 62 36 24.
L'Orchidée Rose: +33 (0)2 62 47 87 22.
Le Petit Coin Créole, light meals:
+33 (0)6 92 36 66 78.
Relais des Cimes: +33 (0)2 62 47 81 58.
Ti Chouchou: +33 (0)2 62 47 80 93.
Villa Marthe: +33 (0)2 62 21 02 02.

🧺 Local Specialties

Food and Drink
Creole produce.
Art and Crafts
Local creations: basketry, pottery, paintings • Chayote straw-braiding.

📅 Events

May: Transrun by Decathlon, race.
June: Fête du Chouchou, festival devoted to the chayote fruit, the emblem of the Cirque de Salazie (tasting sessions, demonstrations, concerts, visits, etc.).
July: Memwar Nout Terroir, festival; Trail de La Réunion Hell-Bourg Ste-Marie, mountain race.
August: "La Cimasalazienne" mountain race; CiMaSa race.
September: Trail des Masters, race.
October: Trail de Bourbon, race.
December 20: Abolition of slavery festival.

🦋 Outdoor Activities

Walking (60 miles/100 km of trails) • Rock climbing • Canyoning • Trail bike station dedicated to nature sports.

🌿 Further Afield

• Natural and heritage sites of Salazie: Bé-Maho viewpoint, Mare à Poule d'Eau, Voile de la Mariée (2–10 miles/ 3–16 km).
• Bras-Panon: vanilla cooperative (16 miles/26 km).
• Grand-Îlet: Église Saint-Martin, church (19 miles/31 km).
• Saint-André: Tamil temples, Parc du Colosse, Bois-Rouge sugar refinery, and Savanna rum distillery (25 miles/ 40 km).
• Plaines des Palmistes plains, national park headquarters (31 miles/50 km).
• Saint-Denis (31 miles/50 km).
• Sainte-Rose: lava tunnels of the Piton de la Fournaise volcano (31 miles/50 km).

1. The Via Podiensis, one of the four French routes to Santiago de Compostela (GR 65).
2. The regional nature park surrounding Saint-Véran (Hautes-Alpes).
3. The Alsace wine route at Mittelbergheim (Bas-Rhin).
4. The Piton d'Anchaing, Hell-Bourg (La Réunion).

Walks and Hikes
in and around some of
The Most Beautiful Villages of France

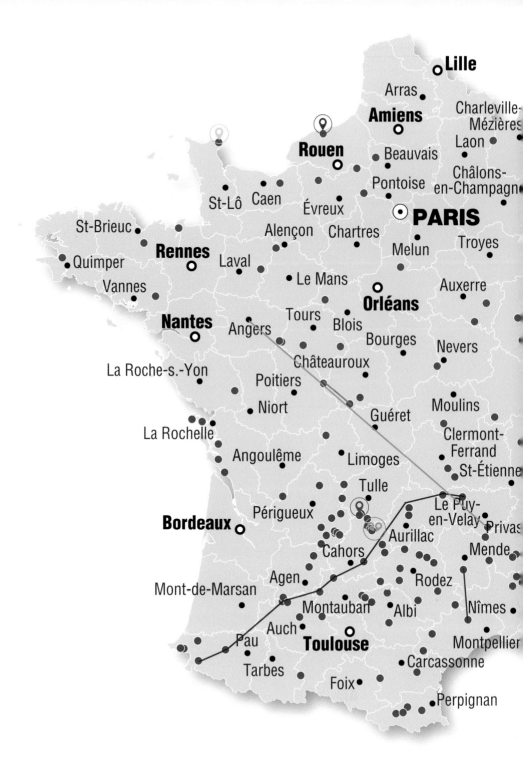

Bar-le-Duc

Metz

Nancy

Strasbourg

Épinal

Colmar

Chaumont

Belfort

Dijon

Vesoul

Besançon

Lons-le-Saunier

Mâcon

Bourg-en-Bresse

Annecy

Lyon

Chambéry

Grenoble

Valence

Gap

Digne-les-Bains

Avignon

Marseille

Nice

Bastia

Toulon

Ajaccio

Longer Hikes

On the St. James's Way, from Puy-en-Velay (Haute-Loire) to Saint-Jean-Pied-de-Port (Pyrénées-Atlantiques) (GR 65)

Puy-en-Velay (43) · Saint-Côme d'Olt (12) · Estaing (12) · Conques (12) · Lauzerte (82) · Auvillar (82) · La Romieu (32) · Larressingle (32) · Montréal-du-Gers (32) · Navarrenx (64) · Saint-Jean-Pied-de-Port (64)

The Via Podiensis (or Le Puy Way), the oldest French route to Santiago de Compostela, is now the GR 65. It is a long-distance footpath posing no real difficulty, way-marked and well served by places to stay.

This route starts in the Haute-Loire department and ends in the French Basque Country, at **Saint-Jean-Pied-de-Port**. Skirting the Gévaudan plateau, it crosses the Margeride mountains, the great flowered-covered steppes of Aubrac, and Aveyron as far as the abbey church at **Conques**. Then it traverses the green valleys of the Lot and, having crossed the Pont Valentré bridge at Cahors, passes Quercy and **Lauzerte**, then Moissac (together with its abbey)—land of the Chasselas and Melon grape varieties—near the Garonne river. Houses made from earth rub shoulders with numerous small limestone chapels, and farms thrive near their dovecotes and hill-top windmills. You can visit the collegiate church of **La Romieu** in Gers, and the

Gothic church of Sainte-Quitterie at Aire-sur-l'Adour in the Landes, before reaching the Basque Country and the foothills of the Pyrenees as you head toward Roncesvalles.

You can discover more of The Most Beautiful Villages of France on the GR 654 route that passes through Vézelay.

- **Best time to go:** April–September
- **Distance:** 470 miles (756 km)
- **Average time:** 32 days
- **Level of difficulty:** Moderately easy
- http://bit.ly/monGR65

The wild Loire river, from Mont Gerbier-de-Jonc (Ardèche) to Guérande (Loire-Atlantique) (GR 3)

Mont-Gerbier-de-Jonc (07) · Arlempdes (43) · Montsoreau (49) · Candes-Saint-Martin (37) · Guérande (44)

- **Best time to go:** May–October (avoiding high water levels)
- **Distance:** 772 miles (1,243 km)
- **Altitude:** Mont Gerbier-de-Jonc 4,600 ft. (1,400 m), Guérande 0 ft./0 m
- **Average time:** 60–70 days
- **Level of difficulty:** Easy
- http://bit.ly/monGR3

The GR 3 runs alongside the Loire river until it reaches the sea in the Gulf of Gascony, via the Brière wetlands and the Guérande salt marshes, following a course some 772 miles (1,243 km) in length.

Arlempdes, once the stronghold of Diane de Poitiers, now in ruins, is the first château along the river. Abundant flora and fauna, including many bird species, live in the game-filled forests and the nature reserves dotted along the course of the river. The GR 3 climbs the plateau of Le Puy-en-Velay, crosses the pasturelands of the Haute-Loire heading north, and ascends the slopes of the Monts du Forez, near Montbrison. Then it passes magnificent, legendary châteaux, almost all built from tufa stone—Sully-sur-Loire, Chambord, Chaumont-sur-Loire, Amboise, Villandry, Azay-le-Rideau, Montsoreau (near **Candes-Saint-Martin** and its abbey), Saumur, and Angers—which are surrounded by historic gardens, vineyards, and cave dwellings. It is impossible to name them all, since there are hundreds: in fact, the Loire valley boasts such a wealth of treasures that it has been listed as a UNESCO World Heritage site.

Crossing the Massif Central, from Sainte-Énimie (Lozère) to Saint-Guilhem-le-Désert (Hérault) (GTMC, GR 7, GR 74)

Sainte-Énimie (48)　Saint-Guilhem-le-Désert (34)

This section of the Grande Traversée du Massif Central (GTMC)—a long-distance hiking route—ends at the abbey of Gellone, where the medieval saint William of Orange (Guilhem in the Occitan language) died. This leg of the route is very diverse, taking in the invigorating landscape of Lozère, the dry stretches of the Causses limestone plateaus, and the Tarn Gorges.

The path starts in the cobbled alleyways of the village of **Saint-Énimie**, then takes in a view over the meandering Tarn river toward the Causse Méjean before tackling the Cévennes mountains at Mont Aigoual. To the south of Meyrueis, at the entrance to the Jonte Gorges, is a forest of chestnut trees, and the route later comes upon the Aulas silkworm farms.

Punctuated by stone crosses, the same route has for centuries been used by peddlars and their mules, weighed down with merchandise, and Mediterranean sheep on their way to summer pastures in the Aubrac region.

Beyond the Cirque de Navacelles, the climate becomes more Mediterranean on the Causse de Blandas, dotted with Neolithic menhirs and dolmens. The route then descends toward the Languedoc plain, the village of **Saint-Guilhem-le-Désert**, and the abbey of Gellone.

- **Best time to go:** April–July, September–October
- **Distance:** 79 miles (127 km)
- **Altitude:** 371 ft. to 4,373 ft. (113 m to 1,333 m)
- **Average time:** 7 days
- **Level of difficulty:** Suitable for experienced, well-equipped hikers
- http://bit.ly/Rando-Massif-central

La Brenne, from Saint-Benoît-du-Sault (Indre) to Angles-sur-l'Anglin (Vienne) (GR Pays de la Brenne)

Saint-Benoît-du-Sault (36)　Angles-sur-l'Anglin (86)

The region of La Brenne is known as the "Land of a Thousand Lakes." Its meadows and wetlands are home to an endangered species of turtle, water plants, 150 bird species, and thousands of cranes. The GR Pays de Brenne hiking route passes through Indre and its regional nature park; conservation of this natural space received a boost when it was included on the Ramsar List of Wetlands of International Importance, in particular as an exceptional waterfowl habitat.

This country route links the medieval town of **Saint-Benoît-du-Sault**—perched on a granite escarpment near Châteauroux—with **Angles-sur-l'Anglin**. The path follows the Anglin river valley, beneath cliffs where fifty varieties of wild orchid flourish.

To reach Angles-sur-l'Anglin, which sits at the crossroads of three provinces inhabited since prehistoric times, you will pass Saint-Benoît, Chaillac, Bélâbre, the church of Nesmes and its tower, which serves as a water tower, and then Ingrandes. Famous for its openwork embroidery (known as *jours*), Angles-sur-l'Anglin has preserved its narrow and twisting streets, medieval houses, and ruined fortress.

- **Best time to go:** All year round
- **Distance:** 60 miles (96 km)
- **Altitude:** 207 ft. to 830 ft. (63 m to 253 m)
- **Average time:** 4 days
- **Level of difficulty:** Easy
- http://bit.ly/Rando-Brenne

Day Hikes

A grand tour of the mine at Saint-Véran (Hautes-Alpes) (GR 58)

 Saint-Véran (05)

- **Distance:** 10 miles (15.7 km) (circular walk)
- **Altitude:** 6,419 ft. to 8,300 ft. (1,955 m to 2,531 m)
- **Average time:** 5½ hours
- **Level of difficulty:** Easy
- http://bit.ly/Circuit-Mine-Saint-Veran

Saint-Véran in the Queyras valley—where its traditional houses and church, with its Baroque altarpiece, are a tourist attraction—is the highest inhabited village in Europe. Shuttles relay visitors to an old mine near Notre-Dame de Clausis, where traces of copper-mining have been dated by archeologists to the Bronze Age, some four millennia ago.

In modern times, a company took over the site in 1901 in order to extract bornite, a sulfide containing 45 percent copper. Miners from Saint-Véran used skis to get here. The mine suffered many accidents, however, and had to close after torrential rains in 1957 destroyed the plant.

The custom officials' path at Barfleur (Manche) to the east of Cotentin (GR 223, from Saint-Vaast-la-Hougue to the Gatteville lighthouse via Barfleur)

 Barfleur (50)

The Val de Saire is a coastal paradise dotted with fishing villages and stormy beaches. At the port of Saint-Vaast-la-Hougue, about fifty trawlers fish for oysters, mussels, and scallops. This place witnessed firsthand the defeat of the famous Vice-Admiral de Tourville, the man who initiated the defensive works built by Vauban that are now listed as UNESCO World Heritage sites—including the towers of La Hougue peninsula and Tatihou island. Covering 72 acres (29 hectares), Tatihou is accessible on foot at low tide and features a bird sanctuary and botanical gardens.

The coast is protected by a dyke and sluice gates. After following the coastline, the trail arrives at **Barfleur**, a favorite haunt of Pointillist painter Paul Signac. Its small harbor is famous for its association with the Vikings and William the Conqueror, while its granite houses and fortified church blend into the gray of the coastline. Wild mussels (known as *Blondes de Barfleur*), crab, and lobster are caught here.

The final stop is Gatteville and its fishing port. The lighthouse over the English Channel stands 250 ft. (75 m) high; it has 365 steps and a range of 33 miles (53 km). Built between 1829 and 1835, it warns of strong currents from the strait down to Barfleur point.

- **Best time to go:** March–November
- **Distance:** 11 miles (16.95 km)
- **Altitude:** 0 ft. to 43 ft. (0 m to 13 m)
- **Average time:** 4½ hours
- **Level of difficulty:** Moderate
- http://bit.ly/Sentier-Douanier-Barfleur

The Piton d'Anchaing via Îlet à Vidot from Hell-Bourg (La Réunion) (GRR1, Hell-Bourg)

 Piton d'Anchaing (97)

- **Best time to go:** All year round (glorious sunshine, but weather can change rapidly)
- **Distance:** 7 miles (14 km)
- **Altitude:** 2,260 ft. to 4,450 ft. (688 m to 1,356 m)
- **Average time:** 5½ hrs
- **Level of difficulty:** Difficult: steep path, slippery when wet
- http://bit.ly/Rando-Hell-Bourg

The Piton d'Anchaing peak is named for a runaway slave who is said to have found refuge here. It can be reached from **Hell-Bourg** near Îlet à Vidot, by taking the path to the Old Baths or a little-used trail. Follow this trail until you reach the concrete track of Bras-Marron, which leads to a car park among the Creole gardens. At this point, a steep, narrow, rocky path plunges down to a footbridge over the river. More than 40 feet (12 m) below, the river collects in little pools between branches of ironwood, ideal for bathing. Take the path toward the Piton d'Anchaing.

At the chapel, the path begins to climb in switchbacks. The slope is steep for 1.2 miles (2 km), and is bordered with chayote squash, cherry guava, giant brambles, and mistflower. The earth steps are overgrown with roots because the vegetation is so dense here. After two hours you reach the summit, a plateau surrounded by ferns which offers a magnificent panorama over the whole Cirque de Salazie: cliffs and spectacular waterfalls, Roche Écrite, Le Cimendef, and all the hamlets in the area. On the descent, take care to avoid slipping on the gravel.

Circular hike from Autoire (Lot) to Loubressac (Lot) and back (GR 480 for the outward route; return by a path along the cliff above Autoire)

Autoire (46) Loubressac (46)

- **Best time to go:** All year round
- **Distance:** 5 miles (8.4 km)
- **Altitude:** Autoire 581 ft. (177 m); Loubressac 1,247 ft. (380 m)
- **Average time:** 2½ hours
- **Level of difficulty:** Moderate
- http://bit.ly/Rando-Autoire-Loubressac

A food-lovers' region offering pâté, truffles, and wine, the Lot also has many unique sites and characterful villages to visit.

The walking route leaves from one of these villages, **Autoire**, at the foot of the Causse de Gramat cliffs. This market town is nicknamed "Little Versailles" because its prestigious dwellings became a popular vacation destination during France's Second Empire (1852–70).

The route leads down a shady path to the Autoire waterfalls, 100 ft. (30 m) tall, which gave the village its name. To see them in all their glory, however, visitors will need to climb higher, to the viewpoint at Siran. From there, you can easily access the ruins of the Roque d'Autoire, the so-called "Château des Anglais," in the direction of **Loubressac**.

A little farther on, Loubressac sits atop its rocky outcrop, taking in the view of neighboring castles and the Dordogne valley, and showing off its elegant medieval houses with their distinctive roofs.

Walks Around the Villages

A ramble through Saint-Amand-de-Coly (Dordogne)

 Saint-Amand-de-Coly (24)

In the 6th century, Saint Amand came to a village in the woods and lived as a hermit in a cave there in order to convert it to Christianity. He founded a monastery (no longer in existence), and in 1124 an abbot ordered the construction of an abbey church nearby, including a porch some 98 ft. (30 m) high.

It was probably during the Hundred Years' War (1337–1453) that steps were taken to make the abbey church of **Saint-Amand-de-Coly** the most highly fortified in the region. In keeping with Périgord Noir tradition, it is built from locally quarried stone and roofed in *lauze* (schist). The church is considered the most beautiful in the area, despite the damage it sustained in the later 16th century during the Wars of Religion.

Themed panels at each stop on the history trail relate the history of the village and add context to the viewpoints, explaining its artistic and architectural heritage, the story of the abbey, and the life of its canons. There is a "fun route" that brings to life Périgord's legends and points out its wildlife, flora, and drystone huts. The forest section goes past a truffle field, complete with educational signboards. The trail then arrives back at the church and the guardhouse before continuing to the old hospital, which, with its washhouse and dovecote, was built by the priests in the 14th century to care for homeless invalids.

- **Best time to go:** All year round
- **Start:** Saint-Amand-de-Coly village
- **Distance:** 1.2 miles (2 km)
- **Altitude:** 413 ft. to 778 ft. (126 m to 237 m)
- **Average time:** 45 mins
- **Level of difficulty:** Easy
- http://bit.ly/Rando-Saint-Amand-de-Coly

France's shortest river at Veules-les-Roses (Seine-Maritime)

 Veules-les-Roses (76)

Nestled in a lush, green valley between Fécamp and Dieppe, beneath the cliffs of the Côte d'Albâtre, **Veules-les-Roses** is one of the oldest villages in the Pays de Caux area. It developed thanks to fishing, watermills, and the weaving of Rouen linen, and is home to churches, a château, and delightful Normandy houses worth discovering.

The village's well-appointed sea front and its wide beach of fine sand at low tide made it a very popular seaside resort in days gone by. Veules-les-Roses is also watered by the shortest river in France, the Veule, which is only three-quarters of a mile (1,149 m) from the sea. Its banks have tourist facilities and are suitable for walking.

Sparkling, clear water flows everywhere—through the village, down past the thatched Normandy cottages and their colorful gardens planted with roses, hortensias, and geraniums, irrigating the washhouses and the many watercress beds, and turning the last mills that were once used to process flax and cereals. Finally it plunges into the English Channel at a rate of 137 gallons (520 litres) per second.

- **Best time to go:** All year round
- **Start:** Veules-les-Roses beach (circular walk)
- **Distance:** 2 miles (3.5 km)
- **Average time:** 1½ hrs
- **Level of difficulty:** Easy
- http://bit.ly/Circuit-Veules

The wine route at Mittelbergheim (Bas-Rhin)

Mittelbergheim (67)

- **Start:** Zotzenberg car park
- **Distance:** 1 mile (1.8 km)
- **Altitude:** 1,050 ft. (320 m)
- **Average time:** 1 hr 40 mins
- **Level of difficulty:** Easy
- For guided tours, contact the town hall
- http://bit.ly/Sentier-Viticole-Mittel

First planted with vines in the 3rd century, Alsace's winegrowing region covers an area of about 59 square miles (15,200 hectares) and produces 160 million bottles per year.

Mittelbergheim is a small village of Renaissance-style houses on the side of a hill. To this day, its inhabitants keep a record of their Zotzenberg vineyard (which produces the only Sylvaner grand cru in existence) in a volume that dates back to 1456.

The winegrowers' trail leads ramblers through the vineyards and up to a viewpoint at the feudal castle of Haut-Andlau. In the spring, the trail is lined with wild tulips. The route is marked by panels depicting the seven grape varieties of the Alsatian winegrowing region, complete with illustrations for children explaining how the vineyards operate. The path climbs up to Rippelsholz, a picnic and relaxation area beside the car park.

The Ocher Trail at Roussillon, in the Luberon (Vaucluse)

Roussillon (84)

- **Best time to go:** February–December, ideally in sunny weather in the fall
- **Average time:** 30 mins (short trail) or 1 hour (long trail)
- **Level of difficulty:** Easy, but not recommended for those with limited mobility (350 steps); dogs on leashes are permitted
- http://bit.ly/Sentier-Ocres-Roussillon

Two different walks are open to the public on the Ocher Trail at Roussillon; both feature regular information panels on the geology, flora (oaks and junipers), and history of the massif. A combined ticket with the Conservatoire des Ocres is available.

Ocher is a pigment derived from the sand of eroded cliffs that owes its red, yellow, or purple color to the presence of iron oxide. The geological process of erosion, dating back millions of years, has created an extraordinary landscape of fairy chimneys in exuberant colors.

Practiced by the Romans in earlier times, ocher mining developed into a flourishing industry in the 17th century. About a hundred quarries used to supply twenty-five factories throughout the world. However, since the development of synthetic colors in the 1930s only one quarry remains.

The Conservatoire des Ocres, an organization based in the Luberon regional nature park, is in charge of this quarry. In addition, visitors can also tour the old factory, ponds, workshops, and furnaces, learning how ocher was extracted and transformed.

Index of Villages

Photographic Credits

With the exception of pages 8, 26, 47, 51, 66, 68, 77, 81t, 93, 104–105, 109, 110, 114, 128b, 133, 138, 162, 168–169, 172, 179, 206–207, 210, 211–212, 215, 216, 218, 223, 232–233, 238, 241, 243, and 259, all of the photographs featured in this book are published courtesy of the Hemis photographic agency:

4–7: Philippe Body; 12t: Philippe Blanchot; 12b: Hervé Levain; 14: Jean-Daniel Sudres; 15l: John Frumm; 15r: Christophe Boisvieux; 16–17: Franck Guiziou; 18: Francis Cormon; 19t: Jean-Daniel Sudres; 19b: René Mattes; 20: Francis Leroy; 21: Philippe Body; 22: Francis Leroy; 23: Hervé Lenain; 25–26: Hervé Lenain; 27 et 28b: Bertrand Rieger; 28t: Emmanuel Berthier; 29–30t: Francis Cormon; 30b: Franck Guiziou; 31–32: Emmanuel Berthier; 33: Hervé Lenain; 34: Philippe Body; 35: Arnaud Chicurel; 36t: Hervé Hughes; 36b: Philippe Body; 37: René Mattes; 38: Philippe Roy; 39–40: Francis Cormon; 41–43: Hervé Lenain; 44–45: Philippe Body; 46: Jean-Daniel Sudres; 48: Bertrand Rieger; 49: Bertrand Rieger; 50: Hervé Lenain; 54–55: Hervé Lenain; 56: Franck Guiziou; 57: Arnaud Chicurel; 58: Sylvain Sonnet; 59t: René Mattes; 59b: Denis Caviglia; 60: Arnaud Chicurel; 61: Denis Caviglia; 62: René Mattes; 63: Sylvain Cordier; 64: Denis Caviglia; 65: Hervé Lenain; 67: Denis Bringard; 69: Philippe Moulu; 70: Franck Guiziou; 71: Andrea Pistolesi; 72–73: René Mattes; 74: Denis Bringard; 75: Denis Caviglia; 76: Arnaud Chicurel; 80–81b: Franck Guiziou; 82: Michel Cavalier; 83t: Camille Moirenc; 83b: Michel Renaudeau; 84: Guy Christian; 85: Sylvain Sonnet; 86: Jean-Pierre Degas; 87–88: Franck Guiziou; 89: Pierre Jacques; 90: René Mattes; 91: Hervé Lenain; 92: Denis Caviglia; 94: Matthieu Colin; 95: Franck Guiziou; 96: Michel Cavalier; 97: Matthieu Colin; 98–99: Jean-Pierre Degas; 99: Camille Moirenc; 100–101: Pierre Jacques; 101: Denis Caviglia; 102: Lionel Montico; 103: Franck Guiziou; 106: Hervé Lenain; 107: Franck Guiziou; 108: Michel Cavalier; 111: Lionel Montico; 112: Franck Guiziou; 113: Pierre Jacques; 115: Lionel Montico; 116: Camille Moirenc; 117: Lionel Montico; 118: Franck Guiziou; 119: René Mattes; 120: Jean-Daniel Sudres; 121: Denis Caviglia; 122–123: Pierre Jacques; 124: Michel Cavalier; 125: Michel Gotin; 127: Franck Guiziou; 128t: Pierre Jacques; 131t: Lionel montico; 131b: Laurent Giraudou; 132: Denis Caviglia; 134: Franck Guiziou; 135t: Westend 61; 135b: Pierre Jacques; 136: Denis Caviglia; 137: Franck Guiziou; 139: Michel Cavalier; 140–141: Denis Caviglia; 142: Denis Caviglia; 143t: Jean-Pierre Degas; 143b: Sylvain Sonnet; 144: Denis Caviglia; 145: Christian Guy; 146: José Nicolas; 147: Franck Guiziou; 148–149: Pierre Jacques; 152: Pierre Jacques; 153: Philippe Body; 154: Didier Zylberyng; 155–156: Hervé Lenain; 157: Camille Moirenc; 158: Hervé Lenain; 159: Jean-Paul Azam; 160: Denis Caviglia; 161t: Jean-Daniel Sudres; 161b: Cédric Pasquini; 163: Pierre Jacques; 165: Bertrand Gardel; 166–167: Oleg Gorski; 170t–171: Hervé Lenain; 173: Francis Leroy; 173: Francis Leroy; 174: Franck Guiziou; 175: Philippe Body; 176: Francis Leroy; 178–179: Jean-Paul Azam; 180: Arnaud Chicurel; 181: Franck Guiziou; 182: Bertrand Gardel; 183: Jean-Paul Azam; 184: Stéphane Lemaire; 185: Jean-Paul Azam; 186: Pierre Jacques; 187: Jean-Paul Azam; 189t: Philippe Body; 189b: Robert Harding; 190–191: Jean-Pierre Degas; 191: Jean-Paul Azam; 192: Francis Leroy; 193: Franck Guiziou; 194: Francis Leroy; 195: Franck Guiziou; 196: Jean-Daniel Sudres; 197–198: Franck Guiziou; 199: Jean-Marc Barrere; 200: Didier Zylberyng; 202–203: Jean-Paul Azam; 204: Jean-Marc Barrere; 205: Jean-Paul Azam; 208: Arnaud Chicurel; 209: Franck Guiziou; 213: Patrick Escudero; 214t: Denis Caviglia; 214b: Francis Leroy; 217: Francis Leroy; 219: Jean-Pierre Degas; 222–223: Franck Guiziou; 225: Pierre Jacques; 226: Hervé Lenain; 227t: Denis Caviglia; 227b: Jean-Marc Barrere; 228–229: Jean-Paul Azam; 233b–234: Denis Caviglia; 235: Patrick Escudero; 237t: Hervé Tardy; 237b: Jean-Paul Azam; 239: Jean-Paul Azam; 240–241: Hervé Lenain; 242: Philippe Roy; 244: Gregory Gerault; 245: Jean-Paul Azam; 246–247: Hervé Lenain; 248: Jean-Daniel Sudres; 249: Hervé Tardy; 250: Jean-Daniel Sudres; 251: Denis Caviglia; 253: Jean-Paul Azam; 254: Francis Leroy; 255: Jean-Paul Azam; 256: Christian Guy; 257: Francis Leroy; 258: Hervé Lenain; 260–261: Christian Guy; 262: Jean-Paul Azam; 263t: Franck Guiziou; 263b: Jean-Daniel Sudres; 264–266: imageBROKER; 267: Gil Giuglio; 268t: Franck Guiziou; 268bl: Jean Robert; 268br: Denis Bringard; 269: image BROKER.

8: Marielsa Niels/PBVF; 26: Anne Gouvernel/PBVF; 47: P. Bernard/PBVF; 51: P. Bernard/PBVF; 66: Kazutoshi Yoshimura; 68: Thierry Drosson/ Mairie de Noyers; 77: Studio Morize; 81t: P. Bernard/PBVF; 93: Kazutoshi Yoshimura; 104–105: P. Bernard/PBVF; 109: Max Labeille/PBVF; 110: Kazutoshi Yoshimura; 114: P. Bernard/PBVF; 128b: P. Bernard/PBVF; 133: P. Bernard/PBVF; 138: P. Bernard/PBVF; 162: Gilles Tordjeman/Mairie de Belcastel; 168–169: P. Bernard/PBVF; 172: René Pierre Delorme/PBVF; 179: Kazutoshi Yoshimura; 206–207: Y. Lemaître/PBVF; 210: Kazutoshi Yoshimura; 211–212: Studio Veysset; 215: M. Laffargue/PBVF; 216: Anne Gouvernel/PBVF; 218: P. Bernard/PBVF; 223: Olivier Robinet; 232–233: Y. Lemaître; 238: P. Bernard/PBVF; 241: P. Bernard/PBVF; 243: Pierre Carton/ PBVF; 259: Jean-Michel Peyral.

All maps featured in this book were produced by Éditerra.

Flammarion would like to thank the Plus Beaux Villages de France association (Anne Gouvernel, Cécile Vaillon, and Pascal Bernard) and Éditerra (Sophie Lalouette).